SYMMETRY
AN ANALYTICAL TREATMENT

To Eva Fabé

SYMMETRY
AN ANALYTICAL TREATMENT

J. Lee Kavanau

University of California, Los Angeles

Science Software Systems, Inc.

Los Angeles, California

ISBN #0-937292-00-1

Library of Congress Catalog Card Number 80-52565

Published in the United States of America by Science Software Systems, Inc.

PREFACE

If this were a conventional work addressed only to mathematicians, I would shorten some of the treatments. There are two principal reasons why I have not done so. First, because I desire the book to be understandable to college students who have had a first course in analytical geometry. Although certain analyses require differential calculus, a background in the latter is not needed to follow the principal results. However, even in its present form, great dedication will be required for an undergraduate college student to comprehend the work in its entirety. Symmetry analyses are not for the faint of heart. One sometimes works with equations of staggering complexity--in some cases containing scores to hundreds of terms. But equations that I regarded as being impractical to work with in the early stages of my studies were handled routinely in later stages, and my assessment of the degree of complexity that constituted impracticality rose several levels.

The second reason for not abbreviating the treatment is that the topics of the book are by no means conventional. Although I expect the basic tenets to be accepted after due consideration, they are not directly intuitive. In the course of arriving at them, it was necessary for me to unburden myself of numerous misconceptions. Nor were substantive errors uncommon. In fact, the self-checking feature provided by the requirement for dimensional balance of equations seems essential in dealing by hand with equations of such complexity.

For these reasons I not only have not condensed the work, I have introduced a certain amount of redundancy and let stand some unintentionally repetitious material. For example, Chapter XI, *Inversion Taxonomy of the Quadratic-Based Inversion Superfamily* could be developed more concisely. I have preferred to leave it unmodified, in the belief that many readers will find it easier to follow in its present form. On the other hand, for mathematicians, only a few hints often suffice to lay bare the essential features of complicated relationships. To them, some parts of the work are bound to be excessively detailed and repetitious, and to them I apologize for not shortening some of the treatments.

I have been more concerned to explore the many and far-reaching geometrical applications of symmetry and inversion analyses than to construct a formal mathematical system. Consequently, I have presented certain results as Maxims, rather than theorems, and have supported many of them by heuristic discussions rather than formal proofs, though I see no obstacle, but time, that prevents these proofs.

It remains to explain why I wish the book to be understandable to the college student. I believe that the findings of this work will lead to greatly increased interest in analytical geometry and, ultimately, in all areas of mathematics, particularly among high school and college students. Because of the new areas of geometry that have been disclosed, a situation has arisen in which it is possible for the first time in many years, perhaps since the time of the Ancients, for beginning students in mathematics to make significant original contributions to the discipline of geometry.

For example, the intriguing topic of *circumcurvilinear symmetry* is one of vast extent, heretofore unexplored. While derivations of circumcurvilinear transforms of curves of higher than 2nd degree involve complex calculations, those of quadratics are readily accessible to beginning students. Aside from the circumconical symmetry of quadratics, only the circumcurvilinear symmetry of the parabola about the cissoid of Diocles is treated here.

In the fascinating area of inversion taxonomy there are hundreds of questions that remain unanswered--even unexplored--merely for the lack of time. There are scores of curves of unknown affinity that remain to be examined systematically. For example, I do not know whether even such a well-known curve as the folium of Descartes is related by inversion to any other previously known curve, and the taxonomy of other elementary point transformations of conic sections is barely in its infancy.

Some of these areas of inquiry are within the competence of virtually any analytical geometry student with a programmable calculator. Of course, that also was true of certain areas before the appearance of this work, but there was no prior appreciation of the significance of point transformations about all points in the plane for the *classification* of curves (although it is implicit that a transformation gives a related curve) or of their importance for providing a systematic organizational framework for symmetry analyses.

Similarly, in the area of undirected-distance coordinate systems, my limited

survey only whets the appetite for a systematic study of the comparative sym-
metry rank of curves in and between different coordinate systems. For this,
only the bare rudiments of algebra and analytical geometry are required, and
the studies can be carried out practically by routine application of formulae.
With few exceptions, undirected-distance coordinate systems have been neglected
by geometers of the past; they have several features that may account for this
neglect. But some of the very features that may have made them unattractive are
at the heart of their exceptional utility for certain aspects of the study of
symmetry.

Almost all aspects of circumpolar and circumlinear symmetry analyses by means
of intercept transformations are within the competence of students with a back-
ground in analytical geometry. Here also, the field is wide open. Even just a
characterization of the appearance of transforms about different point-poles
of a basis curve has yet to be accomplished. I have explored this matter only
for conics, the cardioid and the spiral of Archimedes. Aside from conics, conic
axial vertex cubics, limacons, and Cartesians, no curve has received more than
an exploratory circumpolar symmetry analysis and, even for the curves already
studied, the gaps are many and wide. But this latter area is one that sometimes
demands great fortitude and a calculator that will compute zeros of functions
(roots of equations).

Fig.
1-2

Another fascinating area is that of non-focal self-inversion loci. Here also,
many curves remain to be discovered. At one and the same time this is both the
easiest and the most difficult of the areas I have mentioned. For deriving the
plots of the loci, anyone with a ruler and dividing calculator could do the
work. But for the equational analyses, the difficulties for basis curves of
higher than 2nd degree are great. Some special cases, however, are certain to
yield readily to solution. Even with the experience gained from my studies, I
could spend years working in any one of the five areas mentioned above and
cover only a small fraction of the unknown ground.

A comforting aspect of carrying out complex basic symmetry analyses is that
one is fortified with the knowledge that, no matter how formidable a derivation
may appear to be at first sight, it very likely will work out beautifully in
the final analysis. Time and again I have been awed at the beauty of the combi-
nations, reductions, cancellations, and factoring that occurred in derivatives
or eliminants of expressions that appeared, at face value, to be most in-

tractable and unpromising. But because of the relatively high degree of symmetry that underlies almost all of the problems dealt with, one expects the final form of the equations to be relatively simple and esthetically pleasing.

Whenever a result of unexpected complexity was obtained, the likelihood of an error was great. The dogged checking and double-checking of such results lie behind the achievement of many a difficult derivation--and errors were almost as often based upon misconceptions as upon faulty manipulations. Once the likelihood of a procedural error had been eliminated, I repeatedly reconsidered the basic tenets until the misconception was discovered.

In fact, having rectified many misconceptions in the course of the work, it hardly is likely that none remains; I will be grateful to readers who detect and inform me of additional ones. The reader should not be surprised if he discerns relationships that I have overlooked or failed to mention. Virtually every time I took a fresh look at a topic, or merely in the course of retyping and preparing illustrations, I found relationships that previously had been overlooked, new paths that invited exploration, or shortcomings of the treatment that warrant eventual revision. To have followed all of these leads would have delayed the appearance of the book indefinitely.

To limit errors in the scores of illustrations and over 1,700 equations to my own, alone, I have typed the manuscript and prepared all the figures myself for direct photocopying. On the subject of typing, the cedilla has been omitted from *limaçon* as an expediency. Abbreviations have been held to a bare minimum--*CW, CCW, DP, QBI, LR,* and *eqs.*, for *clockwise, counter-clockwise, double point, quadratic-based inversion, latus rectum,* and *equations.* Faced with the very frequent need to employ a symbol for the unit of linear dimension, and the impracticability of repeatedly changing typing elements (or retracing to fill in many blanks), I selected j but would have preferred γ.

I have not hesitated to include discussions and analyses of matters deemed appropriate in chapters devoted primarily to other topics. For example, some treatments of quartics and a sextic in Chapter IX on cubics, and the circumlinear and circumconical symmetry of quadratics in Chapter XII on quadratic-based inversion quartics.

To minimize confusion, the degree of an equation is written as "degree," whereas for angular measure, the degree sign, °, is employed. Terms, phrases, and sentences are italicized either for emphasis, as Maxims, to introduce new terminology, or as section headings. Italics are not employed for existing

unusual or little-known terminology, or for anachronistic employment of common terms. In the latter cases, quotation marks are used. Footnotes are enclosed in brackets, [], within the text. Pages and equations are numbered according to chapter--10-1, 10-2, 10-3, etc., for pages, and (10-1), (10-2), and (10-3), etc., for equations 1, 2, 3, etc., in Chapter X. References in one chapter to equations and pages in another chapter are with mixed Roman and Arabic numbers, pages I-3, V-14, equations VII-3, IX-4, etc. Tables also are numbered according to chapter--Table VIII-1, X-2, etc. Figures and figure legends are numbered according to chapter and placed at the back of the book for ready access; they are referenced at the appropriate locations in the outer margins.

I have found it necessary to devise scores of terms for new curves, types of equations, procedures, properties, coordinate systems, foci, focal conditions, etc. In this process I have followed the rule of making these terms as descriptive as practical. Most of the new terms are included in Appendix V, the *Glossary of Terms*. I have adhered fairly closely to existing terminology, despite not infrequent disadvantages. In the interests of paralleling the biological nomenclature of classification, the taxons--subspecies, species, genus, family, superfamily, suborder, order, class, phylum, etc.--have been employed, though other mathematical applications of some of these terms have priority.

Aside from classical analytical geometry, all of the material presented is the result of original derivations carried out independently of the literature. In cases where results subsequently were found to be known, appropriate references are made or the fact is otherwise acknowledged; and, in fact, other of my results may exist somewhere in the literature in contexts unrelated to symmetry or classification.

I wish to thank my teen-aged sons for aid with certain calculations and curve plotting, and for proof-reading the final draft of the manuscript. Among other things, Christopher assisted with the derivation of general equations for the normal pedals of conics, and Warren with those for the tangent pedals. I also thank Michael Suzuki for assistance with two derivations (see note, page XI-37 and equation XIV-93c). I owe a great debt of gratitude to Aaron E. Whitehorn for a meticulous reading and correcting of the penultimate draft of the manuscript and for numerous incisive comments. Technical defects that remain are my responsibility; Mr. Whitehorn's assistance infrequently included confirmations of my analyses.

J. Lee Kavanau
Los Angeles, California
July, 1980

FOREWORD

Regarding implications of the treatments of symmetry in this book, it will be evident that the analytical approaches also can be applied in 3 dimensions, though this topic is not touched upon here. But concrete assessments can be made of their implications within the field of plane geometry; in essence they greatly expand the theoretical foundations for the study of curves. This is achieved, moreover, by complementing, rather than by supplementing, conventional methods. To clarify this statement, attention is called to the fact that studies of the properties and classification of curves have heretofore been based heavily on overt structure, chiefly the "exceptional points" of curves (their double points, cusps, points of inflection, etc.), the projective properties of curves, and the branches of curves at infinity.

In other words, both classical and modern studies have been concerned almost exclusively with properties of curves that can be seen and measured directly or described in terms of branches at infinity. As examples of this, I use specific concepts that are familiar to all readers. The basic tools of analytical geometry are applied to the study of curves to find such things as intersections, slopes, tangents, double tangents, normals, asymptotes, and inflection points, to calculate distances, angles, and areas, to find the bisectors of angles, the feet of perpendiculars, inscribed and circumscribed circles, etc.

As an example of the markedly different emphasis of analyses of the symmetry of curves presented in this book, I take its main topic of *circumpolar symmetry*, i.e., the symmetry of a curve about a point or pole. The heart of a circumpolar symmetry analysis consists of finding, ranking, and determining the properties of the focal loci of curves, all of which objectives involve derivations of the intercept transforms of the curves about specific points or representative points of point arrays. The basic feature of a circumpolar inter-

cept transform is that it expresses the algebraic relation between the lengths of two radii that emanate to the curve from a given point, and at a given angle to one another, as these radii rotate about the point and "sweep the curve."

Taken together with its parametric basis equations, a circumpolar intercept transform gives a complete characterization of the symmetry of a curve about a given point at a given angle. Intercept transforms differ from the entities mentioned above in that only rarely can they be "seen," i.e., only very infrequently can they be perceived by mere inspection of the curve, as can the slope, or a double point, or an angle, or inflection point, etc. Correspondingly, the properties of curves that they disclose usually are initially hidden.

As a specific example of a circumpolar intercept transform, and the manner in which its characterization of a property of a curve contrasts with the usual morphological expressions of that property, I take the "harmonic mean" definition of the traditional foci of conics. In the conventional morphological vein, definitions of the traditional foci of conics can take several forms. For example, "a focus of a conic is a point to which certain light rays striking the curve converge by reflection or refraction." Or, in another form, "the foci of conics possess the property that lines joining them to the circular points at infinity touch the curve," or in still another, "the foci of conics are points through which harmonically conjugate lines are orthogonal." More generally, "a point is said to be a focus of a curve when it is the intersection of an I-tangent with a J-tangent."

On the other hand, a traditional focus of a conic also can be defined by means of an analytical property known for well over a hundred years, which is that "the harmonic mean [twice the product divided by the sum, i.e., $2ab/(a+b)$] between the lengths of segments of a focal chord of a conic is constant and equal to half the length of the latus rectum." The little-known definition of a conic traditional focus following this property is that, "if more than two chords of a conic can be drawn through a point such that the segment lengths have the same harmonic mean, that point is a focus."

The harmonic mean relationship is precisely the circumpolar intercept transform of a conic section about its traditional focus for a reference angle of 180°. In other words, the harmonic mean relationship characterizes the 180° symmetry of a conic about its traditional focus. But it is only one of many such characterizations, virtually all unknown, that define aspects of the sym-

metry of conics about different specific points and representative points of point arrays. Even for the traditional focus, the 180° transform is only the most simple of several circumpolar intercept transforms, which is another way of saying that the symmetry of the curve about the traditional focus is greatest for a reference angle of 180°; three other transforms, for example, are those for a 0° reference angle, for a 90° reference angle, and for any reference angle α between the radii--the α-transform.

Because the harmonic mean relationship has such a simple form (for the parabola it can be expressed simply as $1/x + 1/y = 1/a$), it happens to be one of the few non-trivial circumpolar intercept transform relations that was discovered empirically. Once discovered, however, it was a signpost that pointed directly toward the core relations of the circumpolar symmetry of conics. Thus, given that this remarkable relationship exists for radii through the traditional focus at 180° to one another, it is natural to inquire as to the form of the corresponding relationships for other specific angles, and as to the general form of the relation for any reference angle. But the relations for the traditional focus are only the cases for a special point on the axis. What are the corresponding relations for any point on the axis? What are the relations for points on the other line of symmetry, for the vertices, the center, and a point in the plane?

Most of the approaches to the study of curves and their interrelationships, that are provided herein, previously were unknown. They lie in four principal areas: (1) relating to the symmetry properties of curves; (2) relating to the design and synthesis of highly symmetrical curves; (3) relating to the classification of curves; and (4) relating to undirected-distance coordinate systems.

In the first category are: (a) ranking of the symmetry of curves relative to two or more fixed reference elements; (b) ranking of the symmetry of curves about specific points (circumpolar symmetry), specific lines (circumlinear symmetry), and specific curves (circumcurvilinear symmetry); and (c) characterizations of the symmetry of curves on the basis of the properties of their intercept transforms about focal and non-focal loci. The second category deals with the manner in which knowledge of characteristic algebraic relationships for known curves of high symmetry can be employed in the synthesis of new highly-symmetrical curves possessing specific symmetry properties.

The third category includes: (a) new applications of the inversion trans-
formation--involving point-in-the-plane inversions--in which the primary
emphases are on its utility for the classification of curves and for providing
a systematic organizational framework for circumpolar and circumlinear sym-
metry analyses; (b) classification of curves according to criteria of circum-
polar symmetry; and (c) comparative distributions of 1st-generation tangent
pedals and inversion loci of given groups of basis curves. Fourth category
considerations relate to the equations and properties of highly-symmetrical
curves in undirected-distance coordinate systems.

The reader interested in the genesis of the book and a chronological per-
spective of the development of its topics may wish to read the *Historical
Epilogue* before proceeding to Chapter I. A perusal of the Bipolar Maxims
before beginning Chapter II and of the Circumpolar Maxims before proceeding
beyond Chapter IV may be helpful (see Appendix IV).

J. Lee Kavanau
Los Angeles, California
July, 1980

TABLE OF CONTENTS

PREFACE ix

FOREWORD xv

TABLE OF CONTENTS xix

LIST OF TABLES xxx

PART I. COORDINATE SYSTEMS AND CIRCUMPOLAR SYMMETRY

CHAPTER I. INTRODUCTORY TREATMENTS 1

 Introduction 1
 Circumpolar Symmetry Analysis and Inversion Analysis 2
 Limitations of Intuitive Concepts of Symmetry 4
 Directed Versus Undirected Distances 5

COORDINATE SYSTEMS AND SYMMETRY 6

 Polar and Rectangular Coordinates As Tools 6
 for the Analysis of Symmetry
 Undirected-Distance Coordinate Systems Are Most 7
 Illustrative of Relationships Between
 Construction Rules and Symmetry
 The Meaning of the Term "Restrictive" 7
 Representational Restriction 7
 Exponential Degree Restriction 8
 Reflective Redundancy 9
 Circumpolar Intercept Transforms 10
 A Preliminary View of the Circumpolar Intercept 10
 Transformation
 Some Definitions 13
 Circumpolar Focus and Focal Rank 13
 Subfocal Symmetry 14
 Foci and Focal Rank In Other Coordinate Systems 15
 The Most Symmetrical Curves 16
 Specific Examples 17
 Classification of Curves 19
 Introduction 19
 Circumpolar Symmetry Taxonomy 19
 Inversion Taxonomy 20
 Toward an Absolute Classification 22
 Design and Synthesis of Highly Symmetrical Curves 24
 First-Generation Quadratic-Based Pedal Taxonomy 25

CHAPTER II. BIPOLAR COORDINATES 1

 Introduction 1
 Reflective Redundancy In the Polar Axis 2
 Bipolar Focal Rank 3
 Bipolar Subfocal Rank 4

BIPOLAR EQUATIONS 5

 The Linears 5
 The Parabolic 6

BIPOLAR EQUATIONS (continued)

The Equilateral Hyperbolic 7
The Circle .. 7
Central Conics .. 11
The Parabola .. 13
The Parallel Line-Pair 15
The Equilateral Lemniscate 16
The Quartic Twin Parabola 17
A Detailed Analysis of the Parabola 18
Two Poles In the Plane 18
Poles Reflected In the Axes 19
Poles On the x-Axis Reflected In the y-Axis 20
Unreflected Poles On the x-Axis 22
Polarized Versus Unpolarized Bipolar Coordinates: 23
 Reflective Redundancy In the Midline 24

CHAPTER III. POLAR-LINEAR COORDINATES 1

Introduction .. 1
The Most Symmetrical Curves 3
Intrinsic Versus Elective Coordinate Lines of Symmetry 4
 and the Requirement for Axial Equality
The Linears ... 5
 Disparate Two-Arm Hyperbolas 6
 One-Arm and Partial Hyperbolas 7
Polar Exchange Symmetry 9
Parabolas ... 9
Central Conics .. 11
Circles ... 12
Polar Exchange Symmetry and Conchoids 14

CHAPTER IV. OTHER COORDINATE SYSTEMS 1

Tripolar Coordinates 1
Introduction .. 1
Linears ... 1
Conic Sections .. 1
Tetrapolar Coordinates 3
The Parabola .. 3
Harmonic Parabolas 5
Polar Exchange Symmetry 6
Non-Collinear Tetrapolar Coordinates 7
 Pole-Intersecting Two-Arm Parabolas 8
Pentapolar Coordinates 9
Introduction .. 9
Central Conics .. 9
Parabolas ... 10
Hexapolar Coordinates 10
Polar Exchange Symmetry 10
Harmonic Parabolas and Multipolar Coordinates 11
Polar-Circular Coordinates 15
Linear-Circular Coordinates 17
Confocal Two-Arm Parabolas 17
The Linear .. 19
Circles ... 19

Bicircular Coordinates 20
 Introduction 20
 Congruent Non-Concentric Bicircular Coordinates 20
 Linears 20
 Concentric Bicircular Coordinates 21
Bilinear Coordinates 21
 Introduction 21
 Parallel Bilinear Coordinates 22
 45° and 135° Bilinear Coordinates 22
 Linears 23
 The Circular 24
 Equilateral Hyperbolics 24
 Parabolics 25
 Circles 25
 Rectangular Coordinates Versus Other Bilinear Systems 25
Polar Coordinates 29
Coordinate Systems and Symmetry Analyses 29

CHAPTER V. INTERCEPT TRANSFORMS AND CIRCUMPOLAR SYMMETRY 1

 Deriving Circumpolar Intercept Transforms From
 Equations In Rectangular Coordinates 1
 Some Intuitive Intercept Transforms 2
 The Simplest Transforms About A Point In the Plane 4
An Analytical Approach to the Circumpolar Symmetry
 of Curves 5
 Phylum and Class of Circumpolar Symmetry 5
 Some Transforms of Unusual Interest 5
 Circumpolar Intercept Transforms Form Endless
 Branching Chains 8
 Circumpolar Intercept Transforms as Symmetric
 Functions 8
 α-Transforms and Transformation Formats 10
 Relative Frequencies of Low-Degree Circumpolar
 Symmetry Classes 10
 The Complementarity of Polar and Rectangular Coordinates
 For Circumpolar Symmetry Analyses 13
 Three-Dimensional Intercept Transforms 15
 The Order of Circumpolar Symmetry 16
 Ordinal Rank is Independent of Transformation Angle 16
 The Suborder of Circumpolar Symmetry 17
Hierarchical Ordering of Curves By Circumpolar Symmetry 18
 Comparable Foci and Specific Transformation Angles 18
 Hyperbolic Specific Symmetry Class 18
 The Circle, the Line-Pair, and the Parabola 21
 Circular Specific Symmetry Class 22
 Linear Specific Symmetry Class 22
 Single-Parameter Curves 24
Circumpolar Foci 25
 Types of Foci 26
 Definitions 26
 Examples 28
The Rank of Circumpolar Focal Loci 30
Circumpolar Symmetry At the Subfocal Level 31

PART II. CIRCUMPOLAR SYMMETRY ANALYSES

CHAPTER VI. LINES, THE CIRCLE, AND THE PARABOLA 1

Lines .. 1
 The Parallel Line-Pair .. 1
 "Pure" Intercept Products 2
 Ordinal and Subordinal Rank 2
 The Single Line ... 3
 Any Line-Pair ... 3
The Circle .. 4
 The α-Transform ... 4
 Transforms At 0°, 90°, and 180° 5
 Intercept Products .. 6
 Non-Focal Self-Inversion Loci of the Circle 6
 Ordinal and Subordinal Rank 8
 Inversions and Circumpolar Symmetry 9
The Parabola .. 12
 The Simple Intercept Equation and the α-Transform 12
 Intercept Products and 0° and 180° Transforms 13
 The 90° Transforms and α-Transforms 15
 The Curve and the Axial Vertex 15
 The Axis and the Traditional Focus 16
 The Latus Rectum Vertices 17
 Subfocal Rank of the Directrix, Vertex Tangent, 18
 and Latus Rectum
 Ordinal and Subordinal Rank 19

CHAPTER VII. CENTRAL CONICS 1

 Introduction .. 1
 Transforms of 0° and 180° 1
 Intercept Equations and Formats 7
 α-Transforms and Variable-Angle Transforms 8
 (eccentricity-correlated rank)
 The Center .. 9
 The Traditional Foci .. 10
 The x-Axis .. 11
 The Axial Vertices .. 12
 Intercept Formats and 90° Transforms 12
 Points In the Plane ... 12
 Conditions On the Radicand 13
 The Latus Rectum Vertices 14
 The a and b Vertices and Eclipsing of Foci 15
 Traditional Foci and Centers 16
 The Latus Rectum and Subfocal Symmetry 17
 Ordinal and Subordinal Rank 18

NEGATIVE INTERCEPTS, TRIVIAL TRANSFORMS, THE DEGREE OF 20
 TRANSFORMS, AND THE DUALITY OF 0° AND 180° TRANSFORMS

 Introduction .. 20
 Algebraically Complete 0° and 180° Transform Equations 20
 For the Traditional Foci of Conic Sections
 Algebraically Complete 0° and 180° Transform Equations 24
 For the Foci of Self-Inversion of Bipolar Parabolic
 Cartesians

NEGATIVE INTERCEPTS, ETC. (continued)

 Algebraically Complete 90° Transform Equations 25
 for the Traditional Foci of Conic Sections

CHAPTER VIII. INVERSION AND NON-FOCAL SELF-INVERSION 1
 OF CONIC SECTIONS

INTERCEPT PRODUCTS AND NON-FOCAL SELF-INVERSION LOCI 1
 Focal Self-Inversion 1
 Focal Self-Inversion As a Limiting Case of 1
 Non-Focal Self-Inversion
 θ Self-Inversion Loci 2
 The Intercept Product Versus the Intercept Transform 4
 Derivation of Non-Focal Self-Inversion Loci 6
 "Pure" xy Intercept-Product Formats and Self-Inversion 8
 Why Do Conics Not Self-Invert At the Focal Level? 10

NON-FOCAL SELF-INVERSION LOCI OF CONIC SECTIONS 10
The Ellipse - Rotating Chord Analysis 11
 Intersection of Axial Non-Focal Self-Inversion Loci 11
 At the Axial Self-Inversion Centers
 Axial Intersection of Axial Non-Focal Self-Inversion 12
 Loci At the Reference Pole
 Tangent Ovals and the 90° 2j-Chord 12
 j Greater Than b 13
The Parabola 13
The Hyperbola 15

INVERSIONS OF CONIC SECTIONS 18
Inversion Taxonomy 18
 The Inversion Taxonomy Paradigm 18
 Curves of Demarcation 19
Conic Inversion Loci 21
 About a Point In the Plane 21
 About the Traditional Foci 22
 About the Center 22
 About the Vertices 22
 Axial Vertex Cubics 23
 General Inversion Cubics 24
 LR Vertex Cubics 25
Other Transformation Taxonomies 26

CHAPTER IX. CUBICS 1

 Introduction 1
The Cissoid of Diocles 1
 Introduction 1
 A Point On the x-Axis 2
 Transforms for 0° and 180° 3
 The Cusp Focus 3
 The Focus At -a 3
The Hyperbola Axial Vertex Cubics 4
 Introduction 4
 Focal and Potential Focal Conditions 4
 Conservation of Axial Foci 6

The Hyperbola Axial Vertex Cubics (continued)

Bipolar Cartesians With 4, 5, 6, and 8 Discrete Axial Foci 7

Transforms About a Pole On the x-Axis 9
The Double-Point Focus 9
The Loop-Vertex Focus 10
The Variable Focus 10
The Focus At the Asymptote Point 11
The Focus At the Axial Point At Infinity 12
The Loop Pole At h = 2b/3 12
The Ellipse Axial Vertex Cubics 13
Ordinal and Subordinal Rank 14
The Folium of Descartes 16
Introduction 16
The Simple Intercept Equation 16

The Parent Axial Vertex Cubic 18

Inversion Analysis of the Folium of Descartes 19
Circumpolar Symmetry of Other Curves Within the 22
 Superfamily Based Upon the Double-Point Inversion
 Quartic of the Folium of Descartes
 The Double-Point Inversion Quartic of the 22
 Folium of Descartes
 Axial Inversions of the Double-Point Inversion 23
 Quartic
Tschirnhausen's Cubic 25
Introduction 25
The Simple Intercept Equation and Axial Foci 26
Intercept Transforms 27
Cayley's Sextic 28
Inversion Analysis 28
Inversion Analysis Versus Circumpolar Symmetry 31
 Analysis
Circumpolar Symmetry Analysis 32
 Simple Intercept Equations and Axial Foci 32
 Intercept Transforms 32

CHAPTER X. QUARTICS 1

LIMACONS 1
Introduction 1
The Cartesian Group 1
Cartesian Self-Inverters 2
Equations of Limacons Cast About the Axial Foci 3
Construction of Limacons From Circles 4
The "Pedal" Construction, the "Basis Circle," 4
 and the "Directrix Circle"
Inversion Correspondences Between Conics and Limacons 5
The Limacon Vertices 6
 The LR Vertices and the Peripheral (a-b) Vertices 7
 The $-\frac{1}{2}b$ Peripheral Vertices 7
 The $(a^2-b^2)/2b$ Peripheral Vertices 8

LIMACONS (continued)

 Overt Homologies With Conics 9
Circumpolar Symmetry of Limacons 11
 Simple Intercept Equations and Formats 11
 A Point In the Plane 11
 The Line of Symmetry 12
 Poles of Conditional Focal Rank 13
 The Non-Axial $-\frac{1}{2}b$ Covert Linear Focal Locus 15
 The Axial Focal Locus At the Double Point 16
 The Focus At the Double Point and Double-Point 18
 Homologue

 Analytical Transforms Versus Geometrical Expectations 19

 The Focus At $(a^2-b^2)/2b$ 22
 The Focus At $-\frac{1}{2}b$ 23
The Near-Conics 25
 Near-Lines and Near-Circles 25
 0° Transforms 26
 180° Transforms 28
 Near-Ellipses 28
 Changes In the 90° Transforms About the $-\frac{1}{2}b$ Focus 29
 With Increasing Eccentricity
 90° Transforms About Non-Focal Poles 30

 Cartesian Near-Conics 32
 The Vertex-Coincidence Symmetry Condition 34
 Cartesian Near-Conic Transforms 35
 Circle-Deviation Limacons and the Origin of Near-Conics 37

 The Axial Vertex Foci 41
 The Pole of Conditional Focal Rank At $\frac{1}{2}b$ 41
 The Pole of Conditional Focal Rank At $(b^2-a^2)/2b$ 42
Inversions of Limacons 43
 Focal Inversion 43
 Inversions About a Point In the Plane 45

CHAPTER XI. INVERSION TAXONOMY OF THE QUADRATIC-BASED 1
 INVERSION SUPERFAMILY

 Introduction 1
 The Literature On Inversion 1
 Limacon Focal-Inversion Quartics 2
 Limacon Line-of-Symmetry Inversion Quartics 3
 Axial-Inversion Quartics of Central Quartics 7
 Axial-Inversion Quartics of the Conic Axial 10
 Vertex Cubics
Inversion Cycles and Inversion Images 11
 Introduction 11
 Inversion of Limacon Focal-Inversion Quartics 13
 to Conics Through the Double Point
 Non-Focal Inversions of Limacon Axial Vertex Cubics 14
 to Limacons

Inversion Cycles and Inversion Images (continued)

Circumpolar Symmetry of Limacon Axial Vertex Cubics ... 15

Inversion of Pseudo-Exchange-Limacons to Conics Through the Double Point ... 16

Inversion of Central Quartic Vertex Cubics to Conics Through the Double Point ... 17

Inversion of the Axial Inversion Quartics of Central Quartics to Conics Through the Double Point ... 18

Several Generations of Inversions and Inversion Images ... 19

Self-Inversion Within the Quadratic-Based Inversion Superfamily ... 23

Self-Inverting Limacon-Like Axial-Inversion Quartics ... 24
Mutually-Inverting Quartic Circles ... 26
The Inversion-Image Analysis of Axial Self-Inversions ... 28
Inversion Taxonomy of QBI Curves of Unit Eccentricity ... 32
The Form of Curves In the Axially-Symmetrical Ensemble of Unit Eccentricity ... 35
Inversions About the Second Line of Symmetry and Points In the Plane ... 36

CHAPTER XII. CIRCUMPOLAR SYMMETRY OF QUADRATIC-BASED INVERSION QUARTICS ... 1

Introduction ... 1
The Simple Intercept Equation ... 5
Focal Conditions ... 5
Potential Focal Conditions and Eccentricity Independence ... 7
Plots of Focal and Potential Focal Poles ... 9
Focal Rank of the Pole of Self-Inversion ... 12
Focal Conditions, Number of Foci, Imaginary Foci, and Conservation of Foci Under Inversion ... 14
Eccentricity-Dependent Self-Inverters ... 18
The Simple Intercept Format ... 21
The Double Point and Its Homologue ... 24
The 0° and 180° Transforms ... 24
The 90° Transforms ... 26

α-Self-Inversion: Reciprocal Reflective Symmetry Through a Point Along Radii At an Angle, α ... 28

The $-\frac{1}{2}b$ Focus and Its Homologues ... 29
The $-j^2/2h$ Focus of Self-Inversion ... 31
Circumpolar Symmetry of Axial Inversions of the Parabola ... 33
Introduction ... 33
A Point On the Line of Symmetry ... 33
The Foci At the DP Homologue ... 34
Quartic Circles ... 38
Introduction ... 38
A Point On the Axis of Intersection ... 38
The Double Foci of Intersection ... 39

Quartic Circles (continued)
 A Point On the Major Axis 40
 The Foci At the Centers 44
 The True Center 44
 Tangent Circles 45
 Ordinal and Subordinal Rank 45
Covert Focal Loci and Non-Axial Inversions of Conics 46
 Introduction 46
 Simple Intercept Equations About a Point in the
 Plane 46
 Focal Conditions 47
 Non-Axial Covert Linear Focal Loci 49
 The Compound Intercept Equation and Format 50
 Covert Axial Focal Loci 52
 Covert Focal Loci of Point-In-the-Plane Inversions 52
 Covert Curvilinear Focal Loci 54
 The Degrees of 0° and 180° Transforms About Points 55
 On Non-Axial Covert Focal Loci

Transforms With Complex Solutions 57

CIRCUMLINEAR SYMMETRY OF QBI CURVES 61

 Introduction 61
180°-Orthogonal Circumlinear Symmetry of QBI Curves 63
 Lines of Symmetry and Lines Parallel to Lines of
 Symmetry 63
 Covert Focal Loci of QBI Curves 64
 Hyperbola Axial Vertex Cubics 64
 Limacons 67
 Axial QBI Curves 69
α-θ-Circumlinear Symmetry of Quadratics 73
 Introduction 73
 The Ellipse 74
 Lines of Symmetry and Axes Parallel Thereto 74
 The Parabola 78
 A Line In the Plane 79
 The Parallel Line-Pair 81
 Omnidirectional Circumlinear Self-Inversion of 83
 the Hyperbola

90°-0°-CIRCUMCURVILINEAR SYMMETRY OF CONICS 85

 Introduction 85
Derivation of 90°-0°-Circumcurvilinear Transforms 87
90°-0°-Identical Self-Circumcurvilinear Symmetry 88
 of Conics
90°-0°-Congruent Self-Circumcurvilinear Symmetry 89
 of the Parabola
90°-0°-Circumcircular Symmetry of the Parabola 89
90°-0°-Circumelliptical and Circumhyperbolic 90
 Symmetry of the Parabola
Reciprocal Circumcurvilinear Symmetry 91
 90°-0°-Reciprocal Circumcurvilinear Symmetry 92
 of the Circle and Parabola

The Identical Reciprocal Circumcurvilinear 92
 Symmetry of the Centered Circle and
 Equilateral Hyperbola--The Devil's Curve
90°-0°-Circumcurvilinear Symmetry of the Parabola 93
 About the Cissoid of Diocles

CHAPTER XIII. TANGENT-PEDAL TAXONOMY 1

Introduction 1
First-Generation Quadratic-Based Tangent- 1
 Pedal Taxonomy
 The Point, the Line, and the Circle, and 1
 Ensembles Thereof
 The Parabola 2
 Central Conics 8
Compounded Positive and Negative Tangent Pedals 19
Tangent-Pedal Taxonomy Versus Compounded Positive 21
 and Negative Tangent Pedals

NORMAL PEDALS OF CONIC SECTIONS 23

PART III AND CHAPTER XIV

THE HOW AND THE WHY OF CIRCUMPOLAR SYMMETRY 1

Introduction 1
The Circumpolar Symmetry Versus the Inversion 2
 Analyses
Conservation of Focal Loci 6
Complementary Intercept Formats 10
90° Transforms of Greater Than Double the Degree 11
 of 0° Transforms
 Transforms About the Double-Foci of Intersection 11
 of Mutually-Inverting Quartic Circles
 Transforms About the True Center of Mutually- 14
 Inverting Quartic Circles
Transforms of Pseudo-Exchange-Limacons About the 15
 Double Point
180° Transforms About a Point On the Line of 18
 Symmetry of Limacons
90° Transforms of the Equilateral Strophoid 19
 About the Double Point
Inversion Loci With Reciprocal Intercept Formats 21
General Circumpolar Symmetry Analysis of Axial QBI Curves 22
 Focal and Potential Focal Conditions On Simple 22
 Intercept Equations and Formats
 0° and 180° Transforms 25
 90° Transforms 30
Circumlinear Symmetry of Axial QBI Curves 33
On the Origin of Focal Conditions 34
 The $-\tfrac{1}{2}a$ Focus of Cayley's Sextic 34
 The $-\tfrac{1}{2}b$ Focus of Limacons 36
 The Variable Focus of Hyperbola Axial Vertex Cubics 37
 The $A^2d/(A^2-B^2)$ Focus of Bipolar Linear Cartesians 38

Origin of the Special Symmetry of Pseudo-Exchange- 41
 Limacons
Origin of the Special Symmetry of Quadratic-Based 42
 Inversions
Design and Synthesis of Highly Symmetrical Curves 47
 The Coordinate System Approach 47
 The Building-Block Approach 47
 The Intercept Format Approach Through Generic 48
 Double-Foci of Self-Inversion
 Reciprocal Format Symmetry 51
 Root-Format Symmetry 52
 Root-Format Symmetry Groups of the Circle 52
 Root-Format Symmetry Groups of the Equilateral 52
 Strophoid
 Root-Format Symmetry Groups of Mutually- 53
 Inverting Quartic Circles
 The Intercept Format Approach to the Synthesis of 54
 Curves With Designated Specific Symmetry
 Circular Specific Symmetry Class 55
 nth-Degree "Circular" Specific Symmetry Class 57
 Equilateral Hyperbolic Specific Symmetry Class 58
 Linear Specific Symmetry Class 58
 The Linear-Circular-Quartic Sextics 60
 The Linear-Linear-Circular Octics 63
 Symmetry Mimics 65
 The Quartic Symmetry Mimic of the Parallel 68
 Line-Pair
 The Sextic Symmetry Mimic of Tangent Circles 70
 Symmetry Mimics of Central Conics 72
 "Pure" Intercept Products 73
 Self-Inversion At 90° 76
 Tri-Angle Self-Inverters 77
 Multi-Angle Self-Inverters 81
 Comparative Symmetry of Multi-Oval Curves With 83
 a True Center
 The True-Center Approach--Central Cartesians 86
 Introduction 86
 Circumpolar Symmetry of Bipolar Linear Cartesians 87
 The Poles About Which Axial Self-Inverting Curves 89
 Invert to Curves With A True Center
 Central Self-Inversion of Central Cartesians 92
 Number of Axial Point Foci of Members of the
 Central Cartesian-Based Superfamily 93
Circumpolar Symmetry and the 0° and 180° Transforms 94
 Versus the 90° and α-Transforms

HISTORICAL EPILOGUE i
APPENDIX I. Transformation Formats vii
APPENDIX II. Inventory of Axial and Point-In-The viii
 Plane Simple Intercept Equations
APPENDIX III. Complete Inventory of Curve-Pole Combi- xii
 nations With High Ordinal and Sub-
 ordinal Circumpolar Rank

xxx

APPENDIX IV. Symmetry Maxims *xiv*
 Bipolar *xiv*
 Circumpolar *xv*
 Tangent-Pedal Taxonomy *xix*
APPENDIX V. Glossary of Terms *xx*
BIBLIOGRAPHY *xxvi*
INDEX *xxvii*
FIGURES AND FIGURE LEGENDS *xxxix*

LIST OF TABLES

 page

 I-1. Indices Employed In a Circumpolar Symmetry Analysis I-11
 of a Curve.
 I-2. Partial Scheme of Inversions In the QBI Superfamily I-23
 I-3. Toward an Absolute Classification of Curves. I-23
 IV-1. Multipolar Satellite Parabolas of the Basis Parabola, IV-14
 $y^2 = 4a(x+4a)$
 IV-2. Coordinate Systems and Symmetry Analyses. IV-30
 V-1. Inventory of Curve-Pole Combinations With High Ordinal V-13
 and Subordinal Circumpolar Rank.
 V-2. Hierarchical Circumpolar Symmetry Ranking of Curves V-14
 With 180° Linear Symmetry About a True Center.
 VI-1. Inversions of Some Equilateral QBI Curves. VI-10
 VII-1. Degrees of Circumpolar Intercept Transforms of VII-19
 Conic Sections.
VIII-1. Curves of Demarcation. VIII-20
 IX-1. Degrees of Circumpolar Intercept Transforms of Cubics. IX-15
 X-1. Degrees of Circumpolar Intercept Transforms of Limacons. X-40
 X-2. Focal Loci of Hyperbolic QBI Curves. X-40
 X-3. Classification of the Inversion Loci of a Limacon. X-47
 XI-1. Principal Axial Inversions of QBI Curves. XI- 4
 XII-1. Inventory of Quartics. XII-2,3
 XII-2. Degrees of Circumpolar Intercept Transforms of QBI XII-56
 Curves, Including Transforms About Points On Covert
 Focal Loci.
 XII-3. Unique Symmetry Properties of Axial QBI Cubics and XII-72
 Quartics.
 XII-4. Degrees of Circumlinear Intercept Transforms of Axial XII-86
 QBI Curves.
 XII-5. Degrees of 90°-0°-Circumcurvilinear Transforms. XII-94
XIII-1. Compounded Quadratic-Based Sinusoidal Spiral Pedals XIII-20
 XIV-1. 0° and 180° Transforms of the LCQ Sextic. XIV-61
 XIV-2. Symmetry Mimics. XIV-67
 XIV-3. Inversions of Linear Cartesians to Central Cartesians. XIV-91

 A-1. Transformation Formats. *vii*
 A-II. Inventory of Axial and Point-In-the-Plane Simple *viii*
 Intercept Equations.
 A-III. Complete Inventory of Curve-Pole Combinations With *xii*
 High Ordinal and Subordinal Circumpolar Rank.

PART I. COORDINATE SYSTEMS AND CIRCUMPOLAR SYMMETRY

CHAPTER I. INTRODUCTORY TREATMENTS

Introduction

Is the circle the most symmetrical curve? If not, what curve is most sym-
metrical? Or can any curve be regarded as *the* most symmetrical? Can analytical
comparisons be made between the symmetry of the parabola, ellipses, and hy-
perbolas? Do spirals have definable symmetry? What is the nature of the sym-
metry of a straight line? How is the symmetry of curves related to their tra-
ditional foci, and to axes, asymptotes, vertices, and other incident points?
Can curves be ranked hierarchically according to their symmetry? Are there *ana-
lytical* criteria for classifying curves, as opposed to the heretofore employed
structural criteria--namely their projective properties and branches at infinity?
Are the properties of foci limited to points? Is the possession of two branches
by hyperbolas and one branch by the parabola a fundamental property of these
curves?

Within the present framework of analytical geometry, answers to most of the
above questions would lack a firm theoretical foundation. The results and
methods of analysis introduced in this book make possible a rigorous analytical
approach to these topics, as well as to numerous others, many of which lie
outside the domain of current concepts in geometry. Merely to phrase these
topics requires the use of numerous new terms. In the realm of foci, alone,
many different types need to be defined: simple, compound, single, multiple,
linear, curvilinear, covert, self-inverting, eclipsable, and variable.

The answers to the above queries often are not simple or straightforward,
and most questions have to be qualified precisely. To answer the majority of
questions relating to the symmetry of curves, one first must recognize the
relativity of symmetry by specifying a reference system. For example, one can
speak of *circumpolar symmetry* (symmetry about a point), *bipolar symmetry*
(symmetry about two points), *collinear* and *non-collinear tripolar symmetry*
etc., or *circumlinear symmetry* (symmetry about a line), *90° bilinear symmetry*
(symmetry about two orthogonal lines), *bisurfacial symmetry* (symmetry about
or relative to two surfaces), or of symmetry about non-identical reference ele-
ments, such as--for brevity--*point-line symmetry*, *point-curve symmetry*, *point-*

surface symmetry, line-surface symmetry, etc. [In fact, both the number of
types of symmetry and the number of coordinate systems are infinite.]

Fig.
1-1

To answer most questions relating to the circumpolar symmetry of a curve,
i.e., its symmetry relative to a single point-pole, one needs, at the least,
a specification of the location of the reference pole and an angle of refer-
ence for the symmetry. The most symmetrical curves of finite degree in the
polar coordinate system are the point at the polar pole, any line through the
pole, and circles centered at the pole. The parabola is the most symmetrical
curve in several coordinate systems, but the number of arms that it possesses
is not a fundamental property (nor is it for hyperbolas). Not only do true *two-*

Fig.
4-5

arm parabolas exist, a two-arm parabola has the distinction of being the most
symmetrical curve in the *linear-circular coordinate system.*

Of course, answers to questions concerning the foci of curves hinge upon what
is meant by a "focus." While including most of the loci generally encompassed
by the term "focus" in the several restricted senses heretofore employed (such
as "burning points" to which light rays converge by reflection or refraction,
and points through which harmonically conjugate lines are orthogonal), the
analytical definitions of a focus and a focal locus from the point of view of
circumpolar symmetry are quite different. Stated very simple:

> *A circumpolar point focus of a curve is a point about which
> the curve has greater symmetry than about neighboring points.*
>
> *A circumpolar focal locus of a curve is a point array about
> every member point of which the curve has greater symmetry
> than about neighboring non-member points.*

Of course, the meaning of the term "greater symmetry" now becomes crucial but
this is subject to a simple and precise definition.

Circumpolar Symmetry Analysis and Inversion Analysis

To the question concerning analytical criteria for the classification of
curves, the answer is in the affirmative--yes, there are such criteria.
However, more than one paradigm exists that can be applied for this purpose,
depending upon which properties of curves are to be emphasized.

Aside from the similarities of *structure*, the affinities of curves tra-
ditionally have been assessed to large degree upon the basis of *equational*
similarities, i.e., similarities in the rules for their construction speci-
fied by their eqs. I introduce two fundamental but largely independent para-

digms of classification or comparative organization that yield additional
insights into the properties of curves--*circumpolar symmetry analysis* and *inversion analysis*. These paradigms give results that often are similar in certain
respects but different in others; not infrequently the results are unpredictable
from the eqs. of the curves.

For example, two looped cubics of very similar structure are represented by
the eqs., $y^2(a+x) = x^2(a-x)$ and $y^2(a+3x) = x^2(a-x)$. The former is the equilateral strophoid and the latter the folium of Descartes. Equationally, these
curves differ in only a minor respect, in the presence of the coefficient, 3,
in one eq. but not the other. A difference of this nature has relatively
little significance for the rectangular eqs. of conic sections. But the
difference is found to be crucial when the above eqs. are subjected to either
a circumpolar symmetry analysis or an inversion analysis.

From the point of view of the inversion transformation, these two curves are
unrelated. For example, the equilateral strophoid self-inverts through the loop
vertex and inverts through the DP (double point) to a curve with two lines of
symmetry (the equilateral hyperbola), whereas the folium of Descartes does
neither. On the other hand, a circumpolar symmetry analysis discloses both
fundamental differences and similarities (see Chapter IX, *Cubics*).

The basis for the different results of the two approaches is as follows. One
aspect of an inversion analysis is that it organizes curves according to their
relatedness through the inversion transformation. For a given group of curves,
this is achieved by obtaining the 1st and 2nd generation inversion loci of all
member curves about *all points in the plane* and ascertaining the interrelations
between these loci. By this process--*Inversion Taxonomy*--the "family trees" of
curves by inversion can be constructed and an *inversion superfamily* defined.
Of course, curves grouped according to this paradigm will be found to share the
symmetry properties that are conserved by the inversion transformation. Of
these, the number and types of focal loci receive the greatest attention in
later chapters.

On the other hand, a circumpolar symmetry analysis does not probe the
relatedness of curves from the point of view of whether they are derivable
from one another by any transformation. It asks questions strictly about the
symmetry of the curves--do they have similar or homologous symmetry properties?
A group of curves assembled by a circumpolar symmetry analysis usually will
include both members that are related to one another by inversion and members

that are not so related.

More precise distinctions between these methods of classification and ana-
lysis are given later. But a very crude analogy helps to convey the gist of the
matter. Equational and structural classification of curves are like grouping
men according to their appearance. Classifying by Inversion Taxonomy is like
grouping them according to their geneology. Classifying curves upon the basis of
their circumpolar symmetry is like grouping men on the basis of blood type.

Limitations of Intuitive Concepts of Symmetry

In the following, the intuitive concepts of a curve "being symmetrical,"
such as "being unchanged by reflection through a point or axis, or by rotation
about a point," are replaced by concepts that both lend themselves to precise
analysis and apply in circumstances for which the intuitive concepts fail--which
constitute the vast majority. Whereas the intuitive approach is capable of
assessing symmetry only in relation to overt features of curves or figures, such
as axes and points of intersection of axes, the analytical approach allows the
definition of the symmetry of a curve with respect to any reference elements.

In the analytical approach, the "symmetry" of a curve with respect to given
reference elements is assessed in relation to the construction rule for the curve
relative to these elements, while "symmetrical" implies simplicity of this con-
struction rule. More specifically:

"has greater symmetry" translates to *has a simpler construction rule;*
"is most symmetrical" translates to *has the simplest construction rule.*

By way of illustration, the *most symmetrical curve* relative to any two or more
given fixed reference elements is defined as follows.

> *The most symmetrical curve relative to two or more fixed
> reference elements is the curve for which the rule of con-
> struction employing undirected distances is the simplest.*

The new analytical concepts of symmetry harmonize with simple intuitive concepts
but also carry one into regions where simple intuition fails. Some simple illus-
trations are given below.

If one compares the symmetry of the ellipse with that of the parabola intui-
tively, the inevitable conclusion is that the ellipse is more symmetrical. If
the analytical approach is applied to the same problem, the result will be the
same if the application is made relative to the reference element implicit to
the intuitive approach. In this case, the reference element of the intuitive

approach is the center of the ellipse, i.e., a single point-pole (or essentially the equivalent--two lines of symmetry, as opposed to one for the parabola). In other words, the intuitive approach was implicitly *circumpolar*, and an explicit analytical circumpolar approach gives the same result. The ellipse has greater symmetry about its center than the parabola has about any point in the plane.

Suppose, instead, that one is asked to compare the symmetry of an ellipse and the parabola relative to a point and a line. Let the point be the traditional focus of the parabola and the line be its directrix; for the ellipse, let the point be either traditional focus and the line be the nearest directrix. Now simple intuition fails (but see discussion in legend to Fig. 3-1) and one must appeal to the analytical definition. The parabola is the more symmetrical of the two figures relative to these reference elements because the rule for its construction, given by its polar-linear (point-line) eq. is simpler. [For the parabola, both distance variables in the eq. have unit coefficients, whereas for central conics the two coefficients are unequal.]

Figs. 3-1 a-b$_2$

Lastly, simple intuition fails if one is asked to compare the symmetry of an ellipse and the parabola about a single point, say the traditional focus. In this case, also, the parabola is found to be more symmetrical by the analytical circumpolar approach (see Table V-1 and Appendix III). But in another system, polar-circular coordinates (point and circle reference elements), the ellipse is more symmetrical, while in still another, linear-circular coordinates (a line and a circle), the parabola again is more symmetrical.

4-4a$_2$

4-5 a$_1$-a$_4$

Directed Versus Undirected Distances

In relation to coordinate systems and the concept of symmetry, an important feature is inherent in the intuitive concept of "symmetrical" as "being unchanged by one operation or another." The same feature is responsible for the phrase *employing directed distances* in the above analytical definition. Unless undirected distances from the reference elements are employed, i.e., *unless the sense of the distance is unchanged by directional changes*, relationships between the symmetry of a figure and its equational construction rule will be obscured. To achieve the closest correspondence between symmetry and construction rules, the distance variables of eqs. must be undirected.

Again, a simple example illustrates the point. If the reference element is taken to be a single line, say the y-axis, the most symmetrical curve consists of two lines parallel to and equidistant from the reference line. Using

undirected distances, the eq. of this curve is the simplest possible, namely
$x = a$ (including the case $a = 0$). But if directed distances are employed, the
eq. of the same curve is $x^2 = a^2$. Moreover, in the latter case, the simplest
eq., $x = a$, represents a less symmetrical curve than does $x^2 = a^2$, namely,
a single line parallel to the coordinate reference element.

Chiefly because of this consideration, the rectangular and polar coordinate
systems, which are of the greatest utility as *tools* for symmetry analyses, are
not systems of choice for illustrating relationships between the symmetry of
curves and their construction rules. For this purpose, the employment of undi-
rected-distance coordinate systems is much to be preferred (see the outline
of Table IV-2). This is essentially the entire program of Chapters II-IV.

COORDINATE SYSTEMS AND SYMMETRY

Polar and Rectangular Coordinates As Tools
For the Analysis of Symmetry

As a tool for the analysis of symmetry, the polar coordinate system is pre-
eminent, lending itself directly to the formulation of all types of intercept
transforms. This exceptional status hinges upon its unique property of con-
sisting of the combination of an angular reference element and a single, fixed
point reference element or origin. Thus, the polar coordinate system is the
only system in which the specification of the distance from a coordinate origin
to a point on a represented curve involves the value of only a single distance
coordinate.

Polar coordinates also are unique in being the coordinate system of the in-
version transformation--which is a strictly circumpolar construction--and in
which, by virtue of the property just discussed, inversion is carried out with
almost trivial simplicity. Though one may have the impression that curves can
be inverted independently of a coordinate system, this is illusory. The in-
version process is *circumpolar*--involving constructions at specified
distances (reciprocals of distances to the curves) along lines from a single
point at all angles.

The next-most utile coordinate system for symmetry analyses is one which,
in respect to the exponential degree of eqs. for similar or congruent curves,
is the most highly restrictive one, namely, the familiar rectangular system.

But the great utility of this system, as we shall see, depends upon this very restrictiveness. This is one of the properties that underlies its importance as an analytical tool and common language--an adjunct for analyses within less restrictive coordinate systems, many of which are more informative for symmetry.

Undirected-Distance Coordinate Systems Are Most Illustrative
 of Relationships Between Construction Rules and Symmetry

With the exceptions of polar and rectangular coordinates, all of the coordinate systems dealt with in the following chapters employ undirected distances. In other words, the coordinates are not used in a positive and a negative sense, according to the direction in which they are measured relative to the reference elements. In most of these coordinate systems, the *undirected distances* are simply the *least* distances, but in some of them, for example, *polar-circular* or *point-circle* coordinate systems they are the *extremal* distances, i.e., the least *and* the greatest distances. With few exceptions, notably *bipolar* and *tripolar* coordinates, these systems appear to have been ignored by geometers. Though most of them have extremely limited utility as general analytical tools, they have great significance for the study of relationships between symmetry and equational construction rules. Accordingly, the treatments of coordinate systems are devoted almost exclusively to them.

The Meaning of the Term "Restrictive"

Representational Restriction

First, what is meant by the term *restrictive*? There are two principal meanings. The first has to do with the curves that can be represented by a coordinate system. Some coordinate systems cover only a portion of the plane; consequently some curves cannot be plotted in these systems. For example, in undirected-distance *45°-bilinear coordinates* (see Chapter IV)--based on two lines intersecting at 45°--only those portions of curves lying between these lines in the 45° sectors can be represented. Although the full curves can be represented by a combination of the 45° system and the complementary 135° system, a different eq. may be required to represent the segments of the curve in each system. Using directed distances, either the 45° system or the 135° system covers the entire plane. But in neither case do all eqs. give the familiar curves of the rectangular system (see Chapter IV and Fig. 4-8).

Fig.
4-8f

In the most restrictive coordinate systems, only one type of curve exists. For example, in *parallel-bilinear coordinates* and *concentric-bicircular coordinates,* aside from two extraordinary exceptions for each, only lines and circles, respectively, exist. No other curve can be plotted and all eqs., no matter their degree, form, or complexity, give only different numbers of, and differently distributed, lines or circles. Of these lines or circles, only one qualifies as being the most symmetrical curve. Thus, in parallel-bilinear coordinates the most symmetrical line is the midline, while in concentric-bicircular coordinates the mid-circle is most symmetrical.

Since only one particular line or circle is specified as being *the* most symmetrical curve, the implication is that the term *symmetry* refers to more than just the form of the curve in isolation. Indeed, as stated above, the property of symmetry in the analytical theory includes a consideration of the location and orientation of the curve in question relative to the reference elements by means of which its constructional rules are specified.

For example, the most symmetrical curve in the rectangular system (aside from the point at the origin and the coordinate axes themselves) is, from this point of view, the line-pair cross, $x^2 = y^2$, i.e., the combination of the lines, $x = y$ and $x = -y$. If this cross is rotated or translated to any position other than into coincidence with the coordinate axes (eq., $xy = 0$), its eq. becomes more complex and it no longer is the most symmetrical curve. Accordingly, in many coordinate systems, many different eqs. can represent any given curve, but only one of the congruent curves is *most* symmetrical--by virtue of its "favored" relationship to the reference elements.

Exponential Degree Restriction

These considerations lead directly to the other sense in which the term *restrictive* is employed. In almost all of the undirected-distance coordinate systems treated, eqs. for congruent curves can occur to more than one degree in the variables. The degree depends upon the location and orientation of the curve relative to the reference elements about which the eqs. are cast. A mere inspection of these eqs. may lead to much information about the symmetry of the curves represented and the absolute and relative focal rank of the poles about which they are cast, but it leads to little specific information about the nature and form of the curves themselves. Only knowledge of the complete inventory of the eqs. of the system would give this information. For example,

the only other way to tell that 2nd and 8th degree eqs. in bipolar coordinates represent congruent curves, would be by plotting or by recasting the eqs. in rectangular coordinates. Such coordinate systems impose a very low level of restriction on the degree of the eqs. of curves cast in them.

But in coordinate systems that have two lines as fixed-position reference elements, the situation is markedly different. Exponential degree restriction is complete. Any given curve is represented by an eq. of only one degree in the variables (these comments refer only to the terms of highest degree). Accordingly, when passing from the former type of coordinate system to the latter type, one goes from a situation in which the eqs. may convey much information about the symmetry of the represented curves, but very little information about their form and identity, to one in which the reverse tends to be true.

Complete degree restriction is characteristic of all bilinear systems, whether they employ directed or undirected distances. But among all bilinear systems the 90° systems are unique in that: (1) only in them is the orthogonal distance vector from one axis to a point on the curve parallel to the other axis; and (2) in consequence, only in them does the eq., $x^2 + y^2 = j^2$, represent a circle, and the eq., $xy = j^2$, represent an equilateral hyperbola. Together with the absence of *reflective redundancy* (see below) these properties make rectangular coordinates the key bilinear system for symmetry analyses.

Congruent curves generally can be represented by a large number of eqs. in planar coordinate systems in which two or more fixed-position reference elements are employed. But when not more than one of these reference elements is a line (though it is not necessary that any of them be a line), the eqs. fall into more than one degree class, according to the degree of the variables used to specify the distances from the reference elements. For example, in bipolar coordinates, where the reference elements are two fixed points, central conics can be represented by many different eqs., but these fall into at least four degree classes--8, 4, 2, and 1. These four degree classes for central conics also occur in *polar-linear coordinates*. On the other hand, in rectangular coordinates, central conics fall into only one degree class.

Reflective Redundancy

A characteristic feature of directed-distance coordinate systems is that there is no *reflective redundancy*. All undirected-distance coordinate systems that have lines of symmetry have reflective redundancy, i.e., all non-bisected

curves possess mirror images in the lines of symmetry of the system. When the basis curve is bisected, i.e., if a line of symmetry of the curve lies on the line of symmetry of the system (and the system has only one line of symmetry), reflective redundancy does not lead to the presence of a separate image.

Circumpolar Intercept Transforms

Polar coordinates are unique in that there is only one distance variable and one fixed-position reference element. But the polar coordinate representation yields an analytical counterpart to the two-distance-variable eqs. of other planar coordinate systems, namely, the *circumpolar intercept transform*--a basic element of the discipline of *circumpolar symmetry*. An intercept transform is obtained by having two reference radii emanate from a pole at a fixed angle, α, to one another, rotating these radii about the pole in the fixed relation, and

Fig.
1-1a

employing their intercepts with the curve, r_1 and r_2, as the two variables, leading to the relation $f(r_1,r_2) = 0$. When both the foci and the intersections are real, the intercepts are distances and the transforms have real solutions; otherwise the intercepts are imaginary or complex and the transforms have non-real solutions. In essence, the transforms with imaginary or complex solutions complement those with real solutions; both types give valid characterizations of the symmetry of the curve about the pole in question.

Circumpolar intercept transforms define both the circumpolar symmetry *class* (the degree of the transform) of the curve at the angle and about the pole for which they are cast, and the *focal rank* of the pole at that angle (the reciprocal of the degree of the transform). Taken together with information about the value of θ to which the intercepts apply (i.e., the parametric eqs. in θ, r_1, and r_2), they provide complete implicit information about the form and symmetry of the basis curve $r = f(\theta)$ about the pole in question at the fixed

Fig.
1-2

angle α in question. Circumpolar intercept transforms of central conics about different poles at different angles yield eqs. that have at least 11 degree classes, namely, 32, 20, 16, 14, 12, 8, 6, 4, 3, 2, and 1 (Table VII-1). Table I-1 outlines the indices of a circumpolar symmetry analysis of a curve about a specific pole--matters treated in detail in Chapter V.

A Preliminary View of the Circumpolar Intercept Transformation

The following is a preliminary exposition of the circumpolar intercept transformation in terms understandable to the layman. Imagine that a surveyor is commissioned to determine the size and shape of a wall enclosing a city, and

Table I-1. Indices Employed In a Circumpolar Symmetry Analysis of a Curve
(the symmetry of a curve about a specific reference point)

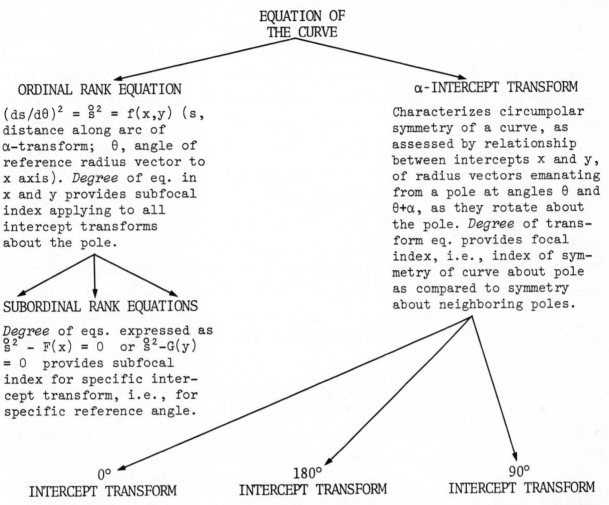

**EQUATION OF
THE CURVE**

ORDINAL RANK EQUATION

$(ds/d\theta)^2 = \overset{\circ}{s}{}^2 = f(x,y)$ (s,
distance along arc of
α-transform; θ, angle of
reference radius vector to
x axis). *Degree* of eq. in
x and y provides subfocal
index applying to all
intercept transforms
about the pole.

α-INTERCEPT TRANSFORM

Characterizes circumpolar
symmetry of a curve, as
assessed by relationship
between intercepts x and y,
of radius vectors emanating
from a pole at angles θ and
$\theta+\alpha$, as they rotate about
the pole. *Degree* of trans-
form eq. provides focal
index, i.e., index of sym-
metry of curve about pole
as compared to symmetry
about neighboring poles.

SUBORDINAL RANK EQUATIONS

Degree of eqs. expressed as
$\overset{\circ}{s}{}^2 - F(x) = 0$ or $\overset{\circ}{s}{}^2-G(y)$
$= 0$ provides subfocal
index for specific inter-
cept transform, i.e., for
specific reference angle.

**0°
INTERCEPT TRANSFORM**

Characterizes symmetry
of curve for $\alpha = 0°$.
For many poles of many
curves is trivial trans-
form x = y. For one or
two poles of many curves
is transform of self-
inversion, xy = constant,
i.e., *a symmetry of posi-
tive reciprocal point
reflection*. For incident
points on many curves is
trivial transform xy = 0.
Degree of non-trivial 0°
transform provides focal
index.

**180°
INTERCEPT TRANSFORM**

Characterizes symmetry
of curve for $\alpha = 180°$.
For many poles of many
curves only trivial
180° transform x = -y
exists. Sometimes
yields transform of
self-inversion xy =
constant, i.e., *a sym-
metry of negative
reciprocal point re-
flection*. *Degree* of
non-trivial 180° trans-
form provides focal
index.

**90°
INTERCEPT TRANSFORM**

Characterizes symmetry
of curve for $\alpha = 90°$.
Is most discriminating
of the 3 transforms for
symmetry characteri-
zation. Infrequently
yields transform of
self-inversion xy =
constant, i.e., *a 90°
reciprocal point re-
flection*. *Degree* of 90°
transform provides
focal index.

that the entire wall is visible from a high point within the city. A simple,
direct approach would be for the surveyor to establish a reference direction,
say north, and then to direct his transit successively along different points
of the compass, determining for each compass heading the distance to the wall,
and making as many distance determinations as necessary to determine the shape
of the wall to the desired accuracy. With this information at hand, the
distances can be plotted against the corresponding compass-heading angles on
polar coordinate graph paper to give a miniature reproduction of the size and
shape of the wall.

Imagine further that the survey must be done in haste. Two surveyors now work
back-to-back on a rotatable platform. One surveyor obtains the distance to the
wall at each successive setting of the platform as it is rotated CW (clockwise)
from north to south, while the other obtains the distance in the opposite
direction. Finally, imagine that 4 surveyors do the job in ¼ of the time by
facing at 90° to one another, or that 8 do it by facing at 45° to one another.
Whatever the number of participating surveyors, if each contributes his distance
measurements at the corresponding compass headings of the platform for his
assigned sector to the polar coordinate plot, the complete curve for the shape
of the wall will be obtained.

So much for the shape of the wall, now to the question of its symmetry. The
symmetry of the wall about the reference point corresponding to the location
of the platform, i.e., its *circumpolar symmetry*, is characterized completely
by a simple deviation from the procedure just described, as follows. Consider
the first case, in which the two surveyors worked back-to-back. Instead of
each filling in his 180° sector of the plot for the polar coordinate graph,
they now cooperatively use each of their corresponding values of the distance
measured in opposite directions. One supplies the x coordinate and the other
the y coordinate for a rectangular xy plot on ordinary graph paper. In
addition, one of them designates the angle θ at which each of the distances
was measured.

The figure obtained by this procedure is the *180° circumpolar intercept trans-
form* of the curve defined by the wall. In a more mathematical framework, the data
obtained by the surveyors are merely the r and θ of the polar coordinate
eq. r = f(θ) of the curve defined by the wall. The rectangular xy plot (the
intercept transform curve in the xy plane) is obtained as follows. One
substitutes x for r in this eq. with θ unchanged, yielding one parametric

eq., $x = f(\theta)$, of the transform curve, and y for r with θ altered to $\theta+\alpha$ (where α is the angle of the transformation), yielding the other parametric eq., $y = f(\theta+\alpha)$. The eq. of the intercept transform in rectangular coordinates now is obtained by eliminating θ between the two parametric eqs., yielding $g(x,y) = 0$.

This intercept transform scarcely ever will bear any resemblance to the shape of the wall. But, taken together with the designated angles at which the specific distances were measured, it completely characterizes the 180° symmetry of the wall about the point of location of the platform. It also contains implicitly all of the original information about the shape of the wall and complete information about the symmetry of the wall at all other angles (i.e., the angles at which the surveyors stand in relation to one another) and about all other points.

Some 180° transforms are taken as specific examples. For an elliptical wall with the platform located at the center and the surveyors working back-to-back, the curve obtained would have the linear eq., $x = y$; with the platform located at the position of a traditional focus, the curve obtained would have the equilateral hyperbolic eq. $xy = (b^2/2a)(x+y)$. These 180° transforms about the center and traditional focus would then be the symmetry-characterizing eqs. The symmetry of the wall would be described in terms of the properties of these eqs. Thus, the wall would be said to have *linear 180° symmetry* about the center position, and *equilateral hyperbolic 180° symmetry* about the position of the focus. If one wished to compare the linear 180° symmetry of the wall about the center with that of some other figure also having linear 180° symmetry about its center (a relatively common class of symmetry), the parametric eqs. of the transform would be employed to extract more specific information about the nature of the linear symmetry, namely, the degrees of the ordinal and subordinal rank eqs. (see Chapter V and Tables I-1 and V-1).

Some Definitions

Circumpolar Focus and Focal Rank

Definitions of the terms, *circumpolar focus, focal rank, subfocal rank,* and *symmetry rank* are in order, because these terms are used repeatedly in the following. I begin with definitions for polar coordinates, because the analysis of symmetry reaches its highest level in this system.

In a given coordinate system, the definition and analytical treatment of sym-

metry depend upon the specification and employment of the same number and types of reference loci that are used in the specification of the system itself. In the case of polar coordinates, symmetry is defined and analyzed in terms of a point and an angle. A *circumpolar point focus* at any angle, then, is defined as a point in the plane for which the eq. of the *intercept transform* is of lower degree than that of transforms about all neighboring points. If the eqs. of intercept transforms for all points on a linear or curvilinear locus are of lower degree than those of transforms for neighboring points not lying on the locus, then the locus is a *focal locus*.

Fig.
1-1
b,c

[In cases of α-θ-circumlinear and α-θ-circumcurvilinear symmetry, the symmetry is referred to a single fixed reference element--a line or curve--rather than to the reference elements of a coordinate system. *Two angles* define these types of symmetry, which are assessed by the relationships between the intercepts with the basis curve of two radius vectors emanating from points on the reference line or curve, at the angles, θ and $\theta+\alpha$.]

To give concrete examples, the 90° circumpolar intercept transforms (*transforms* for short) of a parabola about a point (h,k) in the plane are of 20th degree in the variables (x and y or r_1 and r_2). Thus, any point or point array for which the 90° transform is of less than 20th degree is a focal locus. The 90° transform of the parabola about its traditional focus is of the lowest degree in the variables of any point in the plane, namely 4th degree. Consequently, the traditional focus has the highest 90° *focal rank*, which is defined as the reciprocal of the degree of the corresponding transform, in this case, ¼. The 90° transforms for other focal loci of the parabola are of 16th, 12th, 8th, and 8th degree, for a point on the axis, a point incident upon the curve, the axial vertex, and the LR (latus rectum) vertices, respectively, corresponding to focal ranks of 1/16th, 1/12th, 1/8th, and 1/8th.

With very few exceptions, the focal rank of a circumpolar focus of a given curve depends upon the angle of the transformation. Non-trivial transforms of 0° and 180° often have twice the focal rank of 90° transforms, i.e., their eqs. are of half the degree of that of the 90° transform. The lowest degree of any non-trivial transform of the parabola at any angle is 2, corresponding to the highest focal rank of ½; for central conics, the focal rank of the highest-ranking focus is 1, the corresponding transform being of 1st degree.

Subfocal Symmetry

Symmetry extends beyond the focal level to the *subfocal* level. In other words, a curve may have two foci of equal focal rank, yet be more symmetrical about

one of them than about the other. Of two point-poles having equal focal rank, the one for which the eq. of the transform is the simplest (lowest overall degree in both variables and parameters, fewest terms, fewest parameters, and fewest non-unit dimensionless coefficients) has the highest *subfocal rank*. A paradigm for an absolute scale of subfocal ranking within any given focal rank category based upon these criteria has not been formulated. However, neither does any pressing need for such an absolute ranking scale arise. Usually the relative subfocal ranking of a number of poles lying on a given focal locus is clear cut and carried out without ambiguity.

A good example of subfocal ranking arises in connection with the $180°$ transforms about points on the asymptotes of a hyperbola. For all poles, except the center, the transforms are of 6th degree. But the eqs. of these transforms simplify--though they do not reduce--at poles where the asymptotes intersect the extended latera recta, and they simplify still further for poles that have the same abscissae as the vertices. Since these poles have higher subfocal rank than neighboring points on the asymptotes, the curve has greater symmetry about them than about neighboring points.

The term *symmetry rank* is employed non-specifically to connote either or both focal and subfocal rank; the specific terms, *focal* and *subfocal*, are reserved for explicit applications.

Foci and Focal Rank In Other Coordinate Systems

In bipolar coordinates, symmetry is evaluated relative to focal pairs, i.e., relative to two points or poles, for these are the reference elements in this system. A pair of poles is a *bipolar focus* of a curve if the degree of the bipolar eq. of the curve cast about these poles is lower than the degree of eqs. of the curve cast about neighboring pairs of poles. Similarly for a *polar-linear focus*, for which the eq. of the curve is cast about the combination of a line and a point, for a *tripolar focus*, for which the eq. of the curve is cast about a triad of poles, etc. Likewise, the focal rank of a pair or triad of poles, for example, is the reciprocal of the degree of the eq. of the curve cast about the pair or triad.

In all these definitions, the phrase *has greater symmetry* may be replaced by the phrase *has a simpler construction*. But to say that one curve has a simpler construction than another merely means that the eq. of the first curve is *simpler* than that of the second when cast about two points, or the line and the point, or the three points, or whatever the loci of reference. The simpler

and the lower the degree of the eqs. cast about the loci, the simpler the construction about them, the higher the focal rank of the loci, and the greater the corresponding symmetry of the curve about them.

The Most Symmetrical Curves

In all of the following considerations of the most symmetrical curves in co-ordinate systems, trivial loci that consist merely of a point, an ensemble of points, the reference elements themselves, and their points of intersection, if any, are excluded. Bearing in mind this qualification (and the exceptions noted below), *the most symmetrical curves* in a coordinate system typically are represented by *complete linears*, i.e., linear equations in which *all* the co-ordinate variables appear. In coordinate systems possessing two reference elements, eq. 1 defines *the most symmetrical curve*, where u and v are the undirected distances from the poles p_u and p_v, respectively.

$$u = v \qquad\qquad (1\text{-}1)$$

The polar coordinate system provides the only exceptions to the above rule. In polar coordinates, the complete linear, $r = j\theta$ (j is the unit of linear dimension and θ is expressed in radians), defines the most symmetrical curve of infinite degree, namely, the spiral of Archimedes. But the most symmetrical curves of finite degree are defined by the *incomplete linears*, $r = a$ and $\theta = b$. [*Incomplete linears* are valid eqs. in polar coordinates because the loci defined by $r = a$ and $\theta = b$ encompass all values of the non-appearing variable. However, the requirement that an incomplete linear encompass all values of the non-appearing variable(s) is not satisfied in other coordinate systems. For example, in polar-linear coordinates, lines, $u = a$, parallel to the line-pole, encompass only values of v (the distance from the point-pole) equal to or greater than $\pm(d-a)$. Similarly, $u = d$ encompasses all values of v for the line passing through p_v but not for the reflectively redundant line. Accordingly, $u = a$ is not a valid polar-linear constructional eq. Likewise, a circle, $v = a$, centered at p_v, is not a valid polar-linear construction, since it encompasses only values of u (the orthogonal distance from the line) from $\pm(d-a)$ to $d+a$.]

The next-most symmetrical curves in coordinate systems with two fixed-position reference elements are given by eqs. 2a,b, where C is a positive dimensionless constant and d is the distance between the poles. The least symmetrical among

$$\text{(a)} \quad u \pm v = Cd \qquad\qquad \text{(b)} \quad u = Cv \qquad\qquad \text{(c)} \quad Au + Bv = Cd \qquad\qquad (1\text{-}2)$$

the complete linears is 2c, where A and B are positive or negative dimensionless constants. In general, the fewer the number of non-unit dimensionless constants in a complete linear, the simpler the eq., and the more

symmetrical the curve. In many cases, particularly when there is reflective symmetry in both the midline and the polar axis of the coordinate system, the curves represented by eqs. 2b, as compared to 2a (with $C \neq 1$ in both), or eq. 2a (with $C = 1$), as compared to 2b (with $C \neq 1$), are so highly symmetrical that it may be meaningless to try to draw distinctions between them.

Figs. 2-1 b_1 v. c_1, c_2 and b_1 v. b_2, b_3

The curves next-most symmetrical to the linears are quadratics, such as eqs. 3, followed by cubics, etc.

$$(a) \quad uv = Cd^2 \qquad (b) \quad u^2 = Cdv \qquad (c) \quad v^2 = Cdu \qquad (1\text{-}3)$$

$$(d) \quad u^2 + v^2 = Cd^2 \qquad (e) \quad Au^2 + Bv^2 = Cd^2$$

In coordinate systems with three reference elements, the most symmetrical curves are given by the *complete linears* of eqs. 4. Next-most symmetrical are the quadratics of eqs. 5, followed by cubics, etc.

$$(a) \quad u \pm v = w \qquad\qquad (b) \quad u \pm v \pm w = Cd \qquad (1\text{-}4)$$

$$(c) \quad Au + Bv + Dw = 0 \qquad (d) \quad Au + Bv + Dw = Cd$$

$$(a) \quad uv = dw \qquad (b) \quad u^2 = vw \qquad (c) \quad u^2 \pm v^2 \pm w^2 = Cd^2 \qquad (1\text{-}5)$$

$$(d) \quad u^2 = Adv + Ddw \qquad\qquad (e) \quad Au^2 + Bv^2 + Dw^2 = 0$$

Specific Examples

The curves having the greatest symmetry in polar coordinates are circles centered at the pole, any line passing through the pole, and Archimedes' spiral. In bipolar coordinates, the most symmetrical loci are the midline and all points in the plane. Both are represented by the eq. $u = v$; the former locus obtains when the poles are non-coincident, the latter when they coincide. Next-most symmetrical are centered circles $u+v = 2R$ (for coincident poles), the connecting axis $u+v = d$, the axial arms $u-v = d$, the central conics, $u \pm v = d/e$ (e, the eccentricity), and the "circle of Apollonius," $u = Cv$.

Figs. 2-1a

2-2a

2-1b

In non-incident polar-linear coordinates, the most symmetrical curve is the parabola with the well-known focus-directrix relation, $v = u$. Next-most symmetrical are: (a) the central conics, $v = eu$; (b) the orthogonal, connecting line-segment, $u+v = d$, where d is the distance between the point-pole p_v and the line-pole p_u; (c) the orthogonal, non-intersecting lateral line-segment, $u-v = d$, extending from the focus to infinity; and (d) the combination of a parabola and its exterior axis, $v-u = d$, with p_u being the vertex tangent

3-1a

3-1 b,c

Fig.
3-2

and p_v the traditional focus. The next-most symmetrical curves also are "conic sections," namely, various parabolas, *disparate partial "parabolas," disparate two-arm "hyperbolas," disparate partial "hyperbolas,"* ellipses, and other curves with linear eqs., such as $\pm u \pm v = Cd$, $v - eu = d$, $eu + v = d$, and $u - Bv = d$.

In rectangular coordinates, the most symmetrical curve in the 1st and 3rd quadrants is the 45° bisector, $x = y$ ($u = v$). In the 2nd and 4th quadrants, it is the 45° bisector, $x = -y$ ($u = v$). Viewed from the perspective of bilinear coordinate systems with axes at other angles than 90°, the 1st and 3rd quadrants and the 2nd and 4th quadrants, of the 90°-bilinear system employing *undirected distances*, should be regarded as two separate, complementary coordinate systems that merge with unique compatibility. The eq. of the complete cross in this dual complementary system is simply $u = v$. But when directed distances are employed, as in the rectangular system, a quadratic eq., $x^2 = y^2$, is required to represent both arms.

In collinear tripolar coordinates (3 collinear point-poles), the most symmetrical curve is the collinear axis (or segments thereof), followed by certain cubics and quartics, including *linear Cartesian ovals*--all represented

Figs.
4-4
a_1,a_2

4-4a

4-5
a_1-a_4
4-7
b_1,b_2

4-6
c_1,c_2

by the general eq., $Au + Bv = Dw$. In polar-circular coordinates, the most symmetrical curve, $u = v$, is a hyperbola when the point-pole is outside the circle-pole, an ellipse when it is inside, and a line when it is incident upon the circle-pole. In the case of the hyperbola (and line) one arm (or segment) is given for the least distance to the circle, and the other arm (or segment) for the greatest.

In linear-circular coordinates, the most symmetrical curve is the *confocal two-arm parabola*, $u = v$. Among the next-most symmetrical are central conics, $u = ev$ (u, the distance to the circle-pole). In congruent, non-concentric bicircular coordinates, the most symmetrical curve is the midline, $u = v$. Next-most symmetrical are the central conics, $u + v = Cd$, centered on the connecting axis at midpoint.

The same groups of curves generally rank very high on the symmetry scale in all coordinate systems. In fact, almost all of these curves are members of the *QBI* (quadratic-based inversion) *superfamily* (all curves to which quadratics invert). Curves high on the symmetry scale often invert to themselves and to one another through their foci. The higher the rank of the focus, the higher tends to be the circumpolar symmetry rank of the inversion locus, i.e., of the inverse curve.

Classification of Curves

Introduction

A universally applicable paradigm for the classification of curves and
surfaces has yet to be attained. My own approaches to this problem are still
very much in working stages. As with the classification of living forms, a
number of criteria lend themselves to use for classifying curves. But another
parallel also holds--too great a reliance on any given criterion for classifying
curves is likely to be misleading.

Also to be kept prominently in mind is the fact that classifications of
curves and organisms cannot be regarded as homologous. Curves and surfaces are
not related to one another in the same way that organisms are related. Curves
have not evolved from more primitive antecedents, and never stand solely in
a basis-derivative relationship to one another, as do living forms. One organ-
ism cannot be both parent and offspring of another organism, whereas any basis
curve subjected to a transformation that generates another curve, always can
exchange roles with the transform curve through the medium of the inverse
transformation.

On the other hand, unlike our ability to establish the relationships that
exist between past and present forms of life--which is at worst guesswork and
at best often subject to more than one interpretation--the relationships that
exist between curves and surfaces are subject to precise analysis. They are
not topics that ultimately are tentative and debatable. Though our knowledge
of these matters may presently be extremely limited, there is no insur-
mountable barrier to extending it to any degree of completeness desired.

Circumpolar Symmetry Taxonomy

The most far-reaching basis for classifying curves--possibly the ultimate
tool for this purpose--hinges upon analyses of their circumpolar symmetry. In
some respects the criteria provided by circumpolar symmetry analyses are
absolute. In others they leave something to be desired. For example, the number
of axial circumpolar foci possessed by a curve is, for some purposes, an
important criterion of symmetry relationships. Yet other aspects of the sym-
metry of curves transcend the number of focal poles and hinge instead upon the
nature of the symmetry about specific focal poles, regardless of whether the
number of poles having focal rank is the same for the curves under consideration.

While a circumpolar symmetry analysis provides foundations for a far-reaching classification of curves according to their symmetry, the specific *Circumpolar Symmetry Taxonomy* that is introduced—which employs taxons from the phylum to the suborder—is not one that primarily classifies curves as such. Rather, in its primary application, it classifies curves according to their symmetry about specific poles at specific angles. Thus, hierarchical ranking of curves according to their circumpolar symmetry does not assign to a given curve an absolute position in the hierarchy, but only assigns: (1) positions relative to specific types of symmetry about designated types of poles at specific angles; and, more generally, (2) membership in phyletic groups determined by the highest ranking possessed by any curve-pole combination of a curve in category (1). The following examples relating to category (1) will not be fully understood at this point, but they convey something of the meaning of the above statements.

If, for the sake of simplicity, requirements regarding equal transformation angles and comparable foci are relaxed, the hierarchical *linear-symmetry class rank* (i.e., the rank among intercept transforms that are linear in the variables) of limacons about the DP (double point) or DP homologue is very high —of 14 entries in this class it falls 3rd on the list, behind only Archimedes' spiral and the logarithmic spiral (Table V-1). But when ranked according to its *hyperbolic symmetry* about the focus of self-inversion, it falls relatively low on the list. Contrariwise, central conics are outranked only by the parabola with regard to hyperbolic symmetry about the traditional focus, whereas when ranked according to linear symmetry about the true center, 8 of the other 12 curve-pole entries outrank them (for a more extensive listing see Appendix III).

Inversion Taxonomy

Curves that belong to the same *inversion superfamily* fall naturally into subgroups that have many properties in common, including key aspects of their circumpolar symmetry. They also fall into subgroups according to the degree of their rectangular eqs.—1st, 2nd, 3rd, and 4th for QBI curves—as well as into groups of quite different appearance.

Inversion of all members of a group of basis curves about all points in the plane provides an incomparable basis for the classification and systematic

organization of curves. This is because the inversion transformation is *ultimately conservative of degree* (see Glossary). Accordingly, among point transformations of conic sections that give non-trivial and non-similar curves, successive generations of inversions are of the lowest exponential degree and include many well-known highly-symmetrical curves of great interest. Only the *1st-generation* tangent pedals of conic sections duplicate the entire ensemble of their 1st generation inversions.

A great deal of attention is devoted to the Inversion Taxonomy of the QBI superfamily, both for purely illustrative purposes and because Inversion Taxonomy provides the framework within which the circumpolar symmetry analyses of this superfamily are carried out. Moreover, the Inversion Taxonomy of one superfamily also inevitably reveals principles and relationships of inversion that can be expected to apply within other superfamilies.

But Inversion Taxonomy is of no use for the classification of curves that are not related by inversion, and thus is of no help in comparisons that have the objective of arriving at a more far-reaching classification of curves. To cross the boundaries of inversion superfamilies, other types of transformations --of which the intercept transformation is pre-eminent--must be employed (see Chapter VIII, *Other Transformation Taxonomies*; also Chapter XIII, *Tangent-Pedal Taxonomy*).

Employment of the taxon *superfamily* for an ensemble of curves related by inversion about all points in the plane is arbitrary, and is not intended to signify a level at which this taxonomy interfaces with an absolute method of classifying curves. If the entire QBI ensemble is regarded as a superfamily, then the four families thereof might be taken to be the inversions of conics about: (a) the major axis (or transverse axis); (b) the minor axis (or conjugate axis); (c) points incident upon the curve; and (d) non-axial, non-incident points in the plane.

Although it is not evident at this juncture, these four families include all the members of the superfamily, i.e., all of the inversion loci of conics, all of the inversion loci of these inversion loci, etc. Each of the four families consists of a number of subfamilies based on the types of curves yielded by inversion along or within certain segments or portions of these loci. A scheme outlining some of these relationships is given in Table I-2 (see also Tables VI-1, X-3, and XI-1).

Toward an Absolute Classification

A paradigm for the absolute classification of curves is not at hand but the
starting points and first steps toward it seem clear. These are outlined, not
as an achievement toward such a classification--because the early steps to be
taken are obvious--but to introduce the terminology that is employed through-
out the book. Conic sections and limacons are taken as examples. Starting at
the level of the individual curve, a curve of a given eccentricity is desig-
nated as the *subspecies* "e." For conics, for example, the circle is the sub-
species e = 0 of the *species* ellipse, and the equilateral hyperbola a sub-
species e = $2^{\frac{1}{2}}$ of the *species* hyperbola. The parabola species has only the
single subspecies e = 1. The *genus* (or possibly the *subgenus*) would be the
conic sections (or quadratics). A similar scheme yields the genus, limacons
(Table I-3).

It is at this point that complications enter, namely, in arriving at the
next taxon above the genus (or subgenus) level. If one were to follow the
limited perspective of the Inversion Taxonomy of the curves, the next-highest
level might be a division between axial and non-axial inversions of QBI
curves. On the other hand, if one were to use a common ground revealed by
circumpolar symmetry analyses, the next-highest level could be defined by
the *simple intercept format* for *The Cartesian Group* (see Chapter X) which,
though including conics and limacons, excludes most QBI curves and includes
many curves that do not belong to the QBI superfamily. No attempt is made to
resolve these issues; this is a goal that must await the findings of many
further analyses, including the results of other elementary point trans-
formations.

[Note that, unlike the situation for the classification of organisms, a curve
can be a subspecies of more than one species or genus. Thus, the circle is a
subspecies of both the ellipse species of conics and the elliptical species
of limacons.]

[Use of the designations *species* and *genus* with non-QBI curves in the following
is by superficial analogy with their use for QBI curves, and should be regarded
as tentative. Absolute assignments of even these low taxon levels within other
inversion superfamilies must await the findings of detailed studies of their
member groups.]

Table I-2. Partial Scheme of Inversions in the QBI Superfamily

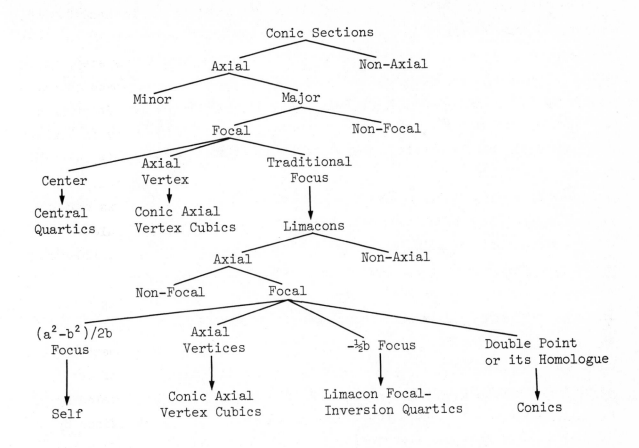

Table I-3. Toward an Absolute Classification of Curves

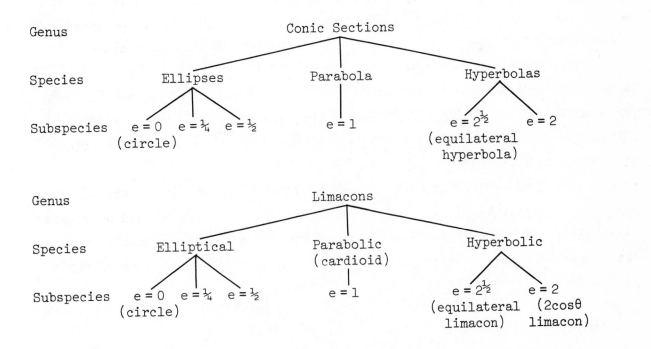

Design and Synthesis of Highly Symmetrical Curves

Once the symmetry characteristics of curves are identified and defined precisely, it becomes possible to synthesize new groups of curves having virtually any desired symmetry properties, often comprising supergenera that contain an infinite number of genera. The coordinate system approach of Chapter II-IV addresses this objective from the point of view of ascertaining the most symmetrical curves with respect to specific reference elements. Approaches of a more synthetic nature--mostly in the polar coordinate system--are elaborated in Chapter XIV, in the section titled as above.

In one approach, highly symmetrical curves can be synthesized by employing individual building-block terms, such as $(x^2+y^2)^n$, which, taken in combination, do not violate design principles for high symmetry. A very fruitful approach stems from the finding that some of the most highly symmetrical genera of curves in the QBI superfamily possess *generic double-foci of self-inversion*, i.e., a focus of self-inversion which, though possessed by practically all genera of QBI curves, is coincident with another focus only in certain genera (for example, at the loop vertex of the curves obtained by inverting conics about their major and transverse axis vertices). Synthesizing new (non-QBI) genera with generic double-foci is the method of this approach. The precise paths that can be followed are many and diverse.

For example, *symmetry mimics* are curves of higher degree than a given basis curve, that have 0° and 180° transforms about some specific pole that are identical to the corresponding transforms of the basis curve about the homologous pole. The design capabilities for such curves even include making the 0° and 180° transforms identical to one another. In some cases, a symmetry mimic may be more highly symmetrical than the basis curve itself. Thus, the sextic symmetry mimic of tangent circles (which are quartics) is more symmetrical than the tangent circles themselves. The latter have linear 0° and 180° transforms and circular 90° transforms, whereas all 3 transforms of the sextic symmetry mimic are linear. Although the rectangular eq. of this symmetry mimic, $(x^2+y^2)^3 = a^2x^4$, is more complex than that of the basis curve, $(x^2+y^2)^2 = a^2x^2$, its polar eq. is simpler, $r = a\cos^2\theta$ versus $r^2 = a^2\cos^2\theta$. The latter situation is to be expected, since the curves are being compared on the basis of their *circumpolar symmetry*.

Another approach to the synthesis of highly symmetrical curves centers around the design of curves that self-invert at many angles about a generic double-

focus. Classical treatments of self-inversion have been confined exclusively to the positive and negative varieties (along radii at 0° or 180°, respectively, to one another). However, self-inversion is simply *reciprocal reflective symmetry through a point*. Consequently, it can be generalized to any angle, i.e., *α-self-inversion*. Many curves are known to self-invert at 0° or 180°, and some have been found to self-invert at both angles (for example, bipolar linear Cartesians). Only one known genus of curves has been found (by circumpolar symmetry analyses) to self-invert at 90°, namely single-oval Cassinians (the same analyses show that two-oval Cassinians self-invert at both 0° and 180°). In Chapter XIV it is shown how curves can be synthesized that self-invert about a single pole at all 3 angles--the *Tri-angle self-inverters*-- and, in fact, one also can synthesize highly symmetrical curves that self-invert about a single pole at as many angles as desired--the *multi-angle self-inverters* (only the circle self-inverts at all angles).

Figs.
2-1e

2-5a
C = 1/8

2-5a
C = 3/8

First-Generation Quadratic-Based Pedal Taxonomy

While the findings of the Inversion Taxonomy of conic sections are of great interest and largely unexpected, those for the 1st-generation tangent pedals of the same group are fascinating and quite remarkable. These findings doubtless are merely a preview of many fundamental taxonomic interrelationships between curves that remain to be revealed by systematic applications of elementary point transformations (excluding those that give trivial or similar loci).

Not only is the ensemble of tangent pedals of conic sections about all points in the plane found to be identical to the ensemble of inversions of conic sections about all such points, the pedal-points of the pedals that invert to conics of a given eccentricity are related in extraordinary ways. The mapping of these pedal points has led to the discovery of fascinating genera of curves --the *constant pedal-eccentricity loci*--that consist of nestling, non-over-lapping ensembles of curves that fill the plane. In the simple case of the parabola, the eq. of the loci is quadratic and represents *monoconfocal* conic sections of all eccentricities--the line, the point-circle, the parabola, all ellipses, and all hyperbolas. For the central conics, the locus for a basis curve of given eccentricity represents both the basis curve itself and a genus of previously unknown quartics. The corresponding picture for the 1st-generation *normal pedals* appears to be quite unrelated but is, as yet, unelucidated.

Introduction

The utility of *bipolar coordinates* for the representation of certain curves has long been known but the relationships between specific aspects of bipolar eqs. and the symmetry of the curves that they represent appear to have escaped notice. Eqs. in bipolar coordinates express relationships between the undirected distances from two fixed points or poles to any point on the represented curve. The bipolar system was chosen for the first detailed treatment because, of all coordinate systems, eqs. expressed in it are the most readily interpreted and give the most information--on mere inspection--about the symmetry of the curves represented, and because some of the eqs. already are known.

The bipolar system will be familiar from the simple constructional eqs. for the hyperbola, 1a, and the ellipse, 1b, where u is the undirected distance

(a) $\pm(u-v) = 2a$ hyperbola (b) $u + v = 2a$ ellipse (2-1) Figs. 2-1 c_1, c_2

from pole p_u and v is the undirected distance from pole p_v to any common point on the curve. In the traditional view, the positive sign in 1a gives one arm of the hyperbola and the negative sign the other arm. The fixed points usually have been referred to as "foci" but the more appropriate term *poles* is employed here.

A characteristic feature of eqs. cast in this system depends on the facts that there are only two fixed-position reference elements, and that these have the properties of being both identical in type and of the simplest nature. The characteristic referred to is that mere inspection of the bipolar eq. gives information about the bipolar symmetry rank of the two poles and reveals the presence or absence of (a) reflective symmetry of the curve in the bipolar midline and (b) a *true center* of symmetry (the pole of intersection of two orthogonal lines of symmetry). For 1st and 2nd degree bipolar eqs., a line connecting the poles is a line of symmetry and a focal locus, i.e., a locus upon which any pole-pair has bipolar focal rank. Furthermore, simple operations on bipolar eqs. reveal the existence and location of pole-pairs that have high focal rank.

BIPOLAR MAXIM 1: *Simple bipolar equations of low exponential degree define highly symmetrical curves and high-ranking bipolar foci (pole-pairs).*

BIPOLAR MAXIM 2: *A line connecting the poles of a bipolar equation of exponential degree 1 or 2 is a line of symmetry of the represented curve and a focal locus, i.e., a locus upon which any pole-pairs have bipolar focal rank.*

[In the sense here employed a *Maxim* is a rule based upon the sum total of experience. Accordingly, Bipolar, Circumpolar, and Pedal Taxonomy Maxims generally are to be regarded as working hypotheses subject to modifications or abandonment that might be necessary to resolve conflicts with future findings. In particular, the Bipolar Maxims are based upon experience with curves that have linear, quadratic, quartic, and octic rectangular eqs.]

Reflective Redundancy In the Polar Axis

In bipolar coordinates and all collinear multipolar coordinate systems, as well as most of the other coordinate systems that are considered, in which coordinate distances are undirected, the *polar axis* (the line on which the poles lie, or a line that intersects all of the poles in a symmetrical fashion) is a line of symmetry of the system. Any curve, or portion of a curve, that is on one side of the polar axis has a mirror image on the other side. This is the property of *reflective redundancy*. Only in the case of curves that are bisected by the polar axis does reflective redundancy not lead to the presence of an image.

Throughout the following treatments of coordinate systems, unless stated to the contrary, it is tacit that qualifying curves possess mirror images in the polar axis. Strictly speaking, a "curve" in bipolar coordinates includes all branches or arms represented by the bipolar eq. For the sake of clarity and simplicity, however, my references to bipolar "curves" usually will apply only to an unreflected portion of the locus. With this qualification one can speak of a curve that is not bisected by the polar axis, whereas if the image is taken into account, all bipolar curves are bisected by this axis. A similar qualification is made at the end of this Chapter in relation to reflective redundancy in the bipolar midline.

Bipolar Focal Rank

The assignment of *bipolar focal rank* follows essentially the same principles
as for circumpolar focal rank, namely, it is the reciprocal of the exponential
degree of the determinant eqs. For circumpolar and circumlinear (in general,
circumcurvilinear) focal rank, it is the intercept transforms that play the key
role, whereas in all other cases, the eqs. of the curve itself are rank determi-
ning. As one would expect, different types of symmetry are interdependent. This
is emphasized by the following finding. For all coordinate systems involving a
point as one of the reference elements, particularly bipolar coordinates, there
tends to be a strong correlation between the circumpolar symmetry of a curve
about a point-pole and the degree, complexity, and weighting of the variables
in eqs. of the curve cast about that pole as a member of a pole-ensemble in the
coordinate system in question.

Ranking of foci in bipolar coordinates is accomplished readily. If the poles
in question are equivalent (such as two traditional foci, two equivalent
vertices, etc.), the bipolar focal rank of the individual poles is the re-
ciprocal of the exponential degree of the eq. cast about the two poles. If a
curve has two lines of symmetry, it is possible to assign an absolute *indi-
vidual bipolar focal rank* to all points in the plane, including points lying
on the lines of symmetry (excepting only a true center).

[For example, in the case of an ellipse, one could take as pole-pairs the two
major axis vertices, the two minor axis vertices, the two traditional foci,
the two LR vertices on the same LR, two contralateral LR vertices, two poles
lying midway between the center and the traditional foci, two poles on the
major axis at the feet of the directrices, etc.]

Figs.
2-1c$_1$
2-4a$_3$

On the other hand, if only one line of symmetry is present, as in the
parabola, it is not possible to assign an absolute individual bipolar focal
rank to poles that lie on the line of symmetry. In such a case, only a re-
lative bipolar focal ranking can be made, based upon the properties of eqs.
cast about these poles.

When an eq. is cast about two non-equivalent poles, the bipolar focal rank
of the pole-pair is the reciprocal of the degree of the eq. In some cases this
focal rank is determined by the member of the pole-pair whose individual bi-
polar focal rank is lowest. For example, if an 8th degree eq. is needed to

define the locus of a curve about two equivalent poles, an 8th-degree eq. sometimes is needed when one of these poles is paired with a pole of higher individual bipolar focal rank (such as a pole of an equivalent pole-pair for which only a 4th-degree eq. is needed to define the locus of the curve).

For a given pole, the bipolar focal rank of a pole-pair of which it is a member tends to be greater the greater the individual bipolar focal rank of the pole with which it is paired. An example is a pole-pair consisting of the traditional focus of an ellipse and any other axial pole. Equivalent and non-equivalent axial pole-pairs of the ellipse lead to eqs. of 4th degree, but when an axial pole is paired with the traditional focus (whose individual bipolar focal rank is 1), the eq. reduces to 2nd degree.

Figs.
2-4a$_3$

2-4a$_2$

BIPOLAR MAXIM 3: *The bipolar focal rank of a pole-pair is the inverse of the exponential degree of the equation of the curve cast about the pole-pair. An individual bipolar focal rank can be assigned to the poles if they are equivalent, i.e., if the equation is symmetrical in u and v.*

Bipolar Subfocal Rank

Defining and comparing the subfocal symmetry of curves presents little difficulty when the comparisons are based on circumpolar intercept transforms. The comparison of symmetry at the subfocal level with respect to eqs. in bipolar coordinates, however, is not so straightforward. The following paradigm gives results that are both internally consistent and not in conflict with other findings.

Comparisons of rank at the subfocal level based upon eqs. cast about non-equivalent poles are valid when: (a) an equivalent pole exists for each of the non-equivalent poles being compared; and (b) an equivalent pole does not exist for either of the non-equivalent poles being compared. Valid comparisons cannot be made when an equivalent pole exists for one but not for the other member of a non-equivalent pole-pair.

As an example of case (a) one can make valid comparisons at the subfocal level based upon eqs. cast about all pole-pairs consisting of points on the major axis of an ellipse, excepting only the center. Exemplifying case (b), one can make valid comparisons at the subfocal level based upon all pole-pairs consisting of points on the axis of the parabola. For both cases the comparisons

also are valid at the focal level. But one cannot make valid comparisons based upon eqs. for which one of the poles is a true center nor for which one pole lies on the axis of the parabola and the other does not.

BIPOLAR EQUATIONS

The Linears

Some of the linear and quadratic bipolar eqs. that are employed as examples in the following are well known; those of higher degree are unknown. All are derivable by elementary analysis. I begin with the most general eq. of the *linears*. In eq. 2, u and v are undirected distances from two point-poles, p_u and p_v, respectively, to any point on the curve. A and B are

$$Bu + Av = Cd \qquad (2-2)$$

dimensionless constants that may take on positive and negative values, C is conventionally a dimensionless positive constant, and d is the distance between the two poles. I deviate from the general practices of the past in employing this distance rather than an arbitrary parameter, and in retaining 3 constants, A, B, and C, rather than eliminating one of them by division. These departures facilitate the symmetry analyses.

Eq. 2 represents central conics, limacons, and *linear Cartesian ovals*. Because the eq. is linear in u and v, poles p_u and p_v can be expected to be either both the highest, or one the highest and the other the second-highest ranking bipolar foci of the curve. In addition, the p_u-p_v polar axis is a line of symmetry. If $A^2 = B^2$, the foci are equivalent and the eq. is that of the central conics cast about the traditional foci (eqs. 1). If $A \neq B \neq C$, the curves are linear Cartesians. Since the foci are not located symmetrically about a true center (because $A \neq B$), they are not equivalent but they possess similar properties (a third focus with similar properties also is present).

On the other hand, for $B \neq A$ and either $B^2 = C^2$ or $A^2 = C^2$, the eq. is that of limacons and the foci are neither equivalent nor possessed of similar

Figs. 2-1 c-e

Figs. 2-1c

Fig. 2-1e

Figs. 2-1d

properties. One is the DP (double point) or DP homologue (the polar center of the eq. $r = a-b\cos\theta$), the other is the *variable focus of self-inversion* (see Chapter V) at $x = (a^2-b^2)/2b$. These are the two highest-ranking *circumpolar foci* of limacons. The higher ranking of the two, the DP or its homologue, is at p_u if $B^2 = C^2$, but at p_v if $A^2 = C^2$. Since these foci are coincident in the cardioid, the cardioid cannot be represented by a *linear* bipolar eq. (or by a linear polar-circular eq.; see Chapter IV). Nor can any limacon cast about any other pair of poles.

The Parabolic

The *parabolic* eq., 3, is an eq. of ovals, the *parabolic Cartesian ovals*,

$$u^2 = Cdv \qquad\qquad (2\text{-}3)$$

Figs. 2-1f some of which are single and others dual, with one oval of the latter within the other. Though these ovals have lesser *bipolar symmetry* than the limacons and linear Cartesians of eq. 2, they have the same *circumpolar symmetry rank* about a homologous focus (p_u of eq. 3; see Chapter V, Table V-1). One ascertains immediately that p_v is the higher ranking of the two foci, because the eq. is linear in v but quadratic in u. However, individual bipolar focal rank cannot be assigned because these poles lie on the single line of symmetry of the curve (see below).

Linearity also reveals p_v to be the highest-ranking focus. The p_v focus is, in fact, a variable circumpolar focus of self-inversion, the homologue of the foci of self-inversion of the linear Cartesians and limacons (mentioned Fig. 2-1f$_2$ above). The equilateral limacon, $r = a(1-2^{\frac{1}{2}}\cos\theta)$, the inversion of the equilateral hyperbola about a traditional focus, lies at the intersection of these two Cartesian groups; it is the only curve described by both eqs. 2 and 3.

[I designate these curves as parabolic *Cartesian* ovals because they share remarkably similar circumpolar symmetry properties with both the bipolar and polar-circular linear Cartesian ovals (see Chapter X).]

BIPOLAR MAXIM 4: *If a bipolar equation is linear in u and v, the corresponding poles will either be the highest-ranking foci of the curve, or one will be the highest-ranking and the other the second-highest.*

BIPOLAR MAXIM 5: *If a bipolar equation is linear in v but not in u, the pole p_v is the highest-ranking focus of the curve.*

The Equilateral Hyperbolic

It can be concluded from mere inspection of the *equilateral hyperbolic*,
eq. 4, that p_u and p_v are equivalent high-ranking foci (because the eq.

Fig.
2-5a

$$uv = Cd^2 \qquad \text{Cassinian ovals} \qquad (2\text{-}4)$$

is symmetrical in u and v) and that a true center of symmetry lies midway
between them; this always is the case for the locus of a bipolar eq. cast
about two equivalent high-ranking foci. Eq. 4 represents Cassinian ovals, of
which the equilateral lemniscate (the inversion of an equilateral hyperbola
about its center) is a special case (a *curve of demarcation*; see *Glossary*).

Fig.
2-5a

BIPOLAR MAXIM 6: *A bipolar equation that is symmetrical in u and v represents
a curve that is symmetrical with respect to the bipolar midline.*

BIPOLAR MAXIM 7: *If the bipolar equation of a curve cast about equivalent
poles is of 1st or 2nd degree, a true center lies midway be-
tween poles p_u and p_v (also frequently true of bipolar
equations of 4th degree).*

[Of course, if reflective redundancy in the polar axis is taken into account,
a true center always lies between equivalent poles, while if reflective re-
dundancy in the midline also is taken into account, a true center lies midway
between even non-equivalent bipolar poles.]

The Circle

As in all undirected-distance coordinate systems having two fixed-position
reference elements, the most symmetrical curves in the bipolar system are
specified by the *complete linear*, $u = v$. The loci of this eq. are: (1) all
points in the plane, for coincident poles; and (2) the midline, for non-co-
incident poles. In both cases, poles p_u and p_v are equivalent highest-
ranking foci, with a true center of symmetry of the loci lying midway between
them (Maxim 7). In the latter case, the true center is the midpoint.

The next-most symmetrical curve for coincident poles is the only other curve
that exists, namely the centered circle of eq. 5a, where R is the radius.

Fig.
2-2a

(a) $u + v = 2R$ (b) $u = Cv$ (2-5)

Although there might be an inclination to regard cases for coincident poles
as trivial, there are good reasons to regard this configuration as valid: (1)
this is merely a limiting case of intersecting poles, which are valid configu-
rations in other coordinate systems (in which different loci also may be given

Fig.
2-2b

for the intersecting and non-intersecting configurations); and (2) the coincident-pole configuration for the circle is the limiting case of the linear construction for ellipses, $u+v=2a$, as these curves converge to a circle with decreasing eccentricity. Thus, as the eccentricity decreases, the poles approach the center of the ellipse and become coincident with it in the limit, when $e=0$ and the curve is a circle.

The highest-ranking non-coincident bipolar foci of the circle are pole-pairs lying on a diameter, one inside and one outside of the curve. This is the situation represented by eq. 5b, the well-known "circle of Apollonius," which thus is the 2nd-most symmetrical circle in bipolar coordinates. No loss of generality is involved if the constant, C, is taken to be less than 1, in which case C represents the fractional distance of the interior pole from the center to the curve, i.e., the distance of this pole from the center is CR.

Diametrically-opposed incident poles are the next-highest ranking foci, and the corresponding circle is the 3rd-most symmetrical circle in bipolar coordinates. The quadratic eq. 6a, cast about such poles, is the essence of the Pythagorean theorem. Since the poles are high-ranking and equivalent, a true center exists midway between them (the center of the circle).

			(2-6)
2-2c	(a) $u^2 + v^2 = d^2$	poles diametrically opposed	
2-2 d,d'	(b) $u^2 + v^2 = Cd^2$	poles equidistant from center, either inside or outside	
	(b') $u^2 + v^2 = 2R^2 + d^2/2$	" " "	
	(c) $(d-2h)u^2+(d+2h)v^2 = 2d(R^2-h^2+d^2/4)$	the general axial equation	
2-2e	(d) $d^2R + (d+R)v^2 = Ru^2$	pole p_v incident, pole p_u external	
2-2e'	(d') $d^2R = Rv^2 + (d-R)u^2$	pole p_u incident, pole p_v internal	
2-2f	(e) $(3d+2R)v^2+d^2(4R+3d/2) = (d+2R)u^2$	both poles external on same side, p_u most distant from center	

If the poles are on a diameter, equidistant from the center, eq. 6b, they have the same focal rank as the poles of 6a but lower *subfocal rank*--because the eq. has been made more complex by the addition of a constant, C. Again, a true center exists midway between the poles, since they are high-ranking and equivalent. [Eq. 6b, but with the minus sign, $u^2-v^2 = Cd^2$, is the eq. of a line normal to the x-axis. A true center does not lie midway between the poles about which this curve is cast, because they are not equivalent.]

The general eq. of a bipolar circle for two poles lying anywhere on a diameter is 6c, where h is the distance of the center of the circle from the origin and the poles are to the right and left of the origin at a distance of $d/2$. When the constant term of this eq., $R^2-h^2+d^2/4$, equals 0, the eq. simplifies to 5b, where $(2h-d)^{\frac{1}{2}}/(2h+d)^{\frac{1}{2}} = C$ is the fractional distance of the interior pole from the center to the curve. For the coefficients of u and v to be equal, h must be 0, i.e., the curve must be centered at the origin, whereupon 6c simplifies to 6b', corresponding to 6b.

Figs.
2-2b

2-2
d,d'

An increase in the symmetry of the curve and subfocal rank of the poles can be achieved if one of the parameters of this eq. is eliminated. This will occur for $R = d/2$, whereupon the eq. simplifies to 6a. The cases $h = R+d/2$ and $h = R-d/2$, respectively, correspond to one pole lying on the curve and the other outside or inside, yielding eqs. 6d and 6d', which are seen to be the 5th-most symmetrical bipolar circles (since in complexity and degree they rank 5th behind eqs. 5a, 5b, 6a, and 6b or 6b'). Other values of the parameters represent less symmetrical circles and lower-ranking poles. For example, for $h = R+d$, both poles lie outside the circle on the same side and the eq. becomes 6e.

2-2
e,e'

2-2f

Eqs. for the circle also can be formulated about poles not lying on an extended diameter and for poles neither lying on the curve nor an extended diameter. Eq. 7a is for a circle centered at any point in the plane (h,k) relative to poles

2-3a

(a) $[(d-2h)u^2+(d+2h)v^2+2d(h^2-k^2-R^2-d^2/4)]^2 =$ any pole (h,k) (2-7)
in the plane

$$4k^2[4d^2R^2-(u^2-v^2-2dh)^2]$$

(b) $d^2[v^2-(k^2+R^2)]^2 = k^2[4d^2R^2-(u^2-v^2-d^2)^2]$ 7a for $h = d/2$ 2-3b'

(c) $d^2[u^2+v^2-2(k^2+R^2+d^2/4)]^2 = 4k^2[4d^2R^2-(u^2-v^2)^2]$ 7a for $h = 0$ 2-3b

(a) $d^2(u^2+v^2-4R^2)^2 = (4R^2-d^2)[4d^2R^2-(u^2-v^2)^2]$ both poles (2-8) 2-3d
(a') $d^2(u^2+v^2-d^2)^2 = (4R^2-d^2)[4d^2u^2-(u^2-v^2+d^2)^2]$ incident on circle

(a") $d^2(u^2v^2+d^2R^2) + R^2(u^2-v^2)^2 = 2d^2R^2(u^2+v^2)$ " " "

$[4d^2u^2-(u^2-v^2+d^2)^2] = 4d^2u^2 - (u^4+v^4+d^4+2d^2u^2-2d^2v^2-2u^2v^2) =$ (2-9)

$$- u^4-v^4-d^4+2d^2u^2+2d^2v^2+2u^2v^2$$

p_u at $x = -d/2$ and p_v at $x = d/2$. Note that 7a is of 4th degree in the

variables u and v, which are non-equivalent. Clearly the subfocal rank of the poles and the symmetry of the represented circles can be increased by

Figs.
2-3
b',b

letting h = d/2 or h = 0, leading to the greatly simplified 4th degree eqs. 7b,c, respectively. The non-axial poles of 7c, of course, are equivalent, consistent with the fact that the represented circle is symmetrical with respect to the midline (Maxim 6). Further minor increases in the subfocal symmetry of the non-axial circles represented by eqs. 7b,c can be achieved by

2-3
c',c

letting d = k in 7b and d = 2k in 7c, whereupon the eqs. reduce from overall 6th degree to overall 4th degree but remain of 4th degree in u and v.

The greatest increase in subfocal symmetry of the non-axial but midline-symmetrical circles of 7c is achieved by bringing the poles into incidence with

2-3d

the circle, i.e., by letting $R^2 = k^2 + d^2/4$, yielding eq. 8a or its equivalent 8a'. The greater simplicity of these eqs. is perceived after expanding and combining and cancelling terms. This leads to 8a'', which possesses only 7 terms compared to 16 terms for the parent eq. 7c. For d = 2R, when the poles

2-2c

are diametrically opposed, eqs. 8 further simplify and reduce to 6a, the 3rd-most symmetrical bipolar circle.

The rightmost term of eq. 8a' illustrates a not uncommon occurrence in bipolar eqs. The poles of this eq. appear at first sight to be non-equivalent and unequally weighted, since the term $4d^2u^2$ has no counterpart in v. In actuality, it is this term that equalizes the weighting and brings about the equivalence, as shown by the expanded expressions of eq. 9. In a term $(u^2-v^2+d^2)^2$, as opposed to $(u^2-v^2)^2$, u and v are not equivalent because the expanded expression has a term $2d^2(v^2-u^2)$. The satellite term $4d^2u^2$ changes this to $2d^2(v^2+u^2)$, bringing about equivalence of u and v.

If the situation as represented above gave the complete picture of the symmetry of the circle in the bipolar system, the circle of Apollonius would constitute the second instance in which a simple bipolar construction rule (eq. 5b) gives a curve that is intuitively less symmetrical than congruent curves given by more complex rules (eqs. 6). The other case is the one-arm hyperbola of eq. 1a (with either of the alternate signs). This inconsistency is resolved when one takes into account *reflective redundancy in the midline*. In the interests of simplicity, a discussion of this matter is deferred to the final section of this Chapter (see also legend of Fig. 2-1).

In summary, the highest-ranking bipolar focus of the circle is a coincident pole-pair lying at the center (1st degree eq.), followed by pole-pairs lying on a diameter, one pole inside and the other outside (1st degree eq. but lower subfocal rank). Next in order are diametrically-opposed pole-pairs lying on the curve (2nd degree eq.), followed by interior or exterior pole-pairs with members equidistant from the center. The next-highest ranking foci are axial pole-pairs in which one pole is incident upon the curve. Eqs. cast about pole-pairs on a diameter in other locations remain of 2nd degree but the poles have lower subfocal rank.

Eqs. cast about non-diametrically-opposed incident poles represent circles of next-highest symmetry rank but the eqs. are of 4th degree. The lowest sub-focal rank is possessed by non-incident, non-axial poles, all combinations of which also are represented by eqs. of 4th degree.

Central Conics

The bipolar eqs. of central conics, using the traditional focus and center as poles, are given by 10a,b. In these eqs. the familiar conic parameters, a

Figs. 2-4a

hyperbolas ellipses

$$\text{(a)} \quad u^2 + b^2 = (v+a)^2 \qquad\qquad \text{(b)} \quad u^2 - b^2 = (v-a)^2 \qquad\qquad (2\text{-}10)$$

and b, are employed ($d = [a^2 \pm b^2]^{\frac{1}{2}}$). In the general case of eqs. having the form of eqs. 10 one could conclude that p_v, the traditional focus, has higher symmetry rank than the center, because a linear term in u or v, or a linear term in u or v augmented or diminished by a constant before squaring, generally corresponds to a pole of higher rank than that of a pole for which u or v occurs as the pure square. In other words, p_v would have the higher rank because the *weight* of v in the eq. is greater (when the right member is squared, v not only occurs as the pure square, it also occurs in the term +2av or -2av).

Although p_v is, indeed, the highest-ranking bipolar focus of the curve, this particular comparison is invalid. Valid *subfocal* comparisons may not be drawn from eqs. 10 because the curves possess a second focus equivalent to p_v (namely, the contralateral traditional focus) but do not possess a second focus equivalent to the center, p_u (see Bipolar Maxim 11, below).

BIPOLAR MAXIM 8: *In a bipolar equation, the focal rank of a pole represented by a linear term in u or v, or the square of the resultant of a linear term augmented or diminished by a constant, generally is greater than the focal rank of a pole for which u or v occurs only as the pure square.*

BIPOLAR MAXIM 9: *The pole with greater "weight" in a bipolar equation in which the highest degree of the variables is the same generally is the pole of higher focal rank.*

One can cast bipolar eqs. for central conics about other poles on the major or transverse axis than the traditional foci, even using poles located asymmetrically relative to the center. As a first example, eq. 11 is cast for any

Fig. 2-4a$_3$

$$(a^2-b^2)(u^2-v^2)^2 + a^2d^2(d^2+4b^2) = 2a^2d^2(u^2+v^2)$$

any two poles symmetrically located on the major axis of an ellipse (2-11)

$$[(u^2-v^2)^2+d^4/4]^2+d^4(u^2+v^2-d^2/2)^2 + 3d^8/16 = 2d^2(u^2+v^2)(u^2-v^2)^2$$

poles at contralateral LR vertices of the hyperbola (2-12)

two poles symmetrically located on the major axis of an ellipse at distances of d/2 units from the center. Since eq. 11 is symmetrical in u and v one can conclude (Maxim 6) that the represented curve is symmetrical with respect to the bipolar midline. This is an example of a 4th-degree eq. for which a true center lies midway between the equivalent poles (Maxim 7).

For comparison, consider the eq. of a curve cast about equivalent poles, which is symmetrical about the bipolar midline but for which a true center does not lie midway between the poles (i.e., when reflective redundancy in neither the bipolar axis nor the midline is taken into account). Eq. 12 is the bipolar eq. of a hyperbola cast about contralateral *LR vertices* (latus rectum vertices). Even though the LR vertices are circumpolar foci, eq. 12 is of 8th degree in the variables and generally is much more complex than eq. 11. The chief basis for the increase in complexity and decrease in focal rank from eq. 11 to eq. 12 is that the poles of eq. 12 do not lie on a line of symmetry.

Eqs. 11 and 12 illustrate the fact that, though symmetry of a bipolar eq. in u and v indicates symmetry of the curve about the bipolar midline, whether or not a true center lies midway between the poles depends upon their focal rank. Bipolar foci that lie on a line of symmetry have a rank of no less than $\frac{1}{4}$, i.e., their eqs. are of no greater than 4th degree. Accordingly, the equivalent poles of a bipolar eq. of degree greater than 4 cannot be axial,

so that a true center cannot lie between them. This is the basis for Maxim 7.

Returning to the ellipse, if one lets p_v be the traditional right focus and p_u be an axial pole at a distance, d, to the left of it (or $-d$ to the right), the resulting eq., 13, is of reduced degree, because of the high focal rank of

$$u^2 + d(e^2-1)(2ae-d)/e^2 = [(v-a)-(d-ae)/e]^2 \quad \text{(traditional focus plus axial pole)} \quad (2\text{-}13)$$

$$(v+d/e)^2 = u^2 + d^2(e+1)^2/e^2 \quad \text{(traditional focus plus vertex, } d = |d_{p_u-p_v}|) \quad (2\text{-}14)$$

p_v. The latter pole is seen to be the highest-ranking bipolar focus (Maxim 8). If one chooses p_u to be a vertex, making both poles circumpolar point foci, the eq. simplifies further to 14 (but does not reduce). Lastly, if one takes p_u to be a higher-ranking circumpolar focus--the center or the left traditional focus--one gets great simplification to the quadratic, 10b, or great simplification and reduction to the linear eq., 1b, respectively.

Fig. 2-4a$_2$
a$_2$

Figs. 2-4a$_1$
2-1c$_1$

BIPOLAR MAXIM 10: *Bipolar equations simplify and reduce for pole-pairs located on a line of symmetry, and for pole-pairs symmetrically located in relation to lines of symmetry, as compared to pole-pairs not so located. For a given member of a pole-pair, the simplification generally is greater the higher the circumpolar focal rank of the second member.*

The Parabola

Eqs. 15 are the bipolar eqs. of the parabola, $y^2 = 4ax$, cast about the traditional focus and another axial pole. p_v is the traditional focus,

(a) $u^2 + 4ad = (v+d)^2$ (b) $u^2 - 4ad = (v-d)^2$ (2-15)

(a) $u^2 + 4d^2 = (v+d)^2$ vertex (2-16)

(b) $u^2 + 2d^2 = (v+d)^2$ foot of directrix

(c) $u^2 + d^2 = (v+d)^2$ conjugate point

(c') $u^2 = v^2 + 2dv$ conjugate point

(d) $u^2 - d^2 = (v-d)^2$ reflection of conjugate point in focus

Figs. 2-4c$_4$
2-4c$_3$
2-4c$_1$
2-4c$_1$
2-4c$_2$

while p_u either is on the vertex side of the focus, 15a, or on the other side, 15b. If the pole, p_u, is taken to be: (a) the vertex; (b) the foot of the directrix on the axis; (c) the focus reflected in the directrix, i.e., the

conjugate point to the focus; and (d) the reflection of the *conjugate point* in the focus, eqs. 15 become 16a-d, respectively. From inspection of these eqs., it is clear that the greatest symmetry is achieved with an eq. cast about the focus and its conjugate point, 16c. The next-most symmetrical parabola is that cast about the focus and a pole at the foot of the directrix, 16b, followed closely by a parabola cast about the focus and the reflection of the conjugate point in the focus, 16d.

Note (16c') that the constant term vanishes only for 16c. Accordingly, the conjugate point to the focus has the second-highest bipolar symmetry rank of any axial pole, while the point at the foot of the directrix has the next-highest rank, followed by the reflection of the conjugate point in the focus.

As assessed from the points of view of both bipolar and circumpolar symmetry, all points on the axis of the parabola have focal rank. The only axial poles that have a higher *circumpolar* focal rank than neighboring axial points are the traditional focus and vertex. The bipolar situation differs considerably. Curves cast about any two axial poles have eqs. of 4th degree. However, when an axial pole is paired with the traditional focus, the bipolar rank is increased, because the eqs. reduce from 4th to 2nd degree (the analytical basis for this reduction is discussed in Chapter IV).

The bipolar eqs. for central conics cast about their centers and a traditional focus (eqs. 10) greatly resemble those for the parabola cast about the traditional focus and either the focus conjugate or the reflection of the focus conjugate in the focus, 16c,d. In fact, for the equilateral hyperbola, the form of the eq. is identical to that of 16c. In other words, of the two bipolar eqs. differing only in the value of the parameter, eq. 16c represents a parabola, whereas eq. 17 represents an arm of an equilateral hyperbola (or both arms in the unpolarized bipolar system).

$$u^2 + d^2 = (v+d)^2 \qquad \text{parabola - focus and conjugate point} \qquad (2\text{-}16c)$$

$$u^2 + d^2/2 = (v+d/2^{\frac{1}{2}})^2 \qquad \text{equilateral hyperbola - center and focus} \qquad (2\text{-}17)$$

$$u^2 - b^2 = (v-a)^2 \qquad \text{ellipse - center and focus} \qquad (2\text{-}10b)$$

$$u^2 - d^2 = (v-d)^2 \qquad \text{parabola - focus and reflection of conjugate point in focus} \qquad (2\text{-}16d)$$

$$u^2 - 4ad = (v-d)^2 \qquad \text{parabola - focus and axial pole} \qquad (2\text{-}15b)$$

A similar comparison can be made between eq. 10b for an ellipse and eq. 15b of 16d for a parabola. But the form of eqs. 10b and 15b or 16c never can be

identical. Thus, if one lets $a = b$ in 10b, the ellipse becomes a circle and its focus and center become coincident, whereupon $p_u = p_v$ and $u = v = a$.

This impossibility can be shown in another way by expressing all parameters in terms of d, the distance between the poles. Eq. 10b becomes 10b', where $d^2 = a^2-b^2$, the focus-center distance, or 10b'', where $a = nd$. For the

$$u^2 + d^2 - a^2 = (v-a)^2 \qquad \text{ellipse - center and focus} \qquad (2\text{-}10b')$$

$$u^2 + d^2(1-n^2) = (v-nd)^2 \qquad \text{ellipse - center and focus} \qquad (2\text{-}10b'')$$

$$u^2 - 4md^2 = (v-d)^2 \qquad \text{parabola - focus and axial pole} \qquad (2\text{-}15b')$$

$$v \pm u = d \qquad \text{axial segments} \qquad (2\text{-}15b'')$$

Figs.
2-1
b_2, b_3

parabola, one lets $a = md$ in eq. 15b, yielding 15b'. Eqs. 10b'' and 15b' will be identical only for $n = 1$ and $m = 0$, which gives 15b''. But these are the eqs. of the connecting segment and the lateral arms of a line passing through the two poles, p_u and p_v. In other words, the conditions for identical form for the bipolar eqs. of an ellipse cast about its focus and center, and of a parabola cast about its focus and a second axial pole on the opposite side of the focus from the vertex are simply the conditions for degeneration to a common line.

Before leaving this topic it should be remarked that, despite close similarities, eqs. 10 for the central conics, and eqs. 16 for the parabola, are not homologous. The eqs. of central conics that are homologous to eq. 16c, i.e., eqs. for central conics cast about their foci and focus conjugates are 18, where p_v is the focus. Here and in the following, the upper alternate

$$(u^2-v^2)(a^2 \pm b^2) = 4ab^2v \qquad (2\text{-}18)$$

sign in eqs. for central conics is for the hyperbola, the lower for the ellipse.

The Parallel Line-Pair

Since the eq. of a line cast about poles lying upon it, 15b'', has been given in the above analysis, this is an appropriate place to give the bipolar eq. of a line-pair cast about poles lying on a line midway between them at a distance, y_1, from each. Letting d be the distance between the poles, the

Fig.
2-4b

eq. is 15'''. Usually one cannot draw a direct comparison between circumpolar and bipolar rank of foci, because the circumpolar rank depends upon a specification of the angle of the intercept transformation. In the case of lines, however, the circumpolar rank of foci is independent of the angle of transformation (except for angles of 0^o and 180^o)--providing the opportunity for a direct comparison of rank. The rank in both systems is found to be $\frac{1}{4}$, because in both cases the rank-determining eqs. are of 4th degree.

$$4d^2v^2 = (v^2-u^2+d^2)^2 + 4d^2y_1^2 \qquad\qquad (2-15''')$$

The Equilateral Lemniscate

For the equilateral lemniscate, 19, u and v of the bipolar eqs. never occur linearly nor as the square of a sum or difference of linear terms. Two poles symmetrically located on the transverse axis, which is a bipolar focal locus, lead to eq. 20. Inspection thereof confirms that the poles are equivalent and that a true center (the DP) lies midway between them.

Figs. 2-5e$_2$

	$r^2 = a^2(2\cos^2\theta-1)$ or $r^2 = a^2(1-2\cos^2\theta)$	polar equations	(2-19)
2-5e$_2$	$2a^2(u^2-v^2)^2 = d^2(u^2+v^2-d^2/2+2a^2)(u^2+v^2-d^2/2)$	symmetrically-located axial poles	(2-20)
2-5e$_1$	$u^4+6u^2v^2+v^4-d^2(u^2+v^2) = 0$	vertices	(2-21)
	$(u^2-v^2)^2-2d^2(u^2+v^4/a^2)+d^4 = 0$	DP and axial pole	(2-22)
2-5c	(a) $u^4-2u^2v^2-v^4+d^2(d^2-2u^2) = 0$	DP and vertex	(2-23)
2-5b	(b) $u^4-2u^2v^2+d^2(d^2-2u^2) = 0$	DP and "loop focus"	
2-5 C = $\frac{1}{4}$	(c) $uv = a^2/2 = d^2/4$	both "loop foci"	

2-5e$_1$

When the poles are the axial vertices (d = 2a), which are circumpolar foci, eq. 20 simplifies to 21, in which the poles again are equivalent. If p_v is the DP (the highest-ranking *circumpolar* focus) and p_u is any axial pole, one obtains eq. 22. The poles of eq. 22 have unequal rank but their relative ranking--based on a comparison of the terms, u^2 and v^4/a^2--is uncertain.

2-5c

If both poles have circumpolar focal rank, with p_v the DP and p_u a vertex (d = a), 22 simplifies to 23a, in which the vertex, p_u, appears to have higher rank (but see next page). The greater simplicity of 23b is achieved when p_u is the "loop focus" (d = a/$2^{\frac{1}{2}}$); in this case, p_u appears to have by far the higher rank. Since the simplicity of eq. 23b is second only to an eq.

cast about the two "loop foci," it establishes the DP as the 2nd-highest-ranking bipolar focus.

Fig.
2-5a
C = ¼

If locational symmetry of the poles is increased by taking both to be the "loop foci" (at a distance $a/2^{\frac{1}{2}}$ on each side of the DP), both reduction of the degree of the eq. and great simplification take place, yielding 23c.

[For the equilateral lemniscate viewed as a hyperbolic subspecies of central quartic, the foci within the loops are not true *loop foci* (see *Glossary*); they are penetrating variable foci that are within the loops in some subspecies, external to the loops in other subspecies, and coincident with the vertices in one subspecies (see Chapter XII and Appendix II). On the other hand, for the equilateral lemniscate viewed as the *curve of demarcation* between one and two-oval Cassinians, they are true loop foci, being within the ovals in all subspecies.]

Eq. 23c defines the focal rank of the "loop foci" to be ½, both individually and as a bipolar pair. Accordingly, these are the highest-ranking bipolar foci. Whereas eqs. 23a,b indicated a higher subfocal ranking for both the vertices and the "loop foci" than for the DP, eq. 23b unequivocally establishes the DP as ranking second only to the "loop foci" as a bipolar focus (or, more accurately, it establishes the "loop focus"-DP pair as ranking second to a pair of "loop foci"). The apparent contradiction regarding the comparative rank of the vertices and DP is resolved by Maxim 11. According to this Maxim, comparative subfocal ranking of the two poles of eqs. such as 22 and 23a,b is invalid, because the DP cannot be paired with an equivalent focus, whereas the other pole in each eq. can be so paired (but if neither pole of a pole-pair could be paired with an equivalent pole, the comparison would be valid).

BIPOLAR MAXIM 11: *Comparative subfocal ranking of the poles of a bipolar equation is valid only if the basis curve possesses an equivalent pole for either both or neither of the poles about which the equation is cast.*

The Quartic Twin Parabola

The finding that the bipolar eq. of the parabola cast about the traditional focus and another axial pole achieves its greatest simplicity when the other axial pole is the conjugate point to the focus raises several questions. For one, could twin parabolas, in which a basis parabola is reflected through the directrix to become the quartic of eq. 24 be regarded as a circumpolar parabolic homologue of central conics?

$$(y^2+4a^2)^2 = 16a^2x^2 \qquad (2\text{-}24)$$

This question can be answered in several ways. A circumpolar symmetry analysis shows that the quartic twin parabola is homologous to central conics in every respect but one. The failure is in the domain of the intercept transforms about the true center created by our synthesis. Whereas the *ordinal rank* for transforms of central conics about their centers is 6th degree, that of the quartic parabola is 20th degree (Table V-1). An inversion analysis also disqualifies the quartic twin parabola from membership in the *quadratic-based inversion superfamily* (see Chapter VIII); it inverts to an octic about a point in the plane, whereas no conic section inverts to a locus of higher than 4th degree (the octic, of course, consists of the degenerate product of 2 quartics).

Another question raised by the bipolar eqs. of the parabola is whether other pole-pairs consisting of two points that are reflections of one another in the directrix will have higher symmetry rank than neighboring pole-pairs that are not reflections of one another. Will conjugate pole-pairs that include a point on the curve itself have higher symmetry rank than neighboring conjugate pole pairs? If so, points on the image of the curve would have higher symmetry rank than neighboring points.

A Detailed Analysis of the Parabola

Two Poles In the Plane

To answer the preceding questions, consider the general case for the bipolar eq. of the parabola, $y^2 = 4a(x-h)$, cast about two poles in the plane, $p_u = (x_1, y_1)$ and $p_v = (x_2, y_2)$. The starting eqs. are 25a-d. The first step

(a) $\quad u^2 = (x-x_1)^2 + (y-y_1)^2$ \qquad (b) $\quad v^2 = (x-x_2)^2 + (y-y_2)^2$ \qquad (2-25)

(c) $\quad y^2 = 4a(x-h)$ $\qquad\qquad\qquad$ (d) $\quad d^2 = (x_1-x_2)^2 + (y_1-y_2)^2$

$$u^2 - v^2 = 2x(x_2-x_1) + (x_1^2-x_2^2) + 2y(y_2-y_1) + (y_1^2-y_2^2) \qquad (2-26)$$

(a) $\quad u^2 - v^2 = 4xx_2$ $\qquad\qquad$ (b) $\quad u^2 - v^2 = 4yy_2$ $\qquad\qquad$ (2-27)

in the solution of these eqs. is to form the difference eq. 26. The eliminant of eqs. 26 and 25c with either 25a or 25b is a complex 8th degree eq. in u and v. This simplifies if p_u and p_v are selected as mirror images in either the y or the x-axis, whereupon eq. 26 yields 27a,b, respectively

(note that for pole-pairs reflected in the y-axis, the poles lie on a line parallel to the axis of the parabola).

Poles Reflected In the Axes

Accordingly, when the eq. is cast about mirror-image poles in the y or the x-axes, the eliminants become eqs. 28a,b, respectively. Eq. 28b is the

<div align="center">poles mirrored in the y-axis</div>

(a) $[(u^2-v^2)^2-8x_2u^2(x_2-2a)-8x_2v^2(x_2+2a)+16x_2^2(x_2^2+y_2^2-4ah)]^2 =$ (2-28)

$(d = 2x_2,\ y_1 = y_2,\ x_1 = -x_2)$ $64^2x_2^4y_2^2a[(u^2-v^2)/4x_2-h]$

<div align="center">poles mirrored in the x-axis</div>

(b) $(u^2-v^2)^4 - 128ay_2^2(x_2-h-2a)(u^2-v^2)^2 = 32 \cdot 64a^2y_2^4[u^2+v^2-2y_2^2-2(h-x_2)^2]$

$(d = 2y_2,\ x_1 = x_2,\ y_1 = -y_2)$

simpler of the two eqs. because the basis parabola is symmetrical about the x-axis but not about any axis orthogonal to the x-axis. The same distinction is responsible for the fact that eq. 28b is symmetrical in u and v but eq. 28a is not. [Note in this connection, that p_u and p_v are non-equivalent poles for all values of h in eq. 28a. For example, letting h = a, which corresponds to reflection through the directrix, leaves the relative symmetry rank of p_u and p_v unaltered. For the central conics, on the other hand, when h = 0, the condition for which the y-axis passes through the center, p_u and p_v become equivalent.]

Though 28b is simpler than 28a, the only increase in symmetry of the curve about pole-pairs reflected in the x-axis is at the subfocal level. If x = h+2a, the case for which the pole-pairs lie on a line parallel to the LR at twice its distance from the vertex on the LR side, the 4th degree term in u and v vanishes, yielding eq. 29. No further significant simplification

$$(u^2-v^2)^4 = 32 \cdot 64a^2y_2^4(u^2+v^2-2y_2^2-8a^2)$$ (2-29)

is possible. Thus, the greatest bipolar symmetry of the parabola relative to poles reflected through the x-axis is for pole-pairs on this line.

Poles Reflected In the y-Axis

Another significant feature of eq. 28a is that substitution of $y_2^2 = 4a(x_2-h)$ gives no simplification. In other words, the symmetry of the curve is not increased about a pole-pair reflected in the y-axis for the general case in which one of the poles lies on the curve itself; this situation holds for any location of the y-axis, i.e., for any value of h. If there were simplification for some value of h, say h = a (which would correspond to reflection through the directrix), it would imply the existence of a parabolic locus having subfocal symmetry rank consisting of all points on the image of the basis curve in the directrix.

Further simplification of eq. 28a is possible if:

(1) $x_2 = 2a$, corresponding to the poles being on two lines parallel to the y-axis at a distance of 2a on each side of it. Since h may take on any value, this condition (eq. 30) simply amounts to pole-pairs on lines 4a units apart.

$$\{64a^2v^2-(u^2-v^2)^2-64a^2[y_2^2+4a(a-h)]\}^2 = 16 \cdot 64^2 a^5 y_2^2 [(u^2-v^2)/8a-h] \qquad (2-30)$$

(2) $x_2^2+y_2^2 = 4ah$, corresponding to pole-pairs lying on a circle of radius $(4ah)^{\frac{1}{2}}$ centered at the origin. For h = a, this circle is tangent to the LR.

(3) the dual conditions, $y_2 = 2a$ and h = a, corresponding to the LR vertices and their images in the directrix.

The most significant of these conditions is the first, because it gives the greatest simplification and, at the same time, increases the relative weight of v in the eq.

Though condition (3) does not lead to a great simplification of eq. 28a, if 28a is recast for points on the curve and with h = a ($y_2^2 = 4a[x_2-a]$), i.e., taking the directrix as the y-axis, it is found that there are only two values of y_2 for which the eq. will reduce or simplify. In other words, there are only two locations on the curve for which a member of a pole-pair reflected through the directrix is a point about which the curve has greater symmetry than about neighboring points on the curve. One of these is given by condition (3) above, for which the points are the LR vertices, yielding eq. 31. The other is $y_2 = 0$, i.e., p_v is the vertex, for which the recast eq., 28a, both simplifies greatly and reduces from 8th to 4th degree, yielding eq. 32.

$$[(u^2-v^2)^2 - 64a^2(v^2-4a^2)]^2 = 2\cdot128^2a^6(u^2-v^2-8a^2)$$ LR vertex plus image in directrix (2-31) Fig. 2-4c$_6$

$$(u^2-v^2)^2 = 8a^2(3v^2-u^2) + 48a^4$$ axial vertex plus image in directrix (2-32) Fig. 2-4c$_5$

It is most noteworthy that these are the locations of the only *circumpolar* point foci of the parabola that lie on the curve.

For both eqs. 31 and 32 the poles have unequal symmetry rank. That the rank of an LR vertex is higher than that of its mirror image in the directrix is evident from the fact that v has greater weight than u in 31. On the other hand, the weight of p_v (the pole at the vertex) in 32 is not markedly greater than that of p_u (the reflection of the vertex in the directrix)--the coefficient of v merely is three times as great as that of u.

Poles On the x-Axis Reflected In the y-Axis

Returning to 28a and casting it about mirror-image poles that lie on the x-axis, i.e., letting $y_2 = 0$, yields 33. Setting $x_2 = h$, i.e., one pole at

$$(u^2-v^2)^2+16x_2^2(x_2^2-4ah) = 8x_2u^2(x_2-2a)+ 8x_2v^2(x_2+2a)$$ axial mirror-images (2-33)

$$(u^2-v^2)^2 + 16h^3(h-4a) = 8hu^2(h-2a) + 8hv^2(h+2a)$$ vertex plus mirror-image (2-34)

the vertex (the vertex will be 2h units distant from its mirror image in the y-axis) gives eq. 34. There are three values of h for which eq. 34 will simplify to a greater extent than when the second pole is the reflection of the vertex in the directrix. When the latter is the case (h = a), 34 yields 32, whereas when $h = 2a, -2a,$ or $4a,$ eq. 34 yields, respectively, 35a-c.

(2-35)

(a) $(u^2-v^2)^2 = 64a^2v^2 + 256a^4$ p_v at vertex, poles 4a units apart, p_u external

(b) $(u^2-v^2)^2 = 64a^2u^2 + 3\cdot16^2a^4$ p_v at vertex, poles 4a units apart, p_u internal

(c) $(u^2-v^2)^2 = 64a^2(3v^2+u^2)$ p_v at vertex, poles 8a units apart, p_u external

$(u^2-v^2)^2 = 64a^2v^2-256a^3(a-h)$ p_v at h+a, poles 4a units apart (2-36)

$u^2 + d^2 = (v+d)^2$ p_v at focus, poles 4a units apart (2-16c)

From inspection of these eqs. it is clear that p_v, the pole at the vertex, has higher subfocal rank than its mirror image when the latter is external to the parabola (eqs. 35a,c), but lower subfocal rank (eq. 35b) when the latter is 4a units inside the curve (as judged from the relative weights of u and

v in the eqs.). Note that the more distant the vertex is from its mirror image, i.e., the larger the value of h in eq. 34, the more the weights of p_v and p_u approximate one another; at $h = \infty$, the weights become equal, because p_u and p_v become one and the same pole.

For $x_2 = 2a$ in eq. 33, i.e., for pole-pairs on the x-axis 4a units apart, eq. 36 is obtained. From this eq. it is evident that the key reduction condition for the eq. of a parabola cast about two poles on the x-axis 4a units apart, is $h = a$. For this value of h the directrix becomes the y-axis, p_v becomes the traditional focus, p_u becomes its reflection in the directrix, and the eq. reduces to 2nd degree (eq. 16c).

Fig.
2-4c$_1$

Unreflected Poles On the x-Axis

Lastly, consider the bipolar eq. of the parabola, $y^2 = 4a(x-h)$, with its vertex at h, cast about any poles, p_v at $x = d_1$ and p_u at $x = d_2$. The starting eqs. are 37a-c. Forming the difference, v^2-u^2, leads to eq. 38.

(a) $v^2 = (x-d_1)^2+y^2$ (b) $u^2 = (x-d_2)^2+y^2$ (c) $y^2 = 4a(x-h)$ (2-37)

$$x = (v^2-u^2+d_2^2-d_1^2)/2(d_2-d_1) \qquad (2\text{-}38)$$

$$v^2 = [(v^2-u^2+d_2^2-d_1^2)/2(d_2-d_1) - d_1]^2 + \qquad \text{any 2 poles on the x-axis} \qquad (2\text{-}39)$$
$$4a[(v^2-u^2+d_2^2-d_1^2)/2(d_2-d_1) - h]$$

(a) $[v + (a+h-d_2)]^2 = u^2 + 4a(a+h-d_2)$ p_v at traditional focus (2-40)

(a') $(v \pm d)^2 = u^2 \pm 4ad$ p_v at traditional focus

Using 37a for v^2 as the master eq. for forming the eliminant yields the 4th degree eq., 39, for any two poles on the x-axis. From inspection of eq. 39 it is clear that both members become perfect squares for $h = (d_1-a)$, i.e., when p_v lies at the traditional focus, whereupon eq. 39 reduces to the 2nd degree eq., 40a. But since $d = \pm(a+h-d_2)$, 40a becomes 40a', the eq. of a parabola cast about the traditional focus and a second axial pole. The latter is the equivalent of eqs. 15a,b. The plus sign applies if $a+h > d_2$ (equivalent to 15a), and the minus sign if $d_2 > a+h$ (equivalent to 15b). Of course, d_2 may not equal a+h, for then p_u would coincide with p_v.

Polarized Versus Unpolarized Bipolar Coordinates:
Reflective Redundancy In the Midline

In the interests of simplicity, the treatment of bipolar coordinates to this juncture has followed in the traditional or classical vein: the poles have been taken as ordered, one designated as p_u and the other as p_v, with u being the undirected distance from the former and v the undirected distance from the latter. This system is appropriately designated as the *polarized bipolar system*, because the ordering of the poles destroys reflective redundancy in the midline of the unpolarized system.

In the *unpolarized bipolar system*, the poles are not ordered, i.e., u is the distance from *a* pole and v is the distance from *the other pole* but the poles do not have fixed labels. All curves in the unpolarized bipolar system are reflectively redundant in both the polar axis and the midline (the perpendicular bisector of the line segment joining the two poles). To obtain the curve represented by a given eq., one either plots the locus with respect to a fixed labeling of the poles and reflects this locus in the midline, or one carries out the equivalent operation of complementing the first plot with a second plot obtained relative to poles with the labels exchanged.

Only in cases of eqs. that are symmetrical in u and v are the same curves defined in both the polarized and unpolarized systems. This comes about because these loci are symmetrical in the midline of the polarized system. Accordingly, reflective redundancy of the same curves in the midline of the unpolarized system leads to no additional arms or branches.

Since a fixed labeling of the poles destroys the symmetry of the unpolarized bipolar coordinate system, it also leads to violations of the relationships that have been advanced between the symmetry of curves and their construction rules. Simple linear eqs. that are asymmetrical in u and v, for example, u-v = 2a and u = Cv, yield loci that are asymmetrical relative to the coordinate elements; in these particular cases the curves are a single hyperbolic arm and an asymmetrically located circle, respectively. Eqs. of 2nd degree are required to represent the same loci complemented with arms that are reflected in the midline (see also legend of Fig. 2-1).

Accordingly, if these violations are to be avoided, the unpolarized bipolar system must be employed. Within this framework, the eqs. u-v = 2a and u = Cv represent a two-arm hyperbola and two circles of Apollonius, both of which loci are symmetrical in both the midline and the polar axis of the coordinate system.

Similar considerations apply to all undirected-distance coordinate systems that possess more than one reference element of a given type, and are taken for granted in the treatments of Chapter IV. For all such coordinate systems that have lines of symmetry, the eqs. represent curves that possess reflectively redundant arms or branches in each line of symmetry of the system. A fixed labelling of poles of identical nature is employed merely for simplicity and convenience.

Taking the factor of reflective redundancy in the lines of symmetry of the coordinate system into account, one arrives at an alternate view of the significance of the degree of a bipolar eq. in relation to the loci represented by it. The point of view taken in the foregoing has followed conventional conceptions of curves and their lines of symmetry. For example, the ellipse of eq. 11, cast about two poles symmetrically located on the major axis, was said to be bisected by the polar axis, with a true center lying midway between the equivalent poles. Contrariwise, in the case of the hyperbola of eq. 12, cast about contralateral LR vertices, it was asserted that the equivalent poles did not lie on a line of symmetry of the curve and that a true center did not lie midway between them.

In the alternate view, it could be argued that if one allows only unreflected plots for the differing segments of the hyperbola that lie above and below the bipolar axis, then one also must limit the locus of the ellipse to an unreflected plot on only one side or the other of this axis. In that event a true center would not lie between the equivalent poles of the hemiellipse. Following this line of analysis, the degree of bipolar eqs. of 4th degree and greater tends to correlate with the number of complete conventional loci that are represented when all reflections in the lines of symmetry of the coordinate system are taken into account.

[For central conics in standard position the situation is as follows. For two poles in the plane at (a,b) and (α,β), the bipolar eq. is of 8th degree and very complicated. There are 4 complete rectangular loci and the poles are not equivalent. For $a = \alpha$ or $b = \beta$, the eq. greatly simplifies but all other characteristics are unchanged. For $a = \alpha = 0$ or $b = \beta = 0$, the poles are axial, the eq. greatly simplifies and reduces to 4th degree, and the number of complete loci reduces to 2. For $a = \alpha = 0$ and $b = -\beta$ or $b = \beta = 0$ and $a = -\alpha$, the eq. simplifies further, the number of complete loci is reduced to 1, and the poles are equivalent. For one pole at the traditional focus, the eq. simplifies and reduces to 2nd degree but the number of loci increases to 2 and the poles are not equivalent. Lastly, for both poles at traditional foci, the eq. simplifies and reduces to 1st degree, there is only 1 complete locus, and the poles are equivalent.]

Fig. 2-4a$_3$

Introduction

When a line and a point are taken as the reference elements of a coordinate system, one enters a domain in which highly unusual curves are represented by simple eqs.--curves of a nature unanticipated upon the basis of knowledge of the well-known polar-linear constructions for the parabola and central conics. This comes about because of the nature of the asymmetry introduced by a linear reference element, which divides the plane into two regions of equal extent, only one of which contains the point-pole (unless the latter lies upon the line).

Because of this asymmetry, the locus on one side of the reference line usually is either dissimilar or similar but of different size from that on the other side (the well-known construction for the hyperbola being an exception), or it is imaginary or non-existent (as in the cases of the constructions for the parabola and ellipses). Furthermore, polar-linear curves often consist of only segments of the full loci of curves of the same subspecies in Cartesian or polar coordinates. These circumstances complicate the interconversion of polar-linear and rectangular eqs.

The rectangular eq. derived from a given basis polar-linear eq. frequently contains segments not represented by the basis eq. but represented by other polar-linear eqs. Contrariwise, the conversion of a given basis rectangular eq. to polar-linear coordinates frequently gives more than one polar-linear eq., since more than one such eq. is required to represent the entire rectangular locus. It also happens frequently that the polar-linear eq. derived for a given rectangular locus also represents another rectangular locus. For example, a polar-linear eq. for a circle on one side of a reference line also may represent a circle of different size on the other side of the line.

Algebraically, these complications are expressed in part through the need for alternate signs appended to expressions for distances from the linear reference element. As a standard procedure, the line-pole, p_u, is taken to be the y-axis, and the point-pole, p_v, the point $x = d$ on the x-axis. The interconversion eqs. then are $u = \pm x$ and $v = [y^2+(x-d)^2]^{\frac{1}{2}}$, in converting polar-

linear to rectangular coordinates, and $x = \pm u$ and $y = \pm[v^2-(\pm u-d)^2]^{\frac{1}{2}}$, in converting from rectangular to polar-linear coordinates.

There is no alternate sign before the expression for v because v is an undirected distance and, hence, always positive. This also is true of the coordinate distance u, but the distance from the y-axis in rectangular co-ordinates is simply the x coordinate, and this may be positive or negative. Accordingly, the expression for the distance from the line-pole is $u = \pm x$, the positive sign being taken when the value of x is positive, i.e., to the right of the line, but the negative sign when the value is negative, i.e., to the left of the line. [In the manipulation of the eqs., the upper sign for u applies to the locus to the right of the line-pole, and the lower sign to the locus to the left of it.]

In practice, radicals in the variables always are eliminated in determining the exponential degree of an eq., so it is immaterial whether the expressions for v and y are preceded by an alternate sign or not. After radicals have been eliminated and a basis eq. $f(\pm x,y) = 0$ or $g(\pm u,v) = 0$ is obtained containing terms in $\pm x$ or $\pm u$, it can be asserted that the resultant eq., in which the alternate signs have been eliminated, always will be degenerate; it will fall into a product of two factors, each usually of the same degree as the basis eq. and constructible therefrom by taking the upper alternate signs (for loci to the right of the line-pole) for one factor and the lower alternate signs for the other, i.e., $f(x,y)f(-x,y) = 0$ and $g(u,v)g(-u,v) = 0$.

The degree of the degenerate eq. is taken to be the sum of the degrees of the component factors if the full locus is to be represented. Of course, if only a part of the full locus is sought, only one of the factors is pertinent. In the following, for convenience, degenerate eqs. usually are represented in abbreviated form, either with the alternate signs present, or as perfect squares, $f^2(u,v) = g^2(u,v)$, corresponding to $(f+g)(f-g) = 0$.

[The situation for circumpolar (and circumlinear) transforms (Chapters V-XII and XIV) is different. In these cases the alternate signs are present in expressions for both x and y, and must be taken in all 4 combinations-- yielding 4 factors--if one seeks to obtain the algebraically complete transform eq. Furthermore, the goal usually is not to obtain the degree of the alge-braically complete transform eq. that represents loci for all possible combi-nations of the intercepts, but rather to obtain the eq. of the lowest-degree non-trivial transform, because this eq. characterizes the highest degree of symmetry possessed by the curve about the given pole at the given angle.]

The Most Symmetrical Curves

The most symmetrical curve in non-incident polar-linear coordinates (point-pole not incident upon the line-pole) is the parabola with the well-known focus-directrix relation, $v = u$ (p_v, the point-pole). Next-most symmetrical are: (a) ellipses and two-arm hyperbolas, $v = eu$, also with the conventional focus-directrix relationships; (b) the orthogonal, connecting line-segment, $u+v = d$; (c) the orthogonal, non-intersecting lateral line-segment, $u-v = d$, extending from the point-pole to infinity; and (d) the combination of a parabola and its exterior axis, $v-u = d$, with p_u being the vertex tangent and p_v the traditional focus.

Fig. 3-1

The next-most symmetrical curves are represented by eqs. 1a-c. The loci of some of these eqs. serve as an introduction to fascinating groups of curves, *disparate, compound,* and *partial "ellipses," disparate two-arm "hyperbolas"* and *"parabolas,"* and *partial "hyperbolas"* and *"parabolas,"* including *one-arm "hyperbolas."* In the following, these unusual curves are referred to as "ellipses," "hyperbolas," and "parabolas," with the justification that the individual arms or segments thereof are elliptical, hyperbolic, or parabolic in form (and usually of the same eccentricity), even though they are not "conic sections" in the conventional sense of the term.

Figs. 3-1 and 3-2

(a) $u \pm v = \pm Cd$, $C \neq 1$ parabolas and partial disparate hyperbolas (3-1)

3-1 d_1-d_3

(b) $Au \pm v = \pm d$ ellipses and disparate two-arm hyperbolas

3-2 a,c

(c) $u \pm Bv = \pm d$ ellipses and combinations of partial hyperbolas and intersecting lines

3-2 b_1-b_3

When the point-pole is incident upon the line-pole--*incident polar-linear coordinates*--the most symmetrical curve, $u = v$, is the orthogonal midline, $y = 0$, i.e., a line passing through the point-pole orthogonal to the line-pole. The next-most symmetrical curves, $v = Cu$, $v-u = Cj$, and $v+u = Cj$, are represented in rectangular coordinates by eqs. 2a-c. The first of these, 2a, for $v = Cu$, represents two intersecting lines of slopes $\pm(C^2-1)^{\frac{1}{2}}$, that meet at the point-pole. The eqs., $v+u = Cj$ and $v-u = Cj$, represent segments of the two congruent parabolas, 2b and 2c, lying on the two sides of (and reflected in) the line-pole. The former eq., $v+u = Cj$, represents the segments of the two parabolas from the vertices to the latera recta, which are coincident with the line-pole; the latter eq., $v-u = Cj$, represents the segments

3-3a

3-3b

3-3c$_1$

3-3c$_2$

Figs.
3-3b
3-3
c_1, c_2

3-4

(a) $y^2 = (C^2-1)x$ intersecting lines, $v = Cu$, in incident
 polar-linear coordinates (3-2)

(b) $y^2 = -2Cj(x-Cj/2)$ parabola contributing to $v \pm u = Cj$ loci
 in incident polar-linear coordinates

(c) $y^2 = 2Cj(x+Cj/2)$ " " " "

beyond the latera recta.

Intrinsic Versus Elective Coordinate Lines of
 Symmetry and the Requirement for Axial Equality

The non-polarized, non-coincident bipolar system is an example of a co-
ordinate system with two *intrinsic* lines of symmetry; other examples of such
systems are non-polarized, congruent, non-concentric bicircular coordinates
and non-coincident, parallel bilinear coordinates. *Two, and only two, lines
of symmetry are intrinsic to these coordinate systems for all configurations
of the reference elements except coincidence.* On the other hand, in most co-
ordinate systems the number of lines of symmetry is *elective*, i.e., it depends
on the configuration selected for the reference elements.

In tripolar coordinates, for example, the systems can have zero, one, two,
or three lines of symmetry; in tetrapolar coordinates there can be from zero
to four lines of symmetry. Still other coordinate systems have both *intrinsic
and elective* lines of symmetry. The present system is an example of the latter
type (as is the linear-circular system). A line through the point-pole and
orthogonal to the line-pole is an intrinsic line of symmetry; but there also
can be an elective line of symmetry, namely when the point-pole is incident
upon the line-pole.

The various possible configurations of a given ensemble of reference
elements very strongly influences the properties of the construction rules of
congruent curves cast about the ensemble. This is a topic that could be
elaborated upon very extensively. The essential point to be made here regards
a necessary condition for valid equational comparisons of the symmetry of
curves cast for different configurations of the reference elements of a given
coordinate system. For valid comparisons of the symmetry of curves based upon
their eqs., the number of lines of symmetry of the system must be the same
in the different configurations. This is the *requirement for axial equality*.

In the present instance, all comparisons within the non-incident polar-linear system are valid, and all comparisons within the incident system are valid; but equational comparisons between the symmetry of curves in the two systems are invalid. For example, one can cast 2nd degree eqs. for congruent hyperbolic arms in incident polar-linear coordinates (a system with two lines of symmetry) that have a much more symmetrical appearance relative to the reference elements than the 1st degree loci of hyperbolic arms that can be cast in the non-incident system (a system with only one line of symmetry). In fact, it is characteristic of the linear eqs. of the non-incident system that when the arms are congruent ($v = eu$) the line-pole is located asymmetrically relative to the vertices of the arms, whereas the arms are incongruent when the line-pole is located symmetrically relative to the vertices ($v-eu = d$).

Figs.
3-5d$_1$

3-1b$_2$

3-1b$_2$

3-2a$_1$

In the following treatments, different configurations of a given coordinate system are not dealt with separately; the *requirement for axial equality* is implicit in comparisons of the symmetry of curves for a given ensemble of reference elements. Neither in the treatment of the polar-linear system nor in subsequent treatments of other coordinate systems with two or more fixed-position reference elements, are fine distinctions drawn regarding subfocal symmetry. For reasons that will become apparent, unambiguous subfocal information may not be obtainable from the eqs.

The Linears

I begin with eq. 3a, a general eq. for linears. In the following, p_v always is the point-pole and p_u the line-pole, with v and u the respective distances from these poles to a point on the curve. If one lets the y-axis be the line-pole, with the point-pole on the x-axis at $x = d$, then the distance from the line is given by $u = \pm x$, and the distance from the point-pole by $v = [(d-x)^2+y^2]^{\frac{1}{2}}$, leading to eqs. 3b and 3b' (in standard form). In the

(a) $Au \pm Bv = Cd$ ⟶ general eq. for linears (3-3)

(b) $x^2(A^2-B^2) + 2dx(B^2 \mp AC) - B^2y^2 =$ ⟶ eq. 3a in rectangular form, represents central conics, line segments, parabolas, and intersecting lines

$(B^2-C^2)d^2$

(b') $[x+d(B^2 \mp AC)/(A^2-B^2)]^2-B^2y^2/(A^2-B^2) =$ ⟶ eq. 3b in standard form

$B^2d^2(A \mp C)^2/(A^2-B^2)^2$

Figs.
3-1
and
3-2

derivation of eq. 3b the sign of the Bv term of eq. 3a is immaterial. In other words, eq. 3b represents both the loci of $Au + Bv = Cd$ and $Au - Bv = Cd$. Which loci, or segments thereof, represented by 3b hold for each of the polar-linear eqs. has to be ascertained by testing.

Figs.
3-1
and
3-2

Eqs. 3b,b' represent central conics, parabolas, line segments, and intersecting lines, but cannot represent circles. From the standard form, 3b', it can be seen that the centers of the central conics lie at $[-d(B^2 \mp AC)/(A^2 - B^2)]$, the square of the semi-major (or semi-transverse) axis is $[B^2 d^2 (A \mp C)^2/(A^2 - B^2)^2]$, and the square of the semi-minor (or semi-conjugate) axis is $[d^2 (A \mp C)^2/(A^2 - B^2)]$ for hyperbolas and $[d^2 (A \mp C)^2/(B^2 - A^2)]$ for ellipses. The eccentricity is A/B. [In all cases the upper alternate sign is for $u = x$, i.e., for the pertinent loci or segments of the loci to the right of the line-pole, and the lower alternate sign for $u = -x$, i.e., for the loci or segments of loci to the left of the line-pole in the starting eqs. for conversion to rectangular coordinates.]

3-1

The most symmetrical derivatives of eq. 3a are those for which the three parameters, A, B, and C, are equal in absolute magnitude. For $u + v = d$, the locus is the orthogonal connecting line segment, whereas for $v - u = d$, it is the combination of the parabola, $y^2 = 4dx$ and its external axis, with the point-pole as focus and the line-pole as vertex tangent.

Figs.
3-1
and
3-2

The next-most symmetrical curves are those for which the magnitudes of only 2 of the 3 parameters are equal. This situation leads to parabolas and the extraordinary loci mentioned above, namely, disparate two-arm hyperbolas, partial parabolas and hyperbolas, and one-arm hyperbolas, as well as to unexceptional ellipses. The loci involving central conics are taken as examples.

Disparate Two-Arm Hyperbolas

3-2

For the cases of eqs. 4a,b, for which $B = C$ (of eq. 3a), one obtains loci consisting of *disparate two-arm hyperbolas*. For $e > 1$, each eq. represents two hyperbolic arms of the same eccentricity $(e = A/B)$ but different size—in

3-2a$_2$ (a) $eu - v = d$ disparate two-arm hyperbolas (3-4)

3-2
a$_1$,c (b) $v - eu = d$ ellipses and disparate two-arm hyperbolas

(c) $v + eu = d$ ellipses

the linear size ratio $(e+1)/(e-1)$. The combined loci make up two conventional

two-arm hyperbolas. The point-pole p_v is the right focus of both of these conventional hyperbolas, and the distance d, is a vertex-focus distance for both of them. But for the smaller hyperbola, d spans the distance from the focus to the contralateral vertex, whereas for the large one it is the focus-vertex distance of each arm.

For eq. 4a, the small arm is to the right of the line-pole, with its focus at p_v, while the large arm is to the left of it, with its focus at -d(e+1)/(e-1). The locus of eq. 4b consists of the opposed other arms of the same two hyperbolas. Both of these other arms are tangent to the line-pole, with their vertices in coincidence. Thus, eq. 4 is an example of how a centered line-pole for similar conic loci *can* be accommodated by a linear construction rule, but only if these loci are of unequal size.

Fig. 3-2 a_1, a_2

For e < 1, eqs. 4b,c are the eqs. of ellipses, one ellipse (eq. 4b) with semi-major axis, d/(1-e), the other (eq. 4c) with semi-major axis, d/(1+e). Both have their left vertices at the line-pole. The point-pole is the right focus for 4c and the left focus for 4b. No locus exists to the left of the line-pole for e < 1.

Fig. 3-2c

One-Arm and Partial Hyperbolas

For the cases in which A = C of eq. 3a, one obtains the loci 5a-c, all of which consist of curves possessing a segment of a conventional two-arm hyperbola and a segment of an intersecting line-pair, with its lines parallel to the asymptotes of the hyperbolic segment. The three loci, 5a-c, taken together

(a) u - v/e = d one-arm hyperbola of eccentricity, e, to left of line-pole and opening to left, plus intersecting lines extending to the right from the point of intersection at the point-pole, p_v, to infinity (3-5) Fig. 3-2b_2

(b) v/e - u = d segment of right arm of hyperbola of 5a, consisting of portion to right of line-pole, with focus at p_v, plus segment of intersecting line-pair of 5a, consisting of portion to left of line-pole--both loci intersect one another at line-pole--represents ellipses for e < 1 Fig. 3-2b_1

(c) u + v/e = d complementary segment of arm of hyperbola of 5b to left of line-pole plus complementary segment of intersecting line-pair of 5b to right of line-pole, terminating at point of intersection--both loci intersect one another at line-pole Fig. 3-2b_3

comprise a complete conventional two-arm hyperbola plus a complete intersecting line-pair that intersects at the latter's right focus. Each of the loci of 5a-c consists of a particular combination of segments of these two curves.

The conventional hyperbola, of eccentricity e, has its right focus at p_v, its center at $-(1+e^2)d/(e^2-1)$, i.e., to the left of the line-pole, a semi-transverse axis of length $2de/(e^2-1)$, and a semi-conjugate axis of length $2de/(e^2-1)^{\frac{1}{2}}$. A "$v = eu$ directrix" of this hyperbola never is coincident with the line-pole. The lines of the intersecting line-pair, which are parallel to the asymptotes of the hyperbola, have slopes of $\pm(e^2-1)^{\frac{1}{2}}$ and intersect at the right focus.

Figs.
3-2b$_2$

The locus of eq. 5a consists of one-half of the total locus. It comprises the left arm of the hyperbola, which is entirely to the left of the line-pole, and the "right arm" of the intersecting line-pair (i.e., the segments to the right of the point of intersection), which is entirely to the right of the line-pole. For cases 5b and 5c the loci consist of segments of the right arm of the hyperbola and the "left arm" of the intersecting line-pair, both of which intersect the line-pole.

3-2b$_1$

Locus 5b consists of the portions of these two arms that extend to infinity in each direction from their points of intersection with one another on the line-pole (at $\pm[e^2-1]^{\frac{1}{2}}d$). Locus 5c consists of the remaining segments of these loci from the same points of intersection with the line-pole. One segment extends from the points of intersection to the vertex of the hyperbolic arm,

3-2b$_3$

the other extends from these points to the point of intersection of the line-pair at the focus of the same hyperbolic arm. In other words, the locus 5c has the shape of a vertex-containing segment cut from the right arm of the hyperbola by the two radii emanating from its focus with slopes $\pm(e^2-1)^{\frac{1}{2}}$.

Of the 3 loci, 5a-c, only 5b has real solutions for $e < 1$ (the imaginary loci are $y^2 = [x-d]^2[e^2-1]$). These are ellipses centered at $d(1+e^2)/(1-e^2)$, with semi-major axis of length $2de/(1-e^2)$, and left focus at p_v. Unlike the curves of eqs. 4b,c, none of the loci of 5a-c has a vertex incident upon the line-pole.

Polar Exchange Symmetry

Polar exchange symmetry arises in coordinate systems with either disparate fixed-position reference elements or more than two reference elements. It consists of any case in which different curves are obtained when two or more variables are interchanged, leaving all coefficients unchanged (for example, in the case of the two eqs., $v-Bu=d$ and $u-Bv=d$). Thus, the ellipses of 4b ($v-eu=d$) have polar exchange symmetry with hyperbola-intersecting line-pair segments of eq. 5a ($u-v/e=d$).

Figs.
3-2c

3-2b$_2$

[For eq. 4b, $e<1$ gives a coefficient of less than unity to the subtracted term, while for eq. 5a, $e>1$ gives a coefficient of less than unity for the subtracted term, but with u and v exchanged.]

Parabolas

Eq. 6 is the starting eq. for the parabola, $y^2=4ax$, cast about any point (x_1,y_1), and any line, $y=mx+b$. When cleared of alternate signs and radicals, in the variables, u and v, eq. 6 becomes of 8th degree in u and v.

eq. of parabola, $y^2=4ax$ cast about point-pole
(x_1,y_1) and line-pole $y=mx+b$

$$v^2m^4 = [2a-mb-m^2x_1\mp mqu\pm 2ap]^2 + [m(2a-my_1\pm 2ap)]^2 \qquad \begin{array}{l} p=[1-m(b\pm uq)/a]^{\frac{1}{2}} \\ q=(m^2+1)^{\frac{1}{2}} \end{array} \qquad (3\text{-}6)$$

eq. corresponding to eq. 6 for a line-pole parallel
to the conventional directrix at $x=h$

$$[(u^2-v^2\pm 2(h-x_1+2a)u+(h-x_1)^2+(y_1^2+4ah)]^2 = 4y_1^2[4a(h\pm u)] \qquad (3\text{-}7)$$

eq. corresponding to eq. 6 for a line-pole parallel
to the x-axis at $y=k$

$$v^2 = (k\pm u)^4/16a^2 + (1-x_1/2a)(k\pm u)^2 - 2y_1(k\pm u)+x_1^2+y_1^2 \qquad (3\text{-}8)$$

(a) $v^2 = (u^2/4a-x_1)^2 + (u-d)^2$ 8 with x-axis as line-pole ($y_1=d>0$) (3-9)

Figs.
3-4d$_1$

(b) $4d^2v^2 = u^4+2d^2u^2-8d^3u+5d^4$ 9a with point-pole at an LR vertex 3-4d$_2$

(a) $u^4 = 16a^2(v^2-u^2)$ 9a with point-pole at axial vertex (3-10) 3-4a$_1$

(b) $(u^2-4a^2)^2 = 16a^2(v^2-u^2)$ 9a with point-pole at traditional focus 3-4a$_2$

If now, one considers any line parallel to the conventional directrix at $x=h$ and any point-pole in the plane (x_1,y_1), the eq., 7, remains of 8th degree. The

corresponding eq., 8, for any line-pole parallel to the x-axis at $y = k$, also is of 8th degree. For the case in which the line-pole intersects the parabola, the locus on one side of the line-pole is given by the upper alternate sign for u (a 4th degree eq.), and the locus on the other side by the lower alternate sign (also a 4th degree eq.). If the parabola lies entirely on one side of the line, a 4th degree eq.—for one or the other of the alternate signs —represents it in its entirety, while the 4th degree locus for the other alternate sign is, in general, imaginary.

Figs.
3-4d_1

3-4d_2

3-4a_1

3-4a_2

Letting p_u be the x-axis, with $y_1 = d > 0$, one obtains eq. 9a for *reflective hemi-parabolas*. More symmetrical hemi-parabolas are obtained with the point-pole at the upper LR vertex, for which the eq. simplifies to 9b. If one inquires as to which point-pole gives the highest-ranking polar-linear pole-pair in combination with the line of symmetry (x-axis), eq. 9 reveals this to be the vertex, i.e., $x_1 = d = 0$ (eq. 10a). The focus as point-pole gives 10b.

Consider now line-poles parallel to the conventional directrix, other than those already considered with the linears. For LR-axial vertex, LR-focus, and directrix-axial vertex, the eqs. are 11a-c, respectively. Since the members of the 4th-degree eqs. 11a,b are perfect squares, the eqs. are degenerate. Expressed in degenerate form as a product of factors, these become 11a',b', the

3-4
c_1, c_2

two factors of which equated to 0 are 2nd-degree eqs. that give the segments of the curve on one side or the other of the line-pole.

3-4
c_1, c_2

(a) $\quad 36d^2u^2 = (v^2-u^2-5d^2)^2$ \qquad LR and axial vertex \qquad (3-11)

(a') $\quad (6du-v^2+u^2+5d^2)(6du+v^2-u^2-5d^2) = 0$ \qquad " \quad " \quad " \quad "

3-3
c_1, c_2

(b) $\quad u^2 = (v-2a)^2$ \qquad LR and traditional focus
$\qquad\qquad\qquad\qquad\qquad\qquad\qquad$ (incident system)

(b') $\quad (u+v-2a)(u-v+2a) = 0$ \qquad " \quad " \qquad " \qquad "

3-4b_1

(c) $\quad v^2 = u^2 + 2du - 3d^2$ \qquad directrix and axial vertex

It would appear from a comparison of eqs. 11a,b that, when paired with k-axes, the focus has higher polar-linear symmetry rank than the axial vertex. Of course, this is to be expected, since the focus paired with another k-axis (the directrix) takes part in the *linears* (see above).

3-1

If one takes, (a) the focus and any k-axis (at $x = h$), or (b) the vertex and any k-axis, eqs. 12a,b, respectively are obtained. "h" is employed in these eqs. rather than d, because the formulation of the eqs. depends on whether the k-axis is to the right or left of the focus, whereas the distance,

(a) $u^2 = (v-h-a)^2$ a k-axis and the focus (3-12)

(b) $(v^2-u^2-h^2-4ah)^2 = 4u^2(h+2a)^2$ a k-axis and the vertex

(b') $v^2+4a^2 = u^2$ or $v^2+d^2 = u^2$ a k-axis at $h=-2a$ and the vertex

$(v^2-u^2) = 4au$ the vertex tangent and the vertex (3-13)

Figs.
3-4b$_2$

3-3d

d, is employed as an undirected distance. Both eqs. are degenerate. If the
line-pole intersects the curve, the root eqs. (or the factors of the degener-
ate eqs. equated to 0) give only the portions of the curve on one side or the
other of the line-pole. Accordingly, a single root does not represent the en-
tire curve for these cases. On the other hand, when the line-pole does not
intersect the curve, a single root eq. is valid. In other words, the parabola
is more symmetrical about non-intersecting k-axes and a point-pole at the
focus or vertex than about intersecting k-axes. The most symmetrical line-
pole combination for the vertex is the k-axis at $h=-2a$, for which 12b
simplifies and reduces to 12b'.

Figs.
3-4b$_2$

The eqs. confirm that, when paired with k-axes, the focus has a higher sym-
metry rank than the axial vertex. One notes from 12b, that for the k-axis at
the vertex--in the incident polar-linear system--the eq. simplifies and reduces
to 13, which is a *reflective, vertex-tangent two-arm parabola*. This curve is
more highly symmetrical in appearance about the reference elements than is a
single arm relative to the traditional focus and directrix, but equational
comparisons between them are invalid because the requirement for axial
equality is violated.

3-3d

3-1a

Central Conics

Only a few illustrative examples are given for central conics. Taking the
line-pole at the center and the point-pole at the traditional focus, the de-
generate eqs. 14 are obtained for hyperbolas and ellipses. As in the pre-
ceding and following, the upper of the alternate signs are for hyperbolas
and the lower for ellipses. The eqs. are perfect squares, representing two
hyperbolas or ellipses, monoconfocal at p_v and in the size ratio $(2a^2 \pm b^2)/b^2$.
The root eqs. give disparate two-arm hyperbolas and *compound ellipses* (ovals
consisting of disparate ellipse segments). Taking the line-pole at the center
with an a vertex as the point-pole leads to the degenerate eqs. 15, which
also represent two hyperbolas or ellipses (not monoconfocal) in the size ratio
$(4a^4+b^4)^{\frac{1}{2}}/b^2$. Again the root eqs. give disparate two-arm hyperbolas and

Figs.
3-5
b$_1$,b$_2$

3-5
a$_1$,a$_2$

compound ellipses.

quadratic polar-linear equations for "central conics"

Figs.			
3-5 b_1,b_2	$(v^2-u^2-a^2{\overset{\pm}{\mp}}b^2u^2/a^2)^2 = 4u^2(a^2\pm b^2)$	central k-axis as line-pole and traditional focus as point-pole	(3-14)
3-5 a_1,a_2	$(v^2-u^2-a^2\pm b^2{\overset{\mp}{}}b^2u^2/a^2)^2 = 4a^2u^2$	central k-axis as line-pole and an a vertex as point-pole	(3-15)
3-5d_1	$a^2v^2 = u^2(a^2\pm b^2) + 2ab^2u$	incident polar-linear eq. for vertex tangent and vertex	(3-16)
3-5d_2	$(v^2\pm b^2) = u^2(a^2\pm b^2)/a^2$	incident polar-linear eq. for central k-axis and center	(3-17)
3-5c	$(x-d/2)^2 + y^2/2 = d^2(C-\tfrac{1}{2})/2$	ellipses represented by circular equation $u^2+v^2 = Cd^2$	(3-18)

3-5d_1

The incident polar-linear eqs. for central conics homologous to eq. 13 for the reflective, vertex-tangent two-arm parabola, which give reflective, vertex-tangent hyperbolic arms and reflective ellipses with a common vertex on a common line-pole, are eqs. 16. The key to the reduction of these eqs. and eqs. 13 and 17 (see below) to 2nd degree, as compared to the 4th-degree eqs. 14 and 15, is that by taking the point-pole incident upon the line-pole, a 2nd line of symmetry of the coordinate system is created. Accordingly, the congruent 2nd arm or 2nd ellipse is the reflectively redundant companion locus.

3-5d_2

One obtains 2nd-degree eqs., 17, if one casts central conics with their centers at the point-pole and on the line-pole, i.e., with the line-pole coincident with the minor (or conjugate) axis. The *circular* eq. in polar-

3-5c

linear coordinates, $u^2+v^2 = Cd^2$, gives the ellipses of eq. 18, centered midway between p_u and p_v, with fixed eccentricity, $e = 1/2^{\frac{1}{2}}$. The most symmetrical of these, for $C = 1$ $(u^2+v^2 = d^2)$, has its b vertices incident upon the two poles.

Of the simplest equilateral hyperbolic eqs., $u^2-v^2 = d^2$ and $v^2-u^2 = d^2$, the former already has been encountered (eq. 12b'); the latter also gives a parabola (polar-exchange symmetrical to the former), but with the line-pole as vertex tangent and the point-pole at the reflection of the vertex in the focus.

Circles

It is evident that the circle is less symmetrical than the parabola and central conics in the polar-linear system, because no linear eq. exists for it. In fact, many of the eqs. of the circle in polar-linear coordinates are

of 8th degree, even though the possible locations of the two reference poles
are much more limited.

If any point, (x_1,y_1), and any line, $(x = h)$, in the plane are taken as
poles, an 8th degree eq., 19, is obtained for a circle of radius R (i.e.,
it will be of 8th degree after regrouping and squaring). A diameter $(h = 0)$ as

Figs.
3-6
f_1,f_2

polar-linear equations for circles

$[v^2+2x_1(h\pm u)-x_1^2-y_1^2-R^2]^2 = 4y_1^2[R^2-(h\pm u)^2]$	any point (x_1,y_1) and any line $x = h$	(3-19)	3-6 f_1,f_2
$[v^2\pm 2x_1u-x_1^2-y_1^2-R^2]^2 = 4y_1^2(R^2-u^2)$	diameter (y-axis; $h = 0$) and any point, in 19	(3-20)	3-6e
$[v^2\pm 2^{\frac{1}{2}}uR-2R^2]^2 = 2R^2(R^2-u^2)$	diameter plus point on circle $(x_1,y_1) = (R/2^{\frac{1}{2}},R/2^{\frac{1}{2}})$	(3-21)	3-6d
$(v^2-R^2-y_1^2)^2 = 4y_1^2(R^2-u^2)$	incident polar-linear eq. for diameter plus point on diameter	(3-22)	3-6b$_2$
$(v^2-2R^2)^2 = 4R^2(R^2-u^2)$	incident polar-linear eq. for diameter plus point incident upon both diameter and circle	(3-23)	3-6a$_3$
$(v^2-2R^2)^2 = 4R^2u^2$	diameter plus point incident upon the circle and on a diameter orthogonal to the line-pole diameter	(3-24)	3-6b$_1$
$v^2 = Cdu$	the most symmetrical polar-linear circles	(3-25)	3-6a$_1$
$[x-d(2\pm C)/2]^2+y^2 = d^2C(C\pm 4)/4$	rectangular eqs. for the circles of eqs. 25	(3-26)	

line-pole and any point in the plane as the other pole yields the 8th degree
eq. 20. A diameter (the x axis) and a point on the circle $(R/2^{\frac{1}{2}},R/2^{\frac{1}{2}})$ but not
on the diameter gives the 8th degree eq. 21. For a diameter and a point-pole
on the diameter, but not on the circle—which is an incident polar-linear
system—eq. 21 reduces to the 4th degree eq., 22. If one lets the incident
pole also be incident upon the circle, eq. 22 simplifies to eq. 23. Still
greater simplicity, eq. 24, is achieved if the pole on the circle is on a
diameter that is orthogonal to the line-pole diameter.

The simplest eq. for circles, i.e., the most symmetrical circles for non-
incident polar-linear coordinates, are represented by the *parabolic* eq., 25,
for which the rectangular eq. is 26. For $C > 4$, these eqs. represent two

3-6e

3-6d

3-6b$_2$

3-6a$_3$

3-6b$_1$

3-6
a$_1$,a$_2$

Fig.
3-6a$_1$

neighboring, non-congruent, non-intersecting, and non-overlapping circles of relative radii $(C^2+4C)^{\frac{1}{2}}/(C^2-4C)^{\frac{1}{2}}$. The line-pole lies between them at a distance ratio of $(2+C)/(2-C)$ from the centers. The point-pole is within the large circle near the periphery and incident upon a line segment connecting the centers. Thus, the large circle passes between the two poles, whereas the small one lies wholly on the other side of the line-pole. For $C = 4$ the small circle becomes a point-circle and for $C < 4$ its locus is imaginary. Accordingly, the only real locus for $C < 4$ is a single circle of radius $d(C^2+4C)^{\frac{1}{2}}/2$, passing between the point-pole and the line-pole, with center at a distance $d(C+2)/2$ from the line-pole and Cd from the point-pole.

Since the most symmetrical circles are obtained for a non-incident non-central point-pole and a line-pole that is not a diameter, it is evident that the two highest ranking polar-linear foci of the circle include neither of the highest ranking circumpolar foci (the center and any incident point), nor the line with the highest circumlinear subfocal rank (any diameter).

[Note that equational comparisons of the symmetry of the loci of eqs. 22 and 23 may not be made with the loci of eqs. 21, 24, and 25, because the requirement for axial equality is violated. When the point-pole comes to lie on the line-pole, a second line of symmetry of the coordinate system is created.]

Polar Exchange Symmetry and Conchoids

The above finding is not the only unusual feature of *non-incident polar-linear parabolic eqs.* There exists--through *polar exchange symmetry*--a *complementary curve* to the circles, $v^2 = Cdu$, namely the curve represented by the eq. $u^2 = Cdv$. In other words, one obtains a polar-exchange symmetrical curve if one uses the same polar-linear eq. that represents the most symmetrical circles but exchanges the distances from the line-pole and the point-pole.

The curves in question, eq. 27, are a simple family of quartics that may previously have been unknown. The appearance of these *polar-linear parabolic conchoids*, that have polar exchange symmetry with *polar-linear parabolic circles*, is reminiscent of the conchoid of Nicomedes, eq. 28, which also are

$$x^4 = C^2d^2[y^2+(x-d)^2] \qquad \text{polar-linear parabolic conchoids} \qquad (3\text{-}27)$$

$$x^2y^2 = (a^2-x^2)(x-d)^2 \qquad \text{conchoid of Nicomedes} \qquad (3\text{-}28)$$

$$\text{(a)} \quad u(v\pm a) = ad \qquad \text{"} \qquad \text{"} \qquad \text{"} \qquad (3\text{-}29)$$

$$\text{(a')} \quad (uv-ad)^2 = a^2u^2 \qquad \text{"} \qquad \text{"} \qquad \text{"}$$

$$x^2[y^2+(x-d)^2] = C^2d^4 \quad \text{polar-linear equilateral hyperbolic conchoids} \quad (3\text{-}30)$$

based on a non-incident polar-linear construction, eqs. 29a,a', where the plus sign in 29a is for the arm between the point-pole and the line-pole and the minus sign is for the arm on the other side of the line-pole (corresponding to the small circle of eq. 26). The parameter a is the undirected distance from a point on the curve to a point on the line-pole along a radius from the point-pole to the point on the curve.

If eq. 29a' is compared with the parabolic eq., $u^2 = Cdv$, it is clear that the polar-linear parabolic conchoids are more symmetrical in polar-linear coordinates than the conchoid of Nicomedes. Another highly symmetrical group of polar-linear curves is represented by the eq., $uv = Cd^2$. In rectangular coordinates they form another simple group of quartics represented by eq. 30. Based upon a comparison of their polar-linear eqs., these conchoids also are more symmetrical in polar-linear coordinates than the conchoid of Nicomedes. [Eq. 28 differs from the commonly employed eq. for the conchoid of Nicomedes, $(x-d)^2(x^2+y^2) = a^2x^2$; the latter is cast about the point-pole as origin, and the line at $x = d$, whereas eq. 28 has the line-pole at $x = 0$ and the point-pole at $x = d$.]

Tripolar Coodinates

Introduction

The tripolar system has been known at least since the time of Chasles (1837). Its utility, together with that of other *multipolar* (more than 2 point-poles) coordinate systems may lie mostly in the realm of illustration of symmetry relations; for example, within limits, the casting of simple multipolar eqs. about poles with unspecified interpolar distances can reveal the locations of the highest-ranking foci. To be emphasized at the outset, however, is the fact that, in one aspect, all multipolar eqs. are intrinsically redundant. Thus, they can be converted to bipolar eqs. by expressing the distances from all other poles in terms of the distances from any two selected poles.

Linears

When more than two poles are employed, the symmetry of *real* loci represented by linear eqs. does not necessarily correlate with the number of unit coefficients, because of inherent restrictions; some of the simplest eqs. have no real solutions. For example, for 3 collinear poles in the sequence, p_u, p_v, p_w, no real solution exists for the eq. $u+w = v$.

The simplest eqs. for 3 non-collinear poles, $u+w = v$, $u+v = w$, and $v+w = u$, represent quartics. The general eq., $Au+Bv = Dw$ also represents quartics, unless $D^2 = (A \pm B)^2$, in which case the curves are complex cubics. A more complex condition on the parameters is required for further reduction.

For 3 *collinear* poles separated by distances of d_1 and d_2, $Au+Bv = Dw$ also represents quartics unless $D^2 = (A \pm B)^2$, for which complicated cubics are obtained. The cubic term vanishes if eqs. 1 are satisfied, leading to the requirement, $y = 0$. In other words, the most symmetrical *collinear tripolar* loci are lines. For example, for $d_1 = d_2 = j$, $u+w = 2v$ represents both lateral axial segments extending from p_u and p_w to infinity, as does also $(2u+w)/3 = v$, for $d_2 = 2d_1$. In the latter case, $(2u-w)/3 \pm v = 0$ represents the segments $p_u - p_v$ and $p_v - p_w$ (lower sign).

(a) $d_1 A = (B-A)d_2$ and $D^2 = (A-B)^2$ (b) $d_1 A = -(A+B)d_2$ and $D^2 = (A+B)^2$ (4-1)

Conic Sections

It is comparatively easy to carry out a multipolar analysis from the starting

point of specific curves and poles. If, for the parabola, poles are taken at the focus, p_v, the vertex, p_t, and the *conjugate point*, p_u, the tripolar 2nd-degree eq., 2, is obtained. Second-degree eqs. are not obtained, however,

$$u^2 + t^2 = 2v^2 + 10av - 3a^2 \qquad (4\text{-}2)$$

(a) $u^2 - w^2 + 2av = 3a^2 \pm b^2$ \qquad (a') $v^2 - w^2 + 2au = 3a^2 \pm b^2$ \qquad (4-3)

(b) $16a^2(w^2 \pm b^2) = (u^2 - v^2)^2$

if the traditional focus is not one of the 3 poles, because, as is well known, only for the traditional focus can the distance, v, to an incident point (x,y) be expressed as a linear function of x, namely $v = x + a$.

Casting the eqs. for central conics about the two traditional foci, p_u and p_v, and the center, p_w, yields eqs. 3, where the upper alternate sign is for hyperbolas and the lower for ellipses. In forming the eliminant, one has the alternative of employing as the *master equation* (see eqs. 6 below) either the eq. for the distance from a point on the curve to one of the foci, yielding the quadratics, 3a,a', or the eq. for the distance from a point on the curve to the center, which yields the quartic, 3b. Eqs. 3a,a' each represents only one arm of the basis hyperbola (i.e., in the polarized system), but eq. 3b represents both arms.

In parallel with the situation for the parabola, only when a traditional focus is included in an ensemble of collinear poles, and only when one employs the eq. for the distance from a point on the curve to that focus as the master eq., can central conics be expressed as 2nd-degree multipolar eqs. The basis for this relationship for central conics also is the known fact that only for the traditional foci can the distance to a point on the curve be expressed as a linear function of the abscissa of that point. For centered ellipses, the eq. is $v = a \pm ex$, where the upper alternate sign is for the right focus and the lower for the left focus. For centered hyperbolas, the eq. is $v = \pm(ex \mp a)$, where the upper alternate signs are for the right arm (external sign) and the right focus (internal sign), and the lower alternate signs are for the left arm (external sign) and the left focus (internal sign).

[The fact that, for a given focus of a hyperbola, a linear eq. applies to only one arm (the eq. must be squared to eliminate the alternate sign to apply to both arms), whereas for the ellipse it applies to the entire curve, is the basis for the fact that in polarized bipolar and multipolar systems the lowest-degree eqs. for central conics represent an entire ellipse but only one arm of a

hyperbola. Whereas a linear polarized bipolar eq. represents an entire ellipse, a 2nd-degree polarized bipolar eq. is required to represent both arms of a hyperbola; in polarized multipolar systems, the corresponding degrees generally are 2 and 4.]

If one employs the center, p_w, and the vertices, p_s and p_t, as poles, both tripolar eqs. are quartics. Eqs. 4a,b are for ellipses. Using the eq. for the distance from the center as the master eq. yields 4a, using that for the distance from the vertex yields 4b (see the following discussion).

Figs. 4-3b

(a) $16a^2(w^2-b^2) = (a^2-b^2)(s^2-t^2)$ (4-4) 4-3b

(b) $[(s^2-w^2-a^2)(a^2-b^2)-2a^4]^2 = 4a^4[(a^2-b^2)t^2+b^4]$

Tetrapolar Coordinates

The Parabola

As noted above, the casting of eqs. in multipolar coordinates is a process that admits of alternative procedures. The tetrapolar system and the parabola are used to illustrate these procedures. Using $y^2 = 4ax$ as the basis eq., poles are taken at the focus, p_v, the conjugate point, p_u, the vertex, p_t (which also is the position of the origin), and the reflection of the vertex in the directrix, p_s.

Fig. 4-1a

First, eqs. for u, v, s, and t are derived using the usual procedures for obtaining the distance between two points, for example, $u^2 = (x+3a)^2+y^2$. In the standard procedures used herein for deriving 2nd-degree multipolar eqs. of conic sections, sums or differences of u^2, s^2, and t^2 are formed and x is eliminated by the substitution $x = (v-a)$, yielding eqs. such as 4-2.

In an alternate procedure that yields 4th-degree eqs., the differences, u^2-v^2 and s^2-t^2, are formed, each of which leads to a linear eq. in x, eqs. 5a and 5b. Two routes now can be taken, each of which has 4 alternatives.

(a) $x = (u^2-v^2-8a^2)/8a$ (b) $x = (s^2-t^2-4a^2)/4a$ (4-5)

four alternative master eqs.

(a) $x^2 + 10ax + (9a^2-u^2) = 0$ (b) $x^2 + 2ax + (a^2-v^2) = 0$ (4-6)

(c) $x^2 + 8ax + (4a^2-s^2) = 0$ (d) $x^2 + 4ax - t^2 = 0$

In these alternatives, one may eliminate y from the eq. for the parabola,

$y^2 = 4ax$, and any one of the four "distance-squared" eqs. in u^2, v^2, s^2, or t^2, giving the four alternative *master equations*, 6a-d. Eq. 7 is one of the 16 possible quartic eliminants between eqs. 5a,b and these master eqs., all of which represent the parabola $y^2 = 4ax$.

<div align="center">

tetrapolar quartic for the parabola, $y^2 = 4ax$
formed as an eliminant between eqs. 5 and 6a

</div>

$$64a^2(u^2-9a^2) = (u^2-v^2-8a^2)^2 + 160a^2(s^2-t^2-4a^2) \tag{4-7}$$

In the other route, eqs. 6 are solved for x using the quadratic-root formula, and squared, yielding eqs. such as 8. Next one forms x^2, as the product of eqs. 5a by 5b, and substitutes it for the x^2 terms in eqs. such as 8, yielding four 8th-degree eliminants, 9a-d; in rectangular form these become 9a'-d'. No arbitrary weighting is employed in obtaining these eqs. The first factor of 9a'-d' equated to 0 represents the basis parabola, and the second factor the *satellite* locus. General eqs. of harmonic parabolas for all axial locations of the basis parabola are derived below (*Harmonic Parabolas and Multipolar Coordinates*).

$$x^2 = 41a^2 + u^2 \pm 10a(16a^2+u^2)^{\frac{1}{2}} \qquad \text{eq. 6a in terms of } x^2 \tag{4-8}$$

<div align="center">

eqs. of harmonic parabolas formed by eliminating x^2
between eqs. such as 8 and the product of eqs. 5

</div>

(a) $100a^2(16a^2+u^2) = (A^2-41a^2-u^2)^2$ eq. 6a gives basis parabola plus satellite arm (x4 magnification) (4-9)

(b) $\qquad\qquad 4a^2v^2 = (A^2-a^2-v^2)^2$ eq. 6b gives basis parabola plus x axis

(c) $64a^2(12a^2+s^2) = (A^2-28a^2-s^2)^2$ eq. 6c gives basis parabola plus satellite arm (x3 magnification)

(d) $16a^2(4a^2+t^2) = (A^2-8a^2-t^2)^2$ eq. 6d gives basis parabola plus congruent satellite arm

$$A^2 = (u^2-v^2-8a^2)(s^2-t^2-4a^2)/32a^2$$

<div align="center">

eqs. 9a-d converted to rectangular coordinates

</div>

(a') $(y^2-4ax)(y^2+16ax) = 0$ (b') $(y^2-4ax)y^2 = 0$

(c') $(y^2-4ax)(y^2+12ax) = 0$ (d') $(y^2-4ax)(y^2+4ax) = 0$

Harmonic Parabolas

Eqs. 9a-d represent 4 remarkable loci that exist in all multipolar coordinate systems. Eq. 9a, which is derived from the master eq. for the conjugate point, p_u, represents the basis parabola plus a *satellite* arm with the same vertex, reflected in the y-axis, and 4 times as large. The feature of having a satellite arm is not unexpected, because the derivation procedure leads to eqs. of higher than the minimum degree needed to cast the eq. of a tetrapolar parabola. The features of interest are that the *satellite* locus is different for each of the eqs., 9a-d, with properties that depend upon the location of the pole whose master eq. was employed in the derivation.

Fig. 4-1a

Eq. 9b, derived from the master distance eq. of the traditional focus, p_v, gives the basis parabola plus the x-axis (a degenerate "collapsed" parabola). Eq. 9c gives the basis parabola plus an opposed parabola with the same vertex but magnified by a linear factor of 3, while eq. 9d, derived from the master eq. for a pole, p_t, at the vertex, gives a congruent opposed satellite parabola with the same vertex. If one also had employed a pole midway between p_s and p_t (the location of the foot of the directrix), the corresponding *satellite* parabola would have been magnified by a linear factor of 2.

Fig. 4-1a

Further, if one were to use a pole a units to the right of p_v (at the focus), the satellite parabola would be congruent to and coincident with the basis curve; in this event, one side of the 8th-degree eliminant eq. (homologous to the left sides of eqs. 9) vanishes, leaving the square of a factor representing the basis curve equated to 0. If one were to use a pole 2a units to the right of p_v, the satellite parabola would be magnified by a factor of 2 and also would open to the right; use of a pole 3a units to the right would give a satellite magnified by a factor of 3 and opening to the right, etc.

Summarizing the derivation of *harmonic parabolas*, one casts a tetrapolar eq. for the parabola $y^2 = 4ax$, using any 4 poles spaced at integral distances, na from the traditional focus. If one uses a derivation route that involves arbitrary weighting of the poles, a total of 16 alternative 4th-degree eqs. are obtained, all of which represent only the basis curve. [The question of whether weighting of the poles is arbitrary or not is not crucial.]

On the other hand, the use of a second procedure (in which substitutions to obtain the eliminant give equal weight to each pole) gives only 4 alternative eqs., but these generally are octics rather than quartics. Each of these eqs. represents both the basis curve and a satellite locus—usually another parabola—which is different for each eq. and characteristic of the position

of the *master pole* (the pole whose distance eq. was employed to obtain the eliminant).

Use of the traditional focus as the master pole gives a "collapsed" parabola, the x-axis, as the satellite locus. For each a-unit step to the left in the position of the master pole, the satellite parabola increases in size by one unit of magnification. These curves have the same vertex as the basis curve but open to the left. Proceeding along the x-axis in a-unit steps to the right, the same phenomenon occurs except that the satellite parabolas now open to the right. For the pole one a-unit to the right of the traditional focus, the satellite parabola is congruent to and coincident with the basis parabola.

But these parabolas obtained by casting tetrapolar eqs. for a basis curve with its vertex at the origin are only special cases of harmonic parabolas. In the general case of a basis parabola, $y^2 = 4a(x-na)$, with the vertex at na, the tetrapolar eqs. still represent the basis curve plus satellite parabolas opening to the right or left (according to whether the *master pole* is to the right or left of the *parameter pole*, $x = a$).

These satellite parabolas also become magnified increasingly by one unit for each a-unit by which the pole is displaced to the right or left of the *parameter pole*, $h = a$. But their locations differ remarkably from those described above for the special case in which the vertex of the basis curve is at the origin. The general location of the vertices progresses inversely in harmonic sequence. For unit magnification, the vertex is at $\pm na$, i.e., at the vertex of the basis curve or at the reflection of this vertex in the y axis; for a magnification of 2, it is at $\pm na/2$, for a magnification of 3, at $\pm na/3$, etc.

The only exception to the above rules occurs when one uses the parameter pole as the master pole, i.e., the pole at $x = a$. For this pole, only the basis curve is represented. The satellite locus generally is imaginary but becomes the x-axis when the vertex of the basis curve is at the origin.

Polar Exchange Symmetry

Unique conditions for polar exchange symmetry exist in tetrapolar coordinates; in this system one can carry out the simplest and most symmetrical possible polar exchanges. Thus, if one (a) takes the 4 poles to be both uniformly spaced and collinear, in the sequence, u, s, t, v, or (b) places the 4 poles at the corners of a square, the eqs. 10a-c are the

(a) $uv = st$ (b) $ut = sv$ $us = tv$ (4-10)

simplest and most symmetrical possible cases of polar exchange symmetry--both sides of the eqs. being symmetrical, no parameters being involved, and the minimum number of poles being involved (as compared, for example to the hexapolar eq. $pqr = stu$).

When the 4 poles are at the corners of a square, the system is somewhat restrictive and the 3 polar-exchange symmetrical loci are the two individual midlines (10a,c) and both midlines (10b). [Both midlines are represented in all 3 cases for the unpolarized system.] The extended crossed diagonals (the incomplete linears $t = u$ and $s = v$) are not valid loci in this system.

Figs. 4-2 a-c

An impressive result is obtained for uniformly spaced collinear poles; eq. 10a represents an equilateral hyperbola ($a = 5^{\frac{1}{2}}d/2$), 10b a circle ($R = 3^{\frac{1}{2}}d/2$) plus the midline, and 10c the midline alone. All 3 curves are centered midway between poles p_s and p_t. Polar exchange symmetry of the circle and equilateral hyperbola in tetrapolar coordinates is one of 5 respects in which symmetry analyses have revealed homologous properties for these curves. They also have: (1) *endless chain circumpolar symmetry classes, all links in which consist of circles and equilateral hyperbolas, respectively;* (2) *eclipsed circumpolar foci;* (3) *identical reciprocal circumcurvilinear transforms;* and (4) *a homologous property involving the tangent pedals of the parabola* (see Chapters V, XII, and XIII).

4-2d

The eqs., $u+s = t+v$ and $u+t = s+v$, in uniformly-spaced collinear tetrapolar coordinates also represent the midline. In addition, $u+t = s+v$ represents the axial segment connecting poles p_s and p_t, while $u+v = s+t$ represents the line segments extending laterally from poles p_u and p_v to infinity. If no two distances between the poles are equal, all 3 curves (eqs. 10) are cubics. If either side of the eqs. is multiplied by a constant, all 3 curves become quartics. The crucial condition for reduction of the degree of represented loci is that the distances between the outer poles be equal, i.e., $d_{us} = d_{tv}$; in such a case the poles are symmetrical about the midpoint of the p_u-p_v segment. Then, regardless of the value of d_{st}, eq. 10a represents equilateral hyperbolas, 10b represents circles, and 10c represents the midline.

Non-Collinear Tetrapolar Coordinates

As another illustration of a non-collinear arrangement of point-poles, the tetrapolar eqs. of the parabola, $y^2 = 4ax$, are cast. If one takes as poles the focus, p_v, the vertex, p_u, and the LR vertices, p_s and p_t, one of

$$u^2 + s^2 + t^2 = 3v^2 + 2av + 5a^2 \tag{4-11}$$

$$256a^2(s^2-u^2) = 3(t^2-s^2)(v^2-u^2) + 128a^2(t^2-s^2) - 16^2 \cdot 27a^4 \tag{4-12}$$

several possible quadratics representing only one arm is eq. 11. If all 4 poles are taken to be incident upon the curve, p_s and p_t at the LR vertices. (a,2a) and (a,-2a), and p_u and p_v at (4a,4a) and (4a,-4a), respectively, quartics are required to represent the curve, an example of which is eq. 12. In deriving eq. 12, the expression for s^2-u^2 was used as the master distance eq. and the difference expression, t^2-s^2, was given greater weight than v^2-u^2.

Pole-Intersecting Two-Arm Parabolas

In the case in which all 4 poles are incident, the alternate route that yields 8th degree eqs. involves arbitrary weighting and gives two-arm homologues of harmonic parabolas, but these differ from those already described in significant respects, depending upon the route of substitutions. One route gives congruent satellites, $(y-2k)^2 = 4ax$, with the same orientation, the other gives congruent satellites, $y^2 = -4a(x-2h)$, with opposed orientation, where the master pole is at (h,k). In both cases the basis parabola intersects the satellite at the master pole.

Hence, unlike their harmonic homologues, one point of intersection of the *pole-intersecting two-arm parabolas* is the pole whose distance eq. was employed as the master eq. in forming the eliminant. As an example, let the distance eq.,13b, for p_s at (a,2a), be employed as the master eq. for the basis parabola of eq. 13a. Two of the possible difference eqs. are 13c,d.

(a) $y^2 = 4ax$　　　(b) $s^2 = (x-a)^2 + (y-2a)^2$　　　(c) $t^2-s^2 = 8ay$　(4-13)

(d) $v^2-u^2 = 16ay$　　　(e) $x = \dfrac{(t^2-s^2)(v^2-u^2)}{4a \cdot 8a \cdot 16a}$

Fig.
4-3f

(f) $s^2 + [(t^2-s^2)(v^2-u^2)/(4a \cdot 8a \cdot 16a)-a]^2 + [(t^2-s^2)/8a-2a]^2$

Eliminating y between eqs. 13a,c,d gives 13e. Substituting x of 13e for x of 13b, and y of 13c for y of 13b gives 13f. This represents the basis

parabola plus a congruent satellite with vertex at (2a,0), opening to the left, and intersecting the basis curve at both LR vertices, (a,2a) and (a,-2a). The LR vertex at (a,2a) is the master pole, p_s, whose distance eq.,13b, was employed as the master eq. to derive 13f (for notes relating to the origin of multipolar satellite curves see legends of Figs. 4-1 and 4-3f).

Pentapolar Coordinates

Introduction

In a 5-pole coordinate system, it becomes possible to accommodate all 5 axial circumpolar foci of central conics in one eq. One might expect this correspondence to lead to eqs. for central conics with unusual properties. However, this is not the case; the eqs. prove to be unexceptional. The reason for this is that the more point-poles--in excess of the 2 or 3 highest-ranking foci--that are employed to represent a curve, the greater the intrinsic redundance of the eqs., and the lesser becomes the dependence of the form, degree, and complexity of the eqs. on the circumpolar symmetry of the basis curve about the additional lower-ranking focal or non-focal poles. The progression is from total dependence in bipolar eqs.--a dependence so rigid that focal properties of the poles can be inferred merely from inspection of the eqs.--to very little dependence in tetrapolar, pentapolar, and hexapolar coordinates.

Central Conics

Consider the case in which one takes as poles the two traditional foci, p_u and p_v, the two vertices, p_s and p_t, and the center, p_w, with the sequence p_{uswtv} for the hyperbola and p_{suwtv} for the ellipse. The resulting 2nd-degree pentapolar eqs. for the hyperbola (upper alternate signs) and ellipse (lower alternate signs) are eqs. 14. The eq. for v was employed as the master distance eq. in deriving the eliminant, and both arms of the hyperbola are represented.

Figs. 4-3h

$$u^2 + s^2 - t^2 - w^2 = 2(a\pm v)[2a+(a^2\pm b^2)^{\frac{1}{2}}]/e + (a^2\pm b^2) \tag{4-14}$$

(a) $u^2+s^2-t^2-w^2 = (2\cdot2^{\frac{1}{2}}+4)a^2+(2\cdot2^{\frac{1}{2}}+2)av$ (b) $u^2+s^2-t^2-w^2 = 6a^2+4av$ (4-15)

4-3 h,i

For the equilateral hyperbola, eq. 14 simplifies to 15a. Eq. 15b is for the case in which the poles of the equilateral hyperbola are *equally spaced* at a distance of $a/2^{\frac{1}{2}}$, in which case p_s and p_t are not vertices. The subfocal symmetry of the curve about the 5 poles of 15b is greater than that about the 5 foci of 15s, because the circumstance of uniform spacing of the poles outweighs the importance of differences in the symmetry of the curve about the differently-located 4th and 5th reference poles, p_s and p_t.

4-3h

Parabolas

Eqs. for parabolas cast about 5 collinear poles show a close parallel with those cast about collinear poles in tetrapolar coordinates. If 5 poles are taken in the sequence uswtv, spaced a units apart, with p_v at the traditional focus, an example of a 2nd-degree eq. for a basis parabola, $y^2 = 4a(x-a)$, is 16.

$$u^2 + w^2 - s^2 - t^2 = 4av + 2a^2 \tag{4-16}$$

$$[(s^2-t^2)(u^2-v^2)/32a^2+12a^2+w^2]^2 = 16a^2(w^2+8a^2) \tag{4-17}$$

If one casts 8th-degree eqs., instead (see *Tetrapolar Coordinates*), harmonic two-arm parabolas are obtained, with the properties already described. For example, for the pole arrangement given above, and employing the distance eq. for p_w (the directrix position), the 8th degree eq. 17, is obtained. The satellite arm of eq. 17 is congruent with the basis curve but is reflected in the y axis (the directrix), i.e., its eq. is $y^2 = -4a(x+a)$.

Consider now a case in which one retains the above pole sequence but places p_u, p_v, p_s, and p_t at $x = -4a$, $4a$, $-3a$, and $3a$, respectively, leaving p_w at the origin. Further, let the vertex of the curve be moved to $x = 2a$, i.e., let the basis curve be $y^2 = 4a(x-2a)$. With this arrangement, one of the 8th-degree eqs. for a harmonic two-arm parabola is 18. In deriving eq. 18, the distance eq. for the pole at $x = 3a$ was employed as the master eq. Since the pole is $2a$ units to the right of the parameter pole at $x = a$, the magnification factor is 2, the vertex is at $2a/2$, and the eq. of the locus is $y^2 = 8a(x-a)$, with the curve opening to the right. It will be noted that

$$[(u^2-v^2)(s^2-w^2-9a^2)/96a^2-a^2-t^2]^2 = 4a^2t^2 \tag{4-18}$$

both sides of eq. 18 are perfect squares; the positive root eq. represents the basis parabola and the negative root eq. the satellite.

Hexapolar Coordinates

Polar Exchange Symmetry

If one takes 6 collinear poles spaced a units apart in the sequence, qrstuv, and forms symmetrical triple-product eqs., such as 19a,b, quintics generally are obtained but eq. 19b yields a quartic, eq. 20, plus the midline.

(a) qvs = rut (b) qtu = rsv (4-19)

Fig.
4-6b

$$(x^2+y^2)^2 = a^2(2x^2+62y^2+255a^2)$$ (4-20)

$$q^2(u^2+t^2) = v^2(r^2+s^2)$$ (4-21)

This unusual quartic is biconcave and somewhat resembles the mammalian red 4-6b
blood cell.

Other interesting cases are those in which one forms the products of squares
with sums of squares. Eq. 21, the counterpart of eq. 19b, yields the circle,
$x^2+y^2 = 25a^2/12$, and the midline. Ten representative cases of the 90 possible
combination eqs. have been investigated. In addition to the circle, the curves
obtained are either cubics or the midline plus an imaginary quadratic
("circular") locus.

The derivation and properties of parabolas cast about 6 collinear poles
parallel the tetrapolar and pentapolar situations.

Harmonic Parabolas and Multipolar Coordinates

The earlier treatments of harmonic parabolas have raised several questions
to which attention will be given here: (a) do harmonic parabolas occur in all
multipolar coordinate systems; (b) what is the significance of the *parameter
pole*, h = a, and the absence of a *satellite* parabola when the distance eq. for
this pole is used as the master eq. in the derivation; (c) how does it come
about that the multipolar eq. of the locus falls into a perfect square when
the distance eq. for the pole at x = 2a is used as the master eq.; (d) do
reduced (as opposed to magnified) satellite parabolas also exist; and (e)
what role, if any, does spacing of the poles play?

Although harmonic parabolas were encountered while seeking to eliminate
arbitrary weighting of poles in multipolar eqs., the existence of these curves
is independent of the weighting of the poles in the eliminant. In the
treatment of tetrapolar and pentapolar coordinates, 8th-degree eqs. of the
basis and satellite parabolas were derived. But these are only for specific
pairs in the series, for given locations of the basis parabola and master
pole. They do not reveal the general relationships between the basis curve and
the satellite for *any* location of the basis parabola and master pole.

The general eq. for harmonic parabolas is derived here. Let eq. 22a be the
square of the distance from the master pole, p_v, to a point on the curve

(a) $v^2 = (g-x)^2 + y^2$ (b) $y^2 = 4a(x-h)$ (4-22)

and eq. 22b be the eq. of the basis parabola, where g is the location of p_v and h is the location of the vertex of the basis curve on the x-axis; g and h may be positive or negative. Eliminating y between eqs. 22a,b and solving for x, using the quadratic-root formula, yields eq. 23. Squaring, regrouping, and squaring again, gives eq. 24.

$$x = (g-2a) \pm [4a(a-g+h)+v^2]^{\frac{1}{2}}$$ eliminant of eq. 22a,b (4-23)

$$[x^2+4a(2g-2a-h)-g^2-v^2]^2 = 4(g-2a)^2[4a(a-g+h)+v^2]$$ eq. 23 squared twice (4-24)

$$y^4 + y^2(8ah-4gx) + 16a(ah^2-ghx-ax^2+gx^2) = 0$$ harmonic parabolas (4-25)

Figs.
4-1
a-c

(a) $y^2 = 4a(x-h)$ basis curve (b) $y^2 = 4(g-a)[x-ah/(g-a)]$ satellite (4-26)

If one were deriving the multipolar eq. about n poles using p_v as the master pole, one now would substitute, say $x^2 = f_1(u^2-v^2)f_2(s^2-t^2)$, in the left member, giving the sought after 8th-degree eq. of the basis parabola and its satellite. Since this is not the goal, instead, v^2 is eliminated between eqs. 22a and 24, leading to the general eq., 25, for harmonic parabolas. [Replacing x^2 of eq. 24 by, say, $f_1(u^2-v^2)f_2(s^2-t^2)$, and then substituting for u^2, v^2, s^2, and t^2, merely leads to recovery of x^2.] Eq. 25 holds for all pairs of harmonic parabolas cast about the master pole, p_v, with the vertex of the basis parabola at h. Solving for y^2 yields 26a,b. The former is the eq. of the recovered basis curve, the latter that of the satellite.

It is clear from inspection of eq. 26b that magnification of the basis curve occurs for any value of g greater than 2a or less than 0. But the eq. also reveals that the size of the satellite decreases as the value of g

Figs.
4-1
a-c

approaches the location of the parameter pole, x = a, from the origin at the left and from x = 2a at the right. As the size of the satellite decreases, the location of its vertex recedes along the x-axis to the right or left, according to whether the parameter pole is approached from the left or right. At g = a, the satellite locus, $y^2 = -4ah$, is given. This is imaginary for all positive values of h; for h = 0, it is the x-axis, y = 0. For negative h, the satellite locus at g = a is the line-pair, $y^2 = -4ah$.

Lastly, it will be noted that for the master pole at the traditional focus,

$g = h+a$, the eq. of the satellite parabola is $y^2 = 4h(x-a)$; the vertex of the satellite always is at the parameter pole, its magnification is h/a, and it opens to the right or left according to whether h is positive or negative. It is identical to the basis parabola only when $h = a$, i.e., when the traditional focus is at $2a$.

To illustrate the above relationships, the eqs., magnification and reduction factors, and vertex locations of the satellite parabolas, $y^2 = 4(g-a)x+16a^2$, of the basis parabola, $y^2 = 4a(x+4a)$, with vertex at $x = -4a$, are given in Table IV-1 for various locations of the master pole, p_v.

Fig. 4-1c

Accordingly, all of the questions posed above have been answered. Harmonic parabolas occur in all multipolar systems because their derivation is independent of the number of poles employed in casting the eqs. (following the procedures outlined, the terms substituted for x^2 in eq. 24 are of 4th degree in the distance variables, so that, with few exceptions, eq. 24 will be of 8th degree).

The significance of the parameter pole $g = a$ is clear from eq. 26b; the parameter pole is a singularity at which the harmonic parabolas "transform" (degenerate) to a line, an imaginary locus, or a line-pair. Further, when $g = 2a$, eq. 26b becomes identical with eq. 26a, and eq. 25 becomes a perfect square. Reduced (as opposed to magnified) satellite parabolas also exist and, lastly, the spacing of the poles plays no role, since no consideration of it enters the derivation procedure.

When 6 to 9 poles are employed, it is necessary to square eq. 24 to accommodate functions for the additional poles. However, only a single satellite locus exists, because the additional loci thereby introduced are imaginary. This appears to be the case for any number of additional loci beyond the single real satellite.

Before leaving the topic of harmonic parabolas, it should be emphasized that these curves do not arise through a direct derivation of the multipolar eq. of a basis parabola. Eqs. of lower degree than 8 exist that represent the basis parabola *alone*. Rather, harmonic parabolas are a phenomenon wherein eqs. that are not degenerate when expressed in the multipolar variables represent two-arm parabolas with arms that generally are of unequal size.

On the other hand, it also should be emphasized that, in one sense, the eqs. of multipolar harmonic parabolas must be regarded as degenerate, that is, a coordinate substitution always exists that will convert the multipolar eq. to

Table IV-1. Multipolar Satellite Parabolas of the Basis Parabola $y^2 = 4a(x+4a)$

g (location of p_v)	Satellite Equation*	Magnification or Reduction Factor	Vertex Location
-5a	$y^2 = -24a(x-2a/3)$	6	2a/3
-4a	$y^2 = -20a(x-4a/5)$	5	4a/5
-3a	$y^2 = -16a(x-a)$	4	a
-2a	$y^2 = -12a(x-4a/3)$	3	4a/3
- a	$y^2 = - 8a(x-2a)$	2	2a
0	$y^2 = - 4a(x-4a)$	1	4a
a/4	$y^2 = - 3a(x-16a/3)$	3/4	16a/3
a/2	$y^2 = - 2a(x-8a)$	1/2	8a
3a/4	$y^2 = - a(x-16a)$	1/4	16a
a	$y^2 = 16a^2$	—	—
5a/4	$y^2 = a(x+16a)$	1/4	-16a
3a/2	$y^2 = 2a(x+8a)$	1/2	- 8a
7a/4	$y^2 = 3a(x+16a/3)$	3/4	-16a/3
2a	$y^2 = 4a(x+4a)$	1	- 4a
3a	$y^2 = 8a(x+2a)$	2	- 2a
4a	$y^2 = 12a(x+4a/3)$	3	- 4a/3
5a	$y^2 = 16a(x+a)$	4	- a

*All parabolas in a harmonic series (eq. 26) intersect at common points, $[0,\pm(-4ah)^{\frac{1}{2}}]$, on the y-axis, in this case, $(0,\pm4a)$; these points are real for negative h, at the origin for h = 0 (all vertices at the origin), and imaginary for positive h (vertices of the basis parabolas to the right of the origin at x = h).

a degenerate bipolar eq. Among the factors of this degenerate eq. will be 2 or 3 which, when equated individually to 0, represent the basis parabola and the satellite locus or loci (a parabola, line segments, or lines).

By way of illustration, eqs. 9a and 9b are converted to degenerate bipolar eqs. by eliminating s and t through the substitution of their equivalents in u and v, yielding eqs. 9a' and 9b'. For eq. 9a', the first factor (equated

$$(B^2+10aB+9a^2-u^2)(B^2-10aB+9a^2-u^2) = 0 \qquad B = (u^2-v^2-8a^2)/8a \qquad (4-9a')$$

$$[u^2-v^2-8a(v+2a)][u^2-v^2+8a(v-2a)](u^2-v^2-8av)(u^2-v^2+8av) = 0 \qquad (4-9b')$$

to 0) represents the $y^2 = 4ax$ basis curve and the second factor the $y^2 = -16ax$ satellite. For 9b', the third term represents the $y^2 = 4ax$ basis curve and the first and second terms represent segments of the x-axis; these segments extend in each direction from the traditional focus to infinity. The fourth term represents an imaginary locus.

Polar-Circular Coordinates

In the polar-circular system, the reference elements consist of a circle, p_u, taken to be centered at the origin $(x^2+y^2 = R^2)$, and a point-pole, p_v, taken to be on the x axis at $x = d$. The variable u represents the un-directed *extremal* distances from a point on the curve to the circle.

The most symmetrical curves in this system, given as usual by the eq. $u = v$, are the line $y = 0$, for p_v incident upon p_u, and the central conics of eq. 27, of eccentricity $e = d/R$ $(d \neq R)$, centered at $x = d/2$, for all other cases. One focus of the latter curves is at the point-pole and the other is at the center of the circle-pole. When the point-pole is outside the circle-pole $(d > R)$, a hyperbola is obtained, when it is inside $(R > d)$, the curve is an ellipse; when it is at the center, the locus is the mid-circle. When

Figs.
4-4
a_1 , a_2

4-4a_1
4-4a_2

4-4
a_1 , a_2
4-4
b_1 , b_2

$$4(x-d/2)^2/R^2 + 4y^2/(R^2-d^2) = 1 \qquad \text{central conics,} \quad u = v \qquad (4\text{-}27)$$

$$4(x-d/2)^2/(Cd\pm R)^2 + 4y^2/[(Cd\pm R)^2-d^2] = 1 \quad \text{"central conics,"} \ u\pm v = Cd \qquad (4\text{-}28)$$

$$\{(x^2+y^2)(1-C^2)+[R^2-C^2 d(d-2x)]\}^2 = 4R^2(x^2+y^2) \qquad \text{quartics,} \quad u = Cd \qquad (4\text{-}29)$$

the point-pole is incident upon the circle-pole, the locus is the line passing through the center of the circle-pole and the point-pole.

The right arm of the hyperbola is given when u is the least distance to the circle, the left arm when it is the greatest distance. Since the arms are congruent, this relationship has been termed *congruent extremal-distance symmetry*. For the ellipse, only the least distance applies. The construction for the ellipse and the least-distance construction for the hyperbola being known, the greatest-distance construction for the hyperbola presumably also is known.

The linear, $u\pm v = Cd$, represents the central conics of eqs. 28, of eccentricity $e = d/(Cd\pm R)$, centered at $d/2$, where the upper sign for R holds when u is the least distance to the circle and the lower sign when u is the greatest distance. For $Cd > R$, in which case a greatest-distance construction exists, eq. 28 represents disparate two-arm hyperbolas and disparate ellipses; otherwise, when only a least-distance construction exists, it represents one-arm hyperbolas and single ellipses.

Figs.
4-4
b_1 , b_2

On the other hand, the linear $u = Cv$, which represents the quartics of eq. 29, is the polar-circular equivalent of bipolar linear Cartesians. It is

closely related both equationally and by circumpolar symmetry to bipolar linear and parabolic Cartesians. For $C = R/d$ $(R \neq d)$, it represents limacons, with the DP or DP homologue at the center of the circle-pole and the focus of self-inversion at the point-pole (the two highest-ranking circumpolar foci of these limacons always are at the point-pole and the center of the circle-pole).

Fig. 2-1f$_2$

For $C = 1$, $u = Cv$ gives central conics (see above). The sole locus in common with bipolar parabolic Cartesians is the equilateral limacon, for $C = 2^{\frac{1}{2}}/2$ and $R = d$, which is the only case of a polar-circular limacon with its focus of self-inversion at the center of the circle-pole and its DP incident upon the circle-pole (and coincident with the point-pole). Other quartics common to polar-circular and bipolar *linear* Cartesians are those for which $2A^2 = B^2 + C^2$ $(Bu + Av = Cd)$. The cardioid is not included among the limacons represented by polar-circular *linear* Cartesians for the same reason that it is excluded from the bipolar *linear* Cartesians.

[In the interests of simplicity, the polar-circular eqs. as written represent loci exterior to the circle-pole. In the expression $u \pm R$, the plus sign applies when u is the least distance to the circle-pole and the minus sign for u the greatest distance, in which case $u \pm R$ always is the distance from the center of the circle-pole (the origin). For portions of loci interior to the circle-pole, the derivations must be carried out with $u = R \mp (x^2 + y^2)^{\frac{1}{2}}$ or $\mp(u - R) = (x^2 + y^2)^{\frac{1}{2}}$, where the upper sign is for u the least distance to the circle-pole and the lower sign is for u the greatest distance. Frequently, derivations for interior and exterior portions of loci lead to the same final eqs. (see further discussion in the legend to Figs. 6a$_1$-a$_4$.]

Quartics also are given by the circular, $u^2 + v^2 = Cd^2$, and the parabolic, $v^2 = Cdu$, whereas the polar-exchange symmetrical parabolic, $u^2 = Cdv$, gives octics. The general polar-circular eq. of a circle is not simple. For a circle of radius D centered at (h, k), the 4th-degree eq. 30 is obtained. But if the circle is centered on the polar-circular axis $(k = 0)$, i.e., on the line connecting the point-pole and the center of the circle-pole, eq. 30 reduces to the 2nd-degree eq. 31. Centering on the orthogonal axis (the y-axis, $h = 0$) leads to simplification of eq. 30 but not to reduction. If the circle is centered at the point-pole, p_v, then $d = h$ in eq. 31, and the eq. reduces to $v = D$, which is not a valid polar-circular locus.

$$\{(u \pm R)^2 - (D^2 + k^2 - h^2) - h[(u \pm R)^2 - v^2 + d^2]/d\}^2 =$$
$$4k^2 D^2 - 4k^2 \{[(u \pm R)^2 - v^2 + d^2]/2d - h\}^2$$

general eq. of a polar-circular circle \qquad (4-30)

$$[(u \pm R)^2 - dh](d - h) = dD^2 - hv^2$$

axial polar-circular circle \qquad (4-31)

In contrast to the 2nd-degree eq. of an axial circle, the eq. of a parabola, $y^2 = 4a(x-h)$, with its axis on the polar-circular axis is 4th degree and much more complicated (eq. 32). For $h = -a$, the right side of eq. 32 becomes a perfect square and the eq. reduces to 2nd degree. However, this is not the only condition for reduction. It can be seen from the distance-squared eqs., 33a,b, that reduction (conversion of the right sides of the eqs. to perfect

$$4d^2(u{\pm}R)^2 = [(u{\pm}R)^2-v^2+d^2]^2 + 8ad[(u{\pm}R)^2-v^2+d^2] - 16ahd^2 \qquad (4\text{-}32)$$

(a) $(u{\pm}R)^2 = x^2 + 4ax - 4ah$ (b) $v^2 = x^2 + 2(2a-d)x + (d^2-4ah)$ (4-33)

(a) $(u{\pm}R-d)^2 = v^2 - 4ad$ (b) $(u{\pm}R)^2 - 2d(u{\pm}R) = v^2$ (4-34)

(a) $(u{\pm}R)^2 = v^2 +2v(a+h) + (h-3a)(h+a)$ (b) $(u{\pm}R)^2 = v^2 + 2dv$ (4-35)

squares) occurs both for $h = -a$ (eq. 33a) and $h = d-a$ (eq. 33b), leading to

eqs. 34a and 35a, respectively (the eqs. corresponding to 33a,b for axial circles lack an x^2 term, so the eliminants always are of 2nd degree). In other words, eqs. of axial parabolas are of 2nd degree if the focus lies at either the point-pole or the center of the circle-pole. Accordingly, in all cases (see also eq. 27), the most symmetrical polar-circular conics have the traditional foci at the point-pole and/or the center of the circle-pole.

[Further reduction of eqs. 34 and 35 occurs if both conditions are fulfilled, but this is trivial, since it leads to the centered polar-circular system (point-pole at center of circle-pole). In the centered system the only loci are circles and segments of the plane; $v = u+R$ represents all exterior points and $v+u = R$ represents all interior points (both loci include incident points).]

Linear-Circular Coordinates

For convenience, the circle-pole, p_u (eq., $x^2+y^2 = R^2$) again is taken to be centered at the origin, and the line-pole, p_v, is taken to be parallel to the y axis at $x = d$ [u equals either $(x^2+y^2)^{\frac{1}{2}}{\mp}R$ or $R{\mp}(x^2+y^2)^{\frac{1}{2}}$, $v = \pm(x-d)$].

Confocal Two-Arm Parabolas

The most symmetrical curve, $u = v$, is a *confocal two-arm parabola*. The eqs. for the two arms in rectangular coordinates are 36a,b. The foci of the two arms always are coincident with one another at the center of the circle-pole, i.e., at the origin.

Linear-circular confocal two-arm parabola, $u = v$

(a) $\quad y^2 = -2(d+R)[x-(d+R)/2]$ \qquad first arm $\qquad\qquad$ (4-36)

(b) $\quad y^2 = -2(d-R)[x-(d-R)/2]$ \qquad companion arm

The *first arm* (eq. 36a) is of fixed nature and orientation, regardless of whether the line-pole intersects the circle-pole. Its construction always employs the *least* distance to the circle. On the other hand, the size, location, orientation, and rule of construction of arm 36b, the *companion arm*, depend upon whether the line-pole and circle-pole become tangent to one another or intersect.

When the line-pole intersects the circle-pole $(R > d)$ the companion arm opens to the right, with a vertex-focus distance of $(R-d)/2$ and vertex at $-(R-d)/2$. The arms intersect one another, the line-pole, and the circle-pole at common points, $[d,\pm(R^2-d^2)^{\frac{1}{2}}]$. As is the case for the first arm, the construction of the companion arm employs the *least* distance to the circle. When the line-pole becomes a diameter, i.e., the y-axis, the opposed arms are congruent.

When the line-pole is outside the circle $(d > R)$, the vertex-focus distance of the companion arm is $(d-R)/2$, it opens to the left (as does the first arm), it does not intersect the first arm, and its construction employs the *greatest* distance to the circle. Since the two arms are incongruent, this (and the constructions of Figs. 4-4b_1,b_2) is an example of *incongruent extremal-distance symmetry*.

As the line-pole approaches the circle-pole, i.e., as d approximates R, the size of the companion arm decreases progressively, but its focus remains at the center of the circle-pole, and it continues to open to the left. At

the tangent point, the locus degenerates into coincidence with the x-axis. In this situation, the x-axis to the right of the center of the circle fulfills the *least-distance* $u = v$ relation, while the x-axis to the left fulfills the *greatest-distance* $u = v$ relation.

As the line-pole leaves the tangent point, moving in the direction of the center of the circle-pole, the size of the companion arm progressively

increases and it opens to the right. When the line-pole is at the center, both arms are of equal size and the coordinate system (and the curve) acquires a second line of symmetry.

Since the linear-circular confocal two-arm parabola is specified by the simplest possible *complete linear* eq., it has the distinction of being the most symmetrical curve in the linear-circular system. It clearly qualifies as a true two-arm parabola; its eq. is not degenerate in any sense and, when the line-pole intersects the circle-pole, both arms are constructed employing the least distance to the circle.

Whereas in multipolar coordinates, the eqs. of two-arm parabolas are of greater degree than those of one-arm parabolas, the reverse is true in linear-circular coordinates, where, as shown above, some two-arm parabolas have linear eqs. Eq. 37a is an example of a 4th-degree eq. that represents a one-arm parabola, $(y-k)^2 = 4a(x-h)$. For axial parabolas, 37a reduces to the 2nd-degree eq., 37b.

(a) $\quad [(u \pm R)^2 - (d \pm v)^2 - 4a(d \pm v) + k^2 + 4ah]^2 = 4k^2[(u \pm R)^2 - (d \pm v)^2] \qquad$ (4-37)

(b) $\quad (u \pm R)^2 - (d \pm v)^2 - 4a(d \pm v) + 4ah = 0$

[Here and below, the upper alternate sign of R is for the least distance to the circle, and the lower alternate sign is for the greatest distance (for cases in which the locus does not intersect the circle-pole). For the v term, the upper alternate sign is for the portion of the locus to the right of the line-pole, and the lower alternate sign for the portion to its left. Although these polar-linear eqs. might have to be squared 2 or 3 times to eliminate all alternate signs (for greatest and least distances, for circle-intersecting and non-intersecting loci, and for line-intersecting and non-intersecting loci), the resulting eqs. would be degenerate, with factors of no higher degree than that of the original eqs. with alternate signs.]

The Linear

The linear, $u = ev$, represents central conics (eq. 38), where e is the eccentricity. One traditional focus always is at the center of the circle-pole.

$$[x + e(de - R)/(1 - e^2)]^2 + y^2/(1 - e^2) = (de - R)^2/(1 - e^2)^2 \qquad \text{central conics} \qquad (4\text{-}38)$$

Circles

The general linear-circular eq. of a circle of radius D centered at (h,k) is 39a. For axial circles ($k = 0$), 39a simplifies and reduces to 39b. The most symmetrical axial circles are those for which $R^2 + h^2 - 2dh - D^2 = 0$, whereupon 39b simplifies greatly to 39c.

Figs.
4-7c_1
4-7
c_2-c_4

(a) $[h^2+k^2-D^2-2h(d\pm v)+(u\pm R)^2]^2 = 4k^2[(u\pm R)^2-(d\pm v)^2]$ linear-circular circles (4-39)

(b) $(u\pm R)^2 - 2h(d\pm v)+(h^2-D^2) = 0$ axial linear-circular circles

(c) $u^2 \pm 2uR \mp 2hv = 0$ the most symmetrical axial linear-circular circles

Bicircular Coordinates

Introduction

Collinear bicircular and multicircular coordinate systems have many homologies with collinear point-pole systems, including reflective redundancy. In fact, bipolar coordinates are a special case of bicircular coordinates in which both R_1 and R_2, the radii of the poles, are 0. Many collinear multipolar eqs. could be converted to multicircular eqs. merely by substituting $u\pm R$ for u and $v\pm R$ for v. It is a reasonable expectation that many of the same possibilities for deducing symmetry properties of curves by mere inspection of eqs.--that remarkable property of bipolar eqs.--exist in both systems.

On the other hand, there may be more differences than similarities. The differences are based primarily on the following: (a) there is no unique distance to the circle-poles, since both least and greatest distances come into play; (b) the poles may intersect one another; (c) the curves may intersect the poles at more than one point; and (d) the poles may be of different size. This treatment is confined to a few examples of curves in *congruent non-concentric bicircular coordinates.*

Congruent Non-Concentric Bicircular Coordinates

Linears

Fig.
4-6c$_2$

Two circle-poles of radius R with centers d units apart are taken on the x axis at $+\frac{1}{2}d$ and $-\frac{1}{2}d$. The most symmetrical curve, $u=v$, is the midline. The next-most symmetrical curves, as in bipolar coordinates, are the central conics $u\pm v = Cd$. The subscripts n (near) and f (far) are used below to connote whether the least or greatest distances to the circles are employed. For example, $u_n + v_n = Cd$ and $u_n - v_f = Cd$ give central conics (eq. 40) of eccentricity $e = d/(Cd+2R)$, centered at the midpoint between the two circle-poles, with foci at the centers of the circle-poles. Because of pole symmetry

(see discussion in Chapter III), both arms of a hyperbola are represented by $u_n - v_f = Cd$, whereas in the polarized system (incongruent or ordered circle poles), only the right arm is represented.

$$4x^2/(Cd+2R)^2 + 4y^2/[(Cd+2R)^2-d^2] = 1$$

centered bicircular central conics, $u_n+v_n = Cd$, $u_n-v_f = Cd$ (4-40)

Fig. 4-6c$_2$

$$4x^2/C^2d^2 - 4y^2/d^2(1-C^2) = 1$$

centered ellipses, $u_n+v_f = Cd$ (4-41)

On the other hand, $u_n+v_f = Cd$ represents ellipses (eq. 41) of eccentricity $e = 1/C$, also centered at the midpoint between the two circle-poles, and also with their foci at the centers of these poles. [Eqs. 40 and 41 hold both for cases in which the curves intersect the circle-poles and for cases in which they do not.] These linears also represent central conics when the circle-poles are incongruent. On the other hand, the linear $u = Cd$ represents quartics. The midcircle of the same size as the reference elements is not one of the most highly symmetrical curves. Its eq. is the quadratic $(v\pm R)^2+(u\pm R)^2 = 2R^2+d^2/2$ (using only the greatest distances if intersection occurs).

Concentric Bicircular Coordinates

Concerning the properties and symmetry of curves in concentric bicircular coordinates, see the section below on parallel bilinear coordinates. Except for the fact that the curves in one system consist of circles, and in the other system of lines, virtually the same comments apply to both.

Bilinear Coordinates

Introduction

Excepting rectangular coordinates, the rules of construction of curves in the planar bilinear systems treated here are stated in terms of the undirected distances u and v from the line-poles p_u and p_v, respectively. Planar bilinear coordinate systems are of two types--intersecting and parallel.

Parallel Bilinear Coordinates

In this exceptional coordinate system, the line-poles consist of two parallel lines which, for convenience, are taken to be parallel to the y-axis, pole p_u at $x = -\frac{1}{2}d$ and pole p_v at $x = \frac{1}{2}d$. The loci of all but two eqs. in this system consist of one or more straight lines parallel to the line-poles. Differences in the form, degree, and complexity of eqs. determine, not the type of curve, but merely the number and location of these lines.

As in many coordinate systems, the most symmetrical curve, $u = v$, is the midline. The next-most simple eq., $u \pm v = d$, represents unusual loci. For the plus sign, the eq. represents all points in the segment of the plane between and bounded by and including the two line-poles. For the minus sign, it includes all points in the segments of the plane extending to infinity and bounded by and including the line-poles. Here, as for the bipolar eq., $u - v = d$, symmetry considerations call for the inclusion of both peripheral segments of the plane in the locus. Reflective redundancy, in this case, is with respect to the midline.

The eq., $u + v = Cd$, because of reflective redundancy, represents the line-pair, $x^2 = C^2 d^2/4$. The equilateral hyperbolic, $uv = d^2$, also represents a line-pair, $x^2 = 5d^2/16$ (imaginary loci are not included), while $uv = Cd$ represents the locus, $x^2 = d^2(\frac{1}{4} \pm C^2)^2$, which is either a line-quartet or a line-pair, depending upon whether or not C is less than $\frac{1}{4}$. On the other hand, though $u^2 + v^2 = Cd^2$ represents only the line-pair, $x^2 = d^2(C-\frac{1}{2})^2/2$, $Au^2 + Bv^2 = Cd^2$ represents either a line-quartet or a line-pair, depending upon whether or not $16AB > C(B-A)$. In general, the higher the degree of the eq., the more the number of parallel lines that are represented.

45° and 135° Bilinear Coordinates

The 45° and 135° bilinear systems considered here are not to be confused with "oblique" coordinates. In the latter system, coordinate distances are measured along the coordinate axes and are *directed*, rather than being the least (or greatest) distances from the point on the curve to the axes, as in the coordinate systems dealt with here. For convenience and purposes of illustration, both the 45° and 135° bilinear systems are considered in this section

(the descriptions apply primarily to the polarized systems).

The $45°$ system applies to two $45°$ portions of the plane lying between and including two lines intersecting at $45°$, while the $135°$ system applies to the two complementary $135°$ portions. The x-axis is taken to be the line-pole, p_u, and the line, $x = y$, is the line-pole, p_v. Using these coordinate axes, $u = y$ and $v = (x-y)/2^{\frac{1}{2}}$, in the portion of the $45°$ system lying in the 1st quadrant, and $u = -y$ and $v = (y-x)/2^{\frac{1}{2}}$, in the portion lying in the 3rd quadrant. Since u and v are undirected distances from p_u and p_v, the unpolarized system has two lines of symmetry and there is reflective redundancy with respect to both lines. In the interests of simplicity, the following descriptions are primarily for the portion of the $45°$ system in the 1st quadrant.

The same line-poles are employed for the $135°$ system; p_u is the x-axis, and p_v the bisector, $x = y$. For this system, $u = y$ and $v = (y-x)/2^{\frac{1}{2}}$ in the 1st and 2nd quadrants, and $u = -y$ and $v = (x-y)/2^{\frac{1}{2}}$ in the 3rd and 4th quadrants. Again, the descriptions are primarily for half of the polarized system. [The general eqs. for v in intersecting θ and $(180°-\theta)$ bilinear systems, with p_u coincident with the x-axis, are $v_\theta = \pm x\sin\theta \mp y\cos\theta$ and $v_{(180°-\theta)} = \pm y\cos\theta \pm x\sin\theta$, where the upper signs are for the 1st and 2nd quadrants.]

Linears Figs.
 4-8a
The most symmetrical curve in both systems is the line bisecting the coordinate axes. Taken together, the two bisecting lines form a $90°$ cross, which is the most symmetrical curve in the dual, complementary $45°$ and $135°$ systems, as it also is in the dual, complementary $90°$-bilinear system and, in fact, in all complementary bilinear systems. The linear, $u+v = j$, represents the line 4-2c$_1$
segment 42a and its reflection, in the $45°$ system, and the line segment 42b and its reflection, in the $135°$ system. These 4 line segments form a parallelogram in the combined complementary systems.

(a) $y = -(1+2^{\frac{1}{2}})x + (2+2^{\frac{1}{2}})j$ \qquad (b) $y = (2^{\frac{1}{2}}-1)x + (2-2^{\frac{1}{2}})j$ $\qquad\qquad$ (4-42) 4-2c$_1$

The linear, $u-v = j$, exchanges these eqs. and their reflections, giving eq. 42b and its reflection, in the $45°$ system, and eq. 42a and its reflection, 4-2c$_2$
in the $135°$ system. But the segments of the lines represented by these eqs. that satisfy $u-v = j$ are not the same as those that satisfy $u+v = j$. Instead, they are the 4 extensions to infinity of the two corners of the parallelogram that intersect the v-axis (in the unpolarized system the extensions from the u axis also would be included).

The Circular

The *circular*, $u^2+v^2 = j^2$, gives the respective segments of a single ellipse, eq. 43a $[e^2 = 2(2^{\frac{1}{2}}-1)]$, that occur in the portions of the plane encompassed by the 45° and 135° systems. A $22^{\frac{1}{2}\circ}$ CW rotation (eq. 43b) brings the axes into coincidence with the coordinate axes. The complete ellipse is represented in the combined complementary systems.

4-8b (a) $x^2/2 - xy + 3y^2/2 = j^2$ (b) $(1-2^{\frac{1}{2}}/2)x^2 + (1+2^{\frac{1}{2}}/2)y^2 = j^2$ (4-43)

[It will be noted that it may require from 1 to 4 eqs. of the same degree to duplicate in the rectangular system the loci represented in Fig. 4-8 in the combined complementary 45° and 135° systems. The number of rectangular eqs. required in any given case depends upon a number of factors stemming from the fact that undirected distances are employed in the non-rectangular systems. In consequence, all loci are reflected through the origin, without regard to the properties of the individual terms of the corresponding eqs. Contrariwise, the loci in rectangular coordinates have symmetry through the origin only if the corresponding eqs. are unchanged by replacing both x by -x and y by -y.

 Two rectangular eqs. are required for the loci of Fig. 4-8a because the eq., $u = v$, gives two lines in the combined complementary undirected-distance systems but only one in rectangular coordinates. On the other hand, 4 rectangular eqs. are required for the loci of Figs. 4-8c_1,c_2 because the reflections through the origin are not collinear, as they are in Fig. 4-8a. In the cases of Figs. 4-8b,e, since the eqs. contain only the squares of u and v, $u^2 = y^2$ and $v^2 = (x-y)^2/2$ in all sectors of the combined system. This has the consequence that the combined locus can be represented by a single 2nd-degree rectangular eq., etc.]

Equilateral Hyperbolas

The *equilateral hyperbolic*, $uv = j^2$, represents *non-equilateral* hyperbolas, 44a,b, both of which have the p_u and p_v line-poles as asymptotes (just as $uv = j^2$ has the coordinate axes as asymptotes in rectangular coordinates). Their eccentricities are $e^2 = 4-2 \cdot 2^{\frac{1}{2}}$ and $e^2 = 4+2 \cdot 2^{\frac{1}{2}}$, respectively, When rotated $22^{\frac{1}{2}\circ}$ CW to bring the transverse axis of one into coincidence with the x-axis, the eqs. become 45a,b, respectively.

4-8d (a) $xy - y^2 = 2^{\frac{1}{2}}j^2$ (b) $y^2 - xy = 2^{\frac{1}{2}}j^2$ (4-44)

 (a) $(2^{\frac{1}{2}}-1)x^2 - (2^{\frac{1}{2}}-1)y^2 = 2 \cdot 2^{\frac{1}{2}}j^2$ (b) $(2^{\frac{1}{2}}+1)y^2 - (2^{\frac{1}{2}}-1)x^2 = 2 \cdot 2^{\frac{1}{2}}j^2$ (4-45)

Unlike the equilateral hyperbolic, $uv = j^2$, the equilateral hyperbolic $u^2-v^2 = j^2$, represents an *equilateral* hyperbola, 46a, of semi-axes, $2^{\frac{1}{4}}j$.

When this is rotated CW $22^{\frac{1}{2}\circ}$ and $67^{\frac{1}{2}\circ}$, the eqs. become 46b,c, respectively.

(a) $y^2/2 + xy - x^2/2 = j^2$ (b) $2^{\frac{1}{2}}xy = j^2$ (c) $x^2/2^{\frac{1}{2}} - y^2/2^{\frac{1}{2}} = j^2$ (4-46)

Parabolics

The parabolic $u^2 = jv$ represents segments of two congruent but differently oriented and located parabolas, 47 and 48, tangent to one another and the v-axis at the origin (at opposed LR vertices), with the curve of eq. 47 opening to the right, and that of eq. 48 opening to the left. Each parabolic segment is the reflectively redundant companion of the other. In the combined 45°-135° systems, the combined segments of the curve represented by the eq. $u^2 = jv$ consist of a two-arm parabola.

Figs. 4-8g

$(y + j/2 \cdot 2^{\frac{1}{2}})^2 = j(x + 2^{\frac{1}{2}}j/8)/2^{\frac{1}{2}}$ parabola $u^2 = jv$ opening to the right (4-47) 4-8g

$(y - j/2 \cdot 2^{\frac{1}{2}})^2 = -j(x - 2^{\frac{1}{2}}j/8)/2^{\frac{1}{2}}$ parabola $u^2 = jv$ opening to the left (4-48) 4-8g

Circles

Lastly, one may inquire as to the eqs. of circles centered at the origin. Segments of the circle, $x^2 + y^2 = j^2$, are represented by eq. 49a in the 45° system and 49b in the 135° system. In the other system, each eq. represents a segment of an ellipse. Since the centered circle is symmetrical about both the origin and the bisectors, reflections give rise to no redundant companion circle.

(a) $u^2 + v^2 + 2^{\frac{1}{2}}uv = j^2/2$ (b) $u^2 + v^2 - 2^{\frac{1}{2}}uv = j^2/2$ (4-49) 4-8f

Rectangular Coordinates Versus Other
Bilinear Systems

The relationships between the rectangular system and other single and dual complementary bilinear systems already may be evident to the reader from the above treatment. They are best understood in terms of a broad view of the conditions that transform the rectangular system to the other systems, and vice versa, without regard to the specific nature of the loci involved or their eqs. In considering these conditions, the changes in the shapes of the curves occasioned by differences in the angles between the coordinate reference lines are accommodated simply by assuming the application of the appropriate "transformation of distortion" (see above eqs. of transformation).

Consider, first, a transformation from the rectangular system to the unpolarized, undirected-distance 45°-bilinear system. To achieve this transformation, the following modifications of the rectangular system are required.

Case 1: Transformation of the rectangular system to the unpolarized, undirected-distance, 45°-bilinear system

1. All loci in the 2nd and 4th quadrants are eliminated.
2. All loci in the 1st and 3rd quadrants are reflected through the origin.
3. All loci in the 1st and 3rd quadrants are reflected through the line x = y.
4. The "transformation of distortion" is carried out.

The first alteration allows for the employment of undirected distances, as a result of which the system is limited to the 45° sectors between the coordinate reference lines. The second alteration also allows for the employment of undirected distances, as a result of which the loci are reflected through the point of intersection of the coordinate reference lines. The 3rd alteration, following upon that of the second alteration, takes into account the lack of polarization of the system, as a result of which all loci are reflected through both of its lines of symmetry, in this case the lines at $22\frac{1}{2}°$ and $112\frac{1}{2}°$ to the positive x-axis.

Consider next the transformation between the rectangular system and the unpolarized, undirected-distance, dual complementary 45°-135°-bilinear system.

Case 2: Transformation of the rectangular system to the unpolarized, undirected-distance, dual complementary 45°-135°-bilinear system

1. All loci are reflected through the origin.
2. All loci in quadrants 1 and 3 are reflected in the line x = y, and all loci in quadrants 2 and 4 are reflected in the line x = -y (an equivalent of alterations 1 and 2 is to reflect all loci in one midline, and then reflect all the resulting loci in the other midline).
3. The "transformation of distortion" is carried out.

Since, if Case 1 had been for conversion to the 135° system, the quadrants with loci to be eliminated would have been the 1st and 3rd rather than the 2nd and 4th, and the quadrants involving reflections would have been the 2nd and 4th rather than the 1st and 3rd, to make the conversion of Case 2, there is no elimination of loci, and all loci are reflected according to alterations 1 and 2.

Consider now the transformation of the rectangular system to the single, polarized, undirected-distance 45°-bilinear system.

Case 3: Transformation of the rectangular system to the single, polarized,
 undirected-distance 45°-bilinear system

Same as Case 1 but omitting alteration 3 thereof.

This situation differs from Case 1 only in the fact that the 45° system is
polarized, rather than unpolarized. Accordingly, alteration 3, which converted
the polarized to the unpolarized system, is omitted.

Consider now the transformation of the rectangular system to the 45°-bilinear
system with *directed* distances.

Case 4: Transformation of the rectangular system to the 45°-bilinear system
 with directed distances.

1. The "transformation of distortion" is carried out.

Since, with directed distances, the 45° system includes the entire plane,
without reflective redundancy, only the "transformation of distortion" need be
carried out to accomplish the transformation.

Lastly, consider transformation of the rectangular system to the unpolarized, un-
directed-distance, dual complementary 90°-bilinear system.

Case 5: Transformation of the rectangular system to the unpolarized, undirected-
 distance, dual complementary 90°-bilinear system.

Same as Case 2 but without carrying out the "transformation of distortion."

It is clear from the above considerations that the only respect in which
the rectangular system differs from other directed-distance bilinear systems, is
in the angle that the axes make with one another, which leads to the unique
properties that the angles are the same in all sectors, which become quadrants, and
that the distances from one reference line are measured off parallel to
the other reference line. These different properties, however, are the basis
for the pre-eminence of the rectangular system--among all bilinear systems--
for symmetry analyses. This pre-eminence consists in the fact that only when
intercept transforms (circumpolar, circumlinear, and circumcurvilinear) are
expressed and analyzed in the rectangular coordinate system do the findings
fall into the form presented in this work, with their many logical and fasci-
nating interrelationships.

As examples of these interrelationships, the two cases of basic transforms
that fall into the algebraic forms $x^2+y^2 = R^2$ and $xy = $ constant are
considered. Within the rectangular system, these eqs. represent circles and
equilateral hyperbolas, whereas in all other directed-distance bilinear systems

they represent unexceptional ellipses and hyperbolas. Whereas in rectangular coordinates the $90°$ circumpolar intercept transform of a circle about an incident point is another circle (the most symmetrical of all ellipses), and all transforms of self-inversion take the form of the equilateral hyperbola (the most symmetrical of all hyperbolas), in any other directed-distance bilinear system the transforms would be unexceptional. Related to the loss of these exceptional properties would be the loss of one of the homologies between the circle and the equilateral hyperbola, namely, that of their being the only curves with endless chains of transforms of the same subspecies as the basis curve (see Chapters V, VI, and VII).

[On the other hand, it readily is shown that if the α-transform (the circumpolar intercept transform at the angle, α) of the circle about an incident point is analyzed in the directed-distance α-bilinear system ($\alpha \neq 0°$ or $180°$), it is a circle for all α, and the same also is true for the α-circumpolar intercept transform of a limacon (eq. X-17) about the DP or DP homologue. In other words, the $90°$ transforms of these curves about the poles in question are circles in the $90°$-bilinear system, the $45°$ transforms are circles in the $45°$-bilinear system, the $10°$ transforms are circles in the $10°$-bilinear system, etc. Following such a paradigm--of analyzing all circumpolar transforms in bilinear systems for the corresponding angles--doubtless would lead to interesting results. However, there are many reasons why it would not be a suitable paradigm for symmetry analyses, not the least of which is that it is not applicable to $0°$ and $180°$ circumpolar analyses, nor to circumlinear or circumcurvilinear analyses, the latter of which entail the use of two reference angles.]

[In carrying out algebraic transformations between the rectangular and other bilinear systems using the eqs. given on page 23, one must not lose sight of the fact that in the other bilinear systems, u is the orthogonal distance from the u-axis and v is the orthogonal distance from the v-axis, whereas in rectangular coordinates, x is the orthogonal distance from the y-axis (not from the x-axis) and y is the orthogonal distance from the x-axis.]

There is, of course, no need to give examples of eqs. and curves in the rectangular system, since it is familiar to all and is employed extensively is this work. Only a few conventional remarks from the point of view of symmetry may be in order. When eqs. contain only "pure" terms in even powers of x and y, such as x^2, y^2, x^4, and y^4, with or without coefficients, both coordinate axes are lines of symmetry, there is symmetry through the origin, and the origin can be expected to be a focus. The presence of an odd power of either variable rules out symmetry about the axis of the other variable; if the eq. is unchanged by replacing x by -x, there is symmetry about the y-axis, if it is unchanged by replacing x by -x and y by -y, there is symmetry about the origin, etc.

Polar Coordinates

The polar coordinate system requires little additional comment, since the elementary rules of symmetry in this system, i.e., the relationships between the appearance of a curve and the properties of its eqs., are well known. Remarks at this point are restricted to a single comment on circumpolar foci and focal rank; other comments are made in the following chapters as the occasion demands. Whenever the polar eqs. can be expressed in the form, $r^n = f(\theta)$, where n is real, no matter how complicated $f(\theta)$ might be, the polar center (origin) is a high-ranking circumpolar focus.

Coordinate Systems and Symmetry Analyses

The significant properties of coordinate systems in relation to symmetry analyses, as discussed to this juncture, are summarized in Table IV-2. The fact that opposite properties of coordinate systems are desirable to achieve goals A and B is not contradictory, because goal A relates primarily to the eqs. of the curves themselves about the reference elements, whereas goal B relates to the derivation and analysis, not of the *equations* of the curves about the reference elements, but of the *transforms* of the curves about these elements.

Table IV-2. Coordinate Systems and Symmetry Analyses

A. For assessing the symmetry of curves relative to two or more fixed-position reference elements, one employs the equations (construction rules) of the curves.

Desirable features of coordinate systems	Resulting properties of coordinate systems
1. undirected distances	greatest correspondence between degree of eqs. and symmetry of represented curves
2. lack of polarization	reflective redundancy
3. at most one linear reference element	no degree restriction (eqs. of different degree represent similar and congruent curves, depending upon location and orientation)

In coordinate systems possessing the above features the most symmetrical curves have the simplest and lowest-degree eqs. (no intuitive concept of symmetry is contradicted)

B. For assessing the symmetry of curves relative to single reference elements, one employs the intercept transforms of the curves.

Desirable features of coordinate systems	Resulting properties of coordinate systems

rectangular system

1. bilinearity	complete degree restriction (similar and congruent curves are represented by eqs. of the same degree)
2. directed distances	polarization, elimination of reflective redundancy, and covering of the entire plane
3. Reference lines at 90° to one another	leads to simplest, most consistent, and most fruitful paradigms for symmetry analyses

polar system

1. combination of a point and an angle as reference elements	distances from coordinate origin expressible directly as the value of a single coordinate variable; lends itself to the formulation of intercept transforms of all types and to the inversion transformation
2. directed distances	eliminates reflective redundancy

Circumpolar, circumlinear, and circumcurvilinear symmetry analyses employ both the polar and rectangular coordinate systems (see Chapter V).

Deriving Circumpolar Intercept Transforms From Equations in Rectangular Coordinates

A Preliminary View of the Circumpolar Intercept Transformation of Chapter I described the derivation of circumpolar intercept transforms from the polar eq. of the basis curve. Transforms also can be obtained readily from the rectangular eq. of a basis curve. One first performs a translation of the basis curve, bringing the desired point of reference to the origin. One then obtains the eq. of the curve relative to rotated axes, using the trigonometric rotation eqs. Next, one obtains the intercept with the rotated x' axis by letting the value of the y' coordinate be 0. This always yields an eq. in x' and θ alone, x' = f(θ), the *simple intercept equation*, which is identical with the polar coordinate eq. of the curve about the same pole, but with r replaced by x' (for simplicity in the following, the rotated x' and y' - axes are relabelled as x and y).

The reason for this equivalence is that the above process for obtaining the intercept with the rotated x-axis is equivalent to the process of converting an eq. from rectangular to polar coordinates Often one can obtain an explicit formulation, the *simple intercept format*, which consists of solutions in the form $\cos^n\theta = f(x)$ or $\sin^n\theta = f(x)$, with n usually being 1 or 2 (eq. 1b).

(a) $b^2x^2+a^2y^2 = a^2b^2$ basis ellipse (b) $\cos\theta = \dfrac{(b^2-ax)}{x(a^2-b^2)^{\frac{1}{2}}}$ simple intercept format for x (5-1)

(c) $\cos(\theta+\alpha) = \dfrac{(b^2-ay)}{y(a^2-b^2)^{\frac{1}{2}}}$ simple intercept format for y

$$b^4(x^2-2xy\cos\alpha+y^2)+x^2y^2[2a^2(1-\cos\alpha)+(b^2-a^2)\sin^2\alpha]$$ α-transform (5-2)

$$- 2ab^2xy(x+y)(1-\cos\alpha) = 0$$

The y intercept then is obtained by replacing x by y and θ by θ+α (eq. 1c). For example, the simple intercept format for an ellipse, 1a, about the right traditional focus is given by 1b. Elimination of θ between 1b and 1c yields eq. 2, the corresponding transform for an angle of transformation, α (for positive intercepts).

If the simple intercept format, 1b, can be obtained, all the intercept transforms characterizing the symmetry of the basis curve about the pole for different angles can be plotted directly from a listing of x against θ. One

simply uses the x for a given θ and then moves up or down the list to the value of x for $\theta+\alpha$ or $\theta-\alpha$ to obtain y.

Often the eqs. cannot be obtained in the simple intercept format in $\cos^n\theta$ or $\sin^n\theta$. In these cases, terms such as $\sin^2\theta$, $\cos^2\theta$, $\sin\theta$, $\cos\theta$, and $\sin\theta\cos\theta$ are present in the simple intercept eq. For example, eq. 3 is the *simple mixed-transcendental intercept equation* cast about a point on the $-\frac{1}{2}b$ k-axis

$$4x^2k^2\sin^2\theta + 2kx(a^2-2x^2-2k^2+b^2)\sin\theta + (x^2+k^2-b^2/4)^2 - \qquad (5\text{-}3)$$
$$a^2(x^2+k^2+b^2/4) = -a^2bx\cos\theta$$

of the limacon $r = a-b\cos\theta$, i.e., a point on the line parallel to the y-axis at $x = -\frac{1}{2}b$ (often referred to in the following as a *k-axis*). In this eq., k is the ordinate of the point on the $-\frac{1}{2}b$-axis about which the transformation is being carried out. Eq. 3 and a similar eq. in which x is replaced by y, and θ by $\theta+\alpha$, have to be solved for a specific transformation angle, α.

First one obtains an eliminant (in which α is eliminated) in the form $\sin\theta$ or $\cos\theta = f(x,y)$, the *compound intercept format*. For example, eq. 4 is the

$$B^4 = (k^2-b^2/4)^2$$
$$C^2 = (k^2+b^2/4)$$
$$\sin\theta = \frac{(x+y)\pm[a^2-2k^2+b^2/2+xy+(B^4-a^2C^2)/xy]^{\frac{1}{2}}}{2k} \qquad (5\text{-}4)$$

eliminant between eq. 3 and the derived eq. in y and $\theta+\alpha$, for $\alpha = 0^\circ$. The eliminant between eq. 3 and eq. 4 then is obtained, in which the transcendental functions are eliminated. This is the *intercept transform* for a transformation angle of 0° about a point on the $-\frac{1}{2}b$ k-axis. Usually it is difficult to work with these eqs. In this case (eqs. 3 and 4), the eliminant is of 20th degree in x and y. However, it is not always necessary to obtain an explicit formulation of the transform to extract the desired information.

Some Intuitive Intercept Transforms

Before proceeding to specific considerations of how the circumpolar symmetry of curves is characterized by means of intercept transforms, a few circumpolar transforms are considered that yield readily to mere inspection. For the circle, the transform about the center for any angle yields simply a point locus, $x = y = R$. If only positive intercepts are considered, i.e., the locus in the 1st quadrant, this will be a single point at (R,R).

In an alternate procedure for obtaining the transforms, one can consider that the curve itself is being rotated about the reference pole and that the transforms are generated in each quadrant by corresponding combinations of positive, negative, or complex intercepts. Though attention is concentrated on the portions of intercept transforms that lie in the 1st quadrant, transform eqs. often represent loci in more than one quadrant and have imaginary or complex solutions. In the case of the circle, if both positive and negative intercepts are considered, the transforms about the center consist of a single point in each quadrant at $x^2 = y^2 = R^2$.

Relatively few curve-pole combinations have circumpolar symmetry properties as readily discernable as those of the circle about its center. Some other curves having transforms that are points, and that are independent of the angle of the transformation, are the point-circle about its center, the line about an incident point, and intersecting lines about the point of intersection. Some curves of infinite degree (for example, the spiral of Archimedes) have transforms that are independent of the angle of transformation, but these transforms are not points and they are not intuitively evident.

Few curves yield to intuitive analysis at any angles except 0^O and 180^O. At 0^O, the transform, $x = y$, is trivial and is discarded, since it gives no information about the symmetry of the curve. However, the 0^O transform in general is not trivial. Non-trivial 0^O transforms always exist relative to poles lying outside simple closed curves, for example, if the wall of the city of the example of Chapter I had to be surveyed from a vantage point lying outside the city. More generally, such transforms exist whenever a curve has more than one intercept lying in the same direction along a rotating radius vector.

[The *trivial intercept transforms* are $x = y$ for the 0^O transformation and $x = -y$ for that at 180^O. Trivial transforms merely express the equality of identical intercepts, i.e., intercepts for which the radius vectors are equal and coincident, excluding cases for which the intercepts are 0 at all angles for which they are defined. Whenever a 0^O or 180^O intercept transform, $f(x,y) = 0$, is given, the trivial transforms $x = \pm y$ already have been factored out from the algebraically complete solution, $(x \mp y)^n f(x,y) = 0$. A *valid locus* is a locus for which non-trivial transforms exist at the angle in question (their solutions may be real or complex).]

Other intercept transforms that are evident from inspection of the basis curve are 180^O transforms of any curve about a true center. It is obvious that the x and y intercepts of a chord rotating about a true center are equal. Accordingly, the transform is a segment of the line, $x = y$.

The Simplest Transforms About a Point In the Plane

Few other circumpolar intercept transforms are evident intuitively. Even for the circle, mere inspection will enable no one to deduce the form or degree of eqs. for intercept transforms about poles other than the center, nor angles other than $0°$, with the possible exception of transforms about points on the curve itself. Nor do transforms of the line about non-incident points yield to intuition. This state of affairs is understandable in view of the fact that, with the exception of transforms about high-ranking foci of highly symmetrical curves, most of the symmetry characterizing intercept transforms are obscure and of high degree--previously unknown and unnamed.

For a point in the plane, only in the case of $0°$ and $180°$ transforms of the circle is the degree of non-trivial transforms as low as 2. For example, the $180°$ transform of the circle about a non-central interior point is eq. 5a, and the $0°$ transform about an exterior point is 5b, where h is the distance of the pole from the center.

(a) $xy = R^2 - h^2$ (b) $xy = h^2 - R^2$ (5-5)

$$y^2(x^2+h^2-R^2)^2 + x^2(y^2+h^2-R^2)^2 - 2xy(x^2+h^2-R^2)(y^2+h^2-R^2)\cos\alpha = \qquad (5\text{-}6)$$

$$4h^2x^2y^2\sin^2\alpha$$

$$y^2(x^2+h^2-R^2)^2 + x^2(y^2+h^2-R^2)^2 = 4h^2x^2y^2 \qquad \begin{array}{l}90° \text{ transform of circle} \\ \text{about point in plane}\end{array} \qquad (5\text{-}7)$$

$$j^4(x^2+y^2) \pm 2j^4xy\cos\alpha = a^2x^2y^2\sin^2\alpha \qquad \begin{array}{l}\alpha\text{-transform of parallel} \\ \text{line-pair about point} \\ \text{on midline}\end{array} \qquad (5\text{-}8)$$

The transforms of the circle about a point in the plane at other angles, α, are given by the 6th degree α-*transform* of eq. 6. For $\alpha = 90°$, eq. 6 simplifies to eq. 7. Only the line and various line-pairs have α-transforms of lower degree about a point in the plane. Eq. 8 is the α-transform for the parallel line-pair $y^2 = j^4/a^2$, about a point on the midline, where j is the unit of linear dimension. For both $0°$ and $180°$ this gives solutions $x = \pm y$. The transform $x = y$, for $180°$, is characteristic of curves with a true center; the equivalent $0°$ transform, allowing negative intercepts, is $x = -y$. The other two transforms, $x = y$ for $0°$ and $x = -y$ for $180°$, are trivial. Transforms of the parallel line-pair for all other angles are of 4th degree.

An Analytical Approach to the Circumpolar Symmetry of Curves

Phylum and Class of Circumpolar Symmetry

An analytical approach is now outlined for characterizing the circumpolar symmetry of curves and ranking them hierarchically according to their symmetry about specific poles. The circumpolar *symmetry class* of a curve about a given pole at a given angle is defined as the lowest degree to which the eq. of the corresponding transform will reduce. The *specific symmetry class* is a more precise specification of the properties of the transform than merely its degree. It is not necessarily a unique characterization, because precision of specification often is a matter of convenience. For quadratic transforms, for example, it is convenient to employ the customary categorizations, "elliptical," "parabolic," etc. The most precise specification of the specific symmetry class is the eq. of the intercept transform itself, and this frequently is employed.

In this connection, when both positive and negative intercepts are taken into account, complete transform eqs. usually are degenerate, i.e., they fall into several factors--often all of the same degree and representing congruent loci-- for example, $f(x,y)g(x,y)h(x,y) = 0$. The factor among these that represents the transform for two positive intercepts (or, if two positive intercepts do not exist, for one positive and one non-trivial negative intercept) defines the symmetry class of the curve about the given pole at the given angle.

The *symmetry phylum* to which a curve belongs is defined as the lowest degree of any of its *non-trivial* class rankings. The circle, the point (or point-circle), the line, and intersecting lines (including ensembles of lines intersecting at a common point)--the simplest non-trivial transforms of all of which are merely a point--are the only members of the $0°$ phylum.

Some Transforms of Unusual Interest

Even this incomplete paradigm for hierarchical ranking of the circumpolar symmetry of curve-pole combinations leads to fascinating results. Eqs. of unusual curves that heretofore merely were interesting curiosities now are found to characterize the specific symmetry classes of curves about specific poles at specific angles. For example, the "4th-degree circle," eq. 9a, is the $45°$

(a) $\quad x^4 + y^4 = a^4 \qquad$ (b) $\quad (x^4+y^4)[x^4y^4+d^8(C^2-1/16)^2] = 4C^2d^4x^4y^4 \qquad$ (5-9)

$\qquad x^2y^2(a^2+b^2) = a^2b^2(x^2+y^2) \quad 90°$ transform of ellipse about center \qquad (5-10)

$\qquad (2-e^2)x^2y^2 + e^2p^2(x^2+y^2) = 2epxy(x+y) \quad \begin{array}{l} 90° \text{ transform of conics} \\ \text{about traditional foci} \end{array} \qquad$ (5-11)

specific symmetry class of the equilateral lemniscate about its center. For comparison, Cassinians--defined by the bipolar eq., $uv = Cd^2$ (of which the equilateral lemniscate is the locus for $C = \frac{1}{4}$)--have the 12th-degree eq., 9b, as their specific symmetry class for a 45° transformation about the center.

The 90° specific symmetry class of an ellipse about its center is the beautifully symmetrical eq., 10, while that for all conic sections about their traditional foci is eq. 11 (e, the eccentricity; p, the focus-directrix distance). Mere inspection of eq. 11 reveals that the equilateral hyperbola, for which $e^2 = 2$, has greater 90° symmetry about its foci than do other conic sections, because, for it, the degree of the transform reduces from 4 to 3. The symmetry of the equilateral hyperbola also is greater in other respects; it stands in the same relationship to the hyperbola as the circle does to the ellipse. In fact, the circle and the equilateral hyperbola are the only known curves to possess a number of homologous properties (see below).

Eq. 12 is a formulation of the 90° specific symmetry class of central conics about their centers. Once again, the transform of the equilateral hyperbola reduces, but in this case the reduction is to the imaginary locus, $x^2 = -y^2$.

$$(e^2-2)(e^2-1)x^2y^2 = e^2p^2(x^2+y^2) \qquad \begin{array}{l}90^\circ \text{ transforms of central} \\ \text{conics about centers}\end{array} \qquad (5\text{-}12)$$

$$x^4y^4 = (2p)^6(x^2+y^2) + 3(2p)^4x^2y^2 \qquad \begin{array}{l}90^\circ \text{ transform of parabola} \\ \text{about the vertex}\end{array} \qquad (5\text{-}13)$$

$$(x^2-y^2)^2 = 4a^2(x^2+y^2) \qquad \begin{array}{l}90^\circ \text{ transform of equilateral} \\ \text{hyperbola about an \ a vertex}\end{array} \qquad (5\text{-}14)$$

$$(h^2-a^2)^2(x^2+y^2)+2a^2xy(h^2-a^2) = 2h^2x^2y^2 \qquad \begin{array}{l}180^\circ \text{ transform of equilateral} \\ \text{hyperbola about a point on} \\ \text{the transverse axis}\end{array} \qquad (5\text{-}15)$$

The 90° specific symmetry class of the parabola about its vertex, eq. 13, is of 8th degree, whereas that for an equilateral hyperbola about a vertex, eq. 14, is only of 4th degree. Eq. 14 belongs to the *inverse-cos²θ group*, $r = j^2/(a+b\cos^2\theta)$. It has the unusual property that the 90° specific symmetry class about its center also is an equilateral hyperbola. For the special case, $r = j/\sin^2\theta$, the eq. of the transform is, $xy = j(x+y)$. In other words, the curve that defines the 90° specific symmetry class of an equilateral hyperbola about a vertex, itself has the 90° specific symmetry class about its center defined by an equilateral hyperbola. The corresponding 180° specific symmetry class of an equilateral hyperbola about a point on the transverse axis is eq. 15.

One of the most remarkable eqs. known to me is eq. 16, for the $90°$ specific symmetry class of hyperbolic limacons about the $-\frac{1}{2}b$ focus. This eq. represents 4 pairs of congruent, concentric, orthogonal elliptical figures--the

$$x^2y^2[(x^6+y^6) - 2c^2(x^4+y^4) + (c^4-2b^2d^2)(x^2+y^2) + b^2(4c^2d^2-a^4)] + \qquad (5\text{-}16)$$
$$b^4d^4(x^2+y^2) = 0$$

$$c^2 = (2a^2+b^2)/2 \qquad d^2 = (4a^2-b^2)/16$$

near-ellipses--one pair in each quadrant (treated in detail in Chapter X). The remarkable property of this eq. is that, the greater the parameter ratio, b/a, the more nearly the orthogonal elliptical figures approximate true ellipses. For example, for $b/a = 20$, the deviation from true ellipses- as estimated from chord ratios at the points of intersection, is 0.01 to 0.001% (the chord ratio is 0.9999). These 8 *near-ellipses* are represented by only a 10th degree eq., whereas for true ellipses a degenerate eq. of 16th degree is required.

In the special case of the "$2\cos\theta$" limacon, $r = a(1-2\cos\theta)$, eq. 16 reduces to a degenerate 6th degree eq. that falls into 3 factors, each of 2nd degree. These represent a pair of congruent, concentric, orthogonal ellipses and a circle, all centered at the origin. These are not the only remarkable features of the symmetry of hyperbolic limacons about the $-\frac{1}{2}b$ focus. The $180°$ transforms are *near-circles* and the $0°$ transforms are *near-lines*, with the property of more nearly approximating the true curves as b/a increases.

Aside from lines and the circle, explicit eqs. for the specific symmetry classes of curves about *a point in the plane* (which always is taken as the origin) have been derived only for conic sections, and in these cases only for the $0°$ and $180°$ transformations. For some curves it is only the practical problem of the time required to achieve a derivation that stands in the way of obtaining these transforms; at the present time only their maximum degree is known. I give as an example of a transform about a point in the plane eq. 17, the 8th degree $180°$ transform of the equilateral hyperbola cast about the pole at $(-h,-k)$ relative to the centered curve (x-h and y-k translations).

$$[c^4(x-y)^2+2c^2xy(h^2+k^2) - 2x^2y^2(k^2-h^2)]^2 = 8c^4h^2xy(c^2+xy)(x-y)^2 \qquad (5\text{-}17)$$
$$c^2= (a^2+k^2-h^2)$$

Circumpolar Intercept Transforms Form
 Endless Branching Chains

Circumpolar intercept transforms can be regarded as forming endless branching chains. Thus, transforms exist for all curves about each of their point foci, about points on all of their focal loci, and about points in the plane. But each of these transforms is the eq. of another curve, the symmetry of which is characterized by still other circumpolar intercept transforms, etc., *ad infinitum*.

As a practical matter, it occurs infrequently that more than a few links of an intercept transform chain can be identified. Only for the circle and the equilateral hyperbola do endless chains of transforms exist in which all the links along one pathway consist of circles and equilateral hyperbolas, respectively. This property is one of 5 homologies between the circle and the equilateral hyperbola that have been revealed by symmetry analyses; the others are the possession of *eclipsed foci, polar exchange symmetry* in collinear tetrapolar coordinates, *identical reciprocal 90°-0°-circumcurvilinear symmetry*, and a property relating to the tangent pedals of the parabola (see Chapter XIII).

Circumpolar Intercept Transforms as
 Symmetric Functions

It will be noted that all of the illustrated eqs. of circumpolar intercept transforms have been "symmetric functions," i.e., functions that are not altered if the variables x and y are interchanged (in which respect they contrast in the extreme with *circumlinear* and *circumcurvilinear* intercept transforms; see Chapter XII). Geometrically, this means that the transforms are symmetrical about the line $x = y$. In fact, this is an inherent characteristic of the circumpolar transforms of curves about poles on lines of symmetry. This ensues because for any given pair of intercepts, $(x,y) = (x_1, y_1)$, on one side of the line of symmetry, there exists an exchanged pair, $(x,y) = (y_1, x_1)$, reflected in this line.

Circumpolar intercept transforms for an angle of 180° also are symmetric functions, even when the pole of the transformation does not lie upon a line of symmetry. This comes about because the x and the y intercepts of a chord rotating about any pole become exchanged every 180°. But what is true of the 180° transform for two positive intercepts also must be true of the 0° transform for one positive and one negative intercept (although it is not true of 0° transforms restricted to two positive intercepts). In fact, the mathematical derivations of *algebraically complete 0° and 180° transforms*--transforms that

take into account all possible combinations of values of positive and negative intercepts--are essentially identical (see Chapter VII, *Negative Intercepts, Trivial Transforms, the Degree of Transforms, and the Duality of 0° and 180° Transforms*). Accordingly, algebraically complete 0° transforms also are symmetric functions. The fact that 0° and 180° transforms usually are of much lower degree than 90° transforms is related to these circumstances.

But whether a transform is a symmetric function or not, all of the information about the circumpolar symmetry of a basis curve (i.e., at the level of the transform eqs.) is contained in transforms for angles of transformation $\alpha \leq 180°$, because the transform for an angle of $360°- \alpha$ merely is located in a different position, namely reflected through the line $x = y$.

CIRCUMPOLAR MAXIM 1: *If no circumpolar point focus of a curve exists at a specific valid locus for either the 0° or 180° transformation, then no focus exists for any angle of transformation.*

In order for Maxim 1 to be applicable, a non-trivial 0° or 180° transform must exist for the locus in question. This often is not the case for point foci incident upon a curve. To ascertain whether an incident pole is a point focus (as opposed merely to having focal rank by virtue of being a point on a focal locus), other angles of transformation must be employed.

For example, eq. 18, for the 0° intercept transform about a point on the *exterior* axis of the parabola $y^2 = 2p(x-h)$ is of 4th degree, where h is

$$x^2y^2 = h^2(x+y)^2 + 2phxy \qquad (h > 0) \qquad (5-18)$$

positive and the abscissa of the vertex. Accordingly, the external axis is a focal locus, because the 0° transforms about any neighboring points not lying on the axis are of 8th degree. However, examination of eq. 18 reveals that degree reduction is impossible for any point on the exterior axis (i.e., for any positive value of h). Accordingly, since no point focus can exist on the exterior axis for a 0° transformation, and the exterior axis is not a valid locus for the 180° transformation, no point focus exists for any angle.

It will be noted that the terms of all eqs. that have been used as examples are homogenous polynomials, i.e., all terms have the same dimensions or degree, taking into consideration both the parameters and the variables. This is a fundamental dimensional requirement that is of great practical value in deriving and checking transforms. In the following, the unit of linear dimension, j, is employed frequently to bring eqs. into dimensional balance.

α-Transforms and Transformation Formats

Although 0°, 90°, and 180° transformation angles are used almost exclusively in illustrations, many of the eqs. are obtainable as α-transforms, the general transform eq. for any angle of transformation α. The degree of these transforms often is twice as great as that for the 90° transforms. Examples of α-transforms already have been given in eqs. 2, 6, and 8. Eq. 19, for α-transforms of central conics about their centers, is a more illustrative example.

$$x^4y^4[(b^2\mp a^2)^2\sin^2\alpha - (b^2\pm a^2)^2\sin^2\alpha\cos^2\alpha] + a^4b^4(x^4+y^4) = \qquad (5\text{-}19)$$

$$2a^2b^2x^2y^2(b^2\mp a^2)(x^2+y^2)\sin^2\alpha + 2a^4b^4x^2y^2(\cos^2\alpha-\sin^2\alpha)$$

Inspection of eq. 19 reveals why greater reductions of the degree or circumpolar transforms about the centers of central conics occur for 180° than for 90°. But the greater possibilities for reduction that exist at 0° and 180° are illustrated for the general case by an example of a *transformation format*. When the simple intercept format is of the form $\cos^2\theta = f(x)$, the general eq. of the transform, i.e., the α-transform, is obtained by substituting the simple intercept format in the *$\cos^2\theta$ transformation format* of eq. 20, where

$$[f(x)-\sin^2\alpha]^2 + [f(y)-\sin^2\alpha]^2 - 2f(x)f(y)(\cos^2\alpha-\sin^2\alpha) = \sin^4\alpha \qquad (5\text{-}20)$$

$f(y)$ is identical to $f(x)$ but with x replaced by y, and α is the angle of the transformation. The relationship of eq. 20 follows directly from the elimination of θ from the parametric eqs. $f(x) = \cos^2\theta$ and $f(y) = \cos^2(\theta+\alpha)$. It is simply a general rule for combining these eqs. for any value of α. For 90°, it gives $f(x) + f(y) = 1$ $[\cos^2\theta+\cos^2(\theta+90^\circ) = 1]$; for 180° it gives $f(x) = f(y)$ $[\cos^2\theta = \cos^2(\theta+180^\circ)]$, etc. (see Appendix I).

Relative Frequencies of Low-Degree Circumpolar
 Symmetry Classes

The symmetry *order* is the next finer means of discrimination after the class rank, for hierarchically ranking the circumpolar symmetry of curves about specific poles at specific transformation angles. But before taking up the symmetry order, a few additional remarks are appropriate concerning the relative frequencies of occurrence of symmetry classes of low degree. As

mentioned earlier, 0-degree symmetry is possessed only by the circle, the
point, the line, and intersecting lines. Excluding trivial linear transforms,
the 1st-degree symmetry class (*linear specific symmetry*) is not uncommon and
characterizes 180^O transforms about the centers of all curves with a true
center (curves that possess orthogonal lines of symmetry).

Curves with one or two foci falling into the equilateral hyperbolic specific
symmetry class are relatively common because transforms about foci of self-
inversion take the form xy = constant, and self-inversion of curves is common
(see Chapters XI and XIV). On the other hand, many highly symmetrical curves
with a true center do not self-invert. In these cases the transforms about
foci other than the center may be of high degree. For example, though bipolar
eqs. cast about the "loop foci" of the equilateral lemniscate are only 2nd-
degree equilateral hyperbolas, $uv = d^2/4$, the 180^O transforms about these
foci are of 6th degree, while the 90^O transforms are of 12th degree.

Fig.
2-4a
$C = \frac{1}{4}$

The degree of transforms of curves about points in the plane typically is
very high; this degree is a maximim of 32 for conic sections. For the 90^O
transforms of limacons the degree is 72, but the degree of the α-transform is
unknown. Among curves falling into the 2nd-degree symmetry class, hyperbolic
symmetry is the most common and parabolic the least common. In fact, the only
known curves with parabolic symmetry are the Norwich spiral (at all trans-
formation angles about the polar center except 0^O) and the *$cos^4\theta$-group*
($r = a+bcos^4\theta$) for 90^O transformations about the polar center.

Some curves fall into the 2nd-degree symmetry class at almost all trans-
formation angles about a given focus (when an exception occurs, it is for the
0^O or 180^O transformation) but fall into different *specific symmetry classes*
at different angles. For example, about the DP or DP homologue, all limacons
have linear specific symmetry at 0^O and 180^O, circular specific symmetry at
90^O, and elliptical specific symmetry at all other angles.

Symmetry classes have been dealt with at length because the *class* taxon is
the first branch point for hierarchically ordering the circumpolar symmetry
of curves about specific foci; consequently, class rank is used most frequently
for comparisons in the treatments that follow. When the taxon of the rank is
not mentioned specifically, it should be understood to be the *class*.

On the other hand, speaking only in terms of indices--1st degree, 2nd degree,
etc., the class rank alone is insufficient for a complete hierarchical circum-

polar symmetry ranking. Not only do many curves fall into the same specific symmetry class, there is a remarkable instance in which two curves have congruent and coincident transforms (see also the general treatment of related phenomena under *Symmetry Mimics* in Chapter XIV). Thus, a *monoconfocal* (confocal at one focus) hyperbola and ellipse with identical parameters a and b, have identical 180° transforms about their foci, namely the equilateral hyperbola of eq. 21. Accordingly, a finer means of discrimination is needed in pursuit of

Fig. 5-1

$$b^2(x+y) = 2axy \qquad\qquad (5\text{-}21)$$

the goal of hierarchical symmetry ranking. [As an example of the above-mentioned phenomenon, the ellipse $(x-5^{\frac{1}{2}}/3)^2+9y^2/4 = 1$, and the hyperbola $(x-13^{\frac{1}{2}}/3)^2-9y^2/4 = 1$, with a = 1 and b = 2/3 for both, are monoconfocal

Fig. 5-1

(left focus of each) at the origin and have the common intercept transform $(4/9)(x+y) = 2xy$; see eqs. VII-8a,b.]

The direction that the finer means of discrimination must take becomes clear if one reflects on the fact that a 2-dimensional representation of an intercept transform does not give complete information about the basis curve. It was for this reason that it was specified that one surveyor record the angle at which each reading was taken (Chapter I, *A Preliminary View of the Circumpolar Intercept Transformation*). For example, in Table V-1 are listed 14 groups of basis curves that have linear transforms about one of their foci, 13 that have hyperbolic transforms, and 4 that have circular ones (it is shown in Chapter XIV in the section on *Design and Synthesis of Highly Symmetrical Curves* that an infinite number of curves exist with such transforms).

Since it is the highly symmetrical curves that present the greatest challenge for hierarchical symmetry ranking, I use as illustrations curves that possess foci about which the transforms have 1st and 2nd degree class rankings. What is needed to give greater specificity than does the class rank, or even the specific symmetry class (even the transform eq. itself), is information about the rate at which the transforms are generated with changes in the positions of the rotating radii that scan the basis curve. In other words, information is needed about how the distance travelled along the arc of the transform changes with θ; this is manifestly different for different basis curves, even for those with transforms that fall into the same specific symmetry class.

Table V-1. Inventory of Curve-Pole Combinations With
 High Ordinal and Subordinal Circumpolar Rank

Linear Specific Symmetry Class

Curve	Angle°	Order	Suborder	Pole
1. Spiral of Archimedes	all	0	0	Polar pole
2. Logarithmic spiral	all	2	2	" "
3. Limacons	0,180	2	2	DP or DP homologue
4. $\cos^2\theta$-group	90	2	2	Polar pole (true center)
5. " "	180	2	2	" " " "
6. Inverse-$\cos^2\theta$ group	180	4	4	" " " "
7. Parallel line-pair	180	4	4	" " " "
8. Root-$\cos^2\theta$ group	180	6	4	" " " "
9. Ellipses	180	6	6	" " " "
10. Hyperbolas	180	6	6	" " " "
11. Squared-$\cos^2\theta$ group	180	8	4	" " " "
12. Mutually-inverting quartic circles	180	10	6	" " " "
13. Cassinians ($C < \frac{1}{4}$)	0,180	18	10	" " " "
14. Quartic twin parabola	180	20	10	" " " "

Circular Specific Symmetry Class

Curve	Angle°	Order	Suborder	Pole
1. Circle	90	2	0	Incident point
2. Limacons	90	2	0	DP or DP homologue
3. $\cos^2\theta$-group	45	2	0	Polar pole (true center)
4. Root-$\cos^2\theta$ group	90	6	4	" " " "

Hyperbolic Specific Symmetry Class

Curve	Angle°	Order	Suborder	Pole
1. Parabola	180	3	6	Traditional focus
2. Equilateral hyperbola	180	4	8	" "
3. Hyperbolas	0,180	4	8	" "
4. Ellipses	180	4	8	" "
5. Reciprocal spiral	all*	4	8	Polar pole
6. Inverse-$\cos^2\theta$ group	90	4	8	" " (true center)
7. Equilateral strophoid	0	4	8	Loop vertex
8. Mutually-inverting quartic circles	0,180	10	8	Polar pole (true center)
9. Limacons	0	10	8	focus of self-inversion
10. Linear Cartesians	0	10	8	" " " "
11. Parabolic Cartesians	0	10	8	" " " "
12. Circle	0,180	10	14	Point in the plane**
13. Cassinians ($C > \frac{1}{4}$)	90	18	8	Polar pole (true center)

 * Only the trivial x = y transform is obtained for $0°$.
** Non-central, non-incident.

Table V-2. Hierarchical Circumpolar Symmetry Ranking of Curves
With 180° Linear Symmetry About a True Center

	Order 2	4	6	6	8	10	18	20	
	Suborder 2	4	4	6	4	6	10	10	Degree
highest ranking	$\cos^2\theta$-group								6
		Inverse-$\cos^2\theta$ group							4
		& Parallel line-pair							2
			Root-$\cos^2\theta$ group						4
				Central conics					2
					Squared-$\cos^2\theta$ group				10
						Quartic circles			4
							Cassinians		4
lowest ranking								Quartic twin parabolas	4

The Complementarity of Polar and Rectangular Coordinates for Circumpolar
 Symmetry Analyses

At this juncture it is appropriate to take note of the fact that both the
rectangular and polar coordinate representations of curves are needed to carry
an analysis of circumpolar symmetry beyond the specific symmetry class. Recall
that if one begins an analysis within the rectangular system, the mere process
of applying elementary trigonometric rotation relations to rotate the co-
ordinate axes in order to derive the eq. of an intercept in terms of the angle
of rotation, leads to the "invention" of the polar coordinate system. The
simple intercept formats, eqs. 22, obtained by rotation of the axes are

$$\text{(a) } \cos\theta = f(x), \quad \text{(b) } \cos^2\theta = f(x), \quad \text{(c) } \sin\theta = f(x), \quad \text{(d) } \sin^2\theta = f(x) \quad (5\text{-}22)$$

nothing other than the polar coordinate eqs. of the curves with r replaced
by x.

Instead of performing the analysis employing rectangular coordinates,
suppose instead, that only polar coordinates were known and the analysis were
pursued exclusively within that framework. One could carry the analysis to
the present point without difficulty and obtain the eqs., $r_1 = f(r_2)$ [equi-
valent to $y = f(x)$]. One also could assign a class rank to the curves
according to the degree of the eq. in the variables, r_1 and r_2, and even
specification of the specific symmetry class would be possible (but not in
the familiar terms of conic sections).

For the circle transformed about any point on its circumference, the eq. for
the 90° transform would be, $r_1^2 + r_2^2 = 4R^2$. This is recognized to be the eq.
of a circle in rectangular and bipolar coordinates. But if only polar co-
ordinates were known, one would have no inkling of the significance of this
eq., other than that conveyed by its degree, form, and complexity, and the
fact that it was the specific symmetry class of the circle for the trans-
formation in question.

The conclusion was reached above that what was needed for the further pursuit
of the analysis of circumpolar symmetry was information about how "s," the
distance along the transform curve, changed with the angle, θ, or the angle,
$(\theta+\alpha)$ of the radius vectors rotating about a pole of the basis curve. The
concept of $ds/d\theta$ would be a familiar one even if polar coordinates were the
only known coordinate system, because $ds/d\theta$ is a familiar derivative in polar

coordinates. The basis for the impasse that would be reached, of course, is that in polar coordinates a distance is plotted against an angle, whereas to obtain $ds/d\theta$ for the transforms, $f(r_1, r_2) = 0$, a coordinate representation is needed in which one distance is plotted against another distance. Thus, an analysis employing polar coordinates leads directly to a point at which further progress in the analysis of the circumpolar symmetry of curves depends upon the avaiability of an appropriate coordinate system employing two distances as the variables.

But, of course, there are infinitely many such coordinate systems; several of these--bipolar, polar-linear, polar-circular, etc.--already have been examined. The realization that such a system is needed for an analysis in greater depth is only one step in the direction of ascertaining that the rectangular system is most suitable for this purpose. The basis for this claim is not far to seek--the rectangular system is the only system in which plots of intercept transforms--which were obtained exclusively by a polar coordinate anaysis-- lead to a simple, consistent, and fruitful analytical treatment of symmetry.

In the rectangular system, transforms of highly symmetrical curves about their highest-ranking foci also are highly symmetrical curves, often interrelated in logical and fascinating ways. Only in the rectangular system is the eq., $x^2 + y^2 = j^2$, a circle and the eq., $xy = constant$, an equilateral hyperbola. Accordingly, only in the rectangular system is the $90°$ transform of a circle about incident points another circle, and transforms of self-inversion equilateral hyperbolas. In all other bilinear systems, $x^2 + y^2 = j^2$ is the eq. of an ellipse of one or another eccentricity, and $xy = constant$ is the eq. of one or two non-equilateral hyperbolas of various eccentricities.

Figs.
4-8b

4-8d

To sum up, then, an analysis of circumpolar symmetry pursued in rectangular coordinates leads to the "invention" of polar coordinates. If the analysis is begun, instead, in polar coordinates one reaches an impasse; further progress requires the employment of a coordinate system employing two distances as variables. Of the infinity of such systems that might be employed, rectangular coordinates emerge as being most (perhaps uniquely) suited to the analysis. In other words, the analysis of the fundamental symmetry properties of curves reveals the complementarity of the two première coordinate systems whose very raison d'être is to make the fundamental properties of curves susceptible to analysis.

But the analysis reveals more than the complementarity of rectangular and polar coordinate systems for symmetry analyses. It also shows that the polar

coordinate system is pre-eminent for this purpose. Using polar coordinates
alone, one can carry the analysis to the present point and pursue directly
the first steps in an adjunct inversion analysis. But using rectangular co-
ordinates alone, it is necessary to "invent" the polar system merely to obtain
the intercepts as a function of the angle of rotation.

Three-Dimensional Intercept Transforms

The conclusion was reached above that what was needed to proceed beyond the
point of having obtained the relation, $r_1 = f(r_2)$, was a coordinate system
employing two distance coordinates (or, more generally, two equivalent vari-
ables). This led, inevitably, to the use of the rectangular system. But one can
go a step further; one can employ a system in which the intercept transform
achieves complete representation, rather than merely supplementing the rec-
tangular coordinate relationship with information about $ds/d\theta$.

The domain of complete representation of intercept transforms is the
directed-distance, mutually-orthogonal, trilinear system, i.e., 3-dimensional
rectangular coordinates. In this system, two of the mutually orthogonal axes,
say the x and the y-axes, represent r_1 and r_2 and the third represents
θ, i.e., $z = \theta$. In this representation, the otherwise similar specific
symmetry classes--the lines, circles, equilateral hyperbolas, etc., of the
2-dimensional plot--become subdivided into specific different curves, each of
which now uniquely characterizes both the shape of its basis curve and the sym-
metry thereof about the pole of the transformation.

For example, the 3-dimensional representation that results when two radii
of a circle are rotated about its center becomes a line at $x = y = R$, paral-
lel to the θ-axis. Of the 14 2-dimensional linear transforms used as ex-
amples in Table V-1, only the spiral of Archimedes remains linear. The other
13 become planar curves. Three of the circular transforms become helices, or
regularly-spaced segments thereof, with constant but different pitch for each
helix, while the 4th becomes a helix with varying pitch. One of the helices
of constant pitch is generated continuously and is a true helix. Another is
recurrent each 90° of rotation about the axes; it does not retrace itself,
but it doubles back along the same $xy = r_1 r_2$ path while progressing
monotonically in the direction of the θ axis. The helix of varying pitch also
is recurrent each 90°, while the third helix of constant pitch proceeds mono-
tonically along the θ-axis but only has a real locus for 90° out of each 360°,

i.e., it is an interrupted helix, with only ¼ of a continuous helical curve being represented.

Similar types of descriptions could be given for the other intercept transforms, but the above examples illustrate sufficiently the fact that each transform contains uniquely-different implicit information about the basis curve.

The Order of Circumpolar Symmetry

Returning to the main path of the circumpolar symmetry analysis, the additional information being sought (i.e., information beyond the 2-dimensional properties of the transform) is contained in the s versus θ relationship. Possession of an explicit polynomial relationship, $s = f(\theta)$, in closed form surely would be suitable. However, to obtain $s = f(\theta)$, it generally is necessary to evaluate an extremely complex root-integral. But all of the essential information in the eq., $s = f(\theta)$, is contained in the derivative, $ds/d\theta$, which is obtained more readily. Even this derivation, however, requires the extraction of the square root of what generally is an extremely complex sum of squares, $[(dx/d\theta)^2 + (dy/d\theta)^2]^{\frac{1}{2}}$. Since all of the information concerning $ds/d\theta$ (which always is positive), also is contained in $(ds/d\theta)^2$, the latter function is employed for the next finer level of discrimination in the analysis of circumpolar symmetry. As was the case for the class rank, it is the degree of the eq, $(ds/d\theta)^2 = \overset{\circ}{s}^2 = f(x,y)$, that is used as the ranking index; specifically, it is the index for the *order* of circumpolar symmetry.

Ordinal Rank Is Independent of Transformation
 Angle

Following this paradigm for the determination of circumpolar ordinal rank, one discovers immediately that it is independent of the angle of the transformation. Thus, though one might get transforms belonging to 3 different specific symmetry classes, say lines, circles, and ellipses, defining the circumpolar symmetry of a curve about a given pole, all 3 transforms have the same ordinal rank. Accordingly, once one has obtained the circumpolar ordinal rank of a transform for a given curve about a given pole by evaluating it for a specific angle of transformation--even for an otherwise trivial 0° transform--that rank applies to all angles.

The basis for this identity is elementary. To begin with, it is inherent

that $dx/d\theta = \overset{o}{x}$ will be the same for all transformation angles because the x intercept is the *reference* intercept. The entity being sought, namely, $\overset{o}{s}{}^2$, is formed by summing $\overset{o}{x}{}^2$ and $\overset{o}{y}{}^2$. But since $x = f(\theta)$, $\overset{o}{x} = f'(\theta)$, and $y = f(\theta+\alpha)$, $\overset{o}{y}$ will take the identical form of $\overset{o}{x}$, namely, $f'(\theta+\alpha)$. Since $f'(\theta)$ and $f'(\theta+\alpha)$ have identical form, the eliminants, $\overset{o}{x} = g(x)$ and $\overset{o}{y} = g(y)$, also will have identical form. Thus to form $\overset{o}{s}{}^2$, one merely adds to the function, $\overset{o}{x}{}^2$, an identical function with terms in x replaced by terms in y. Because of these relationships, simple specific symmetry orders sometimes take the form of eq. 23.

$$a^{n}\overset{o}{s}{}^2 = b^2(x^n+y^n) \pm c^3(x^{n-1}+y^{n-1}) \pm d^4(x^{n-2}+y^{n-2}) \pm \ldots \ldots \qquad (5\text{-}23)$$

Ordinal rank eqs. also can be expressed as functions of θ and α, instead of x and y. These eqs. also have the same form for all transformation angles about a given point, for the same reason mentioned above. To obtain $\overset{o}{s}{}^2$ as a function of θ and α, one merely adds to $\overset{o}{x}{}^2 = f(\theta)$ an identical function with the argument $(\theta+\alpha)$. But this alternative expression is not useful as an ordinal *index* because there exists no theory for ordering transcendental eqs. that is comparable to that for polynomial eqs.

The Suborder of Circumpolar Symmetry

We now have arrived at the point where hierarchical circumpolar symmetry ranking involves a classification according to *class* and *order*. But if one refers to the list of illustrative transforms in Table V-1, it is found that the order of 4 of the 14 linear transforms is 2nd degree, the order of 3 is 6th degree, and the order of 2 is 4th degree. Three of the 4 circular transforms also have 2nd degree order, while 6 of the hyperbolic transforms have 4th degree order and 5 have 10th degree order. Hence, a still finer means of discrimination is needed; a step in this direction is provided by the *subordinal* rank.

Derivation of the index for subordinal ranking involves transforming the ordinal eqs., $\overset{o}{s}{}^2 = f(x,y)$ into eqs. in only $\overset{o}{s}$ and x (or y). This is accomplished merely by substituting $y = h(x)$, from the eq. of the transform itself, into the expression for $\overset{o}{s}{}^2 = f(x,y)$. In other words, each ordinal rank eq. is made specific for the class and angle to which it is to be applied, by using the transform and the angle that apply to the specific case. This

yields the *subordinal rank equation*. The *subordinal rank* is defined as the degree of this eq.

The transcendental rank eq. $\overset{\circ}{s}{}^2 = g(\theta,\alpha)$ also can be made specific for the class and angle to which it applies by giving α its specific value in the above expression. The corresponding *transcendental subordinal rank equations* sometimes are useful for comparing symmetry at the subordinal level.

Hierarchical Ordering of Curves By Circumpolar Symmetry

Comparable Foci and Specific Transformation Angles

It is clear from Table V-1 that an additional symmetry discrimination based upon the degree of subordinal rank eqs. provides only a small additional step toward the ultimate goal, since many cases remain in which curves in a given specific symmetry class have the same ordinal and subordinal rank. However, *direct valid comparisons* of curves according to their circumpolar symmetry may be made only when the transforms are for the same angle about comparable foci, such as true centers, homologous vertices, etc., When these restrictions also are taken into account, qualifying curves that emerge with the same ranking generally are curves that also are closely related equationally. Further discriminations of the relative circumpolar symmetry of curves grouped in this way have to be based upon comparisons between the ordinal and subordinal rank eqs. themselves.

Hyperbolic Specific Symmetry Class

When the above restrictions and the subordinal rankings are taken into account, one finds that for the group of curve-pole combinations with hyperbolic transforms and 4th degree ordinal rank, 3 of the 6 members fall into the same 8th degree suborder; for all 3 the transformation angle is 180° about a comparable focus. The 3 curves in question are the ellipse, the hyperbola, and the equilateral hyperbola.

The other 3 members of this group are the reciprocal spiral, the *inverse-$cos^2\theta$ group* (see eq. 26c) and the equilateral strophoid. The transformation for the reciprocal spiral is about the polar pole at all angles except 0°, for the inverse-$cos^2\theta$ group it is at a 90° angle about a true center, while for the equilateral strophoid it is for a 0° angle about the loop vertex. Accordingly, although these curves all have the same ordinal and subordinal ranks, the data do not provide the basis for a direct valid comparison of the symmetry of any of them, either with one another or with central conics.

However, it is possible to make a direct valid comparison between the inverse-cos$^2\theta$ group and the central conics in a different specific symmetry class. If both groups are transformed about their true centers at an angle of 180°, both have linear transforms (Table V-1). But the inverse-cos$^2\theta$ group has greater circumpolar symmetry about this focus, because both its ordinal and subordinal rankings are of 4th degree, whereas for the central conics both of these rankings are of 6th degree.

Of the 5 members of the group of hyperbolic transforms with 10th degree ordinal rank, 3 fall into the same suborder (limacons and linear and parabolic bipolar Cartesians). For these curves, the subordinal rank is 8 and the transformation angle is 0° about the homologous focus of self-inversion. In the cases of the other 2 members, the subordinal rank also is 8 but neither the transformation angle nor the pole of rotation is the same or comparable. For the circle, the pole is a non-central interior point and the angle is 180°, while for mutually-inverting quartic circles the pole is a true center (though it also is a focus of self-inversion) and the transformation is for angles of both 0° and 180°.

The Circle, the Line-Pair, and the Parabola

At this juncture, having included ellipses and hyperbolas in the same hyperbolic symmetry suborder, the question naturally arises as to the symmetry of the parabola. Actually, the comparative rankings of 3 other conic sections remain to be assessed. In addition to the parabola, there are the circle and the line-pair. The hyperbolic symmetry of the circle, however, may not be compared with that of other conics because the pole of the transformation is not comparable. The circle falls into this specific symmetry class only because its circumpolar symmetry is so great that 180° transformations even about *non-focal* interior points give hyperbolic transforms.

Like the circle, the line-pair also has greater circumpolar symmetry than other conics, but it is not under consideration here because it has no hyperbolic transforms. Although the parabola is a member of this specific symmetry class, it has greater circumpolar symmetry than central conics about the traditional focus. Its ordinal and subordinal rankings for 180° transformations about this focus are 3 and 6, respectively, as compared to 4 and 8 for the latter species.

This is the only circumpolar symmetry criterion by which the parabola can be considered to be more symmetrical than the equilateral hyperbola. In all other respects the equilateral hyperbola either has the same or greater circumpolar symmetry. As noted earlier, however, the parabola is the most symmetrical curve in several coordinate systems, for example, in polar-linear and linear-circular coordinates.

Circular Specific Symmetry Class

There is no taxonomic basis for grouping together the 3 circular transforms that emerged with identical rankings as to class, order, and suborder. One of the transforms was about a point on a curvilinear focal locus (a point incident upon the circle), a second was the 90° transform about the DP or DP homologue of limacons, while the 3rd was about the true center of curves of the $\cos^2\theta$-group.

Linear Specific Symmetry Class

Turning now to the transforms in the linear specific symmetry class, 4 of the original 14 emerged with the same class-through-subordinal rank. This identical ranking does not, however, provide a basis for concluding that their basis curves share a common type of circumpolar symmetry within the linear specific symmetry class, because no two members of the pair stand in comparison for a common angle and a comparable focus. The 2 transforms for which the transformation angle is 180° are about non-comparable foci, while the 2 for which the focus is a true center are representative of different angles of transformation (actually, it is the same curves--the $\cos^2\theta$-group--that are being compared, about the identical focus but at two different angles).

On the other hand, curve-pole combinations 5 through 14 stand in valid comparison, because the transforms for all are about a true center and at a common transformation angle of 180°. The $\cos^2\theta$-group emerges as by far the highest ranking of these (i.e., the most symmetrical) and the quartic twin parabola as the lowest, but only slightly lower ranking than Cassinians (see Table V-2). Within the ensemble, only two curve-pole pairs share a common ranking--the hyperbola and ellipse, the close relationship between which needs no further support, and the parallel line-pair (which is the most symmetrical

subspecies, $a = b$, $r = \pm j^2/a\sin\theta$, of the inverse-root $\cos^2\theta$ group of eq. 26d) and inverse-$\cos^2\theta$ group, which thus are indicated to be very closely related. In fact, 3 of the 4 groups belong to the inverse-root $\cos^2\theta$ group, because that group also represents the central conics.

Accordingly, even within the genus of conic sections, these rankings clearly establish that the parallel line-pair has greater symmetry about a point on the midline than do the central conics about the center. The parallel line-pair also must be regarded as being more symmetrical than the inverse-$\cos^2\theta$ group because it has a simpler subordinal rank eq., 24a, as compared to that for the latter group, 24b. The corresponding transcendental subordinal rank eqs. are 25a,b, respectively.

$$\text{(a) } \overset{o}{s}{}^2 = 2x^2(a^2x^2/j^4 - 1) \qquad \text{(b) } \overset{o}{s}{}^2 = (8x^2/j^4)[-ax^2(a+b)+(2a+b)j^2x - j^4] \qquad (5\text{-}24)$$

$$\text{(a) } \overset{o}{s}{}^2 = 2j^4\cos^2\theta/a^2\sin^4\theta \qquad \text{(b) } \overset{o}{s}{}^2 = 8b^2j^4\sin^2\theta\cos^2\theta/(a+b\cos^2\theta)^4 \qquad (5\text{-}25)$$

The rankings within the linear specific symmetry class also establish that, of the curves considered thus far, the $\cos^2\theta$-group is to be regarded as the group next-most symmetrical to the circle, the line, and intersecting lines, in regard to symmetry about a true center. A remarkable property of this group is that it has linear transforms at both 90^o and 180^o. It was noted earlier that only the transforms of the circle and point-circle about the center, the line about an incident point, and intersecting lines about the point of inter-section, have 0-degree class rank at all angles of transformation. Thus, this property of these highly symmetrical curves supports the above conclusion that the $\cos^2\theta$-group is to be regarded as next-most symmetrical to these curves about a true center; it gives the 2nd-lowest possible degree of a transform (linear) at *two* transformation angles, and the 3rd-lowest possible degree at all other angles (circles at 45^o and ellipses at all other angles). In addition, the $\cos^2\theta$-group has the lowest ordinal and subordinal ranks (2nd degree) among all curves of finite degree with a true center (excepting only circular trans-forms with a subordinal rank of 0). [It is shown in Chapter XIV, however, that an equationally very closely related curve, a *symmetry mimic of tangent circles*, shares the remarkable symmetry properties of the $\cos^2\theta$-group but is even more symmetrical about a true center, albeit at the subfocal level.]

Among curves of infinite degree, the spiral of Archimedes has the greatest circumpolar symmetry, with linear transforms about the pole at all transformation angles and 0° ordinal and subordinal rankings. The logarithmic spiral emerges as the next-most symmetrical curve of infinite degree, also having linear transforms at all angles, but with 2nd degree ordinal and subordinal rankings.

Eqs. 26a-d represent several groups with linear transforms and subordinal rank as low as 4th degree. These are highly symmetrical groups of curves whose eqs. involve the $\cos^2\theta$ function, namely, the *root-$\cos^2\theta$ group* (eq. 26a), the *squared-$\cos^2\theta$ group* (eq. 26b), the *inverse-$\cos^2\theta$ group* (eq. 26c), and the *inverse-root $\cos^2\theta$ group* (eq. 26d). Replacing the cosine function by the sine gives the same curves, but with a 90° phase shift.

(a) $\quad r^2 = a^2 \pm b^2\cos^2\theta$ \qquad (b) $\quad jr = (a+b\cos^2\theta)^2$ \qquad (5-26)

(c) $\quad r = j^2/(a+b\cos^2\theta)$ \qquad (d) $\quad r^2 = j^4/(a^2 \pm b^2\cos^2\theta)$

Single-Parameter Curves

From the foregoing we see that, taken alone, the hierarchical ranking of curves according to their circumpolar symmetry about specific points at specific angles is an insufficient basis for a comprehensive scheme of classification. Even in the relatively simple case of the genus *conic sections* one subspecies --the parabola--has greater 180° circumpolar symmetry about the traditional focus than the others. This appears to be a general phenomenon, whenever at least two parameters are involved in the eq. of a genus.

In these cases, the eqs. that possess the fewest parameters, such as the *single-parameter curves*--the parabola, the cissoid of Diocles, the cardioid, the equilateral hyperbola, the equilateral strophoid, the equilateral lemniscate, the equilateral limacon, the parallel line-pair, and the circle--give rise to the most symmetrical curves (curve-pole combinations). As a result, it may transpire that only the unexceptional subspecies of a species or genus possess identical class-through-subordinal rankings at the endpoint of the hierarchical ranking procedure, a circumstance for which allowance always has to be made.

Circumpolar Foci

As noted earlier, a circumpolar focal locus is a point array, about the member points of which a curve has greater symmetry than about neighboring non-member points (i.e., about neighboring points that do not lie on the locus). In other words, the eqs. of the intercept transforms of a curve about points on a focal locus are of lower degree than the eqs. for corresponding transforms (i.e., for corresponding angles of transformation) about neighboring points that do not lie on the locus.

Explicit examples of the analytical procedures that are employed to detect and evaluate focal loci or to rule out their existence are given in subsequent chapters, in which the treatments are applied at all levels--subspecies, species, genus, and all *axial* members of the superfamily (curves obtained by inverting central conics about points on the major or transverse axis and by inverting the parabola about points on the line of symmetry). In addition, in Chapter XIV, *The How and the Why of Circumpolar Symmetry*, treatments are given of the conservation of focal loci, the mode of origin of focal conditions in particular groups, and the ways in which general focal and potential focal conditions on intercept eqs. influence the general intercept format and the general solutions for intercept transforms.

In the following treatment of focal loci examples are drawn heavily from the conic sections and limacons, genera that are closely related through the inversion transformation, certain circumpolar symmetry properties, and their equational properties (see Chapter X, *The Cartesian Group*). The inversion relationship between these curves is the basis for a new nomenclature that is extended to all QBI curves (curves derived from conic sections by inversion). This nomenclature generally is employed in the remainder of this work (see also Chapter I, Table I-3).

Because hyperbolas invert through their traditional foci to limacons with two loops (b > a, in limacon parameters), the latter are referred to as *hyperbolic limacons*. Upon the same basis, limacons consisting of a single loop and derived from ellipses (a > b) are referred to as *elliptical limacons*, while the cardioid (a = b), the inversion of the parabola about its traditional focus, often is referred to as the *parabolic limacon*. A parallel scheme of nomenclature is applied to the inversion loci of conics about other poles.

Types of Foci

Definitions

Circumpolar focal loci already have been defined in terms of intercept transforms. These focal loci might be termed *ordinary* or *intrinsic* focal loci to distinguish them from cases in which point-poles achieve focal rank only *conditionally*, i.e., from *poles of conditional focal rank*. The definition of the latter is facilitated by a more precise description of the former, as follows. A particular genus of curves is defined by an eq., $f(x,y,a_1,...a_n) = 0$, in the variables x and y and two or more parameters, $a_1,...a_n$. A specific set of the values of these parameters defines a particular curve, which is referred to as a subspecies. If there are two functions, $g_1(a_1,...a_n)$ and $g_2(a_1,...a_n)$, such that the point (g_1,g_2) is always a point focus (as previously defined) of the corresponding subspecies, then such points are connoted *ordinary* or *intrinsic point foci*, hereafter referred to almost exclusively merely as *foci* (or a *focus*). For example, for ellipses, $b^2x^2+a^2y^2 = a^2b^2$, the g functions, $g_1(a,b) = (a^2-b^2)^{\frac{1}{2}}$ and $g_2(a,b) = 0$, define the right traditional focus for all values of a and b; accordingly, it is an intrinsic focus.

In the aforementioned genus of curves, other functions, $h_1(a_1,...a_n)$ and $h_2(a_1,...a_n)$, may exist--defining points that usually are conjugate points to the poles defined by the g functions. For certain values of the parameters, i.e., in certain subspecies, the points defined by the h functions coincide with the points defined by the g functions. These points defined by the h functions achieve focal rank at these coincidences and, whether coincident with intrinsic foci or not, are connoted *poles of conditional focal rank*. In brief, *ordinary* or *intrinsic foci* have focal rank in all subspecies, whereas *poles of conditional focal rank* become point foci only in those subspecies in which they come into coincidence with the intrinsic foci.

Point, linear (axial), and *curvilinear focal loci* need no further definition. For simplicity in the following, the single designation *curvilinear* often is used to include both linear and curvilinear focal loci.

A curvilinear focal locus is *simple* if intercept transforms for a given angle about all points lying upon it have the same degree in the variables, but *compound* if transforms about one or more points are of reduced degree. All point foci known to me lie upon curvilinear focal loci.

A *multiple-focus* is a point-pole at which two or more point foci are in

coincidence, as opposed to a *single focus*, which is not in coincidence with any other point focus. Multiple-foci can be *generic*, *subspecific*, or *dual*. A *generic multiple-focus* is multiple in all subspecies (or all but a finite number of subspecies) of a genus, whereas a given *subspecific multiple-focus* exists only in a single subspecies. A *dual multiple-focus* is the result of the coming into coincidence of one or more point foci with a generic multiple-focus.

A *variable focus* is a point focus whose position relative to the curve can be different in different subspecies. If, in different subspecies, a variable focus can be inside, incident upon, or outside of a curve or loop thereof, or on one side, incident upon, or on the other side of a curve or an arm thereof, it is designated as a *penetrating* variable focus.

A variable focus that can be inside or outside of a curve or loop thereof but not incident upon it is designated as *conditionally penetrating*. A variable focus that is either inside or outside of a curve or loop thereof in some sub-species, and incident upon it in one or more other subspecies, but does not penetrate the curve or loop, is designated as *incident*.

A *covert focal locus* is a curvilinear locus, all points of which possess focal rank, but which is not a line of symmetry.

A *focus of self-inversion* at an angle α is a point-pole about which a curve possesses reciprocal reflective symmetry along radius vectors at an angle α (the intercept transform for the angle α is of the form $xy = $ constant). Three common modes of self-inversion are *positive intra-oval* (an oval inverts into itself along coincident radii), *positive inter-oval* (one oval inverts into an-other), and *negative inter-oval* (one oval inverts into another along oppo-sitely-directed chord segments). *Negative intra-oval* self-inversion (an oval inverts into itself) is a property of the circle alone.

In the sole cases of the circle and equilateral hyperbola, some foci lose their point-focal rank. Such foci are referred to as *eclipsable foci*. If all but a finite number of points on a linear focal locus can lose their focal rank in a subspecies, the locus is referred to as an *eclipsable focal locus*.

CIRCUMPOLAR MAXIM 2: *No point focus is known that does not lie on a linear or curvilinear focal locus. All point foci lie upon linear or curvilinear point arrays, every point of which has or is presumed to have transforms of lower degree than the transforms about neighboring points that are not members of the array.*

Examples

Simple linear and curvilinear focal loci: The only known cases are the line, the midline of the parallel line-pair, the circle, and the equilateral hyperbola.

Compound linear and curvilinear focal loci: With the exceptions noted immediately above, this category includes all curves, all lines of symmetry, and all covert focal loci.

Ordinary or intrinsic foci: The traditional foci and vertices of conics, the centers of central conics, the DP and DP homologues of limacons and central conic axial vertex cubics.

Pole of conditional focal rank: The $+\frac{1}{2}b$ pole of limacons is the conjugate point to the $-\frac{1}{2}b$ focus. It achieves focal rank in: (1) the $a^2 = 2b^2$ subspecies of elliptical limacon, in which it coincides with the $(a^2-b^2)/2b$ focus; and (2) the $2a = 3b$ subspecies of elliptical limacon, in which it coincides with the $(a-b)$ vertex focus.

Transforms of curves about poles of conditional focal rank that are not coincident with point foci may be more simple, though of the same degree, than those of other points on the lines of symmetry on which they lie (excluding foci). Accordingly, poles of conditional focal rank may have greater subfocal rank than neighboring points, and may lead to an increase in the subfocal rank of foci with which they come into coincidence, i.e., to an increase in the symmetry of the curve about these foci.

Multiple-focus: A double-focus occurs at one of the points of intersection of mutually-inverting quartic circles, at which two vertex foci come into coincidence. A quadruple-focus occurs in the $b = 2a$ subspecies of hyperbolic limacon, in which the $-\frac{1}{2}b$ focus, the $(a-b)$ vertex focus, and two peripheral vertex foci become coincident (the latter two foci ordinarily lie at the points of intersection of the $-\frac{1}{2}b$ covert linear focal locus with the small loop). The only known *generic* multiple-foci of axial QBI curves are the $(a^2-b^2)/2b$ focus of limacons, the true center of mutually-inverting quartic circles[*] the vertex focus of conic axial vertex cubics, and the focus of self-inversion of eccentricity-dependent self-inverters (all of which are discussed in Chapter XII). A *dual multiple-focus* occurs in the equilateral strophoid, in which the variable focus comes into coincidence with the generic double-focus at the loop vertex.

[*and the true centers of their intersecting-line inversions]

Penetrating variable focus: The $(a^2-b^2)/2b$ focus of limacons is outside the curve in elliptical species, at the cusp in the cardioid, and inside of the small loop in hyperbolic species. The $x = 0$ focus of parabolic Cartesians (bipolar eq., $u^2 = Cdv$) is a *conditionally penetrating* variable focus; this focus becomes internalized by being "captured" within the small loop when the latter closes (for a value of $C = 4$). In subspecies with a lesser value of C it is either wholly outside the large loop or within the indentation of the large loop that becomes the small loop (for $C \geq 4$). The DP or DP homologue of limacons is an example of an *incident* variable focus; it is within the loop in elliptical subspecies, incident upon the curve at the cusp in the cardioid, and comprises the DP of all hyperbolic species.

Covert linear focal locus: The asymptotes of the hyperbola and the $-\frac{1}{2}b$ k axis of limacons (the line orthogonal to the line of symmetry at the position of the $-\frac{1}{2}b$ point focus).

Focus of self-inversion: The $(a^2-b^2)/2b$ focus of elliptical and hyperbolic limacons, the loop-vertex focus of hyperbola vertex cubics, and the vertex focus of ellipse vertex cubics.

Eclipsable foci and focal loci: The axial and LR vertices of the ellipse and hyperbola, the asymptotes of the hyperbola (for a transformation angle of $90°$), the axes of the ellipse.

The circle is the extreme case of eclipsing of foci; not only are all 8 vertex foci and the major and minor axes of the ellipse eclipsed, they also lose their identity. Eclipsing of foci in the equilateral hyperbola is only partial. The asymptotes retain focal rank for the $180°$ transformation but seemingly are eclipsed for the $90°$ transformation, together with all vertex foci. But the locations of the eclipsed foci are not lost. The only focal loci of the hyperbola that are not eclipsed in the equilateral subspecies for the $90°$ transformation are the lines of symmetry, the traditional foci, and the center (although the transform for the latter has only imaginary solutions).

The Rank of Circumpolar Focal Loci

The rank of the circumpolar focal loci of curves of finite degree generally adheres to the following sequence:

The highest-ranking circumpolar focal loci are: (1) either point foci that lie on a line of symmetry of the curve; or (2) linear focal loci, all points of which share highest focal rank. The centers of the circle and point-circle are the highest-ranking foci in this category. Any two orthogonal axes through them are lines of symmetry of the curve, the degree of the transforms is independent of the transformation angle, and intercept pairs are defined at all angles of the reference radius vectors (defining the x intercepts). Next-highest ranking is the line. The curve itself and any axis orthogonal to it are lines of symmetry, the degree of the transform is independent of the transformation angle, and intercept pairs are defined for all but four angles of the reference radius vectors(the four angles at which one or the other of the radius vectors coincides with the line). Next-highest ranking is the point of intersection of the intersecting line-pair. There are only two orthogonal lines of symmetry of the curve, the degree of the transform is independent of the angle of the transformation, and intercept pairs are defined for all but eight angles of the reference radius vectors.

The next-highest ranking focal loci usually are point foci that lie at the intersection of a *covert linear focal locus* with the curve itself, or that lie on the curve "opposite" an axial point focus. [By "opposite" is meant the location at which a line orthogonal to the line of symmetry at the position of the axial point-focus intersects a curve, asymptote, or other locus (excluding vertices that lie on the line of symmetry.)]

The next-highest-ranking focal loci usually are lines of symmetry, followed by covert linear focal loci and, lastly, the curve itself. In the case of the conic sections, the curve itself is a higher-ranking focal locus than the lines of symmetry.

Circumpolar Symmetry At the Subfocal Level

Treatments of circumpolar symmetry can be extended beyond those for focal loci to non-focal loci and to specific poles on linear and curvilinear focal loci about which a curve has greater symmetry than about neighboring points, but for which the degree of the transforms is the same. In other words, among the ensemble of transforms of the same degree about points on focal loci, some may be simpler than others.

For example, the asymptotes of hyperbolas are covert linear circumpolar focal loci, incident points of which yield 180° transforms of only 6th degree, as compared to 8th degree for transforms about neighboring points. As noted earlier, the points of intersection of the asymptotes with the extended latera recta are not foci, since their 180° transforms also are of 6th degree. But these intersections are found to be points about which hyperbolas have greater symmetry when viewed from the standpoint of the simplicity and overall degree of their transforms in both variables and parameters.

$$180^{\circ} \text{ transforms of hyperbolas about points}$$
$$\text{incident upon the asymptotes}$$

(a) the general transform (5-27)

$$a^4(a^2+b^2)(x+y)^4 + 16h^4(a^2+b^2)x^2y^2 = 16a^2h^2(x+y)^2x^2y^2 + 8a^2h^2(a^2-b^2)(x+y)^2xy$$

(a) the transform for intersections
 with the extended latera recta (5-28)

$$a^4(x+y)^4 + 16(a^2+b^2)^2x^2y^2 = 16a^2(x+y)^2x^2y^2 + 8a^2(a^2-b^2)(x+y)^2xy$$

(a) the transform for points at the
 level of the axial vertices (5-29)

$$(a^2+b^2)(x+y)^4 + 16(a^2+b^2)x^2y^2 = 16(x+y)^2x^2y^2 + 8(a^2-b^2)(x+y)^2xy$$

(b) $a^4(x+y)^4 + 16h^4x^2y^2 = 8h^2(x+y)^2x^2y^2$ 27a for equilateral hyperbola (5-27)

(b) $a^2(x+y)^4 + 64a^2x^2y^2 = 16(x+y)^2x^2y^2$ 28a for equilateral hyperbola (5-28)

(b) $a^2(x+y)^4 + 16a^2x^2y^2 = 8(x+y)^2x^2y^2$ 29a for equilateral hyperbola (5-29)

Thus, eqs. 27a,b are the general expressions for the 180° transforms about points incident upon the asymptotes of hyperbolas, where h is the abscissa

of the center, and the transverse axis is coincident with the x-axis. On
the other hand, the corresponding eqs. for $180°$ transforms about the points
of intersection with the extended latera recta are 28a,b.

Eq. 27a simplifies to 28a because, when the latera recta are coincident with
the y-axis $(h^2 = a^2+b^2)$ a term in (a^2+b^2) factors out, reducing the overall
degree of the eq. from 10 to 8 (or from 8 to 6 for the equilateral hyperbola).
Mere inspection of the general transforms for linear and curvilinear focal
loci often reveals such possibilities for simplifications. For example, if
one lets $h = a$ in eqs. 27a,b, bringing a vertex onto the y-axis, the
simplification is even greater, with reduction of the overall degree of the
transform to 6 (eqs. 29a,b).

It will be noted that, in the derivation of the transforms for the equi-
lateral hyperbola (eqs. 27b-29b), in which $a = b$, the rightmost term of each
of the eqs. 27a-29a vanishes, leading to greater subfocal symmetry. However,
this increase in symmetry at the subfocal level is subspecific rather than
specific, i.e., it has to do with differences between the symmetry of differ-
ent subspecies of hyperbolas about the *same* poles on a focal locus, rather
than with the comparative symmetry of all subspecies in the species about
different poles on the locus.

Lines

The Parallel Line-Pair

When $a = b$, the inverse-root-$\cos^2\theta$ eq. (1a) for centered central conics simplifies to 1b or 1c, which represent two parallel lines. If one lets $r_1 = r$, with θ unmodified, and $r_2 = r$, with θ altered to $(\theta + \alpha)$ in 1b, one obtains the simple intercept formats, 2a and 2b, for the values of r_1 and r_2, which are the intercepts of the radii emanating from any point on the mid-line to the parallel line-pair, at angles of θ and $(\theta + \alpha)$, respectively.

$$\text{(a)} \quad r^2 = j^4/(a^2 - b^2\cos^2\theta) \qquad \text{(b)} \quad r^2 = j^4/a^2\sin^2\theta \qquad \text{(c)} \quad r = \pm j^2/a\sin\theta \qquad (6\text{-}1)$$

$$\text{(a)} \quad \sin^2\theta = j^4/a^2 r_1^2 \qquad\qquad \text{(b)} \quad \sin^2(\theta+\alpha) = j^4/a^2 r_2^2 \qquad (6\text{-}2)$$

$$[f(x) - \sin^2\alpha]^2 + [f(y) - \sin^2\alpha]^2 - 2f(x)f(y)(\cos^2\alpha - \sin^2\alpha) = \sin^4\alpha \qquad (6\text{-}3)$$

$$\text{(a)} \quad j^4(r_1^2 + r_2^2) \pm 2r_1 r_2 j^4 \cos\alpha = a^2 r_1^2 r_2^2 \sin^2\alpha \qquad\qquad \text{(b)} \quad r_1 = \pm r_2 \qquad (6\text{-}4)$$

$$\text{(c)} \quad j^4(r_1^2 + r_2^2) = a^2 r_1^2 r_2^2 \qquad\qquad\qquad\qquad \text{(d)} \quad r_1 = \pm r_2$$

$$\text{(a)} \quad (r_1 + r_2)j^2/a = \pm k(r_1 - r_2) \qquad\qquad 0° \text{ transform, } k^2 > j^4/a^2 \qquad (6\text{-}5)$$

$$\text{(b)} \quad k(r_1 + r_2) = \pm(r_1 - r_2)j^2/a \qquad\qquad 180° \text{ transform, } j^4/a^2 > k^2$$

$$\text{(c)} \quad (k^2 + j^4/a^2)(r_1^2 + r_2^2) \pm 2j^2 k(r_1^2 + r_2^2)/a = r_1^2 r_2^2, \quad \theta = 0°\text{-}90°\,(\text{upper sign}) \text{ and } 180°\text{-}270°$$

$$\text{(c')} \quad (k^2 + j^4/a^2)(r_1^2 + r_2^2) \pm 2j^2 k(r_2^2 - r_1^2)/a = r_1^2 r_2^2, \quad \theta = 90°\text{-}180°\,(\text{upper sign}) \text{ and } 270°\text{-}360°$$

Elimination of θ between eqs. 2a,b using the *$\sin^2\theta$ transformation format* (eq. 3) gives the α-transform, 4a; this holds for a transformation angle, α, about a pole on the midline (the upper alternate sign holds for pairs of intercepts of opposite signs, the lower sign for pairs of intercepts having the same signs). The $0°$, $90°$, and $180°$ transforms, derived from 4a, are 4b, 4c, and 4d, respectively. The $0°$ transform $r_1 = r_2$ of eq. 4b is trivial, while $r_1 = -r_2$ is the valid transform about a true center for one positive intercept and one negative intercept; the positive sign in 4d yields the valid $180°$ transform $r_1 = r_2$ for curves with a true center, while the negative sign yields the transform $r_1 = -r_2$, which is trivial. The $90°$ transform, 4c, will be recognized as belonging to the same symmetry class and being of the same

form (only the parameters being different) as the 90° transforms of central conics about their centers (eq. V-12). For positive intercepts and poles lying at a distance k from the midline, the non-trivial 0° and 180° transforms are 5a,b; the 90° transform $(k^2 < j^4/a^2)$ is represented by 5c,c'.

"Pure" Intercept Products

Among the most interesting relationships to emerge from circumpolar symmetry analyses of conic sections are the *"pure" intercept products*, $r_1 r_2 = f(\theta,h,k)$ for different transformation angles about *a point in the plane*. These products express fundamental properties of the basis curves but only for conic sections can they be expressed in such simple form. Although transforms of self-inversion of a curve also occur in the form of a simple product of the intercepts, $r_1 r_2 = $ constant, the latter products hold only about specific point-poles, not about any point in the plane.

By way of introduction, it is evident from eq. 2 that the "pure" intercept product about any point on the midline of the parallel line-pair for a transformation angle, α, is eq. 6a, where j^2/a is the distance from the pole to each line. The 0° (upper sign) and 180° "pure" intercept products about a point in the plane at a distance k from the midline are 6b.

$$(a) \quad r_1 r_2 = \frac{j^4}{a^2 \sin\theta \sin(\theta+\alpha)} \qquad (b) \quad r_1 r_2 = \frac{\pm(k^2 - j^4/a^2)}{\sin^2\theta} \qquad (6\text{-}6)$$

Ordinal and Subordinal Rank

The *ordinal rank*--the degree in the variables r_1 and r_2 of the eq., $\overset{o}{s}{}^2 = f(r_1,r_2)$--is obtained by forming the derivatives, $dr_1/d\theta$ and $dr_2/d\theta$, from eqs. 2a,b, eliminating θ (or eliminating r_1 and r_2 to obtain the transcendental expression), and summing the squares of the eliminant derivatives, as in eq. 7. For the parallel line-pair, the ordinal rank eqs. are 8a,b.

$$\overset{o}{s}{}^2 = (dr_1/d\theta)^2 + (dr_2/d\theta)^2 \qquad (6\text{-}7)$$

$$(a) \quad \overset{o}{s}{}^2 = a^2(r_1^4 + r_2^4)/j^4 - (r_1^2 + r_2^2) \qquad (a') \quad \overset{o}{s}{}^2 = 2r_1^2(a^2 r_1^2/j^4 - 1) \qquad (6\text{-}8)$$

$$(b) \quad \overset{o}{s}{}^2 = j^4 \cos^2\theta/a^2 \sin^4\theta + j^4 \cos^2(\theta+\alpha)/a^2 \sin^4(\theta+\alpha)$$

$$(b') \quad \overset{o}{s}{}^2 = 2j^4 \cos^2\theta/a^2 \sin^4\theta$$

It can be seen from eq. 8a that the ordinal circumpolar symmetry rank of the parallel line-pair cast about a point on the midline is 4th degree. To obtain the subordinal rank for any given angle, one substitutes for r_2 of eq. 8a, its values from eqs. such as 4a,b,c. The subordinal rank eq. for $\alpha = 180^\circ$ is 8a'; the corresponding subordinal transcendental expression is 8b'.

The Single Line

The transforms for the single line (or coincident line-pair) are identical to those for the parallel line-pair, with the exception that a non-trivial 180° transform does not exist. If one takes a single line, $y = j^2/a$, at the position of one of the lines of the parallel line-pair, the intercept formats are, $\sin\theta = j^2/ax$ and $\sin(\theta+\alpha) = j^2/ay$. Eliminating θ by substituting in the *sinθ* (or *cosθ*) *transformation format* (eq. 9) yields the α-transform, eq. 10, which differs from 4a only in the lack of an alternate sign for the $2j^4xy\cos\alpha$ term (in the following, the symbols, x and y, are used, rather than r_1 and r_2, for intercepts at the angles θ and $\theta+\alpha$, respectively).

$$f^2(x) + f^2(y) - 2f(x)f(y)\cos\alpha = \sin^2\alpha \qquad \text{sinθ transformation format} \qquad (6\text{-}9)$$

$$j^4(x^2+y^2) - 2j^4xy\cos\alpha = a^2x^2y^2\sin^2\alpha \qquad \text{α-transform of single line} \qquad (6\text{-}10)$$

The transforms and ordinal and subordinal ranks are the same as those for the parallel line-pair, with the exception that there is no 180° transform, $x = y$. However, eq. 10 does give the locus, $x = -y$, for this angle, the trivial solution for one positive and one negative intercept.

Any Line-Pair

If the eqs. of any two lines are taken in the slope-intercept form, 11a,b,

(a) $y = m_1x + b_1$ line 1 (b) $y = m_2x + b_2$ line 2 (6-11)

(c) $(b_1m_2y \mp b_2m_1x)^2 + (b_1y \mp b_2x)^2 = x^2y^2(m_2-m_1)^2$, $m_1 \neq m_2$ 0° and 180° transforms

(c') $h^2(C^2+1)(x^2+y^2) \pm 2h^2(1-C^2)xy = 4x^2y^2$ 11c for $m_1 = C$, $m_2 = -C$, $b_1 = -hC$, $b_2 = hC$

(d) $b_2^2x^2(m_1^2+1) + b_1^2y^2(m_2^2+1) + 2b_1b_2(m_1-m_2)xy = x^2y^2(1+m_1m_2)^2$ 90° transform

(e) $y = \pm b_2x/b_1$ (f) $y = b_2x/b_1m_2$ (f') $y = -b_2m_1x/b_1$ special cases of c(e) and d(f,f')

the general 0^O (upper signs) and 180^O transforms about the origin are 11c, while that for 90^O is 11d; all of these are seen to be of 4th degree. All, however, are linear when the slopes of the two lines stand in certain relationships.

Thus, the 0^O and 180^O transforms reduce for the case $m_1 = m_2$, i.e., parallel lines, for which the transforms are 11e (these are derived from the simple intercept eqs.). These are seen to be independent of the slope of the parallel line-pair. For all cases in which the lines intersect, the eq. is of 4th degree. For the 90^O transform, the situation is somewhat different; reduction then occurs only for $m_1 m_2 = -1$, i.e., lines intersecting at 90^O, whereupon the linear transforms, 11f,f', are obtained. For all other angles of intersection and for non-intersection the transforms are of 4th degree.

In all cases the linear transforms pass through the origin. If negative intercepts are not allowed, the 0^O transform (upper sign) is valid only for cases in which b_1 and b_2 are of the same sign, while the 180^O transform is valid only for the cases in which b_1 and b_2 are of opposite sign. For comparison, if one takes as basis curve the intersecting line-pair, $y^2 = C^2(x-h)^2$, of slopes, $\pm C$, and intersecting the x axis at $x = h$, the 0^O and 180^O transforms about the origin as pole are given by eq. 11c'.

The Circle

The α-Transform

Because of the unique symmetry of the circle, the general transform for it can be cast about any pole on an extended diameter without loss of generality. The general eq. for a circle with center on the x-axis at the point h, eq. 12, is taken and the axes are rotated CCW through an angle, θ, about the origin as pole, giving eq. 13; x and y now are coordinates relative to the rotated

$$(x-h)^2 + y^2 = R^2 \tag{6-12}$$

$$(x\cos\theta - y\sin\theta - h)^2 + (x\sin\theta + y\cos\theta)^2 = R^2 \qquad \text{eq. 12 with axes rotated } \theta^O \text{ CCW} \tag{6-13}$$

$$\text{(a)} \quad (x\cos\theta - h)^2 + x^2\sin^2\theta = R^2 \qquad \text{simple intercept equation} \tag{6-14}$$

$$\text{(b)} \quad \cos\theta = (x^2 + h^2 - R^2)/2hx \qquad \text{simple intercept format}$$

$$y^2(x^2 + h^2 - R^2)^2 + x^2(y^2 + h^2 - R^2)^2 \qquad \text{α-transform} \tag{6-15}$$

$$- 2xy(x^2 + h^2 - R^2)(y^2 + h^2 - R^2)\cos\alpha = 4h^2 x^2 y^2 \sin^2\alpha$$

axes. The simple intercept eq., 14a, now is obtained by letting $y = 0$.

[All circumpolar intercept transformations are carried out about the origin as pole, with the basis curve appropriately displaced to bring the point about which the transformation is to be carried out to the origin.]

Completing the square in 14a and rearranging terms gives the simple intercept format in the form 14b (which, in fact, is a statement of the "law of cosines"). By use of the *transformation format* of eq. 9 one obtains the α-transform, 15, which is seen to be of 6th degree for all transformation angles except 0° and 180°.

Eqs. 14b and 15 hold for all values of h except $h = 0$, which means that the pole about which the axes are rotated may be at any point except the center of the circle (since one multiplied through by $4h^2x^2y^2$ to obtain eq. 15, $h = 0$ is not a permissible value). Of course if the pole is too distant from the circle, the transform will have only imaginary solutions for large values of α . [Note also that intercept transforms do not necessarily have real solutions for all values of θ . Very often the portion of the transform with a real solution consists of only a segment of the full locus represented by the transform eq.]

Transforms At 0°, 90°, 180°

The 0°, 90°, and 180° transforms about a pole at a distance h from the center are 16a-c, respectively, where real solutions of 16b hold to a distance of $h = 2^{\frac{1}{2}}R$. Eqs. 16a and 16c express well-known properties of the circle. For the special case, $h = 0$, eq. 14a becomes $x^2 = R^2$, which is independent of the angle of rotation (θ).

(a) $xy = (h^2 - R^2)$ $\qquad\qquad$ 0° transform (intercept product) \quad (6-16)

(b) $y^2(x^2+h^2-R^2)^2 + x^2(y^2+h^2-R^2)^2 = 4h^2x^2y^2$ \qquad 90° transform

(c) $xy = (R^2 - h^2)$ $\qquad\qquad$ 180° transform (intercept product)

\qquad $x^2 - 2xy\cos\alpha + y^2 = 4R^2\sin^2\alpha$ \quad α-transform for an incident point \quad (6-17)

(a) $x^2(1-\cos\alpha) + y^2(1+\cos\alpha) = 4R^2\sin^2\alpha$ \qquad eq. 17a after 45° CCW rotation of axes \quad (6-18)

(b) $e^2 = (\pm 2\cos\alpha)/(1\pm\cos\alpha)$ \qquad eq. defining e^2 of ellipses of eq. 17

\qquad $xy = (h\pm R)[h\cos\alpha \pm (R^2-h^2+h^2\cos^2\alpha)^{\frac{1}{2}}]$ \qquad α-intercept product (one radius vector passing through the center \quad (6-19)

For incident points, i.e., when $h = R$, the α-transform is given by eq. 17, for which the 0° and 90° transforms are $x = y$, which is trivial, and $x^2 + y^2 = 4R^2$, respectively. There is no 180° transform for positive intercepts about incident points, but the eq. also takes into account negative intercepts, for which the trivial 180° transform is $x = -y$.

A 45° CCW rotation of the coordinate axes for eq. 17 gives 18a, whereupon the transforms at all other angles are seen to be ellipses of eccentricity given by 18b, where the plus signs hold for transformation angles of 0°-90° and 270°-360°, and the minus signs for 90°-270°.

Intercept Products

The 0° and 180° intercept products about a point in the plane are given directly by the relations 16a,c, respectively. A general eq. for these products for any angle α, for cases in which one of the radius vectors passes through the center of the circle, is 19, where the product is real only for $h^2\cos^2\alpha + R^2 \geq h^2$.

Non-Focal Self-Inversion Loci of the Circle

Since the 180° transform of the circle of eq. 12 about the origin is $xy = R^2 - h^2$, this relation becomes a transform of negative self-inversion whenever h and R stand in the relation $R^2 - h^2 = j^2$, because the transform then becomes $xy = j^2$ (where j is the unit of linear dimension). In other words, the circle will negatively self-invert about all points on a concentric interior circle of radius $h = (R^2 - j^2)^{\frac{1}{2}}$. This being the case, all points on this concentric interior circle will have higher subfocal rank than neighboring points not lying on the circle (because, although all 180° transforms about a given point in the plane are of 2nd degree, the transform about points on the concentric circle is simpler). Such a locus is referred to as a *non-focal self-inversion locus*. Since the unit of linear dimension, j, can be chosen at will, any interior circle can be a non-focal self-inversion locus.

A similar analysis holds for the 0° intercept transform $xy = h^2 - R^2$. When h and R stand in the relation $h^2 - R^2 = j^2$, the transform becomes $xy = j^2$, and the external concentric circle of radius h becomes a non-focal self-inversion locus. In this case, the self-inversion is of the positive type, i.e., both of the distances from the inversion centers to the curve are

measured in the same direction. In general, for a given value of R and j,
only one interior and one exterior non-focal self-inversion locus will exist.

The non-focal self-inversion loci of the circle are special cases of more
general non-focal self-inversion loci that exist for all curves and reference
poles about which there also exist non-trivial 0° or 180° intercept transforms.
But the circle is the only curve whose non-focal self-inversion loci have
subfocal rank and are curves of the same type as the basis curve, i.e., other
circles. In the cases of other conic sections, the non-focal self-inversion
loci are previously unknown quartics. These are treated in Chapter VIII.

In the general case, a *non-focal self-inversion locus* of a curve relative to
a given reference pole is defined as the locus of all points through which
chords or coincident radii that also pass through the reference pole have
intercepts with the curve (distances from points on the locus to the curve)
that stand in the relation $xy = j^2$. An example of the plotting of an interior
non-focal self-inversion locus of a curve relative to an interior reference pole
is as follows. Chords are drawn through the reference pole at all angles. If
the length of a given chord is taken to be 2a, one divides the chord into two
segments of lengths $x = [a+(a^2-j^2)^{\frac{1}{2}}]$ and $y = [a-(a^2-j^2)^{\frac{1}{2}}]$. The product
of these lengths is simply $xy = j^2$.

There will be two interior points on each chord at a distance of
$[a-(a^2-j^2)^{\frac{1}{2}}]$ from each end that divide the chord into segments of the
stated lengths. The locus of these points on all chords is the interior non-
focal self-inversion locus relative to the given reference pole. The exterior
non-focal self-inversion locus relative to the given pole passes through
external points on the extensions of the same chords at a distance
$[(a^2+j^2)^{\frac{1}{2}}-a]$ from the curve.

In the case of the circle, the selection of a given value of j uniquely
determines the radii of the two circular non-focal self-inversion loci, inde-
pendently of the location of the reference pole. For example, for any selection
of an interior reference pole, the interior non-focal self-inversion locus will
be a circle of radius $R-[2R-(4R^2-4j^2)^{\frac{1}{2}}]/2 = (R^2-j^2)^{\frac{1}{2}}$, where R is the
radius of the basis circle. For $j^2 = R^2-h^2$, as in the first example, the
radius of the non-focal self-inversion locus is h.

In summary, if the general procedure for obtaining non-focal self-inversion
loci of a curve relative to a reference pole is applied to the circle, it is

found that: (1) all the non-focal self-inversion loci of a basis circle are other concentric circles; and (2) the specification of a reference pole is superfluous because the basis circle self-inverts *in all directions through each point* on its non-focal self-inversion loci, rather than merely along lines passing through both a specific reference pole and points on the locus (as in the general case).

Ordinal and Subordinal Rank

The ordinal and subordinal ranks of the transform of a circle about its center are both of 0 degree, because the transform is the point $x = y = R$. For the α-transform about a point incident upon the curve, eq. 17, the ordinal eqs. are 20a,b, whence the ordinal rank is 2nd degree. For $\alpha = 90^{\circ}$, both of these expressions reduce to $\overset{o}{s}{}^2 = 4R^2$, giving a subordinal rank of 0.

(a) $\overset{o}{s}{}^2 = 8R^2 - (x^2+y^2)$ ordinal rank eq. for transforms of the circle about an incident point (6-20)

(b) $\overset{o}{s}{}^2 = 4R^2[\sin^2\theta+\sin^2(\theta+\alpha)]$ transcendental ordinal rank eq. corresponding to 20a

<div align="center">ordinal rank eq. for transforms of the
circle about a point in the plane</div>

(a) $\overset{o}{s}{}^2(R^2+x^2-h^2)^2(R^2+y^2-h^2)^2 =$ (6-21)

$\quad x^2(R^2+y^2-h^2)^2[4h^2x^2-(R^2-h^2-x^2)^2] + y^2(R^2+x^2-h^2)^2[4h^2y^2-(R^2-h^2-y^2)^2]$

<div align="center">transcendental ordinal rank eq. corre-
sponding to 21a</div>

(b) $\overset{o}{s}{}^2 = h^2[h\cos\theta\pm(R^2-h^2\sin^2\theta)^{\frac{1}{2}}]^2 \sin^2\theta/(R^2-h^2\sin^2\theta) +$

$\quad h^2[h\cos(\theta+\alpha)\pm\{R^2-h^2\sin^2(\theta+\alpha)\}^{\frac{1}{2}}]^2\sin^2(\theta+\alpha)/[R^2-h^2\sin^2(\theta+\alpha)]$

For transforms about a point in the plane, an expression in $\overset{o}{s}{}^2$ is derived readily from the $\cos\theta$ intercept format, 14b, and has 10th degree ordinal rank (eq. 21a). The corresponding transcendental expression is 21b. For the 0° and 180° transforms, one substitutes $y = (h^2-R^2)/x$ and $y = (R^2-h^2)/x$ in 21a, which yields eqs. of 14th degree subordinal rank.

Inversions and Circumpolar Symmetry

The inversion of curves through foci has been studied since the first
examples were given by Quetelet in 1825, while self-inversion first was
discussed by Moutard in 1864. The positive and negative self-inversions of
the circle discussed above are well known. One of the new aspects of inversions
that is treated here has to do with the relationships between the symmetry
properties of the basis and inverse curves relative to the poles about which
the inversions take place.

CIRCUMPOLAR MAXIM 3: *Highly symmetrical curves invert to one another through
poles on their lines of symmetry. For curves of even
degree, the higher the circumpolar symmetry rank of the
pole of inversion, the higher, in general, the circum-
polar symmetry rank of the inverse curve.*

The centered circle (including the point-circle) and lines passing through
the polar pole are the most symmetrical curves of finite degree in the polar
coordinate system. Corresponding to the high symmetry of these two curves, it
is found that the circle inverts to itself through its highest-ranking circum-
polar focus, the center, and to the line through any point on its second-highest
ranking circumpolar focus, namely the curve itself. Moreover, for the appropri-
ate selection of the unit of linear dimension, the circle also self-inverts
through any non-incident, non-central point in the plane. Points in the plane
also fall into non-focal self-inversion loci, and these also are circular. In
a complementary fashion, the line self-inverts about any incident point and
inverts to the circle about any non-incident point.

Another example is provided by the highly symmetrical equilateral limacon
and its focal inversions (Table VI-1). The highest-ranking circumpolar focus
of limacons is the DP (or its homologues), through which this subspecies inverts
to the equilateral hyperbola (a curve of such high symmetry as to share proper-
ties with the circle and line). The next-highest-ranking focus of limacons is
the variable focus at $x = (a^2 - b^2)/2b$, through which the curves self-invert
(limacons are among the curves with the highest-ranking circumpolar symmetry;
see Table V-1). The third-highest-ranking circumpolar focus of a limacon is
the $x = -\frac{1}{2}b$ focus, through which the equilateral subspecies inverts to the

Table VI-1. Inversions of Some Equilateral Axial QBI Curves

Equilateral Basis Curve	Pole of Inversion	Equilateral Inversion Locus	Reciprocal Inversion Pole
limacon	DP focus	hyperbola	traditional foci
	$(a^2-b^2)/2b$ focus	self	$(a^2-b^2)/2b$ focus
	$-\frac{1}{2}b$ focus	lemniscate	"loop focus"
	$(a-b)$ vertex focus	strophoid	$(1+2^{\frac{1}{2}})a/(1\frac{1}{2}+2^{\frac{1}{2}})$
	$-(a+b)$ vertex focus	strophoid	$(1-2^{\frac{1}{2}})a$
hyperbola	traditional foci	limacon	DP focus
	center focus	lemniscate	center (DP) focus
	vertex foci	strophoid	DP focus
lemniscate	center (DP) focus	hyperbola	vertex foci
	"loop foci"	limacon	$-\frac{1}{2}b$ focus
	vertex foci	strophoid	$x = 2a$
strophoid	DP focus	hyperbola	vertex foci
	loop-vertex focus plus variable focus (2 foci in coincidence)	self	loop-vertex focus plus variable focus
	asymptote-point focus ($x = -a$)	*3a post-focal quartic*	large-loop vertex focus
	loop pole at $x = 2a/3$	*pseudo-exchange-limacon*	small-loop vertex focus
	$x = 2a$	lemniscate	vertex foci
	$x = (1-2^{\frac{1}{2}})a$	limacon	$-(a+b)$ vertex focus
	$x = (1+2^{\frac{1}{2}})a/(1\frac{1}{2}+2^{\frac{1}{2}})$	limacon	$(a-b)$ vertex focus

equilateral lemniscate, which also is the inversion locus of the equilateral hyperbola about its center (and a member of the highly symmetrical root-cos$^2\theta$ group; see Table V-1).

The inversion locus about each of the axial vertices, the lowest-ranking foci on the line of symmetry of a limacon, is the highly symmetrical equilateral strophoid. The latter has the lowest circumpolar symmetry rank of the inversion loci mentioned. It is the only one of these loci that does not possess a valid transform in the *linear specific symmetry class*. Accordingly, it belongs to a phylum of lesser circumpolar symmetry, namely, the *phylum of 2nd degree*. It will be noted (Table VI-1) that possession of focal rank (or lack thereof) by an inversion pole does not imply focal rank (or lack thereof) for the pole of the reciprocal inversion.

A fundamental limitation of the inversion transformation, from the point of view of its utility for the analysis of the circumpolar symmetry of curves, is that it is a *single-vector transformation*, in which the intercepts along a single vector emanating from a fixed reference pole are positively or negatively *reciprocally reflected* through the reference pole to yield a transformation locus of a single shape.

The intercept transformation, in contrast, is a *two-vector transformation* in which the intercepts along two generally differently-directed vectors from a fixed reference pole are *copied directly* (as opposed to having their reciprocals taken) and plotted orthogonally to yield transformation loci of a shape that generally is different for each specified angle between the two radius vectors.

Although, in an inversion transformation, the reciprocal "reflection" through the reference pole need not be along the line of the radius vector itself, "reflection" at other angles merely produces congruent, though rotated, loci. Only in the case of self-inversion does the angle of reciprocal "reflection" of the vector from the pole to the curve become a determinant factor (see Chapter XII, α-*Self-Inversion: Reciprocal Reflective Symmetry Through a Point Along Radii At an Angle,* α).

As a consequence of these fundamental differences between the two transformations, Inversion Taxonomy classifies curves from a relatively narrow

base, whereas Circumpolar Symmetry Taxonomy does so by a deep-probing paradigm that is capable of taking both their angle-dependent and angle-independent symmetry properties into precise account.

The Parabola

The Simple Intercept Equation and the α-Transform

I take as the basis curve the parabola 22a, with its line of symmetry parallel to the x axis and employ an x+h translation along the direction of the x axis and a y-k translation along the direction of the y-axis, giving eq. 22b. As mentioned above, throughout the treatment of circumpolar symmetry the origin, whether in polar or rectangular coordinates, always is the pole about which the "scanning" radii rotate (or about which the curve is rotated).

(a) $y^2 = 2px$ basis parabola (6-22)

(b) $(y-k)^2 = 2p(x+h)$ translated basis parabola

(a) $x^2\sin^2\theta - 2x(k\sin\theta + p\cos\theta) + (k^2 - 2ph) = 0$ simple mixed-transcendental intercept eq. in θ (6-23)

(b) $y^2\sin^2(\theta+\alpha) - 2y[k\sin(\theta+\alpha) + p\cos(\theta+\alpha)] + (k^2 - 2ph) = 0$ simple intercept eq. in θ+α

For a parabola opening to the right, an x+h translation (for h positive) usually brings the origin--the pole of rotation--within the curve, since it translates the vertex to the left. A y-k translation (for k positive) translates the curve upward, i.e., in the positive y direction. Rotation of the axes leads to eq. 23a, the *simple mixed-transcendental intercept equation*. Examination thereof reveals the first focal condition on transforms about a point in the plane, namely $k^2 = 2ph$. When this condition is fulfilled, which means that the pole of rotation is incident upon the curve, the α-transform reduces from 32nd degree, making the curve itself a curvilinear focal locus.

To obtain the α-transform about a point in the plane, one now substitutes y for x and θ+α for θ in eq. 23a, yielding 23b; θ then is eliminated between 23a and 23b, yielding a 32nd degree eq. in x and y. Since this eq. is very complex, transforms are derived instead for specific angles.

Intercept Products and 0° and 180° Transforms

Employing angles of 0° and 180°, one obtains from eqs. 23a,b the *compound intercept formats*, 24a,b. Here and in the following, wherever applicable, the upper of the alternate signs is for the 0° transform and the lower one for the 180° transform.

(a) $\sin^2\theta = \dfrac{\pm(k^2-2ph)}{xy}$ (b) $xy = \dfrac{\pm(k^2-2ph)}{\sin^2\theta}$

compound intercept format and "pure" intercept product (6-24)

Eq. 24b is the simple expression for the *"pure" intercept products* for chord segments to the curve from any interior point and coincident radii from any exterior point. The similarities to, and differences from, the intercept products for the circle are those to be expected; the single curve-size parameter p (the focus-directrix distance) appears instead of R, while the vertex-displacement parameters h and k appear in place of h alone, the displacement of the center of the circle along the x-axis. Additionally, the product for the parabola depends upon the angle, θ, that the chord segments or coincident radii make with the x-axis.

Elimination of θ from 23a and 24a leads to the 8th degree eqs. 25, representing the 0° and 180° transforms about a point in the plane. This point is at (h,-k) relative to the parabola in standard position but is at the origin for transforms, since eq. 22b translated the vertex to (-h,k). The condition for a focal locus is that the degree of eq. 25 reduce from 8. Only 4 possibilities for reduction in degree exist; $A^2=0$, an xy term may be factored out, an (x\pmy) term may be factored out, or a root may be taken.

$$16p^4x^4y^4 \mp 32p^2A^2(k^2+p^2)x^3y^3 + 16A^4(k^2+p^2)^2x^2y^2 \pm \qquad (6\text{-}25)$$

$A^2 = (k^2-2ph)$ $\qquad 8A^6(p^2-k^2)(x+y)^2xy - 8A^4p^2x^2y^2(x\pm y)^2 + A^8(x\pm y)^4 = 0$

$$\{\pm 4xy[p^2xy\mp A^2(k^2+p^2)]\}^2 - 8A^4xy(x\pm y)^2[p^2xy\mp(p^2-k^2)A^2] + A^8(x\pm y)^4 = 0 \quad (6\text{-}26)$$

$A^2=0$ (an incident point) is excluded and there is no possibility to factor an xy or (x\pmy) term. To take a root, eq. 25 must fall into a perfect square. This can occur if the eq. partitions into right and left members, each of which is a perfect square, or if the entire polynomial is a perfect square. Both occurrences are common in circumpolar symmetry analyses.

The former possibility is eliminated readily. To investigate the possibility

for the entire polynomial expression falling into a perfect square, eq. 25 is
regrouped and rearranged, yielding eq. 26. The alternate sign of the $\pm 4xy$
term of eq. 26 is a true alternate that holds for both the 0° and 180° trans-
forms. It is evident that reduction can occur only for the case $k = 0$, for
which the line of symmetry is coincident with the x-axis, whereupon one
obtains the root eq., 27, where the alternate sign to the far left continues

$$\pm xy(xy \pm 2ph) = h^2(x \pm y)^2 \qquad \text{roots of eq. 26 for } k = 0 \qquad\qquad (6\text{-}27)$$

(a) $x^2y^2 = h^2(x+y)^2 - 2phxy \qquad 0^\circ$ line-of-symmetry transform $\qquad\qquad (6\text{-}28)$

(b) $x^2y^2 = h^2(x-y)^2 + 2phxy \qquad 180^\circ$ line-of-symmetry transform

to hold for both solutions. Eq. 27 yields 28a for the 0° line-of-symmetry
transform that holds for two positive intercepts about axial poles exterior
to the parabola and 28b for the 180° line-of-symmetry transform for two
positive intercepts about interior axial poles.

[The derivation of algebraically complete transform eqs. that are valid for all
combinations of positive and negative intercepts is illustrated in Chapter VII,
*Negative Intercepts, Trivial Transforms, the Degree of Transforms, and the
Duality of 0° and 180° Transforms.*]

The condition for the existence of a point focus (with a non-trivial 0° or
180° transform) lying on the line of symmetry is that 28b for the 180° trans-
form reduce for interior axial points, i.e., for some positive value of h,
or that eq. 28a for the 0° transform reduce for exterior axial points, i.e.,
for some negative value of h. It is apparent that 28a will not yield a
perfect square for any negative value of h, but that 28b will yield a perfect
square uniquely for the value $h = p/2$, the location of the traditional focus
of the parabola (x+h translation)--whereupon 28b reduces to the 180° equi-
lateral hyperbolic transform given in three forms as eqs. 29.

(a) $xy = a(x+y)$ \qquad (b) $\dfrac{2xy}{(x+y)} = 2a$ \qquad (c) $\dfrac{1}{x} + \dfrac{1}{y} = \dfrac{1}{a}$ $\qquad (6\text{-}29)$

Accordingly, the 0° and 180° intercept transform analyses of the parabola
reveal that points in the plane have 8th degree transforms. The only focal loci
that exist for these angles that give non-trivial transforms are the external
axis for 0° (eq. 28a), the internal axis for 180° (eq. 28b), and the traditional
focus for 180° (eq. 29a). The transforms about points on the axis (line of
symmetry) are of 4th degree, while the transform for the focus is of 2nd degree;
specifically the latter is an equilateral hyperbola.

The $90°$ Transforms and α-Transforms

The Curve and the Axial Vertex

Returning now to eq. 23a, that revealed the curve itself to be a focal locus, one sets $k^2 = 2ph$, yielding 30a. To derive the $90°$ *compound intercept format*

(a) $x\sin^2\theta - 2(k\sin\theta + p\cos\theta) = 0$ (b) $y\cos^2\theta - 2(k\cos\theta - p\sin\theta) = 0$ (6-30)

(c) $xy = \dfrac{4(k\sin\theta + p\cos\theta)(k\cos\theta - p\sin\theta)}{\sin^2\theta\cos^2\theta}$ $90°$ intercept product

(a) $(kx + py)\sin^2\theta - 2(k^2 + p^2)\sin\theta - py = 0$ compound intercept eq. (6-31)

(b) $\sin\theta = \dfrac{(k^2 + p^2) \pm [(k^2 + p^2)^2 + py(kx + py)]^{\frac{1}{2}}}{(kx + py)}$ compound intercept format

about points on the curve, one first obtains the eq. for the y intercept by substituting y for x and $(\theta + 90°)$ for θ in 30a, yielding 30b. One next eliminates $\cos\theta$ from 30a and 30b, yielding eq. 31a and the $\sin\theta$ compound intercept format, 31b. Note that eqs. 30a,b also yield a simple expression, 30c, for the $90°$ intercept product, i.e., the product of the intercepts with the curve of radii that emanate from any point thereon at $90°$ to one another. Eliminating θ from eqs. 30a and 31b gives a 12th degree eliminant in x and y that is the $90°$ transform for all points on the curve, but is too complex to illustrate (but see Chapter XIV, *$90°$ Transforms*).

In the cases of the $0°$ and $180°$ transforms derived above, the axial vertex, being a point on the curve, has only trivial transforms. In the case of a $90°$ transformation, however, transforms exist for all points on the curve. The focal condition for the vertex is that the degree of the $90°$ transform reduce below 12 (the latter being the degree for transforms about all unexceptional points on the curve). To obtain the transform for the vertex from the intercept eqs., one simply lets $k = 0$ in 30a, which allows recasting the eq. in terms of $\cos\theta$ alone, giving 32a. Solving for $\cos\theta$ and letting $p = 2a$ gives the $\cos\theta$ simple intercept format, 32b, whence the α-transform, 33, for the vertex is readily derived. Elimination of the radicals leads to a 16th degree eq. For a $90°$ transformation, the cross-product term vanishes from eq. 33. The resulting transform, 34, about the vertex is 8th degree.

(a) $x\cos^2\theta + 2p\cos\theta - x = 0$ (b) $\cos\theta = \dfrac{-2a + (4a^2+x^2)^{\frac{1}{2}}}{x}$ (6-32)

$$y^2(A-2a)^2 + x^2(B-2a)^2 - 2xy(A-2a)(B-2a)\cos\alpha = x^2y^2\sin^2\alpha \qquad (6\text{-}33)$$

$$A = (4a^2+x^2)^{\frac{1}{2}} \qquad B = (4a^2+y^2)^{\frac{1}{2}}$$

$$x^4y^4 = (4a)^6(x^2+y^2) + 3(4a)^4x^2y^2 \qquad \begin{array}{l}90^\circ \text{ vertex} \\ \text{transform}\end{array} \qquad (6\text{-}34)$$

The Axis and the Traditional Focus

Eq. 35 is the simple intercept format for a parabola, $y^2 = 4a(x+h)$, with its line of symmetry coincident with the x-axis and vertex at $-h$. Substituting in the *cosθ transformation format* (eq. 9) yields a complex α-transform of 16th degree for points on the x-axis. For $\alpha = 90^\circ$ the transform simplifies somewhat (eq. 36) but remains of 16th degree. In fact, it is clear from in-

$$\cos\theta = \dfrac{-2a + (4a^2-4ah+x^2)^{\frac{1}{2}}}{x} \qquad \begin{array}{l}\text{simple intercept} \\ \text{format}\end{array} \qquad (6\text{-}35)$$

$$\{[(8a^2-4ah)(x^2+y^2)+x^2y^2]^2 - 16a^2(A^2y^4+B^2x^4)\}^2 = 32^2a^4A^2B^2x^4y^4 \qquad (6\text{-}36)$$

$$A^2 = (4a^2-4ah+x^2) \qquad B^2 = (4a^2-4ah+y^2) \qquad \begin{array}{l}90^\circ \text{ transform about} \\ \text{a point on the x axis}\end{array}$$

spection of the α-transform that it will remain of 16th degree for all angles of transformation except 0° and 180°.

The criterion for the existence of a point focus on the x-axis is that eq. 36 reduce. The left member already is a perfect square, and it is evident that for $h = a$, the right member also will become a perfect square. Accordingly, for $h = a$, 36 reduces to the 8th degree eq. 37a. On regrouping terms, 37a also becomes a perfect square and further reduces to 37b or 37c. These are merely alternative expressions for the 4th degree 90° transform about the focus.

(a) $[4a^2(x^2+y^2)+x^2y^2]^2 - 16a^2x^2y^2(x^2+y^2) = 32a^2x^3y^3$ (6-37)

(b) $4a^2(x^2+y^2) + x^2y^2 = 4axy(x+y)$ (c) $[2a(x+y)-xy]^2 = 8a^2xy$

$$[128a^4x^2y^2+x^4y^4]^2 = 32^2a^4x^4y^4(4a^2+x^2)(4a^2+y^2) \qquad \begin{array}{l}90^\circ \text{ vertex} \\ \text{transform}\end{array} \qquad (6\text{-}38)$$

For $h = 0$, when the vertex is at the origin, eq. 36 simplifies to 38, from which x^4y^4 will factor, giving a reduction to 8th degree. Multiplying out and combining and cancelling terms leads to a simplification to the 90° vertex

transform given above (eq. 34). Eq. 36 also obtains for the x axis external to the curve, although no 90° transforms with real solutions exist beyond x = -h.

Thus far in this analysis, 4 circumpolar foci of the parabola have been detected: the line of symmetry, the traditional focus, the axial vertex, and the curve itself. The existence of a *covert linear focal locus* orthogonal to the line of symmetry has been ruled out by the analysis of eqs. 25 and 26; if such a locus intersected the curve, eq. 25 or 26 would reduce for some specific value of h for 180° transforms, while if one existed external to the curve, reduction would occur for 0° transforms. Since no reduction other than that given by k = 0 is possible, there can be no covert linear focal locus. This conclusion is the essence of Maxim 1, according to which, if no circumpolar focus of a curve exists at a specific valid locus for either the 0° or 180° transform, no focus exists for any angle of transformation.

The Latus Rectum Vertices

On the other hand, the existence of other foci *on the curve* cannot be ruled out by the 0° and 180° analyses, since at these angles a point on a quadratic curve is not a valid focal locus. It is difficult to work with the 12th degree eliminant of eqs. 30a and 31b (the general eq. for 90° transforms about points on the curve). Accordingly, consider, instead, the eq. for 90° transforms about the points of intersection of the latera recta with the curve. These points are the only likely locations for other foci on the curve. The starting eq. is 39, for a parabola cast about the point (p/2,-p) relative to the curve

$$(y-p)^2 = 2p(x+p/2) \qquad \text{basis curve} \qquad (6\text{-}39)$$

$$\text{(a)} \quad x^2\sin^2\theta - 2px\sin\theta = 2px\cos\theta \qquad \begin{array}{c}\text{simple mixed-transcendental} \\ \text{intercept equation}\end{array} \qquad (6\text{-}40)$$

$$\text{(a')} \quad x\sin^2\theta - 2p\sin\theta = 2p\cos\theta \qquad \text{(b)} \quad y\cos^2\theta - 2p\cos\theta = -2p\sin\theta$$

$$\sin\theta = \frac{2p \pm (4p^2+xy+y^2)^{\frac{1}{2}}}{(x+y)} \qquad \text{coumpound intercept format} \qquad (6\text{-}41)$$

90° transform about the LR vertices

$$x^4y^4 - 2(2p)^2x^2y^2(x^2+y^2) + (2p)^4(y^4+4y^3x+6y^2x^2-4yx^3+x^4) = \qquad (6\text{-}42)$$

$$8(2p)^6(x^2+y^2)$$

in standard position, i.e., with its lower LR vertex at the origin. The simple mixed-transcendental intercept eq. cast about this vertex is 40a, from which an x factors out immediately, 40a', a sure sign of focal rank at the lower LR vertex, because factoring out an x automatically leads to reduction in the degree of the transforms. This does not, however, signify that the lower LR vertex is a point focus, since it lies on a focal locus. When $\cos\theta$ is eliminated between the simple mixed-transcendental intercept eqs. for the $90°$ transformation (40a' and 40b), the compound intercept format, 41, is obtained.

Eliminating θ between eqs. 40a' and 41 yields a 12th degree eq. in x and y, from which a term $(x+y)^4$ factors out, giving the 8th degree $90°$ transform, 42. Accordingly, the LR vertices have focal rank. Comparison of eq. 42 with eq. 34, the corresponding $90°$ transform for the *axial* vertex, reveals that the latter possesses by far the higher *subfocal rank* (by virtue of its much greater simplicity). It is noteworthy that one term in eq. 42 differs from the polynomial expansion of $(y+x)^4$ only in the sign of the $4yx^3$ term. This is a not infrequent occurrence among intercept transforms, namely, the possession of polynomial expressions that differ from perfect squares, cubes, etc., only because of the sign or value of one of the coefficients. It is by virtue of the asymmetry in this term that eq. 42 lacks being a symmetric function.

Subfocal Rank of the Directrix, Vertex Tangent,
 and Latus Rectum

As a last analysis, consider the comparative subfocal ranks of points on 3 lines orthogonal to the line of symmetry of the parabola--the directrix, the vertex tangent, and the LR. For the first two, it is the $0°$ transforms that are of interest, while for the LR, it suffices to examine the $180°$ transforms. Setting $h = -\frac{1}{2}p$, 0, and $+\frac{1}{2}p$, respectively, in eq. 26 yields the transforms, 43a-c, for points on these lines. From comparisons of these eqs., it would appear that the highest subfocal rank of points on the 3 lines is possessed by points on the vertex tangent line, 43b. The validity of this comparative

(a) $16x^2y^2[p^2xy-(k^2+p^2)^2]^2+(x+y)^4(k^2+p^2)^4 = 8xy(x+y)^2(k^2+p^2)^2[p^2xy-(p^4-k^4)]$

(b) $16x^2y^2[p^2xy-k^2(k^2+p^2)]^2+(x+y)^4k^8 = 8xy(x+y)^2k^4[p^2xy-k^2(p^2-k^2)]$ (6-43)

(c) $16x^2y^2[p^2xy+(k^4-p^4)]^2+(x-y)^4(k^2-p^2)^4 = 8xy(x-y)^2(k^2-p^2)^2[p^2xy-(k^2-p^2)^2]$

(a) $xy = (k^2+p^2)/\sin^2\theta$ (b) $xy = k^2/\sin^2\theta$ (c) $xy = (p^2-k^2)/\sin^2\theta$ (6-44)

ranking also is evident from inspection of eqs. 44a-c for the corresponding intercept products for all points lying on the lines. Recall, in this connection, that all of the polar-linear eqs. of the parabola cast about these lines belong to the highly symmetrical *linears*.

Ordinal and Subordinal Rank

As examples of ordinal and subordinal rank, consider the transforms about the traditional focus. In all cases, the transcendental eqs. also are given. The ordinal rank at all transformation angles is 3rd degree, defined by eq. 45a.

(a) $\quad a\overset{o}{s}{}^2 = (x^3+y^3) - a(x^2+y^2)$
(a') $\quad \overset{o}{s}{}^2 = \dfrac{4a^2\sin^2\theta}{(\cos\theta-1)^4} + \dfrac{4a^2\sin^2(\theta+\alpha)}{[\cos(\theta+\alpha)-1]^4}$ \quad (6-45)

(a) $\quad a\overset{o}{s}{}^2 = 2x^2(x-a)$
(a') $\quad \overset{o}{s}{}^2 = \dfrac{8a^2\sin^2\theta}{(\cos\theta-1)^4}$ $\quad\quad$ (6-46)

(b) $\quad a\overset{o}{s}{}^2(x-2a)^6 = x^3(x-2a)^6 + 8x^3[ax\pm2a(ax-a^2)^{\frac{1}{2}}]^3 -$

$$ax^2(x-2a)^2\{(x-2a)^4+4[ax\pm2a(ax-a^2)^{\frac{1}{2}}]^2\}$$

(b') $\quad \overset{o}{s}{}^2 = \dfrac{4a^2\sin^2\theta}{(\cos\theta-1)^4} + \dfrac{4a^2\cos^2\theta}{(\sin\theta+1)^4}$ \quad (c') $\quad \overset{o}{s}{}^2 = \dfrac{4a^2\sin^2\theta}{(\cos\theta-1)^4} + \dfrac{4a^2\sin^2\theta}{(\cos\theta+1)^4}$

(c) $\quad a(x-a)^3\overset{o}{s}{}^2 = x^6 - 4x^5a + 6x^4a^2 - 4a^3x^3 + 2x^2a^4$

Subordinal ranks for the 0°, 90°, and 180° transforms are defined by eqs. 46a,b,c, respectively. Eq. 46b becomes 16th degree when the radical is eliminated, which establishes the subordinal rank of the 90° transform. The transcendental eqs. are expressed as the sum of the $\overset{o}{x}{}^2$ and $\overset{o}{y}{}^2$ contributions (except for 46a), the former of which remains constant and the latter of which is the identical function in $(\theta+\alpha)$.

In summary, the parabola possesses 6 loci with circumpolar focal rank. Of these, the traditional focus has the highest rank, followed by the axial and LR vertices, of which the axial vertex has the highest subfocal rank. The curve itself has the next-highest focal rank, while the line of symmetry of the curve has lowest focal rank (see Table VII-1).

Introduction

From the point of view of circumpolar symmetry, the ellipse and the hyperbola are so closely related that it is preferable to treat both together, drawing parallels and pointing out differences as they arise. Virtually every eq. for these conic sections and their transforms and other properties is identical except for the signs of terms, though differences in sign, of course, can lead to marked differences in properties.

In the following, dual eqs. representing both curves often are used, with the upper of the two alternate signs always applying to the hyperbola and the lower to the ellipse. In some cases, only the eq. for the one or the other curve is given as an example, or both are given separately. In all noteworthy instances, eqs. also are given for the equilateral hyperbola.

Transforms of 0° and 180°

I begin with the general eq. of a central conic cast about a point in the plane and employing $x-h$ and $y-k$ translations, which displace the centers upward and to the right (assuming h and k to be positive). Accordingly

$$b^2(x-h)^2 \mp a^2(y-k)^2 = a^2b^2 \qquad (7\text{-}1)$$

(a) $x^2(b^2-a^2)\cos^2\theta - 2b^2hx\cos\theta + a^2x^2 + (b^2h^2+a^2k^2-a^2b^2) = 2a^2kx\sin\theta \qquad (7\text{-}2)$

(b) $x^2(b^2+a^2)\cos^2\theta - 2b^2hx\cos\theta - a^2x^2 + (b^2h^2-a^2k^2-a^2b^2) = -2a^2kx\sin\theta$

formats and transforms generally will be cast about the left focus, left vertex, left LR, left lower LR vertex, etc. Because alternate signs also are employed in eqs. that represent the 0° and 180° transforms, the practice is followed in this section of giving an eq. for the ellipse above or to the left, labelled (a), and an eq. for the hyperbola below or to the right, labelled (b). If an eq. also is given for the equilateral hyperbola, it is labelled (c).

The simple intercept eqs. 2a,b are obtained from eqs. 1 by CCW rotation of the axes. As was the case for the parabola, the simple intercept eqs. reveal the curve itself to be a focal locus, for if $b^2h^2+a^2k^2 = a^2b^2$ for the ellipse,

or $b^2h^2-a^2k^2 = a^2b^2$ for the hyperbola, an x will factor out from the corresponding eq., with consequent reduction of the degree of the transform about points incident upon the curve.

CIRCUMPOLAR MAXIM 4: *In the simple intercept equation cast about a point in the plane, the vanishing of the constant term gives the focal condition for points incident upon the curve (the constant term equated to 0 is, in fact, merely the equation of the curve in* h *and* k *rather than* x *and* y*). In simple intercept equations for points on a linear focal locus, the vanishing of the constant term gives the focal condition for vertices.*

I proceed with the $0°$ and $180°$ analyses by obtaining the y intercepts for transformations at these angles and eliminating $\sin\theta$ between the two intercept eqs., thereby obtaining the compound intercept formats about a point in the plane. For conics, these are uniquely expressible as "pure" intercept products in a very simple form, $xy = f(\theta,h,k)$, as in 3a-c (see Chapter XIV, *"Pure" Intercept Products*). If the pole of the intercept transformation (which always is at the origin) lies on the major or transverse axis, the minor or conjugate axis, the LR, or is at the center, or the traditional focus, the denominators of these expressions are unchanged but the numerators become the polynomials of 4a-c. When an intercept product is negative, either a negative intercept is involved or the solution is complex or imaginary.

ellipse	hyperbola

(a) $\quad xy = \dfrac{\mp(a^2b^2-b^2h^2-a^2k^2)}{(b^2-a^2)\cos^2\theta+a^2}$

(b) $\quad xy = \dfrac{\pm(b^2h^2-a^2k^2-a^2b^2)}{(a^2+b^2)\cos^2\theta-a^2}$ (7-3)

(c) $\quad xy = \dfrac{\pm(h^2-k^2-a^2)}{(2\cos^2\theta-1)}$ equilateral hyperbola

transverse or major axis	conjugate or minor axis	LR	center	focus		
(a) $\mp b^2(a^2-h^2)$	$\mp a^2(b^2-k^2)$	$\mp(b^4-a^2k^2)$	$\mp a^2b^2$	$\mp b^4$	ellipse	(7-4)
(b) $\pm b^2(h^2-a^2)$	$\mp a^2(b^2+k^2)$	$\pm(b^4-a^2k^2)$	$\mp a^2b^2$	$\pm b^4$	hyperbola	
(c) $\pm(h^2-a^2)$	$\mp(a^2+k^2)$	$\pm(a^2-k^2)$	$\mp a^2$	$\pm a^2$	equilateral hyperbola	

The *coincident-radii intercept products* (upper signs) hold when the pole of the transformation is outside the ellipse, while the *chord-segment intercept products* (lower signs) hold when it is within the ellipse. For the hyperbola, both the $0°$ coincident-radii and $180°$ chord-segment intercept products exist for all non-incident points (though the solutions are not real for all angles). For incident points, one of the intercepts always is 0; for these points the numerators are identically 0.

[Coincident-radii intercept products correspond to the $0°$ transform, in which the two radii are taken to be positive if they emanate from the pole in the same direction, whereas chord-segment intercept products correspond to $180°$ transforms in which the two radii are taken to be positive if they are oppositely directed from the pole.]

If θ is eliminated between eqs. 2 and 3, 8th degree $0°$ and $180°$ transforms about a point in the plane are obtained. Eqs. 5 are those for a hyperbola. For a focus to exist at a specific pole designated by coordinates (h,k), eqs. 5 must reduce in degree at that locus ($h,k = 0,0$ would be for the pole at the center; $h,k = a,0$, for a pole at the left vertex; $h,k = h,0$, for a pole on the major or transverse axis, etc.).

$0°$ and $180°$ transforms of a hyperbola about a point in the plane

$$[A^8(x\pm y)^2(a^2+b^2) + 4a^2b^2x^2y^2(b^2h^2-a^2k^2) \pm 4A^4xy(b^4h^2+a^4k^2)]^2 = \qquad (7\text{-}5)$$

$$16A^8(a^2+b^2)b^4h^2xy(x\pm y)^2(a^2xy\pm A^4)$$

$$A^4 = (b^2h^2-a^2k^2-a^2b^2)$$

$0°$ and $180°$ transforms of an ellipse about a point in the plane

(a) $$16x^2y^2[a^2b^2(b^2h^2+a^2k^2)xy\mp A^4(b^4h^2+a^4k^2)]^2 + A^{16}(b^2-a^2)^2(x\pm y)^4 + \qquad (7\text{-}6)$$

$$8A^8(b^2-a^2)(x\pm y)^2xy[a^2b^2(b^2h^2-a^2k^2)xy\pm A^4(a^4k^2-b^4h^2)] = 0$$

$0°$ and $180°$ transforms of a hyperbola about a point in the plane

(b) $$16x^2y^2[a^2b^2(b^2h^2-a^2k^2)xy\pm B^4(b^4h^2+a^4k^2)]^2 + B^{16}(a^2+b^2)^2(x\pm y)^4 -$$

$$8B^8(a^2+b^2)(x\pm y)^2xy[a^2b^2(a^2k^2+b^2h^2)xy\mp B^4(a^4k^2-b^4h^2)] = 0$$

$$A^4 = (b^2h^2+a^2k^2-a^2b^2) \qquad\qquad B^4 = (b^2h^2-a^2k^2-a^2b^2)$$

The possibility that the entire polynomials are perfect squares is investigated first by casting eqs. for an ellipse and hyperbola in the form 6a,b,

analogous to eq. VI-26 for the parabola (note that the first two terms are perfect squares while the 3rd is the potential cross-product term). Inspection of eqs. 6 reveals that for both ellipses and hyperbolas, the condition $k = 0$ leads to the polynomial being a perfect square, whereupon the eqs. reduce to 7a,b, which are the 0° and 180° transforms about points on the major or transverse axis.

For a point focus to exist on either axis, eqs. 7, in turn, must reduce. For a pole at $h^2 = a^2-b^2$, the 180° transform for a point on the major axis of an ellipse (7a) reduces to 8a, which is the transform about a traditional focus. The axial 180° transform, 7b, reduces for $h^2 = a^2+b^2$, which yields the corresponding transform of a hyperbola about a traditional focus. Hyperbolas also have a non-trivial, non-redundant 0° transform, 8b-0°, by virtue of the possession of two arms. Eqs. 8a and 8b-180° are the congruent and coincident transforms of the *monoconfocal* hyperbola-ellipse pair, with identical parameters a and b (see Chapter V).

Figs. 5-1

roots of eqs. 6a,b for points on the major or transverse axis

(a) $\quad 4a^2h^2x^2y^2 = (a^2-b^2)(h^2-a^2)^2(x \pm y)^2 \pm 4b^2h^2(h^2-a^2)xy \qquad$ ellipse \qquad (7-7)

(b) $\quad 4a^2h^2x^2y^2 = (a^2+b^2)(h^2-a^2)^2(x \pm y)^2 \mp 4b^2h^2(h^2-a^2)xy \qquad$ hyperbola

5-1 \quad (a) $\quad 2axy = b^2(x+y) \qquad$ (a') $\quad \dfrac{2xy}{x+y} = \dfrac{b^2}{a} \qquad \begin{array}{l} 180^{\circ} \text{ transform of an ellipse} \\ \text{about a traditional focus} \end{array} \quad$ (7-8)

5-1 \quad (b) $\quad 2axy = b^2(x+y) \qquad$ (b') $\quad \dfrac{2xy}{x+y} = \dfrac{b^2}{a} \qquad \begin{array}{l} 180^{\circ} \text{ transform of a hyperbola} \\ \text{about a traditional focus} \end{array}$

\quad (c) $\quad 2axy = b^2(x-y) \qquad$ (c') $\quad \dfrac{2xy}{x-y} = \dfrac{b^2}{a} \qquad \begin{array}{l} 0^{\circ} \text{ transform of a hyperbola} \\ \text{about a traditional focus} \end{array}$

\quad (d) $\quad [2axy-b^2(x+y)][2axy+b^2(x+y)] = 0 \qquad \begin{array}{l} \text{8a for 2 positive intercepts} \\ \text{and for 2 negative intercepts} \end{array}$

\quad (e) $\quad [2axy-b^2(x-y)][2axy+b^2(x-y)] = 0 \qquad$ 8c for exchangeable intercepts

Reorganizing eqs. 8a,b yields 8a',b'. These eqs. have been known for many years. Together with eqs. VI-29 for the parabola, they express the fact that "the harmonic mean between the segment lengths of a focal chord of a conic is constant and equal to the semi-latus rectum." As pointed out in the *Foreword*, they can be used to define the traditional focus of conic sections. But their

significance in relation to the circumpolar symmetry of the curves was un-known. These now are seen to characterize the 180° *equilateral hyperbolic specific symmetry class* of all conic sections about the traditional foci. Eqs. 8c,c' do not appear to have been known.

Eqs. 8a,a' and 8b,b' are valid for two positive intercepts. If two negative intercepts also are to be represented, the eqs. take the degenerate form of 8d (which holds for both ellipses and hyperbolas). Although the degree of these eqs. is 4, the individual transforms remain of 2nd degree. For comparative purposes, whenever a transform eq. is degenerate, the degree of the transform for the particular pole and angle is taken to be that of the lowest degree factor of the transform eq. If trivial transforms also were to be taken into account by eq. 8d, an additional multiplicative term (x+y) would have to be included. These matters are discussed in detail at the end of the Chapter (*Negative Intercepts, Trivial Transforms, the Degree of Transforms, and the Duality of 0° and 180° Transforms*).

Eqs. 8c,c', on the other hand, represents x intercepts on the contralateral arm and y intercepts on the basis arm. If the intercepts are to be interchange-able, the degenerate transform 8e applies, where the right multiplicative function takes the exchanged labelling of the intercepts into account. Inclusion of the trivial 0° transform would necessitate multiplication by a term (x-y).

Further examination of eqs. 7 reveals that a perfect square also is obtained for h = 0, the condition for points on the minor or conjugate axis, whereupon the transform becomes 9a,b. Unlike the situation for eqs. 7a,b, except for

<div style="text-align:center">

0° and 180° transforms of central conics for

for points on the minor or conjugate axis

</div>

(a) $4b^2k^2x^2y^2 = (b^2-a^2)(k^2-b^2)^2(x \pm y)^2 \pm 4a^2k^2(k^2-b^2)xy$ ellipse (7-9)

(b) $4b^2k^2x^2y^2 = (a^2+b^2)(k^2+b^2)^2(x \pm y)^2 \mp 4a^2k^2(k^2+b^2)xy$ hyperbola

k = 0 (see below), these eqs. will not reduce, i.e., there are no transforms with real solutions for the reduction conditions $k^2 = b^2-a^2$ for 9a, and $k^2 = -(a^2+b^2)$ for 9b (for transforms with complex solutions, see Chapter XII). Accordingly, aside from the center (k = 0), there can be no real point foci for 0° or 180° transforms on the minor axis of the ellipse or the conjugate axis of the hyperbola (0° and 180° transforms about the ellipse b-vertex give only trivial solutions, as they do for any incident point).

The center, (h,k) = (0,0), which lies at the point of intersection of the

two axial focal loci, is found to have higher focal rank than either of these loci; the conditions $h = 0$, $k = 0$ lead to identical linear transforms, $x = \mp y$, for both curves. The $x = -y$ solution for 0° is the transform eq. for one positive and one negative intercept, while the $x = y$ solution for the 180° transform is for two positive or two negative intercepts; these are the lowest-degree transforms of central conics (excluding the circle; see Table VII-1).

CIRCUMPOLAR MAXIM 5: *Points of intersection of linear and curvilinear focal loci have higher focal rank than either of the intersecting loci* (exceptions: many covert focal loci, and the vertex foci of the ellipse and the hyperbola when they are eclipsed in the circle and the equilateral hyperbola).

These foci do not exhaust the possibilities for focal loci for 0° and 180° transformations of central conics. There is another focal reduction condition on eq. 6b; for $b^2h^2 = a^2k^2$, i.e., when (h,k) is incident upon an asymptote, the term $a^2b^2(b^2h^2-a^2k^2)xy$ vanishes from the left-most squared term. The latter then reduces to 4th degree, leaving the 6th degree cross-product term as the term of highest degree. Accordingly, the asymptotes are circumpolar focal loci, with 0° and 180° transforms given by eqs. 10 (they also are circumlinear foci; see Chapter XII, α-θ-*Circumlinear Symmetry of Quadratics*).

$$16h^4(a^2+b^2)x^2y^2 + a^4(a^2+b^2)(x{\pm}y)^4 =$$
$$8a^2h^2xy(x{\pm}y)^2[2xy{\pm}(a^2-b^2)]$$

0° and 180° transforms about points on the asymptotes $\qquad(7\text{-}10)$

In summary, analyses of central conics to this juncture have revealed the curve itself to be a focal locus--on mere inspection of the simple intercept format--before specification of a transformation angle. In the subsequent 0° and 180° analyses, the major and minor axes of ellipses, the transverse and conjugate axes of hyperbolas, the traditional foci, the centers, and the asymptotes of hyperbolas also were found to have focal rank. Thus, in all, 6 foci of ellipses and 8 foci of hyperbolas have been identified. It will become apparent as the analysis proceeds, that the disparity in the number of loci that have focal rank for 0° and 180° transformations of ellipses and hyperbolas is offset by an equal disparity in the number of foci that have only trivial 0° and 180° transforms (i.e., the vertices), giving both species the identical number of 14 *real* focal loci (see Table X-2, page X-40).

Intercept Equations and Formats

We have noted that for both the parabola and central conics, it is possible to detect the existence of focal loci from examination of the simple intercept eqs. about a point in the plane, before the specification of a transformation angle. Accordingly, it is desirable to illustrate how similar deductions arise from the eqs. for specific curvilinear loci; i.e., given the simple x or y intercept format for a curvilinear locus, it is in general possible to detect the points on the locus having focal rank.

I begin with points on the major axis of the ellipse. For an ellipse having its major axis coincident with the x-axis, $b^2(x-h)^2+a^2y^2 = a^2b^2$, the simple intercept format is found to be eq. 11. A few simple manipulations of the

$$\cos\theta = \frac{b^2h \pm [b^4h^2-(b^2-a^2)(b^2h^2+a^2x^2-a^2b^2)]^{\frac{1}{2}}}{x(b^2-a^2)} \qquad (7\text{-}11)$$

(a) $\quad \cos\theta = \dfrac{(ax-b^2)}{x(a^2-b^2)^{\frac{1}{2}}}$ (b) $\quad \cos\theta = \dfrac{\pm a(x^2-b^2)^{\frac{1}{2}}}{x(a^2-b^2)^{\frac{1}{2}}}$ $\qquad (7\text{-}12)$

(c) $\quad \cos\theta = \dfrac{-ab^2 \pm a[b^4-x^2(b^2-a^2)]^{\frac{1}{2}}}{x(a^2-b^2)}$

radicand reveal that it will be eliminated or simplified greatly for three alternative conditions, $h = (a^2-b^2)^{\frac{1}{2}}$, $h = 0$, and $h = a$. These are the abscissae of the focus, the center, and the vertex, yielding the 3 simplified formats 12a-c, respectively, all of which lead to reduction of the general 16th degree α-transform for points on the x-axis.

The corresponding format for the y-axis is eq. 13. The radicand will simplify

$$\sin\theta = \frac{a^2k \pm [a^4k^2-(a^2-b^2)(a^2k^2+b^2x^2-a^2b^2)]^{\frac{1}{2}}}{x(a^2-b^2)} \qquad (7\text{-}13)$$

(a) $\quad \sin\theta = \dfrac{(-a^2\pm bx)}{x(b^2-a^2)^{\frac{1}{2}}}$ (b) $\quad \sin\theta = \dfrac{\pm b(a^2-x^2)^{\frac{1}{2}}}{x(a^2-b^2)^{\frac{1}{2}}}$ $\qquad (7\text{-}14)$

(c) $\quad \sin\theta = \dfrac{a^2b \pm b[a^4-x^2(a^2-b^2)]^{\frac{1}{2}}}{x(a^2-b^2)}$

greatly for the 3 conditions, $k = (b^2-a^2)^{\frac{1}{2}}$, $k = 0$, and $k = b$, yielding,

respectively, eqs. 14a-c. These eqs. are the simple intercept formats for the imaginary focus at $y = (b^2-a^2)^{1/2}$, for the center, and for the b vertex.

Consider now the simple intercept eqs., 15, for the latera recta of an ellipse (lower signs) and a hyperbola. There are only two possible conditions

$$(b^2\pm a^2)x^2\cos^2\theta - 2b^2(a^2\pm b^2)^{1/2}x\cos\theta + (\mp a^2 k^2 \pm b^4 \mp a^2 x^2) = \mp 2a^2 kx\sin\theta \qquad (7\text{-}15)$$

$$(b^2\pm a^2)x\cos^2\theta - 2hb^2\cos\theta \mp a^2 x = \mp 2ab(\mp a^2 \pm h^2)^{1/2}\sin\theta \qquad (7\text{-}16)$$

under which this eq. will simplify; (a) $k = 0$, corresponding to the traditional focus, for which the term on the right drops out; and (b) $k^2 = b^4/a^2$, which corresponds to the LR vertices, for which the constant term vanishes, allowing an x to be factored out.

Eqs. 16 are the simple intercept eqs. for points on the curves. There are only 3 conditions for which these eqs. will simplify, $h = 0$, $h = a$, and $h = (a^2\pm b^2)^{1/2}$. For the ellipse (lower alternate signs), all three are focal conditions, leading to the b vertices, the a vertices, and the LR vertices. For the hyperbola, $h = 0$ is the focal condition for the imaginary b vertices but the other two focal conditions yield real foci, the a vertices and the LR vertices, respectively. Accordingly, it is the deficiency of two vertex foci for the hyperbola that balances the lack of asymptote foci of the ellipse and brings the total number of real foci of each central conic to equality at 14.

Lastly, the simple intercept eq. for the asymptotes of the hyperbola is eq. 17, which leads to the 0° compound intercept format, 18, expressed as a coincident-radii intercept product.

$$(b^2+a^2)x^2\cos^2\theta - 2b^2 hx\cos\theta - a^2(b^2+x^2) = -2abhx\sin\theta \qquad (7\text{-}17)$$

$$xy = \frac{a^2 b^2}{[a^2-(a^2+b^2)\cos^2\theta]} \qquad (7\text{-}18)$$

α-Transforms and Variable-Angle Transforms (eccentricity-correlated rank)

The 8th degree α-transforms of central conics about their centers (eqs. V-19) and the 4th degree α-transform for an ellipse about its right focus (eq. V-2) already have been considered. The former is repeated here (eq. 19). There are several focal conditions on eq. 19, one of which is of exceptional interest.

$$[(b^2 \mp a^2)^2 - (b^2 \pm a^2)^2 \cos^2\alpha]x^4 y^4 \sin^2\alpha + a^4 b^4 (x^4 + y^4) = \tag{7-19}$$

$$2a^2 b^2 x^2 y^2 (b^2 \mp a^2)(x^2 + y^2)\sin^2\alpha + 2a^4 b^4 x^2 y^2 (\cos^2\alpha - \sin^2\alpha)$$

(a) $\quad x^2 y^2 (a^2 + b^2) = a^2 b^2 (x^2 + y^2)$ \qquad (b) $\quad x^2 y^2 (b^2 - a^2) = a^2 b^2 (x^2 + y^2)$ \qquad (7-20)

(c) $\quad x^2 + y^2 = 0$

If $\alpha = 0°$ or $180°$, the transform reduces to $x = \mp y$, representing the non-trivial $x = -y$ negative intercept solution for $0°$ and the $x = y$ transform for $180°$. If $\alpha = 90°$, eq. 19 reduces to 20a-c, which are the general 4th degree transforms for the ellipse and hyperbola, but the 2nd degree imaginary locus for the equilateral hyperbola.

In addition to these focal conditions, however, the coefficient of the $x^4 y^4$ term yields a *variable-angle focal condition*; if the coefficient of this term is zero, which occurs at an angle determined by the eccentricity, the α-transform reduces to 6th degree. This unusual variable-angle focal condition is given by eqs. 21a-b', where the alternate signs directly to the right of the equality signs are true alternates. Condition 21a for the ellipse cannot be

(a) $\quad \cos\alpha = \pm(b^2 + a^2)/(b^2 - a^2)$ $\qquad\qquad$ (7-21)

(b) $\quad \cos\alpha = \pm(b^2 - a^2)/(b^2 + a^2) = \pm(2 - e^2)/e^2$ \qquad (b') $\quad \sin\alpha = \pm 2ab/(b^2 + a^2)$

fulfilled because the cosine cannot exceed unity. Conditions 21b,b' for the hyperbola translate to $\alpha = 90°$ for the equilateral subspecies, for which the transform, 20c, has imaginary solutions.

The Center

The variable-angle transform for hyperbolas about the center, corresponding to the focal condition, 21b,b', is obtained by substituting this condition in eq. 19. Eq. 22 is the resulting 6th degree transform.

$$8(b^2 - a^2)(x^2 + y^2)x^2 y^2 = 16a^2 b^2 x^2 y^2 + (a^2 + b^2)^2 (x^2 - y^2)^2 \tag{7-22}$$

We have here the phenomenon of a focus having *eccentricity-correlated rank*, wherein the α-transform reduces, not for a specific parameter-independent

angle of transformation, but for a variable angle that is determined by the eccentricity. For the equilateral hyperbola, this angle attains the maximum value of $90°$. For eccentricities greater and less than $2^{\frac{1}{2}}$, the magnitude of the angle decreases monotonically to a limiting minimum value of $0°$.

The Traditional Foci

However, the center does not enjoy the distinction of being the only focus of the hyperbola with eccentricity-correlated rank. Consider the α-transform of the hyperbola about its left focus, eq. 23, in which all the alternate

$$b^4(x^2-2xy\cos\alpha+y^2) + [2a^2(1\pm\cos\alpha)-(a^2+b^2)\sin^2\alpha]x^2y^2 = \qquad (7\text{-}23)$$
$$\pm 2ab^2xy(x+y)(1\pm\cos\alpha)$$
$$b^4(x^2+y^2) + (a^2\mp b^2)x^2y^2 = 2ab^2xy(x+y) \qquad (7\text{-}24)$$

signs are true alternates. Both this transform and the homologous transform for the ellipse reduce to the trivial $x = y$ transform for $0°$. For $180°$ they reduce to the equilateral hyperbolic transforms (eqs. 8), while for $\alpha = 90°$, they reduce to the 4th degree transforms of eqs. 24.

But in addition to the "conventional reductions," the focal condition on the coefficient of the x^2y^2 term of eq. 23 yields the variable-angle reduction condition, 25a. A similar focal condition, 25b, exists for the homologous eq. of the ellipse (eq. V-2). The variable angles, α, of 25a,b are found to be

(a) $(a^2+b^2)\sin^2\alpha = 2a^2(1\pm\cos\alpha)$ (b) $(b^2-a^2)\sin^2\alpha = 2a^2(\cos\alpha-1)$ $(7\text{-}25)$

(a) $a^2b^2(x-y)^2+b^4(x+y)^2 = 4a^3xy(x+y)$ (b) $a(x^2+y^2) = 2xy(x+y)$ $(7\text{-}26)$

identical to those for the variable-angle transforms about the center (21a); they are non-existent for the ellipse and are given by $\tan^{-1}\alpha = \pm 2(e^2-1)^{\frac{1}{2}}/(2-e^2)$, for the hyperbola. At these angles, the 4th degree α-transform reduces to 3rd degree (eq. 26a). The corresponding eq. for the equilateral subspecies is 26b. This is one of the rare instances of a cubic transform.

The x-Axis

On the basis of these two cases, one may conjecture that eccentricity-correlated rank is a property of all the foci of the hyperbola, and that the reduction condition will be the same for all. Partial confirmation of this conjecture is given by an analysis of the complex 16th degree α-transform, eq. 27, for points on the x-axis of central conics. Eq. 27 reduces to 4th degree for the 0° and 180° transforms of the ellipse (eq. 7a) but remains 16th degree

$$\{A^{16}+4x^2y^2X^6Y^6\cos^2\alpha-B^6[(xy\cos\alpha+y^2)^2X^6+(xy\cos\alpha+x^2)^2Y^6]\}^2 = \quad (7\text{-}27)$$
$$[4A^8xy\cos\alpha+2B^6(xy\cos\alpha+y^2)(xy\cos\alpha+x^2)]^2X^6Y^6$$

$$A^8 = 2h^2b^4(x^2-2xy\cos\alpha+y^2) \pm x^2y^2(b^2\pm a^2)[2a^2\mp(b^2\pm a^2)\sin^2\alpha] -$$
$$(b^2\pm a^2)(h^2-a^2)b^2(x^2+y^2)$$
$$X^6 = b^4h^2 - (b^2\pm a^2)(b^2h^2\mp a^2x^2-a^2b^2)$$
$$Y^6 = b^4h^2 - (b^2\pm a^2)(b^2h^2\mp a^2y^2-a^2b^2) \qquad B^3 = 2b^2h$$

for the 90° transform. The reductions are the same for the hyperbola (eqs. 7b,c). For the locations of the traditional foci, $h^2 = (a^2\pm b^2)$, the α-transforms reduce to 4th degree (eq. 23); for the vertices, $h = a$, they remain 16th degree (eq. 30, below), while for the centers, $h = 0$, they reduce to 8th degree (eqs. 19).

The starting eqs. for the focal reduction conditions on the coefficients of the 16th degree terms in x and y for eqs. 27 are given by eqs. 28. After

$$\{(b^2\pm a^2)^2[2a^2\mp(b^2\pm a^2)\sin^2\alpha]^2 + 4a^4(b^2\pm a^2)^2\cos^2\alpha\}^2 = \quad (7\text{-}28)$$
$$a^4(b^2\pm a^2)^2\{-4(b^2\pm a^2)[2a^2\mp(b^2\pm a^2)\sin^2\alpha]\cos\alpha\}^2$$

(a) $\quad [2a^2\mp(b^2\pm a^2)\sin^2\alpha]^2 + 4a^4\cos^2\alpha = \pm4a^2[2a^2\mp(b^2\pm a^2)\sin^2\alpha]\cos\alpha \quad (7\text{-}29)$

(b) $\quad 2a^2\mp(b^2\pm a^2)\sin^2\alpha = \pm2a^2\cos\alpha$

factoring $(b^2\pm a^2)^4$ and taking the square root of each side, eqs. 29a are obtained, for which the external alternate sign of the right member is a true alternate. After regrouping terms on the left or right, the entire polynomial is seen to be a perfect square, the roots of which are 29b. These eqs. lead to the same variable-angle focal conditions as do eqs. 21 and 25.

Accordingly, for the focal conditions of eqs. 29b, the α-transforms of eqs. 27 reduce to 14th degree (that of the next-highest degree terms). Thus, a variable-angle transform of 14th degree exists for points on the x-axis. We already knew that variable-angle transforms of 6th and 3rd degree exist for the traditional focus and center, respectively, and the present result shows that a variable-angle transform must exist for the vertex also, since eqs. 27 include the vertex as a special case. Accordingly, it seems likely that *eccentricity-correlated rank* is a property of all the foci of the hyperbola, and that the reduction condition also is the same for all.

The Axial Vertices

I close this section with a consideration of the α-transforms of the a vertices, eqs. 30. Elimination of the radicals leads to eqs. of 16th degree.

$$y^2(b^2{\pm}A^2)^2 + x^2(b^2{\mp}B^2)^2 - 2xy(b^2{\mp}A^2)(b^2{\mp}B^2)\cos\alpha = x^2y^2C^4/a^2\sin^2\alpha \qquad (7\text{-}30)$$

$$A^2 = [b^4-x^2(b^2{\pm}a^2)]^{\frac{1}{2}} \qquad B^2 = [b^4-y^2(b^2{\pm}a^2)]^{\frac{1}{2}} \qquad C^4 = (b^2{\pm}a^2)^2$$

For α = 0° and 180°, eqs. 30 reduce to the trivial transforms x = y and x = -y, while for α = 90°, they reduce to 8th degree. Since eqs. 30 are merely the special cases of the α-transform for points on the x-axis (eqs. 27) at the a vertices (h = a), the eq. for the hyperbola will reduce to a variable-angle transform of lower than 16th degree when the focal condition of eqs. 21b,b' hold.

The degree of the variable-angle transform for the a vertices has not been ascertained. If one is guided by the reductions for the α-transforms of the focus, center, and x-axis (Table VII-1), 12th degree is a reasonable expectation. Since the indications are that the coefficient of the 14th degree term extracted from eq. 30 will not vanish, any reduction in the degree of this term would have to be by factoring (taking a root would lead to too low a degree).

Intercept Formats and 90° Transforms

Points In the Plane

To round out the treatment of central conic intercept formats and transforms, some of those for the 90° transformation are given here. The most complex of

these are for points in the plane. Eqs. 31 are the starting eqs. for the x intercepts. The y intercepts are obtained by substituting y for x and

$$x^2(b^2{\pm}a^2)\cos^2\theta - 2b^2hx\cos\theta \mp a^2x^2 + (b^2h^2{\mp}a^2k^2-a^2b^2) = \mp 2a^2kx\sin\theta \quad (7\text{-}31)$$

$$y^2(b^2{\pm}a^2)\sin^2\theta \pm 2a^2ky\cos\theta \mp a^2y^2 + (b^2h^2{\mp}a^2k^2-a^2b^2) = -2b^2hy\sin\theta \quad (7\text{-}32)$$

$$\cos\theta = \frac{-xy(b^4h^2+a^4k^2) \pm (G^{16})^{\frac{1}{2}}}{xy(b^2{\pm}a^2)(\mp a^2ky-b^2hx)} \quad (7\text{-}33)$$

$$G^{16} = x^2y^2(b^4h^2+a^4k^2)^2 - xy(b^2{\pm}a^2)(\mp a^2ky-b^2hx)\cdot$$

$$\cdot[(\pm a^2kx-b^2hy)(b^2h^2{\mp}a^2k^2-a^2b^2) \pm a^2b^2xy(hx+ky)]$$

$$\cos\theta = \frac{b^2(a^2{\pm}b^2)^{\frac{1}{2}} \pm (a^2x^2)^{\frac{1}{2}}(a^2{\pm}b^2)^{\frac{1}{2}}}{x(b^2{\pm}a^2)} = \frac{(b^2{\pm}ax)}{\pm x(a^2{\pm}b^2)^{\frac{1}{2}}} \quad (7\text{-}34)$$

(θ+90°) for θ, yielding eqs. 32. Elimination of $\sin\theta$ between 31 and 32 leads to the compound intercept formats, 33. An alternate sign before a radical always is a true alternate.

If θ is eliminated between 31 and 33, one obtains very complex transforms of 20th degree in x and y, except in the case of the equilateral hyperbola, for which the degree reduces to 16. These transforms hold for points in the plane. There is one condition for which the radicand of eqs. 33 reduces to a perfect square in the variables, namely, $h^2 = (a^2{\pm}b^2)$ together with $k = 0$, the conditions satisfied by the traditional focus. For these conditions the radicand becomes a perfect square in $f(x)$ and the radical is eliminated, yielding eq. 34.

CIRCUMPOLAR MAXIM 6: *A condition for which the square-root radicand of an intercept format is converted to a perfect square in the variables reveals the location of a high-ranking focus.*

Conditions On the Radicand

An examination of all the conditions on h and k that lead to simplification of the radicand of eq. 33 (G^{16}) reveals all the focal conditions for central conics. I detail these step by step. The eqs., $b^2h^2{\mp}a^2k^2 = a^2b^2$ or $k^2 = b^2(\mp a^2{\pm}h^2)/a^2$, hold for points on the curve. When these conditions are

met, eq. 33 is simplified markedly. Elimination of the single expression, $(b^2h^2 \mp a^2k^2 - a^2b^2)$, from the radical yields eqs. 35. I leave it to the reader

$$\cos\theta = \frac{(b^4h^2+a^4k^2) \pm \{(b^4h^2+a^4k^2)^2 - (b^2 \pm a^2)(\mp a^2ky - b^2hx)[\pm a^2b^2(hx+ky)]\}^{\frac{1}{2}}}{(b^2 \pm a^2)(\pm a^2ky + b^2hx)} \quad (7\text{-}35)$$

$$[a^2(x^2-y^2)+4h(h^2-a^2)^{\frac{1}{2}}xy]^2 = 4(2h^2-a^2)^3(x^2+y^2), \quad (h > a) \quad (7\text{-}36)$$

(a) $$\cos\theta = \frac{b^2h \pm [b^4h^2+(b^2 \pm a^2)(a^2b^2-b^2h^2 \pm a^2x^2)]^{\frac{1}{2}}}{x(b^2 \pm a^2)} \quad (7\text{-}37)$$

(b) $$\cos\theta = \frac{\pm a^2k \pm [a^4k^2+(b^2 \pm a^2)(\mp a^2k^2-a^2b^2+b^2y^2)]^{\frac{1}{2}}}{y(b^2 \pm a^2)} $$

to complete the elimination of k from this expression.

Elimination of θ between eqs. 31 and 35 leads to a complex 12th degree transform for the 90° transformation about a point on the curve. However, for the equilateral hyperbola the transform simplifies and reduces to the 4th degree eq., 36. Substitution of k = 0 and h = 0 in eqs. 33 gives the simple intercept formats for points on the x and y- axes, eqs. 37a and 37b, respectively. Elimination of θ between eqs. 31 and 37a,b leads to complicated 16th degree transforms for points on both of these axes (see eqs. 27 for the α-transforms for points on the x-axes).

The Latus Rectum Vertices

For the LR vertices one lets $h = (a^2-b^2)^{\frac{1}{2}}$ and $k = b^2/a$ in eqs. 33 or 35, yielding eqs. 38. The eliminants of 38 with 31 are complex transforms of 8th degree. For the equilateral hyperbola, however, the simple intercept format greatly simplifies to eq. 39, and the transform reduces to 4th degree (eq. 40).

$$\cos\theta = \frac{b^2(2a^2 \pm b^2) \pm [b^4(2a^2 \pm b^2)^2 \pm a(b^2 \pm a^2)(ahx+b^2y)(hx+ay)]^{\frac{1}{2}}}{(b^2 \pm a^2)(hx+ay)} \quad (7\text{-}38)$$

$$\cos\theta = \frac{3a \pm [9a^2+2(2^{\frac{1}{2}}x+y)^2]^{\frac{1}{2}}}{2(2^{\frac{1}{2}}x+y)} \quad (7\text{-}39)$$

$$108a^2(x^2+y^2) = (x^2+4 \cdot 2^{\frac{1}{2}}xy-y^2)^2 \quad (7\text{-}40)$$

The a and b Vertices and Eclipsing of Foci

For the a and b vertices, one lets h = a in eq. 37a and k = b in eq. 37b, giving 41a,b. The 90° transforms for these vertices also are of 8th degree. Those for the a vertices are 42a-c. Transforms for the b vertices of the hyperbola, of course, have complex (non-real) solutions.

(a) $\cos\theta = \dfrac{ab^2 \pm a[b^4 \pm x^2(b^2 \pm a^2)]^{\frac{1}{2}}}{x(b^2 \pm a^2)}$ simple intercept (7-41)
formats, a vertices

(b) $\cos\theta = \dfrac{\pm a^2 b \pm b[a^4 + (b^2 \pm a^2)(\mp a^2 - a^2 + y^2)]^{\frac{1}{2}}}{y(b^2 \pm a^2)}$ simple intercept
formats, b vertices

90° intercept transforms about the a vertices

(a) $x^4 y^4 (a^4 - b^4)^2 (a^2 + b^2)^2 + 8a^2 b^6 (a^4 - b^4)(a^2 + b^2)(x^2 + y^2)x^2 y^2 +$ (7-42)

$16a^4 b^8 [(a^2 + b^2)^2 - 4a^4]x^2 y^2 + 16a^4 b^{12}(x^2 + y^2)^2 - 64a^6 b^{12}(x^2 + y^2) = 0$

(b) $x^4 y^4 (a^4 - b^4)^2 (a^2 - b^2)^2 - 8a^2 b^6 (a^4 - b^4)(a^2 - b^2)(x^2 + y^2)x^2 y^2 +$

$16a^4 b^8 [(a^2 - b^2)^2 - 4a^4]x^2 y^2 + 16a^4 b^{12}(x^2 + y^2)^2 - 64a^6 b^{12}(x^2 + y^2) = 0$

(c) $(x^2 - y^2)^2 = 4a^2(x^2 + y^2)$

(d) $x^2 + y^2 = 4a^2$ 90° transform about a point
incident upon the circle

Note that for the equilateral hyperbola, the transforms for the a vertices (42c) and for the LR vertices (40) are of 4th degree, the same as for the 90° transforms for points on the curve (eq. 36). This means that, although the a vertices and the LR vertices have higher subfocal rank than neighboring points on the curve, all the vertex foci lose their point focal rank, i.e., they are *eclipsed* in the equilateral subspecies, just as all the vertex foci of the ellipse lose their point focal rank in the circle subspecies (a = b for the ellipse yields eq. 42d, which also is the 90° transform for all other points incident upon the circle).

The 4th degree a-vertex transform for the equilateral hyperbola (42c) is a "4-arm" curve consisting of two concentric, congruent, orthogonal, two-arm hyperbola-like components. Intercepts of both arms of the basis curve contribute to each arm of the transform curve.

Traditional Foci and Centers

The only remaining foci to be considered are the traditional foci and centers, for which many of the transforms and formats already have been given. These are repeated for convenience. For the traditional foci, the formats and 90° transforms are 43a-c and 43a'-c'. For the centers, they are 44a-c and 44a'-c'.

(a) $\cos\theta = \dfrac{(ax-b^2)}{x(a^2-b^2)^{\frac{1}{2}}}$ (b) $\cos\theta = \dfrac{(b^2\pm ax)}{x(a^2+b^2)^{\frac{1}{2}}}$ (c) $\cos\theta = \dfrac{(a\pm x)}{2^{\frac{1}{2}}x}$ (7-43)

(a') $b^4(x^2+y^2) + (a^2+b^2)x^2y^2 = 2ab^2xy(x+y)$

(b') $b^4(x^2+y^2) + (a^2-b^2)x^2y^2 = 2ab^2xy(x+y)$ (c') $a(x^2+y^2) = 2xy(x+y)$

(a) $\cos^2\theta = \dfrac{a^2(x^2-b^2)}{x^2(a^2-b^2)}$ (b) $\cos^2\theta = \dfrac{a^2(x^2+b^2)}{x^2(a^2+b^2)}$ (c) $\cos^2\theta = \dfrac{(x^2+a^2)}{2x^2}$ (7-44)

(a') $x^2y^2(a^2+b^2) = a^2b^2(x^2+y^2)$

(b') $x^2y^2(b^2-a^2) = a^2b^2(x^2+y^2)$ (c') $x^2 + y^2 = 0$

While the 90° transform for the equilateral hyperbola about its focus is a symmetric function, it does not have reflective symmetry through the origin. A full 4-quadrant plot of this transform consists of 3 arms. In the 1st quadrant (all positive intercepts) is an arm resembling one arm of an equilateral hyperbola that derives wholly from positive intercepts of the basis arm of the basis curve. Since the left member of 43c' always is positive, it is clear that if either x or y is negative (i.e., a negative intercept), the other variable must be positive and of lesser magnitude (in order for the product of xy and x+y to be positive). This means that the other segments of the curve must lie on the other side of the line x = -y. There are two such segments, in the 2nd and 4th quadrants, lying on the other side of the x = -y bisector. Note that the solutions to eq. 44b' are not real for $a \geq b$, i.e., for $e^2 \leq 2$.

[There is a similarity between the 90° transforms of central conics about their centers (eqs. 44a',b') and the Bullet-Nose curve for the hyperbola and unicursal Cross Curve for the ellipse, $x^2y^2 = a^2y^2\mp b^2x^2$ (the product of squares is equal to the sum or difference of squares). The latter curves are derived by drawing parallels to the coordinate axes through the points where tangents to the basis curve intersect these axes. The locus of the points of intersection of the parallels is the curve in question. Since this is not a circumpolar construction (but rather a 90°-bilinear construction), the Bullet-Nose and unicursal Cross Curves do not necessarily bear any relationship to the circumpolar symmetry of ellipses or hyperbolas. Such relationships do, in fact, exist but they lie in the domain of the tangent and normal pedals (see Chapter XIII, *Tangent-Pedal Taxonomy*).]

The Latus Rectum and Subfocal Symmetry

The discovery that points on the asymptotes have focal rank came about in the course of a search for point foci on the LR of central conics, i.e., through a search for points on the LR (other than the traditional foci) at which the 180° transforms would reduce from 8th degree. In the course of this search, in addition to detecting that points on the asymptotes have focal rank, there were detected several points on the LR about which the curve has greater subfocal symmetry than about neighboring points. Both for their interest from the point of view of subfocal symmetry, and as illustrations of complementary features of the ellipse and hyperbola, these point loci are treated here.

Eqs. 45 are the 180° transforms of central conics about the LR. For a point

$$F_0^{16}(x+y)^4 + 16a^4b^4[F_1^8/B^4 \mp 4a^2b^2k^2/A^2]x^4y^4 + 32a^2b^2[F_1^4F_2^{10}/B^4 - 2a^2b^2k^2F_3^6/A^2 +$$

$$F_0^8F_1^4/B^2]x^3y^3 - 8a^2b^2F_0^8F_1^4(x+y)^2x^2y^2/B^2 - 8F_0^8F_2^{10}(x+y)^2xy/B^2 - \qquad (7\text{-}45)$$

$$8F_0^{16}(x^2+y^2)xy + 16[F_2^{20}/B^4 - 4a^4b^4k^2F_4^8/A^2 + 2F_0^8F_2^{10}/B^2]x^2y^2 = 0$$

$$F_0^4 = \mp b^4 \pm a^2k^2 \qquad F_1^4 = a^2k^2 \pm b^2A^2 \qquad F_2^{10} = \mp a^6k^4 + a^2b^4k^2(\pm 2a^2+b^2) - b^8A^2$$

$$F_3^6 = (a^2k^2-b^4)(-a^2 \pm b^2) \qquad F_4^8 = 2a^2b^4k^2-a^4k^4-b^8 \qquad A^2 = (a^2 \pm b^2) \qquad B^2 = (b^2 \pm a^2)$$

$k = d$ on the LR to have point-focal rank, the degree of eq. 45 must reduce at $k = d$. In the derivation of eq. 45 there were numerous steps at which simplification and possible eventual reduction would occur if a coefficient were to vanish. The coefficients in question at these steps are the *F-terms* of eq. 45. Although none of these terms proved to be focal at 180°, they did reveal points on the LR about which the curve has greater subfocal symmetry than about neighboring points, as follows:

(1) $F_0^4 = 0$ yields the LR vertices, which are not foci for 180° transformations.

(2) $F_1^4 = 0$ yields $k^2 = \mp b^2e^2$, which are imaginary loci for the hyperbola

(3) $F_2^{10} = 0$ yields $k^2 = b^4e^2/a^2$ (e^2 times the square of the semi-LR).

(4) $F_3^6 = 0$ yields condition (1) above.

(5) $F_4^8 = 0$ yields condition (1) above.

(6) $k^2 = \pm b^2e^2$, which are imaginary loci for the ellipse.

The only condition that led to reduction was (6), obtained by equating the coefficient of the x^4y^4 term in eq. 45 to zero; for the hyperbola, condition (6) yields the points of intersection of the extended LR with the asymptotes, for which eq. 45 simplifies and reduces to eq. V-28a. Upon further investigation, the asymptotes themselves were found to be focal loci (eqs. 10).

Ordinal and Subordinal Rank

The ordinal rank for transforms about the traditional foci is defined by eqs. 46. Here, and for eq. 48, the alternate sign on the x^3 term holds for

$$b^2\overset{\circ}{S}^2 = \pm(x^4+y^4) \pm 2a(x^3+y^3) - b^2(x^2+y^2) \tag{7-46}$$

$$\overset{\circ}{S}^2 = \frac{b^4(a^2\pm b^2)\sin^2\theta}{[(a^2\pm b^2)^{\frac12}\cos\theta\pm a]^4} + \frac{b^4(a^2\pm b^2)\sin^2(\theta+\alpha)}{[(a^2\pm b^2)^{\frac12}\cos(\theta+\alpha)\pm a]^4} \tag{7-47}$$

$$b^2 A^8 \overset{\circ}{S}^2 = \pm x^4(A^8+b^8)\pm 2aA^2 x^3(A^6+b^6)-A^4b^2x^2(A^4+b^4), \quad A^2 = (2ax-b^2) \tag{7-48}$$

$$a^2b^2\overset{\circ}{S}^2 = \pm(x^6+y^6) + (b^2\mp a^2)(x^4+y^4) - a^2b^2(x^2+y^2) \tag{7-49}$$

$$a^2b^2\overset{\circ}{S}^2 = 2x^2[\pm x^4+(b^2\mp a^2)x^2-a^2b^2] \tag{7-50}$$

$$a^4\overset{\circ}{S}^2 = 2x^2(x^4-a^4) \tag{7-51}$$

the hyperbola; for the ellipse it is positive. The corresponding transcendental eq. is 47. The alternate sign of "a" holds for the hyperbola; for the ellipse the sign is negative. Eqs. 48 establish the 8th degree subordinal rank of the $180°$ transform, $b^2(x+y) = 2axy$, which holds for both members of the monoconfocal hyperbola-ellipse pair with identical parameters. However, because of differences in the signs of the terms, eqs. 46 and 48 also differentiate between the transforms of these monoconfocal curves.

For the center, the ordinal rank for all transformation angles is 6, as defined by the ordinal eq. 49. For the $180°$ transformation, the transform is $x = y$, whereupon the subordinal eq., 50, retains 6th degree rank. For the equilateral hyperbola this simplifies to 51. [Eqs. 49 and 50 are not valid for $a = b$ with the lower alternate signs (i.e., for the circle), since their derivation involved division by a term $(b^2\pm a^2)$.]

Fig. 5-1

Table VII-1. Degrees of Circumpolar Intercept Transforms of Conic Sections[1]

Curve	Parabola				Ellipses				Circle			
Transformation angle	α°	90°	180°	0°	α°	90°	180°	0°	α°	90°	180°	0°
Locus												
Point in plane	32*	20	8	8	32*	20	8	8	6	6	2	2
x-axis	16	16	4	4	16	16	4	4	-	-	-	-
y-axis	-	-	-	-	16	16	4	4	-	-	-	-
Incident point	32*	12	-	-	32*	12	-	-	2	2	-	-
a vertex	16	8	-	-	16	8	-	-	-	-	-	-
b vertex	-	-	-	-	16	8	-	-	-	-	-	-
LR vertex	32*	8	-	-	32*	8	-	-	-	-	-	-
Focus	4	4	2	2	4	4	2	2	-	-	-	-
Center	-	-	-	-	8	4	1	1	0	0	0	0

Curve	Hyperbolas					Equilateral hyperbola				Parallel line-pair			
Transformation angle	α°	Variable	90°	180°	0°	α°	90°	180°	0°	α°	90°	180°	0°
Locus													
Point in plane	32*	-	20	8	8	32	16	8	8	4	4	1	1
x-axis	16	14	16	4	4	16	12	4	4	-	-	-	-
y-axis	16	14	16	4	4	16	12	4	4	-	-	-	-
Asymptotes	32*	-	-	6	6	32*	16	6	6	-	-	-	-
Incident point	32	-	12	-	-	32*	4	-	-	4	4	-	-
a vertex	16	14*	8	-	-	16	4	-	-	-	-	-	-
LR vertex	32*	-	8	-	-	32*	4	-	-	-	-	-	-
Focus	4	3	4	2	2	4	3	2	2	-	-	-	-
Center	8	6	4	1	1	8	2^2	1	1	-	-	-	-

[1]Dash indicates degree unknown, transform non-existent, or focus and transform non-existent

[2]Solution is imaginary

*Maximum value

NEGATIVE INTERCEPTS, TRIVIAL TRANSFORMS, THE DEGREE OF

TRANSFORMS, AND THE DUALITY OF 0° AND 180° TRANSFORMS

Introduction

It is inherent in the procedures of circumpolar symmetry analyses that transform eqs. encompass negative intercepts and trivial transforms. The trivial $0°$ transform $x = y$ and $180°$ transform $x = -y$ tell nothing about the symmetry of a curve and are properly discarded. Once expressions in $(x \mp y)^n$ have been factored out of a transform eq., the final form of the transform, $f(x,y) = 0$, no longer encompasses the trivial solution. From the point of view of a circumpolar symmetry analysis, the intercept transform, $f(x,y) = 0$, characterizes the symmetry completely (for the given pole and angle). But from the point of view of a complete algebraic solution to the starting eq., the solution is the degenerate eq. $(x \mp y)^n f(x,y) = 0$.

Early in my studies of circumpolar symmetry, in the interests of simplicity, I adopted the procedure of considering only transforms for: (1) two non-trivial positive intercepts; or (2) a positive and a non-trivial "negative intercept." [Case (2) encompasses the situation where the "negative intercept" is positively directed from the geometrical point of view but algebraically negative (see Chapter X, *Analytical Transforms Versus Geometrical Expectations*).] This convention is maintained throughout most treatments.

Although this procedure usually does not influence the exponential degree of transforms, it gives a misleadingly simple picture of intercept transform eqs. (which almost always are degenerate) and leads to the false impression that the $0°$ and $180°$ transforms are fundamentally different. Accordingly, a detailed examination of these matters is undertaken here employing transform eqs. of central conics and bipolar parabolic Cartesians.

Algebraically Complete $0°$ and $180°$ Transform Equations
 For the Traditional Foci of Conic Sections

Consider first the simple intercept formats and $0°$ and $180°$ intercept transforms about the traditional foci of conic sections that have been given earlier but are repeated below. All three of the $180°$ transforms 52a'-c' hold for two positive intercepts. Since the hyperbola has two arms, eq. 52c' also holds for one positive and one negative intercept, but only if the negative intercept is on the contralateral arm (i.e., only if the absolute magnitude of the negative intercept exceeds that of the positive intercept). But it does

not hold for the case of a positive and a trivial negative intercept because the trivial solution $(x+y)^2 = 0$ was factored out in the derivation. A 0° transform for two positive intercepts exists only for the hyperbola; in the form given, 52d', it applies only for the case in which the x intercept is larger than the y intercept (i.e., when the x intercept is on the contralateral arm).

Simple intercept formats and transforms of conic sections about the traditional focus

Basis curve

Formats Transforms

(a) $\cos\theta = \dfrac{-2a+x}{x}$ (a') $xy = a(x+y)$ parabola, 180° (7-52)

(b) $\cos\theta = \dfrac{ax-b^2}{x(a^2-b^2)^{\frac{1}{2}}}$ (b') $2axy = b^2(x+y)$ ellipse, 180°

(c) $\cos\theta = \dfrac{b^2\pm ax}{x(a^2+b^2)^{\frac{1}{2}}}$ (c') $2axy = b^2(x+y)$ hyperbola, 180°

(d) $\cos\theta = \dfrac{b^2\pm ax}{x(a^2+b^2)^{\frac{1}{2}}}$ (d') $2axy = b^2(x-y)$ hyperbola, 0°

The rigorous derivation of these transforms is illustrated for 180° transforms. For these derivations one employs the complete simple intercept formats 53a-c, which are valid for both positive and negative intercepts. The first step is to form the eq. 54a, which is the equivalent of $\cos\theta = -\cos(\theta+180^\circ)$.

parabola ellipse hyperbola

(a) $\cos\theta = \dfrac{-2a\pm x}{x}$ (b) $\cos\theta = \dfrac{-b^2\pm ax}{x(a^2-b^2)^{\frac{1}{2}}}$ (c) $\cos\theta = \dfrac{b^2\pm ax}{x(a^2+b^2)^{\frac{1}{2}}}$ (7-53)

(a) $\dfrac{-b^2\pm ax}{x} = \dfrac{-b^2\pm ay}{-y}$ (b) $b^2(x+y) = \pm axy \pm axy$ (7-54)

(c) $b^4(x+y)^2 - 2a^2x^2y^2 = \pm 2a^2x^2y^2$ (d) $b^4(x+y)^4 = 4a^2x^2y^2(x+y)^2$

(e) $(x+y)^2[b^2(x+y)-2axy][b^2(x+y)+2axy] = 0$ complete algebraic solution corresponding to 52b',c'

(f) $(x+y)^2[a(x+y)-xy][a(x+y)+xy] = 0$ complete algebraic solution corresponding to 52a'

This was formed using the simple intercept format 53b for the ellipse, but the result is the same if one uses 53c for the hyperbola. Cross-multiplying and segregating terms gives 54b, where the alternate signs hold in both "same" and "opposite" combinations (if the eq. is to represent all combinations of positive and negative intercepts). Squaring gives 54c, and a second squaring, 54d.

Eq. 54d is seen to be degenerate (as usually is the case when both sides of an eq. are perfect squares) and representable as the product of 3 quadratic terms, 54e. The first (leftmost) term equated to 0 represents the trivial solution x = -y for one valid positive or negative intercept and one trivial negative or positive intercept, respectively. The second (middle) term equated to 0 is valid for two positive intercepts of the ellipse and hyperbola, and for one positive and one non-trivial negative intercept for the hyperbola, provided that the latter is on the contralateral arm. Moreover, since it is a symmetric function it also holds when positive x and y intercepts are interchanged.

The 3rd (rightmost) term is valid for two negative intercepts for the ellipse and hyperbola, and for one positive and one negative intercept for the hyperbola, provided that the latter is on the basis arm. The corresponding complete algebraic solution for the parabola is eq. 54f. From the point of view of a complete, rigorous symmetry analysis, one of the (x+y) terms may be factored out because it is redundant, leaving a 5th degree degenerate transform eq. Although the remaining (x+y) term gives no information about the symmetry of the curve, it provides presumptive identification of the angle of the transformation.

In relation to the symmetry of the curve, the most pertinent information given by the degenerate transform eq. 54e is that, aside from trivial relationships, the intercepts are related to one another by the eqs. of equilateral hyperbolas (interchangeability of the intercepts is more or less irrelevant in this connection). It is for this reason that the transforms are taken to be of 2nd degree and, in the interests of simplicity, represented solely by the middle term. The latter is chosen in preference to the rightmost term because it represents the relationship between two *positive* intercepts and, accordingly, stands in the closest relationship to a purely geometrical concept of a 180° transformation.

In the case of the complete algebraic 0° transform eqs., the derivations follow the same course (omitting the negative sign in the denominator of the right side of eq. 54a), except that (x-y) terms replace the (x+y) terms, leading to the corresponding eqs. 55e,f. The 1st term of 55e represents the

complete algebraic solutions for the 0°
transforms of conics about the focus

(e) $(x-y)^2[b^2(x-y)-2axy][b^2(x-y)+2axy] = 0$ ellipse and hyperbola (7-55)

(f) $(x-y)^2[a(x-y)-xy][a(x-y)+xy] = 0$ parabola

trivial 0° transform x = y. The 2nd and 3rd terms represent valid 0° transforms for the hyperbola, for the cases in which the x intercept is on the contralateral arm (2nd term) and in which it is on the basis arm (3rd term).

The ellipse, of course, has no valid 0° transform about the focus for two non-trivial positive intercepts, but it does have a valid transform for one positive and one non-trivial negative intercept. The 2nd term of 55e (equated to 0) is a valid 0° transform of the ellipse when the y intercept is taken to be positive, while the 3rd term yields a valid 0° transform when the x intercept is taken to be positive.

It is abundantly clear from this treatment that the complete algebraic 0° and 180° transform eqs. of a given curve about a given pole give identical information about its circumpolar symmetry about that pole (compare eqs. 54e,f with eqs. 55e,f). The two transform eqs. differ only in the signs of some terms, and these differences are attributable entirely to (and merely are an expression of) the fact that 0° intercepts are considered to be positive when they lie in the same direction along the radius from the pole, whereas 180° intercepts are considered to be positive when they are oppositely directed from the pole. Accordingly, any separate treatment of 0° and 180° transforms, such as the present one, merely emphasizes relationships between intercepts that are associated with geometrical concepts of the 0° and 180° transforms, i.e., relationships between *coincident-radii* intercepts as opposed to those between *chord-segment* intercepts.

In drawing this arbitrary dividing line, one selects from the degenerate transform eqs. the factor which, when equated to 0, expresses the relationship

between coincident-radii intercepts and labels the eq. as the $0°$ transform, and similarly for the factor that expresses the chord-segment relationship and the $180°$ transform. The pursuit of this course usually leads to an assignment of the same exponential degree to both the $0°$ and $180°$ transforms, because it is typical of degenerate transform eqs. that their non-trivial factors have the same exponential degree. For some curves, however, this is not the case. Accordingly, the example below illustrates a case in which the non-trivial factors differ in degree, and in which the $0°$ and $180°$ transform eqs. are more complex.

Algebraically Complete $0°$ and $180°$ Transform Equations
For the Focus of Self-Inversion of Bipolar Parabolic Cartesians

It is true of all members of the Cartesian self-inverters (eq. X-1, A,B,C,D, $\neq 0$) that their $0°$ transforms of self-inversion differ in degree from their $180°$ transforms about the same pole, in other words that their algebraically complete transform eqs. for $0°$ and $180°$ possess non-trivial factors that differ in degree. The bipolar and rectangular eqs. of parabolic Cartesians are 56a,b, and their simple intercept format is 56c. Formation of the algebraically complete $0°$ and $180°$ transform eqs. yields 56d,e, respectively.

(a) $uv = Cd^2$ bipolar parabolic Cartesians (7-56)

(b) $(x^2+y^2-2dx+d^2)^2 = C^2d^2(x^2+y^2)$ rectangular eq. of 56a

(c) $\cos\theta = \dfrac{x^2 \pm Cdx+d^2}{2dx}$ simple intercept format of 56b

$0°$ transform equations of bipolar parabolic Cartesians for the focus of self-inversion

(d) $(x-y)^2(d^2-xy)^2[(x-y)(d^2-xy)-2Cdxy][(x-y)(d^2-xy)+2Cdxy] = 0$

(d') $xy = d^2$ (d") $(x-y)(d^2-xy) = 2Cdxy$ (d''') $(x-y)(xy-d^2) = 2Cdxy$

$180°$ transform equations of bipolar parabolic Cartesians for the focus of self-inversion

(e) $(x+y)^2(d^2+xy)^2[(x+y)(d^2+xy)-2Cdxy][(x+y)(d^2+xy)+2Cdxy] = 0$

(e') $xy = -d^2$ (e") $(x+y)(d^2+xy) = 2Cdxy$ (e''') $(x+y)(d^2+xy) = -2Cdxy$

These eqs. are seen to be degenerate and to consist of the product of 4 factors, including (when equated to 0) the trivial transforms, the equilateral hyperbolic transforms of self-inversion, and two cubic transforms. Each of the 4 different terms in the transform eqs. vanishes for a different combination of positive and negative intercepts than for the others. Following the practices outlined above for the simplified geometrically-oriented treatment of $0°$ and $180°$ transforms, eq. 56d' is designated as the $0°$ transform of self-inversion, and 56e" (or 56e''') as the 3rd degree $180°$ transform.

Algebraically Complete $90°$ Transform Equations
For the Traditional Foci of Conic Sections

The derivation of the algebraically complete $90°$ transform eqs. of conics about the traditional focus is illustrated for an ellipse. The starting eq. is 57a, which is the equivalent of $\cos^2\theta+\cos^2(\theta+90°) = \cos^2\theta+\sin^2\theta = 1$. After squaring and collecting terms one obtains 56b. In the derivation of the $180°$

Derivation of the algebraically complete $90°$ transform equations of the ellipse about the traditional focus

(a) $\quad (-b^2\pm ax)^2/x^2(a^2-b^2) + (-b^2\pm ay)^2/y^2(a^2-b^2) = 1$ (7-57)

(b) $\quad (a^2+b^2)x^2y^2 + b^4(x^2+y^2) = 2ab^2xy(\pm x\pm y)$

(c) $\quad [(a^2+b^2)x^2y^2+b^4(x^2+y^2)-2ab^2xy(x+y)][(a^2+b^2)x^2y^2+b^4(x^2+y^2)+2ab^2xy(x+y)]\cdot$

$\quad [(a^2+b^2)x^2y^2+b^4(x^2+y^2)-2ab^2xy(x-y)]\cdot$

$$[(a^2+b^2)x^2y^2+b^4(x^2+y^2)+2ab^2xy(x-y)] = 0$$

transform eqs. (54a-e), two additional squarings were carried out beyond the point of obtaining the equation equivalent to 57b (namely, 54b). However, elimination of the alternate signs from an eq. of the form 57b always leads to a degenerate transform eq. composed of the product of 4 factors, each of which derives from 56b by a selection of the alternate signs in all combinations, as illustrated in 57c. Unless the degree of one of the factors is altered by cancellations, each factor of 57c will be of the same degree as the original eq. (57b). Of the 4 factors, the first (upper leftmost) vanishes for two positive intercepts (but not necessarily *only* for two positive intercepts; see

the discussion of the locus of eq. 43c') and, when equated to 0, is taken to be the 90° transform (eq. 43a'').

It will be noted that eq. 57c represents 4 congruent loci, each the reflection of two of the others through the coordinate axes, and of the 3rd through the origin. Accordingly, the algebraically complete 90° transform typically represents 4 congruent loci and has reflective symmetry through both coordinate axes. In cases in which a radical in the variables is present in the simple intercept format, the elimination of the radical by squarings to derive the 90° transform automatically leads to the representation of this transform by an algebraically complete--*but non-degenerate*--90° transform eq. for 4 congruent loci with reflective symmetry in both coordinate axes. But when alternate signs are present, in the case of the absence of a radical in the variables, the algebraically complete 90° transform eq. is degenerate and is represented conventionally only as the single locus of the congruent quartet that applies for two positive intercepts.

CHAPTER VIII. INVERSION AND NON-FOCAL SELF-INVERSION OF CONIC SECTIONS

INTERCEPT PRODUCTS AND NON-FOCAL SELF-INVERSION LOCI

Focal Self-Inversion

As noted earlier, curves with great circumpolar symmetry invert to themselves (*focal self-inverters*) and to one another through their highest-ranking foci. The fact that many curves self-invert has been known for well over 100 years. For these curves the self-inversion formulae are identical with the 0° or 180° intercept transforms about the poles of self-inversion. For example, the 0° transforms of limacons, parabolic Cartesian ovals, and linear Cartesian ovals about their foci of self-inversion are la-c, respectively, where the corre-

(a) $xy = (a^2-b^2)^2/4b^2 = d^2$ (a') $r = a-b\cos\theta$ polar limacons (8-1)

(b) $xy = d^2$ (b') $u^2 = Cdv$ bipolar parabolic Cartesians

(c) $xy = d^2(B^2-C^2)/(B^2-A^2)$ (c') $Bu+Av = Cd$ bipolar linear Cartesians

sponding eqs. of the curves are given by la'-c'; for eqs. lb' and lc', d is the distance between the poles, p_u and p_v.

Focal Self-Inversion As a Limiting Case of Non-Focal Self-Inversion

The above are cases of *focal self-inversion*, since the curves self-invert with respect to a point-pole that always has focal rank (because the curve always has a 0° or 180° transform of self-inversion, $xy = $ constant, about this point-pole). But a broader view of the process of self-inversion can be taken in which the classical *focal* process is regarded as a limiting case of a more general self-inversion process designated as *non-focal self-inversion*. Both types involve *loci* and point *reference poles* for the self-inversion, both of which entities are defined below.

In the focal type of self-inversion there are a finite number of loci and point reference poles (frequently only one of each); the loci are points, they have focal rank, and they are coincident with the reference poles. In the

non-focal type there are an infinite number of loci and reference poles; the loci are curvilinear, they do not have focal rank, and they generally do not pass through the corresponding reference pole. The loci of the non-focal type are designated as *non-focal self-inversion loci* (see also page VI-7).

θ Self-Inversion Loci

Non-focal self-inversion is illustrated by deriving the non-focal self-inversion loci of the conic sections. With the exception of those for the circle, these are quartics. Eqs. VII-3a, repeated here as eqs. 2, give the intercept

$$xy = \mp(a^2b^2 - b^2h^2 - a^2k^2)/[a^2 + (b^2 - a^2)\cos^2\theta] \tag{8-2}$$

products for 0° (upper sign) and 180° transforms of an ellipse about a point in the plane (h,k). Unlike the intercept products about poles of self-inversion (eqs. 1), the product xy of eqs. 2 is not constant; its value depends upon both the location of the point (h,k) and the angle θ that the radii or chord make with the x-axis. [In the case of a 0° intercept product, the designation *coincident-radii* intercept product frequently is employed; the corresponding designation for 180° is *chord-segment* intercept product.]

Eqs. 2 were derived by eliminating the $\sin\theta$ term from the 0° and 180° eqs. for the x and y intercepts of radii emanating from the pole (h,k) at the angle θ. The significance of these eqs. in the present application is that for all lines cutting the basis ellipse at an angle θ to the x-axis, there exist two interior points on each line, the *interior inversion centers*, (h_1,k_1) and (h_2,k_2), for which the product of the intercepts x and y at 180° is a given constant, and two exterior points on each line, the *exterior inversion centers*, (h_3,k_3) and (h_4,k_4), for which the product of the intercepts x and y at 0° is a given constant. h_n and k_n are the abscissae and ordinates of these self-inversion *centers* relative to the basis curve, $b^2x^2 + a^2y^2 = a^2b^2$, centered at the origin.

If one takes the product xy of eqs. 2 to be the constant j^2, the square of the unit of linear dimension (the value of which is at one's disposal), h and k become variables that define the loci of the *self-inversion centers* of the curve on lines at angles θ to the x-axis, i.e., a locus of centers about

which the products of the intercepts measured along lines through the centers in question at angles θ is constant and equal to j^2. For each angle, the locus of the centers about which the ellipse self-inverts is derived by substituting x for h, y for k, and j^2 for xy in eqs. 2, giving eqs. 3, in which the upper alternate sign is for the exterior locus. These θ *self-*

$$b^2x^2 + a^2y^2 = \pm j^2[a^2+(b^2-a^2)\cos^2\theta] + a^2b^2 \qquad (8-3)$$

(a) $a^2 \pm j^2[a^2+(b^2-a^2)\cos^2\theta]/b^2$ (b) $b^2 \pm j^2[a^2+(b^2-a^2)\cos^2\theta]/a^2$ (8-4)

inversion loci are seen to be other ellipses with centers at $(0,0)$, having the same eccentricity as the basis curve, with the squares of the semi-major and semi-minor axes being $4a,b$, respectively.

The results are similar for other species of conics; the θ self-inversion loci are conics of the same species and, in fact, of the same subspecies, since they have the same eccentricity as the basis curve. Only for the circle does the locus become independent of θ. Thus, for $a = b = R$ and $j^2 = R^2$, eqs. 3 yield eqs. 5. For chord-segment intercept products (180°) this locus is the point circle, $x^2+y^2 = 0$, which means that the center is the only interior

$$x^2 + y^2 = \pm R^2 + R^2 \qquad (8-5)$$

$$j^2 = \mp(R^2 - x^2 - y^2) \qquad (8-6)$$

point for which the product of the intercepts is R^2. For coincident-radii intercept products, this locus is $x^2+y^2 = 2R^2$, in other words, a concentric circle of radius $2^{\frac{1}{2}}R$.

Also, letting $a = b$ in eqs. 2, the 0° and 180° intercept products are given by eqs. 6. These eqs. differ from eqs. VI-19 in that they apply to 0° and 180° intercept products for the circle about any point in the plane, whereas the latter eqs. apply only to cases in which one of the radii passes through the center of the circle.

To illustrate eqs. 3 for the ellipse, let $\theta = 90^\circ$ (i.e., taking chords orthogonal to the x axis) and $j^2 = b^4/a^2$, the square of the semi-LR. Eq. 3 then yields eq. 7 for the interior θ self-inversion locus, which is an ellipse with semi-major axis $(a^2-b^2)^{\frac{1}{2}}$ and semi-minor axis $b(a^2-b^2)^{\frac{1}{2}}/a$. This ellipse

$$b^2x^2+a^2y^2 = b^2(a^2-b^2)$$ interior θ self-inversion (8-7)
locus for $\theta = 90°$ (90° chords)

$$b^2x^2+a^2y^2 = b^2(a^4-b^4)/a^2$$ interior θ self-inversion (8-8)
locus for $\theta = 0°$ (0° chords)

$$[a-(a^4-b^4)^{\frac{1}{2}}/a][a+(a^4-b^4)^{\frac{1}{2}}/a] = b^4/a^2$$ chord-segment intercept (8-9)
product at a vertices of 8

is centered within the basis curve, with its vertices coincident with the foci of the basis curve. The foci mark the lateral limits of the θ self-inversion locus, because beyond them the 90° intercept products are less than b^4/a^2, which is the value that has been adopted for j^2. This emphasizes the fact, also evident from eqs. 3 and 4, that the size of the θ self-inversion locus depends upon the value adopted for j^2.

If, instead, one lets $\theta = 0°$ (i.e., taking chords parallel to the x-axis) for the ellipse, one gets eq. 8 for the interior θ self-inversion locus, which is an ellipse with semi-major axis $(a^4-b^4)^{\frac{1}{2}}/a$ and semi-minor axis $b(a^4-b^4)^{\frac{1}{2}}/a^2$. The chord-segment intercept product at the a vertices of this ellipse, for example, is given by eq. 9.

The Intercept Product Versus the Intercept Transform

The matter of the relationship of the 0° and 180° intercept products to the 0° and 180° intercept transforms now is addressed. Briefly, the intercept transforms express the relation between the x and y intercepts for all angles of the opposed chord-segments or coincident-radii to the x-axis, whereas the intercept products do so only for some specific angle θ. In other words, the same values that satisfy the intercept product eq. for some given angle θ also must satisfy the intercept transform eq.

(a) $xy = (a^2+k^2-h^2)/(2\cos^2\theta-1)$ 180° intercept product for (8-10)
the equilateral hyperbola

(b) $xy = (h^2-a^2-k^2)$ 10a for 90° chords

(a) $y = (h^2-a^2-k^2)/a$ (b) $x-y = (2a^2-h^2+k^2)/a$ (8-11)

180° transform of the equilateral hyperbola
about any point (h,k) in the plane

$$[c^4(x-y)^2+2c^2(h^2+k^2)xy - 2(k^2-h^2)x^2y^2]^2 = 8c^4h^2(c^2+xy)xy(x-y)^2$$ (8-12)

$$c^2 = (a^2+k^2-h^2)$$

$$(2a^2-h^2+k^2)^2 = 4a^2k^2 \qquad \text{eliminant of 10b, 11b, and 12} \qquad (8\text{-}13)$$

$$h^2 - (k\pm a)^2 = a^2 \qquad \text{roots of 13} \qquad (8\text{-}14)$$

The 180° intercept product eq., 10a, and 180° intercept transform, eq. 12, for the equilateral hyperbola are taken as examples. Note first that for θ unspecified it takes an 8th degree eq. to express the general relationship between the intercepts, whereas for θ specified the relationship can be expressed by an eq. of only 2nd degree. If the angle of the chords along which the intercepts are measured is taken to be 90° to the x-axis, 10a becomes 10b. To obtain a set of intercept values (x,y) that satisfy 10b, one is free to let x (or y) equal any positive value, say a, whereupon y is given by 11a and x-y by 11b.

The values of xy given by 10b, and of $x-y$ given by 11b must satisfy the general 180° transform eq., 12, of the equilateral hyperbola because this eq. holds for chords oriented at any angle to the x-axis. If one substitutes these values in the 180° transform eq., 12, one should obtain an eliminant defining a locus of points (h,k) that cut off segments of length a (the x intercept) from chords of the basis hyperbola that are parallel to the LR (perpendicular to the x-axis).

Substituting, cancelling, factoring, and taking a root leads to eq. 13. This is a perfect square that yields the root eq. 14 (after rearranging and putting in standard form), in which the alternate sign is a true alternate. Letting $x = h$ and $y = k$, this is seen to represent two hyperbolas having the same orientation as the basis hyperbola but with one having its center displaced a units along the positive y-axis and the other a units along the negative y-axis. These displacements bring the arms of the hyperbolas of eq. 14 into precisely the expected relationship with the arms of the basis hyperbola.

For example, each point on the lower half of the right arm of the upper hyperbola is a units above the corresponding point on the lower half of the right arm of the basis hyperbola, and each point on the upper half of the lower hyperbola is a units below the corresponding point on the upper half of the basis hyperbola, etc. Moreover, the other halves of the hyperbolas of eq. 14 stand in a similar *external* relationship to the basis arm and cut off coincident-radii at 90° to the x-axis that satisfy the 0° intercept product relation, 15.

The fact that the same solution represents both the 0^O and 180^O cases is an expression of the circumstances that the changes in sign from the 180^O to the 0^O intercept product compensate the changes in sign from the 180^O to the 0^O intercept transform when the expressions derived from the one are substituted in the other. The hyperbolas of eq. 14, however, are not θ self-inversion loci, because the value of the intercept product xy is not constant but varies with the location of the point (h,k) on the hyperbolas.

$$xy = (k^2+a^2-h^2) \hspace{3cm} (8\text{-}15)$$

Derivation of Non-Focal Self-Inversion Loci

With this introduction, the derivation of the *non-focal self-inversion loci* now is undertaken. Unlike the θ self-inversion loci, non-focal self-inversion loci are independent of θ. Each non-focal self-inversion locus is associated with a specific *reference pole* for the inversion and, for a given value of j^2, is related to the reference pole as follows. A line passing through the reference pole at any angle intersects the non-focal self-inversion locus at *centers* about which the curve self-inverts along the intersecting line.

As an example, consider lines passing through a traditional focus of an ellipse at all angles. For an appropriate value of j^2 there will be two interior inversion centers and two exterior inversion centers on each line, through which the curve self-inverts (i.e., through which the intercepts of each line with the curve invert to one another along the line). The interior locus of these centers is the 180^O non-focal self-inversion locus of the ellipse referred to the conventional focus, while the exterior locus is the 0^O non-focal self-inversion locus. Non-focal self-inversion loci exist for every pole for which a 0^O or 180^O intercept transform exists. Such loci are described as *non-focal* because they do not have circumpolar focal rank.

Non-focal self-inversion loci are derived as follows. First, an intercept product is obtained which contains the variables x and y only as the *pure* product xy. In the cases of the parabola and central conics, the compound intercept formats provide these products directly. Being in possession of a *pure* intercept product, one replaces xy with j^2 and solves for the $\cos^2\theta$ and the $\sin^2\theta$. For central conics, one obtains the 0^O (upper external alter-

nate sign) and 180° (lower external alternate sign) eqs., 16, in which the

(a) $\cos^2\theta = \dfrac{\mp(a^2b^2-b^2h^2\pm a^2k^2)}{j^2(b^2\pm a^2)}$ (b) $\sin^2\theta = \dfrac{\pm[(a^2b^2-b^2h^2\pm a^2k^2)+j^2b^2]}{j^2(b^2\pm a^2)}$ (8-16)

internal alternate signs are for the hyperbola (upper) and ellipse.

If one now replaces h by x and k by y, these eqs. define the θ self-inversion loci described above, i.e., they give the centers of self-inversion on all lines cutting the central conics at the angle θ. But to obtain non-focal self-inversion loci one does not seek centers on all lines at a *given angle*; rather, one seeks centers on all lines through a given single reference pole (h,k) at *all angles*. Accordingly, the next step is to formulate the eq. of a line through the reference pole (h,k) at the angle θ, namely eq. 17a.

(a) $(x-h)\sin\theta = (y-k)\cos\theta$ (b) $(x-h)^2\sin^2\theta = (y-k)^2\cos^2\theta$ (8-17)

Following this one squares both members of 17a, giving 17b, and forms the eliminant between 17b and 16a,b (but with h and k of 16a,b replaced by x and y, respectively).

By eliminating θ between 16a,b (which represents self-inversion centers on all lines through all points at the angle θ) and 17b (which represents a line through the reference pole at the angle θ), one obtains the eqs. for the loci of inversion centers on lines through the given point at all angles, namely eq. 18, the *non-focal self-inversion loci* of central conics. These are previously unknown quartics.

basis curve

$$\mp[(y-k)^2+(x-h)^2](a^2b^2-b^2x^2\pm a^2y^2) = j^2[b^2(x-h)^2\mp a^2(y-k)^2] \qquad \begin{matrix}\text{central} \\ \text{conics}\end{matrix} \qquad (8\text{-}18)$$

$$\mp[(x-h)^2+(y-k)^2](2px-y^2) = j^2(y-k)^2 \qquad \text{parabola} \qquad (8\text{-}19)$$

$$\mp[(x-h)^2+(y-k)^2](d^2-y^2) = j^2(y-k)^2 \qquad \begin{matrix}\text{parallel} \\ \text{line-pair}\end{matrix} \qquad (8\text{-}20)$$

(a) $(x^2+y^2)(d^2-x^2) = j^2x^2$ eq. 20 cast about the midpoint (8-21)

(b) $(x^2+y^2)(d-x)^2 = b^2x^2$ conchoid of a line

A parallel derivation gives eq. 19 for the non-focal self-inversion loci of the parabola, and eq. 20 for the corresponding loci for the parallel line-pair,

$y^2 = d^2$, where the external alternate signs differentiate between the 0° (upper) and 180° inversions, and the internal alternate signs (eq. 18) differentiate between the hyperbola (upper) and the ellipse.

It will be noted that, aside from the case of the circle, all the non-focal self-inversion loci of conic sections are quartics. When one casts the non-focal self-inversion locus for the parallel line-pair about the midpoint, eq. 21a, a similarity of the eq. to that of the conchoid of a line, eq. 21b, is evident. The essential difference is that the term in d and x is the difference between the squares for 21a, but the square of the difference in 21b. In both eqs., d is taken to be the distance from the reference pole to the line. For the conchoid, the parameter b is the distance from the curve to the reference line along any radius from the pole; for the non-focal self-inversion locus, j plays an analogous role to that of b, since it is the unit of linear dimension.

Non-focal self-inversion loci of other curves are of higher than 4th degree and their eqs. do not fall into the simple format of eqs. 18; the degree appears to be a minimum of $n+2$, where n is the degree of the basis curve. The general and specific eqs. of these loci are difficult to derive, because obtaining the loci even relative to reference poles that lie on the *axes* of other curves often involves obtaining analytical solutions for the roots of complex eqs. of 3rd degree and higher.

On the other hand, plotting of non-focal self-inversion loci is accomplished readily. One merely: (a) draws lines at all angles through the reference pole for the inversion; (b) establishes the unit of linear dimension; (c) marks off the two poles on each line for the positive or negative inversion; and (d) draws a continuous curve through these points. The rules for locating the poles merely establish that the product of the two segments thereby delineated is j^2.

"Pure" xy Intercept-Product Formats and Self-Inversion

Before describing some specific non-focal self-inversion loci of conics, a few remarks are in order concerning the "pure" xy compound 0° and 180° intercept-product formats, $xy = f(\theta,h,k)$, possessed by conics. The fact that intercept-product formats holding for *a point in the plane* are expressible in very simple form for conics, alone, goes hand-in-hand with the very high degree of symmetry of these curves, and is an indication of a higher degree of circumpolar symmetry than the property of self-inversion about a point-pole (see Chapter XIV, *"Pure" Intercept Products*). It already has been found that one conic

or another emerges as the most symmetrical curve in virtually every coordinate system considered (though not always in the conventional association, i.e., not always as a single parabolic arm or two opposed congruent hyperbolic arms, etc.).

CIRCUMPOLAR MAXIM 7: *The possession of "pure" xy compound 0° and 180° intercept-product formats that hold for a point in the plane and are expressible in very simple form, $xy = f(\theta, h, k)$, is an indication of a higher degree of circumpolar symmetry of a curve than the property of self-inversion about one or more poles.*

A few circumpolar symmetry comparisons between conics and the most highly symmetrical self-inverting QBI curves are illustrative. Limacons, for example, have lesser symmetry about the focus of self-inversion--as judged by the 180° transforms--than do conics about the traditional focus, which is a homologous pole. Thus, their 180° transforms about this pole are of 3rd degree compared to only 2nd degree (the "harmonic mean" eqs.) for conics. If one compares only the ordinal ranks of limacon and conic transforms about these poles (the ordinal rank is independent of the angle of transformation), the conics emerge with much higher circumpolar symmetry rank (i.e., a lower degree of their ordinal rank eqs.; see Table V-1).

On the other hand, limacons emerge with higher symmetry if one compares their transforms about the DP (or DP homologue)--which is the reciprocal inversion pole--with those of conics about the traditional focus. Limacons not only have linear 180° and 0° symmetry about the DP--compared to equilateral hyperbolic symmetry of conics about the traditional focus--they are among the highest ranking curves with linear symmetry of any curve of finite degree, with ordinal and subordinal rank eqs. of only 2nd degree (see Table V-1 and Appendix III).

The hyperbola (and ellipse) axial vertex cubics self-invert about the loop vertex. If a circumpolar symmetry comparison between them and central conics were valid, the equilateral strophoid would emerge with equivalent symmetry, even to the level of subordinal rank. However, the comparison is invalid because the loop-vertex focus of the equilateral strophoid is a subspecific double-focus, by virtue of coincidence with the variable focus. [In fact, the loop-vertex focus of this subspecies is a *dual multiple focus* because the loop vertex itself is a *generic double-focus of self-inversion*; a discussion of this property is deferred to treatments in Chapters XII and XIV.]

Why Do Conics Not Self-Invert At the Focal Level?

The above considerations inevitably raise the question of why conics do not self-invert at the focal level. Although in these chapters concern is primarily with matters of *what?*, not *how?* or *why?*, which are deferred to Chapter XIV, this question is answered here. A first prerequisite for a curve to self-invert about a point is that its degree remain the same under the inversion transformation about that point. But it is inherent in the algebra of the inversion transformation that if the highest degree term in an eq. (in which lower degree terms also are present) of a curve being inverted about a pole is of the form $a(x\pm h)^2 + b(y\pm k)^2$, then, unless $a = b$, the degree of the basis curve will not be conserved, i.e., the inverse curve will be of higher degree. This basic feature of the inversion process immediately disqualifies all conic sections but the circle and intersecting lines from meeting even the first prerequisite for self-inversion.

The circle, of course, does undergo negative self-inversion about its center, with the $180°$ transform being $xy = R^2$. The parallel line-pair also is disqualified by the above considerations, but the intersecting line-pair, $x^2 = Cy^2$, is not; it self-inverts about the point of intersection. It also is inherent in the algebra of the inversion process that if the highest-degree term in the eq. of a curve is linear, the inversion locus will be circular, unless the constant term is 0. Accordingly, the single line only self-inverts about incident points.

NON-FOCAL SELF-INVERSION LOCI OF CONIC SECTIONS

Examples of some specific $180°$ non-focal self-inversion loci of conics (but including $0°$ loci for the hyperbola) are considered, with attention confined almost entirely to axial reference poles. With the exception of non-focal self-inversion loci referred to the center of central conics, the non-focal self-inversion loci referred to these poles have only one line of symmetry. Loci referred to non-axial poles have no line of symmetry. The choice of the unit of

linear dimension, j^2, greatly influences the properties of these loci. The ellipse is used as the chief example to describe these influences.

The Ellipse - Rotating Chord Analysis

Just as the description of the generation of intercept transforms about a given pole was facilitated by considering rotating radii and their intercepts with the basis curve, a description of non-focal self-inversion loci is facilitated by considering rotating radii emanating from the reference pole for self-inversion at $0°$ or $180°$ to one another, and their intercepts with the self-inversion locus. Since this analysis concentrates on the $180°$ loci, it is a rotating *chord* with which one deals.

When this chord rotates about a reference pole that lies on the x or y-axis, its two *inversion centers* always are at the same distance from the intersections of the chord with the basis curve; but the distances of these centers from the reference pole are, in general, different from one another. Only when the reference pole is the center of a central conic, leading to a non-focal self-inversion locus with two lines of symmetry, are the self-inversion centers equidistant both from the intercepts with the curve and the reference pole, i.e., of the 4 segments into which the chord is divided by the 3 points, the 2 outer ones always are of equal length and the two inner ones always are of equal length. As the location of the reference pole recedes from the center, the maximum possible disparity between the 2 inner distances increases.

Intersection of Axial Non-Focal Self-Inversion Loci
At the Axial Self-Inversion Centers

Each axis has upon it two unique points--the *axial self-inversion centers*. Since all chords rotated about points on, for example, the x-axis become coincident with the axis when $\theta = 0°$ and $180°$, all will have in common the same axial self-inversion centers. This means that all non-focal self-inversion loci about reference poles on a given axis (in fact on any *chord*) intersect that axis at two common points. Accordingly, all such loci intersect one another at a minimum of two points. The choice of j determines the location of these centers according to the eq., $h = \pm(a^2-j^2)^{\frac{1}{2}}$, for the x-axis.

Axial Intersection of Axial Non-Focal Self-Inversion Loci
 At the Reference Pole

Another influence of the choice of j is to determine whether the self-
inversion locus for a given reference pole also intersects the axis (on which
the pole lies) at a third point. This third point, when it exists, is coinci-
dent with the reference pole, which thus comes to lie on the self-inversion
locus which it, itself, defines. When this occurs, the self-inversion locus
consists of two ovals with a DP at the reference pole and with the vertex of
the small loop at the proximal self-inversion center. If the reference pole
is coincident with an axial center, the locus consists of a single oval pos-
sessing a cusp at the point of coincidence. Of course, in the limiting case in
which the self-inversion locus is a point coincident with the reference pole,
one has *focal* self-inversion.

Tangent Ovals and the 90° 2j-Chord

For a given value of j less than b, a 90° chord of length 2j intersects
the x-axis at $h = a(b^2-j^2)^{1/2}/b$. If this point of intersection is taken as the
reference pole, the self-inversion locus will consist of two non-congruent
ovals tangent to one another and the 90° chord at the point of intersection
with the x-axis.

The basis for this phenomenon is that for any chord of length 2j, there
exists only one inversion center, namely its midpoint. If the chord is perpendi-
cular to the x-axis, the midpoint is the point of intersection with the x-
axis. Accordingly, since the portion of the self-inversion locus on each side
of the chord is symmetrical about the x-axis, yet is in contact with the axis
and the chord at only one point, it has to be tangent to the chord at the axis.

Although a self-inversion locus can have a cusp at the axial reference pole
(when the pole coincides with the axial center), this cannot occur at the point
of intersection of the 2j-chord with the x-axis, for then $h = (a^2-j^2)^{1/2} = a(b^2-j^2)^{1/2}/b$, which leads to the condition a = b, for which the basis curve
is a circle. When j = b, the chord intersects the x-axis at the center of
the ellipse and the tangent ovals comprise the self-inversion locus about the
center as reference pole. Accordingly, the two ovals are congruent, since they
have mirror-image symmetry about both axes.

j Greater Than b

For values of j greater than b, the self-inversion loci are as follows.
For h = 0 --the center--all loci consist of two congruent lemniscate-like
ovals with their double points at the center and vertices at the axial inversion
centers. For poles between the center and the vertices, the curves consist of
either single ovals or two ovals joined at a DP. The DP is the reference pole
for the self-inversion locus, and the vertices are the axial inversion centers.
The loci for the vertices of the ellipse as reference poles consist of single
ovals, regardless of the value of j.

In summary, the non-focal self-inversion loci of the ellipse for internal
reference poles on the major axis consist of quartic single or double ovals.
The single ovals intersect the axis at two points--the axial self-inversion
centers. The double ovals intersect the axis at 3 points, the 3rd point being
either a DP or a point where the locus breaks up into two tangent ovals. The
self-inversion loci always are symmetrical about the major axis (or minor axis
if cast relative to reference poles thereon) but also are symmetrical about
the minor axis if the pole is at the center.

The choice of the unit of linear dimension, j, has a great influence on
the self-inversion loci, determining whether the locus for a given reference
pole consists of a single or a double oval; a single oval may have a cusp,
while double ovals may be tangent to one another or joined at a DP.

The Parabola

While possessing marked similarities to the non-focal self-inversion loci of
the ellipse, those for the parabola and hyperbola also are markedly different,
in having at least one open portion, rather than being closed. The loci for the
parabola are most similar to those of the ellipse, in keeping with the fact
that a parabola may be likened to an ellipse with its second traditional focus
at infinity.

The choice of j has essentially the same types of influences on the non-
focal self-inversion loci of the parabola as discussed above for the ellipse.
For illustration, j is taken to be equal to the length of the semi-LR (p or
2a) and the description is based on this case.

Since the axis of the parabola is infinite in extent, the axial inversion centers are fixed at 0, i.e., at the vertex, and at ∞. This means that all non-focal self-inversion loci for reference poles on the x-axis must intersect that axis at the vertex. For all reference poles between the focus and the vertex, but not including either, the self-inversion loci consist of a closed oval and an "open oval," with the DP lying on the axis at the reference pole. In the case of the vertex as reference pole, the locus has a cusp at the vertex. For the focus as reference pole--inasmuch as $j^2 = 4a^2 =$ semi-LR2 (i.e., the 90° 2j-chord is at this position)--the locus breaks up into a closed and an open oval tangent to one another and to the LR at the focus.

For reference poles beyond the focus, the loci intersect the x-axis only at the vertex (and infinity). At points just beyond the focus, the loci divide into upper and lower arms as the oval "opens" at the former DP, yielding arms that face one another on opposite sides of the x-axis. These arms "spring rapidly off" the x-axis and the former cusp regions become "drawn out" to inflections; for a pole at $x = 1\frac{1}{2}a$, the locus already is 1.4a units distant from the x-axis and the only trace of the former cusp region is an irregularity in the structure of the curve between $x = 0.8a$ and 1.6a. Loci quite different in appearance exist for 0° inversions about poles on the x axis external to the curve, but a treatment of these is deferred.

Accordingly, the single-arm open structure of the parabola makes evident a regular progression in the form of its non-focal self-inversion loci. Beginning with the reference pole at the vertex, the locus has a cusp, from the tip of which the arms gradually increase in slope (both positively and negatively). Before reaching the level of the focus they inflect, and gradually decrease in slope thereafter to 0 at ∞. They get closer and closer to the basis lateral arms as they recede from the vertex. For reference poles immediately beyond the vertex, the arms of the locus are essentially unchanged but the cusp becomes a loop and DP, with the loop vertex at the basis curve vertex and the DP at the reference pole for the self-inversion. The lateral arms follow closely those of the locus for the vertex.

As the reference pole becomes more distant from the vertex, the location of the DP keeps pace with it, the loop enlarges, and the lateral arms become displaced commensurately; but they eventually group into a band of parallel loci running along just within and parallel to the lateral arms of the basis

curve. At the focus (or wherever the location of the 90° 2j-chord) the closed loop becomes tangent to the open loop and the LR. For reference poles just beyond the focus, the loops open at the former DP and present opposing arms, with the lateral arms joining the "parallel band" of arms of other loci. The opposed arms "spring rapidly off" the x-axis as the reference pole recedes from the focus. The lateral arms lose their simple structure as the former cusp region becomes a region of double inflection. This region gradually "smooths out" as the pole recedes to infinity.

The Hyperbola

The non-focal self-inversion loci of hyperbolas are more complex and, in some respects, quite different from those of the parabola, by virtue of the existence of two arms. Moreover, since points "interior" to one arm are "exterior" to the other arm, the 0° and 180° self-inversion loci form continuous curves (through merging) and are discussed together below.

The right arm of an equilateral hyperbola with j equal to the semi-LR (a units) is taken as an example. The non-focal self-inversion loci are complicated and are not described in detail. The following general relations hold. Loci within one arm may be either 180° loci for the basis arm or 0° loci for both arms. At the points where the loci intersect an arm, the point of intersection is the inversion center for a point at infinity on both arms. If one follows a self-inversion locus to its intersection with the curve, one completes the inversion construction of one arm at infinity and picks up the locus at infinity on the other arm, etc.

Beginning with the vertex as reference pole, the self-inversion locus for the basis arm is very similar in form to that for the parabola. But the complete locus includes a segment for the other arm as well, which is external to the basis arm. Together, the two segments join to form a DP at an x-like intersection at the vertex. Just as do the internal loci in the neighborhood of the lateral arms, the external loci bend over toward the basis curve and, together with the lateral extensions of the other external loci, form a parallel, virtually coincident, band paralleling the lateral arms of the basis arm just beneath the asymptotes.

For reference poles between the vertex and the focus (i.e., between the vertex and the 90° 2j-chord), the curves possess a loop, as they do in the parabola. However, the orientation of the loop is reversed; its DP remains at the reference pole but its vertex is at the focus. The lateral-arm extensions of the self-inversion loci now intersect the curve, exterior to which they follow along the paths taken by the exterior segments of the loci for the vertex.

As the reference pole approaches the focus, the loop becomes ever smaller (in the parabola it becomes ever larger) and disappears at the focus. When the reference pole is at the focus, the locus consist of: (a) a fully internal hyperbola-like segment (i.e., interior to the basis arm), which is the 180° locus for the basis arm alone; together with (b) one segment partly internal (the 0° locus for both arms) and partly external (a 0° locus for the basis arm alone) which resembles the external vertex locus and meets the focus in a cusp; and (c) a loop from the center to the focus, with its DP at the former and its vertex at the latter. Interior to the basis arm, locus (c) is a 180° locus for that arm alone, but exterior to the basis arm it is a 180° locus for both arms. Together with the mirror-image segments of the self-inversion locus relative to the focus of the other arm, a lemniscate-like locus is produced. Both the "open loop" (a) and the lemniscate-like loop (c) are tangent to one another and the LR at the focus.

The complete self-inversion locus for a reference pole at the center is strictly for 180° self-inversions involving both arms. It consists of two opposed hyperbola-like arms with the y-axis as their transverse axis, tangent to one another at the center, and having the asymptotes of the basis curve for asymptotes--but the latter are internal to the self-inversion locus rather than external to it. There is no 0° self-inversion locus for the center.

The center acts as an axial inversion center for all 180° external self-inversion loci (i.e., self-inversion loci lying between the arms). Consider an axial reference pole at x = 2a as an example. In the 1st quadrant, segments of the locus leave the center and the focus (tangent to the LR) and intersect the basis arm at a common point. Preceding this intersection, the segment from the focus is a 0° self-inversion locus for both arms. After the intersection, the segment from the center is a 180° locus for the basis arm alone. Both

segments have inflection points.

Considerable attention has been devoted to non-focal self-inversion loci of conic sections for several reasons. Chief among these is the fascination of the curves themselves, both from the intrinsic point of view and inasmuch as they are non-focal self-inversion loci of the most highly symmetrical genus of curves that exists. A second reason is that, though the formal derivation of the eqs. of these loci is in general a formidable task, the curves themselves are virtually at one's fingertips--given a chord of length 2a, the 180° self-inversion centers are at a distance of $(a^2-j^2)^{\frac{1}{2}}$ on each side of the center of the chord.

A third reason is that the circumpolar symmetry properties of the non-focal self-inversion loci may be fundamentally related to the circumpolar symmetry of the curve about the reference pole for the self-inversion. One gets a hint of this in the progressive changes that occur in the loci for the parabola for axial reference poles; beginning with a simple cusped curve for a reference pole at the vertex, through a looped curve with a DP, to tangent "open" and closed ovals, etc. The arbitrary selection of the unit of linear dimension presents a complication, but does not preclude a rigorous analysis; if anything, it provides a richer substratum for analysis. There are reasons to anticipate that a circumpolar symmetry analysis of the basis curve in terms of the properties of its non-focal self-inversion loci will be founded upon considerations of the number and types of inflections possessed by these loci.

Of course, the center of central conics would emerge as the reference pole about which the curve would have the greatest 180° circumpolar symmetry by this criterion. This would be the second respect in which the curves would have higher 180° circumpolar symmetry rank about the center than about the focus. It will be recalled that the 180° transform of central conics about the center is $x = y$, which possesses the highest class rank of any conic intercept transform.

The non-focal self-inversion loci of conics invert to 6th degree curves about a point in the plane. Because the inversion transformation is *ultimately conservative of degree*, the inversion superfamily to which these curves belong has members of exponential degree no greater than 6 (see below).

INVERSIONS OF CONIC SECTIONS

Inversion Taxonomy

The analytical treatment of the circumpolar symmetry of conic sections is concluded with an analysis of their inversions and an introduction to Inversion Taxonomy.

The Inversion Taxonomy Paradigm

Given a genus of basis curves, the ensemble of inversions of all of its members through all points in the plane, plus the ensemble of all inversion derivatives of the first inversion ensemble, etc., are classified together as members of the same superfamily. The superfamily is designated after the member genus of lowest even degree (or the most symmetrical such member genus).

Because of the property of the inversion transformation, that it is *ultimately conservative of degree*, the number of degree classes in any superfamily is finite. For example, assume that a basis curve of degree n includes among its inversion loci curves of degree n+4. The inversion loci of these (n+4)th degree curves, then, will be conservative of degree, i.e., they will include no curves of degree higher than n+4. [Note that the term *conservative* in the phrase *conservative of degree* is being employed to mean that there is no increase, rather than that there is no change.]

In a familiar example, the line inverts to the circle through any non-incident point in the plane, but the circle inverts only to lines and circles, not to any curve of higher degree. Similarly, other conic sections invert to cubics and quartics, but none of the curves so derived will invert to a curve of higher degree than 4. On the other hand, many other quartics include curves of higher degree than 4 among their inversion loci; it is common for a basis curve to invert through any non-incident point in the plane to curves of degree n+2 but increases can be up to a degree of 2n.

According to this paradigm (see Table VI-1), the *quadratic-based inversion superfamily* numbers among its axial inversions all the conic sections, the cissoid of Diocles, the equilateral strophoid, the trisectrix of Maclaurin, numerous other *axial vertex cubics*, limacons (but not other Cartesians), *pseudo-exchange-limacons*, *central quartics*, and other genera of axial-inversion

quartics. To be added to this list are all of the non-axial inversion cubics and quartics (see Chapter XII).

Accordingly, the QBI (quadratic-based inversion) superfamily possesses curves of 1st, 2nd, 3rd, and 4th degree. But the fact that a curve is not quadratic-based does not preclude its possessing very similar circumpolar symmetry properties to those of QBI curves. For example, from the point of view of circumpolar symmetry, bipolar parabolic and linear Cartesians and polar-circular linear Cartesians are closely related to limacons (which are special cases of both groups of linear Cartesians). Yet Inversion Taxonomy places them in different superfamilies.

Curves of Demarcation

Three highly symmetrical members of the QBI superfamily, the equilateral limacon, the e = 2 (b = 2a) limacon, and the equilateral lemniscate also are the *curves of demarcation* between several genera or species of curves that are unrelated to members of the QBI superfamily by any known *planar* transformation (Table VIII-1).

[A curve of demarcation is a single and sole subspecies of a supergenus or genus defined by an eq. $f(x,y,a_1,....a_n) = 0$, that has two or more communicating ovals (in the cases of two ovals, the ovals either are opposed or one is internalized relative to the other). The ovals do not come into communication as in, for example, hyperbolic limacons, by the "opening out" of a tiny loop from the cusp of the cardioid when b exceeds a, with gradual enlargement of the loop as the ratio b/a increases. Instead, they do so by the gradual pinching together of the opposed segments of a single loop or oval with increasing or decreasing values of a parameter of the eq. of the curve. The locus formed when the opposed pinching segments touch to form a DP is the *curve of demarcation*. With further increase or decrease in the value of the parameter the DP is lost as the ovals detach. When two ovals result from the detachment, the separation of the opposed vertices typically continues to increase with further progressive changes in the parameter. It is inherent in the above-described method of change in the locus represented by an eq. from, say, a one or two-oval genus or species to a genus or species with two or three discrete ovals, that the number of axial foci changes. This is the result of the formation of an additional vertex and, in some cases, a true center that is non-incident (though the number does not necessarily always change on passage from a curve with one oval to a curve with two communicating ovals).]

QBI curves of demarcation, and they alone among QBI curves, are related to the genera or species that they demarcate through an *equational*, and therefore *constructional* correspondence. On the other hand, circumpolar symmetry relationships are not restricted by transformation boundaries. Accordingly, the curves of demarcation in question, as well as other QBI curves, may be closely related

Table VIII-1. Curves of Demarcation

BIPOLAR PARABOLIC CARTESIANS \longrightarrow	EQUILATERAL LIMACON \longrightarrow	BIPOLAR PARABOLIC CARTESIANS
[4 (or 5*) axial foci, one oval, one line of symmetry]	[5 discrete axial foci, 2 communicating non-congruent loops, one line of symmetry]	[6 (or 7*) axial foci, 2 discrete non-congruent ovals, one line of symmetry]
CASSINIANS \longrightarrow	EQUILATERAL LEMNISCATE \longrightarrow	CASSINIANS
[5 axial foci, one oval, 2 lines of symmetry]	[5 axial foci, 2 communicating congruent loops, 2 lines of symmetry]	[7 axial foci, 2 discrete, congruent ovals, 2 lines of symmetry]
TRUE EXCHANGE-LIMACON \longrightarrow	e = 2 LIMACON \longrightarrow	TRUE EXCHANGE-LIMACON
[4 (or 5*) axial foci, one oval, one line of symmetry]	[5 discrete axial foci, 2 communicating, non-congruent loops, one line of symmetry]	[6 (or 7*) axial foci, 2 discrete non-congruent ovals, one line of symmetry]
LCQ SEXTICS** \longrightarrow	LCQ SEXTIC CURVE OF DEMARCATION \longrightarrow	LCQ SEXTICS**
[2 tangent ovals, 3 vertices, one line of symmetry, number of foci unknown]	[3 ovals, 2 tangent to one another, 2 communicating at DP, 4 vertices, one line of symmetry]	[3 ovals, 2 tangent ovals within discrete large 3rd oval, 5 vertices, one line of symmetry]

* The circumpolar symmetry analyses of these curves have not been carried out in sufficient detail to preclude the existence of a 5th or 7th focus in the one-oval and two-oval members, respectively. In subsequent treatments of these curves it is assumed, strictly as a working hypothesis, that only 4 foci exist in the single-oval groups and 6 in the double-oval ones.

** See Chapter XIV.

to the members of the demarcated genera by their circumpolar symmetry.

For example, for $C < 4$, bipolar parabolic Cartesians (bipolar eq. $u^2 = Cdv$) consist of a single oval with 4 axial foci. For $C = 4$ an indentation in the oval closes, creating a DP between two communicating ovals of a curve with 5 discrete axial foci. This curve is the equilateral limacon--the sole parabolic Cartesian possessing communicating loops. For $C > 4$, the loops detach,

creating a 4th vertex and a 6th axial focus. Limacons are closely related to parabolic Cartesians through their circumpolar symmetry about a homologous variable focus.

In the case of the equilateral lemniscate and Cassinians, for which the bipolar eq. is $uv = Cd^2$, the second loop that is created for the value $C = \frac{1}{4}$ is an *opposed* loop, the two loops that exist for $C > \frac{1}{4}$ are external to one another, and Cassinians are closely related by circumpolar symmetry to *central quartics* rather than to limacons.

Conic Inversion Loci

About A Point In the Plane

Eqs. for inversions of conics about a point in the plane are given by 22a-d, where the upper signs of 22b are for hyperbolas and the lower for

Inversion loci about a point in the plane	Basis curve	
(a) $(k^2+4ah)(x^2+y^2)^2 = 2j^2(x^2+y^2)(ky+2ax) - j^4y^2$	parabola	(8-22)
(b) $(b^2h^2\mp a^2k^2-a^2b^2)(x^2+y^2)^2 =$ $2j^2(x^2+y^2)(b^2hx\mp a^2ky) - j^4(b^2x^2\mp a^2y^2)$	central conics	
(c) $(h^2-k^2-a^2)(x^2+y^2)^2 = 2j^2(x^2+y^2)(hx-ky) - j^4(x^2-y^2)$	equilateral hyperbola	
(d) $(h^2+k^2-R^2)(x^2+y^2) = 2j^2(hx+ky) - j^4$	circle	

ellipses. These results were obtained by casting the eqs. of the curves in standard form in rectangular coordinates, employing $x-h$ and $y-k$ translations of axes, converting to polar coordinates, inverting (substituting j^2/r for r), clearing of fractions, and restoring rectangular coordinates. The parameters a and b are those of the basis curves in rectangular coordinates. It is evident that the inversion loci of conics are at most of 4th degree, as are their non-focal self-inversion loci.

About the Traditional Foci

For the traditional conic foci, one lets $k = 0$ for all three groups and $h = -a$ for the parabola, $h = (a^2 \pm b^2)^{\frac{1}{2}}$ for the hyperbola and ellipse, and $h = 0$ for the circle in 22a-d, respectively, yielding 23a-d. For $j = R$, 23d is the recovered basis circle.

Inversion loci about traditional focus	Inverse curves

(a) $4a^2(x^2+y^2)^2+4aj^2x(x^2+y^2) = j^4y^2$ cardioid (8-23)

(b) $\mp b^4(x^2+y^2)^2+2b^2j^2(a^2\pm b^2)^{\frac{1}{2}}x(x^2+y^2) = j^4(b^2x^2\mp a^2y^2)$ hyperbolic and elliptical limacons

(c) $-a^2(x^2+y^2)^2+2\cdot 2^{\frac{1}{2}}aj^2x(x^2+y^2) = j^4(x^2-y^2)$ equilateral limacon

(d) $x^2 + y^2 = j^4/R^2$ circle

About the Center

For the center conditions, $h = 0$, $k = 0$, the central conics give the *central quartics*, 24a, which are members of the root-$\cos^2\theta$ group. (b) is the equilateral lemniscate.

Inversion loci about the center	Inverse curves

(a) $a^2b^2(x^2+y^2)^2 = j^4(b^2x^2\mp a^2y^2)$ central quartic (8-24)

(b) $a^2(x^2+y^2)^2 = j^4(x^2-y^2)$ equilateral lemniscate

About the Vertices

The next-highest ranking foci are the vertices. Letting $h = k = 0$ for the parabola, $h = a$, $k = 0$ for the central conics, and $h = h$, $k = \pm(R^2-h^2)^{\frac{1}{2}}$ for the circle yields 25a-d. (a) is the cissoid of Diocles, (b) are the transverse and major axis vertex cubics of the central conics, including the trisectrix of Maclaurin (for $e = 2$), (c) is the equilateral strophoid, and (d) are the lines derived by inverting the circle, $x^2+y^2 = R^2$ through any point $[h,\pm(R^2-h^2)^{\frac{1}{2}}]$ on the curve. Although the hyperbola subspecies, $e = 2$, appears to have no unusual features, its inversion loci, particularly the $2\cos\theta$ limacon, are of exceptional interest.

Inversion loci about vertices	Inverse curves	
(a) $4ax(x^2+y^2) = j^2y^2$	cissoid of Diocles	(8-25)
(b) $2ab^2x(x^2+y^2) = j^2(b^2x^2\mp a^2y^2)$	central conic axial vertex cubics	
(c) $2ax(x^2+y^2) = j^2(x^2-y^2)$	equilateral strophoid	
(d) $2hx \pm 2(R^2-h^2)^{\frac{1}{2}}y = j^2$	lines	

Axial Vertex Cubics

All hyperbolas invert through their axial vertices to looped cubics that possess a DP. The reciprocal pole of inversion of the cubic is this DP, through which the loop inverts to one arm of the basis hyperbola, and the "open loop" (or lateral arms) of the cubic inverts to the other arm. The vertex of the latter arm is coincident with the DP. It is, of course, a property of the hyperbola axial vertex cubics that the two hyperbolic arms obtained by inversion through the DP are congruent.

Though all looped cubics of the general form of the hyperbola axial vertex cubics invert to hyperbola-like curves with two arms, the two arms generally are incongruent. For example, the arms produced by inverting the folium of Descartes through its DP are highly disparate. The arm passing through the DP is conventional in appearance, whereas the contralateral arm is more sharply curved at the vertex and its lateral arms are almost linear (an indication of near circularity of the segments of the loop of the folium of Descartes in the proximity of the DP; see also page IX-19).

Since the cissoid of Diocles has only a cusp (i.e., it lacks a loop extension), it inverts to a one-arm parabola, the vertex of which is at the cusp. The central region of the cissoid is internal to the parabola, while its lateral arms intersect the basis curve at unit distance from the vertex. The ellipse axial vertex cubics resemble the bow-like arms of certain conchoids (i.e., they resemble the profile of a gently sloping hill on a plane), with their convexity facing the concavity of the ellipse vertex. The near vertices of the curves are $j^2/2a$ distant from one another.

CIRCUMPOLAR MAXIM 8: *Inversions through homologous non-variable foci of basis curves that belong to the same genus produce members of a single genus.*

The firmest grounds for establishing what might be called *familial* or *geneological* relationships between curves are provided by elementary point transformations. Of these, the inversion transformation is pre-eminent. Just as inversions through the traditional foci of conics--limacons--fall into a single related group (taken to be the taxon *genus*), and those through the centers--the *central quartics*--fall into a single group, all inversions of conics about homologous axial vertices also fall into a single group.

Upon this basis, the cissoid of Diocles, equilateral strophoid, trisectrix of Maclaurin, and other cubics obtained by inverting the parabola and central conics about vertices upon the axes on which the traditional foci lie also are members of the same genus, the *conic axial vertex cubics* (which does not include ellipse b-vertex cubics). Two forms of the eqs. for members of this genus are 26a,b, where e and p have the conventional meanings. The para-

(a) $2epx(x^2+y^2) = j^2x^2(1-e^2) + j^2y^2$ conic axial vertex cubics (8-26)

(b) $\pm 2ax(x^2+y^2) = (a^2-b^2)x^2 + a^2y^2$ " " " "

(c) $j^2/2a = a$ (d) $aj^2/\pm(b^2-a^2) = a$ (e) $j^4/\pm(b^2-a^2) = b^2$

(f) $x^2(x-j^2/2a) = y^2(aj^2/2b^2-x)$ ellipse a-vertex cubics

(g) $x^2(y-j^2b/2a^2) = y^2(j^2/2b-y)$ ellipse b-vertex cubics

(g') $x^2(x-j^2/2b) = y^2(bj^2/2a^2-x)$ ellipse b-vertex cubics,
 rotated 90° clockwise

meters a and b of eqs. 26b are those of the polar eq. for conics, $r = j^2/(a-b\cos\theta)$. They are related to the parameters a and b of the standard rectangular eqs. (from which eqs. 22-25, 26f,g,g', and those below are derived) as shown in 26c-e. Eq. 26c is for the parameters of the parabola, while eqs. 26d,e are for those of the central conics. The polar parameters are on the left, the rectangular ones on the right (the upper alternate signs are for hyperbolas and the lower for ellipses).

Eqs. 26f and g, respectively, are the ellipse a-vertex and b-vertex inversion cubics (conic parameters). To facilitate a comparison, the b-vertex cubic is rotated 90° CW in 26g', whereupon the asymptotes of both 26f and 26g' are parallel to the y-axis (with the double-point [DP] homologues at the origin). These two species of inversion loci are seen to differ only in the

fact that the parameters, a and b, are exchanged.

The quotients, $aj^2/2b^2$ and $bj^2/2a^2$ are the distances of the asymptotes from the DP homologues, and the quotients, $j^2/2b$ and $j^2/2a$, are the corresponding distances of the vertices. Expressed in terms of eccentricity, the distance ratio, (a-vertex cubic)/(b-vertex cubic), is $1/(1-e^2)^{3/2}$ for the asymptotes and $(1-e^2)^{\frac{1}{2}}$ for the vertices.

In other words, the asymptotes of the a-vertex cubics always are farther from, and their vertices always closer to, the DP homologues, than those of the b-vertex cubics. In actuality, the asymptote lies on the far side of the curve from the DP homologue for the a-vertex cubics but on the near side for the b-vertex cubics; correspondingly, the a-vertex cubics present their convex aspect, and the b-vertex cubics their concave aspect, to the DP homologue. Accordingly, the a-vertex and b-vertex cubics differ fundamentally in their properties. [As ellipses become more nearly circular, the vertex cubics "straighten out" and approximate to the asymptotes, becoming lines in the limit, when a = b.]

In consequence of these differences between ellipse vertex cubics, all the line-of-symmetry vertex cubics of conic sections are basically different. In the cissoid of Diocles, the DP homologue and the "vertex" are in coincidence at the cusp. In hyperbola axial vertex cubics, the DP lies between the asymptote and the loop vertex. In ellipse a-vertex cubics, the vertex lies between the asymptote and the DP homologue, while in the b-vertex cubics the asymptote lies between the vertex and the DP homologue. For circles, of course, the curve (a line) and asymptote are in coincidence and the DP homologue and vertex are in coincidence, with the latter points incident upon the former lines.

General Inversion Cubics

Conic axial vertex cubics and ellipse b-vertex cubics are only the most symmetrical members of a much larger group of curves, the supergenus or sub-family of *conic inversion cubics*, that includes all inversion loci through incident points, rather than merely those about the axial vertices. The eqs. for this group are 27a-c. It will be noted that, with the exception of the axial vertex cubics, the members of this larger group do not possess a line of symmetry and have pure cubic terms in both x and y, i.e., x^3 and y^3, whereas axial vertex cubics have pure cubic terms in x or y alone.

Inversion loci through incident points Inverse curves

(a) $2(x^2+y^2)(2ax+ky) = j^2y^2$ parabola inversion (8-27)
cubics

(b) $2a(x^2+y^2)[bx(b^2\pm k^2)^{\frac{1}{2}}\mp aky] = j^2(b^2x^2\mp a^2y^2)$ central conic inversion
cubics

(c) $2(x^2+y^2)[(a^2+k^2)^{\frac{1}{2}}x-ky] = j^2(x^2-y^2)$ equilateral hyperbola
inversion cubics

LR Vertex Cubics

Lastly, there are the *LR vertex cubics*, 28a-c, which also are seen to have pure cubic terms in x and y. Although these curves lack a line of symmetry, the fact that they are derived by inversion through the LR vertices (which are circumpolar foci) ensures their having greater circumpolar symmetry than any other members of the group except the axial vertex cubics. Greater circumpolar symmetry of the LR vertex cubics at the subfocal level is evident merely from a comparison of eqs. 27 and 28. Whether their symmetry also is greater at the focal level remains to be ascertained.

Inversion loci through LR vertices

(a) $4a(x^2+y^2)(x+y) = j^2y^2$ parabola LR vertex cubics (8-28)

(b) $2b^2(x^2+y^2)[(a^2\pm b^2)^{\frac{1}{2}}x\mp ay] = j^2(b^2x^2\mp a^2y^2)$ central conic LR
vertex cubics

(c) $2a(x^2+y^2)(2^{\frac{1}{2}}x-y) = j^2(x^2-y^2)$ equilateral hyperbolic
LR vertex cubic

Other Transformation Taxonomies

Inversion is only one of several point transformations that might be employed as bases for classifying and elucidating relationships between curves. Thus, interesting facets of the Inversion Taxonomy of conics are complemented in fascinating ways by the 1st-generation Tangent-Pedal Taxonomy of the same group. Classifications also could be based on such point transformations as the normal pedal, the radial, the catacaustic, and the diacaustic. It is doubtful that any of these other transformations is ultimately conservative of degree. In this respect, the inversion transformation apparently is unique among point transformations that do not give a similar or congruent curve.

Of course, the superfamily arrays given by other point transformations will be different from those given by inversion, and will be based upon other properties of the basis curves. For example, since Cayley's sextic is the tangent pedal of the cardioid about the cusp, both of these curves fall into the same tangent-pedal superfamily. Though the general tangent pedals of a basis curve about a point in the plane are curves of higher degree, tangent pedals about high-ranking foci may be of the same or lower degree. For example, the tangent pedal of the parabola about the traditional focus is the vertex tangent, while those of central conics about their traditional foci are the major auxiliary circles (circles of radius 'a' centered at the central conic center).

While other point transformations have been known and studied for many years, they have not been employed for the classification or systematic study of the relationships between curves. Although Maclaurin (1718) introduced the concept of compounding pedal transformations about a single pole, for example, by taking the pedal of the pedal of the pedal, etc., this process does not lead to a Pedal Taxonomy (see Chapter XIII). The latter must be based upon pedals about all points in the plane.

What is the significance of other point transformations with respect to the circumpolar symmetry of the basis curve? In the case of the inversion transformation, the transform of any point on the curve for any given chord or radii at the angle θ depends only on the distance to the point; it is entirely independent of distances and values of θ for neighboring points. This contrasts in the extreme with the intercept transformation, which is a process in which

one compares the distances to points on the curve having some specific difference in their values of θ (including, of course, a difference of 0°). The latter procedure clearly is pre-eminent for circumpolar symmetry analyses but the former also has its merits. But where do the other elementary point transformations (i.e., point transformations based upon simple geometrical constructs) fit into the overall picture?

The properties of a curve that form the basis for other point transformations are not far to seek. To take the case of the tangent pedal as an example, one must form the tangents--i.e., obtain the derivative dy/dx--at all points of the basis curve. This means that each point obtained for the transform curve depends not only on the location of the point on the basis curve, but also upon the derivative at that point and, accordingly, upon the locations of neighboring points.

It is evident, however, that the number of elementary point transformations that could be of utility for transformation taxonomies is severely restricted. Thus, the number of different properties and constructions of curves at given points, that can be used as a basis for non-redundant transformations, such as the tangent, normal, radius of curvature, etc., is limited. The orthotomic point transformation (see Glossary), for example, duplicates the tangent pedal but in a locus of twice the linear dimensions.

Introduction

Although cubics are a fascinating group of curves in their own right, as
intercept transforms they play an insignificant role in circumpolar symmetry
analyses. Notable cubic transforms are the variable-angle transforms of hy-
perbolas about the traditional foci (eqs. VII-26) and the 180° transforms of
parabolic and linear bipolar Cartesians (including limacons) about the variable
foci of self-inversion (for example, eq. X-20c).

On the other hand, these curves play a major role in both Inversion Taxonomy
and Tangent-Pedal Taxonomy. All QBI curves except lines and circles invert to
cubics about unexceptional incident poles (the exceptional poles are the double
points, through which all QBI curves invert to conics). Even high-ranking foci
of curves of degree higher than 4 give inversions to cubics. For example,
Cayley's sextic inverts to Tschirnhausen's cubic through the vertex of its small
loop, whereas inversions about a general incident point give quintics, and
about a general point in the plane give other sextics. All the tangent-pedals
of the parabola about points in the plane (with the sole exception of the tra-
ditional focus) are conic inversion cubics.

Cubics are the lowest degree curves in which a number of fascinating phe-
nomena of circumpolar symmetry appear; some of these, for example, are variable
foci, subspecific multiple foci, and generic double-foci of self-inversion. In
studying the circumpolar symmetry of cubics, one enters the domain of trans-
forms that frequently contain coefficients divisible by 3, which is an in-
frequent occurrence in circumpolar intercept transforms of quadratics. Most
attention is devoted to foci that lie on the line of symmetry of the conic
axial vertex cubics.

The Cissoid of Diocles

Introduction

Remarkably, the *conic axial vertex cubics* have received the greatest amount of
attention in connection with geometrical constructions, rather than as inversions
of conics through their axial vertices. For example, the cissoid is said to

have been invented by Diocles (c. 100 b.c.) to solve the problem of the dupli-
cation of the cube. The eq. of this cissoid, with its cusp at the origin and
asymptote at x = 2a, is given by 1a. For comparison, eq. 1b is the inversion
of the standard parabola, $y^2 = 4ax$, through the vertex.

(a) $x(x^2+y^2) = 2ay^2$ (b) $x(x^2+y^2) = (j^2/4a)y^2$ (9-1)

A Point On the x-Axis

 The simple intercept eq., 2a, for a point on the x-axis (x+h translation)
is obtained readily, and from it the simple intercept format, 2b. The location
of foci and potential foci is ascertained by inspection of eq. 2a. The pole

(a) $2x^2(a+h)\cos^2\theta + x(x^2+3h^2)\cos\theta + [(h-2a)x^2+h^3] = 0$ simple (9-2)
intercept eq.

(b) $\cos\theta = \dfrac{-(x^2+3h^2)\pm[(x^2+3h^2)^2-8x^2(a+h)(h-2a)-8h^3(a+h)]^{\frac{1}{2}}}{4(a+h)x}$ simple intercept
format

$\cos\theta = \dfrac{a(a^2+3x^2)}{x(3a^2+x^2)}$ eq. 2b for h = -a (9-3)

h = -a is a focus, because for this condition, the *cos²θ-condition*, the $\cos^2\theta$
term vanishes and the intercept format simplifies greatly to eq. 3. By homology
with the findings for looped members of the genus, the *hyperbola axial vertex
cubics*, it can be asserted that the -a focus is the homologue of the *variable
focus*.

 The cusp point, specified by the *constant-condition*, $h^3 = 0$, also is a
focus, because when this condition obtains, x^2 factors out from each term
of the eq. and the degree of the transform reduces accordingly (the extent of
the reduction consequent to this change depends upon the number of times the
eqs. need to be squared in order to eliminate radicals). The cusp is the highest-
ranking focus and the homologue of the DP of hyperbola axial vertex cubics. It
is a *triple focus* by virtue of coincidence with the homologues of the loop-
vertex focus and the focus of self-inversion of central conic axial vertex
cubics. [The cissoid of Diocles does not self-invert, however, because the 0°
transform is the trivial xy = 0.]

 A 5th focus is at h = 2a, defined by the *x²-condition*, for which the x^2
term vanishes from 2a and the radicand of 2b simplifies considerably. This is
the condition for the intersection of the asymptote with the x-axis, the
asymptote point.

Transforms For 0° and 180°

Eighth degree $0°$ and $180°$ transforms exist for a point on the x-axis between the cusp and the asymptote point. For all other points the only transforms with non-imaginary solutions that exist are the trivial $x = \pm y$. Consequently, focal rank tests at all other locations have to be applied for other angles of transformation.

The asymptote-point focus of all conic vertex cubics is exceptional in that the degree of its $90°$ transform is the same as that for neighboring points on the line of symmetry (this also is the case for almost all foci of self-inversion of QBI curves; see Chapter XII). Accordingly, since non-trivial $0°$ and $180°$ transforms do not exist for it in either the cissoid of Diocles or the ellipse vertex cubics, its focal character in these species has to be inferred from the reduction of the non-trivial $0°$ transform that occurs in the hyperbola axial vertex cubics (see below and Chapters XII and XIV).

The Cusp Focus

The $90°$ transform for a point on the x-axis is complex and of 22nd degree (see Chapter XIV). For the cusp point, the simple intercept format is 4a. The corresponding $90°$ transform is of 6th degree (eq. 5). For comparison, the simple intercept format for the DP of the hyperbola axial vertex cubics is 4b.

(a) $\quad \cos\theta = \dfrac{-x + (x^2+16a^2)^{\frac{1}{2}}}{4a}$ \qquad simple intercept format for cusp point \qquad (9-4)

(b) $\quad \cos\theta = \dfrac{x \pm [x^2+4a(a+b)]^{\frac{1}{2}}}{2(a+b)}$ \qquad simple intercept format for DP of hyperbola axial vertex cubics

$$64a^6 = 12a^2x^2y^2 + x^2y^2(x^2+y^2) \qquad\qquad 90° \text{ transform for 4a} \qquad (9\text{-}5)$$

The Focus At -a

The α-transform for the -a focus is derived by substitution of $\cos\theta$ of eq. 3 in eq. VI-9 and found to be of 12th degree. For the $90°$ transform it becomes 6a. Eq. 6b is the identical expression before expansion.

90° transform for the -a focus

(a) $\quad x^6y^6 + 3a^4x^2y^2(x^4+y^4) = 9a^{10}(x^2+y^2) + 27a^8x^2y^2 + \qquad\qquad (9\text{-}6)$

$\qquad 63a^6x^2y^2(x^2+y^2) + 6a^8(x^4+y^4) + 72a^4x^4y^4 + 3a^2x^4y^4(x^2+y^2)$

eq. 6a before expanding and regrouping

(b) $\quad x^2y^2(3a^2+x^2)^2(3a^2+y^2)^2 = a^2y^2(a^2+3x^2)^2(3a^2+y^2)^2 + x^2(3a^2+x^2)^2(y^2-a^2)^3$

The Hyperbola Axial Vertex Cubics

Introduction

Rearranging eq. VIII-25b for the central conic axial vertex cubics gives 7a. The ratio of the constant terms is given by 7b and seen to be simply related to the parameters of the basis central conics. Attention is confined primarily to the *hyperbola axial vertex cubics* (upper sign).

(a) $\quad y^2(x\pm aj^2/2b^2) = x^2(j^2/2a-x)$ central conic axial vertex cubics from VIII-25b $\qquad (9\text{-}7)$

(b) $\quad (aj^2/2b^2)/(j^2/2a) = a^2/b^2$ ratio of constant terms of 7a

(c) $\quad y^2(x\pm a) = x^2(b-x)$ central conic axial vertex cubics in standard form

The term $aj^2/2b^2$ is the distance between the DP or DP homologue and the asymptote, and is designated simply as a. Similarly, $j^2/2a$, the distance between the DP or its homologue and the loop vertex is designated simply as b, giving 7c as the general eq. for the central conic axial vertex cubics. The orientation of the hyperbola axial vertex cubics with the eq. in this form finds the loop axis coincident with the x-axis, the loop lying in the 1st and 4th quadrants, the DP at the origin, and the asymptote at x = -a (as compared to the cissoid of Diocles, the curve is reflected in the y-axis).

Focal and Potential Focal Conditions

The simple intercept eq. (x+h translation) for a pole on the x-axis is 8a. In the subsequent treatment the coefficients and constant term of this eq. sometimes are represented as in 8b, whereupon the simple intercept format

(a) $(2h-a-b)x^2\cos^2\theta+[x^2+h(3h-2b)]x\cos\theta+(a+h)x^2-h^2(b-h) = 0$ simple (9-8)
intercept eq.

(b) $A^2 = h(3h-2b)$ $B = (2h-a-b)$ focal and potential
focal conditions

$C = (a+h)$ $D^3 = h^2(b-h)$

(c) $\cos\theta = \dfrac{-(A^2+x^2) \pm [(A^2+x^2)^2-4B(Cx^2-D^3)]^{\frac{1}{2}}}{2Bx}$ simple
intercept format

becomes 8c. These coefficients and constant term, when set equal to 0, specify poles on the x axis of focal or potential focal rank. A focal condition is one for which the vanishing of the coefficient leads to an x or x^2 factoring out of the simple intercept eq. directly, as when the constant term is 0 (the condition for vertices), or for which the $\cos^2\theta$ or $\cos\theta$ term vanishes.

These conditions invariably lead to a reduction in the degree of transforms. A potential focal condition is one for which the eq. simplifies merely by the vanishing of a term, such as a term in x^4 or x^2, or by the vanishing of the constant portion of the coefficient of the $\cos\theta$ term. Whether such a condition is focal or not can be ascertained only by derivation of the corresponding intercept transforms, unless, as often is the case, it duplicates one of the focal conditions. These *conditions*, i.e., the loci specified by setting the coefficients equal to 0, are designated after the terms to which the coefficients belong.

Thus, the *$\cos^2\theta$-condition* is obtained by setting the coefficient $B = 2h-a-b$ equal to 0, for which the $\cos^2\theta$ term vanishes and the simple intercept format greatly simplifies to a form in which no radical in the variable is present (see below). This focal condition specifies a pole at $h = (a+b)/2$, which is a penetrating, variable focus--sometimes within the loop, sometimes outside the loop, and at the loop vertex for a = b in the equilateral strophoid (for which the basis curve is the equilateral hyperbola).

The *$\cos\theta$-constant condition* $A^2 = h(3h-2b) = 0$, has two possible consequences. If h = 0, which specifies the DP, then $D^3 = h^2(b-h)$ also is equal to 0, and an x^2 term factors out of the eq.--a certain condition for the existence of a focus (for this automatically leads to reduction in the

degree of transforms). On the other hand, $3h = 2b$ leads only to a simplification of the coefficient of the $\cos\theta$ term, which qualifies only as a *potential focal condition*. This condition specifies a point on the loop axis at $h = 2b/3$ (2/3rds of the distance from the DP to the loop vertex). This pole is focal in some non-QBI cubics, for example, the folium of Descartes, but possesses only subfocal rank in conic axial vertex cubics (it becomes focal in the trisectrix of Maclaurin only by virtue of coincidence with the variable focus).

For the *x^2-condition*, one sets the coefficient C of the x^2 term equal to 0. This leads to the vanishing of the x^2 term, which proves to be the focal condition for the asymptote point, $h = -a$. Lastly, for the *constant-condition* one sets the constant term equal to 0 ($D^3 = 0$), which defines the loop vertex ($h = b$) and DP. The condition for the loop vertex is focal because it allows an x to be factored out from the simple intercept eq.

The conditions discussed above reveal the existence of 4 discrete axial foci. A 5th discrete axial focus of the conic axial vertex cubics occurs at the axial point at infinity. It also is specified by a $\cos^2\theta$-condition but this fact is not conveyed by reference solely to the generic intercept eqs. (see Chapter XII).

Each of the *parameter functions*, A^2, B, C, D^3 (and A^2 and D^3 taken together), when set equal to 0, specifies a focal (or potential focal) condition. Accordingly, by setting one or another of these various functions equal to 0 in certain of the following eqs., and giving the remaining ones their specific values in terms of a and b, a general eq. for a point on the line of symmetry becomes that for a specific focal pole. Alternatively, giving a or b fixed values relative to one another specifies a particular *subspecies* and converts the eq. to the form valid for that subspecies.

Conservation of Axial Foci

In view of the above considerations, the hyperbola axial vertex cubics and the cissoid of Diocles are seen to possess at least 5 axial foci. The same is the case for the ellipse axial vertex cubics (see below), because for each focal condition in the former curves there is a homologue in the latter ones (although the variable focus loses its property of variability in the ellipse axial vertex cubics--always being on the opposite side of the curve from the asymptote). Other axial QBI curves, such as limacons and central quartics--inversions of conics through their traditional foci and centers, respectively--

possess 5 discrete axial point foci, as do the hyperbola and ellipse themselves, whence Maxim 9.

[The situation as to the number of axial foci of QBI curves is more complicated than is represented above and below because of the existence of *generic double-foci* of self-inversion and interactions between foci of self-inversion and lines of symmetry. That is the basis for the qualification in Maxim 9. A more comprehensive treatment of this topic and more comprehensive maxims (Maxims 18, 24-28) are presented in Chapter XII (see also Appendix IV).]

CIRCUMPOLAR MAXIM 9: *With the possible exceptions of foci of self-inversion, inversions about a point on a line of symmetry conserve the number of circumpolar foci on that axis.*

The cusp of the cissoid of Diocles--the site of the triple focus--inverts to the axial point at infinity in the parabola. From this relationship it appears that the other 3 axial foci of the parabola should be regarded as forming a triple focus at the axial point at infinity. In other words, one is justified to take a step or two beyond the traditional view that "a parabola may be regarded as an ellipse with its other focus at infinity," and regard the parabola as "an ellipse with its other 3 axial foci--the center, the other vertex, and the other traditional focus--at the axial point at infinity." [The orthogonal line of symmetry of the parabola also should be regarded as being at infinity.]

Bipolar Cartesians With 4, 5, 6, and 8 Discrete Axial Foci

From the perspective provided by the treatment to this point, one is in a better position to understand the relationships between linear and parabolic bipolar Cartesians. At one end of the spectrum lie the parabolic bipolar Cartesians, $u^2 = Cdv$, for which $C < 4$. These curves possess only a single loop and only 4 axial foci (but see Table VIII-1); two of these are at the vertices, a third is at $x = -d$, and the 4th is at $x = 0$. These Cartesians invert to cubics through their vertices; they are self-inverting through the $x = 0$ focus and invert to quartics through the $x = -d$ focus. Their inversion cubics and quartics have not been studied but would be expected to have the same number of axial foci.

For $C = 4$, the bipolar parabolic Cartesian acquires a 5th axial focus by the closing of a small incipient loop, and becomes an equilateral limacon. The latter has the same class-through-subordinal rank as the former by Circumpolar

Symmetry Taxonomy (Table V-1) but does not belong to the same inversion superfamily. Its inversions have 5 discrete axial foci.

For $C > 4$, the "just closed" small loop detaches, leading to a curve with 6 axial foci (by virtue of the addition of a 4th vertex). The $h = 0$ focus is variable and only *conditionally penetrating* (so designated because it becomes penetrating only by virtue of being "captured" by the closing of the small loop). As the value of C increases beyond 4, the small loop progressively decreases in size and becomes displaced toward the center of the large loop. Since the variable focus remains within the small loop, it undergoes a similar displacement. The $-d$ focus moves in pace, leading the way inward and always remaining at a distance d from the variable focus (recall that d is the distance between p_u and p_v).

The linear Cartesians, $Bu + Av = Cd$, are tremendously more varied than the parabolic ones, since two independent parameters are involved in their specification (only 2 of the 3 parameters are independent). Conics ($A^2 = B^2$) and limacons ($A^2 = C^2$ or $B^2 = C^2$) belong to this *equational* group (*The Cartesian Group*) as special cases; seemingly they are the only members of this group that possess 5 discrete axial foci.

Linear Cartesians generally have 8 discrete foci. Four vertex foci lie at $(A+C)d/(A-B)$, $(A+C)d/(A+B)$, $(A-C)d/(A-B)$, and $(A-C)d/(A+B)$ [defined for absolute values of A, B, and C]. In addition there are 3 foci of self-inversion (all of which are generic double-foci), lying at $x = 0$, $x = d$, and $x = (A^2-C^2)d/(A^2-B^2)$, and a penetrating, variable focus at $x = A^2d/(A^2-B^2)$, which is the homologue of the limacon $-\frac{1}{2}b$ focus. If any vertex lies at the origin (the $x = 0$ focus) a second does also, and the limacon condition is attained (and similarly if a vertex comes into coincidence with the $x = d$ focus).

No attempt is made here to describe even the variety among these curves that I have examined (but see Chapters X and XIV and Table IV-3). However, it is worth noting that for all the cases in which A, B, and C are very nearly equal in absolute value, say 1.00, 1.05, and 1.075, respectively, the curves are near the limacon transition point. For the case cited (Table XIV-3, Ovals No. 6), there is a large loop that is practically indistinguishable from the large loop of a hyperbolic limacon and a very tiny internal loop very close to its "cusp." Two foci of self-inversion are within the tiny loop, the 3rd is external, just beyond the "cusp," while the variable, penetrating focus lies at about one-half the distance to the center of the large loop.

Following Maxim 9, the members of the parabolic and linear Cartesian groups fall into at least 4 different inversion superfamilies, the quadratic-based one for conics and limacons, and 3 quartic-based superfamilies possessing members with 4, 6, and 8 discrete axial foci. Because of (1) their equational homologies with members of the QBI superfamily; (2) their high circumpolar symmetry; and (3) their amenability to circumpolar symmetry analysis (as opposed to traditional approaches), these latter superfamilies are prime candidates for future studies(see also Chapter XIV, *The True-Center Approach--Central Cartesians*).

Transforms About a Pole On the x-Axis

Returning now to the topic of the circumpolar symmetry of the hyperbola axial vertex cubics, the 0^O and 180^O transforms (eqs. 9) for a point on the x-axis

$$Cx^4y^4 \pm A^2D^3xy(x^2+y^2) + A^4Cx^2y^2 - D^3x^2y^2(x^2+y^2) \pm A^4D^3xy = \qquad (9-9)$$

$$- BD^6(x\pm y)^2 \pm (D^3+2A^2C)x^3y^3$$

are found to be of 8th degree. The corresponding transforms for each of the foci on the x-axis are obtained from eq. 9 by setting the appropriate parameter functions equal to 0. The other parameter functions are replaced by their explicit values (eqs. 8b, with h specified in terms of a and b).

The 90^O transform is of 22nd degree. Since this transform is complex, and the derivation and properties of transforms for a point on the axis of all QBI cubics and quartics are treated in Chapter XIV, its eq. is not given. The 5 foci on the x-axis now are taken up individually in decreasing rank order.

The Double-Point Focus

The DP at h = 0 is the highest-ranking focus. Its simple intercept format is eq. 10a. The only real 0^O and 180^O transforms for this format are x = ±y.

(a) $\cos\theta = \dfrac{x\pm[x^2+4a(a+b)]^{\frac{1}{2}}}{2(a+b)}$ simple intercept format (9-10)

(b) $(a+b)^2x^2y^2(x^2+y^2) + 2b(a^2-b^2)^2(a+b)(x^2+y^2) =$ 90^O transform for 10a

$(a^2-b^2)^4 + b^2(a+b)^2(x^2+y^2)^2 + [(a^2-b^2)^2-4a^2(a+b)^2]x^2y^2$

(c) $a^2(x^2-y^2)^2 = x^2y^2(x^2+y^2)$ 90^O transform for equilateral strophoid

(d) $x^2y^2(x^2+y^2) + 96a^4(x^2+y^2) = 9a^2(x^2+y^2)^2 + 256a^6$ 90^O transform for trisectrix of Maclaurin

These, however, are not to be regarded as "trivial" in the same sense as for a pole lying on a quadratic curve. On the contrary, the points on a cubic for which the 0° and 180° transforms are $x = \pm y$ are unique, so that this feature reveals a very special symmetry property.

The 90° transform, 10b, being only of 6th degree, is of the lowest degree at that angle for any focus of the species. The DP attains the highest *subfocal* rank in the equilateral strophoid, with the highly interesting transform, 10c. Next-highest subfocal rank is attained in the trisectrix of Maclaurin, with the transform 10d, but the *focal* rank is 1/6th for all subspecies.

The Loop-Vertex Focus

The next-highest 0° and 180° rank is possessed by the focus of self-inversion at the loop vertex. Its intercept format is 11a. Although this format does not

(a) $\cos\theta = \dfrac{-(b^2+x^2)\pm[(b^2+x^2)^2-4x^2(b^2-a^2)]^{\frac{1}{2}}}{2x(b-a)}$ simple intercept format for loop vertex (9-11)

(b) $xy = \pm b^2$ 0° transform for 11a

(c) $M^2(x^2Y^4+y^2X^4)[4M^2y^2X^4+4M^2x^2Y^4-4x^2y^2(2M^2+N^2)^2-X^4Y^4] +$ 90° transform for 11a

 $N^2(N^2-4M^2)x^2y^2X^4Y^4+(N^8+2N^6M^2+4N^4M^4+32N^2M^6+16M^8)x^4y^4 = 0$

(d) $X^4 = (b^2+x^2)^2$ $Y^4 = (b^2+y^2)^2$ $M^2 = (b^2-a^2)$ $N^2 = (b-a)^2$

(e) $\cos\theta = -2ax/(a^2+x^2)$ 11a for equilateral strophoid (a = b)

(f) $x^4y^4+a^4(x^4+y^4)+a^8 = 2a^6(x^2+y^2)+12a^4x^2y^2+2a^2x^2y^2(x^2+y^2)$ 90° transform for 11e

look promising, for 0° and 180° it yields the transforms of self-inversion, 11b (where the lower sign is for 180° and a negative intercept). The transform for 90° is complicated and of 14th degree (11c,d). However, for the equilateral strophoid subspecies (the vertex inversion of the equilateral hyperbola), both the format, 11e, and the transform, 11f, greatly simplify and reduce, with the latter being of only 8th degree.

The Variable Focus

The variable focus at $x = (a+b)/2$ ranks next highest on the basis of 0° and 180° transforms but is higher ranking than the loop vertex for the 90° trans-

form. Its simple intercept format, 12a, like that for the homologous focus of the cissoid of Diocles, involves no radical. The $0°$ and $180°$ transforms are of

(a) $\cos\theta = \dfrac{h^2(b-h)-(a+h)x^2}{x[x^2+h(3h-2b)]} = \dfrac{D^3-Cx^2}{x(x^2+A^2)}$, $h = \dfrac{a+b}{2}$ 　　simple intercept format for variable focus 　(9-12)

(b) $4(a+b)(b^2-a^2)(x^2\pm xy+y^2) \mp 4(a+b)(3a+b)(3a-b)xy$ 　$0°$ and $180°$ intercept transforms of 12a

$+ (a+b)^2(b^2-a^2)(3a-b) - 16(3a+b)x^2y^2 = 0$

(c) $x^6y^6 + (C^2-2A^2)x^4y^4(x^2+y^2) + (A^4-2CD^3)x^2y^2(x^4+y^4)$ 　$90°$ intercept transforms of 12a

$+ 4A^2(C^2-2A^2)x^4y^4 + (A^4C^2+D^6-4A^2CD^3-2A^6)x^2y^2(x^2+y^2)$

$- A^4(4CD^3+A^4)x^2y^2 + 2A^2D^6(x^4+y^4) + A^4D^6(x^2+y^2) = 0$

4th degree (eq. 12b) and the $90°$ ones of 12th degree (eq. 12c). This focus never can be on the asymptote side of the DP, but it can be anywhere beyond the center of the loop (on the vertex side). For example, for $a = b$, in the equilateral strophoid, it is coincident with the loop vertex.

In the trisectrix of Maclaurin, for which $b = 3a$, the variable focus comes to be coincident with the pole of the loop axis at $h = 2b/3$ (which is a focus in the folium of Descartes). The increase in the symmetry of the curve about this pole is at the subfocal level. Thus, the $0°$ and $180°$ transforms remain of 4th degree and the $90°$ one remains of 12th degree, 15b.

The Focus At the Asymptote Point

Next-highest ranking is the focus at the asymptote point, $h = -a$, for which the simple intercept eq. is 13a. The $0°$ transform, 13b,b', is of 6th degree,

(a) $(3a+b)x^2\cos^2\theta - [x^2+a(3a+2b)]x\cos\theta + a^2(a+b) = 0$ 　simple intercept eq. 　(9-13)

(b) $x^3y^3 + x^2y^2(x^2+y^2) = A^2xy(x^2+y^2) + BD^3(x+y)^2 + A^4xy$ 　$0°$ transform

(b') $x^3y^3 + x^2y^2(x^2+y^2) = a(3a+2b)xy(x^2+y^2) -$ 　eq. 13b in terms of parameters a and b

$a^2(a+b)(3a+b)(x+y)^2 + a^2(3a+2b)^2xy$

but the $90°$ transform does not reduce from 22nd degree. It is clear from 13a,b,b' that there can be no special cases of higher focal rank for this focus and only minor increases in subfocal rank, because the coefficients all involve parameter *sums*.

The Focus At the Axial Point At Infinity

A 5th focus at the axial point at infinity (see Chapter XII) is of undefined focal rank. [Accommodation of a point focus at infinity, of course, requires an extension of the concept of a point focus (as defined in Chapter I).]

The Loop Pole At h = 2b/3

The loop pole at $h = 2b/3$ is of particular interest because a pole at this position is focal in some other looped cubics and because it has been recognized to be a focus in the traditional sense in the trisectrix of Maclaurin. The $0°$ and $180°$ transforms, 14b, about this pole are obtained by

(a) $9(b-3a)x^2\cos^2\theta+27x^3\cos\theta+9(3a+2b)x^2-4b^3 = 0$ simple intercept eq. (9-14)

(b) $BD^6(x\pm y)^2+Cx^4y^4 = D^3x^2y^2(x^2\pm xy+y^2)$ $0°$ and $180°$ transforms

(c) $3x^2y^2 = 4a^2(x^2\pm xy+y^2)$ 14b for the trisectrix of Maclaurin (b = 3a)

(d) $5\cdot3^6x^4y^4 = 32a^6(x\pm y)^2+4\cdot3^4a^2x^2y^2(x^2\pm xy+y^2)$ 14b for the equilateral strophoid

(a) $\cos\theta = (4a^3-3ax^2)/x^3$ intercept format for trisectrix of Maclaurin (9-15)

(b) $9a^2x^4y^4(x^2+y^2) + 16a^6(x^6+y^6) =$
$$24a^4x^2y^2(x^4+y^4) + x^6y^6$$

$90°$ transform of 15a

letting $A = h(3h-2b)$ equal 0 in eq. 9. Although they are very much simpler than eq. 9, their degree remains at 8. Reduction to 4th degree occurs in the trisectrix of Maclaurin, 14c, but this is attributable to coincidence with the variable focus. The corresponding eq. for the equilateral strophoid, 14d, is unexceptional.

The general $90°$ transform is complex and of 22nd degree (see Chapter XIV). For the trisectrix of Maclaurin, however, the degree of the transform reduces to 12. The simple intercept format and transform for the pole in this subspecies are 15a,b.

In summary (see also Table IX-1), the analyses to this point have revealed the existence of 5 point foci on the line of symmetry of hyperbola axial vertex cubics. The highest ranking of these is the DP, which is the reciprocal

inversion pole of the vertex of the basis hyperbola. This pole is unique in being the only point on the curve for which the 0° and 180° transforms are linear (though trivial). Its 90° transform is of 6th degree. Second rank goes to the loop vertex or variable focus, depending upon the transformation angle that is used as a criterion (see Table IX-1). The curves self-invert through the loop vertex, with the transform of self-inversion being $xy = b^2$. The variable focus is penetrating and becomes coincident with the loop vertex in the equilateral strophoid. Fourth rank goes to the asymptote point, with 0° and 180° transforms of 6th degree but 90° transforms that do not reduce from 22nd degree. The focus at the axial point at infinity has undefined focal rank. Lastly, a pole within the loop at $x = 2b/3$ has high subfocal rank and is the homologue of the loop focus of certain non-QBI cubics.

The Ellipse Axial Vertex Cubics

If one employs a derivation for the ellipse axial vertex cubics paralleling that for the hyperbola axial vertex cubics, the basis eqs. are 16a,b, where 16a employs conic parameters and 16b employs central conic vertex cubic parameters.

(a) $\quad y^2(x-aj^2/2b^2) = x^2(j^2/2a-x)$ \qquad ellipse axial vertex cubic from VIII-25b \qquad (9-16)

(b) $\quad y^2(x-a) = x^2(b-x)$ \qquad ellipse axial vertex cubic in standard form

$$x^2(2h+a-b)\cos^2\theta+[x^2+h(3h-2b)]x\cos\theta+x^2(h-a)-h^2(b-h) = 0 \qquad \text{simple intercept eq.} \qquad (9\text{-}17)$$

The simple intercept eq. for a point on the x axis is 17. The homologue of the variable focus of the hyperbola axial vertex cubics has focal rank (because the $\cos^2\theta$ term vanishes) and lies at $h = (b-a)/2$. Since the vertex is at $h = b$, which always is to the right of the $(b-a)/2$ pole, this focus is not variable in this species.

The pole at $h = 0$ is the homologue of the DP focus. It has the highest focal rank because for $h = 0$ an x^2 factors out of eq. 17. Similarly, the vertex condition $h = b$ specifies a pole of focal rank because an x factors out of eq. 17 and the vertex is the pole of self-inversion. The $\cos\theta$-constant condition defines a pole at $h = 2b/3$ that lies at the same position relative to the homologues of the loop vertex and DP foci as the similarly defined pole in

hyperbola axial vertex cubics. Lastly, the condition h = a leads to the vanishing of the x^2 term and specifies the asymptote-point focus.

Because of the very close homologies between the hyperbola and the ellipse, which are the basis curves for these cubics, very close homologies also are to be expected in the inverse curves. However, a detailed analysis has not been carried out for the ellipse axial vertex cubics. The above treatment merely illustrates the likelihood that these homologies exist.

Ordinal and Subordinal Rank

The following are a few examples of ordinal and subordinal rank eqs. for conic axial vertex cubics. It already has been noted that the loop-vertex focus of self-inversion of the equilateral strophoid has an equilateral hyperbolic 0° transform with 4th degree ordinal and 8th degree subordinal ranks (Table V-1). The corresponding ordinal and subordinal rank-determining eqs. are 18a,b, respectively. The pole in question is a double-focus by virtue of coincidence with the variable focus. By contrast, the general ordinal rank for the variable focus of hyperbolic axial vertex cubics is 20 (eq. 19).

(a) $4a^2\overset{o}{S}{}^2 = (a^2+x^2)^2 + (a^2+y^2)^2$ ordinal-rank eq., loop-vertex focus, equilateral strophoid (9-18)

(b) $4a^2x^4\overset{o}{S}{}^2 = (a^4+x^4)(a^2+x^2)^2$ 0° subordinal rank eq. from 18a (9-19)

$$\overset{o}{S}{}^2 = \frac{4x^4(A^2+4x^2)^2[16x^4+(8A^2-B^2)x^2+A^4-2BC^3]}{[16Bx^4-(4A^2B+12C^3)x^2-A^2C^3]^2} +$$

ordinal rank eq., variable focus, hyperbola axial vertex cubics (9-19)

$$\frac{4y^4(A^2+4y^2)^2[16y^4+(8A^2-B^2)y^2+A^4-2BC^3]}{[16By^4-(4A^2B+12C^3)y^2-A^2C^3]^2}$$

$A^2 = (a+b)(3a-b)$ $B = (3a+b)$ $C^3 = (a+b)^2(b-a)$

ordinal-rank equation, variable focus, trisectrix of Maclaurin

$$9a^4(4a^2-x^2)(4a^2-y^2)\overset{o}{S}{}^2 = (4a^2-y^2)^2[x^6-a^2(4a^2-3x^2)^2] +$$

 (9-20)

$$(4a^2-x^2)^2[y^6-a^2(4a^2-3y^2)^2]$$

ordinal-rank equation, -a focus, cissoid of Diocles

$$9a^2(x^2-a^2)(y^2-a^2)\overset{o}{S}{}^2 = x^2(3a^2+x^2)^2(y^2-a^2) + y^2(3a^2+y^2)^2(x^2-a^2)$$ (9-21)

In the trisectrix of Maclaurin, the variable focus becomes coincident with the pole of the loop at $x = 2b/3$, for which coincidence the ordinal rank eq. is of 10th degree (eq. 20). The cissoid of Diocles has no variable focus but the focal condition for its $-a$ focus--the $\cos^2\theta$-condition--is the same condition that specifies the variable focus for the hyperbola axial vertex cubics. The 8th degree ordinal rank of this focus is defined by eq. 21.

Table IX-1. Degrees of Circumpolar Intercept Transforms of Cubics

Focal Locus Basis Curve	DP 0° & 180°	90°	Loop Vertex[6] 0° & 180°	90°	Variable Focus 0° & 180°	90°	Asymptote Point 0° & 180°	90°	Loop Focus 0° & 180°	90°	Line of Symmetry 0° & 180°	90°
Hyperbola Axial Vertex Cubics	1[1]	6	2	14	4	12	6	22	8[4]	22[4]	8	22
Cissoid of Diocles	1[1]	6	*	*	**	12	**	22	*[4]	*[4]	8	22
Equilateral Strophoid	1[1]	6	2	8[3]	2[2]	8[2]	6	22	8[4]	22[4]	8	22
Trisectrix of Maclaurin	1[1]	6	2	14	4	12	6	22	4[3,4]	12[3,4]	8	22
Folium of Descartes	1[1]	-	6	-	none		10	-	8	-	12	-
Tschirnhausen's Cubic	1[1]	-	12	-	-	-	12[5]	none	-	-	-	-

* Same as cusp (DP) by virtue of coincidence
**No real solution except trivial
[1]Trivial, $x = \pm y$
[2]Double-focus by virtue of coincidence with the loop vertex
[3]Reduces by virtue of coincidence with the variable focus
[4]Not a focus
[5]Transform for polar center, there is no asymptote point.
[6]A *generic double-focus* of self-inversion in conic axial vertex cubics (see Chapter XII).

The Folium of Descartes

Introduction

The folium of Descartes is an asymptotic looped cubic greatly resembling the hyperbola axial vertex cubics. A circumpolar symmetry analysis of this cubic is performed and its Inversion Taxonomy explored to illustrate the existing similarities and differences. The eq. for the folium of Descartes as conventionally represented, 22a, obscures its equational relationship to the

$$\text{(a)} \quad x^3 + y^3 = 3axy \qquad\qquad \text{(b)} \quad y^2(3x+b) = x^2(b-x) \qquad\qquad (9\text{-}22)$$

hyperbola axial vertex cubics. If the coordinate axes are rotated $45°$ CCW to bring the line of symmetry of the curve into coincidence with the x-axis, this equational relationship becomes apparent. The constant, $b = 3a/2^{\frac{1}{2}}$, is the length of the loop axis, which is three times the DP-asymptote distance, $a/2^{\frac{1}{2}}$. These relative dimensions are exactly the same as those of the trisectrix of Maclaurin, to which it goes over by an affine transformation.

It will be noted that the form of eq. 22b is the same as that for the equilateral strophoid, with the exception that the absolute magnitudes of the coefficients of the linear x terms are unequal by a factor of 3. This, of course, is the fundamental equational difference between the folium of Descartes and a hyperbola axial vertex cubic.

The Simple Intercept Equation

By the usual procedure one obtains the simple intercept eq., 23, for a point

simple intercept eq. for a point on the x-axis

$$2x^3\cos^3\theta + 2bx^2\cos^2\theta - [3x^2 + h(3h-2b)]x\cos\theta - (b+3h)x^2 - h^2(h-b) = 0 \qquad (9\text{-}23)$$

Simple intercept eqs. for axial foci Focus

$$\text{(a)} \quad 2x\cos^3\theta + 2b\cos^2\theta - 3x\cos\theta - b = 0 \qquad\qquad \text{DP,} \ h = 0 \qquad\qquad (9\text{-}24)$$

$$\text{(b)} \quad 2x^2\cos^3\theta + 2bx\cos^2\theta - (b^2+3x^2)\cos\theta - 4bx = 0 \qquad\qquad \text{loop vertex,} \ h = b$$

$$\text{(c)} \quad 2x^3\cos^3\theta + 2bx^2\cos^2\theta - x(b^2+3x^2)\cos\theta + 4b^3/27 = 0 \qquad\qquad \text{asymptote point,} \ h = -b/3$$

$$\text{(d)} \quad 2x^3\cos^3\theta + 2bx^2\cos^2\theta - 3x^3\cos\theta - 3bx^2 + 4b^3/27 = 0 \qquad\qquad \text{loop focus,} \ h = 2b/3$$

on the x-axis which, though it has a $\cos^3\theta$ term, bears recognizable similarities to the simple intercept eqs. for points on the axes of conic axial vertex cubics. Since the coefficient of the $\cos^3\theta$ term does not involve a relationship between the pole position h and the parameter b, there is no focal condition on this term, i.e., there is no condition for which the $\cos^3\theta$ term vanishes from the eq.

Nor does such a relationship exist for the coefficient of the $\cos^2\theta$ term, from which it is evident that the *$\cos^2\theta$ focal condition* of the conic axial vertex cubics does not exist when the absolute magnitudes of the coefficients of the linear terms in x of the basis eq. are unequal. On the other hand, the other 3 foci of the conic vertex cubics have homologues with identical locations in the folium of Descartes--the DP focus at h = 0, the loop-vertex focus at h = b, and the asymptote-point focus at h = -b/3. In addition, the $\cos\theta$-constant condition is identical and specifies a pole at h = 2b/3. For the folium of Descartes this pole--the *loop focus*--has focal rank. The simple intercept eqs. for these foci are 24a-d, respectively.

The key to obtaining the compound intercept formats and intercept transforms about the poles specified by these eqs. at a given transformation angle is to eliminate the $\cos^3\theta$ term. I will not attempt an exhaustive treatment, but merely consider the $0°$ and $180°$ transforms. The degree of transforms for a point on the x-axis is found to be 12, as opposed to 8 for the conic axial vertex cubics (Table IX-1). The DP is the focus of highest rank, with the same property of giving trivial linear x = ±y transforms as found in the conic axial vertex cubics.

The next-highest-ranking focus is the loop vertex, for which the $0°$ compound intercept format and transform are given by eqs. 25a,b. Though the folium of

(a) $\cos\theta = \dfrac{b(x+y) \pm [b^2(x+y)^2 + 32x^2y^2]^{\frac{1}{2}}}{4xy}$ $0°$ compound intercept format for loop vertex (9-25)

(b) $b^2(x+y)^2(3xy-b^2) = 2xy(xy+b^2)^2$ $0°$ transform for loop vertex

Descartes is closely related equationally to the hyperbola axial vertex cubics, the fact that it has notably different circumpolar symmetry is evident from eq. 25b. Thus, the $0°$ transform is of 6th degree as compared to 2nd degree for the hyperbola axial vertex cubics, and the curve does not self-invert about the loop vertex.

The next-highest-ranking focus is the loop focus, for which the corresponding eqs. of the compound intercept format and the 0° and 180° transforms are 26a,b.

(a) $\quad \cos^2\theta = \dfrac{81x^2y^2 - 4b^2(x^2 \pm xy + y^2)}{54x^2y^2}$ \qquad compound intercept format, loop focus \qquad (9-26)

(b) $\quad (x^2 \pm xy + y^2)^2[4b^2(x^2 \pm xy + y^2) + 81x^2y^2] = 54b^2x^2y^2(x \pm y)^2$ \quad 0° and 180° transforms, loop focus

The lowest-ranking focus is the asymptote-point, for which the compound 0° intercept format is eq. 27. The corresponding 10th-degree transform is complicated.

$$\cos\theta = \frac{b(x+y) \pm b[(x+y)^2 - 32(x^2+xy+y^2)/27]^{\frac{1}{2}}}{4xy} \qquad\qquad (9\text{-}27)$$

The Parent Axial Vertex Cubic

Before discussing the significance of the similarities and differences between the folium of Descartes and the conic axial vertex cubics, it is instructive to cast the simple intercept eq. for the hyperbolic species of the parent supergenus of axial vertex cubics from which both this folium and the conic axial vertex cubics can be derived. This is accomplished by allowing free variation for the numerical coefficient and parameters, as in eq. 28a. [Using only the positive sign in the term $y^2(Cx+a)$, the eq. represents only the hyperbolic species. To include both the hyperbolic and elliptical representatives, the term would have to be $y^2(Cx \pm a)$.] The corresponding simple intercept

(a) $\quad y^2(Cx+a) = x^2(b-x)$ $\qquad\qquad$ parent axial \qquad (9-28) vertex cubic

(b) $\quad (1-C)x^3\cos^3\theta + [h(3-C)-a-b]x^2\cos^2\theta +$ \qquad simple intercept eq., point on $\;$ x-axis

$\qquad x[Cx^2+h(3h-2b)]\cos\theta + (Ch+a)x^2 + h^2(h-b) = 0$

eq. for a point on the x-axis is 28b, in which C is a dimensionless constant.

Several germane relationships are revealed by eq. 28b. First, the critical symmetry condition is C = 1 --the conic axial vertex cubic condition--for only when C has this value does the $\cos^3\theta$ term vanish from the intercept eq.

This is a crucial circumpolar symmetry condition, because all symmetry-governing eqs. and transforms are greatly complicated by the presence of the term in $\cos^3\theta$.

Second, the $\cos^2\theta$-condition yields a focus, though not always variable, for any value of C except 3, i.e., $C = 3$ --its value in the folium of Descartes--is the sole value for which the $\cos^2\theta$-condition is non-focal. Third, the $\cos\theta$-constant condition always specifies a pole within the loop at the same position relative to the vertex and DP. Fourth, a focus always is present at the asymptote point and the relative position of the asymptote changes with changes in the value of C. Fifth, the DP always is a high-ranking focus, probably the highest ranking, because x^2 factors out of eq. 28b when $h = 0$. Sixth, the constant-condition, $h = b$, which specifies the loop vertex, is focal because an x factors out of the eq.

Last, for $C = 3$ the focus otherwise specified by the $\cos^2\theta$-condition is replaced by a loop focus specified by the $\cos\theta$-constant condition. Furthermore, the folium of Descartes apparently is to be regarded as a highly symmetrical single-parameter subspecies of eq. 28 in which $C = 3$ and $a = b$. The "hyperbolic" species to which the folium of Descartes belongs then would be defined by the eq., $y^2(3x+a) = x^2(b-x)$, all of the subspecies of which, after the analysis of eq. 28b, would have 4 of their axial foci defined by the simple intercept eq.

Inversion Analysis of the Folium of Descartes

The folium of Descartes inverts through its DP to a quartic with two opposed non-congruent hyperbola-like arms and a single line of symmetry that bisects each of them. The DP tangents of the folium are asymptotes for these arms. The asymptotes are internal to the arm--the *internal-asymptote arm*--with its vertex at the pole of inversion (the DP of the folium) and external to the other arm (which has its vertex on the loop side of the DP)--the *external-asymptote arm*. The unit of linear dimension has been set equal to b, the diameter of the loop, in eqs. 29a-f. Eq. 29a is that of the DP-inversion quartic.

Inversions about the loop vertex, asymptote point, and loop focus give the

<div align="center">Inversions of folium of Descartes</div>

Pole

(a) $bx(x^2+3y^2) = (x^4-y^4)$ DP (9-29)

(b) $x(x^2+y^2)^2+3b(x^2+y^2)^2+b^2x(x^2+3y^2) = b(x^4-y^4)$ loop vertex

(c) $4(x^2+y^2)^3/27 = bx(x^2+y^2)^2-b^2x^2(2x^2+y^2)+b^3x(x^2+3y^2)$ asymptote point

(d) $4(x^2+y^2)^3/27 = b^2(x^2+y^2)^2+2b^2y^4+b^3x(x^2+3y^2)$ loop focus

(e) $[k^2(b+3h)-h^2(b-h)](x^2+y^2)^3+2b^2k(b+3h)y(x^2+y^2)^2 +$ point in plane

$\qquad b^2[3k^2+h(3h-2b)]x(x^2+y^2)^2+6b^4kxy(x^2+y^2) +$

$\qquad 3hb^4(x^2+y^2)^2+b^5(x^2+y^2)(y^2-x^2)+b^6x(x^2+3y^2) = 0$

(f) $h^2(h-b)(x^2+y^2)^3+b^2h(3h-2b)x(x^2+y^2)^2+b^4(3h-b)x^4 +$ point on x-axis

$\qquad b^4(3h+b)y^4+3hb^4x^2y^2+b^6x(x^2+3y^2) = 0$

quintic of 29b and the sextics of 29c,d, respectively. From these inversions it is clear that the inversion superfamily to which the folium of Descartes belongs possesses members of at least 3rd, 4th, 5th, and 6th degree. Inversion of the folium about a point in the plane (x+h and y+k translations) gives the sextic, 29e. Eq. 29e serves as a basis both for clarifying the Inversion Taxonomy of the folium of Descartes and for illustrating the ability--though limited--of a pure inversion analysis to reveal actual and potential circumpolar foci.

For example, it is clear from 29e that the inversion superfamily to which the folium of Descartes belongs contains no member of greater than 6th degree, because eq. 29e is conservative of degree under the inversion transformation (see Chapters VIII, XI, and XIV). Although confirmation that a locus has circumpolar focal rank often requires a "conventional" circumpolar symmetry analysis--either inspection of the intercept eqs. or obtaining the transforms-- an inversion analysis also can identify and order certain poles that have focal rank. The basis for this is that: (a) conditions for which there is a reduction of the degree of the eq. for inversion about a point in the plane reveal focal loci; and (b) the greater the reduction in the degree of this eq., the higher the rank of the corresponding focal locus.

The shortcoming of this approach to the analysis of circumpolar symmetry is

that there are but few classes of inversion reductions, which are the criteria
that provide its quantitative index. This is illustrated with eq. 29e. The
condition for the elimination of the 6th degree term is that $k^2(b+3h) = h^2(b-h)$.
But since this is the eq. of the curve itself (with x replaced by h and y
replaced by k), it identifies all points incident upon the curve as having
circumpolar focal rank. One next notes that when $h = k = 0$, the condition for
the DP, the quintic term also vanishes and the eq. reduces to 4th degree. Since
this is the only condition for which eq. 29e reduces to a quartic, the DP almost
certainly is the highest-ranking focus (i.e., from the point of view of the
inversion analysis).

Confining attention to a point on the x-axis, letting $k = 0$ in 29e gives
29f, which is much simplified though also of 6th degree. At the loop vertex,
$b = k$, the 6th degree term vanishes. This cannot be taken as a direct indication
of point focal rank because reduction to a quintic occurs at any point incident
upon the curve. Indications of subfocal rank, and possibly of focal rank, are
given by letting $h = 2b/3$ (the location of the loop focus) and $h = -b/3$ (the
location of the asymptote-point focus), because for the first of these conditions
the 5th degree term vanishes, while for the second the term in y^4 drops out.
A similar analysis for a point on the y-axis suggests only subfocal rank for
any point but the DP, because though eq. 29e simplifies and one of the quartic
terms vanishes, it does not reduce for any value of k except 0. Higher
subfocal rank is indicated for a point on the asymptote, because one of the two
quintic terms vanishes for any point on this locus.

It is evident that, though the folium of Descartes bears many similarities
to the hyperbola axial vertex cubics, it also is characterized by fundamental
differences. In addition to the fact that it does not self-invert through the
loop vertex (nor through any pole), all of its axial inversions give curves
with only one line of symmetry. Since the lowest even-degree member of its
superfamily is the quartic obtained by inversion through the DP, the super-
family should be designated after the genus to which this single-parameter
curve belongs.

Circumpolar Symmetry of Other Curves Within the Superfamily Based Upon
the Double-Point Inversion Quartic of the Folium of Descartes

Lastly I consider the question of the existence of additional axial foci in
this superfamily beyond the 4 specified by conditions on the simple intercept
eq. for a point on the line of symmetry of the folium of Descartes. It will be
recalled that only 4 foci also are specified by the corresponding simple inter-
cept eq. for conic axial vertex cubics. In the latter case, a 5th focus is
present at the axial point at infinity. Although this focus is specified by a
$\cos^2\theta$-condition, that fact is evident only if one examines the general axial
inversion eqs. of non-cubic axial QBI curves. Examination of the corresponding
loci of this superfamily is one of the objectives of this section.

The Double-Point Inversion Quartic of the Folium of Descartes

The simple intercept eq. for a point on the line of symmetry of the DP-
inversion quartic of the folium of Descartes is eq. 30. Only 3 indubitable foci
are specified by this eq.: (a) the vertex of the internal-asymptote arm, $h = 0$,

$$2(b+2h)x^3\cos^3\theta + 2(x^2+3h^2)x^2\cos^2\theta + \qquad\qquad (9\text{-}30)$$

$$[h^2(4h-3b)-3bx^2]x\cos\theta - x^2(x^2+3bh) - h^3(b-h) = 0$$

which is specified by the constant-condition (triple root), the x^2-condition
(single root), the $\cos\theta$-constant condition (double root), and the $\cos^2\theta$-constant
condition (double root); (b) the vertex of the external-asymptote arm, $h = b$,
specified solely by the constant-condition; and (c) the focus of the internal-
asymptote arm, $h = -\frac{1}{2}b$, specified by the $\cos^3\theta$-condition. The $\cos\theta$-constant
condition also specifies a pole at $h = 3b/4$ which very likely is a 4th focus,
but this has not been established.

Eq. 30 was derived from eq. 29a, in the derivation of which j had been set
equal to b, the diameter of the loop. If, instead, one uses as the basis eq.
that for the species to which the folium of Descartes belongs, $y^2(3x+a) =$
$x^2(b-x)$, the picture that emerges is not greatly different. The $\cos^2\theta$-condition
now defines a variable focus within the internal-asymptote-arm at $h = -j^2/(a+b)$
and the constant-condition defines the internal-asymptote-arm vertex focus at
$h = 0$ (triple root) and the external-asymptote arm vertex focus at $h = j^2/b$.

In addition, the vertex focus of the internal-asymptote arm is specified by the $\cos^2\theta$-constant condition, the $\cos\theta$-constant condition and the x^2-condition. Lastly, the potential focal pole defined by the $\cos\theta$-constant condition is at $h = 3j^2/4b$, 3/4 of the distance from the vertex of the internal-asymptote arm to the vertex of the other arm.

Accordingly, the simple intercept eq. for the DP quartic of the folium of Descartes defines at most 4 foci, and the same is true for all of the DP quartics in the "hyperbolic" species. Additional foci might be defined by conditions on the radicand of the simple intercept format, by an equational condition (see below under *Tschirnhausen's Cubic*), or by conditions for the reduction of the general transforms themselves. In the case of QBI curves, such conditions are highly exceptional, being known only in conics, limacons, and for foci of self-inversion. However, it is unlikely that any self-inverting axial inversion loci exist in the superfamily based upon this DP inversion quartic, because none of its axial inversions possesses a 2nd line of symmetry (see Maxim 18, Chapter XI).

Axial Inversions of the Double-Point Inversion Quartic

Lastly, it is shown that additional foci beyond those already considered are present in other axial inversion loci of the superfamily. The specification of only 4 foci by the simple intercept eqs. of the folium of Descartes and its DP-inversion quartic depend on the fact that 3 or 2 foci, respectively, that generally are specified by the $\cos^3\theta$-condition, are not so specified in these curves. The questions of the number of axial foci possessed by members of the superfamily (apparently either 5 or 6) and the location of the additional foci in the folium and its inversion quartic are deferred.

The DP-inversion quartic of the folium of Descartes, eq. 29a, first is inverted about an axial pole h ($x+h$ translation), giving the sextic, 31a. The

(a) $h^3(b-h)(x^2+y^2)^3 + h^2(3b-4h)j^2x(x^2+y^2)^2 + 3bhj^4(x^2+y^2)^2$ (9-31)

$\quad - 6h^2j^4x^2(x^2+y^2) + (b-4h)j^6x^3 + 3bj^6xy^2 - j^8(x^2-y^2) = 0$

(b) $2[4h^3(b-h)H^3 + 2h^2(3b-4h)j^2H^2 - 6h^2j^4H - (b+2h)j^6]x^3\cos^3\theta$

(c) $H^2[h^3(b-h)H^4 + h^2j^2(3b-4h)H^3 + 3hj^4(b-2h)H^2 + j^6(b-4h)H - j^8]$

simple intercept eq. (x+H translation) then is obtained for a point on the line of symmetry. Examination of the $\cos^3\theta$ term, 31b, reveals that as many as 3 foci are specified by this term. For $h = 0$ (the folium of Descartes), the $\cos^3\theta$ coefficient becomes $-2bj^6x^3$, which specifies no focus; for $h = b$ (the quintic inversion about the vertex of the external-asymptote arm), 2 foci are specified; and for $h = -\frac{1}{2}b$ (the inversion about the focus of the internal-asymptote arm), 3 foci are specified, one of which is at $H = 0$, the reciprocal inversion pole. For the basis quartic itself (eq. 30), of course, only one focus is specified.

The coefficient of the $\cos^2\theta$ term (not listed) is complex and yields as many as 4 potential focal conditions, but none for $h = 0$, the inversion that gives the folium of Descartes. The coefficient of the $\cos\theta$ term (not listed) also is complex and yields as many as 4 potential focal conditions (plus duplication of $H = 0$, which is a multiplier of the entire $\cos\theta$-constant term). Lastly, the constant term 31c always yields 2 vertices and a DP for non-incident inversions. Although the bracketed expression is a quartic in H, the vertex of the internal-asymptote arm, $H = -j^2/h$, is a triple root and the other vertex, $H = j^2/(b-h)$, only a single root.

Accordingly, the $\cos^3\theta$-condition and the constant-condition between them may specify as many as 6 foci in quartic axial inversions within this superfamily. [In the case of the $h = -\frac{1}{2}b$ inversion about the loop focus of the internal-asymptote arm, both the $\cos^3\theta$-condition and the constant-condition specify the $H = 0$ focus, so the total number specified by them is 5. The other 4 foci are at $H = 2j^2/b$, $2j^2/3b$, and $-j^2(5\pm7^{\frac{1}{2}})/3b$.] If the $\cos\theta$-constant condition-- which specifies the loop focus in the folium of Descartes--also is focal in other inversion loci, as many as 7 foci could exist.

Tschirnhausen's Cubic

Introduction

Before proceeding to a consideration of quartics, and to round out the treatment of vertex cubics, consideration is given to Tschirnhausen's cubic, the curve obtained by inverting Cayley's sextic, eq. 32, about the loop vertex.

$$(x^2+y^2-ax)^3 = 27a^2(x^2+y^2)^2/4 \qquad \text{Cayley's sextic} \qquad (9-32)$$

Cayley's sextic, being a curve of 6th degree, is not a member of the QBI superfamily (although it is a member of the quadratic-based tangent-pedal superfamily). It is the curve generated by the cusp of a cardioid as this curve rolls on the perimeter of an identical cardioid, with corresponding points in contact (a locus known as a "roulette"). It also is the tangent-pedal of the cardioid about the cusp-point. In view of these relationships, Cayley's sextic clearly belongs to an inversion superfamily of curves of high symmetry whose members have affinities with QBI curves (see Chapter XIII). Accordingly, it (or more appropriately, its DP inversion quartic) provides an excellent starting point for the Inversion Taxonomy of another significant superfamily.

The affinity of Cayley's sextic with limacons is evident from eq. 32. The latter differs from the eq. of a cardioid in having the exponents increased by one degree for each of the two parenthetical terms, and in the presence of the coefficient 27/4. Because the great circumpolar symmetry of limacons can be traced to the form of these terms, curves specified by the same terms with altered exponents also will have exceptional symmetry properties (see Chapter XIV). The coefficient $27/4$ is one that we have encountered before and that arises repeatedly in connection with quartics, sextics, and inversions of cubics about the loop pole at $h = 2b/3$.

If Cayley's sextic is inverted through the vertex of the small loop, taking the parameter a as the unit of linear dimension, one obtains a looped cubic, eq. 33, that somewhat resembles the hyperbola vertex cubics and the folium of Descartes but does not possess an asymptote. The sextic loop vertex lies on the axis of the cubic loop, 1/9th of the axial length from the vertex of the latter, while its DP is coincident with the loop focus of the cubic at the 1/3rd point.

(a) $4(a-x)^3 = 27a(x^2+y^2)$ Tschirnhausen's cubic (9-33)

(b) $x^3\cos^3\theta - 3(a+h)x^2\cos^2\theta + 3(h^2-5ah/2+a^2)x\cos\theta$ simple intercept eq.

 $+ \; 27ax^2/4 - (h^3-15ah^2/4+3a^2h+a^3) = 0$

Both loops have the same orientation, but the sextic loop is tiny compared to that of the inversion cubic (for the selection j = a). Although the eq. of this cubic also is very simple, it differs considerably from the eqs. of the conic axial vertex cubics and the folium of Descartes. Accordingly, bearing in mind the relationships of the basis sextic to the cardioid, it provides excellent material for making comparisons with the cubics previously considered.

The Simple Intercept Equation and Axial Foci

The simple intercept eq., 33b (x-h translation), for a point on the line of symmetry, like the corresponding eq. for the folium of Descartes, contains a term in $\cos^3\theta$. Tschirnhausen's cubic is sufficiently closely related to the axial vertex cubics already considered that homologies in their intercept eqs. are obvious.

There is no focal condition on the $\cos^3\theta$ term. On the other hand, the $\cos^2\theta$-condition is h = -a, which reveals the presence of a focus outside the loop on the vertex side, 3a/4 distant from the vertex. Since the condition for the variable focus of other looped cubics is specified by the coefficient of the $\cos^2\theta$ term, there may be no variable focus. The constant-condition, as usual (Maxim 4), reveals the presence of foci at h = -a/4 and h = 2a, the loop vertex and DP, respectively. The $\cos\theta$-condition reveals the existence of two foci; the one at h = 2a is the DP just considered, the other, at h = a/2 is the loop focus, located at the typical position, 2/3 of the axial distance from the DP and coincident with the sextic DP.

Accordingly, 4 foci are revealed by focal conditions *on the coefficients* of the simple intercept eq. for a point on the x-axis. However, a 5th focus is present at the pole of inversion, h = 0, which also is the position of the sextic loop vertex (i.e., at the reciprocal inversion pole). The focal condition for this focus is an *equational condition*, i.e., a condition on the entire simple intercept eq. Thus, for h = 0, eq. 33b simplifies to 34a,a', which is

(a) $(a-x\cos\theta)^3 = 27ax^2/4$ simple intercept eq. (9-34)

 33b for h = 0

(a') $\cos\theta = (a - 3a^{1/3}x^{2/3}/4^{1/3})/x$ " " "

 $x = (9a\cos^2\theta -27a/4)/\cos^3\theta$ simple intercept eq. (9-35)

 of 33 cast about DP

simply the polar eq. of the curve (with r replaced by x). Although this intercept eq. is relatively simple, it is not the simplest in which the curve can be represented (i.e., as an explicit function of x). That distinction is possessed by the simple intercept eq. 35, cast about the DP which, accordingly, is the highest-ranking focus.

Failure of a high-ranking focus to be revealed by simple conditions on the coefficients of an intercept eq. is not unusual, for after all, as illustrated here, there are more ways for an eq. to simplify than by having terms vanish. In fact, as we have seen in Chapters VI and VII, the traditional foci of conic sections are not specified by the coefficients of terms in the intercept eqs., but by conditions on the radicands of the simple intercept formats whereby they become independent of x. The same is true of the limacon variable focus at $(a^2-b^2)/2b$. A similar situation holds in other self-inverting axial QBI curves, where the focus of self-inversion typically is revealed by a different type of *equational* condition, namely a condition for the reduction of the 0° (or 180°) intercept transform about a point on the line of symmetry.

According to these considerations, Tschirnhausen's cubic has 5 axial foci. Cayley's sextic, then, also would possess 5 such foci (Maxim 9), as would all other axial inversion loci in the same inversion superfamily (i.e., all curves derived by line-of-symmetry inversions).

Intercept Transforms

When attention turns to the intercept transforms of Tschirnhausen's cubic, the first question that comes to mind is whether or not the curve is self-inverting through the loop vertex. Eqs. 36a-d give, respectively, the simple intercept eq., the compound intercept eq. for 0° transformations, the compound 0° and 180° intercept formats, and the 0° transform--all cast about the loop vertex. The form of the latter is very interesting for several reasons, including the fact that it possesses both square and cubic expressions whose

(a) $16x^2\cos^3\theta - 36ax\cos^2\theta + 81a^2\cos\theta + 108ax = 0$ simple intercept eq. about loop vertex (9-36)

(b) $4xy\cos^2\theta - 9a(x+y)\cos\theta - 12xy = 0$ compound $0°$ intercept eq. about loop vertex

(c) $\cos\theta = \dfrac{-9a(x\pm y) \pm [81a^2(x\pm y)^2 + 192x^2y^2]^{\frac{1}{2}}}{8xy}$ compound $0°$ and $180°$ intercept formats, loop vertex

(d) $27a^2[27a^2(x^3+2x^2y+2xy^2+y^3) - 48x^2y^2(x+y)]^2 =$

$\quad [27a^2(x+y)^2 + 64x^2y^2][27a^2(x^2+xy+y^2) + 16x^2y^2]^2$ $0°$ intercept transform for 36b,c

$\quad 16[a^2(x\mp y)^2/27 - x^2y^2/4]^3 = a^2x^5y^5$ $0°$ and $180°$ transforms, polar center (9-37)

$\quad y\sin^3\theta = x\cos^3\theta + 9a/2$ compound $90°$ intercept (9-38) eq. about double point

cross-product coefficients fall one unit short of making the entire expression either a perfect square or a perfect cube. But being a complex 12th degree eq., it departs from an equilateral hyperbolic transform of self-inversion to a far greater degree than does the corresponding 4th degree eq. for the folium of Descartes.

Eqs. 37 are the $0°$ and $180°$ transforms about the pole at $x = 0$, for which the simple intercept eq. is 34. Like the $0°$ transform about the loop vertex, these transforms also are of 12th degree but of much simpler form. Lastly, $0°$ and $180°$ transforms about the DP are, of course, linear ($x = \pm y$). This focus has highly interesting simple and compound $90°$ intercept eqs. (eqs. 35 and 38, respectively).

In view of the derivation of Tschirnhausen's cubic from Cayley's sextic, it is desirable to give a brief treatment of the basis curve here, while the properties of its loop-vertex inversion cubic still are fresh in mind.

Cayley's Sextic

Inversion Analysis

To what loci does this curve invert about a point in the plane ($x+h$, $y-k$ translations)? The answer is that, like QBI quartics, all of which invert to curves of no higher than 4th degree about a point in the plane--and for the

same reasons--Cayley's sextic inverts to curves (eq.39) of no higher than 6th
degree. The condition for the 6th degree term to vanish is eq. 40 which, since
it specifies any point on the curve, reveals the curve itself to be a focal
locus.

inversion of Cayley's sextic about a point in the plane

$$4\{j^4+j^2[(2h-a)x-2ky]+(h^2-ah+k^2)(x^2+y^2)\}^3 = \tag{9-39}$$

$$27a^2(x^2+y^2)[j^4+2j^2(hx-ky)+(h^2+k^2)(x^2+y^2)]^2$$

$$4(h^2+k^2-ah)^3 = 27a^2(h^2+k^2)^2 \qquad \begin{array}{l}\text{condition on eq. 39 for the}\\ \text{vanishing of the 6th degree terms}\end{array} \tag{9-40}$$

inversion of Cayley's sextic about a point on the line of symmetry

$$4[j^4+j^2(2h-a)x+h(h-a)(x^2+y^2)]^3 = 27a^2(x^2+y^2)[j^4+2hj^2x+h^2(x^2+y^2)]^2 \tag{9-41}$$

(a) $\quad 4h^3(h-a)^3 = 27a^2h^4 \qquad \begin{array}{l}\text{condition on eq. 41 for the}\\ \text{vanishing of the 6th degree terms}\end{array}$ (9-42)

(b) $\quad h^2j^2(h-a)^2(2h-a) = 9a^2h^3j^2 \qquad \begin{array}{l}\text{condition on eq. 41 for the}\\ \text{vanishing of the 5th degree terms}\end{array}$

(c) $\quad 6h^2j^4(h-a)^2 = 27a^2h^2j^4 \qquad \begin{array}{l}\text{conditions of eq. 41 for the}\\ \text{vanishing of the 4th degree terms}\end{array}$

(c') $\quad hj^4(h-a)(2h-a)^2 = 9a^2h^2j^4$

Letting $k = 0$ in 39 yields the inversion loci of eq. 41 about a point on
the line of symmetry. The condition for the vanishing of the 6th degree terms
is 42a, which specifies the DP at $h = -\frac{1}{2}a$, the small-loop vertex at $h = 0$
(triple root), and the large-loop vertex at $h = 4a$. The condition for the
5th degree terms to vanish is 42b, while those for the 4th degree terms are
42c and 42c'. The only common root of eqs. 42a,b,c,c' is $h = 0$, the small-
loop vertex. For this condition, Tschirnhausen's cubic, eq. 43., is the
inversion locus.

The DP at $h = -\frac{1}{2}a$ satisfies eqs. 41a and 41b, whereupon the inversion locus
becomes an asymmetrical quartic "hyperbola" similar to the DP-inversion quartic
of the folium of Descartes. For $j = a$, the eq. of this curve is 44. This
quartic is a basis curve* for the inversion superfamily of which Cayley's
sextic is one of the axial members. The pole $h = 4a$ --the large-loop vertex--

*[The genus to which this quartic belongs provides the basis curves.]

$$4(j^2-ax)^3 = 27a^2j^2(x^2+y^2) \qquad \text{inversion of Cayley's sextic about the small-loop vertex} \qquad (9\text{-}43)$$

the DP-inversion quartic of Cayley's sextic

$$27(x^2+y^2)^2/4 - 9(x^2+2ax-2a^2)(x^2+y^2) - 8ax(4x^2-6ax-3a^2) - 4a^4 = 0 \qquad (9\text{-}44)$$

$$4(a^2-x^2/4-y^2/4)^3 = 27(x^2+y^2)[(a+x/2)^2+y^2/4]^2 \qquad \begin{matrix}\text{inversion of Cayley's}\\\text{sextic about } h = \tfrac{1}{2}a\end{matrix} \qquad (9\text{-}45)$$

$$4a^3(a+x)^3 = 27(x^2+y^2)[(a+x)^2+y^2]^2 \qquad \begin{matrix}\text{inversion of Cayley's}\\\text{sextic about } h = a\end{matrix} \qquad (9\text{-}46)$$

is a root only of eq. 42a, whereupon the inversion locus is the quintic obtained by letting $h = 4a$ in eq. 41 (and expanding, cancelling the 6th degree terms, etc.)

Lastly, there are two points on the x axis that are not vertices, inversions about which lead to great simplifications of the 6th degree locus of eq. 41. For $h = \tfrac{1}{2}a$, an internal point at a distance $\tfrac{1}{2}a$ from the small-loop vertex, the inversion locus is eq. 45 (letting $j = a$), while for $h = a$, an internal point at a distance a from the small-loop vertex, it is eq. 46.

In summary, an inversion analysis of Cayley's sextic identifies the curve itself, the DP, and the small-loop vertex as having circumpolar focal rank. The inversion loci about these points reduce from 6th degree for the general eq. for a point in the plane to 5th, 4th, and 3rd degree, respectively. Inversions about two other circumpolar focal loci--the large-loop vertex and a point on the line of symmetry--do not reduce. For the former, the eq. for a point on the curve, though much simplified, does not reduce from a quintic. For the latter, while similarly much simplified, the general eq. for a point in the plane does not reduce from a sextic. Two axial poles that do not lie on the curve are potential circumpolar foci; for them, the general 6th degree inversion locus for a point on the line of symmetry greatly simplifies.

CIRCUMPOLAR MAXIM 10: *The weakest condition for reduction in the degree of an inversion locus for a curve inverted about a point in the plane is that this point be incident upon the curve. For such a location, at the very least the highest-degree term of the inversion locus vanishes. If the inversion locus is obtained about a point on a line of symmetry, reduction occurs at the vertices.*

Inversion Analysis Versus Circumpolar
 Symmetry Analysis

It has become abundantly clear from the foregoing that an inversion analysis
falls far short of a circumpolar symmetry analysis in regard to its ability to
detect circumpolar foci and to rank the degrees of symmetry of curves about
them. Since the condition for the vanishing of the term of highest degree
always is that the point (h,k) lie on the curve, reduction of the general
inversion eq. occurs only for such points. Accordingly, this inherently limits
the utility of an inversion analysis to the detection and relative ranking of
focal loci that are incident upon the curve, and to relative ranking of the
symmetry of the curve about other poles that lie on lines of symmetry. The
method cannot identify these other axial poles as circumpolar foci, since
reduction cannot occur for inversions about them.

The identification of a *line of symmetry* as a circumpolar focal locus is
accomplished automatically whenever there is a greater reduction of the eqs.
for one or more axial vertices or a DP than of the general eq. for a point on
the curve. This follows because no case is known of a vertex focus that lies
on a line of symmetry that is not itself a circumpolar linear focal locus
(though vertex foci may lie at intersections with an axis that does not have
circumpolar focal rank, such as the LR of conic sections). Through much the
same line of reasoning it follows that if there is reduction for any vertex or
DP that lies on a line of symmetry, the other intersections of the curve with
this axis also are circumpolar foci.

However, these observations do not necessarily provide a complete picture
of the potential of the inversion transformation to form the basis for a more
thorough analysis of circumpolar symmetry. One could take several views of
the situation. In one view, some of the seeming limitations of an inversion
analysis might be only a shortcoming in our ability to appreciate its full
implications (i.e., to interpret the significance of the vanishing of terms
that are not of highest degree). A more plausible view is that, since the
inversion transformation is only a *single-vector transformation*--one merely
reciprocally reflects the curve through a given pole at a given angle (no
matter what the angle)--it is inherently incapable of yielding all of the
information provided by the circumpolar intercept transformation (see also
Chapter VI, *Inversions and Circumpolar Symmetry*, and the analytical scrutiny
in Chapter XIV, *The Circumpolar Symmetry Versus the Inversion Analyses*).

Circumpolar Symmetry Analysis

Simple Intercept Equations and Axial Foci

The circumpolar symmetry of Cayley's sextic has not been investigated in detail and, accordingly, is discussed but briefly. The simple intercept eq. for a point on the line of symmetry (x+h translation) is given by 47.

simple intercept equation of Cayley's sextic for a point on the x-axis

$$-x^3(a-2h)^3\cos^3\theta + x^2[3(a-2h)^2x^2-3h(a-h)(a-2h)^2-27a^2h^2]\cos^2\theta + \qquad (9-47)$$

$$x\{-3(a-2h)x^4+2hx^2[3(a-h)(a-2h)-27a^2/2]-3h^2(a-h)^2(a-2h)-27a^2h^3\}\cos\theta +$$

$$\{x^6-x^4[3h(a-h)+27a^2/4]+3h^2x^2[(a-h)^2-9a^2/2]-h^3[(a-h)^3+27a^2h/4]\} = 0$$

simple intercept equation for the loop focus at h = ½a

$$-27a^4x^2\cos^2\theta - 27a^3x(2x^2-a^2/2)\cos\theta + (4x^6-30a^2x^4-51a^4x^2/4-7a^6/4) = 0 \quad (9-48)$$

The vanishing of the coefficient of the $\cos^3\theta$ term yields the focal condition h = ½a for one of the foci of the large loop, for which the simple intercept eq. 47 greatly simplifies to 48. The constant-condition of eq. 41 specifies the 2 vertex foci at h = 0 and h = 4a and the DP at h = -½a. For the condition h = 4a an x factors out of the eq. But for h = 0 and h = -½a an x^2 factors out, because these conditions also lead to elimination of the cosθ-constant term--a certain indication of higher focal rank for these foci than for the focus at h = 4a.

The 5th focal condition appears to be h = a. Although this assignment does not lead to the factoring out of an x or x^2 from the eq.--anymore than for h = ½a of the $\cos^3\theta$-condition--the (h-a) term occurs in the eq. no less than 6 times (equalling the number of occurrences of the [a-2h] term). Accordingly, for h = a the eq. also greatly simplifies.

Intercept Transforms

Examples of intercept transforms are given for the small-loop vertex at h = 0. The simple intercept format is 49a, while the 6th degree 0° and 180° transforms are given by 49b. The eq. for the 90° transform can be set down in simple form

(a) $\cos\theta = (x - 3a^{2/3}x^{1/3}/4^{1/3})/a$ simple intercept format (9-49)
for small-loop vertex

(b) $xy = \mp(a^2/4)[4(y\mp x)^2/27a^2-1]^3$ $0°$ and $180°$ transforms
about small-loop vertex

(c) $(x^2+y^2-a^2) = 6a^{2/3}(x^{4/3}+y^{4/3})/4^{1/3}$ $90°$ transform about
small-loop vertex

$\qquad - 9a^{4/3}(x^{2/3}+y^{2/3})/4^{2/3}$

in fractional exponents, 49c, but the degree of this eq. has not been ascertained. The relative simplicity and relatively low degree of the $0°$ and $180°$ transforms attest to the relatively high circumpolar symmetry of the basis curve (i.e., considering the fact that it is a sextic). But the existence of these 6th degree transforms also raises the possibility that the 12th degree $0°$ transform of Tschirnhausen's cubic about the small-loop vertex, eq. 37d, will reduce.

The resemblance of the simple intercept eq., 49a, for the small-loop vertex of Cayley's sextic, to that for the pole at h = 0 (the reciprocal inversion pole) of Tschirnhausen's cubic, 34a', merely is an expression of the fact that the curves are inversions of one another about this pole (except for the exchange of x and a, 34a' and 49a are identical).

LIMACONS

Introduction

Limacons are a remarkable group of quartics, closely related to conics, and having many homologies with conics, but possessing in addition extraordinary circumpolar symmetry properties that cannot exist in curves of only 2nd degree. Unfortunately, limacons are a neglected group of curves from the standpoint of traditional analytical geometry; there apparently exists in the literature no treatment of them that can be characterized as anything but cursory. In perhaps the most extensive treatment (Zwikker, 1950), 9 of 11 pages are devoted to the cardioid. Since we shall have need for familiarity with their geometrical properties in analyzing their Circumpolar Symmetry and Inversion Taxonomy, this introductory treatment covers these topics in some detail.

The Cartesian Group

Limacons belong to a major equational group of curves, *The Cartesian Group*, which includes all conic sections, bipolar linear and parabolic Cartesians, polar-circular linear Cartesians, and other members not yet characterized. The bipolar eqs., $u^2 = Cdv$ and $Bu+Av = Cd$, and polar-circular eq., $u = Cv$, of Cartesians encompass the representatives known to me but do not include the parabola or cardioid. Although some members of this group are closely related as judged by circumpolar symmetry and inversion analyses, others are found to have basic differences.

Each curve of *The Cartesian Group* has a simple intercept format of the form 1a. For the quartic members of the group this eq. is cast about a focus of self-inversion. The terms A, B, C, D, E, F, and G are composite, consisting

(a) $\quad \cos\theta = \dfrac{Bx^2 + Ax + C}{Dx}$ \qquad simple intercept format of \qquad (10-1)
$\qquad\qquad\qquad\qquad\qquad\qquad$ The Cartesian Group

(b) $\quad \cos\theta = Ex + F + G/x$ \qquad another form of 1a

(c) $\quad r = \dfrac{(A+D\cos\theta)^2 \pm \left[(A+D\cos\theta) - 4BC\right]^{\frac{1}{2}}}{2B}$ \qquad polar equation of 1a,b

of both dimensionless coefficients and parameters. They may be positive or
negative and their degree is such as to bring the eq. into dimensional balance.
If, in la, one divides termwise by Dx, one obtains the simpler format, lb.
In polar coordinates, the eq. of The Cartesian Group is lc.

All curves possessing a focal pole for which the $\cos\theta$ simple intercept format
(1) involves no radical, (2) has a denominator linear in x, and (3) has a
numerator with a constant term and at least one other term of no higher than
2nd degree in x belong to The Cartesian Group. Although this characterization
might seem to open wide its membership, the facts are to the contrary. There
are relatively few groups of curves whose members have foci for which the
simple intercept format does not involve a radical and, of these, there are
very few that have numerators as low as 2nd degree. For example, the simple
intercept format for a member of the highly symmetrical root-$\cos^2\theta$ group,
$r^2 = a^2 \pm b^2\cos^2\theta$, involves a radical for the center focus and a 4th degree
polynomial divided by a 3rd degree polynomial for the $\pm\frac{1}{2}b$ axial focus.

Cartesian Self-Inverters

For $B = 0$ the format la becomes that of a conic section about a tra-
ditional focus, while for $A = 0$ it is that of a circle about a point in the
plane (excluding the center and incident points). If one stipulates that none
of the coefficient terms, A, B, C, or D can be 0, the curves characterized
by eqs. 1 are restricted to membership in a group that appropriately may be
called *Cartesian Self-Inverters*, by virtue of the fact that all of its
members have at least one circumpolar focus through which the curve self-
inverts.

Recall in this connection that the circle and line (and certain ensembles of
circles and lines) are the only conic sections that undergo focal self-inversion
and that the central conic axial vertex cubics self-invert through a non-
variable focus, in fact a vertex focus. The simple intercept format for the
latter (IX-lla) involves a radical but simplifies to $-2ax/(a^2+x^2)$ for the
equilateral strophoid.

The circumpolar symmetry basis for grouping together the Cartesian Self-
Inverters is that the ordinal rank for the $0°$ transforms of curves about foci
having the formats la,b is 10th degree and the subordinal rank is 8th degree

(Table V-1). The positive self-inversion of members of this group through the focus in question is shown by deriving the $0°$ intercept transform, which proves to be the equilateral hyperbola $xy = C/B$. Note that if zero-valued coefficients were allowed, this transform would rule out the parabola, ellipse, and hyperbola as self-inverters (since for them $B = 0$) but would include the circle.

Equations of Limacons Cast About the Axial Foci

The special cases of eqs. 1 for limacons are eqs. 2. Self-inversion through the pole about which 2a is cast is proved readily. In one proof one inverts 2b by substituting j^2/r for r and, after obtaining the inversion locus, multiplies j^2/r of this locus by r of eq. 2b. This yields the expression $(a^2-b^2)^2/4b^2$. But this is simply the square of the distance from the DP to the variable focus (the pole of eq. 2a), which lies at $x = (a^2-b^2)/2b$. When this distance is taken to be the unit of linear dimension, the limacon self-inverts.

(a) $\cos\theta = \dfrac{4b^3x-4b^2x^2-(a^2-b^2)^2}{4a^2bx}$ simple intercept format about pole of self-inversion (10-2)

(b) $r = \dfrac{(b^2-a^2\cos\theta)\pm[(b^2-a^2\cos\theta)^2-(b^2-a^2)^2]^{\frac{1}{2}}}{2b}$ equation 2 in polar form

(c) $[x^2+y^2+a^2x/b+(a^2-b^2)^2/4b^2]^2 = b^2(x^2+y^2)$ eq. 2 in rectangular form

(a) $\cos\theta = \dfrac{a^2(x^2+b^2/4) - (x^2-b^2/4)^2}{a^2bx}$ simple intercept format, $-\frac{1}{2}b$ focus (10-3)

(b) $a^2br\cos\theta = (r^2+b^2/4)a^2-(r^2-b^2/4)^2$ equation 3a in polar form

$$r(2a\pm b)^2\cos^2\theta \mp[2r^2(2a\pm b)+2a(a\pm b)^2]\cos\theta + 2r[r^2+a(a\pm2b)] = 0$$

polar eqs. cast about the axial vertices (10-4)

A second set of eqs. for the limacon, cast about the axial focus at $x = -\frac{1}{2}b$ is given by eqs. 3. Two additional eqs. of limacons are those cast about the $-(a+b)$ and $(a-b)$ vertex foci (eq. 4, upper and lower alternate signs, respectively). As anticipated, the complexity of polar eqs. of the limacon

inversely parallel the focal rank of the poles about which they are cast; thus, the DP and its homologues, about which the eq., $r = a - b\cos\theta$, has the simplest form, have the highest focal rank, the variable focus (eq. 2b) the next-highest rank, and the $-\frac{1}{2}b$ focus (eq. 3b) the 3rd-highest rank. The $-(a+b)$ and $(a-b)$ vertex foci have equal 4th-highest rank. To express eqs. 3b and 4a,b in the explicit form $r = f(\theta)$ involves the solution of cubic and quartic eqs. An eq. cast about a point in the plane (eqs. 11a,b) is much more complicated.

The eq. of limacons about the DP and its homologues is, of course, only one of the simple alternatives of eqs. 5a-d, which simply phase shift by $90°$ in the sequence given. The form 5a* is employed in the analyses that follow.

(a) $r = a - b\cos\theta$ (b) $r = a - b\sin\theta$ (c) $r = a + b\cos\theta$ (10-5)

(d) $r = a + b\sin\theta$ (e) $r = a$ (f) $r = b\sin\theta$

Construction of Limacons From Circles

The analytical and constructional bases for the homologies between limacons and conics are clearly evident from inspection of eqs. 5a-d, because all express the fact that a limacon is constructed by taking as the coordinate, r, sums and differences of the distances to points on two circles, 5e,f, where 5f is a circle of radius $\frac{1}{2}b$ centered at $\frac{1}{2}b$.

If the diameter of the $\frac{1}{2}b$ circle is greater than the radius of the a circle, a *hyperbolic limacon* is obtained; if the converse is true, an *elliptical limacon* results; while if these values are equal, one obtains the *parabolic limacon*, i.e., the cardioid. These designations are employed because these different species of limacons are the types obtained by inversion of the corresponding conic species through their traditional foci. The inverse of the equilateral hyperbola is the *equilateral limacon.*

The "Pedal" Construction, the "Basis Circle,"
 and the "Directrix Circle"

Selection of the $\frac{1}{2}b$ circle centered at $\frac{1}{2}b$ was arbitrary. It also could have been centered at $-\frac{1}{2}b$, and the construction could have been carried out with equal facility. In fact, the $-\frac{1}{2}b$ circle is known as the "directrix circle" of the limacon and has another significance besides the constructional one de-

*[a and b always positive]

scribed above. This has to do with the pedal construction of the limacon.

In this construction, a reference pole is selected relative to a basis circle. Perpendiculars are dropped from the reference pole to tangents to the basis circle. The locus of the feet of these perpendiculars on the tangents is a limacon. The reference pole becomes the center pole of eqs. 5 (the DP or its homologue). When the pole is outside of the basis circle the limacon is hyperbolic, when incident upon the basis circle it is parabolic, while the elliptical species is obtained when the pole is within the basis circle. The $-(a+b)$ and $(a-b)$ vertices of the limacon lie at diametrically opposed points on the basis circle. Accordingly, the center of the basis circle is at $-b$.

If "diameters" (or secants) of the limacon are drawn through the reference pole (the center pole), and normals to the limacon are dropped from the termini of these "diameters," the locus of their points of intersection is the "directrix circle," i.e., the $-\frac{1}{2}b$ circle. The directrix circle was discovered independently of the discovery of the $-\frac{1}{2}b$ focus, which was detected by Chasles (1837) through casting the eqs. of linear Cartesians in tripolar coordinates.

Inversion Correspondences Between Conics and Limacons

Some pertinent inversion relationships between conics and limacons are as follows. The reciprocal inversion pole of a conic inverted through its traditional focus is the limacon DP or DP homologue. The contralateral focus of central conics inverts through this pole to the position of the limacon variable focus at $x = (a^2-b^2)/2b$. Accordingly, the center, which is at only half the distance of the contralateral focus, inverts to twice the distance of the $(a^2-b^2)/2b$ focus, namely to $(a^2-b^2)/b$. In the parabolic limacon the DP homologue, the $(a-b)$ vertex focus, and the $(a^2-b^2)/2b$ variable focus (which, in itself, is a *generic double-focus*; see Chapter XII) are coincident. The limacon variable $-\frac{1}{2}b$ focus inverts to the reflection of the traditional focus in the directrix, i.e., to the conjugate point to the focus. It already has been noted that in the parabola, for example eqs. II-21, this pole has the second-highest bipolar symmetry rank of any axial pole.

In the ellipse and hyperbola, the foot of the basis directrix (i.e., of the directrix closest to the focus about which the conic is inverted) inverts to the center of that portion of the limacon axis that lies between the $-(a+b)$ and $(a-b)$ vertices, i.e., to $-b$, which also is the center of the pedal basis circle. The directrix of the parabola also inverts to this location in the cardioid, but in that case the directrix intersects the center of the

cardioid axis.

The LR of the conic basis arm is coincident with the line through the DP or DP homologue of the limacon orthogonal to its line of symmetry (the *axial covert linear focal locus*; see below). For this reason and for convenience, its points of intersection with the limacon (at $k = \pm a$) are referred to hereafter as the *LR vertices* of the limacon. The axial vertices, of course, invert to one another. The DP of hyperbolic limacons is exceptional (considered as a vertex); since it is the reciprocal inversion pole, it is coincident with the traditional focus of the basis arm.

The Limacon Vertices

The *limacon vertices* are defined as those points lying on the curve at the levels of the axial foci. Points of this type are referred to as *peripheral vertices*, where necessary, to distinguish them from the corresponding axial vertices. However, the LR vertices of the limacon, though they fall in this category, still are called *LR vertices*. The locations of the peripheral vertices are described primarily in terms of the locations of the corresponding axial foci.

The analysis begins with eq. 6b. This is the rectangular coordinate eq. of the limacon, 5a or 6a, obtained from 6a by solving explicitly for y^2 and

(a) $(x^2+y^2+bx)^2 = a^2(x^2+y^2)$

rectangular eq. of limacon (10-6)

(b) $2k^2 = a^2- 2h(h+b) \pm a(a^2-4bh)^{\frac{1}{2}}$

equation defining the limacon peripheral vertices

 $2k^2 = a(2b-a) \pm a(2b-a) = 2a(2b-a)$ & 0 6b for $h = (a-b)$ (10-7)

replacing y by k and x by h. It is apparent from 6b that no real peripheral vertices can exist unless the radicand is positive or 0, i.e., unless h is less than or equal to $a^2/4b$, which simply means that lines orthogonal to the y axis at abscissae greater than $a^2/4b$ will not intersect the curve, but that a line at $a^2/4b$ will be tangent to it.

What is the condition for peripheral vertices to exist at $h = (a-b)$, the location of the corresponding axial vertex? Letting $h = (a-b)$ in 6b yields eq. 7, whence b must be greater than $\frac{1}{2}a$ for k to be real. This result means that the limacon is wholly convex for all b equal to or less than $\frac{1}{2}a$.

For b greater than ½a, a concavity appears and its rims protrude beyond
h = (a-b) to $a^2/4b$. For b > a, the concavity remains but the (a-b) vertex
becomes internalized as the vertex of the small loop.

For example, for b = 3a/4, the (a-b) axial and peripheral vertices are
at h = ¼a and the rims of the concavity protrude to a/3. For a = b, the
parabolic limacon, the (a-b) vertices are at h = 0 and the rims protrude
to ¼a. For b = 3a/2. the (a-b) vertices are at h = -½a, the DP is at
h = 0, and the rims protrude only to a/6.

The LR Vertices and the Peripheral (a-b) Vertices

As b increases from the value ½a, the distance between the LR vertices
and the peripheral (a-b) vertices decreases (i.e., the distance measured
along the x-axis), because the value of this distance, a-b, approaches 0.
At a = b, these peripheral vertices are coincident with one another at a
distance a units above and below the cusp (the LR vertices always are at
y = ±a). When b exceeds a, the peripheral (a-b) and LR vertices lose
their coincidence and the former progressively migrate toward the h = -(a+b)
vertex. The inner loop concomitantly enlarges and both loops become more
nearly circular.

The -½b Vertices

For h = -½b eq. 6b yields the roots 8a,b. The first set of vertices, 8a,
are the -½b vertices of the large loop, which are unexceptional, i.e., they
exist for all values of a and b. For the existence of real (as opposed to

(a) $k = \pm[a^2/2+b^2/4+a(a^2+2b^2)^{\frac{1}{2}}/2]^{\frac{1}{2}}$ -½b vertices of large loop (10-8)

(b) $k = \pm[a^2/2+b^2/4-a(a^2+2b^2)^{\frac{1}{2}}/2]^{\frac{1}{2}}$ -½b vertices of small loop

(c) $a^2 + b^2/2 \geq a(a^2+2b^2)^{\frac{1}{2}}$ condition for vertices of 10b
 to be real

imaginary) vertices defined by 8b, the condition 8c must hold. The latter leads
to the result that b must be greater than or equal to 2a. This is the
condition for the existence of -½b vertices on the small loop.

In other words, the $-\frac{1}{2}b$ focus does not enter the small loop until the value of b exceeds $2a$. Or, if one prefers, the vertex of the small loop is at $-(b-a)$, but this point will fall short of the $-\frac{1}{2}b$ focus until $b = 2a$. The reason for this is that $b-a$ is less than $\frac{1}{2}b$ for all b greater than a but less than $2a$. At $b = 2a$, an axial $-\frac{1}{2}b$ vertex exists and is co-incident with the peripheral $-\frac{1}{2}b$ vertices.

The $(a^2-b^2)/2b$ Vertices

If $h = (a^2-b^2)/2b$ in 6b, one gets the condition 9a for the existence of peripheral vertices for the corresponding focus. It is evident from 9a that no real vertices will exist for this focus unless the radicand is 0 or positive,

(a) $\quad k^2 = \dfrac{(b^2+a^2)^2 - 2a^4 \pm 2ab^2(2b^2-a^2)^{\frac{1}{2}}}{4b^2}$ 　eq. defining location of $(a^2-b^2)/2b$ vertices 　(10-9)

(b) $\quad b \geq a/2^{\frac{1}{2}}$ 　condition that real vertices exist for 9a

(c) $\quad 2ab^2(2b^2-a^2)^{\frac{1}{2}} + (a^2+b^2)^2 > 2a^4$ 　condition for vertices exclusively on large loop

(d) $\quad (b^2+a^2)^2 > 2a^4 + 2ab^2(2b^2-a^2)^{\frac{1}{2}}$ 　condition for vertices on small loop

(e) $\quad (b^2-a^2)^2 > 0$ 　same as condition 9d

i.e., $b \geq a/2^{\frac{1}{2}}$. We recall that the concavity in the loop does not begin to appear until $b = \frac{1}{2}a$. For $b = \frac{1}{2}a$, the $(a^2-b^2)/2b$ focus is at $3a/4$, whereas the rims protrude only to $a^2/4b = a/2$. But when $b = a/2^{\frac{1}{2}}$, the focus is at $2^{\frac{1}{2}}a/4$, which also is the distance to which the rims protrude (since $a^2/4b = 2^{\frac{1}{2}}a/4$). Thus, for $b = a/2^{\frac{1}{2}}$, there are two vertices at the tangent points of the $(a^2-b^2)/2b$ axis.

The conditions for having a set of vertices exclusively on the large loop are 9b and 9c. The latter holds for all b satisfying 9b. The conditions for the other set of vertices are 9b and 9d. These eqs. apply to the vertices on the small loop and the "near" set of vertices on the loop of the elliptical species. Condition 9d reduces to 9e, which holds for all b except $b = a$, the condition in the cardioid, in which the "near" set of large loop vertices become coincident at the cusp.

In summary, all these sets of focus-associated vertices, i.e., peripheral and axial vertices that are coincident with or are at the levels of the foci, display different properties. In the progression elliptical-parabolic-hyperbolic species they show the following behavior. Two center pole (h = 0) vertices of elliptical species become a set of 3 vertices in the parabolic species and remain so in hyperbolic species. One (a-b) vertex becomes a set of 3 vertices when b exceeds ½a and remains so throughout. The -½b vertices begin as a set of 2, become 3 in number in the b = 2a subspecies and 4 in number in hyperbolic subspecies with larger small loops. Lastly, the $(a^2-b^2)/2b$ set of vertices begins with no members and acquires 2 vertices at b = a/2^½; it acquires 2 more vertices for larger values of b --all on the large loop-- acquires a 5th vertex in the cardioid, with 3 of the vertices being coincident at the cusp and 2 occurring on the large loop, and then loses one vertex in the hyperbolic species, in all subspecies of which it has 4 vertices, 2 on the small loop and 2 on the large loop. For b increasingly large relative to a, the $(a^2-b^2)/2b$ focus becomes more and more nearly coincident with the -½b focus, as do the peripheral vertices of these foci.

Overt Homologies With Conics

The fact that limacons and conics belong to the same inversion superfamily automatically leads to numerous homologies between the two genera, many of which are overt but not generally appreciated. As is well known, the polar eq. of conics, stated in terms of e and p (p = 2a) is 10a. Inversion gives the

(a) $\quad r = \dfrac{ep}{(1-e\cos\theta)}$

(b) $\quad r = j^2[(1/ep)-(1/p)\cos\theta]$ \qquad (10-10)

(c) $\quad r = a(1-e\cos\theta)$

(d) $\quad r^2 = \dfrac{j^4}{(a^2-b^2\cos^2\theta)}$

homologous eq. of limacons, 10b, whence it can be seen that b/a of the standard formulation, eq. 5a, is simply (1/p)/(1/ep) = e, leading to 10c. In fact the same also is true for b/a of the inverse-root-cos²θ eq., 10d, for central conics, i.e., b/a = e.

In the following, the eccentricity e is employed to identify limacons and

subspecies of other genera of QBI curves, in place of the designations employed hereto. This could be justified purely upon the basis of homologous eccentricity-dependent properties. However, as will be seen when the topic of the Inversion Taxonomy of limacons and other QBI curves is taken up, the employment of e to delineate subspecies of all genera of QBI curves is both natural and analytically justified.

The case e = 1 for both limacons and conics gives the *single-parameter subspecies*, the cardioid and parabola, some of the homologies of which already have been noted. To the one or two arms of conics there correspond the one or two communicating loops of limacons; in both cases there are two of these for e > 1 but only one for e ≤ 1. The reciprocal inversions, the equilateral hyperbola and equilateral limacon, for which $e = 2^{\frac{1}{2}}$, also are single-parameter subspecies; they have special symmetry properties, of which those for the limacon are treated below. Both of these curves invert to the equilateral leminiscate about one of their axial foci.

As e approaches 0 in conics, the two traditional foci move toward the center of the ellipse. In the limit they are at the center and a circle results. As e approaches 0 in elliptical limacons the oval becomes more and more nearly circular, and the $-\frac{1}{2}b$ focus migrates toward the axial center, always maintaining a position midway between the center pole and the axial center. As e increases for hyperbolas, the two foci recede to infinity and the arms become more and more nearly linear. In hyperbolic limacons, as e increases, the $-\frac{1}{2}b$ focus moves toward the axial center of the large loop; the smaller loop enlarges relative to the large one, and both loops become more and more nearly circular. The $-\frac{1}{2}b$ focus always is midway between the axial centers of the two loops, which are a units apart.

The limacon for which e = 2 is a most extraordinary curve, for which no homologies are known in the properties of the corresponding hyperbola. Not only does the e = 2 limacon have remarkable circumpolar symmetry properties (based on the coincidence of the $-\frac{1}{2}b$ and a-b foci), it is the *curve of demarcation* between two types of *true exchange-limacons* (which are not QBI curves). It also is a subspecies of the QBI *pseudo-exchange-limacons*, which are the quartics obtained by inverting the axial vertex cubics of central conics about a pole at x = 2b/3, and the central conics about a pole at x = 2a.

Circumpolar Symmetry of Limacons

Simple Intercept Equations and Formats

A Point In the Plane

The analysis of the circumpolar symmetry of limacons is begun by casting a simple mixed-transcendental intercept eq. (x+h and y+k translations) about a point in the plane, 11a,b. Eq. 11b is obtained by squaring the left member of 11a and grouping terms. The constant terms of 11b give the first (and weakest) focal condition, for they make up the eq. of the basis limacon in h and k; if these terms vanish, i.e., if the point (h,k) lies on the curve, an x will factor from the eq. and the intercept transforms will reduce.

<div align="center">

simple mixed-transcendental intercept equations
about a point in the plane

</div>

(a) $[x(b+2h)\cos\theta+2kx\sin\theta+x^2+(h^2+bh+k^2)]^2 = a^2(x^2+2hx\cos\theta+2kx\sin\theta+h^2+k^2)$ (10-11)

(b) $x^2[(b+2h)^2-4k^2]\cos^2\theta + 2x[(b+2h)(x^2+h^2+bh+k^2)-a^2h]\cos\theta +$

$\qquad 4kx(x^2+h^2+bh+k^2-a^2/2)\sin\theta + 4kx^2(b+2h)\sin\theta\cos\theta +$

$\qquad 2x^2(h^2+bh+k^2) + x^2(x^2+4k^2-a^2) + (h^2+bh+k^2)^2 - a^2(h^2+k^2) = 0$

(c) $\cos\theta = \dfrac{(a-x)}{b}$ limacon parameters (c') $\cos\theta = \dfrac{\mp b^2x \pm aj^2}{j^2(a^2\pm b^2)^{\frac{1}{2}}}$ central conic parameters

A second focal condition is h = -½b, for a point on a k-axis at the level of the -½b focus. For this condition, the eq. simplifies and the cross-product term in sinθcosθ vanishes. This condition, which defines the *non-axial covert linear focal locus* (see below) greatly simplifies the subsequent analytical operations and leads to reduction of the degree of the transforms (see Chapters XII and XIV). A third focal condition is k = 0, for a point on the x-axis. For this condition the eq. simplifies and both the sinθ and the sinθcosθ terms vanish, with further reduction in the degree of the transforms. A fourth focal condition, h = k = 0, is the condition for the highest-ranking focus--the DP or DP homologue (also the polar center)--for which the eq. reduces

directly to the simple intercept format 11c; the latter, of course, also is the eq. of the curve with r replaced by x.

Explicit transforms about a point in the plane have not been obtained but the elimination procedure for the transforms has been carried through to the final stages. The 0° and 180° transforms are found to be of 56th degree, and the 90° transforms of 72nd degree; these compare to 8th degree and 20th degree for conics. The derivations are outlined in Chapter XIV (see also Table XII-2).

The Line of Symmetry

Since all point foci lie either on the curve or the line of symmetry, I proceed directly to an analysis of a point on the latter locus. The simple intercept eq. for such a point is 12a, and the corresponding simple intercept

simple intercept equation for a point on the line of symmetry

(a) $x^2(b+2h)^2\cos^2\theta + 2x[x^2(b+2h)+h(2h^2+3bh+b^2-a^2)]\cos\theta +$ (10-12)

$$x^4 + [2h(b+h)-a^2]x^2 + h^2[(b+h)^2-a^2] = 0$$

(b) $\cos\theta = \dfrac{a^2h-(b+2h)(x^2+h^2+bh)\pm a[b(b+2h)x^2+h^2(a^2-2bh-b^2)]^{\frac{1}{2}}}{x(b+2h)^2}$ simple intercept format for 12a

(c) $h^2[(h+b)^2-a^2] = 0$ constant-condition

(d) $2h^2+3bh+b^2-a^2 = 0$ parenthetical portion of $\cos\theta$-constant condition

format is 12b. The resulting 0° and 180° intercept transforms are of 10th degree, while the 90° transform is of 24th degree.

If the bracketed portion of the constant term, 12c, is equal to 0, an x will factor, which is the condition for the vertices, $h = -(a+b)$ and $(a-b)$. But if $h = 0$, the focal condition for the DP or DP homologue, an x^2 will factor, because the constant part of the coefficient of the $\cos\theta$ term also vanishes. But the parenthetical portion, 12d, of the $\cos\theta$-constant condition, alone, is not focal, because an x^2 will not factor unless the constant term also vanishes.

The $\cos^2\theta$-condition is $h = -\frac{1}{2}b$, for which the $\cos^2\theta$ term vanishes (and the eq. simplifies)--a situation conferring high focal rank. These conditions on the simple intercept eq. account for 4 of the axial foci. The 5th focus is the variable, penetrating focus of self-inversion at $h = (a^2-b^2)/2b$, for which condition the $(a^2-2hb-b^2)$ term of the radicand vanishes and the remainder of the radicand becomes a perfect square, eliminating the need for squarings to clear of radicals in the variables in the subsequent derivation of transforms.

In deriving the $0°$ and $180°$ transforms, reduction of the eqs. from 12th to 10th degree occurs by the factoring out of a term in $(x\mp y)^2$. But an additional xy will factor out, with reduction to a maximum of 8th degree, if the 6th degree determinant eq. 13a--an *intercept transform condition*--is satisfied. After factoring out the two roots, $h^2 = 0$, for the DP or its homologue, and expand-

(a) $h^2[a^2-(b+2h)(h+b)]^2 = a^2h^2(a^2-2bh-b^2)$ reduction condition on axial intercept transform (10-13)

(b) $4h^4+12bh^3+h^2(3b^2-4a^2)+2bh(3b^2-2a^2)+b^2(a^2-b^2) = 0$ 13a after factoring out h^2 and expanding

(c) $[h-(a+b)][h+(a+b)](h+b/2)^2 = 0$ 13b factored

ing, 13b is obtained. This factors to the degenerate eq. 13c, giving the 4 additional roots, $h = -\frac{1}{2}b$ (twice) and $h = -(a+b)$ and $(a-b)$, which are the locations of 3 other axial foci. Of course, the condition for factoring out a term in xy does not necessarily lead to the specification of all axial point foci, because reduction also can occur by other routes, such as through factoring out other terms, cancellations, or root-taking.

Poles of Conditional Focal Rank

The above employment of eqs. 13 is from the point of view of *ordinary* or *intrinsic foci*, i.e., poles having focal rank for all parameter values of the genus. But these eqs. also can be employed for a different purpose if one takes a different point of view. Since the $0°$ and $180°$ transforms reduce for *all* values of a, b, and h that satisfy eqs. 13 (i.e., not merely for values of h alone), these eqs. can be employed to detect poles of *conditional focal rank;* i.e., to detect poles that attain focal rank only in certain subspecies.

The principal candidates for poles of conditional focal rank are axial poles that otherwise have only subfocal status, such as poles conjugate to the foci, i.e., the reflections of the foci in the DP or DP homologue, $h = 0$. Thus, the conjugate pole to the $-\frac{1}{2}b$ focus attains focal rank in the elliptical subspecies, $e = 2/3$, in which it coincides with the $(a-b)$ vertex. The pole conjugate to the center of the tangent-pedal basis circle attains focal rank in the elliptical subspecies $e = \frac{1}{2}$, in which it coincides with the $(a-b)$ vertex; the center of the basis circle itself (at $-b$) never attains focal rank.

The pole conjugate to the $(a-b)$ focus attains focal rank in the cardioid, where it is coincident--at the cusp--with the $(a-b)$ focus itself, with the $(a^2-b^2)/2b$ focus, with the pole conjugate to the latter, and with the $h = 0$ focus (the cardioid cusp, of course, is the homologue of the DP of hyperbolic limacons). It also attains focal rank in the elliptical subspecies, $e = 2/3$, in which it is coincident with the $-\frac{1}{2}b$ focus. The pole conjugate to the $-(a+b)$ vertex focus also attains conditional focal rank, namely, in the elliptical subspecies, $e = 1/3$, in which it coincides with the $(a^2-b^2)/2b$ focus.

An extremely interesting situation arises in the case of the pole conjugate to the $(a^2-b^2)/2b$ focus. When the 0° and 180° transforms for this conjugate pole are derived, an intercept transform condition for reduction and attainment of conditional focal rank can be extracted from the eqs. This seemingly unpromising determinant eq. for reduction is 14. Since the $(b^2-a^2)/2b$ pole

$$36b^8-76b^6a^2+53b^4a^4-14b^2a^6+a^8 = 0$$

intercept transform condition for attainment of conditional (10-14) focal rank

can occupy any position on the large loop axis, for various values of the parameters a and b, the roots of eq. 14 must specify the locations of all 5 foci in those subspecies in which each of them becomes coincident with this pole (because these are the situations in which the pole attains conditional focal rank). This is found to be the case; the 8 roots of eq. 14 are $b = \pm a$, $\pm a/2^{\frac{1}{2}}$, $\pm a/2^{\frac{1}{2}}$, and $\pm a/3$ (only the positive roots are valid, since the parameters a and b are positive by definition).

The first root, $b = a$, defines the coincidence with 3 of the 5 foci--those for $h = 0$, $(a-b)$, and $(a^2-b^2)/2b$--all at the cusp of the cardioid. The double

root, $b = a/2^{\frac{1}{2}}$, defines the coincidence with the $-\frac{1}{2}b$ focus in the sub-species, $e = 1/2^{\frac{1}{2}}$, while the third root, $b = a/3$, defines the coincidence with the $-(a+b)$ vertex focus in the subspecies $e = 1/3$.

A point of considerable interest that emerges from the above analysis is that none of the poles of conditional focal rank attains focal rank in the hyperbolic species (i.e., all subspecies for which $e > 1$). The basis for this is that all the poles of conditional focal rank mentioned above, $b/2$, $b-a$, $a+b$, and $(b^2-a^2)/2b$ are external to the curve in the hyperbolic species (for which $b > a$). Since all the foci are either inside the curve or coincident with it in this species, there can be no coincidence of any of them with a pole of conditional focal rank. The same intercept transform conditions for reduction, namely eqs. 13 and 14, can be extracted from the eq. for 90° transforms about a point on the line of symmetry, for which the reduction is from 20th to 16th degree.

The Non-Axial $-\frac{1}{2}b$ Covert Linear Focal Locus

As noted above, inspection of the simple mixed-transcendental intercept eqs. 11a,b reveals that an orthogonal axis intersecting the line of symmetry at $h = -\frac{1}{2}b$ is a high-ranking linear focal locus (because for $h = -\frac{1}{2}b$ there is no $\sin\theta\cos\theta$ cross-product term in the square of the left member of eq. 11a). Such a focal locus is referred to as a *non-axial covert linear focal locus* to distinguish it from *axial covert focal loci*. The latter are characterized by the fact that, in addition to being orthogonal to a line of symmetry of the basis curve, they pass through the DP or DP homologue (including the cusp).

The simple mixed-transcendental intercept eq. for a point on the non-axial covert linear focal locus is 15a. The corresponding 0° and 180° compound

(a) $4k^2x^2\sin^2\theta - 2kx(a^2-2B^2-2x^2)\sin\theta +$

 $x^2[x^2+(2B^2-a^2)] + (B^4-a^2C^2) = -a^2bx\cos\theta$

 simple intercept eq. (10-15)
 for point on non-axial
 $-\frac{1}{2}b$ covert focal locus

(b) $4k^2xy\sin^2\theta + 4kxy(x\pm y)\sin\theta +$

 $xy(x^2\pm xy+y^2) + (2B^2-a^2)xy \mp (B^4-a^2C^2) = 0$

 compound 0° and 180°
 intercept eq. from 10a

(c) $\sin\theta = \dfrac{-(x\pm y)\pm[(a^2-2B^2)\pm xy\pm(B^4-a^2C^2)/xy]^{\frac{1}{2}}}{2k}$

 compound 0° and 180° inter-
 cept format from 10a

 $B^2 = (k^2-b^2/4)$ $C^2 = (k^2+b^2/4)$

intercept eqs. and formats are 15b,c. An x will factor out of eq. 15a if the constant term is equal to 0. This is the focal condition for the $-\frac{1}{2}b$ peripheral vertices (eqs. 8).

The eliminant of 15a and 15c is a complex transform of 20th degree, compared to 56th degree for a point in the plane, making the $-\frac{1}{2}b$ k-axis a high-ranking non-axial covert focal locus (only covert linear focal loci passing through the DP and parallel or orthogonal to lines of symmetry of the basis curve are designated as *axial*). The 0° transform for the $-\frac{1}{2}b$ peripheral vertices is complex but reduces to 12th degree. Accordingly, the $-\frac{1}{2}b$ vertices (of which there are 4 real ones for $e > 2$ and 2 real and 2 imaginary ones for $e < 2$) also are foci. The 90° transform about a point on this axis is very complex and of 72nd degree.

The Axial Covert Focal Locus At the Double Point

The simple mixed-transcendental intercept eq., 16a, for a point on an axis orthogonal to the line of symmetry at the DP or DP homologue is obtained by

simple mixed-transcendental intercept equation
for the axial covert focal locus

(a) $(4k^2-b^2)x^2\sin^2\theta + 2kx(2k^2-a^2+2x^2)\sin\theta + 2bx(x^2+k^2)\cos\theta +$ (10-16)

$$x^4 + (b^2-a^2+2k^2)x^2 + k^2(k^2-a^2) = -4bkx^2\sin\theta\cos\theta$$

0° compound intercept equation derived from 16a

(b) $2kxy(2xy-2k^2+a^2)\sin\theta+2bxy(xy-k^2)\cos\theta+x^2y^2(x+y)-k^2(k^2-a^2)(x+y) = 0$

(c) $2a(2xy-a^2)\sin\theta + 2b(xy-a^2)\cos\theta + xy(x+y) = 0$ 0° compound intercept
eq. for LR vertices

0° compound intercept format for LR vertices

(d) $\sin\theta = \dfrac{axy(a^2-2xy)(x+y)\pm b(a^2-xy)[x^2y^2(x+y)^2-4a^2(2xy-a^2)^2-4b^2(a^2-xy)^2]^{\frac{1}{2}}}{2[a^2(2xy-a^2)^2+b^2(a^2-xy)^2]}$

letting h = 0 in eq. 11a. The 0^o compound intercept eq. is 16b. Eliminating θ between 16a,b leads to a complex eliminant for which reduction below 56th degree has not been demonstrated.

On the other hand, for k = ±a, the locations of the LR vertices, the term in (x+y) vanishes from 16b, allowing an xy to be factored out, yielding 16c, the 0^o compound intercept eq. for the LR vertices. The corresponding 0^o compound intercept format for the LR vertices is 16d. The 0^o transform for the LR vertices is the eliminant of 16a (k = a) with 16d. This is a complex eq. for which focal reduction from 44th degree (the value for unexceptional points on the curve) has not yet been established.

Accordingly, the analyses of the complex (i.e., complicated and lengthy) transforms for points on the k-axis at h = 0, including the LR vertices, has failed to establish focal reduction for any locus except the DP and its homologue. Notwithstanding this failure, other points on this axis, including the LR vertices, are believed to be focal, and this is assumed as a working hypothesis in the following. The basis for regarding the k-axis at h = 0 to be a focal locus is that in non-axial inversions of conic sections, the foci of self-inversion lie on orthogonal axes passing through the reciprocal inversion pole (the DP, DP homologue, or cusp) parallel to the lines of symmetry of the basis curve (see a further treatment of this matter in Chapter XII, *Covert Focal Loci and Non-Axial Inversions of Conics*). Since no case is known of a point focus that does not lie on a linear or curvilinear focal locus, the presumption is very strong that these axes and their homologues in axial inversions are focal loci.

The LR vertices of limacons are believed to be foci because they are the only peripheral vertices of limacons that have an invariant relationship to peripheral vertices of the basis conic, namely the conic LR vertices, which are foci; they always lie at the intersection of the LR of the basis conic (i.e., the LR at the pole of inversion) with the inversion locus. For j = a (limacon parameters) they are coincident with one set of LR vertices of the basis conic.

The intercept transforms for points on a k-axis at the level of the $(a^2-b^2)/2b$ focus of self-inversion, including the vertices, are complex and there is no reason to believe that they have focal rank.

CIRCUMPOLAR MAXIM 11: *The loss of a line of symmetry in an axial QBI locus is accompanied by the gain of both an axial and a non-axial covert linear focal locus.*

The Focus At the Double Point and Double-Point Homologue

The axial foci now are considered in decreasing rank order, beginning with the highest ranking, the DP. From the point of view of a simple intercept format of the form $\cos\theta = f(x)$, the format for this focus is outranked only by formats for the circle and the line, since it is merely $\cos\theta = (a-x)/b$. The $180°$ transforms of the curve about this focus, 17b, are linear (the $0°$ transforms also are linear, as discussed in the following section). If one

(a) $(x-a)^2 + (y-a)^2 - 2(x-a)(y-a)\cos\alpha = b^2\sin^2\alpha$ \quad α-transform for DP \qquad (10-17)

(b) $x + y = 2a$ \qquad (c) $x = y$ \qquad (d) $(x-a)^2 + (y-a)^2 = b^2$

(e) $[(x+a)^2+(y+a)^2-b^2][(x-a)^2+(y-a)^2-b^2]\cdot$ \qquad algebraically complete
\qquad $90°$ transform

\quad $[(x-a)^2+(y+a)^2-b^2][(x+a)^2+(y-a)^2-b^2] = 0$

(a) $\dfrac{(x - 2^{\frac{1}{2}}a)^2}{b^2(1+\cos\alpha)} + \dfrac{y^2}{b^2(1-\cos\alpha)} = 1$ \qquad equation 17a with axes rotated $45°$ CCW \qquad (10-18)

(b) $e^2 = 2\cos\alpha/(1+\cos\alpha)$ \qquad eccentricities of 18a for 0-$90°$ and 270-$360°$

(c) $e^2 = -2\cos\alpha/(1-\cos\alpha)$ \qquad eccentricities of 18a for 90-$270°$

(a) $\overset{o}{s}{}^2 = b^2[\sin^2\alpha+\sin^2(\theta+\alpha)] = 2(b^2-a^2)+2a(x+y)-(x^2+y^2)$ \qquad ordinal rank eq. for 17a \qquad (10-19)

(b) $\overset{o}{s}{}^2 = 2b^2 - 2(a-x)^2$ \qquad $180°$ subordinal rank eq. for 17a

(c) $\overset{o}{s}{}^2 = b^2$ \qquad $90°$ subordinal rank eq. for 17a

refers to Table V-1, the transforms of the curve about this pole will be seen the have the highest standing in the linear specific symmetry class (i.e., the lowest ordinal and subordinal ranks) of any curve-pole combination for curves of finite degree. This property of limacons is well known, the customary description being that "any chord or secant through the polar center has a constant length of 2a."

The trivial $0°$ transform is given by 17c (but see below). The α-transform, 17a, is one of the simplest in existence for curves of finite degree, while the

90° transform, 17d, is one of only 4 circular transforms for known curves
(Table V-1; however, it is shown in Chapter XIV--*Circular Specific Symmetry
Class*--that one can synthesize an infinite number of genera of curves, all of
the subspecies of which possess circular transforms). The transforms are
elliptical for all other angles. This can be seen if the axes are rotated 45°
CCW to the α-transform, yielding 18a. The eccentricities of these ellipses are
given by 18b,c. The ordinal rank eq., 19a, for this pole is one of the simplest
known. For the 180° linear transform the subordinal rank is 2 (eq. 19b), while
for the 90° circular transform (19c) it is 0, i.e., $\overset{o}{s}$ is constant.

Analytical Transforms Versus Geometrical Expectations

 The circumpolar symmetry analysis of the limacon provides an appropriate
juncture to discuss the origins of disparities that sometimes exist between
algebraically derived transforms and one's expectations based upon the geometry
of the curves under analysis. Whether or not such disparities exist depends
entirely on the precise form of the basis polar eq. from which the simple or
mixed-transcendental intercept formats are derived. The present treatment of
this matter begins with a detailed consideration of a representative example,
namely that considered in the preceding section--the circumpolar symmetry of
the e = 2 limacon, expressed as r = a(1+2cosθ), about the DP.

 Considering first the geometry of the curve, it is found that 0° and 180°
transforms about the DP exist (from the geometrical point of view), but only
for certain ranges of θ (of the above eq.). In other words, for some ranges
of θ coincident-radii intercepts exist and for some other ranges of θ chord-
segment intercepts exist. For example, at θ = 90°, a secant passing through
the DP intersects the curve at the LR vertices, both of which are at a distance
a from the DP. Both of these intercepts are positive and satisfy the 180°
transform x+y = 2a. The same transform relation holds as θ progresses from
90° to 120°, during the course of which one segment of the secant (which is
labelled as the x intercept) increases monotonically in length, while the other
decreases. At 120°, the x intercept has attained the length 2a and the y inter-
cept has vanished.

 As θ progresses from 120° to 240°, no geometrical 180° transform exists,
because a y radius vector extending from the DP in a direction opposed to

that of the x radius vector does not intersect the curve (except at the DP itself, i.e., for a length y = 0). However, a geometrical 0° transform does exist in this range, because a radius vector extending from the DP at any angle in the range of $\theta = 120^{\circ}$ to 240° intersects the curve at two points.

Considering now the algebraic analysis, it is found that for $r = a(1-2\cos\theta)$ there is a one-to-one correspondence between values of r and values of θ, and the curve is traced once as θ progresses from 0° to 360°. As θ progresses from 0° to 60°, r is negative and progresses from a value of -a to 0, thereby tracing the lower half of the small loop from its (a-b) vertex to the DP. For θ progressing from 60° to 180° the values of r are positive, ranging from 0 to 3a, tracing the upper half of the large loop from the DP to the -(a+b) vertex. The lower half of the large loop is traced for θ progressing from 180° to 300°, and the upper half of the small loop from 300° to 360°.

The reason why no algebraic non-trivial 0° transform of $r = a(1-2\cos\theta)$ exists about the DP, despite the fact that coincident-radii intercepts exist about this pole as θ ranges from 120° to 240°, is that the starting eq. yields only one value of r for each value of θ. In order for a 0° transform to exist, the algebraic representation of the curve must yield at least two values of r for each value of θ. Accordingly, no simple intercept format for a pole of a curve will yield a non-trivial 0° intercept transform in any range of θ in which two or more values of r do not exist. But this is true only for the 0° transforms. A transform exists for all other angles, α, between 0° and 360° regardless of how many values of r correspond to a given value of θ.

For the 180° transform, for example, as θ progresses from 90° to 120° the intercepts are both positive and sum to 2a. From 120° to 180° to 240° the two positively-directed chord-segment intercepts are replaced by one positively-directed and one negatively-directed chord-segment intercept. The algebraic procedure gives a 180° transform for this combination, namely, the same eq., x+y = 2a, as for 90° to 120°. The difference between the properties of the intercepts in the two ranges is that between 90° and 120° neither intercept exceeds a length of 2a, whereas from 120° to 180° to 240° one of the intercepts ranges from 2a at 120° to 3a at 180° and back to 2a at 240°, while the other ranges from 0 to -a (as r progresses from 300° to 360°) and -a to 0 (as r progresses from 0° to 60°). Accordingly, they sum to 2a for both ranges because in the latter case (120° to 240°) one of the 180° intercepts always is negative (or 0) and the sum of the long intercept, of length

2a+z and the companion intercept of length -z is 2a for all θ in the range.

In Chapter VII (*Negative Intercepts, Trivial Transforms, the Degree of Transforms, and the Duality of 0° and 180° Transforms*) it was demonstrated that, except for the signs of some terms, algebraically complete 0° and 180° transform eqs. are identical. It now is seen that a given intercept format does not yield algebraically complete transform eqs. for a given angle unless the format represents all of the geometrically valid intercepts—positive, negative, trivial, and non-trivial—that exist for radii subtending that angle. This is true for all angles, α, not merely for α = 0.

For example, the eq., $r = a(1-2\cos\theta)$, yields a 90° transform, 17d (with b = 2a), representing a circle of radius 2a, centered in the 1st quadrant at (a,a). One does not obtain the algebraically complete transform eq. because the intercept format, $\cos\theta = (a-x)/2a$, represents only one of the two intercepts for each of the two orthogonal radius vectors. On the other hand, if the simple intercept format, $\cos\theta = (\pm a-x)/2a$ (derived from the corresponding rectangular eq. of limacons) is employed, one obtains the algebraically complete degenerate 90° transform eq., 17e, consisting of 4 circles of radius 2a, one centered in each quadrant at the points (a,a), (a,-a), (-a,a), (-a,-a).

It remains to consider the question of why some formats represent all intercepts and lead to algebraically complete transform eqs. for all angles of transformation and others do not. In this connection, one finds that when the polar eq. of a basis curve is derived from its rectangular eq. (free of radicals in the variables), the simple intercept format frequently not only represents all existing positive and negative intercepts at all angles, but the entire locus is traced in a progression of θ from 0° to 180° (or from ω to ω+180°).

The basis for the above finding is that a negative root frequently is introduced in the conversion of rectangular to polar eqs., and this negative root leads to a second value of r that is 180° out of phase with the value for the positive root. For example, when the limacon eq., $r = a-b\cos\theta$, is converted to rectangular coordinates, one squaring is necessary to yield the eq., $(x^2+y^2+bx)^2 = a^2(x^2+y^2)$, free of radicals in the variables. In the inverse conversion one obtains the eq. $(r+b\cos\theta)^2 = a^2$. Taking roots leads to the degenerate eq., $(r+a+b\cos\theta)(r-a+b\cos\theta) = 0$ (or $r = \pm a-b\cos\theta$).

Both factors of the degenerate eq. equated to 0 separately represent the identical basis limacon, but the tracing of the curve following one of the resulting eqs. is $180°$ out of phase with the tracing following the other eq. From a purely informational point of view, the degenerate eq. is redundant, but from the point of view of a circumpolar symmetry analysis, it yields results that are in closest accord with the geometry of the curve.

As a result of the circumstances described above, a routine algebraic circumpolar symmetry analysis does not always give a complete picture of the circumpolar symmetry of a curve, i.e., a picture completely in harmony with its geometry. To ensure that the analysis is complete, the results either must be checked by direct appeal to geometry, or it must be confirmed that the $0°$ and $180°$ algebraically complete transform eqs. are identical except for signs. Since it always is desirable to verify results geometrically, the first method is preferred.

The Focus At $(a^2-b^2)/2b$

This variable, penetrating focus of self-inversion is outside the loop of the elliptical species ($e < 1$), coincident with the cusp ($h = 0$) and the $(a-b)$ vertex in the parabolic species ($e = 1$), and within the small loop in the hyperbolic species ($e > 1$). For large e it approaches coincidence with the $-\frac{1}{2}b$ focus. For $e = 1/2^{\frac{1}{2}}$ it is coincident with the pole conjugate to the $-\frac{1}{2}b$ focus, while for $e = 1/(1+2^{\frac{1}{2}})$ it lies at $x = a$.

The simple intercept format, 20a, yields the $0°$ transform of self-inversion, 20b, wherein the product of the intercepts is equal to the square of the distance between the focus and the DP or DP homologue. Accordingly, the locus

(a) $\quad \cos\theta = \dfrac{4b^2x(b-x)-(a^2-b^2)^2}{4a^2bx}$ \qquad simple intercept format \qquad (10-20)

(b) $\quad xy = \dfrac{(a^2-b^2)^2}{4b^2}$ $\qquad\qquad$ $0°$ intercept transform

(c) $\quad xy(2b-x-y) = (x+y)(a^2-b^2)^2/4b^2$ \qquad $180°$ intercept transform

(d) $\quad 16b^4x^2y^2(x^2+y^2) + 16b^4(3b^2-2a^2)x^2y^2 +$ \qquad $90°$ intercept transform

$\qquad (a^2-b^2)^4(x^2+y^2) = 8b^3xy(x+y)[(a^2-b^2)^2+4b^2xy]$

for the cardioid, in which the foci concerned are in coincidence, is $xy = 0$.
In the $e = 2$ limacon the distance is $3a/4$, while in the equilateral
limacon it is $a/2^{\frac{1}{2}}$.

The 180° transform is unusual in being one of the few known 3rd-degree
transforms. For most values of b, this eq. represents a "3-sided oval"
which becomes more and more nearly circular as: (1) b increases relative to
a; and (2) the location of the focus becomes more central. For some locations
of the focus, i.e., for some values of b (for example, $b = 1\frac{1}{2}a$), the trans-
form does not consist of the entire oval but only of an arc of it that is
traced recurrently. For other locations, no non-trivial 180° transform exists.

The 90° transform, 20d, is a 6th degree eq. that represents either one oval
or two crossed ovals, depending upon whether the focus is outside the basis
curve (in the elliptical species) or within the small loop (in the hyperbolic
species). When the focus is outside the basis curve, the single oval becomes
progressively more circular as the focus approaches the (a-b) vertex. At the
vertex, the transform is a circle, since the basis curve becomes the cardioid,
in which the $(a^2-b^2)/2b$ focus coincides with the cusp.

When the focus is within the limacon small loop, the transform ovals are
highly disparate in shape and are non-concentric and crossed (4 points of
intersection). One oval tends to be somewhat pear-shaped, with curvature in
the neighborhood of one vertex increased. This is referred to in the following
as "distortion in the a-vertex region." The other has complementary distortion,
in which one side is greatly flattened, giving it something of the shape of a
boomerang but with both sides convex. This type of distortion is referred to
in the following as "distortion in the b-vertex region." As b increases
relative to a, the ovals become more nearly congruent, more nearly elliptical,
more nearly concentric, and they approach more nearly to having a second line
of symmetry. The closer this focus comes to coincidence with the $-\frac{1}{2}b$ focus, the
more nearly the ovals approximate to the *near-ellipses* that are discussed below.

The Focus At $-\frac{1}{2}b$

This variable, penetrating focus is the most extraordinary focus known to me.
Although its remarkable properties are discussed in some detail below, the
completion of the description has to await the treatment of Chapter XII.

With regard to the basis limacon, eccentricities greater and less than 2
are the values at which the $-\frac{1}{2}b$ focus makes the transition from a location
within to one external to the small loop. For e = 2 it is coincident with
the (a-b) focus at the vertex of the small loop, just one of the several
respects in which the e = 2 subspecies is exceptional.

The simple intercept format, 21a, like the formats of the two foci just
considered, contains no radical. Although this format is otherwise unexception-
al in appearance, its transforms are quite remarkable and of compelling
interest. The 0° and 180° transforms are 21b, the 90° transform is 21c, and
the special cases of these transforms for the e = 2 limacon are 21b',c',c".

(a) $\cos\theta = \dfrac{a^2(x^2+b^2/4) - (x^2-b^2/4)^2}{a^2bx}$ simple intercept format (10-21)

(b) $(a^2+b^2/2)xy \pm (b^2/4-a^2)b^2/4 = (x^2\pm xy+y^2)xy$ 0° and 180° transforms of 21a

(b') $x^2\pm xy+y^2 = 3a^2$ equation 21b for e = 2

(c) $x^2y^2[(x^6+y^6)-2c^2(x^4+y^4)+(c^4-2b^2d^2)(x^2+y^2)+b^2(4c^2d^2-a^4)]$ 90° transform of 21a

$$+ b^4d^4(x^2+y^2) = 0$$

$c^2 = (2a^2+b^2)/2, \ d^2 = (4a^2-b^2)/16$

(c') $(x^6+y^6) - 6a^2(x^4+y^4) + 9a^4(x^2+y^2) = 4a^6$ equation 21c for e = 2

(c") $(x^2+y^2-4a^2)(x^2+y^2+3^{\frac{1}{2}}xy-a^2)(x^2+y^2-3^{\frac{1}{2}}xy-a^2) = 0$ equation 21c', factored

(a) $3x^2 + y^2 = 6a^2$, 0° (b) $x^2 + 3y^2 = 6a^2$, 180° 21b' for axes
rotated 45° CCW (10-22)

The 0° transform 21b (upper signs) is of 4th degree and consists of re-
current-arc segments of ellipse-like curves (the *near-lines*). For e = 2
(b = 2a), however, the constant term of 21b vanishes, allowing an xy to be
factored out, with consequent reduction to the 2nd-degree eq., 21b', of a
centered ellipse (i.e., it is centered at the polar center, h = 0, of the
basis limacon) of eccentricity $e^2 = 2/3$.

The 180° transform 21b (lower signs) also is of 4th degree and also consists
of recurrent-arc segments of ellipse-like curves (the *near-circles*). Its eq.
differs from that of the 0° transform only in the values of two signs. For

e = 2, an xy term also can be factored out of it, giving another centered ellipse, 21b', with the same eccentricity as that of the 0^{o} transform, and also congruent, concentric, and orthogonal to the latter. A 45^{o} CCW rotation of the coordinate axes displays these ellipses in the more familiar form, 22a,b, for 0^{o} and 180^{o}, respectively.

The 90^{o} transform 21c,c',c" is that of the remarkable concentric, crossed *near-ellipses*. It is of 10th degree in the general case and of somewhat unusual form. It represents two complete, non-recurrent, concentric, orthogonal ellipse-like figures in each quadrant. For e = 2, the constant term vanishes, yielding 21c', which is found to be degenerate, falling into 3 factors, 21c". The latter are the eqs. of a circle of radius 2a, concentric with two congruent, orthogonal ellipses of eccentricity $e = 3^{\frac{1}{2}}/(1+3^{\frac{1}{2}}/2) = 0.9282$. When the axes are rotated CCW 45^{o}, the eqs. of the ellipses become 23a,b.

$$\text{(a)} \quad x^2(1+3^{\frac{1}{2}}/2)+y^2(1-3^{\frac{1}{2}}/2) = a^2 \qquad \text{(b)} \quad x^2(1-3^{\frac{1}{2}}/2)+y^2(1+3^{\frac{1}{2}}/2) = a^2 \qquad (10\text{-}23)$$

The Near-Conics

Near-Lines and Near-Circles

As noted above, the *near-line* 0^{o} transforms and *near-circle* 180^{o} transforms of the $-\frac{1}{2}b$ limacon focus consist of 4th-degree eqs. which take the form 24a,b after a 45^{o} CCW rotation of the coordinate axes. When expressed in

$$\text{(a)} \quad (x^2-y^2)(3x^2+y^2-2a^2-b^2) = (b^2/4-a^2)b^2/2 \qquad \begin{array}{l} 0^{\text{o}} \text{ near-line} \\ \text{transforms} \end{array} \qquad (10\text{-}24)$$

$$\text{(b)} \quad (x^2-y^2)(x^2+3y^2-2a^2-b^2) = (a^2-b^2/4)b^2/2 \qquad \begin{array}{l} 180^{\text{o}} \text{ near-circle} \\ \text{transforms} \end{array}$$

this form it can be seen that for b = 2a, the e = 2 subspecies, the terms on the right are equal to 0 and the eqs. are degenerate and fall into two factors. Equating the (x^2-y^2) terms to 0 gives the trivial 0^{o} and 180^{o} transforms $x = \pm y$, whereas equating the other terms to 0 gives the ellipses. The latter, of course, are congruent, concentric, and orthogonal, and have an area of $2\cdot3^{\frac{1}{2}}\pi a^2$. Since the curves represented by both eqs.

undergo parallel changes as the eccentricity is increased and decreased, it is convenient to treat them together.

For values of e greater or less than 2, each ensemble, consisting of an ellipse crossed by orthogonal centered lines, falls apart into 4 separate curves consisting of segments carved out of the original ensemble. Moreover, the manner in which this occurs for one transform is complementary to the manner in which it occurs for the other, for each direction of departure of e from the value 2. Additionally, the manner in which it occurs for each transform is self-complementary on each side of the value, e = 2.

Description of these processes is facilitated if one considers the full 4-quadrant transform relative to axes that have been rotated 45° CCW. Needless to say, the actual transform consists, at most, only of the portion of this full representation that lies between the lines, x = y and x = -y, in the 1st and 4th quadrants (because of rotation of the axes). In some cases it consists only of some recurrently traced arcs of the portion in question. However, these extraordinary curves have a compelling interest in their own right, quite aside from the fact that they characterize the 0° and 180° symmetry of limacons about the $-\frac{1}{2}b$ focus.

0° Transforms

Taking the 0° transform as the initial example, as e decreases from the value 2, two pie-shaped segments (triangular with one side curved convexly) separate from the ensemble. These consist of the 45° lines from the center (origin) to their points of intersection with the ellipse in the 1st and 4th quadrants, on the one hand, and the 2nd and 3rd quadrants, on the other. The other two segments consist of the remaining portions of the lines and ellipses in the 1st and 2nd quadrants and in the 3rd and 4th quadrants. The latter resemble mirror-image profiles of a deep volcanic crater with its full rims and sides.

On the other hand, as e increases from the value 2, the separation of segments from the ensemble occurs in a complementary fashion. The pie-shaped segments now come from the 1st and 2nd and from the 3rd and 4th quadrants, while the volcanic crater-shaped segments--now those of a very shallow crater-- come from the 1st and 4th and from the 2nd and 3rd quadrants.

Since the most remarkable properties of these curves consist in the changes in the pie-shaped segments of the 180° transforms, and of the volcanic crater-shaped segments of the 0° transforms, as e increases beyond 2 without limit, the description concentrates on the changes in these segments. In fact, though, it applies to the changes in the entire ensemble, because with increasing e, the changes in the pie-shaped segments and crater-shaped segments of both transforms are similar (the curves themselves would be congruent--merely 90° out of phase--but for the change in the sign of the constant term).

At the juncture where e has attained the value $2\frac{1}{2}$, for the 0° transforms, the crater region of the volcanic-crater profile has become so nearly flat that scarcely any crater is left. This, in fact, is the *near-line* region that comprises the 0° transform. The curves now could be described better as resembling the profile of a flat-topped mountain or an arm of a hyperbola with the vertex region almost flat. The latter comparison is most appropriate, because the lateral arms of the "hyperbola" are very close to being linear, even at this stage. This segment of the curve is referred to hereafter as the *hyperbola segment.*

The "vertex" of the hyperbola segment actually is an extremal point (a minimum) for the transform. To illustrate the extent of the flattening in the neighborhood of the vertex, the values of the slope from the vertex point to one extreme of the (unrotated) transform are given below for e = 20. In other

Slopes at points on near-line for e = 20

x	y	$-dy/dx$
10.0	10.0000000	1.0000000
9.9	10.0999751	0.9999509
9.7	10.2999794	0.9998766
9.5	10.4999529	0.9998743
9.3	10.6999370	0.9999925
9.0	11.0000000	1.0005039

words, one half of the total arc of the transform is represented (the total arc is retraced each 180° of rotation). The deviation from linearity in this region averages only one part in 7,500 and decreases to 0 with increasing values of e. The deviations from linearity of the far regions of the lateral

arms is even much smaller, but this is not impressive because these regions
are not part of the transform, the approximation to linearity is not accomplished
by "expansion" of the region of an extremal, and it is merely due to the influ-
ence of the (x^2-y^2) term.

180° Transforms

While the hyperbola segment of the $0°$ transform is undergoing these remarkable
changes, even more remarkable modifications are taking place in the pie-shaped
segments of the $180°$ transforms. These are becoming *near-circles*. At e = 20,
these already appear circular to the naked eye. One useful index of their
circularity is the axial ratio. In the true ellipse of the e = 2 limacon, the
ratio is 1.7321, but for e = 2¼ it has dropped to only 1.0889. At e = 8
it has decreased to 1.008, and at e = 20 to 1.0006. However, as could be
concluded from an analysis of eq. 21b, the figure is not circular in the limit,
even though the axial ratio in the limit is 1 (for e = 1,000, the ratio is
1.000006, for e = 100,000 it is 1.00000004). If, instead, one uses as an index
the maximum deviation of *any* radius from the axial radius, the deviation is
1.7%, even for e = 100,000. Not only do the ovals never attain true circu-
larity, they apparently never acquire a second line of symmetry.

Near-Ellipses

The 90° transforms are the most remarkable of the group. Like the $0°$ and $180°$
transforms, they are true conic sections for the e = 2 limacon, namely two
congruent, concentric, orthogonal ellipses of area $2\pi a^2$ each, and a concentric
circle of twice that area, $4\pi a^2$. These curves are centered at the origin
(the –½b pole). None of the segments of this transform is recurrent. The full
transform, i.e., the portions of the centered figure lying in the 1st quadrant,
is made up of segments contributed by the intercepts of both loops of the basis
curve taken in different combinations.

For example, the outer part of the portion of the ellipse with its major axis
at 45° in the 1st quadrant, the *45° major-axis ellipse*, together with the
segment of the circle that cuts through it, are contributions of the positive
intercepts for the large loop of the basis curve. The remainder of this ellipse
in the 1st quadrant has two origins. One side has its y value contributed by
intercepts of the large loop and its x value contributed by intercepts of the
small loop, as θ progresses from 270 to 360°; for the other side, large loop

intercepts contribute the x value and small loop intercepts the y value, as θ undergoes the same changes, etc.

Changes In the 90° Transforms About the −½b Focus With Increasing Eccentricity

In elliptical limacons with eccentricities up to about ¼, the 90° transforms resemble those for the interior of a circle out to about ¼ of its radius (but those for the circle are of 6th degree compared to 10th degree for those of the limacon), i.e., they are somewhat 3-sided ovals. As the eccentricity increases, however, two of the "corners" become more angular and the "side" between becomes more and more concave (the forerunner of a segment of the $4\pi a^2$ circle). At e = 1 these corners become cusps and the figure somewhat resembles a very broad boomerang.

For e > 1, as the domain of the hyperbolic species is entered, the presence of the small loop of the basis curve is reflected in the conversion of the transform cusps to double points with satellite loops. These loops enlarge progressively, as the −½b focus approaches the vertex of the small loop. At this stage, the transform is composed of segments having their origin in LL (large-large), LS (large-small), and SL (small-large) intercept contributions from the two basis curve loops. There is no SS (small-small) contribution, because the internalized loop is too small to subtend an angle of 90°. However, eventually a segment having its origin in SS intercepts is added to the figure. This ultimately will contribute to the second true ellipse of the transform of the e = 2 limacon--the ellipse with its minor axis at 45° (the *45° minor-axis ellipse*).

As the eccentricity increases beyond 2, the small loop of the basis curve enlarges and the −½b focus enters it. Now, instead of the transform consisting of two congruent, concentric, orthogonal ellipses and a circle, it becomes 4 pairs of concentric, crossed *near-ellipses*, one such pair in each quadrant. This is an increase from 3 true conics to 8 near-conics, which is accomplished as follows. Once the focus has entered the small loop, SS intercepts contribute for the full 360° sweep of the radii, rather than just for 90°. Additionally, the 4 previous ¼-circle segments that in combination made up the $4\pi a^2$ circle, now each provide half of the 4 *45° minor-axis near-ellipses*. These additional contributions complete the ensemble of 4 pairs of crossed near-ellipses.

At the stage e = 2¼, when the focus is just a/8 units within the loop,
the crossed near-ellipses each have one line of symmetry, but are far from
having a second one. In fact, the portions of the *45° major-axis near-ellipse*
made up of the SS contributions--which is nearest the origin--is of quite
different shape from the portion made up of the LL segments. A rough assessment
of the deviation of these near-ellipses from true ellipses can be obtained
using the criterion of the ratio of the lengths of the chords between the
points of intersection of the figures (45° major-axis, near-ellipse chord/
45° minor-axis, near-ellipse chord). Inspection of the table below reveals

Deviations of near-ellipses from a chord ratio of 1

limacon e	45° major-axis near-ellipse axial lengths		e	chord lengths	chord ratio
	a	b			
2	2.7321	0.7320	0.9634	2.5000/2.5000	1.0000*
2¼	1.3428	0.6173	0.8881	1.0295/1.0906	0.9440
2½	1.3316	0.5877	0.8973	1.0250/1.0612	0.9659
8	1.3081	0.5449	0.9091	1.0034/1.0040	0.9994
20	1.3068	0.5418	0.9100	1.0006/1.006	0.9999

*a true ellipse

that the asymmetry of the figures quickly disappears as the size of the small
loop increases. Unlike the case with the near-circles, for e = 20, the plotted
near-ellipses show perfect coincidence with a plotted true ellipse having the
same values of a and b. The calculated deviation from a true ellipse (point-
by-point mean deviation from the mean) is less than 0.15% (1 part in 667).
Moreover, it would appear that this deviation, as with the deviation for
near-lines, decreases without limit with increasing eccentricity.

90° Transforms About Non-Focal Poles

The question now is asked: what is the nature of transforms about non-focal
axial poles? The object is to assess the role that the location of the pole
plays in relation to the generation of near-conic transforms. Consider first
a transform about the (a-b) vertex of the e = 1½ subspecies. Although this
is a vertex focus, it is desirable to compare the transforms about it with the

true conic transforms obtained at the same location when e = 2. In the
e = 1½ subspecies, the -½b focus is at -3a/4, which is a/4 units outside
the small loop. The $(a^2-b^2)/2b$ focus is inside the small loop at -5a/12, just
a/12 units from the vertex in question, which is at -½a.

Although all the elements of the transforms about the (a-b) vertex in the
e = 1½ subspecies are homologues of those for the e = 2 subspecies, the
corresponding transforms differ markedly. In place of the orthogonal ellipses
of the 90° transform are crossed curves somewhat resembling electric fan blades,
while the circle is replaced by a square-like figure with rounded corners and
concave sides. The true elliptical segment of the e = 2 180° transform--the
segment that gives rise to a near-circle at greater eccentricities--is replaced
by a much flattened recurrent arc. The true elliptical segment of the 0° trans-
form--the segment that gives rise to a near-line at greater eccentricities--
is replaced by a much-curved recurrent arc.

The above vertex pole was a/4 units from the -½b focus. A non-focal pole
now is taken at x = -1.125 in the e = 2½ subspecies. This pole is only a/8
units from the -½b focus but 3.375a/8 units from the $(a^2-b^2)/2b$ focus. For
this pole, the 90° transform consists of crossed ovals that are not unlike
ellipses, except that both ovals are markedly asymmetrical about the axes
orthogonal to the lines of symmetry. The 45° major-axis curve is distorted in
the a-vertex region, while the 45° minor-axis curve is distorted in the b-
vertex region. The 0° and 180° transforms are not unlike their near-line and
near-circle homologues.

Lastly, a pole is taken at the center of the small loop of the e = 2 sub-
species. This location is ½a units from the -½b focus, and ¼a units from
the $(a^2-b^2)/2b$ focus, and to the right of both. In this case the curve is of
24th degree (as compared to 10th for the 90° transform about the -½b focus)
and much more complex than two intersecting ovals, possessing no less than 4
triple points and 3 double points. The near-line and near-circle homologues in
no way resemble near-lines or near-circles.

In summary, transforms of limacons about axial poles that are not coincident
with either of its two penetrating, variable foci tend, as expected, to resemble
most those characteristics of the transforms of the focus to which they are
closest. The more distant the pole from an axial focus, the more complex the

transforms tend to become. Transforms that resemble near-conics only appear when the pole is relatively near to the $-\frac{1}{2}b$ focus, and they become more and more like near-conics the closer the approximation to this focus.

Cartesian Near-Conics

A very close homologue of the $-\frac{1}{2}b$ focus of limacons occurs in bipolar parabolic and linear Cartesians and in polar-circular linear Cartesians. The rectangular eqs. of these curves are 25a,b,c, respectively, and the bipolar and polar-circular eqs.,25a',b',c'. The simple intercept formats for the foci

(a) $(x^2+y^2-2dx+d^2)^2 = C^2d^2(x^2+y^2)$ 　　　　　(a') $u^2 = Cdv$ 　　(10-25)

(b) $[(x^2+y^2)(A^2-B^2)-2A^2dx+d^2(A^2-C^2)]^2 = 4B^2C^2d^2(x^2+y^2)$ 　　(b') $Bu+Av = Cd$

(c) $[(x^2+y^2)(1-C^2)+2C^2dx+R^2-C^2d^2]^2 = 4R^2(x^2+y^2)$ 　　　　(c') $u = Cv$

(a) $\cos\theta = \dfrac{x^4 - C^2d^2(d^2+x^2)}{2C^2d^3x}$ 　　simple intercept format, bipolar parabolic Cartesians 　　(10-26)

simple intercept format, bipolar linear Cartesians

(b) $\cos\theta = \dfrac{4B^2C^2d^2[(B^2-A^2)^2x^2+A^4d^2] - [d^2(A^2B^2+A^2C^2-B^2C^2) - x^2(B^2-A^2)^2]^2}{8A^2B^2C^2d^3x(B^2-A^2)}$

(a) $xy(x^2\pm xy+y^2) = C^2d^2xy \mp C^2d^4$ 　　0° and 180° transforms bipolar parabolic Cartesians 　　(10-27)

0° and 180° transforms, bipolar linear Cartesians

(b) $(B^2-A^2)^4xy(x^2\pm x-+y^2) = 2d^2(B^2-A^2)^2(A^2B^2+A^2C^2+B^2C^2)xy \pm$

$$d^4[(A^2B^2+A^2C^2-B^2C^2)^2 -4A^4B^2C^2]$$

in question for the bipolar groups are 26a,b. In the bipolar parabolic Cartesian, the homologue of the $-\frac{1}{2}b$ focus is at $x = d$, in the bipolar linear Cartesian at $x = A^2d/(A^2-B^2)$, and in the polar-circular linear Cartesian at $x = C^2d/(1-C^2)$.

Considering only the bipolar groups, inspection of the formats 26a,b and the 0° and 180° transforms 27a,b (upper and lower signs, respectively) and 90°

90° transform, bipolar parabolic Cartesians

(a) $x^2y^2[(x^6+y^6)-2C^2d^2(x^4+y^4)+C^2d^4(C^2-2)(x^2+y^2)] + C^4d^8(x^2+y^2) = 0$ (10-28)

90° transform, bipolar linear Cartesians

(b) $(B^2-A^2)^2x^2y^2\{(B^2-A^2)^6(x^6+y^6) - 4d^2(A^2B^2+A^2C^2+B^2C^2)(B^2-A^2)^4(x^4+y^4)$

 $+ 2d^4[3(A^4B^4+A^4C^4+B^4C^4)+2A^2B^2C^2(A^2+B^2+C^2)](B^2-A^2)^2(x^2+y^2) -$

 $4d^6[10A^4B^4C^4+(A^6B^6+A^6C^6+B^6C^6)] +$

 $16A^2B^2C^2d^6[A^2(B^4+C^4)+B^2(A^4+C^4)+C^2\{A^4+B^4)]\} -$

 $d^8[(A^2B^2+A^2C^2-B^2C^2)^2-4A^4B^2C^2]^2(x^2+y^2) = 0$

transforms 28a,b clearly reveals the homologies (compare 27a,b with 21b, and 28a,b with 21c). However, there also are marked differences based on the different properties of the curves with respect to the ovals, and the number of, and location of, the foci.

For example, excluding the *curve of demarcation* (the equilateral limacon), the ovals of bipolar parabolic Cartesians never come into contact, and the focus in question (the pole p_u of 25a', located at x = d) never enters the small loop nor becomes coincident with a loop vertex. In other words, insofar as the focus at x = d is concerned, there is no subspecies corresponding to the e = 2 limacon. In consequence, the constant term never vanishes from 27a and there can be no reduction to 2nd degree. Furthemore, eq. 28a never reduces from 10th to 6th degree, as the 90° limacon transform does in the e = 2 subspecies. Since the x = d focus can approach the center of only one oval as C increases, and since the internal oval always is tiny compared to the large one, the near-conic homology will fail in certain respects.

Bipolar linear Cartesians also differ markedly from limacons but nonetheless have very close near-conic parallels. The chief difference is that the ovals of these linear Cartesians never come into contact. Although this causes a fundamental difference in their near-conic homologies, it alters their circumpolar symmetry but little. In these Cartesians, the $A^2d/(A^2-B^2)$ focus can become coincident with a loop vertex, for which the condition is 29a.

When 29a obtains, 27b becomes 29b, which represents congruent, concentric,

loop-vertex coincidence transforms

(a) $(A^2B^2+A^2C^2-B^2C^2)^2 - 4A^4B^2C^2 = 0$ loop-vertex coincidence condition (10-29)

(b) $(x^2\pm xy+y^2) = 2d^2(A^2B^2+A^2C^2+B^2C^2)/(B^2-A^2)^2 = \alpha^2$ 0° and 180° transforms

(b') $3x^2+y^2 = 2\alpha^2$, 0° (b") $x^2+3y^2 = 2\alpha^2$, 180° 45°CCW rotation of axes

90° transform

$$4d^2(A^2B^2+A^2C^2+B^2C^2)(B^2-A^2)^4(x^4+y^4) + \qquad\qquad (10\text{-}30)$$

$$4d^6\{10A^4B^4C^4+(A^6B^6+A^6C^6+B^6C^6)-4A^2B^2C^2[A^2(B^4+C^4)+B^2(A^4+C^4)+C^2(A^4+B^4)]\} =$$

$$(B^2-A^2)^6(x^6+y^6)+2d^4[3(A^4B^4+A^4C^4+B^4C^4)+2A^2B^2C^2(A^2+B^2+C^2)](B^2-A^2)^2(x^2+y^2)$$

orthogonal ellipses, as do the corresponding transforms for e = 2 limacons-- even to having the same eccentricity and being represented in the transforms only by recurrent-arc segments. A 45° CCW rotation of the axes gives 29b',b". The 0° and 180° transforms 27b have complete homology with those of limacons, in that they are the eqs. of near-lines and near-circles that become more nearly linear and circular, respectively, as the ovals of the basis curve become more nearly equal in size and the focus becomes more nearly centered in them.

For the same symmetry condition (29a) the 90° transform (28b) also reduces to 6th degree (eq. 30) and also represents a variety of near-conics that more closely approximate ellipses as the ovals become more nearly of the same size and the focus approaches center position. The fundamental difference is that, since the ovals never touch, the transforms do not become unicursal, and complete elliptical figures do not form. In addition, the transforms are comprised only of ovals that form an a-vertex region of the near-ellipses-- as if the central regions had been cut off by the LR chords.

The Vertex-Coincidence Symmetry Condition

As an example of a bipolar linear Cartesian oval that satisfies the vertex-coincidence symmetry condition 29a, consider the subspecies, A = 1, B = 3, C = 1½ (eqs. 25b,b'). This consists of a large oval with vertices at

x = 0.625d and -1.25d, and a small oval with vertices at x = 0.25d and -0.125d. The $A^2d/(A^2-B^2)$ focus is at the latter vertex. The center pole p_u is within the small oval, the p_v pole is at x = d, outside of both ovals, and the 3rd focus of self-inversion is at x = $(A^2-C^2)d/(A^2-B^2)$.

The 0^o and 180^o transforms, aside from the trivial x = y, are the expected recurrent-arc segments of ellipses, 29b, and include contributions from both ovals (referred to below as loops to avoid confusion). In view of the fact that the basis loops are not in contact, one does not expect a close resemblance to the 90^o transform of the e = 2 limacon about the $-\frac{1}{2}b$ focus (the orthogonal ellipses and circle). In fact, a full 4-quadrant plot of the 90^o transform consists of 9 separate ovals (the 6th-degree transform has symmetry about both coordinate axes and both bisectors).

The most nearly elliptical of the 9 transform ovals are the 4 that lie on the 45^o bisectors, that arise wholly from the large loop. These closely resemble half-ellipses and are homologues of the 90^o transforms of circles about near-central poles. In this case the pole is 3d/16 units from the center of the large loop, which restricts the largest diameter of those portions of the 90^o transforms that are made up of contributions from the large loop alone to about 3d/8. The other 4 peripheral ovals possess contributions from both loops and have the typical minor-axis distortion seen earlier in several limacon transforms.

The 9th oval is a small central one derived entirely from contributions of the small loop, and is the homologue of the 90^o circular transform of a circle about an incident point. It departs from being circular to essentially the same extent that the small loop departs from circularity.

Cartesian Near-Conic Transforms

The above example illustrates the bipolar linear Cartesian symmetry condition in which the $A^2d/(A^2-B^2)$ focus is coincident with a vertex, homologous with the situation in the e = 2 limacon, where the 90^o transforms about the $-\frac{1}{2}b$ focus are *true conics*. The second example illustrates a *near-conic transform* of a linear Cartesian. For this purpose, one needs a Cartesian basis curve that consists of two large ovals in which the $A^2d/(A^2-B^2)$ focus is near the center of both.

A bipolar linear Cartesian having the parameters, A = 0.7126096407, B = 1/8, and C = 1, fits these particular well. Its vertices are at x = 2.044639361d, 2.914536322d, -0.343107750d, and -0.4890838057d. The 3 foci of self-inversion

are at $x = 0$, d, and $-d$. The 8th focus, at $A^2 d/(A^2-B^2) = 1.03174603d$, the homologue of the $-\tfrac{1}{2}b$ focus, lies close to the $x = d$ focus of self-inversion-- just $0.03174603d$ units from it (see also Table XIV-3, Ovals No. 3).

This homologue of the $-\tfrac{1}{2}b$ focus lies $0.180980228d$ units from the center of the small oval and the same distance from the center of the large oval. In other words, it lies midway between the centers of the two ovals. This property is the homologue of a corresponding property of the limacon $-\tfrac{1}{2}b$ focus, because the $A^2 d/(A^2-B^2)$ focus of bipolar linear Cartesians always lies midway between the axial centers of the two ovals, at a distance $ACd/(A^2-B^2)$ from each. The ovals of this subspecies barely are discernibly different from circles; the diameter of the larger is 42.5% greater than that of the smaller.

The ovals of this subspecies undergo *negative inter-oval self-inversion* about the $x = 0$ focus (each oval inverts into the other along oppositely-directed chord segments; eq. 31a), *positive inter-oval self-inversion* about the $x = d$ focus (each oval inverts into the other along coincident radii; eq. 31b), and *positive intra-oval self-inversion* about the $x = (A^2-C^2)d/(A^2-B^2)$ focus (each oval inverts into itself along coincident radii; eq. 31c).

(a) $\quad xy \;=\; \dfrac{d^2(A^2-C^2)}{(A^2-B^2)} \;=\; \pm d^2 \qquad$ eq. of self-inversion about the $x = 0$ focus $\qquad\qquad$ (10-31)

(b) $\quad xy \;=\; \dfrac{d^2(B^2-C^2)}{(B^2-A^2)} \;=\; \pm 2d^2 \qquad$ eq. of self-inversion about the $x = d$ focus

(c) $\quad xy \;=\; \dfrac{d^2(B^2-C^2)(A^2-C^2)}{(A^2-B^2)^2} \;=\; \pm 2d^2 \qquad$ eq. of self-inversion about the focus at $x = (A^2-C^2)d/(A^2-B^2)$

$0°$ and $180°$ transforms about the $A^2 d/(A^2-B^2)$ focus

$$xy(x^2 \pm xy + y^2)(B^2-A^2)^4 = 2d^2(B^2-A^2)^2(A^2B^2+A^2C^2+B^2C^2)xy$$

$$\pm\, d^4[(A^2B^2+A^2C^2-B^2C^2)^2 - 4A^4B^2C^2]$$

The $0°$, $180°$, and $90°$ transforms of this subspecies about the focus in question fulfill all of the expectations for near-conics. The $0°$ transform (eq. 32, upper sign) is almost linear and the $180°$ one (eq. 32, lower sign), consisting of 4 recurrent arcs, appears to be perfectly circular to the naked eye. The $90°$ transform consists of 4 near-ellipses, occupying the locations

of the distal regions of the complete near-ellipses of limacons. The 0° near-line transform occupies the position of a diameter of the 180° near-circle transform and of the major axis of the 45° minor-axis near-ellipse transform. Since my intention here only is to illustrate the homologies of the transforms about the focus of this subspecies with the transforms of the $-\frac{1}{2}b$ focus of limacons, a quantitative analysis is not pursued.

Circle-Deviation Limacons and the Origin of Near-Conics

It was noted above that a limacon can be constructed about the polar center by adding or subtracting contributions from two circles for each value of θ. It also has been remarked that near-conics more closely approximate true conics as the limacon loops become more nearly circular and equal in size, and as the $-\frac{1}{2}b$ focus approaches the center of the loops. However, these assessments are only on a relative basis; in the limit, the loops neither are circular nor of equal size, and the $-\frac{1}{2}b$ focus is not central to either. The diameter of the large loop, no matter its size, always is $2a$ units greater than that of the small one, the deviation from circularity approaches a limiting value with increasing e (the absolute magnitude of which is the same for both loops), and the $-\frac{1}{2}b$ focus always lies midway between the axial centers of the two loops, $\frac{1}{2}a$ units from each center (recall the homologous property of the $A^2d/[A^2-B^2]$ focus of bipolar linear Cartesians).

The 90° transforms about the $-\frac{1}{2}b$ focus of *circular limacons*, i.e., limacons in which each loop is replaced by a circle of the same axial diameter, are not near-ellipses, nor do they resemble near-ellipses. In fact, they consist of a square tetrad of 4 mutually-tangent ovals (each oval tangent to two of the others). These ovals are simply the pure and hybrid 90° transforms of circles about near-central poles. Were they to be near-conics, one would have a situation in which the symmetry-characterizing transforms of circles were identical with those of limacons which, of course, is impossible.

Accordingly, the key to the intercept transformation of limacons to near-conics about the $-\frac{1}{2}b$ focus lies in the deviations of the limacon loops from circularity; the more nearly the deviations approach the limiting value, the more nearly the near-lines approximate true lines, the near-ellipses approximate true ellipses, and the near-circle axial ratio approximates that of a circle.

In the light of these facts, the deviations of limacon loops from circularity
--as measured along radii emanating from the $-\frac{1}{2}b$ focus--become of great
interest.

The large loop of limacons always is larger than a circle of its axial di-
ameter and the small loop always is smaller than a circle of its axial diameter,
at all points except the axial vertices. If one plots these deviations at the
respective angles at which they are measured (along radii from the $-\frac{1}{2}b$ focus),
one obtains the *circle-deviation limacons*. These consist of two large loops
and two small loops, mutually tangent at the origin. The two large loops are
derived from the large loop of the basis limacon and are tilted 30-40° forward
from the vertical, i.e., down toward the positive x-axis. The two small loops
are derived from the small loop of the basis limacon and are tilted an equal
amount in the other direction, i.e., toward the negative x-axis. Neither of
the individual loops has a line of symmetry, but the ensemble of 4 loops is
symmetrical about the x-axis (each loop above the x-axis is tangent to both
loops below the x-axis, and vice versa, but the two loops above and below the
x-axis are not tangent to one another; rather, they intersect). As e increases,
the large loops decrease and the small loops increase in size. In the limit, the
dimensions of both are equal (which means that the limacon loops have the same
deviation from circularity), with a major axis of length approximately 0.26a.

The intercept transforms of the circle-deviation limacons about their polar
center also are of considerable interest. By way of introduction, recall that
the transforms of limacons about the DP and its homologue are true conics,
namely lines, circles, and ellipses. Of a paralleling nature are the transforms
about the $-\frac{1}{2}b$ focus--near-lines, near-circles, and near-ellipses. But a
limacon is constructed about the DP or DP homologue by taking the sum or
difference of two radii to points on two circles, whereupon the deviation from
a circle centered at the DP is simply the circle, $-b\cos\theta$. The transforms
about this deviation circle (actually about a point incident upon it) are
circles and ellipses--circles for 90° and ellipses at all other angles except
0° and 180°.

On the other hand, the hyperbolic limacon constructed about the $-\frac{1}{2}b$ pole
is the sum of its small-loop circle-deviation limacon and a circle of radius
(a-b)/2 centered at (a-b)/2, and the sum of its large-loop circle-deviation
limacon and a circle of radius (a+b)/2 centered at -(a+b)/2. The two loops

of the circle-deviation limacon thus are the analogues of the -bcosθ deviation circle. [They are not the homologues because the latter is the deviation curve from a circle centered at the polar center (the DP or its homologue), whereas former are deviation curves from circles that are not centered at -½b.] The basis for the near-conic transforms about the -½b focus lies in the symmetry of the limacon loops, which are formed by adding these circle-deviation loops to circles. Therein lies the principal interest in the symmetry of the circle-deviation loops.

The symmetry of these loops is characterized by seemingly unknown curves. The 180° transforms about the center pole consists of two symmetrical inter-secting "tops" with their tips (cusps) at the origin, derived from LL and SS, and two long, narrow, "rabbit ear" lobes, also issuing from the origin and located just to each side of, and reflected in, the 45° bisector. The 0° transform consists of two asymmetrical "tops" intersecting on the bisector and reflected in it.

The most interesting transform is the 90° one, best described as follows. Imagine an ellipse in which the upper segments do not meet at the b vertex but cross one another beneath it and continue on down to, and terminate at, the LR vertices of the lower half, at which points the curve is tangent to the x and y-axes. Then imagine a "capping" segment consisting of the peripheral portion of another ellipse (the portion beyond the LR) sitting atop the above-described first portion, with the LR vertices of each in contact. The whole forms a "sombrero-like" curve nestled between the coordinate axes with the tip of the "sombrero" on the 45° bisector. This description applies to both the LL and SS segments of the transform. The SL and LS segments are very similar to the above but are individually asymmetrical and reflections of one another in the 45° bisector.

These "sombrero-like" transforms of circle-deviation limacons are not entirely new to me. A very similar curve is the 90° transform (24th degree) of the cardioid about its axial center at x = -a, which is not a focus. The latter curve, however, has an additional cusp, because the top of the "sombrero" is cusped rather than convex. Accordingly, the cardioid transform has two triple-point cusps, one ordinary cusp, and 3 double points, whereas the curves described above lack the ordinary cusp.

Table X-1. Degrees of Circumpolar Intercept Transforms
of Limacons

	0°	180°	90°
A point in the plane	56	56	72
A point incident upon the curve	44	44	60
A point on the h = -½b non-axial covert linear focal locus	20	20	72
A point on the h = 0 axial covert focal locus	—*	—*	—*
-½b peripheral vertices	12	12	< 60
A point on the line of symmetry	10	10	24
-(a+b) and (a-b) axial vertices	6	6	16
-½b focus	4	4	10
-½b focus (e = 2)	2	2	2
$(a^2-b^2)/2b$ focus	2	3	6
DP and its homologues	1	1	2

*unknown

Table X-2. Focal Loci of Hyperbolic QBI Curves

	Conics	Central quartics	Limacons	Mutually-inverting quartic circles
Vertices				
real	6	6 or 2	8 or 6	8
imaginary	2	2 or 6	0 or 2	0
Linear focal loci				
lines of symmetry	2	2	1	2
covert	0	0	2	0
Other point foci				
real (including DP)	3	3	3	3
imaginary	2	2	0	2
Focus of self-inversion	0	0	1	1
Curve itself	1	1	1	2
Total	16	16	16	18
Asymptotes	2	0*	0**	0
Total	18	16*	16**	18

* The DP tangents probably are covert linear focal loci.
**The DP tangents may be covert linear focal loci.

The Axial Vertex Foci

The simple intercept eqs. (x+h translation) for the -(a+b) and (a-b) vertex foci of limacons are eqs. 33a. The upper sign is for the -(a+b) focus and the lower for the (a-b) focus. The corresponding simple intercept formats are 33b.

simple intercept equations for the -(a+b) and (a-b) vertex foci

(a) $\quad x(2a{\pm}b)^2\cos^2\theta - [2x^2(b{\pm}2a){\pm}2a(a{\pm}b)^2]\cos\theta + x[x^2+a(a{\pm}2b)] = 0$ \qquad (10-33)

(b) $\quad \cos\theta = \dfrac{[(b{\pm}2a)x^2{\pm}a(a{\pm}b)^2]{\pm}a[(a{\pm}b)^4-b(b{\pm}2a)x^2]^{\frac{1}{2}}}{(b{\pm}2a)^2x}$ \qquad simple intercept format for 33a

0° transforms for the -(a+b) and (a-b) foci

(c) $\quad (b{\pm}2a)^3x^2y^2(x-y)^2 + 4a(b{\pm}2a)^2xy[abxy{\mp}(a{\pm}b)^2(x-y)^2] +$

$\qquad 4a^2(b{\pm}2a)(a{\pm}b)^2[(a{\pm}b)^2(x^2-3xy+y^2){\mp}2abxy] + 4a^3(a{\pm}b)^4[ab{\pm}2(a{\pm}b)^2] = 0$

The 0° and 180° transforms are of 6th degree (see Chapter XIV). Those for 0° are given by eq. 33c. Since a term (b±2a) was factored out in the derivation of these transforms, eq. 33c does not hold for the (a-b) vertex of the e = 2 limacon, for which the 0° and 180° transforms are 21b'. The 90° transforms are of 16th degree (see Chapter XIV). The known degrees of transforms about point foci and points on focal loci of limacons are tabulated in Table X-1, while the focal loci of hyperbolic conics, central quartics, and limacons are listed in Table X-2.

The Pole of Conditional Focal Rank At ½b

The treatment of the circumpolar symmetry of limacons is concluded with a consideration of the simple intercept formats and transforms of poles of conditional focal rank. The pole conjugate to the -½b focus is a variable, penetrating pole of conditional focal rank. Its simple intercept format is 34a.

(a) $\quad \cos\theta = \dfrac{(a^2-3b^2-4x^2) \pm a(a^2-2b^2+8x^2)^{\frac{1}{2}}}{8bx}$ \qquad simple intercept format for pole at ½b \qquad (10-34)

(b) $\quad \cos\theta = \dfrac{-4x^2 \pm 3^{\frac{1}{2}}b(b^2+8x^2)^{\frac{1}{2}}}{8bx}$ \qquad 34a for e = $1/3^{\frac{1}{2}}$ ($a^2 = 3b^2$)

(c) $\quad \cos\theta = \dfrac{{\pm}4bx-4x^2-b^2}{8bx}$ $\quad \dfrac{-(2x{\mp}b)^2}{8bx}$ \qquad 34a for e = $1/2^{\frac{1}{2}}$ ($a^2 = 2b^2$)

(d) $\quad \cos\theta = \dfrac{-3b^2-16x^2 \pm 3b(b^2+32x^2)^{\frac{1}{2}}}{32bx}$ \qquad 34a for e = 2/3 (a = 3b/2)

(a) $16x^4y^4(x+y)^2+192b^2x^4y^4+9b^8(x-y)^2 = 72b^4x^2y^2(x^2+y^2)$ $180°$ transform for 34b (10-35)

(b) $4xy(x+y) + b^2(x+y) = 8bxy$ $180°$ transform for 34c

(c) $16x^2y^2(x^2+y^2) + b^4(x^2+y^2) =$ $90°$ transform for 34c

$$16b^2x^2y^2 + 8b^3xy(x+y) + 32bx^2y^2(x+y)$$

(d) $xy(x^2+y^2)(4xy-3b^2/2)^2 + 2[(2xy-3b^2/8)^2+2a^2xy]^2$ $180°$ transform for 34d

$$- (81b^4/8)(4x^2y^2+b^4/256) = 0$$

Since this pole becomes coincident with the (a-b) vertex when $e = 2/3$, it is inside the curve for $e < 2/3$ and outside for $e > 2/3$. Note from format 34a, that the constants in the numerator outside of the radical vanish for $a^2 = 3b^2$, leading to the simplified format 34b. However, this simplification of the format is of no consequence at the focal level, leading as it does to $180°$ transforms, 35a, of 10th degree.

The pole achieves focal rank when it becomes coincident with the $(a^2-b^2)/2b$ focus in the $e = 1/2^{\frac{1}{2}}$ limacon ($a^2 = 2b^2$). For this location, the radical vanishes, yielding 34c and $180°$ and $90°$ transforms of only 3rd and 6th degree, respectively (35b,c). Eq. 35c has terms that are all of different degree in the variables (2,3,4,5, and 6). This pole also achieves focal rank when it becomes coincident with the (a-b) focus, yielding the format 34d and an 8th degree $180°$ transform, 35d.

It is evident from comparing the formats, 34b and 34d, that the values of the coefficients and the presence or absence of constant terms, even outside of a radical, can play a crucial role in the achievement of focal rank. Thus, the former format, which is simpler, yields a 10th degree $180°$ transform, whereas the latter yields one of only 8th degree.

The Pole of Conditional Focal Rank At $(b^2-a^2)/2b$

The pole conjugate to the $(a^2-b^2)/2b$ focus also is a pole of conditional focal rank of the variable, penetrating type. In fact, it is the only such pole that penetrates the -(a+b) vertex. It is coincident with the latter for $e = 1/3$ but lies to the left of it, external to the curve, for smaller values

of e. It penetrates the (a-b) vertex for e > 1 and is coincident with it in the cardioid. At e = 1/2^½, it is coincident with the -½b focus. Two of these coincidences, e = 1/2^½ ($a^2 = 2b^2$) and e = 1 (a = b), are evident from inspection of the simple intercept format 36a, for both of which the radical is eliminated, yielding 36b and 36c (36b must be rederived from the simple intercept eq.; the alternate sign of the radical becomes merely a positive sign for the cardioid).

simple intercept format for the pole at $(b^2-a^2)/2b$

(a) $\cos\theta = \dfrac{(a^2-6b^2)(a^2-b^2)^2-4b^2x^2(2b^2-a^2)\pm[4b^2x^2(2b^2-a^2)-2(b^2-a^2)^3]^{\frac{1}{2}}(2ab^2)}{4bx(2b^2-a^2)^2}$

$$(10\text{-}36)$$

(b) $\cos\theta = \dfrac{-16x^4+40b^2x^2+7b^4}{32b^3x}$ 36a for e = 1/2^½ (c) $\cos\theta = \dfrac{a-x}{a}$ 36a for e = 1

The coincidence with the -(a+b) vertex in the e = 1/3 subspecies leads to insufficiently high focal rank to bring about much simplification of the format (see eq. 33a, upper sign).

Inversions of Limacons

Focal Inversion

The fact that limacons are QBI quartics increases interest in their Inversion Taxonomy, because the properties of their inversion loci can be expected to cast light on the membership of the QBI superfamily. The polar and rectangular eqs. of limacons cast about the highest-ranking focus, the DP or its homologue, h = k = 0, are repeated here for convenience (eqs. 37a,b). Inverting about

(a) $r = a-b\cos\theta$ polar eq. of limacon (10-37)

(b) $(x^2+y^2+bx)^2 = a^2(x^2+y^2)$ rectangular eq. of limacon

(c) $r = j^2/(a-b\cos\theta)$ inversion of 37a,b

(d) $[(x-b/2)^2+y^2+b(x-b/2)]^2 = a^2[(x-b/2)^2+y^2]$ 37a,b cast about -½b focus

this pole is accomplished merely by inspection of 37a, leading to 37c. It already has been noted that limacons self-invert about the 2nd-highest ranking focus, at $(a^2-b^2)/2b$, and this can be affirmed readily by following the inversion procedure described for eq. 2b.

Inversion of the limacon cast about the focus at $x = -\frac{1}{2}b$ (eq. 37d) yields 38a,b, in rectangular and polar coordinates. This group of curves is desig-

(a) $\quad j^2(x^2+y^2)[a^2bx-j^2(a^2+b^2)/2)] = (b^2/4)(a^2-b^2/4)(x^2+y^2)^2 - j^8$ $\hspace{2cm}$ (10-38)

(b) $\quad j^8 + a^2bj^2r^3\cos\theta = r^2j^4(a^2+b^2/2) + (b^2/4)(a^2-b^2/4)r^4$

nated as the *limacon focal-inversion quartics* or merely the *limacon focal quartics*, since they are the only quartics obtained from limacons by inversion about an axial point focus (other than those obtained by self-inversion).

For the special case, $e = 2^{\frac{1}{2}}$ $(b^2 = 2a^2)$, eqs. 38 are those of the equilateral lemniscate, which is the only inversion of a limacon through the $-\frac{1}{2}b$ focus that has a true center (two orthogonal lines of symmetry). The $-\frac{1}{2}b$ inversions for other subspecies are single ovals (elliptical subspecies), a cusped oval (the parabolic subspecies), and either two-looped curves consisting of opposed loops of disparate size communicating via a DP, or limacon-like curves in which the second loop is internalized (the hyperbolic species).

For the subspecies, $e = 2$ $(b = 2a)$, the $-\frac{1}{2}b$ focus is coincident with the $(a-b)$ vertex focus. Letting $b = 2a$ and $j = a$, eqs. 38 reduce to the cubic, 39a,b, which are the eqs. of the trisectrix of Maclaurin cast about

Equations of trisectrix of Maclaurin $\hspace{2cm}$ pole

(a) $\quad y^2(x-3a/2) = x^2(3a/2-x) + a^3/2$ $\hspace{2cm}$ $x = -2a$, rectangular $\hspace{1cm}$ (10-39)

(b) $\quad a^3 + 2r^3\cos\theta = 3ar^2$ $\hspace{3cm}$ $x = -2a$, polar

(c) $\quad y^2(A-x) = x^2(3A+x)$ $\hspace{3.5cm}$ DP

the loop pole at $x = 2a$ (a focus by virtue of coincidence with the variable focus). In eq. 39c, cast about the DP, the trisectrix has been reflected in the y-axis, compared to eq. IX-7c, in order to conform with the orientation

of its inversion locus. The constant a is that of the basis limacon, $r = a(1-2\cos\theta)$, and is related to A of 39c by $a = 2A$.

The homology between the behavior of the foci involved is noteworthy. In the limacon, the $e = 2$ subspecies is formed when the variable, penetrating focus at $-\frac{1}{2}b$ becomes coincident with the (a-b) vertex focus. In the hyperbola vertex cubics, the trisectric subspecies is formed when the variable, penetrating (a+b)/2 focus becomes coincident with the loop pole at 2b/3 (which has only subfocal rank in the hyperbola vertex cubics but is focal in some non-QBI cubics).

It is apparent from the above treatment of the $-\frac{1}{2}b$ inversions of limacons, that inversions about a *variable* focus do not produce members of a single genus unless the variable focus is of the self-inverting type. This is the basis for the disclaimer in Maxim 8, whereby variable foci are excluded from its domain of application.

Inversions About A Point In the Plane

Inverting the limacon 37b about a point in the plane $(x+h, y+k$ translations) yields 40a. Except for the special cases of cubics and conics this defines the

inversions of limacons about a point in the plane

(a) $[j^4+(x^2+y^2)(h^2+bh+k^2)+j^2(b+2h)x+2j^2ky]^2 =$ (10-40)

$$a^2(x^2+y^2)[j^4+(x^2+y^2)(h^2+k^2)+2j^2(hx+ky)]$$

(b) $(h^2+bh+k^2)^2 = a^2(h^2+k^2)$

inversions of limacons about a point incident upon the curve

(a) $2[(h^2+bh+k^2)(b+2h)-a^2h]x(x^2+y^2) + 2k[2(h^2+bh+k^2)-a^2]y(x^2+y^2) +$ (10-41)

$$+ j^2[2(h^2+bh+k^2)-a^2](x^2+y^2) + 4j^2k(b+2h)xy + j^2(b+2h)^2x^2 +$$

$$4j^2k^2y^2 + 2j^4(b+2h)x + 4j^4ky + j^6 = 0$$

inversions of limacons about axial vertices

(b) $2h[(b+h)(b+2h)-a^2]x(x^2+y^2) + j^2[2h(b+h)-a^2](x^2+y^2) +$

$$j^2(b+2h)^2x^2 + 2j^4(b+2h)x + j^6 = 0$$

inversions of limacons about -(a+b) and (a-b) vertices

(c) $j^2[(2a\pm b)x \mp j^2]^2 + a[j^2(a\pm 2b) \mp 2(a\pm b)^2x](x^2+y^2) = 0$

limacon inversion quartics. The condition for points incident upon the curve is 40b. When this condition obtains, 40a reduces to a 3rd degree eq., 41a, which defines the *limacon inversion cubics*. For $k = 0$, 41b is obtained, which defines the *limacon axial vertex inversion cubics* (but see Chapter XI). The generic eqs. for the $-(a+b)$ and $(a-b)$ vertices are obtained by letting $h = -(a+b)$ and $h = (a-b)$, yielding 41c, where the upper signs are for the $-(a+b)$ vertex (but the vertex inversions belong to the same subspecies).

The relationships described above, and others, are illustrated in Table X-3 which, it is to be noted, is not a *chain* of inversions but a *classification* of the inversions of a single subspecies of limacon. Inversion taxons are not assigned to the different levels represented, but with the exceptions of the *focal-inversion quartics* and the *non-focal cubics*, which probably are to be regarded as being comprised of more than one genus, each of the lowest levels represented is a genus.

Table X-3. Classification of the Inversion Loci of a Limacon

ALL INVERSION LOCI
(all points in the plane)

CUBICS
(any point on the curve)

NON-FOCAL INVERSION LOCI
(all points not on focal loci)

AXIAL INVERSION LOCI
(all points on focal axes)

LINE-OF-SYMMETRY INVERSION LOCI
(all points on the line of symmetry)

LINE-OF-SYMMETRY NON-FOCAL INVERSION LOCI
(all non-focal axial poles)

SELF
$[(a^2-b^2)/2b$ focus$]$

COVERT AXIS INVERSION LOCI
(all points on covert focal axes)

LINE-OF-SYMMETRY FOCAL-INVERSION LOCI
(axial foci)

CONICS
(DP focus)

COVERT AXIS NON-FOCAL INVERSION LOCI
(all non-focal covert axial poles)

FOCAL-INVERSION QUARTICS
($-\frac{1}{2}b$ focus)

VERTEX CUBICS
(axial vertices)

PERIPHERAL VERTEX CUBICS
($-\frac{1}{2}b$, 0 peripheral vertices)

NON-FOCAL CUBICS
(all incident points except axial and $-\frac{1}{2}b$, 0 peripheral vertices)

Chapter XI. INVERSION TAXONOMY OF THE QUADRATIC-BASED
INVERSION SUPERFAMILY

Introduction

It already has been noted that the degree of quartic members of the QBI superfamily is conserved by the inversion transformation; no inversion of a member of this group is of greater than 4th degree. We also have noted that the inversion transformation ultimately is conservative of degree. Accordingly, all inversion superfamilies are limited in degree from both above and below. The question now is addressed of whether the QBI superfamily is open or closed, i.e., do chains of inversions--beginning with, say, a basis central conic--give rise to ever new cubics and quartics in successive generations, or is a point reached at which the inversion loci are redundant? It is shown below that insofar as axial inversions are concerned, the QBI superfamily is closed; all of the member groups are included in the 1st-generation inversions of the basis conics. Furthermore, these groups can be categorized in terms of the locations of the poles of inversion relative to the 5 axial foci of the basis conics. Based upon considerations of continuity, it may be assumed that the same stricture concerning membership obtains for non-axial inversions.

The Literature on Inversion

Before embarking on this program it is appropriate to cite pertinent previously known properties of inversions, but excluding self-inversions, which are dealt with at the end of the Chapter. Aside from references to inversions about specific traditionally defined foci and specific vertices of well-known highly symmetrical curves, most of the literature on inversion of which I am aware is couched in very general language (see the 5 summary statements below). In fact, even among the citations of specific inversions, I have seen no mention in the literature of a case in which the pole for the inversion and the reciprocal inversion pole were not *both* vertices or one or another traditional focus. For example, there is no mention of: (a) the fact that the equilateral lemniscate inverts through its vertices to an equilateral strophoid, with the reciprocal inversion pole being at x = 2a (twice the

loop diameter from the DP on the loop vertex side); (b) the identity of the inversion loci of the trisectrix of Maclaurin or the equilateral strophoid through the loop pole at $x = 2b/3$ (which has point focal rank in the trisectrix); or (c) the facts that limacons invert to the same cubic subspecies through both vertices and that these cubics are conic axial vertex inversion cubics (see Table VI-1).

The principal previously known facts about inversion that are pertinent to these treatments of the Inversion Taxonomy of QBI curves are as follows: (1) to a *traditional* focus (i.e., a focus as defined traditionally) of any curve there corresponds a focus of the inverse curve; (2) quartics consisting of communicating loops invert to looped cubics through points on the curve; (3) hyperbolas invert to quartics with communicating loops; (4) the inverse of a conic section generally is of 4th degree; and (5) conics invert to cubics through points on the curve. The concept and fact of *conservation of degree* were known to Königs (1892) who used precisely this expression for the phenomenon.

Limacon Focal-Inversion Quartics

For the purposes of the present analyses it is desirable to cast the eqs. of all QBI quartics about the DP or its homologue (in the following it is implicit in the references to the DP that the DP homologue also is included). Accordingly, returning to the topic of limacon focal-inversion quartics (inversions about the $-\frac{1}{2}b$ focus), these curves are cast about the DP in both rectangular and polar form in eqs. 1a,b. The corresponding simple intercept format is 1c. If one compares eqs. 1a and 2 for the basis limacon, similarly

limacon focal-inversion quartics cast about the DP

(a) $(b^2/4)(a^2-b^2/4)(x^2+y^2)^2+bj^2(a^2-b^2/2)x(x^2+y^2)-j^4[(b^2-a^2)x^2-a^2y^2] = 0$ (11-1)

(b) $r = \dfrac{j^2(b^2/2-a^2)\cos\theta \pm aj^2(b^2/4-a^2\sin^2\theta)^{\frac{1}{2}}}{(b/2)(a^2-b^2/4)}$ polar form of eq. 1

(c) $\cos\theta = \dfrac{(a^2-b^2/2)x \pm a(a^2x^2+4j^4)^{\frac{1}{2}}}{2bj^2}$ intercept format of 1a,b

$$(x^2+y^2)^2 + 2bx(x^2+y^2) + (b^2-a^2)x^2 - a^2y^2 = 0 \qquad \text{basis limacon} \qquad (11-2)$$

cast about the DP and employing limacon parameters, it can be seen that they differ only in the values of the coefficients. As noted in Chapter X, for $b^2 = 2a^2$ ($e = 2^{\frac{1}{2}}$) the cubic term vanishes, yielding the eq. of the equilateral lemniscate, while for $b^2 = 4a^2$ ($e = 2$), the quartic term vanishes and the eq. becomes that of the trisectrix of Maclaurin.

As also remarked above, these curves are single ovals for elliptical basis subspecies. As e increases toward unity, the oval elongates, attaining a cusped "teardrop" shape at $e = 1$. When e exceeds 1, a second loop opens from the cusp, which now becomes a DP. For $1 < e < 2^{\frac{1}{2}}$, the curves consist of two opposed loops communicating at a DP--but the left loop is larger than the right loop. At $e = 2^{\frac{1}{2}}$, the opposed loops are of identical shape and size and the curve is the equilateral lemniscate. For $2^{\frac{1}{2}} < e < 2$, it is the right loop that is the larger of the two. At $e = 2$, the limacon $-\frac{1}{2}b$ focus comes to lie at the (a-b) vertex, and the enlarging right loop opens, forming the trisectrix of Maclaurin. The pole of the reciprocal inversion for the latter is not its DP (about which it inverts to the $e = 2$ hyperbola), but the loop pole at $x = 2b/3$.

For these hyperbolic quartics, as well as for all other hyperbolic QBI quartics, the properties of the inversion loci can be deduced from the signs of the terms in their eqs. But these properties are most readily understood according to the following scheme. If the pole of inversion of a hyperbolic cubic or quartic is inside an internalized small loop, inside either of two opposed loops, or outside a cubic loop on the asymptote side, the inversion loci are limacon-like. But if the pole of inversion is outside both loops, outside an internalized small loop, or outside a cubic loop on the loop vertex side, the inversion loci have opposed communicating loops.

Limacon Line-of-Symmetry Inversion Quartics

The limacon focal-inversion quartics are but one of 3 groups of 4th-degree curves belonging to the *limacon line-of-symmetry inversion quartics*, the other two of which are the limacon self-inversions and the *limacon line-of-symmetry non-focal inversion quartics* (see Tables X-3 and XI-1). The question of the nature of the general eq. of these quartics now is addressed. Accordingly, eq. 2 for the limacon is inverted about a point h on the line of symmetry (x+h translation), yielding 3a. Since eq. 3a is cast about the

Table XI-1. Principal Axial Inversions of QBI Curves[1,2]

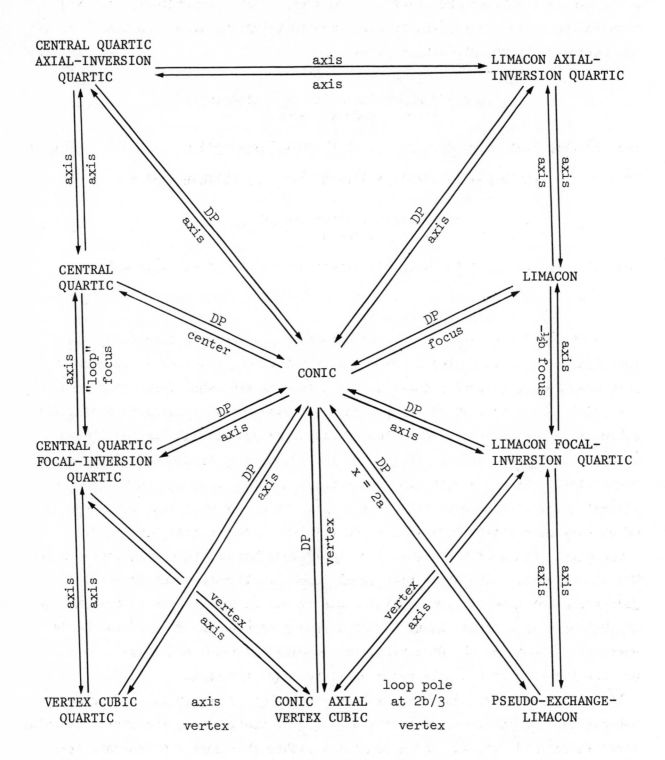

[1]Every locus represented inverts to every other locus, and all loci
 self-invert except the conics, central quartics, and curves of unit
 eccentricity.
[2]Circles, lines, and ensembles thereof omitted.

pole of inversion at $x = h$ as origin, the DP of the basis curve is at $-h$, which places the DP of the inversion locus at $-j^2/h$. Accordingly, an $x+H$ translation, where $H = -j^2/h$, is performed to bring the origin to the DP of the inversion locus, yielding eq. 3b.

<div align="center">

line-of-symmetry inversion of a limacon
about a pole at $x = h$

</div>

(a) $h^2[(b+h)^2-a^2](x^2+y^2)^2 + 2hj^2[(b+h)(b+2h)-a^2]x(x^2+y^2) +$ (11-3)

$$j^4[2h(b+h)-a^2](x^2+y^2) + j^4(b+2h)^2x^2 + 2j^6(b+2h)x + j^8 = 0$$

<div align="center">

eq. 3a recast about the DP
($x-j^2/h$ translation)

</div>

(b) $h^2[(b+h)^2-a^2](x^2+y^2)^2 + 2hj^2(a^2-bh-b^2)x(x^2+y^2) + j^4[(b^2-a^2)x^2-a^2y^2] = 0$

 $h \neq 0$

Inspection of the latter eq. reveals that it has the same form as eq. 1a for limacon focal-inversion quartics. In other words, the special case of the line-of-symmetry inversion quartics for a pole at the $-\frac{1}{2}b$ focus preserves the precise quartic form of the general eq., rather than leading to a simplification in which terms are lost. Accordingly, the eqs. of all limacon line-of-symmetry inversion quartics cast about the DP, as well as the eq. of the basis curve itself, have a single quartic term in $(x^2+y^2)^2$, a single cubic term in $x(x^2+y^2)$, and single terms in x^2 and y^2. There are no linear terms and, of course, no constant term (since the point[0,0] must satisfy the eq.).

The significance of the above findings extends beyond the conclusions stated. The latter conclusions apply with equal force to all subsequent inversion generations of line-of-symmetry inversion quartics, because the inversion locus of the curve when recast about the DP always preserves the form of the basis curve cast about the DP. Of course, the conclusions hold regardless of the precise location of the pole about which the eqs. are cast.

If one compares eqs. 3a,b, it will be noted that the essential difference between them is that, excluding the quartic and cubic terms, the former contains terms in (x^2+y^2), x^2, x, and a constant, rather than just two separate terms in x^2 and y^2. But this form also is preserved under inversion. Were it not so, neither would the form cast about the DP be preserved. In the inversion transformation, the basis constant term merely makes a contribution to the

inverse quartic term, the basis term in x makes a contribution to the inverse quartic term and the inverse cubic term, while the basis term in x^2 contributes to the inverse quartic and cubic terms and to the inverse term in x^2. At the same time the basis quartic term casts off a new constant term, j^8 times its coefficient. The essential feature is the absence of terms such as xy^3 and x^2y^2 (see Chapter XIV).

These findings, then, demonstrate that membership in the class of quartics derived by chain inversions of a basis limacon about poles on the line-of-symmetry is closed. The general eq. for all limacon line-of-symmetry inversion quartics, when cast about the DP, may be taken as 4a, where the parameters are those of the basis limacon and the eccentricity is b/a. With 4a as the basis eq., the inversion locus is given by 4b. Since an odd power of x occurs only in the cubic term, the sign of this term is merely a reflection sign, a change of which reflects the curve in the y axis. Note that the coefficients of x^2 and y^2 remain in the same ratio.

1st-generation line-of-symmetry limacon inversion quartic cast about the DP

(a) $B(x^2+y^2)^2 + A^2x(x^2+y^2) + C[(b^2-a^2)x^2-a^2y^2] = 0$ (11-4)

inversion of eq. 4a about x = h and recast about the DP

(b) $h^2[Bh^2+A^2h+C(b^2-a^2)](x^2+y^2)^2 - hj^2[hA^2+2C(b^2-a^2)]x(x^2+y^2) +$

$h \neq 0$ $\qquad\qquad\qquad\qquad Cj^4[(b^2-a^2)x^2-a^2y^2] = 0$

(c) $\dfrac{h^2j^4(a^2-bh-b^2)^2}{h^4[(b+h)^2-a^2]^2} = \dfrac{j^4[(b^2-a^2)+a^2]}{h^2[(b+h)^2-a^2]}$ condition for self-inversion of eq. 2

(d) $\dfrac{j^4h^2[hA^2+2C(b^2-a^2)]^2}{h^4[Bh^2+A^2h+C(b^2-a^2)]^2} = \dfrac{4Cj^4[(b^2-a^2)+a^2]}{h^2[Bh^2+A^2h+C(b^2-a^2)]}$ condition for self-inversion of eq. 4a

$h \neq 0$

If eqs. 2 and 3b are compared, it can be seen that the condition for self-inversion of eq. 2 is 4c. The latter has not been simplified, in order that its derivation will be evident. In words, the condition for self-inversion of the basis limacon of eq. 2 about a pole on the line of symmetry is that in the

inverse eq. cast about the DP, the square of half the coefficient of the cubic term be equal to the coefficient of the x^2 term minus the coefficient of the y^2 term. For eqs. 4a,b, this condition translates to 4d, on the assumption that eq. 4a represents a limacon. Both 4c and 4d yield the location of the focus of self-inversion at $h = (a^2-b^2)/2b$.

The 2nd-generation line-of-symmetry inversion quartic of eq. 5 is obtained either by applying to eq. 3b the transformation formula deduced from eqs. 4a,b or by inverting eq. 3 about the pole H and recasting the inversion locus about the DP ($x-j^2/H$ translation).

<div align="center">

2nd-generation limacon line-of-symmetry
inversion quartic cast about the DP
</div>

$$H^2\{h^2H^2[(b+h)^2-a^2]+2hHj^2(a^2-bh-b^2)+j^4(b^2-a^2)\}(x^2+y^2)^2 - \qquad (11-5)$$

$$2Hj^4[hH(a^2-bh-b^2)+j^2(b^2-a^2)]x(x^2+y^2) + j^8[(b^2-a^2)x^2-a^2y^2] = 0$$

$$H \neq 0, \quad h \neq 0$$

Axial Inversion Quartics of Central Quartics

Central quartics are the curves represented by eqs. 6b,c, obtained by inverting central conics, 6a, about their centers (Table XI-1). These have to

(a) $b^2x^2 \mp a^2y^2 = a^2b^2$ basis central conic (11-6)

(b) $(x^2+y^2)^2 = j^4(x^2/a^2 \mp y^2/b^2)$ central quartic

(c) $r^2 = (j^4/a^2b^2)[(b^2 \pm a^2)\cos^2\theta \mp a^2]$ 6b, polar coordinates

(d) $r^2 = a^2 \mp b^2\cos^2\theta$ root-$\cos^2\theta$ group

be distinguished from the root-$\cos^2\theta$ group 6d because the latter also includes curves for which the parameters are not related as in 6c (for which conic para-meters are employed). Central quartics are a subgroup of the *inter-vertex quartics*, which include all the quartics obtained by inverting central conics about poles lying between the axial vertices.

Central quartics, 6b, first are inverted about a loop pole at $h = j^2/2^{\frac{1}{2}}a$ and the inversion locus is recast about the DP at $-2^{\frac{1}{2}}a$, giving 7a. This

eq. is seen to have the same general form as that for limacon line-of-symmetry inversion quartics. For the case $e^2 = 2$ ($a = b$), for which the basis curve 6b is the equilateral lemniscate, 7a represents the equilateral limacon. The "loop foci" of central quartics lie at $h^2 = j^4(b^2 \pm a^2)/4a^2b^2$.

inversion of 6b about the pole at $h = j^2/2^{\frac{1}{2}}a$
recast about the DP

(a) $(x^2+y^2)^2 - 4 \cdot 2^{\frac{1}{2}}ax(x^2+y^2) + 4a^2(x^2 \mp a^2y^2/b^2) = 0$ \hfill (11-7)

central quartic axial inversion quartics \hfill generation

(b) $b^2h^2(j^4-a^2h^2)(x^2+y^2)^2 - 2b^2hj^6x(x^2+y^2) + j^8(b^2x^2 \mp a^2y^2) = 0$ \hfill 1st

(c) $b^2H^2[h^2H^2(j^4-a^2h^2)-2hHj^6+j^8](x^2+y^2)^2 + 2b^2Hj^8(hH-j^2)x(x^2+y^2)$ \hfill 2nd

$\qquad\qquad\qquad\qquad\qquad\qquad\qquad + j^{12}(b^2x^2 \mp a^2y^2) = 0$

$h,H \neq 0$

The general eq. for 1st-generation central quartic axial-inversion quartics is 7b, that for the 2nd generation, 7c. In the first case, the inversion is about any axial pole h, and in the second, about any axial pole H; in both cases the inversion loci are recast about the DP at $-j^2/h$ and $-j^2/H$, respectively. As was the case with the limacon line-of-symmetry inversion quartics, it is evident that membership in this inversion class also is closed, and the coefficients of the quadratic terms remain in the same ratio from generation to generation. [The term *axial*, used without qualification in the following, designates the major or transverse axis. If the curve has only one line of symmetry, that is the axis being designated.]

Some characteristics of the inversion of hyperbolic central quartics are as follows. The cubic term only vanishes if the inversion pole is at the DP, in which case the basis hyperbola is obtained. On the other hand, the quartic term vanishes if the inversion pole is at either the DP or a vertex; in the latter case, central quartic vertex cubics*are obtained. As with those of limacons (see below), the vertex cubics* of central quartics are identical with conic vertex cubics (in this case, central conic vertex cubics). They are referred to with the former designation only for purposes of specifying their origin.

*[Reference is to the *axial* vertex cubics.]

The reciprocal pole of inversion is not at the DP of the central quartic vertex cubic; only for inversion of the vertex cubic to conics is this pole at the DP. The reciprocal inversion pole, in fact, does not have circumpolar focal rank. In this case it is at x = 2b, twice the distance of the loop vertex from the DP on the loop vertex side. As noted earlier, the equilateral lemniscate inverts through its vertices to an equilateral strophoid.

CIRCUMPOLAR MAXIM 12: *The reciprocal inversion pole of the curve obtained by inverting a parabola or central conic about a point on a line of symmetry is the highest-ranking focus of the inversion locus. Contrariwise, the reciprocal inversion pole of the curve obtained by inverting other QBI curves about a point on a line of symmetry generally is non-focal in the inversion locus.*

If the axial pole of inversion of a hyperbolic central quartic is within one of the loops, the inversion locus will resemble a hyperbolic limacon, i.e., it will possess an internalized loop communicating with the external loop at the DP. On the other hand, if the axial pole is outside the loops, the inversion locus will consist of opposed loops communicating at a DP. In both cases, the loops will be of unequal size. Inversion of elliptical central quartics (e < 1), as with all single ovals, is straightforward; unless the pole of inversion is incident upon the curve, the inversion locus consists of another single oval.

From a comparison of eqs. 6b and 7a, it is evident that central quartics do not positively or negatively self-invert; self-inversion would require the cubic term to drop out. But the condition for this is a = 0, which is not permitted. Geometrically speaking, no curve consisting of congruent opposed loops, communicating at a single point and possessing two lines of symmetry, can self-invert. However, as is demonstrated below, the axial inversion quartics of central quartics do self-invert. The basis for this, insofar as the hyperbolic species is concerned, is that the loops are asymmetrical (i.e., a line of symmetry has been lost).

Nor do elliptical central quartics self-invert, as does the elliptical limacon species. This failure results because the central quartic ovals have two lines of symmetry. The only single-oval curve with multiple lines of symmetry that can self-invert at 0° or 180° is the circle (single-oval curves with two lines of symmetry can, however, self-invert at other angles; see Chapter XIV, *Self-Inversion at 90°*).

Axial-Inversion Quartics of the Conic Axial Vertex Cubics

As basis curves, I again take central conics, 6a, which invert about their axial vertices to the conic axial vertex cubics of eq. 8 (Table XI-1). Inversion of the latter about an axial pole at $x = h$, and recasting about the DP leads to the 1st-generation quartic 8b. Repetition of the process about a pole at $x = H$ leads to the 2nd-generation quartic 8c.

(a) $y^2(x \pm aj^2/2b^2) = x^2(j^2/2a - x)$ conic axial vertex cubics (11-8)

<div style="text-align:center">axial-inversion quartics of 8a generation</div>

(b) $h^2(j^2/2a - h)(x^2+y^2)^2 + hj^2(h - j^2/a)x(x^2+y^2) +$ 1st

$$j^6(x^2/2a - ay^2/2b^2) = 0$$

(c) $H^2[h^2H^2(j^2/2a - h) + hHj^2(h - j^2/a) + j^6/2a](x^2+y^2)^2 -$ 2nd

$Hj^2[hHj^2(h - j^2/a) + j^6/a]x(x^2+y^2) + j^{10}(x^2/2a - ay^2/2b^2) = 0$ $h, H \neq 0$

(a) $[x^2 + (2/3 \pm a^2/b^2)y^2 + 2ax] = (x^2+y^2)^2/27a^2$ pseudo-exchange-limacons (11-9)

(b) $(x^2 + y^2 + 2ax) = (x^2+y^2)^2/27a^2$ true exchange-limacon

(c) $a^2(x^2 + y^2 + bx) = (x^2+y^2)^2$ generic rectangular eq. of true exchange-limacons

(d) $\cos\theta = \dfrac{x(x^2 - a^2)}{a^2 b}$ simple intercept format of 9c

If one inverts the vertex cubic 8a about the loop pole of the hyperbolic species at $x = 2b/3$, or about its homologue in the elliptical species (an $x + j^2/3a$ translation), a genus of looped curves with somewhat different symmetry properties is obtained (eq. 9a). This group is designated as *pseudo-exchange-limacons* because, except for the fact that the coefficient of the y^2 term on the left is not equal to that of the x^2 term, its eq. is the same as that of limacons (eq. X-37) but with the exponents of the bracketed and parenthetical terms exchanged. The significance of this change in the eq. is that no cubic term is present, a change that modifies the simple intercept format (see below).

For the special case, $e = 2$ ($b^2 = 3a^2$ and upper sign), the trisectrix of

Maclaurin, the coefficients of the x and y terms of the left member of the eq. become equal, and the eq. becomes that of a *true exchange-limacon*, 9b. If the general eq. for this genus is taken to be 9c, its simple intercept format is given by 9d, one of the relatively uncommon instances of a simple intercept format that does not involve a radical (and a strong indication of a high degree of symmetry of the basis curve about the polar center). [Of course, highly symmetrical curves can be synthesized at will through the assembly of radical-free non-complex simple intercept formats. In fact, even curves belonging to a given specific symmetry class can be synthesized in this manner (see Chapter XIV, *Design and Synthesis of Highly Symmetrical Curves*).]

True exchange-limacons resemble bipolar parabolic Cartesians in consisting of one or two non-intersecting ovals. Accordingly, they are not QBI curves. The special case 9b, for which $b^2 = 3a^2$ and the ovals meet at a DP, is the e = 2 limacon (cast about the a-b vertex). This is the *curve of demarcation* between a genus of the true exchange-limacons having only one oval and a genus having two non-intersecting ovals (Table VIII-1).

Inversion Cycles and Inversion Images

Introduction

We now have arrived at the realization that membership in axial inversion chains based upon conic sections is closed, because, except for changes in the coefficients of the terms, the eqs. of axial inversion quartics retain their form under the inversion transformation. But what are the specific relationships between the axial inversion quartics derived from limacons, central quartics, conic axial vertex cubics, and conics inverted about non-focal poles?

Another question has to do with the inversions of members of the quartic chains derived from the focal inversions of conics. Is there a pole about which a 1st-generation limacon inversion quartic inverts to a conic? If so, how is the conic so obtained related to the basis conic (produced by inverting the basis limacon through the DP)? If not, does a member of the 2nd generation do so, or the 3rd?

The phenomena of a subspecies lying at the intersection of two genera (where

the member curves of all of the taxons involved have the *same* number of axial foci) or being the curve of demarcation between two genera (where the member curves of at least one of the demarcated taxons have a different number of axial foci from the curve of demarcation) can provide the starting point for numerous taxonomic queries, from the points of view of both Inversion Taxonomy and Circumpolar Symmetry Taxonomy. As an example of the former category, the equilateral lemniscate is both a 1st-generation limacon focal-inversion quartic and a central quartic. Examples of the latter category are the $e = 2$ and $e = 2^{\frac{1}{2}}$ limacons and the equilateral lemniscate (see Table VIII-1). Investigations relating to the equilateral lemniscate as a curve of intersection played a large role in the findings that follow.

The equilateral lemniscate inverts through its center to the equilateral hyperbola, and other central quartics invert to other central conics through their centers. The finding that the 1st-generation focal-inversion quartic of the equilateral limacon is an equilateral lemniscate leads to the following question. Since the equilateral lemniscate inverts to the equilateral hyperbola through its center, and since the equilateral lemniscate is a subspecies of limacon focal-inversion quartics, to what curves will other hyperbolic subspecies of limacon focal-inversion quartics invert through their DP?

Two alternatives might be envisioned. The first is that, like the equilateral lemniscate, the equilateral hyperbola lies at the intersection of two genera of curves; one genus would be the quadratics, to which all central quartics invert through their centers, the other genus would be a group of curves to which all limacon focal-inversion quartics invert through the DP. The second alternative is that all limacon focal-inversion quartics invert to conics through the DP or its homologue.

The latter alternative has proved to be the actual situation. All axial QBI quartics invert to conics through the DP. This property, wherein an inversion through the DP gives the inversion locus of lowest degree does not hold universally. For example, the lowest degree inversion locus of Cayley's sextic is the cubic obtained by inverting about the loop vertex. Inversion about the DP gives a quartic (eq. IX-39a).

CIRCUMPOLAR MAXIM 13: *All quadratic-based axial inversion quartics invert to conics through their DP or its homologue.*

Inversion of Limacon Focal-inversion Quartics
to Conics Through the Double Point

Several examples of inversion cycles within the QBI superfamily are given.
The rectangular and polar eqs. of limacon focal-inversion quartics cast about
the DP or its homologue are 10a,b, and the simple intercept format is 10c.

limacon focal-inversion quartics cast about the DP

(a) $(b^2/4)(b^2/4-a^2)(x^2+y^2)^2 - 4bj^2(a^2-b^2/2)x(x^2+y^2) +$ (11-10)

$$4a^2j^4(x^2+y^2) + 4b^2j^4x^2 = 0$$

(b) $br(b^2/4-a^2) = 2j^2(a^2-b^2/2)\cos\theta \pm 2aj^2(b^2/4-a^2\sin^2\theta)^{\frac{1}{2}}$

(c) $\cos\theta = \dfrac{x(a^2-b^2/2) \pm a(a^2x^2+4j^4)^{\frac{1}{2}}}{2bj^2}$ simple intercept format of 10a,b

(a) $[x+b(b^2/2-a^2)/2(b^2-a^2)]^2 - a^2y^2/(b^2-a^2) =$ inversion (11-11)
of 10a,b
$$a^2b^4/[16(b^2-a^2)^2]$$

(b) $[x+bj^2/(b^2-a^2)]^2 - a^2y^2/(b^2-a^2) = a^2j^4/(b^2-a^2)^2$ basis conic

The inversion loci in rectangular coordinates are given by 11a, and seen to
be central conics centered at $b(b^2/2-a^2)/2(b^2-a^2)$, of semi-major (or trans-
verse) axis $ab^2/4(b^2-a^2)$ and eccentricity b/a.

It is, of course, of great interest to compare this *inversion image* with
the basis conic of the parent limacon of the limacon focal-inversion quartic,
i.e., to compare the first and last members of the chain. The basis conic in
question is 11b, which is seen to be centered at $bj^2/(b^2-a^2)$, of semi-major
axis $aj^2/(b^2-a^2)$ and eccentricity b/a, where the limacon parameters are
retained. Accordingly, as could be anticipated (since the inversion trans-
formation is conformal), the inversion cycle conserves eccentricity. The major
axis ratio (inversion image/basis curve) is seen to be $b^2/4j^2$, while the
ratio of the distances of the centers from the origin is $(b^2-2a^2)/4j^2$.

It was noted earlier that the equilateral lemniscate inverts through the
vertex foci to an equilateral strophoid. The reciprocal inversion occurs

through the pole at 2b, i.e., an axial pole outside the cubic loop on the loop vertex side, at twice the distance of the loop vertex from the DP (see also below). Although this pole lies on a focal axis it is not a circumpolar point focus. Similarly, the limacon focal-inversion quartics invert through the DP to axial poles of central conics that are not circumpolar point foci.

Non-Focal Inversions of Limacon Axial Vertex Cubics to Limacons

The above was an example of a conic-quartic-quartic-conic loop. The following are examples of conic-quartic-cubic-conic loops. Detection of these inversion cycles was facilitated by the knowledge that the e = 2 limacon inverts to the trisectrix of Maclaurin through both of its vertex foci, and that the equilateral lemniscate (e = $2^{\frac{1}{2}}$) inverts to the equilateral strophoid through its vertices. These findings raised the same kinds of questions posed above. For example, does the trisectrix of Maclaurin lie at the intersection of two genera, namely, the conic axial vertex cubics and the limacon axial vertex cubics, or do all limacons invert to conic axial vertex cubics through their axial vertices? The latter alternative turns out to be the case. Although the curves in question are referred to as *limacon axial vertex cubics*, the designation *conic axial vertex cubics* has priority (since the superfamily is designated after the genus of lowest even degree).

As in the cases cited above, and in accord with Maxim 12, the reciprocal inversion pole of the limacon axial vertex cubics, i.e., the pole about which they invert to limacons, is not a circumpolar point focus. Relative to the DP, it lies at $x = j^2/(a-b)$ for the (a-b) vertex cubic, and at $-j^2/(a+b)$ for the vertex cubic obtained by inverting about the -(a+b) vertex. Accordingly, eqs. X-41b, for limacon axial vertex cubics, invert to limacons about a variable axial inversion pole.

If eqs. X-41c, for limacon -(a+b) and (a-b) vertex cubics, are inverted through the DP (which is at $j^2/[a+b]$ for the -[a+b] vertex cubic), they give the inversion image conics of eqs. 12a,b, where both polar and rectangu-

<div align="center">
inversions of limacon -(a+b) and (a-b)

vertex cubics through the DP
</div>

(a) $r = 2a(a\pm b)^2\cos\theta/[\pm(b^2\cos^2\theta-a^2)]$ (11-12)

(b) $[x-a(a\pm b)/(b\mp a)]^2 - a^2y^2/(b^2-a^2) = [a(a\pm b)/(b\mp a)]^2$

lar representations are employed. It will be noted, again, that inversion conserves eccentricity, because in both cases $e = b/a$. Additionally, it will be noted that both vertices of the image conics are reciprocal inversion poles. [The magnitude of the shift, $a(a \pm b)/(b \mp a)$, is equal to the length of the semi-major axis (or semi-transverse axis)]. This accords with expectations, since (by definition) all DP inversions of conic axial vertex cubics must give conics cast about an axial vertex.

CIRCUMPOLAR MAXIM 14: *Inversions within the QBI superfamily conserve eccentricity.*

Circumpolar Symmetry of Limacon Axial Vertex Cubics

A very brief circumpolar symmetry analysis of the (a-b) vertex inversion cubics is given here employing the parameters of the limacon basis curve. The simple intercept eq. for an $x+h$ translation of eq. X-41c for limacon (a-b) vertex cubics (lower sign) is 13a. The focal condition on the $\cos^2\theta$ term is

simple intercept eq. of limacon (a-b) vertex cubic

(a) $x^2\cos^2\theta[4ah(a-b)^2+j^2(2a-b)^2] +$ (11-13)

$2x[ax^2(a-b)^2+3ah^2(a-b)^2+hj^2(5a-b)(a-b)+j^4(2a-b)]\cos\theta +$

$ax^2[2h(a-b)^2+j^2(a-2b)]+2ah^3(a-b)^2+h^2j^2(5a-b)(a-b)+2hj^4(2a-b)+j^6 = 0$

(b) $4ah(a-b)^2 + j^2(2a-b)^2 = 0$ $\cos^2\theta$-condition

(c) $3ah^2(a-b)^2 + hj^2(5a-b)(a-b) + j^4(2a-b) = 0$ $\cos\theta$-constant condition

(d) $2h(a-b)^2 + j^2(a-2b) = 0$ x^2-condition

(e) $2ah^3(a-b)^2+h^2j^2(5a-b)(a-b)+2hj^4(2a-b)+j^6 = 0$ constant-condition

(f) $b^2j^2x^2\cos^2\theta + 2a(a-b)^2x^3\cos\theta - a^2j^2x^2 = 0$ simple intercept eq. about the DP

13b, that on the $\cos\theta$-constant term, 13c, and those on the x^2 term and constant term, 13d and 13e.

The solution to 13b gives the variable focus at $h = -j^2(2a-b)^2/4a(a-b)^2$; eq. 13c gives the DP at $h = -j^2/(a-b)$ and the loop pole (at $x = 2b/3$) at $h = j^2(b-2a)/3a(a-b)$, 13d gives the asymptote-point focus at $h = -j^2(a-2b)/2(a-b)^2$, and 13e gives the DP focus twice (a double root) and

the loop vertex at $-j^2/2a$. The simple intercept eq. cast about the DP is 13f. These eqs. are in unfamiliar form compared to eqs. IX-8 and IX-10a because the parameters of the limacon basis curve have been retained. If one designates the parameters a and b of IX-8 and IX-10a by A and B, they are related to those of eqs. 13a-f by the relations of 14a,b.

(a) $\quad A = -aj^2/2(a-b)^2$ \qquad (b) $\quad B = j^2(a+b)/2a(a-b)$ \qquad (11-14)

Inversion of Pseudo-Exchange-Limacons to Conics
 Through the Double Point

In the following example of the inversion of pseudo-exchange-limacons to central conics, conic parameters are employed throughout. The basis curve 15a is a central conic (upper sign for the hyperbola) which is inverted about the left vertex. This gives the familiar conic axial vertex cubic 15b, cast about the

(a) $\quad (x-a)^2 \mp a^2y^2/b^2 = a^2$ \qquad basis conic \qquad (11-15)

(b) $\quad y^2(x\pm aj^2/2b^2) = x^2(j^2/2a-x)$ \qquad conic axial vertex cubic

(c) $\quad x^2+(2/3\pm a^2/b^2)y^2+2ax = (x^2+y^2)^2/27a^2$ \qquad pseudo-exchange-limacon

(d) $\quad (h^2+2ah-h^4/27a^2)$ \qquad coefficient of quartic term
$\qquad\qquad\qquad\qquad$ of inversion of 15c

(e) $\quad 2j^2(h+a-2h^3/27a^2)$ \qquad coefficient of cubic term
$\qquad\qquad\qquad\qquad$ of inversion of 15c

(f) $\quad (x-2j^2/9a)^2 \pm a^2y^2/b^2 = (j^2/9a)^2$ \qquad inversion image of 15c

(g) $\quad (x-2a/9)^2 \pm a^2y^2/b^2 = (a/9)^2$ \qquad inversion image of 15c with $j = a$

DP. Next, one inverts through the loop pole at $x = j^2/3a$ and obtains the pseudo-exchange-limacon 15c, for which the reciprocal inversion pole is the small-loop vertex. Following this, 15c is inverted about an axial pole h ($x+h$ translation) yielding the corresponding axial inversion quartic. The coefficients of the quartic and cubic terms of this inversion locus are 15d,e, respectively. The determinant eqs. for reduction to a conic are obtained by setting 15d and 15e equal to 0 and solving simultaneously.

Simultaneous solution of these eqs. locates the DP at $h = -3a$ of the pseudo-exchange-limacon (where a is the semi-major axis of the basis conic).

Letting $h = -3a$ then leads to the conic inversion image 15f. Letting $j = a$ yields 15g. Comparing the inversion image to the basis curve 15a reveals that its center is shifted $2a/9$ units to the right of the origin, while the linear dimensions of the curve have been reduced to $1/9$ those of the basis curve. Accordingly, the reciprocal inversion pole of the image is twice the distance of the vertex to the left of center. In other words, if a central conic is inverted about a pole at $(x,y) = (\pm 2a, 0)$ a pseudo-exchange-limacon is obtained. Eccentricity, of course, is conserved.

Inversion of Central Quartic Vertex Cubics to Conics Through the Double Point

The chain, central conic (center)--central quartic (loop vertex)--central quartic vertex cubic (DP)--central conic, now is illustrated. A centered central conic in standard form 16a is inverted through the center, yielding the central quartic 16b. The loop vertices of the latter (see the circumpolar symmetry analysis of Chapter XII) are at $x = \pm j^2/a$. One now inverts 16b about the right vertex at j^2/a employing the same unit of linear dimension (j), yielding 16c, or in somewhat more familiar form, 16c'.

(a) $b^2 x^2 \mp a^2 y^2 = a^2 b^2$	basis central conic	(11-16)
(b) $b^2 j^4 x^2 \mp a^2 j^4 y^2 = a^2 b^2 (x^2+y^2)^2$	central quartic	
(c) $2b^2 x(x^2+y^2)+5ab^2 x^2+a(2b^2 \pm a^2)y^2+4a^2 b^2 x+a^3 b^2 = 0$	central quartic axial vertex cubic	
(c') $y^2(2x+2a\pm a^3/b^2) - x^2(5a-2x) + a^2(4x+a) = 0$	same as 16c	
(d) $b^2(2h^3+5ah^2+4a^2 h+a^3)$	coefficient of quartic term of axial inversion of 16c,c'	
(e) $2b^2 j^2(2a+3h)(a+h)$	coefficient of cubic term of axial inversion of 16c,c'	
(f) $y^2(x\pm a^3/2b^2) = x^2(a/2-x)$	16c,c' cast about the DP	
(g) $(x-j^2/a)^2 \mp a^2 y^2/b^2 = j^4/a^2$	inversion image of 16a	

The latter eqs. are not cast about the DP, the form with which we are most familiar, but about the reciprocal inversion pole (inversion about which gives

the basis central quartic). The pole for inversion to central conics (the DP) next is located by performing an axial inversion (x+h translation) of 16c or 16c' and examining the coefficients of the quartic and cubic terms--the parameter polynomials of 16d,e, respectively. The common root of these eqs. at h = -a gives the location of the DP relative to the reciprocal inversion pole. Once again, it is found that the reciprocal inversion pole, in this case for inversion to central quartics, is not a circumpolar point focus. [The reader already may have discerned that the location of the DP relative to the reciprocal inversion pole can be located simply by taking the negative reciprocal of the pole of inversion. For example, if the pole of inversion is at j^2/a, the location of the DP will be at $-(j^2)/(j^2/a) = -a$.]

Eq. 16c next is recast in familiar form about the DP by performing an x-a translation of the curve, giving 16f. The parameters a and b still are those of the basis central conic. Inspection of 16f reveals that the loop axis (or its homologue) is of length a/2 units, and the asymptote is $a^3/2b^2$ units from the DP. The pole of inversion to central quartics is twice the loop-axis length from the DP on the loop vertex side. The x-a translation shifted the loop along the x axis to the standard position employed in Chapter IX, with the DP at the origin.

Lastly, 16c is inverted about the DP, leading to the inversion image 16g of the basis central conic 16a; the latter inversion employs the same unit of linear dimension j as did the other inversions in the chain. In fact, if j is taken to be the length of the semi-major axis (or semi-transverse axis), a, the inversion image is congruent to the basis curve but shifted a units to the right, bringing the left vertex to the origin.

Inversion of the Axial-Inversion Quartics of Central Quartics
 to Conics Through the Double Point

As a last specific example of inversion cycles and inversion images, central quartic axial-inversion quartics are inverted to conics about the DP. The eqs. of the basis central conics 16a, basis central quartics 16b, and 1st-generation axial-inversion quartic 7b, are given above.

Inversion of the general eq. 7b for axial-inversion quartics about the DP gives the conic inversion image 17, from which it is seen that the linear

dimensions of the basis conic are magnified or reduced by a factor of h^2/j^2, where $x = h$ is the point on the axis of the central quartic about which the

$$(x-h)^2 \mp a^2y^2/b^2 = a^2h^4/j^4 \qquad \text{inversion of central quartic axial-} \atop \text{inversion quartics about the DP} \qquad (11\text{-}17)$$

inversion occurs. If one lets $j = a$ (the length of the semi-major or semi-transverse axis of the basis conic), the center of the inversion image is shifted by an amount h to the right of the origin, compared to a length of h^2/a for its semi-major axis. For $h = a$, these distances are equal, corresponding to a vertex inversion of the central quartic to a conic vertex cubic, followed by an inversion of the latter through its DP to a central conic cast about its vertex.

The "loop foci" of central quartics are at $h = \pm j^2(b^2 \pm a^2)^{\frac{1}{2}}/2ab$. They are both variable and penetrating, and are imaginary in the elliptical species (which has real "loop foci" on the other line of symmetry at $k = \pm j^2[a^2 - b^2]^{\frac{1}{2}}/2ab$). They are at the loop vertices for $e = 2 \cdot 3^{\frac{1}{2}}/3$, outside of the loop for lesser values of e, and within the loop for greater values. Thus, different subspecies of central quartic focal-inversion quartics, like those of the limacon about the $-\frac{1}{2}b$ focus, have either internalized or opposed loops, depending upon whether the foci are within or outside of the loop of the basis central quartic. Central quartic focal-inversion quartics invert to hyperbolas through the DP. The reciprocal poles of inversion are at $\pm 2ab/(a^2+b^2)^{\frac{1}{2}}$, which places them at the traditional foci for $e = 2^{\frac{1}{2}}$. In other words, the focal-inversion quartics of the equilateral lemniscate are equilateral limacons, which invert to equilateral hyperbolas through their DP.

Several Generations of Inversions and
Inversion Images

From the above treatment alone very much of the total picture of the Inversion Taxonomy of the QBI superfamily and, by inference, other inversion superfamilies, has become evident. But before elaborating on this picture, the general case of inversion of central conic axial quartics (and cubics) through several generations is considered, together with the image conic of each generation. Up until this juncture, it may be remarked, concern has been almost entirely with chains of inversion loci based on *focal* inversions of conics. Accordingly, none of the above treatments displays unequivocally the general properties of an inversion cycle.

(a) $(x+h)^2 \mp a^2y^2/b^2 = a^2$ basis central conic (11-18)

Axial-inversion quartics (or cubics) generation

(b) $b^2(h^2-a^2)(x^2+y^2)^2+2b^2hj^2x(x^2+y^2)+j^4(b^2x^2\mp a^2y^2) = 0$ 1st

(c) $b^2H^2[H^2(h^2-a^2)+2hHj^2+j^4](x^2+y^2)^2 +$ 2nd

$\quad [-Hj^2(2b^2hHj^2+2b^2j^4)]x(x^2+y^2)+j^8(b^2x^2\mp a^2y^2) = 0$

(d) $J^2[A^8J^2+B^9J+b^2j^8](x^2+y^2)^2 +[-j^2J(B^9J+2b^2j^8)]x(x^2+y^2)$ 3rd

$\qquad\qquad j^{12}(b^2x^2\mp a^2y^2) = 0$

$\quad A^8 = H^2[b^2H^2(h^2-a^2)+2b^2hj^2H+b^2j^4]$

$\qquad\qquad B^9 = -2b^2j^4H(hH+j^2)$

Inversion images generation

(a) $[x-(H/j^2)(j^2+hH)]^2 \mp a^2y^2/b^2 = a^2(H^2/j^2)^2$ 1st (11-19)

(b) $\{x+(J/j^4)[HJ(j^2+hH)-j^4]\}^2 \mp a^2y^2/b^2 = a^2(H^2J^2/j^4)^2$ 2nd

(c) $\{x-(K/j^6)[JK[HJ(j^2+hH)-j^4]+j^6]\}^2 \mp a^2y^2/b^2 =$ 3rd

$\qquad\qquad a^2(H^2J^2K^2/j^6)^2$

Eqs. 18a-d are those of the basis central conic and 1st, 2nd, and 3rd generations of axial-inversion quartics (or cubics), respectively, with respect to inversions about axial poles at x = h, H, and J for the basis conic and the 1st and 2nd generations, respectively. Each eq. is cast about the DP, which is at $-j^2/h$, $-j^2/H$, and $-j^2/J$ for the 1st, 2nd, and 3rd generations, respectively, relative to the respective reciprocal inversion poles. The paradigm for forming subsequent generations is evident from inspection of these eqs.

Eqs. 19a-c are the 1st, 2nd, and 3rd-generation inversion images obtained by inverting eqs. 18c, 18d, and the 4th generation (eq. not given), respectively, about the DP. Of course, the 1st-generation curve, 18b, does not strictly speaking produce an image; it inverts directly to the basis conic.

Rules of formation of the eqs. of subsequent generations of images also are evident from the eqs. for the first 3 generations.

Inspection of the image eqs. reveals at once that image magnification or reduction is independent of the location of the pole h about which the *basis conic* is inverted. In other words, it is of no consequence whether the inversion chain takes a focal route through limacons, central quartics, or conic vertex cubics, or whether it takes a non-focal route. In each case the magnification or reduction is by a factor of the product of the squares of each distance of displacement of the inversion pole from the DP of the quartic or cubic, divided by a power of j equal to twice the number of distances of displacement involved.

It also is evident that the amount of displacement of the centers of the image conics from the center of the basis conic depends upon the location of each inversion pole involved in the chain to the juncture in question. The most significant and revealing feature, however, is one which bares with crystal clarity--if it were not already abundantly evident--the fundamental properties of Inversion Taxonomy. This feature is that there is no restriction on the locations of the reciprocal inversion poles of the various generations of quartics and cubics along the axis of the basis conic. Any generation can form an image centered about any pole on this axis for appropriate selections of h, H, J, K, and j. Furthermore, the degree of freedom is very high. For example, even if both j and h of eq. 19a were fixed, an appropriate selection of H would make possible any location of the reciprocal inversion pole.

But why is this such a significant feature of these inversion cycles? To answer this question, recall that: (a) all axial inversions of, for example, hyperbolas about points lying between the two vertices yield two-looped quartics with opposed non-congruent loops communicating at a DP (except those about the center, which yield central quartics); (b) all axial inversions on the opposite side of the vertex from the center give limacon-like curves; while (c) all vertex inversions give conic axial vertex cubics. Yet eqs. 19a-c reveal that any generation of any axial quartic or cubic can invert through its DP to any of these locations.

The significance of this finding is obvious for the 1st-generation quartic.

Inversion of the basis conic through the appropriate axial pole automatically generates the type of curve that inverts back to the basis conic with this point as the reciprocal inversion pole. For the other generations the situation is only slightly more complex. It already has been described how one obtains one or another type of curve--lemniscate-like, limacon-like, or vertex cubic--for different locations of the inversion poles on the axis of each QBI curve, such as within the small loop, within an "open loop" on the vertex side of the "small loop," outside of both loops, etc.

Accordingly, the significance of eqs. 19a-c is that they reveal that by the appropriate selection of the locations of the inversion poles and the unit of linear dimension, j, any axial QBI curve of given eccentricity can invert to any other QBI curve having the same eccentricity. Self-inverting QBI curves can invert, not to any *other* member, but to *any* member having the same eccentricity.

CIRCUMPOLAR MAXIM 15: *The members of the QBI superfamily that possess at least one line of symmetry consist of all conics plus all curves to which conics invert about all axial poles.*

CIRCUMPOLAR MAXIM 16: *The members of the QBI superfamily of eccentricity e, and possessing at least one line of symmetry, consist of the conic of that eccentricity plus all curves to which that conic inverts about all axial poles.*

CIRCUMPOLAR MAXIM 17: *Any member of the QBI superfamily of eccentricity e, and possessing at least one line of symmetry, inverts through poles on its line(s) of symmetry to all other members of the superfamily of the same eccentricity that have at least one line of symmetry.*

There is no reason to doubt--and the assumption is made, based upon considerations of continuity--that homologous maxims hold for members of the QBI superfamily that have no line of symmetry, i.e., for cases of non-axial inversions. Nor is there any reason to doubt that homologous maxims hold for the members of other inversion superfamilies.

In summary, the QBI superfamily is seen to be a closely-knit group of highly symmetrical curves consisting of the conic sections and all curves to which conic sections invert through all points in the plane. A conic section or central quartic of given eccentricity inverts to all *other* members of the superfamily having the same eccentricity; any other member of the superfamily of a given eccentricity inverts to *all* members of that eccentricity.

Though the concept of eccentricity originated for the characterization of conics, and is defined directly by their polar-linear eqs., it is seen to be a property that can be carried over to all members of the QBI superfamily. Since eccentricity is conserved under the inversion transformation, which is to say that the image conic of any generation preserves the eccentricity of the basis curve, it serves to characterize all members of the superfamily derived by inversion of any given basis conic about all points in the plane.

Non-reciprocal inversion cycles have a maximim chain length of 3 members, because any inversion of an inversion locus of a conic inverts to the basis conic of the same eccentricity through its DP. The inversion image of any conic subspecies is the reconstitution of that subspecies through an inversion cycle that includes at least 3 members (counting the basis conic only once). The *magnification* or *reduction* of the basis curve in its image is independent of the location of the inversion pole of the basis curve, whereas its *location* relative to the basis curve is influenced by the locations of all inversion poles and the choice of the unit of linear dimension for each inversion.

Self-Inversion Within the Quadratic-Based Inversion Superfamily

The self-inverting members of the QBI superfamily discussed hereto are the line, the circle, the central conic axial vertex cubic, and the limacon. However, other self-inverting members exist; in fact, *self-inversion of QBI curves is the rule--it is the failure to self-invert that is the exception.* We now are in a position to derive the eqs. of other self-inverting members, examine their properties, and discuss their significance.

Eqs. 18b-d for the 1st, 2nd, and 3rd generations of axial QBI curves are the general eqs. for all axial QBI cubics and quartics. Accordingly, a general test for self-inversion of any generation of this group can be carried out by equating the coefficients of the eqs. of this generation to those of the next generation. For example, from eqs. 18b,c one obtains two determinant eqs., 20a,b, for self-inversion of the 1st generation. In these eqs., h is the

(a) $H^4(h^2-a^2) + 2hH^3j^2 + H^2j^4 - j^4(h^2-a^2) = 0$ (11-20)

(b) $hH^2 + Hj^2 + hj^2 = 0$

location of the pole of inversion of the basis conic and H is the location
of the pole of inversion of the 1st-generation axial-inversion cubic or quartic.
The criterion for self-inversion, then, is that an H exist that is a common
root of both eqs.

In the case for which h = ±a, for which the 1st-generation curves are the
central conic axial vertex cubics, the solutions to eqs. 20a,b are j = 2a
and H = -2a, corresponding to self-inversion of central conic axial vertex
cubics through the vertex (or loop vertex). Accordingly, in the analysis of
the self-inversion of axially symmetrical QBI curves that follows, attention
is confined to quartics.

Self-Inverting Limacon-Like Axial-Inversion Quartics

Central quartics cannot positively self-invert about the center because a
given radius from the center intersects the curve at only one point. They
cannot self-invert about a non-central pole nor negatively self-invert about
the center, because they have two lines of symmetry. But the axial-inversion
quartics of central quartics lose a line of symmetry in the 1st generation.
Accordingly, one expects the 1st generation curves to self-invert, and this
proves to be the case. In fact, it is the question of whether a line of sym-
metry is lost in an axial-inversion locus that is the key to whether or not
the inverse curve will self-invert.

CIRCUMPOLAR MAXIM 18: *The loss of a line of symmetry in an axial-inversion
locus is accompanied by the gain of a focus of self-
inversion.*

Since the pole of inversion of central conics to central quartics is h = 0,
eqs. 18b,c and 20a,b merely lead to the result that central quartics themselves
do not self-invert. A test for self-inversion of the axial-inversion quartics
of central quartics is to equate the coefficients of the 1st and 2nd-generation
curves (eq. 21a,b), leading to the determinant eqs. 21c,d, in which h now is
the pole of inversion of the basis central quartic rather than that of the basis
conic, and H is the sought-after self-inversion pole for the 1st-generation
axial-inversion quartic of the central quartic (rather than that of the central
quartic itself).

Central quartic axial inversion quartics — generation

(a) $\quad b^2h^2(j^4-a^2h^2)(x^2+y^2)^2 - 2b^2hj^6x(x^2+y^2) +$

$$j^8(b^2x^2 \mp a^2y^2) = 0 \qquad \text{1st} \qquad (11\text{-}21)$$

(b) $\quad b^2H^2[h^2H^2(j^4-a^2h^2)-2hHj^6+j^8](x^2+y^2)^2 + \qquad \text{2nd}$

$$2b^2Hj^8(hH-j^2)x(x^2+y^2) + j^{12}(b^2x^2 \mp a^2y^2) = 0$$

(c) $\quad h^2H^4(j^4-a^2h^2)-2hH^3j^6+H^2j^8-h^2j^4(j^4-a^2h^2) = 0 \qquad$ determinant eq. for self-inversion

(d) $\quad hH^2 - Hj^2 + hj^2 = 0 \qquad$ determinant eq. for self-inversion

(e) $\quad H = \dfrac{j^2 \pm (j^4-4h^2j^2)^{\frac{1}{2}}}{2h} \qquad$ 21d cast in the quadratic-root form

When 21d is cast in the quadratic-root form 21e, inspection reveals that the conditions for the vanishing of the radicand, $h = \pm j/2$, lead to the solutions $H = \pm j$, which also satisfy 21c (one solution is merely the reflection of the other in the y-axis). Accordingly, the condition for self-inversion of 21a is that it be inverted about a pole H at twice the distance from its DP as the distance of the pole h from the DP of the basis central quartic. Thus, the eq. of the 1st-generation self-inverting axial-inversion quartic of a central quartic is 22a. For the choice $j = a$, this is the eq. of a limacon-like curve that self-inverts about the pole $x = \pm j$, with axial vertices given

1st-generation self-inverting axial-inversion quartic of a central quartic

(a) $\quad (b^2/4)(j^2-a^2/4)(x^2+y^2)^2-b^2j^3x(x^2+y^2)+j^4(b^2x^2 \mp a^2y^2) = 0 \qquad (11\text{-}22)$

(b) $\quad x = 2j^2(j\pm a/2)/(j^2-a^2/4),\ 0 \qquad$ locations of vertices of 22a

by 22b. The hyperbolic species differs from hyperbolic limacons in that the axial diameters of the two loops are independent of the value of the parameter b (note also that b does not appear in the determinant eqs. 21c,d).

Changes in eccentricity influence the height and shape of the loops of individual hyperbolic subspecies but not their axial size, which is in 3/1 ratio for $a = j$. The smaller the eccentricity, the more nearly circular the large loop and the greater its height relative to that of the small loop, which

becomes progressively flattened. The elliptical species, of course, possesses only a single loop which becomes increasingly flattened with increasing eccentricity and more nearly circular with decreasing eccentricity. For $e = 0$ $(b = a)$, i.e., when the basis conic is a circle, it also is a circle. For this condition an (x^2+y^2) term factors from 21a, leaving the eq. of a circle.

Are there any other self-inverting solutions to the determinant eqs. 21c,d? Simultaneous solution of these two eqs. leads to the single 10th-degree determinant eq. 23a. After factoring the two roots $h = \pm j/2$, 23b is obtained,

(a) $16a^4h^{10} - 4a^4h^8j^2 + 16a^2h^6j^6 - 12a^2h^4j^8 +$

$\qquad\qquad 2h^2j^{10}(2j^2+a^2) - j^{14} = 0$

solution to determi- (11-23)
nant eqs. 21c,d

(b) $4a^4h^8 + 4a^2h^4j^6 - 2a^2h^2j^8 + j^{12} = 0$

3a with two roots,
$h = \pm j/2$ factored

but all 8 roots of this eq. are complex. Accordingly, there are no other solutions. However, this does not mean that there are no other types of self-inverting curves; as we shall see below, the type of self-inverting locus obtained depends upon the choice of the value of j in terms of the semi-major or transverse axis a.

Mutually-Inverting Quartic Circles

Taking as the starting point the general eqs. of 1st (24a) and 2nd (24b) generation hyperbolic limacon axial-inversion quartics (basis limacon parameters) leads to the determinant eqs. 24c,d. The condition for self-inversion

1st-generation hyperbolic limacon axial-inversion quartic

(a) $B(x^2+y^2)^2 + A^2x(x^2+y^2) + C[(b^2-a^2)x^2-a^2y^2] = 0$ (11-24)

2nd-generation hyperbolic limacon axial-inversion quartic

(b) $h^2[Bh^2+A^2h+C(b^2-a^2)](x^2+y^2)^2 - hj^2[A^2h+2C(b^2-a^2)]x(x^2+y^2) +$

$\qquad\qquad Cj^4[(b^2-a^2)x^2-a^2y^2] = 0$

(c) $Bj^4 = h^2[Bh^2+A^2h+C(b^2-a^2)]$ determinant equation

(d) $A^2j^4 = -hj^2[A^2h+2C(b^2-a^2)]$ determinant equation

(a) $B^2[16C^2(b^2-a^2)^2] - B[8A^4C(b^2-a^2)] + A^8 = 0$ eliminant of 24c,d (11-25)

(b) $A^4 = 4BC(b^2-a^2)$ solution to 25a

mutually-inverting quartic circles

(d) $A^4(x^2+y^2)^2 + 4A^2C(b^2-a^2)x(x^2+y^2) + 4C^2(b^2-a^2)[(b^2-a^2)x^2-a^2y^2] = 0$

(d') $A^4r^2 + 4A^2C(b^2-a^2)r\cos\theta + 4C^2(b^2-a^2)^2\cos^2\theta - 4a^2C^2(b^2-a^2)\sin^2\theta = 0$

(e) $[x + C(b^2-a^2)/A^2]^2 + [y \pm aC(b^2-a^2)^{\frac{1}{2}}/A^2]^2 = [bC(b^2-a^2)^{\frac{1}{2}}/A^2]^2$

is that an h exist that simultaneously satisfies these eqs. Elimination of
h between 24c,d leads to eqs. of 26th degree in the variables and parameters.
These undergo several extensive simplifications by cancellations and factoring,
including--in the final stages--the factoring of a term $A^4j^2+C^2(b^2-a^2)^2$. The
final eliminant takes the form of a quadratic in B (eq. 25a) with the
solution 25b.

Direct substitution of 25b in 24a leads to the self-inverting axial quartic
25d,d'. When this is plotted, it is found to consist of two intersecting
circles, with one of the points of intersection at the origin. The pole of
self-inversion is at the center of the chord of intersection at
$h = -C(b^2-a^2)/A^2$. Having this knowledge of the nature of the curve, in-
spection of 25d reveals that it can be expressed as the difference between two
squares. Accordingly, it also can be written as two quadratic eqs., 25e,
each representing one of the circles.

The degree of overlap is dependent upon the relative values of a and b.
The condition for non-overlap is that $aC(b^2-a^2)^{\frac{1}{2}}/A^2 > bC(b^2-a^2)^{\frac{1}{2}}/A^2$, i.e.,
a > b. However, this is not allowed, for then the radius and y displacement
become imaginary.

Where do intersecting circles fit into the QBI superfamily? The answer is
not far to seek. Circles are known to invert to lines through incident points.
Since eq. 25d,d' is cast about a point of intersection,(the homologue of the DP),
which is the reciprocal inversion pole, the basis curve clearly is two
intersecting lines. [It is, of course, well known that intersecting circles
invert to intersecting lines and vice versa.] According to Maxim 12, all QBI
quartics invert to conics through the DP; in this case the conic section is

the one obtained when a plane cuts the cone through the apex (at any angle smaller than the angle between an element and the axis).

Regarded from another aspect, one obtains the image conic 26a by inverting 24b through the DP in the usual manner. Examination of 26a reveals that the bracketed expression in the numerator on the right is equated to 0 by the solution 25b. For this condition one obtains the specific inversion locus 26b of the intersecting circles. This is the eq. of two lines intersecting at the pole, $[A^2j^2/2C(b^2-a^2), 0]$, of slopes $\pm(b^2-a^2)^{\frac{1}{2}}/a$. In fact, these inter-

(a) $[x+A^2j^2/2C(b^2-a^2)]^2-a^2y^2/(b^2-a^2) = j^4[A^4-4BC(b^2-a^2)]/4C^2(b^2-a^2)^2$ (11-26)

(b) $[x+A^2j^2/2C(b^2-a^2)]^2 = a^2y^2/(b^2-a^2)$

secting lines are the asymptotes of a hyperbola of eccentricity b/a (limacon parameters). [Equating the bracketed expression to 0, as above, is the procedure for obtaining the eq. of the asymptotes of a hyperbola.] Since the eccentricity of a limacon in limacon parameters also is b/a, the hyperbola in question is the basis hyperbola and the mutually-inverting quartic circles are the inversions of the latter's asymptotes about a non-incident axial pole.

The Inversion Image Analysis of Axial Self-Inversions

Just as the general analysis of axial inversions of QBI quartics and cubics through inversion images revealed the essence of Inversion Taxonomy, so does a parallel approach to axial self-inversions expose the full picture of this phenomenon within the QBI superfamily.[Although the analysis is equivalent to one based on equating coefficients, it is simpler and its significance is more readily comprehended.]

For convenience, the inversion images of the 2nd and 3rd-generation conic axial-inversion quartics, 19a,b, are repeated here (inversion of the 1st-

	inversion images of conic axial-inversion quartics	generation	
(a)	$[x - (H/j^2)(j^2+hH)]^2 \mp a^2y^2/b^2 = a^2(H^2/j^2)^2$	2nd	(11-27)
(b)	$\{x + (J/j^4)[HJ(hH+j^2) - j^4]\}^2 \mp a^2y^2/b^2 = a^2(H^2J^2/j^4)^2$	3rd	

generation curve about the DP gives the basis conic). The 1st-generation curve is the locus obtained by inverting a central conic about an axial pole h, the 2nd-generation locus is obtained by inverting the 1st-generation curve about an axial pole, H, while J is the pole about which the 2nd-generation curve is inverted to obtain the 3rd generation.

Clearly, if the 3rd-generation axial-inversion locus (about the pole J) is identical to the 2nd-generation basis curve, i.e., if the 2nd-generation curve self-inverts, then the image conics obtained by inverting these curves about the DP should be congruent and coincident.

Since the eccentricities of all QBI curves derived by inversions of a given basis curve are identical to that of the basis curve (which also is evident from 27a,b), one need be concerned only with orientation, size, and location. Since the images of both the 2nd and 3rd-generation curves are seen to have the same orientation, the topics of their size and location are considered next.

Eqs. 27a,b are expressed in such a form that the right member of each is the square of the length of the semi-major axis. Accordingly, for self-inversion of the 2nd-generation basis curve, these quantities must be equal. This requirement leads to the simple condition $J = \pm j$. A parallel relationship holds for all successive generations. In other words, self-inversion of any generation of curves derived by successive axial inversions of a basis conic always occurs through a pole at unit distance from the DP or its homologue.

The DP is the unique point on the curve for which the above is true. In the cases of all other incident points, a point on one loop inverts to a point on the other loop. At the position where the two loops communicate (the DP), the two points have become coincident. Accordingly, the distance of one point from the inversion pole must equal its own inverse; only the unit of distance satisfies this requirement. [The question of the location of the pole of self-inversion of the inverse locus of a curve possessing a line of symmetry was dealt with specifically by Maleyx (1875); see also page 37, below.]

CIRCUMPOLAR MAXIM 19: *It is a necessary condition for axial self-inversion of a QBI curve that the unit value of distance be assigned to the distance between the pole of inversion and the double point.*

The existence of alternate values, $\pm j$, for J does not mean that the pole of inversion can lie on either side of the DP. The choice between these alternate signs for the subsequent analysis merely determines the orientation of the 2nd and 3rd-generation curves.

One now substitutes $J = +j$ in eq. 27b. For self-inversion, eqs. 27a and 27b must be identical. Orientation, size, and eccentricity already are identical, so it remains only to make the displacements from the origin the same by equating the displacements in the squared brackets on the left of 27a,b. These displacements will be the same when the relationship of eq. 28a holds.

(a) $(-H/j^2)(j^2+hH) = J[HJ(j^2+hH)-j^4]/j^4$ condition for equality of displacements of 27a,b (11-28)

(b) $2H^2h + 2Hj^2 - j^3 = 0$ eliminant of 28a

(c) $H = [-j^2 \pm j(j^2+2hj)^{\frac{1}{2}}]/2h$ roots of 28b

Eq. 28a yields the simple quadratic eq. 28b, with roots given by 28c. One now is free to choose any values of h and H that satisfy eqs. 28 and do not violate any prior assumption.

The choice $h = -j/2$ eliminates the radical and yields $H = j$. This means that if one inverts the centered basis central conic about a pole $h = -j/2$ from center, one obtains a 1st-generation quartic, which if inverted about $H = j$ gives a 2nd-generation quartic, which self-inverts about a pole $J = j$.

If one substitutes for h, H, and J in eqs. 27a,b, one finds that the inversion images are, indeed, identical, confirming that the 2nd and 3rd-generation axial-inversion loci self-invert to one another. But one further ascertains that, under these conditions, the 1st-generation axial-inversion locus is identical with those of the 2nd and 3rd generations, and that all 3 inversion images are identical with one another and with the basis conic. In other words, the proof obtained is more inclusive than the proof sought.

It was sought to demonstrate that poles h, H, and J exist such that the 2nd and 3rd-generation axial inversions of conics would give congruent and coincident inversion images and, thus, were self-inverting. What was achieved following this route was a proof that *all* non-central axial inversions of central conics self-invert.

[Working with different methods, and taking a different point of view, Maleyx (1875) advanced a theorem to the effect that the inverse of any curve possessing a line of symmetry is, in general, self-inverting. Though there are exceptions to this theorem, insofar as axial inversions are concerned, these are encompassed by Maxim 18: a pole of self-inversion is gained only if a line of symmetry is lost.]

CIRCUMPOLAR MAXIM 20: *All non-central axial inversions of central conics self-invert.*

With these results in hand, the characteristics of self-inverting axial QBI curves now are evident. Taking the hyperbolic species as an example, inversions of hyperbolas about any axial pole between the vertices (except the center) give self-inverting two-looped quartics with opposed non-congruent loops. Inversions about the vertices give the self-inverting hyperbola axial vertex cubics, while inversions about any "interior" axial pole give self-inverting limacon-like two-looped quartics (i.e., with an internalized loop). The self-inverting curves discussed above (eq. 22a) belong to the latter group, the *post-vertex group*. Inversions of central conics about their traditional foci, of course, give limacons.

The limacon thus is seen to be merely the special case of an interior axial inversion of conics for which the pole of inversion is the traditional focus. In view of the above findings, it seems clear that the distinctive features of limacons (see Table XII-3) relative to other limacon-like QBI curves must be sought primarily in the realm of their circumpolar (and circumlinear) symmetry, not in the realm of their inversion properties (see Chapter XII).

If $H = J = j$ and $h = -j/2$ are substituted in eq. 18b,c, or d for the hyperbolic species, one obtains the general eq. 29a for hyperbolic axial QBI curves that self-invert about the axial pole at $x = j$. This eq. is derived from and employs the parameters of the basis central conic inverted about the pole $x = -j/2$.

self-inverting hyperbolic axial QBI curves

(a) $\quad b^2(j^2/4-a^2)(x^2+y^2)^2-b^2j^3x(x^2+y^2)+j^4(b^2x^2-a^2y^2) = 0$ $\hspace{2cm}$ (11-29)

(b) $\quad (3b^2/4)(x^2+y^2)^2+ab^2x(x^2+y^2)-a^2(b^2x^2-a^2y^2) = 0$ \quad 29a for a = j (inter-vertex group, opposed loops)

(c) $\quad 3b^2r^2/4 + ab^2r\cos\theta - a^2[(b^2+a^2)\cos^2\theta-a^2] = 0$ \quad 29b in polar coordinates

(d) $\quad 3x^2/4 + jx - j^2 = 0$ $\hspace{3cm}$ eq. of vertices of 29b

CIRCUMPOLAR MAXIM 21: *Excepting central conics, central quartics, and axial QBI curves of unit eccentricity, all axial QBI curves self-invert.*

The group of hyperbolic axial inversions represented by eq. 29a depends upon the choice of j relative to the semi-transverse axis of the basis hyperbola; this illustrates the fact that it is j and a that are fundamentally inter-dependent in relation to transverse axis inversions (as opposed to j and b). Thus, if j is chosen to be less than 2a, the axial pole x = -j/2 lies between the vertices, and the curve is in the hyperbolic *inter-vertex group* of axial inversions with opposed non-congruent loops, for which the cubic and quartic terms have the same sign. If j is taken to be equal to 2a, the quartic term vanishes and eq. 29a represents hyperbola axial vertex cubics. If j is taken to be greater than 2a, the curves fall into the *post-vertex group* with an internalized loop, and the quartic and cubic terms have opposite signs.

The choice j = a in the section on *Self-Inverting Limacon-Like Axial-Inversion Quartics* was equivalent to the latter choice for, by placing the pole within a loop, it led to limacon-like inversion loci. Had a value of j greater than 2a been selected, curves in the inter-vertex group would have been obtained. Since an example of self-inverting curves in the post-vertex group already has been treated, the first case is examined here.

Letting j = a yields eq. 29b for curves in the inter-vertex group. Con-verting to polar coordinates gives 29c. All the curves in this group are centered at the DP at -a/2 = -j/2 relative to the center of the basis conic, and all self-invert about the pole j = a relative to the DP. With the parameter a fixed at unity, the vertices are fixed at x = -2j and 2j/3, as given by 29d.

Inversion Taxonomy of QBI Curves of
 Unit Eccentricity

Considerable prominence was given to the parabola in early Chapters. In proper perspective, however, the parabola and its axial inversions comprise but one group among an infinite number of groups of axial QBI curves (each characterized by a different eccentricity), all the other groups of which belong to either elliptical or hyperbolic species. But despite its minor con-stituency, the parabola and its axial inversions provide features of unusual interest, that now are treated briefly.

The failure of the parabola itself to self-invert already has been accounted
for purely on the basis of the algebra of the inversion transformation (see
Chapters VIII and XIV). The present treatment of axial QBI curves of unit
eccentricity deals further with the question of self-inversion; the fact that
these curves do not self-invert is confirmed in 3 different ways. These have to
do with: (a) the location of the homologue of the focus of self-inversion of
axial curves of non-unit eccentricity; (b) examination of the coefficients in
the eqs. of successive inversion generations; and (c) reversals of the orien-
tation of the loci of successive inversion generations and their inversion
images.

Because some of the eqs. of the axial inversion loci of the parabola are of
unusual form and interest, these loci are cast about both the DP homologue and
the homologue of the $-(a+b)$ vertex of limacons. The standard parabola $y^2 = 4ax$
is inverted about a pole at $x = h$ (eq. 30a) yielding the 1st-generation
axial-inversion locus, 30b, with vertices at $x = 0$ and $x = -j^2/h$.

(a) $y^2 = 4a(x+h)$ standard parabola with vertex at $-h$ (11-30)

 axial inversion loci of 30a generation

(b) $4ah(x^2+y^2)^2 + 4aj^2x(x^2+y^2) = j^4y^2$ 1st

(c) $4aH^3(hH+j^2)(x^2+y^2)^2 - 4aH^2j^4x(x^2+y^2) = j^8y^2$ 2nd

(d) $y^2 = (-4aH^2/j^2)[x-(hH^2/j^2+H)]$ inversion image of 30c

Just as was found to be the case for central conics, regardless of the
location of the pole of inversion of the basis curve, the inversion locus is
cast about the DP homologue at $h = 0$. This occurs because points at infinity
always invert to the pole of inversion, which is the reciprocal inversion pole
for the inverse locus. Since, for the parabola, the axial point at infinity
is a triple focus (the pole of coincidence of the center, the second vertex,
and the second traditional focus), and in consideration of Maxims 9 and 17,
the reciprocal inversion pole is a triple focus.

In the cardioid, the other two foci that are coincident with the DP homo-
logue ($h = 0$) at the cusp are the variable focus at $(a^2-b^2)/2b$ (which is a
generic double-focus), and the $(a-b)$ vertex focus. This variable focus is the

pole of self-inversion, and since it always becomes incident upon axial inversion loci of unit eccentricity (see Chapter XII, *The Foci At the Double Point Homologue*), the failure of these axial QBI quartics to self-invert is understood readily in terms of the two factors: (a) a vertex inversion of a quartic cannot yield another quartic; and (b) a curve consisting of only a single oval cannot self-invert about an incident point.

The eq. of the 1st-generation axial-inversion quartic 30b also is cast about the $-(a+b)$ vertex homologue at $-j^2/h$, yielding 31a. Both of the 1st-generation eqs., 30b and 31a, now are inverted about an axial pole H and recast about the homologous focus at $-j^2/H$ $(H \neq 0)$, yielding the two corresponding eqs. for the 2nd-generation quartics 30c and 31b, with the latter having highly interesting form.

the axial-inversion loci of eqs. 30 cast about
the $-(a+b)$ vertex homologue
generation

(a) $4ah^3(x^2+y^2)^2-12ah^2j^2x(x^2+y^2)+8ahj^4x^2-h^2j^4y^2-4aj^6x = 0$ 1st (11-31)

(b) $4aH^3(hH-j^2)^3(x^2+y^2)^2+12aj^4H^2(hH-j^2)^2x(x^2+y^2) +$ 2nd

$4aj^8H(hH-j^2)(x^2+y^2)+8aj^8H(hH-j^2)x^2-h^2H^2j^8y^2+4aj^{12}x = 0$

(c) $(A^8J^4+B^9J^3+C^{10}J^2+JF^{11}+D^{10}J^2)(x^2+y^2)^2 +$ 3rd

$(4j^2J^3A^8+3j^2J^2B^9+2j^2JD^{10}+j^2F^{11}+2j^2JC^{10})x(x^2+y^2) +$

$(2j^2J^4A^8+j^4JB^9+j^4C^{10})(x^2+y^2)+(4j^4J^2A^8+2j^4JB^9+j^4D^{10})x^2$

$- h^2j^{12}y^2+(4A^8j^6J+B^9j^6)x + A^8j^8 = 0$

(c') $A^8 = 4aH(h^3H^3-3h^2H^2j^2+3hHj^4-j^6)$, $B^9 = 12aj^4(h^2H^2-2hHj^2+j^4)$,

$C^{10} = 4aj^8(h-j^2/h)$, $D^{10} = 8aj^8(h-j^2/h)$, $F^{11} = 4aj^{12}/H^2$

(d) $J = -j^4/H(hH-j^2)$ condition for J of 31c being at the DP homologue

(e) $y^2 = [-4a(hH-j^2)^2/h^2j^2][x-h(hH-j^2)/j^2]$ inversion image of 31b
(eliminant of 31c,d)

Comparisons of 30b with 30c and of 31a with 31b reveal that equality of the coefficients of corresponding terms of the 1st and 2nd generations of both series cannot occur, thereby ruling out the possibility of self-inversion of

the 1st generation. The same situation is found to obtain for all pairs of successive generations. It also is evident from 31b that if the pole H about which 31a is inverted stands in the relation $hH = j^2$ to the pole h about which the basis parabola was inverted, the basis curve is recovered in 31b. This is the equivalent condition to inverting 30b about the DP homologue (about which it is cast) and recovering the basis curve.

Consider now inversion images produced by inverting the 2nd-generation curves. For eq. 30c, cast about the DP homologue, one simply inverts through this pole, yielding 30d, which is seen to have opposed orientation to the basis curve. For eq. 31b, which is cast about the -(a+b) vertex homologue, one inverts about a pole at $x = J$, giving the 3rd-generation curve 31c. Eq. 31d is the condition for J being coincident with the DP homologue. When 31d is satisfied, 31c becomes the inversion image, 31e, which also is seen to have an orientation opposed to that of the basis parabola.

These observations reveal another fundamental obstacle to the self-inversion of *axial* QBI curves of unit eccentricity. Thus, the finding that the orientation of the inversion images of 2nd-generation parabola axial-inversion quartics is opposed to that of the basis parabola simply is an expression of the fact that the relative orientation of parabola axial inversion loci reverses in each successive inversion about axial poles (except the DP homologue, inversion about which gives an inversion image of the basis parabola).

These reversals are readily visualized in terms of the inversion of cusped parabola axial-inversion quartics. It is evident that the process of axial inversion to another cusped curve reverses the orientation of the cusp. Because of the occurrence of such reversals in successive generations, self-inversion of parabola axial-inversion quartics (and the cissoid of Diocles) is, by definition, impossible. [This stricture does not apply to inversions of the axial-inversion cubics and quartics of central conics, because of the influence of the second line of symmetry of the basis curves on their axial inversion loci; see Maxim 18 and treatment below.]

The above considerations apply solely to *axial* inversions of QBI curves of unit eccentricity. In non-axial inversions of these curves the line of symmetry is lost in the inversion loci. Following Maxim 18, all of these inversion loci

self-invert. The fact that non-axial inversions of the parabola self-invert has been known at least since the time of Maleyx (1875).

The Form of Curves In the Axially-Symmetrical
Ensemble of Unit Eccentricity

The form of curves belonging to the ensemble of unit eccentricity now is considered. The non-vertex inversions, i.e., all curves other than the parabola and the cissoid of Diocles, are of three types: (a) cardioid-like curves are obtained by inverting the cardioid about axial poles external to the cusp; (b) teardrop-like curves are obtained by inverting about axial poles interior to the cardioid; and (c) circle-like curves, indented at one extremity of the axis are obtained by inverting about axial points exterior to the -(a+b) vertex. Curves (a) resemble two full coalesced circles indented to form a cusp at one axial point, whereas curves (c) resemble an indented single circle.

According to Maxim 17, these three types of curves are generated by axial inversions of any axial QBI curve of unit eccentricity. This leads to interesting questions, one of which is the following. Since the parabola also inverts to all three types of curves but has no demarcating 2nd vertex, as does the cardioid, where are the axial divisions between the poles that give the three different types of inversion loci? The answer is that the traditional focus demarcates between poles that yield the circle-like curves and the cardioid-like curves, while the point at infinity plays the role of the cardioid cusp in demarcating between poles that give cardioid-like and teardrop-like curves.

Inversions About the Second Line of Symmetry
and Points In the Plane

In the preceding treatments of the inversions of QBI curves, relevant Maxims, statements, and findings generally have been qualified with the adjective *axial*, and it was stated that this qualification was meant to specify the major or transverse axis. Most detailed inversion and circumpolar symmetry analyses have been confined almost entirely to poles on the major or transverse axis.

When one enters the domain of inversions about points in the plane, the

studies of Maleyx (1875) and Königs (1892) become particularly relevant. The most pertinent findings are those of Maleyx. Following Tweedie's (1902) translations:

Theorem I. The inverse of any curve possessing a line of symmetry is, in general, self-inverting.

Corollary. The inverse of a central conic is, in general, self-inverting in at least two different ways, for a central conic possesses two lines of symmetry.

It can be anticipated that findings for the inversion transformation about poles on the minor and conjugate axes and for the corresponding inverse curves will have close parallels with the findings and Maxims for major and transverse axis inversions of central conics. Inversion loci about poles on the minor and conjugate axes, of course, will fall into a different family and different genera from any of those that have been treated.

Non-axial inversions have no line of symmetry and, following the above Maleyx Corollary and Maxim 18, they have two poles of self-inversion. The latter lie on orthogonal axes that pass through the inversion pole of the basis curve (Maleyx, 1875) and are parallel to the lines of symmetry thereof --the *axial covert focal loci*. A detailed inversion analysis of non-axial QBI curves has not been carried out, but the general eqs. for these loci are VIII-22 (see also eqs. XII-72-75).

[An algebraic proof of the self-inversion of non-axial inversions of any curve with a line of symmetry is tedious but straightforward. First one takes any arbitrary ensemble of points reflected in a line. Pairwise inversion of these points about any non-axial pole for any value of the unit of linear dimension yields pairs of inverse poles (the inverse ensemble). Lines joining the members of each pair of inverse poles intersect at a common pole. This pole is incident upon a line passing through the pole of inversion and orthogonal to the line of symmetry of the basis ensemble. The inverse ensemble self-inverts about this common pole of intersection. If x is the distance from the line of symmetry to the pole of inversion and j is the unit of distance for the inversion, the common pole of intersection lies on the orthogonal line at a distance $(x-j^2/2x)$ from the line of symmetry. The unit of distance for self-inversion of the inverse ensemble about the common pole of intersection is $j^2/2x$.]

Introduction

Analyses of the circumpolar symmetry of QBI quartics bring to light several crucial and, in some respects, surprising findings regarding the axial foci of these curves and relationships between their circumpolar symmetry and inversion properties. Not the least of these is the fact that all axial QBI curves except conics and central quartics have 6 axial foci. The general significance of these findings remains to be evaluated, but their specific implications are clear. Attention is confined primarily to the significance of the findings within the QBI superfamily. The analyses also reveal and emphasize the unique circumpolar symmetry properties of limacons and conic axial vertex cubics.

Before beginning the analyses, the general locational terminology of QBI quartics is outlined and some curves of interest are listed. For purposes of reference, the QBI quartics are divided into locational subgroups as follows. Since the treatment will concentrate on the hyperbolic species (e > 1), when not

The Elliptical Species		The Hyperbolic Species	
inter-vertex	post-focal	inter-vertex	post-vertex
central	focus-vertex	central	vertex-focus
focal	post-vertex	pre-vertex	focal
center-focus			post-focal
(pre-focal)		pre-focal	
focus-vertex		central	
		inter-vertex	
		vertex-focus	

otherwise specified, references will be to the hyperbolic subdivisions. Where necessary, the designations will be accompanied by the qualification *hyperbolic* or *elliptical*.

In the Inventory of Quartics (Table XII-1), eqs. 1-3 are the general eqs. of axial QBI quartics (and cubics) derived from conics (conic parameters) that have been encountered in the foregoing. Eq. 1b is that of the parabola axial

Table XII-1. Inventory of Quartics

QBI axial-inversion quartics and cubics

DP
(1st form)

$$b^2(h^2-a^2)(x^2+y^2)^2 + 2b^2hj^2x(x^2+y^2) + j^4(b^2x^2\mp a^2y^2) = 0 \qquad (12\text{-}1a)$$

cusp

$$4ah(x^2+y^2)^2 + 4aj^2x(x^2+y^2) - j^4y^2 = 0 \qquad (12\text{-}1b)$$

DP
(2nd form)

$$[x^2+y^2+hj^2x/(h^2-a^2)]^2 = a^2j^4[b^2x^2\pm(h^2-a^2)y^2]/b^2(h^2-a^2)^2 \qquad (12\text{-}2)$$

Pole at H

$$b^2(h^2-a^2)(x^2+y^2)^2 + 2b^2[2H(h^2-a^2)+hj^2]x(x^2+y^2) + \qquad (12\text{-}3)$$

$$2b^2H[H(h^2-a^2)+hj^2](x^2+y^2) + b^2[4H^2(h^2-a^2)+4hHj^2+j^4]x^2 \mp$$

$$a^2j^4y^2 + 2Hb^2[2H^2(h^2-a^2)+3hHj^2+j^4]x +$$

$$b^2H^2[H^2(h^2-a^2)+2hHj^2+j^4] = 0$$

Limacons

DP
(2nd form)

$$[x^2+y^2\pm(a^2\pm b^2)^{\frac{1}{2}}j^2x/b^2]^2 = a^2j^4(x^2+y^2)/b^4 \qquad \text{conic parameters} \qquad (12\text{-}4a)$$

$$[x^2+y^2+bx]^2 = a^2(x^2+y^2) \qquad \text{limacon parameters} \qquad (12\text{-}4b)$$

Focus of
self-
inversion

$$[x^2+y^2+a^2x/b+(a^2-b^2)^2/4b^2]^2 = b^2(x^2+y^2) \qquad \text{limacon parameters} \qquad (12\text{-}4c)$$

Mutually-inverting quartic circles

$$A^4(x^2+y^2)^2 + 4A^2C(b^2-a^2)x(x^2+y^2) + 4C^2(b^2-a^2)[(b^2-a^2)x^2-a^2y^2] = 0 \qquad (12\text{-}5)$$

Inversion of Cayley's sextic about the DP

$$27(x^2+y^2)^2/4 - 9(x^2+y^2)(x^2+2ax-2a^2) - 8ax(4x^2-6ax-3a^2) - 4a^4 = 0 \qquad (12\text{-}6)$$

Table XII-1. Inventory of Quartics (continued)

Inversion of the folium of Descartes about the DP

$$(x^4-y^4) = bx(x^2+3y^2) \qquad\qquad\qquad (12\text{-}7)$$

Polar-circular linear Cartesians

$$\{(x^2+y^2)(1-C^2) + [R^2-C^2d(d-2x)]\}^2 = 4R^2(x^2+y^2) \qquad (u = Cv) \qquad (12\text{-}8)$$

Bipolar Parabolic Cartesians

$$(x^2+y^2-2dx+d^2)^2 = C^2d^2(x^2+y^2) \qquad\qquad (u^2 = Cdv) \qquad (12\text{-}9)$$

Bipolar linear Cartesians

$$[(x^2+y^2)(A^2-B^2)-2A^2dx+d^2(A^2-C^2)]^2 = 4B^2C^2d^2(x^2+y^2) \qquad (Bu+Av = Cd) \qquad (12\text{-}10)$$

Cassinians

$$(x^2+y^2)^2 - d^2(x^2-y^2)/2 = d^4(C^2 - 1/16) \qquad (uv = Cd^2) \qquad (12\text{-}11)$$

[Focal conditions that define imaginary focal loci play a prominent role in this Chapter. The practice is followed of designating such focal loci after existing homologous real loci that generally exist in a co-species or upon the orthogonal line of symmetry. For example, the *imaginary asymptotes* of the ellipse are defined by the homologous conditions for ellipses that define the real asymptotes of hyperbolas. Similarly, the *imaginary vertices* of hyperbolas and hyperbolic central quartics are defined by the homologous conditions on the simple intercept eq. for a point on the conjugate axis (the constant-condition), that define the real vertices in the corresponding eq. for a point on the transverse axis of hyperbolic species and the real vertices for the minor axes of elliptical species. But the use of these designations is not meant to imply the existence of geometrically defined imaginary counterparts.]

inversion quartics. All central conic axial inversion quartics and cubics can be represented by eq. la, for which the pole is at the DP or its homologue. The same curves are represented by eq. 2, cast about the same pole, but with the terms grouped in a manner that facilitates comparisons with the Cartesians of eqs. 8-10. Eq. 3 is for the same curves represented by eqs. la and 2 but cast about any axial pole H. Eqs. 4a,b are special cases of eq. 2 for limacons $(h^2 = a^2 \pm b^2)$, i.e., for inversion about the traditional conic focus. Eq. 4c is the eq. of a limacon cast about the focus of self-inversion. Eq. lb represents all axial inversions of the parabola, while eq. 5 is that of mutually-inverting quartic circles.

The utility of the form of eq. 3 is that various properties and special cases of axial QBI curves can be examined through determinations of the conditions under which the coefficients of the various terms vanish. For example, setting the constant term equal to 0 gives the locations of the vertices at H = 0 and $H = -j^2/(h \pm a)$, while setting the coefficient of the cubic term equal to 0 gives the conditions obtaining in pseudo-exchange-limacons, the eqs. for which (eq. XI-15c) have no cubic term when cast about the loop vertex. The latter condition, in conjunction with the condition for the vertices, identifies the poles at h = ±2a as those about which inversions give pseudo-exchange-limacons. In other words, when central conics are inverted about the reflection of the center in the vertex, quartics of special symmetry--*pseudo-exchange-limacons*--are obtained. This group intersects the limacons for e = 2, i.e., at the 2cosθ limacon, the special properties of which have already been noted.

Eq. 6 is the quartic"hyperbola"obtained by inverting Cayley's sextic about the DP. Though this curve is not a member of the QBI superfamily, it is of interest because Cayley's sextic is a quadratic-based pedal curve (see Chapter XIII). It is the pedal of the cardioid about the cusp which, in turn, is the pedal of the circle about an incident pole. The quartic"hyperbola"obtained by inverting the folium of Descartes about its DP (eq. 7) is of interest because of the affinity of this folium to the conic axial vertex cubics (see Chapter IX), including the fact that it was shown by Maclaurin to go over to the trisectrix of Maclaurin by an affine transformation.

Eqs. 8 through 10 are not, and cannot be, QBI curves because the ovals of their 2-oval members are dissociated. No curve possessing two ovals that are

not in communication (any type of contact) can be a QBI curve. For the special
case, $C = 4$, of eq. 9, an incipient loop (formed by "inpocketing" at one
vertex of a single oval) closes to form the curve of demarcation (Table VIII-1),
which is the equilateral limacon.

Figs.
2-1
f_1-f_3

Likewise, the bipolar linear Cartesians of eq. 10, which generally have 8 dis-
crete foci, become limacons when $A^2 = C^2$. The corresponding condition for the
polar-circular linear Cartesians of eq. 8 to represent limacons is $R^2 = C^2d^2$,
while for $C = 1$ they represent central conics. Accordingly, both types of
linear Cartesians (eqs. 8 and 10) represent limacons and central conics. The
curves described by eqs. 8 and 10 also overlap for other quartics, namely,
those bipolar linear Cartesians for which $2A^2 = B^2+C^2$. Note that when all 3
eqs. of Cartesians (and eq. 4b) are converted to polar coordinates, the members
of both sides become perfect squares. Both roots of these eqs. define an identi-
cal curve. However, the individual root eqs. do not represent both positive and
negative intercepts and will not lead to algebraically complete transform eqs.
(see Chapter VII, *Negative Intercepts, Trivial Transforms, the Degree of Trans-
forms, and the Duality of 0° and 180° Transforms*, and Chapter X, *Analytical
Transforms Versus Geometrical Expectations*).

2-1e
2-1
d_1,d_2

Eq. 11 is that of Cassinians, defined by the bipolar equilateral hyperbolic
eq. $uv = Cd$. These curves are of exceptional interest for two reasons: (1) for
$C = \frac{1}{4}$ the curve of demarcation is an equilateral lemniscate (both a central
quartic and limacon focal-inversion quartic); and (2) subspecies of the single-
oval genus $(C > \frac{1}{4})$ self-invert about the DP homologue at $90°$ (Table V-1), while
subspecies of the two-oval genus $(C < \frac{1}{4})$ self-invert at both $0°$ and $180°$ (see
below, α-*Self-Inversion* and Chapter XIV, *Self-Inversion At 90°*, et seq.).

Figs.
2-5a
2-5
b-e

The Simple Intercept Equation

Focal Conditions

The simple intercept eq. of all axial QBI quartics and cubics except those
of unit eccentricity, derived from eq. 1, 2, or 3, is 12. This is cast about a

$$[4b^2(h^2-a^2)H^2 + 4b^2hj^2H + j^4(b^2\pm a^2)]x^2\cos^2\theta + \tag{12-12}$$
$$2b^2x\{[2(h^2-a^2)H+hj^2]x^2 + H[2(h^2-a^2)H^2+3hj^2H+j^4]\}\cos\theta +$$
$$b^2(h^2-a^2)x^4 + [2b^2(h^2-a^2)H^2+2b^2hj^2H\mp a^2j^4]x^2 + b^2H^2[(h^2-a^2)H^2+2hj^2H+j^4] = 0$$

pole H on the major or transverse axis (corresponding to the major or transverse axis of the basis central conic). Three focal conditions and 3 potential focal conditions are evident from eq. 12. All play focal roles in the symmetry analyses of one or another of the axial (line of symmetry) QBI curves but only the focal conditions do so for all member groups. Of the three universal focal conditions, the highest ranking is H = 0, which delines the DP and its homologues. For this condition, both the constant term and the constant portion of the $\cos\theta$ term vanish, allowing an x^2 to be be factored out of eq. 12, with consequent reduction of the degree of the transforms. The lowest ranking of the 3 focal conditions is that on the bracketed portion of the constant term (13a), which yields the loop vertices at $-j^2/(h\pm a)$. For this condition an x

(a) $(h^2-a^2)H^2 + 2hj^2H + j^4 = 0$ constant-condition (12-13)
 (focal)

(b) $4b^2(h^2-a^2)H^2 + 4b^2hj^2H + j^4(b^2\pm a^2) = 0$ $\cos^2\theta$-condition
 (focal)

(c) $H = \dfrac{-bhj^2 \pm aj^2[b^2\mp(h^2-a^2)]^{\frac{1}{2}}}{2b(h^2-a^2)}$ solutions to 13b

(d) $2(h^2-a^2)H + hj^2 = 0$ $\cos\theta-x^2$ condition
 (potentially focal)

(e) $2(h^2-a^2)H^2 + 3hj^2H + j^4 = 0$ $\cos\theta$-constant condition
 (potentially focal)

(f) $2b^2(h^2-a^2)H^2 + 2b^2hj^2H \mp a^2j^4 = 0$ x^2-condition
 (potentially focal)

(f') $H = \dfrac{-bhj^2 \pm j^2[b^2h^2\pm 2a^2(h^2-a^2)]^{\frac{1}{2}}}{2b(h^2-a^2)}$ solutions to 13f

factors from eq. 12.

Having located the loop vertices and DP, having knowledge that all QBI quartics except central quartics and those of unit eccentricity self-invert (Maxims 20 and 21), and knowing that the pole of self-inversion must lie at unit distance from the DP (Maxim 19), one readily derives the location of the pole of self-inversion to be at $-j^2/2h$, whence the unit distance is $j^2/2h$. [If γ is the abscissa of the pole of self-inversion and α and β the abscissae of the vertices, then one must have $(\gamma-\alpha)(\gamma-\beta) = \gamma^2$, or $\gamma = \alpha\beta/(\alpha+\beta)$.]

Accordingly, the 3 foci identified by the conditions treated above, taken

together with the focus of self-inversion, account for 4 axial foci in all
axial QBI curves that self-invert. It therefore came as a surprise to discover
that the 3rd focal condition--the $\cos^2\theta$-condition--defines 2 additional axial
foci in almost all axial QBI curves. However, only those foci in the post-
focal elliptical species and pre-focal hyperbolic species are real (the 3rd
focal condition also defines 2 real foci in the pre-focal parabolic species).
This brings the total number of real axial foci in most groups to 6. Inspection
of 13c reveals that its roots for elliptical species are complex when
$h^2 < a^2-b^2$ (lower sign) and those for hyperbolic species are complex for
$h^2 > a^2+b^2$ (upper sign).

The $\cos^2\theta$-condition was known to define 2 axial "loop foci" (see note below)
in hyperbolic central quartics, but in hyperbola axial vertex cubics and
limacons--the two groups investigated most extensively--it defines only one
axial focus, the $(a+b)/2$ and $-\frac{1}{2}b$ variable foci, respectively. The basis
for this difference now is seen to lie in the exceptional properties of the
latter two genera, while the situation in the pre-focal hyperbolic central
quartics is typical of the cases for which the roots of 13c are real. The basis
for the specification of but a single focus in limacons is that the radical
vanishes for $h^2 = a^2 \pm b^2$, while in central conic axial vertex cubics it is
that one of the two foci lies at infinity.
[The "loop foci" of hyperbolic central quartics referred to above actually
are *variable* foci. They are within the loops for $a^2 < 3b^2$, incident upon the
vertices for $a^2 = 3b^2$, and external to the loops for $a^2 > 3b^2$. In elliptical
central quartics the "loop foci" lie on the minor axis. They lie within the
loop for $b^2 < 3a^2$, incident upon the vertices for $b^2 = 3a^2$, and external
to the loop for $b^2 > 3a^2$; see Appendix II.]

Potential Focal Conditions and Eccentricity Independence

The first of the potential focal conditions, 13d, is the $\cos\theta$-x^2 condition
of eq. 12, wherein the x^2 portion of the $\cos\theta$ term vanishes. Being independent
of the b parameter of the basis curve, this condition is independent of
eccentricity. It becomes focal in limacons and central quartics. For the latter
it yields the center, while for the former it yields the $-\frac{1}{2}b$ variable focus,
in both cases duplicating a focal condition of the corresponding simple intercept
eq. (bear in mind that eqs. 1, 2, 3, 4a, and 12 employ basis conic parameters).

The second potential focal condition, which also is independent of eccentricity, is the $\cos\theta$-constant condition, 13e. For the central quartics this condition becomes $H = \pm j^2/2^{\frac{1}{2}}a$, which coincides with the "loop foci" in the equilateral lemniscate. The general expression for the location of central quartic "loop foci" is $H = \pm j^2(b^2 \pm a^2)^{\frac{1}{2}}/2ab$ (see Appendix II, *Inventory of Simple Intercept Equations*).

The last of the potential focal conditions is the x^2-condition, 13f,f'. But this condition is eccentricity-dependent. One of the poles defined by the x^2-condition in hyperbolic species always is on the positive side of the DP (eq. 13f' with both upper alternate signs); in the conic axial vertex cubics this pole is the asymptote-point focus, the location of which, it will be recalled, also is eccentricity-dependent (because $h = \pm a$ in conic axial vertex cubic parameters corresponds to $h = \pm aj^2/2b$ in central conic parameters).

The previous analyses of the circumpolar symmetry of axial QBI curves were relatively straightforward. The central conic axial vertex cubics were found to self-invert through the loop vertex, with the pole of self-inversion being defined by a condition on the simple intercept eq. for a point on the line of symmetry. Similarly, limacons self-invert through a focus defined by the *radicand constant-condition* of the simple intercept format (the condition obtained by setting the constant term of the radicand of the simple intercept format equal to 0). Central conics (excluding the circle) and the parabola do not self-invert, and these, together with axial QBI curves of unit eccentricity, were recognized to be exceptional in this regard for reasons already discussed. All other QBI curves were shown to self-invert. All 5 of the above groups were believed to possess 5 axial foci.

The expectation was that the pole of self-inversion of other axial QBI curves would be specified by one or another condition for the vanishing of coefficients of the simple intercept eq. or for the simplification of the radicand of the simple intercept format, and that all would be found to have 5 axial foci. It develops, instead, that all 5 of the above-mentioned groups of curves are exceptional, and that some of the fundamental findings relating to them are completely misleading insofar as other axial QBI curves are concerned.

Thus, it is now realized that QBI curves generally have 6 axial foci, two of which are imaginary in roughly half of all genera. Limacons, central conic axial vertex cubics, and axial quartics of unit eccentricity also have 6 axial foci.

Moreover, the former two groups, together with the eccentricity-dependent self-inverters (see below) and mutually-inverting quartic circles, are the only genera of axial QBI curves that have *generic double-foci of self-inversion*, i.e., generic double-foci that include a focus of non-trivial self-inversion which is coincident with a pole specified by a condition on the simple intercept eq. or format (a trivial self-inversion is $xy = 0$). In all other self-inverting genera, the 5 foci defined by conditions on the simple intercept eq. are distinct from the 6th focus--the focus of self-inversion--which is defined by an *intercept transform condition*, i.e., a condition on the 0° or 180° intercept transform (namely, the condition reducing the transform to the form $xy = $ constant $\neq 0$). Only for the 4 genera mentioned above, and the circle and intersecting lines, is the focus of self-inversion defined by the intercept transform condition coincident with one of the other axial foci.

Plots of Focal and Potential Focal Poles

In order to elucidate the relationships between focal loci, the locations of all the focal and potential focal poles were plotted. Two types of plots were made; in both, all locations were referred to the DP as origin. One plot was for a constant location of the pole of inversion, h, of the basis conic, but for different eccentricities; the other was at constant eccentricity for differing values of h. As examples, the results are given for: (a) hyperbolic subspecies with opposed loops and eccentricities from 1 to $10^{\frac{1}{2}}$, obtained by inverting the basis hyperbola about a pole at $h = \frac{1}{2}a$; and (b) all types of hyperbolic subspecies of eccentricity $5^{\frac{1}{2}}$ inverted about poles from $h = 0$ to $h = 3a$ (which includes subspecies with both opposed and internalized loops).

Taking first the case with the fixed pole of inversion at $h = \frac{1}{2}a$, it is found that one vertex is at $x = -2a/3$ and the other at $x = 2a$, for all eccentricities. This is the basis for one of the characteristic features of axial QBI curves: for any given location of the pole of inversion dependent only on the parameter a (as opposed to an eccentricity-dependent location), for example $h = na$, "n" any real number, the ratio of the axial diameters of the loops is constant at $|(h+a)/(h-a)|$, for all values of eccentricity and all values of n. For example, for pseudo-exchange-limacons ($h = 2a$) the ratio is 3/1, while for the hyperbola axial vertex cubics it is infinite.

This ratio is not constant for limacons because they do not have a "fixed"

pole of inversion; the location $h^2 = a^2 \pm b^2$ is variable and depends upon eccentricity, yielding a variable ratio of the loop diameters, $|(a-b)/(a+b)|$. Thus, expressed in units of a, the location of the pole of inversion of a conic that yields a limacon of a given eccentricity is different from that which yields a limacon of any other eccentricity (even though the pole always is at the conic traditional focus).

The same situation--enabling one to specify a constant location of the potential focal pole for all values of eccentricity--holds for both the $\cos\theta$-constant potential focal condition, 14a, and the $\cos\theta-x^2$ potential focal condition, 14b. The former gives locations at $H = -0.4547a$ and $+1.4547a$, and the

(a) $\quad H = j^2[-3h\pm(h^2+8a^2)^{\frac{1}{2}}]/4(h^2-a^2)$
$\qquad \cos\theta$-constant condition
\qquad (potentially focal) \qquad (12-14)

(b) $\quad H = -hj^2/2(h^2-a^2)$
$\qquad \cos\theta-x^2$ condition
\qquad (potentially focal)

(c) $\quad H = j^2\{-bh\pm[b^2h^2\pm2a^2(h^2-a^2)]^{\frac{1}{2}}\}/2b(h^2-a^2)$
$\qquad x^2$-condition
\qquad (potentially focal)

latter at $H = a/3$ (letting $j = a$). The x^2 coefficient gives a potential focal condition, 14c, which is eccentricity-dependent, but which gives imaginary values of H for $h = \frac{1}{2}a$ and $e < 7^{\frac{1}{2}}$. At the latter value of e it gives a single pole at $H = a/3$. As e increases, the condition becomes two-valued, with the location of one pole gradually decreasing from the value $a/3$ and the other increasing from it. At $e = 10^{\frac{1}{2}}$ one pole is at $H = +0.5258a$ and the other is at $H = +0.1409a$.

The last two poles defined by the simple intercept eq. are focal poles yielded by the $\cos^2\theta$-condition. These are undefined for $e = 1$ because the basis curves for eq. 12 are central conics. As e increases from 1, they approach the DP monotonically from great axial distances outside the loops, one from the positive, the other from the negative side. At $e = 1.0198, 1.1180$, and 1.4144 the poles are at $H = +3.2961a$ and $-2.6294a$, $+1.6667a$ and $-a$, and $+1.2153a$ and $-0.5486a$, respectively.

Lastly, the eccentricity-independent pole of self-inversion is considered. For h fixed at $\frac{1}{2}a$, this lies at $x = -a$. It thus becomes coincident with a pole defined by a focal or potential focal condition of the simple intercept eq. at only one point, namely, where it intersects the focal locus of the

$\cos^2\theta$-condition at $e = +1.1180$ and $x = -a$.

Turning now to the plot for a constant eccentricity of $5^{\frac{1}{2}}$, and a variable location of the pole of inversion of the basis curve, it is found that all the focal and potential focal loci vary with the location of the pole of inversion of the basis hyperbola. The foci specified by the $\cos^2\theta$-condition are located within the loops of hyperbolic central quartics of this eccentricity (in fact, for all $e > 2/3^{\frac{1}{2}}$). One remains within each loop as one loop enlarges and the other shrinks with increasing values of h. The focus within the enlarging loop goes off to infinity from the positive side when the hyperbola axial vertex cubic condition is attained at $h = a$.

In the post-vertex quartics (which have an internalized loop) these foci come closer and closer together. When the pole of inversion is at the traditional focus ($h = 5^{\frac{1}{2}}a$) of the basis hyperbola, the inversion locus is a limacon and the $\cos^2\theta$-condition specifies only a single focus. Beyond this pole, two imaginary foci are specified. In elliptical subspecies the complementary situation occurs as the location of the pole of inversion of the basis ellipse recedes from the center along the major axis, i.e., two imaginary foci are specified in pre-focal quartics, one real focus is specified in the limacon, and two diverging real foci are specified in post-focal quartics.

From these properties of the loci specified by the $\cos^2\theta$-condition, which defines the $-\frac{1}{2}b$ variable foci of limacons, it is clear that the limacon genus is unique among all genera of QBI quartics in that it is the only genus in which the $\cos^2\theta$-condition defines only a single *real* focus in all subspecies of all 3 species (see Table XII-3). In all other axial QBI quartics the $\cos^2\theta$-condition defines two real foci, but only in either all the elliptical subspecies or all the hyperbolic subspecies, never in both species. [The $\cos^2\theta$-condition also specifies two real foci in pre-focal parabola axial-inversion quartics and two imaginary foci in the post-focal members. These are treated below in the section, *Axial Inversion Quartics of Unit Eccentricity*.]

The initial location of the vertices in central quartics is at $H = \pm a$ (taking $j = a$); as h increases from 0, the vertex on the negative side of the DP approaches the DP monotonically, while the location of the vertex on the positive side becomes ever more distant. At $h = a$, in the hyperbola axial vertex cubic, the vertex focus is replaced by its analogue, the asymptote-point focus. [Considering the curves to be unicursal, with the arms joining at

infinity, the asymptote-point lies on the axis at the level of the extremity of the "large loop."] A second vertex reappears on the negative side in post-vertex quartics. This is the process by which the small loop becomes internalized.

The poles specified by the $\cos\theta$-constant condition shift along with the vertices, maintaining a position between them and the DP, but remaining closer to them than the foci specified by the $\cos^2\theta$-condition. The pole specified by the $\cos\theta$-x^2 condition is located at the DP in central quartics, recedes from it monotonically to infinity as the pole of inversion of the basis hyperbola approaches a vertex (in the hyperbola axial vertex cubics), then approaches the DP monotonically from infinity on the negative side as the pole of inversion recedes from a vertex. The poles specified by the x^2-condition have an initial value of $H = 0.4330a$ at $h = a/3^{\frac{1}{2}}$. One pole then approaches the DP monotonically with increasing h, while the other goes off to infinity from the positive side (for the hyperbola axial vertex cubic) and reappears on the negative side, approaching the DP monotonically.

Focal Rank of the Pole of Self-Inversion

A pole of self-inversion of a curve has circumpolar focal rank by virtue of the fact that the eq. of the $0°$ or $180°$ transform reduces to $xy = $ constant (a point on a line and a non-central point in the plane of the circle are the only exceptions). Self-inversion is, in itself, a type of circumpolar symmetry, namely, *reciprocal reflective symmetry through a point*. That a curve admits of self-inversion guarantees its membership in, at least, the 2nd-degree circumpolar symmetry phylum (see Chapter V), and a class rank of no greater than 2nd degree.

The following discussion concerns the changes in location of the focus of self-inversion with changes in the locus of the pole of inversion of the basis hyperbola. For convenience, a pole of self-inversion is referred to as having *focal rank* or acquiring *focal rank* when it is in coincident with a focal pole defined by the simple intercept eq. or format. Although this designation is adopted primarily as a convenience, it also is an appropriate one, as subsequent analyses show. Thus, aside from the focal property conveyed to the pole of self-inversion by the 2nd degree $0°$ transform of the curve about it, or by its coincidence with other axial foci (i.e., when such coincidence occurs), this pole

is unexceptional among axial poles. It generally has the same 90° and 180° focal rank as any other non-point-focal pole on the line of symmetry. In other words, from the point of view of the circumpolar symmetry of the curve, a pole of self-inversion generally achieves point-focal rank only for the angle, α, of self-inversion. [Of course, if negative intercepts are taken into account, the algebraically complete transforms will convey focal rank at both the angles, α and $\alpha + 180^{\circ}$.]

A pole of self-inversion (at $-j^2/2h$) does not exist for central quartics ($h = 0$) but a pole having this property (for $h \neq 0$) approaches the DP monotonically from a great axial distance on the negative side as h increases from 0. [One could take the view that a pole of self-inversion of central quartics is at infinity but this is contradictory to the view adopted here (see Maxims 23-28).] The path of this approach, as it intersects other focal loci, is of great interest. The pole of self-inversion first acquires *generic* focal rank at $h = a$, i.e., in the hyperbola axial vertex cubics. Since the pole of self-inversion is in coincidence with a vertex of the curve in all subspecies of the genus of conic axial vertex cubics, the combination of the two foci in coincidence is designated a *generic double-focus of self-inversion*.

The pole of self-inversion next acquires focal rank in pseudo-exchange-limacons at $h = 2a$, where it coincides with the focal pole of the $\cos^2\theta$-condition at $H = -0.25a$. But its focal rank in this case is only *subspecific* because, though the pole of self-inversion always is at the position $H = -0.25a$, and all pseudo-exchange-limacons self-invert through this pole (their vertices always stand in the same relationship to it), the focal pole defined by the $\cos^2\theta$-condition is at this location only for an eccentricity of $5^{\frac{1}{2}}$.

The last position at which the pole of self-inversion acquires focal rank is at $H = -0.22361$ and $h = 5^{\frac{1}{2}}$, in the case of limacons, where it comes into coincidence with the $(a^2-b^2)/2b$ variable focus. The location of the latter focus is specified by the radicand constant-condition. In this case, also, the focal rank of the pole of self-inversion is generic, because the coincidence occurs for all e (but at different values of h and H for each value of e). Accordingly, the pole of self-inversion becomes a component of a generic double-focus in this genus in the same sense that it does so in the conic axial vertex cubics.

In summary, it is found that, except in 4 of the axial genera in the QBI superfamily, the location of a pole of self-inversion is not coincident with

any of the 5 focal poles generally defined by the simple intercept eq. and format. Because two of the member axial genera--conic axial vertex cubics and limacons--in which the pole of self-inversion comes into coincidence with such a focal pole, are curves of uniquely high circumpolar symmetry (among cubics and quartics, respectively; see Table XII-3), they are comparatively well known and have been the objects of much attention in the foregoing treatments. But a consideration of these genera alone--or even in conjunction with self-inverting non-QBI groups of high circumpolar symmetry, such as Cartesian self-inverters-- gives a quite misleading picture of the relationship of poles of self-inversion to the circumpolar foci defined by simple intercept eqs. and formats, because it leads to the impression that a pole of self-inversion always occurs at the location of one of these foci (linear Cartesians have 3 such poles).

Focal Conditions, Number of Foci, Imaginary Foci,
 and Conservation of Foci Under Inversion

The above findings provide much of the information needed to clarify the picture of axial foci of QBI curves--their specification, number, type (real or imaginary), and conservation under the inversion transformation. Accordingly, the picture is formalized here and several additional maxims are formulated.

Since all but a small fraction of axial QBI curves self-invert, it is clear that the property of self-inversion, taken alone, provides only a weak basis for circumpolar symmetry comparisons within the superfamily. The closest links between self-inversion and high circumpolar symmetry within the superfamily are that: (a) in the 4 most highly symmetrical self-inverting genera, the focus of self-inversion is coincident with a focus specified by one of the focal conditions on the simple intercept eq. or format: and (b) the simple intercept format for curves cast about the focus of self-inversion often does not contain a radical in the variables (see Chapter XIV).

The significance of this almost complete dissociation of foci of self-inversion from foci specified by intercept eqs. and formats can be understood in terms of the fact that self-inversion is strictly a symmetry property of a curve about a point along radii at a specific angle to one another, traditionally only along coincident radii or chord segments. Accordingly, it is consonant to find that a focus of self-inversion typically is specified by a condition on the corresponding *angle-dependent* indices of circumpolar symmetry--the $0°$ and $180°$ transforms--rather than by the *angle-independent*

ones--the simple intercept eq. and format (recall in this connection that foci of self-inversion generally do not qualify as point foci at any angle of transformation other than the angle of self-inversion, or that angle plus 180°).

By contrast, all other axial foci may be characterized as angle-independent, because they are defined at the level of the simple intercept eq. or format, in the formation of which there occurs no specification of angle. Accordingly, a pole of self-inversion typically is more readily detected by an inversion analysis than by a circumpolar symmetry analysis, since conditions for the reduction of intercept transforms at the level of the transforms themselves (as opposed to the level of the simple intercept eq. or format) usually are the most difficult to detect.

CIRCUMPOLAR MAXIM 22: *A focus of self-inversion typically is specified by a condition on the 0° or 180° intercept transform, rather than by a condition on the simple intercept equation or format.*

For axial QBI curves, the axial loci of focal rank that come closest to being specified by invariant focal conditions, i.e., conditions that do not vary from genus to genus or species to species, are points incident upon the curves and the DP or its homologue. Equating the constant term of axial intercept eqs. to 0 usually specifies 3 foci--two vertices and the DP or its homologue, which sometimes is a true center. The notable exceptions are: (a) the parabola, in which one vertex is specified; (b) the central conics, in which two vertices are specified; (c) the cissoid of Diocles, in which a DP homologue--the cusp--is specified; (d) the hyperbola axial vertex cubics, in which a DP and one vertex are specified; (e) the ellipse axial vertex cubics, in which a DP homologue and one vertex are specified; and (f) mutually-inverting quartic circles, in which a true center and 4 vertices are specified (see Appendix II, *Inventory of Simple Intercept Equations*).

When present, a DP or its homologue--including a true center--is the highest-ranking focus of QBI curves. In simple intercept eqs. cast about the DP or DP homologue, this pole also is specified by a condition on the $\cos\theta$ or $\sin\theta$ term. When it is a true center, the entire coefficient of the term vanishes (as in the eqs. for the circle, central conics, central quartics, etc.), whereas, when it is not a true center, only the constant portion of the coefficient of the term vanishes.

CIRCUMPOLAR MAXIM 23: *A non-parameter-involving condition for which the entire $\cos^2\theta$ term of a simple intercept equation in $\cos^2\theta$ and $\cos\theta$ vanishes (specifically, when h is a multiplicative coefficient for the entire term) establishes that the equation of the basis curve is cast about a true center. One of the conditions for which only the $\cos\theta$-constant term vanishes usually corresponds to the point about which the equation is cast.*

The above-numerated conditions together generally specify 4 real foci for self-inverting QBI curves. In pre-focal hyperbolic and post-focal elliptical species, the $\cos^2\theta$-condition specifies two additional real foci, bringing the total number to 6. The latter foci never are incident upon the curve. In the only known cases in which the $\cos^2\theta$-condition specifies only one focus, the 6th focus is specified by the x^2-condition (conic axial vertex cubics) or the radicand constant-condition (limacons).

In the cases of the other axial QBI curves, in which the $\cos^2\theta$-condition does not specify real foci, it appeared to be a not unreasonable expectation that 2 additional real foci would be specified by either: (a) other potential focal conditions, as they are in some non-QBI curves (the folium of Descartes, Tschirnhausen's cubic, Cayley's sextic); (b) by a condition for simplification of the radicand of the simple intercept format; (c) by a condition for the reduction of intercept transforms; or (d) by an equational condition--a condition on the entire simple intercept eq. (see Tschirnhausen's cubic).

However, this expectation was not realized. For the axial curves in question --the pre-focal elliptical and post-focal hyperbolic species--potential focal conditions do not yield additional foci. Moreover, the specification of an additional focus by the vanishing of the constant term of the radicand of the simple intercept format is unique to the limacon genus, and, with the exception of foci of self-inversion, conditions on intercept transforms do not lead to the specification of additional foci. [Aside from the specification of foci of self-inversion (by the condition that the intercept transform reduce to $xy =$ constant) no case is known of an intercept transform condition that specifies a focus not already specified by the simple intercept eq. or format.]

In the light of these findings and prior considerations, it is clear that axial inversions do not conserve either *real* axial foci, the sum of the numbers

of *real and imaginary* axial foci, or axial foci of self-inversion. But the inversion transformation does conserve the *sum* of the number of axial foci and the number of orthogonal lines of symmetry, whence one has the following comprehensive Maxims.

CIRCUMPOLAR MAXIM 24: *Excluding a focus of self-inversion, all line-of-symmetry inversions of the parabola and central conics conserve the number of real and imaginary axial circumpolar foci.*

CIRCUMPOLAR MAXIM 25: *For the parabola and central conics, and all their line-of-symmetry inversions, the number of real and imaginary axial circumpolar foci, excluding foci of self-inversion, is 5.*

CIRCUMPOLAR MAXIM 26: *The sum of the number of real and imaginary axial circumpolar foci and the number of orthogonal lines of symmetry of a basis curve is conserved by line-of-symmetry inversions.*

CIRCUMPOLAR MAXIM 27: *For the parabola and central conics, and all their line-of-symmetry inversions, the sum of the number of real and imaginary axial circumpolar foci and the number of orthogonal lines of symmetry is 6.*

CIRCUMPOLAR MAXIM 28: *For any given axial QBI curve except the line, the circle, and quartic circles, and for all its line-of-symmetry inversions, the sum of the number of real and imaginary axial circumpolar foci and the number of orthogonal lines of symmetry is constant.*

[In connection with the wording of Maxims 26-28, it is understood that the number of othogonal lines of symmetry is either 0 or 1.]

The basis for the restriction of Maxim 27 to the parabola, central conics, and their line-of-symmetry inversions is that for mutually-inverting quartic circles the sum in question is 9 rather than 6, because there are two additional vertices and an orthogonal line of symmetry (as well as 2 other vertices, 2 centers and the true center, which is a generic double-focus of self-inversion).

With a broadened conception of circumpolar foci, that includes qualifying imaginary poles (and, in consequence, transforms with complex solutions), the central conics are found to have a total of 18 circumpolar foci; the 14 real foci in the ellipse are supplemented by 2 imaginary foci on the minor axis at $k^2 = b^2 - a^2$ (eq. VII-9a) and 2 imaginary asymptotes at $k^2 = -b^2h^2/a^2$ (eq. VII-6a), while the 14 real foci of the hyperbola are supplemented by 2 imaginary foci on the conjugate axis at $k^2 = -(a^2+b^2)$ (eq. VII-9b) and 2 imaginary vertex foci at $k^2 = -b^2$ (eq. VII-16). Maxims 24-28 apply to all lines of symmetry.

In central quartics there are 4 imaginary foci on the orthogonal line of sym-

metry--the k-axis through the DP--of hyperbolic species (2 specified by the $\cos^2\theta$-condition and 2 by the constant-condition) but none for the elliptical species, which has 2 vertex foci and 2 "loop foci" on this line of symmetry (see Appendix II, *Inventory of Simple Intercept Equations*). Thus, the absence of real "loop foci" on the major axis of pre-focal axial inversions of the ellipse probably is compensated by the presence of foci on an orthogonal covert linear focal locus, and vice versa for the post-focal inversions of the hyperbola.

If real and imaginary asymptotes are excluded from the reckoning, the total number of foci for the central conics is 16. The number appears to be the same for central quartics; for example, for $a^2 < b^2$ (for which the "loop foci" are within the loop), there are the DP, 2 "loop foci," 2 vertices, 4 imaginary point foci on the orthogonal line of symmetry, 4 peripheral vertices at the level of the "loop foci," 2 lines of symmetry, and the curve itself (see Table X-2). The inequality between the numbers of imaginary point foci on the lines of symmetry--4 for hyperbolic species, 2 for elliptical species--parallels the situation in central conics.

Lastly, two significant facts are emphasized. The first is that the traditional focus assumes still another distinction as an exceptional pole for conics; for all 3 species it is the axial pole of demarcation between inversion loci with 2 real foci specified by the $\cos^2\theta$-condition and inversion loci with 2 imaginary ones so specified. Only one real focus is specified at the pole itself. The second fact is that the unique circumstance among QBI cubics and quartics, wherein the limacon pole of self-inversion is coincident with the focus specified by the radicand constant-condition, has significance beyond the confines of the QBI superfamily. This is because the simple intercept format for this focus is precisely the equational relationship that establishes limacons as members of the Cartesian self-inverters, all members of which have at least one generic double-focus of self-inversion (linear Cartesians have 3 such foci).

Eccentricity-Dependent Self-Inverters

It was noted above that the pole of self-inversion of an axial QBI quartic acquires subspecific focal rank for $e = 5^{\frac{1}{2}}$ in pseudo-exchange-limacons ($h = 2a$). But what of the other locations at which it acquires subspecific focal rank, of which an infinite number remain to be identified? In other words, where are the locations at which the axial pole of self-inversion has sub-

specific focal rank for other values of e?

To answer this question, eqs. for focal and potential focal conditions (in-cluding the radicand constant-condition) were solved for H and the solutions equated to $-j^2/2h$, the location of the pole of self-inversion. The result emerged that, excluding limacons and conic axial vertex cubics, there is only one *subspecific focal self-inverter* in each center-focus genus of axial QBI curves. In other words, in every center-focus QBI genus (defined by a specific real value of h, the axial pole of inversion of the basis conic) there exists one hyperbolic subspecies that self-inverts about a pole that is coincident with a *real* circumpolar focus defined by the simple intercept eq. (a corresponding pole exists in the elliptical subspecies but it is imaginary). The eccentricity of this subspecies is $e = (a^2+h^2)^{\frac{1}{2}}/a$.

In reaching this result, the vertex and DP were excluded as possible lo-cations for a coincidence with the pole of self-inversion for reasons already mentioned. Further, it was found that none of the locations specified by potential focal conditions could be a locus of coincidence with the pole of self-inversion. That left only the focal poles specified by the $\cos^2\theta$-condition, 13c, as possible candidates. The single real root obtained by simultaneous solution of 13c and $H = -j^2/2h$ is $h = b$.

Another way of looking at the above-described situation is in terms of "creating" or synthesizing a new genus or species of highly symmetrical QBI curves using as a formula or guideline the distinctive condition that has been found to characterize limacons, central conic axial vertex cubics, and mutually-inverting quartic circles. This condition is that the focus of self-inversion be a component of a generic double-focus, i.e., that for each admissible value of e it be coincident with a focus defined by the simple intercept eq. or format. An intriguing difference between the new genus and the prototype genera is that for limacons the coincidence is with a focus defined by the radicand-constant condition, for central conic axial vertex cubics it is with a focus defined by the constant-condition, for mutually-inverting quartic circles it is with a focus defined by the $\cos\theta$-condition, whereas for the new genus--the *eccentricity-dependent self-inverters*--it is with a focus defined by the $\cos^2\theta$-condition.

The new genus of QBI self-inverting curves cuts across all those QBI genera obtained by inversion about poles lying between the center and the focus. It is synthesized by selecting and including from each genus the subspecies at

$e = (a^2+h^2)^{\frac{1}{2}}/a$. This is equivalent to having each basis hyperbola contribute one axial inversion locus, namely, the one obtained by inverting it about a pole on its transverse axis at a distance b from its center.

This new genus should be one of high circumpolar symmetry because each pole of self-inversion coincides with a focus determined by the simple intercept eq. Though this genus has certain other characteristics in common with limacons, it differs in significant respects. Like the genus of limacons, it is generated from the basis curves by inversions about *variable axial poles*. For limacons these poles lie at ae, whereas for the eccentricity-dependent self-inverters they lie at $a(e^2-1)^{\frac{1}{2}}$. The new genus or superspecies differs from limacons (and conic axial vertex cubics) in at least two major respects. First, all of its members are hyperbolic, i.e., inversions of hyperbolas. Second, it contains subspecies with both opposed and internalized loops, because the condition $h = b$ includes representatives of both the inter-vertex quartics and the vertex-focus quartics (but not the focal quartics).

The genus in question is defined by eq. 15a, which was derived by letting

eccentricity-dependent self-inverters

(a) $b^2(b^2-a^2)(x^2+y^2)^2+2b^3j^2x(x^2+y^2)+j^4(b^2x^2-a^2y^2) = 0$ rectangular eq. (12-15)

(b) $8a^2bj^2x(4b^2x^2+j^4)\cos\theta + 16b^4(b^2-a^2)x^4 -$

$\qquad 8b^2j^4(b^2+3a^2)x^2 + j^8(b^2-a^2) = 0$ simple intercept eq.

(c) $\cos\theta = \dfrac{-16b^4(b^2-a^2)x^4+8b^2j^4(b^2+3a^2)x^2-j^8(b^2-a^2)}{8a^2bj^2x(4b^2x^2+j^4)}$ simple intercept format

$h = b$ in the hyperbolic representatives of eq. 1a. Its simple intercept eq. and format, 15b,c, cast about the pole of self-inversion, follow from substitution of b for h, and $-j^2/2b$ for H, in the hyperbolic representatives of eq. 12. Note that the format 15c is considerably more complex than the corresponding format for limacons (eq. X-20a) but that it involves no radical in the variable. Accordingly, though the curves represented can be expected to be highly symmetrical (i.e., to have transforms of relatively low degree about its foci), their symmetry should fall short of the symmetry of limacons.

The curves of eqs. 15 can approximate to limacons as near as one wishes. This is accomplished by appropriately increasing the value of b relative to a. This brings the pole of inversion, b, of the basis hyperbola closer and closer to its focus at $(a^2+b^2)^{\frac{1}{2}}$, inversion about which produces a limacon. In other words, the greater the eccentricity of the basis hyperbola, the more nearly does its inversion about the pole h = b resemble a limacon. However, eccentricity-dependent self-inverters never can become limacons, because b never can equal $(a^2+b^2)^{\frac{1}{2}}$.

Of course, the above limitation is just another expression of the fact that the $(a^2-b^2)/2b$ focus of limacons never can become coincident with the $-\frac{1}{2}b$ variable focus. These are the two poles that correspond to the $-j^2/2b$ pole of self-inversion and the pole defined by the $\cos^2\theta$-condition. This restriction does not hold for the hyperbola vertex cubics, which contribute the $e = 2^{\frac{1}{2}}$ subspecies to the genus or superspecies in question because, as we have seen, the variable focus of the hyperbola axial vertex cubics (defined by the $\cos^2\theta$-condition) becomes coincident with the loop vertex in the equilateral strophoid (at $-j^2/2b = -j^2/2a$).

CIRCUMPOLAR MAXIM 29: *Among axial QBI curves, only limacons, conic axial vertex cubics, eccentricity-dependent self-inverters, mutually-inverting quartic circles, the circle, and intersecting lines self-invert about a pole specified by the simple intercept eq. or format.*

CIRCUMPOLAR MAXIM 30: *The most highly symmetrical curves of given degree within an inversion superfamily are those axial members that self-invert about axial poles that are specified by the simple intercept equation or format, i.e., for which the pole of self-inversion is coincident with a circumpolar focus so specified.*

The Simple Intercept Format

Casting the simple intercept eq. for a point on the line of symmetry, 12, in the familiar quadratic-root form $[-B \pm (B^2-4AC)^{\frac{1}{2}}]/2A$ yields eqs. 16, inspection of which reveals the unique symmetry of limacons among axial QBI quartics.

components of the simple intercept format $\cos\theta = [-B\pm(B^2-4AC)^{\frac{1}{2}}]/2A$ for a point on the line of symmetry of axial QBI cubics and quartics

(a) $-B = -b^2\{x^2[2H(h^2-a^2)+hj^2] + H[2H^2(h^2-a^2)+3hHj^2+j^4]\}$ (12-16)

(b) $B^2-4AC = a^2b^2j^4x^4[b^2\mp(h^2-a^2)] +$

$$a^2j^4x^2\{-2b^2H^2[b^2\mp(h^2-a^2)]\pm2b^2hHj^2\pm j^4(b^2\pm a^2)\}$$

$$+ a^2b^2j^4H^2\{H^2[b^2\mp(h^2-a^2)]\mp2hHj^2\mp j^4\}$$

(c) $2A = x[4b^2H^2(h^2-a^2)+4b^2hHj^2+j^4(b^2\pm a^2)]$

(d) $\cos\theta = \dfrac{Ax^2+B^3\pm(C^2x^4+D^4x^2+E^6)^{\frac{1}{2}}}{F^2x}$ general form of 8a-c

limacon parameters	conic parameters

(a) $a^2 = a^2j^4/b^4$ (b) $H = \dfrac{\pm hj^2\pm j^2(a^2\pm b^2)^{\frac{1}{2}}}{b^2\mp(h^2-a^2)} = \dfrac{-j^2}{h+(a^2\pm b^2)^{\frac{1}{2}}}$ (12-17)

$b = j^2(a^2\pm b^2)^{\frac{1}{2}}/b^2$

The expression $b^2\mp(h^2-a^2)$ is the focal-inversion condition for limacons, i.e., this expression vanishes when the basis central conic is inverted about its focus at $h^2 = a^2\pm b^2$. It occurs in all three terms of the radicand. Accordingly, for limacons--and limacons alone--the quartic term of the radicand, 16b, vanishes, the quadratic term greatly simplifies, and the constant term simplifies to $\mp a^2b^2j^6H^2(2hH+j^2)$, which vanishes for a location of the pole of self-inversion at $H = -j^2/2h$.

But the expression $H = -j^2/2h = -j^2/2(a^2\pm b^2)^{\frac{1}{2}}$, when converted to limacon parameters (the conversion equations are 17a) yields the location of the limacon variable focus of self-inversion at $H = (a^2-b^2)/2b$. Accordingly, when the format is cast about this pole, x^2 can be extracted from the radical, leaving it independent of x. As a consequence, there is a reduction of the degree of the resulting transforms, X-20c,d, because additional squarings to eliminate the radical in the variable(s), with consequent increases in degree, no longer are necessary.

[In general, when a radical becomes independent of the variable(s), additional squarings to eliminate the alternate signs (or expression as a degenerate eq. possessing a product of factors that take into account all combinations of the alternate signs) are necessary only if one seeks to obtain the algebraically

complete transform eqs. To obtain intercept transforms that hold for positive intercepts only, as is the general practice in this work, one selects the form(s) of the simple intercept format that hold(s) for positive intercepts. In the case treated above, no squaring is required to obtain the 0° and 180° transforms for positive intercepts (the latter of which is one of the few known 3rd-degree transforms) and only one squaring is required to obtain the corresponding 90° transform (see the treatment of these matters in Chapter VII, *Negative Intercepts, Trivial Transforms, the Degree of Transforms, and the Duality of 0° and 180° Transforms*).]

It will be recalled that the limacon variable focus of self-inversion at $(a^2-b^2)/2b$ is the inversion of the contralateral traditional focus of the basis curve. It now can be seen that the radicand constant-condition always yields as one of its solutions, the pole to which the contralateral focus inverts, 17b. [The contralateral focus at $-\{h+(a^2\pm b^2)^{\frac{1}{2}}\}$ inverts to $-j^2/\{h+(a^2\pm b^2)^{\frac{1}{2}}\}$]. However, this condition is merely subfocal in all the other axial QBI quartics; only in limacons does it assume focal rank.

Despite the fact that, for limacons, reduction and extensive simplifications occur in the radicand, 16b, the alterations carry only *subfocal* force. The general form of this simple intercept format is 16d, and the transforms derived therefrom do not reduce for either $C^2=0$ or $E^6=0$, alone, though they greatly simplify (see the detailed treatments in Chapter XIV, *General Circumpolar Symmetry Analysis of Axial QBI Curves*). The general format, 16d, leads to 0° and 180° transforms of 10th degree. The reduction from the maximum value of 12th degree is by the usual factoring out of a term--in this case $(x\mp y)^2$-- for the trivial transforms. But since there is no equivalent term for trivial transforms that factors out of the general 90° transform eqs., there is no reduction in the 90° transforms, which are of 24th degree.

The conic axial vertex cubics, however, have greater circumpolar symmetry about a point on the line of symmetry than does any axial QBI quartic (but this is not necessarily true of the symmetry about homologous axial foci). For them, the 0° and 180° transforms reduce to 8th degree and the 90° transform to 22nd degree (by the vanishing of the term of highest degree). The condition for these reductions is $A^2=C^2$, which obtains in the conic axial vertex cubics, for which $A=-1$ and $C^2=1$. The general format, 16d, actually holds for all QBI curves. In conics, for example, for which $A=C=0$, the 0° and 180° transforms reduce to 4th degree and the 90° transforms to 16th degree. [Note the progression from $A^2=C^2=0$ in conics, to $A^2=C^2=1$ in cubics, to $A^2\neq C^2\neq 0$ in quartics.]

The Double Point and Its Homologue

The 0° and 180° Transforms

The simple intercept eq. and simple intercept format for the DP and its homologue in all hyperbolic and elliptical QBI cubics and quartics are 18a,b.

(a) $j^4(b^2 \pm a^2)\cos^2\theta + 2b^2 hj^2 x\cos\theta + b^2(h^2-a^2)x^2 \mp a^2 j^4 = 0$ simple intercept eq. (12-18)

(b) $\cos\theta = \dfrac{-b^2 hx \pm a[b^2(b^2 \mp h^2 \pm a^2)x^2 \pm j^4(b^2 \pm a^2)]^{\frac{1}{2}}}{j^2(b^2 \pm a^2)}$ simple intercept format

(a) $a^4(h^2-a^2-b^2)^2(x\pm y)^2 + b^4 h^4(x \mp y)^2 - 4a^2 h^2 j^4(a^2+b^2)$ 0° and 180° (12-19) transforms

$\qquad\qquad + 2a^2 b^2 h^2(h^2-a^2-b^2)(x^2+y^2) = 0$

(b) $[a^2(h^2-a^2-b^2)x^2+b^2 h^2 y^2] = \dfrac{2a^2 h^2 j^4(a^2+b^2)}{[a^2(h^2-a^2-b^2)+b^2 h^2]}$ 0° transform with axes rotated 45° CCW

To avoid confusion, and because the results often are the same for both species, in the following analyses attention is confined primarily to members of hyperbolic species.

The general 0° and 180° transforms for the DP and DP homologue of all QBI axial cubics and quartics are found to be of only 2nd degree and are given by 19a. Rotating the axes CCW 45° gives a more easily analyzed form. For the 0° transform this yields 19b. The eq. for the 180° transform is the same, except that the coefficients of the x^2 and y^2 terms are exchanged. Accordingly, the 0° transform generally is a centered central conic, while the 180° transform generally is a congruent centered, but orthogonal, central conic; in other words, they are "crossed" ellipses or hyperbolas. If $h^2 > a^2+b^2$, i.e., if the pole of inversion of the basis hyperbola is post-focal, the transforms are ellipses. If $h^2 < a^2+b^2$, corresponding to a pre-focal pole, they are hyperbolas.

Returning to 19a, several special cases are considered. For limacons, $h^2 = a^2+b^2$, i.e., the pole of inversion is at the traditional focus, and 19a

reduces to 20a. Thus, we see that the non-trivial 0° transform is not lost following this route of analysis because a form of the DP eq. (1a) has been employed in which the simple intercept format involves a radical.

	conic parameters	limacon parameters	

(a) $x \mp y = \quad 2aj^2/b^2 = \quad 2a$ 19a for limacons (12-20)

(b) $x = \mp y$ 19a for central quartics

(c) $9(a^2+b^2)^2(x^2+y^2) \pm 6(a^2+b^2)(3a^2-5b^2)xy = 16j^4(a^2+b^2)$ 19a for pseudo-exchange-limacons

$\quad a^4b^4(x \pm y)^2 + a^4b^4(x \mp y)^2 - 2a^4b^4(x^2+y^2) = 4a^4j^4(a^2+b^2)$ 19a for cubics (12-21)

For central quartics, for which $h = 0$, 19a reduces to 20b, the 180° alternative of which (lower sign) is a valid linear transform; the 0° alternative is valid only if negative intercepts are allowed. For pseudo-exchange-limacons, for which $h = \pm 2a$, 19a simplifies to 20c. Since the coefficient of the x^2 term in 19b becomes $a^2(3a^2-b^2)$, the 0° and 180° transforms about the DP of pseudo-exchange-limacons are ellipses for $3a^2 > b^2$ but hyperbolas for $b^2 > 3a^2$.

For cubics, for which $h = a$, substitution in 19a gives eq. 21; all the terms in the left member now cancel one another and there are no loci except the trivial $x = \pm y$. The latter loci exist because an $(x \mp y)^2$ term was factored out of the parent eq. to obtain 19a.

For the eccentricity-dependent self-inverters, for which the inversion poles always are pre-focal, the 0° and 180° transforms are hyperbolas but reduce from an *overall* degree of 10 (eq. 22a) to 8 (eq. 22b). A 45° rotation gives eq. 22b' for the 0° transform.

(a) $a^8(x\pm y)^2 - 2a^4 b^4(x^2+y^2) + b^8(x\mp y)^2 =$ 　　19a for eccentricity- 　　(12-22)
　　　　　　dependent self-inverters

$$4a^2 b^2 j^4(a^2+b^2)$$

(b) $(a^4-b^4)(a^2-b^2)(x^2+y^2) \pm 2(a^4+b^4)(a^2-b^2)xy = 4a^2 b^2 j^4$ 　　22a reduced

(b') $(b^2-a^2)(b^4 y^2-a^4 x^2) = 2a^2 b^2 j^4$ 　　22b for 45° CCW rotation of axes

The 90° Transforms

The fully expanded 90° transforms are too complex to exhibit for the general case (but see Chapter IV). Eq. 23 is the general case for hyperbolic species before the final squaring. Individual cases are taken up in place of complete

general 90° transforms about the DP of hyperbolic
axial QBI curves before the final squaring

$$b^4(b^2 h^2+a^2 A^2)^2(x^2+y^2)^2 + j^8(a^4-b^4)^2 + 2b^2 j^4(a^4-b^4)(b^2 h^2+a^2 A^2)(x^2+y^2) \qquad (12\text{-}23)$$

$$- 4a^2 A^2 b^6 h^2(x^4+y^4) - 4a^2 b^4 h^2 j^4(a^2+b^2)(x^2+y^2) =$$

$$\pm 8a^2 b^4 h^2 xy[b^2 A^2 x^2+j^4(a^2+b^2)]^{\frac{1}{2}}[A^2 b^2 y^2+j^4(a^2+b^2)]^{\frac{1}{2}}$$

$$A^2 = (a^2+b^2-h^2)$$

(a) $\cos\theta = \dfrac{-b^2 x\pm aj^2}{j^2(b^2\pm a^2)^{\frac{1}{2}}}$ 　　18b for limacons 　　(12-24)

(b) $(x\mp aj^2/b^2)^2 + (y\mp aj^2/b^2)^2 = j^4(b^2\pm a^2)/b^4$ 　　90° transform of 24a

(a) $r^2 = a^2 \mp b^2\cos^2\theta$ 　　basis central quartic 　　(12-25)

(b) $\cos^2\theta = \mp(x^2-a^2)/b^2$ 　　simple intercept format of 25a

(c) $x^2 + y^2 = 2a^2 \mp b^2$ 　　90° transform of 25b

(d) $x^2 + y^2 = 0$ 　　25c for the equilateral lemniscate ($b^2 = 2a^2$)

(a) $[(x^2-a^2)\pm b^2\sin^2\alpha]^2 + [(y^2-a^2)\pm b^2\sin^2\alpha]^2 -$ 　　α-transform 　　(12-26)
　　　　　　of 25b
$$2(x^2-a^2)(y^2-a^2)(\cos^2\alpha-\sin^2\alpha) - b^4\sin^4\alpha = 0$$

(b) $(x^4+y^4) + (\pm b^2-a^2)(x^2+y^2) = \pm 2a^2 b^2 - 2a^4 - b^4/2$ 　　26a for 45°

(c) $x^4 + y^4 = a^4$ 　　26b for the equilateral lemniscate

general solutions. For limacons, 18b becomes 24a, which yields the 90° transform 24b, one of the few circular transforms in any category for a well-known curve (see also eq. 17d and Table V-1).

For the central quartics (h = 0), the parameters of the basis curve, 25a, are employed, yielding the simple intercept format 25b. This yields the 90° circular (recurrent arc) transform of 25c. For the equilateral lemniscate, for which $b^2 = 2a^2$, 25d is obtained. The conversion to the point-circle of 25d occurs because two rotating radii at 90° to one another never both intersect the basis curve simultaneously, except at the DP itself. Hence, the transform locus consists only of the point-circle at the origin. Eq. 25d, however, also has a complex solution, because when one non-zero intercept is real the other non-zero intercept is imaginary, namely, when $x = \alpha$, $y = \alpha i$, and the sum of the squares always is 0 (see also the section below, *Transforms With Complex Solutions*).

Substitution of 25b in the $cos^2\theta$ *transformation format* (eq. V-20 and Appendix I) yields 26a. For a transformation angle of 45° this simplifies to the quartic locus 26b; for the equilateral lemniscate this yields the remarkable transform 26c--the quartic "circle."

Figs. 2-5 b-e

Because of the unusual nature of the latter locus (which, however, characterizes the symmetry of an infinite number of curves about a focal pole; see Chapter XIV, *nth Degree "circular" specific Symmetry Class*), I also derive the 90° intercept transforms for Cassinians (bipolar eq. $uv = Cd^2$), for which the equilateral lemniscate (C = ¼) is the curve of demarcation. The rectangular eq. of these curves and the simple intercept format are given by eqs. 27a,b. The 90° transform

2-5a

(a) $(x^2+y^2)^2 - d^2(x^2-y^2)/2 = d^4(C^2-1/16)$ basis Cassinian (12-27) 2-5a

(b) $cos^2\theta = \dfrac{x^4 + d^2x^2/2 - d^4(C^2-1/16)}{d^2x^2}$ simple intercept format of 27a

(c) $xy = d^2(C^2-1/16)^{\frac{1}{2}}$ 90° intercept transform of 27a about the DP for $C > ¼$

(d) $(x^4+y^4)[x^4y^4+d^8(C^2-1/16)] = 4C^2d^4x^4y^4$ general 45° transform of 27a

locus for these curves for $C > ¼$ is the equilateral hyperbola, 27c. The general 45° intercept transform, 27d, is of 12th degree; it reduces only for the special case of the equilateral lemniscate ($d = 2^{\frac{1}{2}}a$, $C = ¼$). The transform, 27c, is the only instance of self-inversion at an angle of 90° that has been encountered for a known curve (see below and Chapter XIV, *Self-Inversion at 90°*).

ordinal rank eq. for the DP (format 27b)

(a) $(x^4-Ad^4)^2(y^4-Ad^4)^2\overset{o}{s}^2 = (y^4-Ad^4)^2[d^4x^4/4-(x^4+Ad^4)^2]x^2 +$ (12-28)

$$(x^4-Ad^4)^2[d^4y^4/4-(y^4+Ad^4)^2]y^2$$

$$A = (1/16-c^2)$$

(b) $(x^4+Ad^4)x^2\overset{o}{s}^2 = d^4x^4/4 - (x^4+Ad^4)^2$ subordinal rank eq. for 90° transform 27c

(c) $[x^4-Ad^4]^2\overset{o}{s}^2 = 2x^2[d^4x^4/4-(x^4+Ad^4)^2]$ subordinal rank eq. for 180° transform x = y

The ordinal rank eq. for the format 27b (about the true center) is 28a, which is of 18th degree. Substitution of the 90° equilateral hyperbolic locus, 27c, gives 28b, a subordinal rank eq. of only 8th degree, while for the 180° linear transform x = y, the subordinal rank eq., 28c, is of 10th degree.

α-Self-Inversion: Reciprocal Reflective Symmetry
 Through a Point Along Radii At an Angle, α

It already has been noted that self-inversion of a curve about a pole in itself constitutes a type of symmetry, namely, *positive or negative reciprocal reflective symmetry through a point along lines.* Eq. 27c for a 90° transformation of Cassinians about the DP has the identical form, xy = constant, of a 0° or 180° transform of self-inversion. This circumstance serves to direct attention to the fact that, just as focal self-inversion is merely a limiting case of non-focal self-inversion (see Chapter VIII, *Focal Self-Inversion As a Limiting Case of Non-Focal Self-Inversion*), so also are all self-inversions of curves through points along lines merely special cases of reciprocal reflective symmetry of curves through points along two radius vectors at any angle, α --for short, α-*self-inversion*. α-self-inversion, in turn, is merely a small facet of a circumpolar symmetry analysis, namely, it encompasses the domain of equilateral hyperbolic specific symmetry in which the intercept transforms take the form xy = constant.

The generalization of the property of positive and negative *self-inversion* of a curve about a pole to α-*self-inversion* about a pole does not, however, have direct implications for a fruitful generalization of the general case of

an inversion transformation. If, instead of replacing r_θ of a polar eq. of a curve by j^2/r_θ, one replaces r_θ by $j^2/r_{(\theta\pm\alpha)}$, non-congruent loci are not obtained. Instead, one merely obtains a locus that is rotated CW or CCW through the angle α. In other words, the described generalization of the inversion transformation merely leads to an infinite ensemble of congruent curves, which generally neither are identical nor congruent with the basis curve, whereas α-self-inversion requires that a specific member of this ensemble be both congruent and identical to the basis curve.

The $-\tfrac{1}{2}b$ Focus and Its Homologues

The locations of the $-\tfrac{1}{2}b$ focus and its homologues are given by the $\cos^2\theta$-condition, 13c, which in combination with eq. 12 yields the simple intercept format 29a. For limacons, this becomes the familiar simple intercept format of

(a) $\cos\theta = \dfrac{A^4x^4+B^6x^2+C^8}{-(D^5x^3+E^7x)}$

simple intercept format about the $-\tfrac{1}{2}b$ homologue (12-29)

$A^4 = b^2(h^2-a^2)$ $B^6 = 2b^2H^2(h^2-a^2)+2b^2hHj^2\mp a^2j^4$

$C^8 = b^2H^2[(h^2-a^2)H^2+2hHj^2+j^4]$ $D^5 = 2b^2[2H(h^2-a^2)+hj^2]$

$E^7 = 2b^2H[2H^2(h^2-a^2)+3hHj^2+j^4]$

(b) $\cos\theta = \dfrac{a^2(x^2+b^2/4) - (x^2-b^2/4)^2}{a^2bx}$

29a for limacons

(c) $8a^2x^2y^2 \mp 4x^3y^3 = a^4(x^2\pm xy+y^2)$

0° and 180° intercept transforms for the equilateral lemniscate about the "loop focus"

the $-\tfrac{1}{2}b$ focus, 29b, which yields the near-conic transforms already treated in detail.

For the central quartics (h = 0) and pseudo-exchange-limacons (h = 2a), the format remains complex and the transforms are correspondingly quite complex. Those for 0° and 180° are of 6th degree, while for 90° they are of 12th degree. They much simplify for the equilateral lemniscate (a = b), for which the 0° and

180° transforms about the "loop focus" are given by 29c, in which a is the length of the loop axis. For the vertex cubics ($h = a$), of course, the format simplifies to that of the variable focus, given by IX-12a, the transforms of which already have been treated.

For eccentricity-dependent self-inverters, the format becomes 30a. The $-\frac{1}{2}b$

$$\text{(a)} \quad \cos\theta = \frac{16b^4(a^2-b^2)x^4+8b^2j^4(3a^2+b^2)x^2+j^8(a^2-b^2)}{8a^2bj^2x(4b^2x^2+j^4)} \qquad \text{(b)} \quad xy = \frac{j^4}{4b^2} \qquad \text{(12-30)}$$

homologue is the pole of self-inversion for this group, and the quite unpromising simple intercept format 30a yields the simple equilateral hyperbolic transform 30b. Recall that the pole for self-inversion is $-j^2/2b$ distant from the DP. Since, following Maxim 19, this is the unit distance for self-inversion, it follows that $xy = (-j^2/2b)(-j^2/2b) = j^4/4b^2$. The 180° and 90° transforms have not been derived explicitly, but they are a maximum of 6th and 12th degree, respectively.

The simple intercept format of 30a is the 4th radicand-free format that we have encountered for a pole of self-inversion. That for the circle about a non-incident, non-central point in the plane is 31a, that for the equilateral

Formats of self-inversion

$$\text{(a)} \quad \cos\theta = \frac{Cx^2+B^3}{A^2x} \qquad \text{circle} \qquad \qquad \text{(12-31)}$$

$$\text{(c)} \quad \cos\theta = \frac{A^3x+B^2x^2+C^4}{D^3x} \qquad \text{Cartesian self-inverters}$$

$$\text{(b)} \quad \cos\theta = \frac{A^2x}{B^3+Cx^2} \qquad \text{equilateral strophoid}$$

$$\text{(d)} \quad \cos\theta = \frac{F^6x^4+G^8x^2+H^{10}}{J^7x^3+K^9x} \qquad \text{eccentricity-dependent self-inverters}$$

$$\text{(e)} \quad \cos\theta = \frac{-(B^2+x^2) \pm [x^4+2(2A^2-B^2)x^2+B^4]^{\frac{1}{2}}}{2(B-A)x} \qquad \text{hyperbola axial vertex cubics}$$

strophoid about the loop vertex is 31b, that for Cartesian self-inverters (including limacons) is 31c, while 30a takes the form of 31d. The format for hyperbola axial vertex cubics, 31e, involves a radical.

The 0° transform of self-inversion of both 31a and 31b is $xy = B^3/C$, that of 31c is $xy = C^4/B^2$, and that of 31e is $xy = B^2$. To these general findings are now added that for the eccentricity-dependent self-inverters (all of which are hyperbolic species), namely, $xy = (H^{10}/F^6)^{\frac{1}{2}}$.

The previous treatment has amply documented the unique circumpolar symmetry of limacons among axial QBI quartics (see Table XII-3). It will be recalled that limacons and all other quartic focal self-inverters that have been treated have 10th-degree ordinal rank and a subordinal rank of 8 about the focus of self-inversion. Accordingly, it is of considerable interest to compare these values with the ordinal rank for the eccentricity-dependent self-inverters. The latter is found to be 26. This much higher degree of the ordinal rank eq. (lesser circumpolar symmetry) can be attributed to two factors: (a) the degree of the ordinal and subordinal rank eqs. of the Cartesian self-inverters are exceptionally low because of their high circumpolar symmetry; and (b) the eccentricity-dependent self-inverters cut across all other pre-focal genera of axial QBI curves, including curves with opposed, internalized, and "open" loops --accordingly, it is not surprising that an ordinal rank eq. that has to encompass this diverse membership is of such high degree.

The $-j^2/2h$ Focus of Self-Inversion

Substitution of $H = -j^2/2h$ in the format of eqs. 16a-c leads to the simple intercept format 32a for the focus of self-inversion, which applies to all axial QBI cubics and quartics. The 0° transform, which reduces to the self-inverting form 32b, is obtained by forming a like expression to 32a in the variable y, equating to 32a, and eliminating the radical by two successive squarings.

(a) $\quad \cos\theta = \dfrac{ab^2(x^2+j^4/4h^2)/h \pm (A^2b^2x^4+a^2j^4x^2-A^2b^2j^4x^2/2h^2+A^2b^2j^8/16h^4)^{\frac{1}{2}}}{aj^2x(b^2\mp h^2)/h^2}$ \quad (12-32)

(b) $\quad xy = j^4/4h^2$ $\hspace{4cm}$ $A^2 = b^2\mp(h^2-a^2)$

To convey a realistic impression of the formidable task faced by one who seeks to obtain the reduction of the resulting expression to 32b, the 19 complex polynomials that comprise the unmanipulated basis eq. (only cancellations have been

carried out) are given in 33. It seems quite evident that 33 will not reduce merely by factoring and cancellations, as so frequently is the case; root-taking is essential. That $xy = j^2/4h$ satisfies eq. 33 can be confirmed by substitution (for example, by letting $x = y = j^2/2h$, or by letting $x = j^2/h$ and $y = j^2/4h$, etc.).

$$a^4b^8x^4y^4(x-y)^4/h^4 - 2a^2A^2b^6x^4y^4(x-y)^2(x^2+y^2)/h^2 + A^4b^4x^4y^4(x^2-y^2)^2 - \quad (12-33)$$

$$a^4b^8j^4x^3y^3(x-y)^4/h^6 - 4a^2b^4j^4(a^2-A^2b^2/2h^2)x^4y^4(x-y)^2/h^2 +$$

$$a^2A^2b^6j^4x^3y^3(x-y)^2(x^2+y^2)/h^4 + a^4b^8j^8x^2y^2(x-y)^4/4h^8 + a^4b^8j^8x^2y^2(x-y)^4/8h^8 -$$

$$a^2A^2b^6j^8x^2y^2(x-y)^2(x^2+y^2)/8h^6 + 2a^2b^4j^8(a^2-A^2b^2/2h^2)x^3y^3(x-y)^2/h^4$$

$$a^2A^2b^6j^8x^2y^2(x-y)^2(x^2+y^2)/8h^6 + A^4b^4j^8x^2y^2(x^2+y^2)^2/8h^4 - A^4b^4j^8x^2y^2(x^4+y^4)/4h^4 -$$

$$a^4b^8j^{12}xy(x-y)^4/16h^{10} + a^2A^2b^6j^{12}xy(x-y)^2(x^2+y^2)/16h^8 -$$

$$2a^2b^4j^{12}(a^2-A^2b^2/2h^2)x^2y^2(x-y)^2/8h^6 - a^2A^2b^6j^{16}(x-y)^2(x^2+y^2)/128h^{10} +$$

$$a^4b^8j^{16}(x-y)^4/256h^{12} + A^4b^4j^{16}(x^2-y^2)^2/256h^8 = 0$$

$$A^2 = b^2 \mp (h^2-a^2)$$

The maximum degree of the $180°$ transform of 32a is 10, while for the $90°$ transform it is 24. It is most significant that the substitution of $H = -j^2/2h$ in 16a-c leaves the form of the format unchanged from that for a non-focal point on the axis of all QBI cubics and quartics. This means that, aside from the 2nd degree $0°$ transform of self-inversion, the general rank of transforms about the focus of self-inversion is the same as that for any non-focal pole on the line of symmetry. Excepting, once again, the 2nd degree $0°$ transform, this makes the focus of self-inversion the lowest ranking (i.e., possessing transforms of the highest degree) of the axial foci. In essence, if the transform of self-inversion is excepted, the focus of self-inversion qualifies as a point focus only at those locations at which it achieves focal rank by virtue of coincidence with a focus specified by the simple intercept eq. or format, for example, in limacons, central conic axial vertex cubics, and eccentricity-dependent self-inverters.

Whereas conditions for the reduction of all transforms of 16a-c specify focal poles (values of H) on the line of symmetry, conditions for the reduction of the $90°$ and $180°$ transforms of 32a specify genera and subspecies in which the pole of self-inversion achieves focal rank at other angles than $0°$.

CIRCUMPOLAR MAXIM 31: *With the exceptions of the foci occurring in limacons, conic axial vertex cubics, eccentricity-dependent self-inverters, mutually-inverting quartic circles, the circle, and intersecting lines, foci of self-inversion of axial QBI curves do not qualify as circumpolar point foci at any angle other than the angle of self-inversion (0° or 180° or both).*

Aside from the vertex foci, which are treated in Chapter XIV under *General Circumpolar Symmetry Analysis of Axial QBI Curves*, the only remaining focus to be considered for quartics derived by axial inversions of central conics is that given by the constant term of the radicand in the simple intercept format 16b. However, this yields a pole of focal rank only for limacons, for which it is the variable, penetrating focus of self-inversion at $(a^2-b^2)/2b$; the latter already has been treated in Chapter X.

Circumpolar Symmetry of Axial Inversions of the Parabola

Introduction

To round out the above treatment, axial QBI curves of unit eccentricity now are considered. The circumpolar symmetry properties of both QBI quartics of unit eccentricity and QBI cubics direct attention to a number of exceptional phenomena relating to number, homologies, coincidences, and other properties of foci. For example, the foci of axial QBI cubics are exceptional in that: (a) one axial focus and a covert linear focal locus are at infinity; (b) the degree of $90°$ transforms about the asymptote-point focus does not reduce below that for neighboring axial points; and (c) the homologue of the loop focus of some non-QBI cubics does not have focal rank. In the cases of axial QBI quartics of unit eccentricity, the homologue of the focus of self-inversion is incident upon the curve at the DP homologue. Some of these matters are touched upon in the following treatment.

A Point On the Line of Symmetry

Eq. 1a, the general eq. for axial inversions of the parabola, leads to the simple axial intercept eq. 34, cast about a pole H on the line of symmetry. The components of the simple intercept format are given by 34b-d. It is evident from 34e, for the roots of the coefficient of the $\cos^2\theta$ term, that the $\cos^2\theta$-condition specifies 2 real roots for all pre-focal axial inversions of the

simple intercept equation for point on axis
of parabola axial inversions

(a) $[16ahH^2+8ah^2H+j^4]x^2\cos^2\theta + 4a[x^2(4hH+j^2)+(4hH+3j^2)H^2]x\cos\theta$ (12-34)

$+ 4ahx^4 + (8ahH^2+4aj^2H-j^4)x^2 + 4a(hH+j^2)H^3 = 0$

components of the simple intercept format $\cos\theta = \dfrac{-B\pm(B^2-4AC)^{\frac{1}{2}}}{2A}$

(b) $-B = -2a[(4hH+j^2)x^2+(4hH+3j^2)H^2]$

(c) $B^2-4AC = 4aj^4(a-h)x^4 + j^4[8a(a-h)H^2+4aj^2H+j^4]x^2 + 4aj^4H^3[(a-h)H-j^2]$

(d) $2A = [16ahH^2+8aj^2H+j^4]x$

(e) $H = (-j^2/4ah)[a\pm(a^2-ah)^{\frac{1}{2}}]$ (f) $4aH^3(hH+j^2)$ (g) $H = -j^2/h$

parabola and 2 imaginary foci for all post-focal inversions (poles beyond the focus on the side opposite the vertex). The two real foci always are within the oval, which has its DP homologue at $H = 0$ (specified by the constant-condition, 34f), its vertex at $H = -j^2/H$ (also specified by the constant-condition, 34f,g), and an axial length of j^2/h.

The Foci At the Double Point Homologue

In axial inversions of the parabola, its 3 foci at the axial point at infinity--the center and the other traditional focus and vertex--invert to the DP homologue. One of these 3 foci is the homologue of the focus of self-inversion of the corresponding hyperbola and ellipse inversions. This follows because the focus of self-inversion of axial QBI curves of non-unit eccentricity approaches and achieves coincidence with the DP or DP homologue as the eccentricity approaches and achieves unity (whereupon the 0° transform becomes the trivial $xy = 0$).

The limacon genus is taken as an example to illustrate this phenomenon. Consider first the post-focal inversions of the parabola. In these curves, 2 imaginary foci are specified by the $\cos^2\theta$-condition, 34e, the loop vertex is specified by the constant-condition, 34g, and 3 foci are at the DP homologue, specified by $H^3 = 0$, which also is a component of the constant-condition. [Although it is tempting to assume that the exponent of H in the constant term specifies the multiplicity of the focus, this leads to contradictions.]

As the axial pole of inversion of the parabola approaches the traditional focus, the absolute magnitude of the square of the imaginary radical of 34e approaches 0; at the traditional focus, where the inversion locus is the cardioid, it equals 0, and the $\cos^2\theta$-condition specifies only one real root. With this replacement of two imaginary roots of post-focal inversions by only one real root in the cardioid, the number of foci would decrease from 6 to 5 if no other factor intervened. However, a factor does intervene, namely, the fact that in all limacons the x^4 term of the radicand of the simple intercept format vanishes (eq. 16b) and, in consequence, the radicand-constant condition becomes focal.

The origin of the 6 axial foci of the cardioid can be given without recourse to the fact that 3 of the 4 foci in coincidence at the cusp derive as inversions of the 3 axial foci of the parabola at infinity. This origin is described best by following the changes in the locations of the foci as the eccentricity of the limacon (and the basis conic section) decreases from greater than one to one, and then to less than one. A hyperbolic limacon is taken as the starting point.

In the hyperbolic limacon with eccentricity only slightly greater than one, the focus specified by the $\cos^2\theta$-condition ($b+2h = 0$) is outside of a tiny loop at $h = -\tfrac{1}{2}b$. The constant-condition, $h^2[(b+h)^2-a^2] = 0$, specifies 3 foci: the DP at $h = 0$; the large-loop vertex at $h = -(a+b)$; and the small-loop vertex at $h = a-b$. The pole of self-inversion forms a generic double-focus with the pole specified by the radicand constant-condition at $h = (a^2-b^2)/2b$, which lies within the tiny loop close to the DP. The $0°$ transform of self-inversion is $xy = (a^2-b^2)^2/4b^2$.

As the eccentricity ($e = b/a$) approximates one, i.e., as the value of the parameter b approximates the value of the parameter a, both the vertex of the tiny loop at $a-b$ and the generic double-focus at $(a^2-b^2)/2b$ converge onto the DP. When $e = 1$ they become coincident with it as a quadruple focus at the cusp of the cardioid. The $0°$ transform of self-inversion now is the trivial $xy = 0$. For $e < 1$, the cusp becomes the single $a-b$ vertex focus, the DP homologue becomes internalized within the loop, the generic double-focus becomes externalized to the right of the $a-b$ vertex at $(a^2-b^2)/2b$, and a non-trivial transform, $xy = (a^2-b^2)^2/4b^2 \neq 0$, once again exists.

Having illustrated why one of the coincident foci at the DP homologue of axial

inversions of the parabola is to be regarded as the homologue of the focus of self-inversion of the corresponding hyperbola and ellipse inversions, we return to the topic of axial inversions of the parabola and consider the vertex-focus inversions ($0 < h < a$). For these, the $\cos^2\theta$-condition, 34e, defines 2 real foci, there are only 3 foci in coincidence at the DP homologue, and the constant-condition, 34f,g, specifies the loop-vertex focus, $h = -j^2/h$.

It is evident from the above-considered axial post-vertex inversions of the parabola that the DP homologue is a quadruple focus only when the pole of post-vertex inversion of the basis curve is at the traditional focus. This raises the question of the possibility of arriving at distinctions between focal and non-focal inversions. As a first step, consider the hypothesis that the number of foci in coincidence at the DP homologue is augmented by 1 whenever the pole of inversion of the basis parabola is a focus. Accordingly, we now examine the other focal inversion of the parabola, namely that at its vertex.

For the vertex inversion, one of the foci goes off to infinity, while the other (the variable focus) is at $H = -j^2/8a$. A 3rd focus at the asymptote point is specified by the x^2 condition of eq. 34, which becomes $4aH^3j^2 = 0$. The origin of these foci could be traced by following the paths of the foci in the conic axial vertex cubic genus, just as was done for the limacon genus. In this event, the 3 foci at the cusp of the cissoid of Diocles would be found to arise by the merging of the DP or DP homologue of the hyperbolic or elliptical species with the generic double-focus.

But the hypothesis that focal inversions of the parabola augment the number of foci at the DP homologue by 1 either has to be reconsidered or modified to take into account the fact that there are only 3 foci at the cusp of the cissoid of Diocles. In the case of the cardioid, augmentation of the foci at the DP homologue (which becomes the cusp) occurs when one of the foci speci-fied by the $\cos^2\theta$-condition--and not lying at the DP homologue--is lost and replaced by the $(a^2-b^2)/2b$ focus (specified by the radicand constant-con-dition). On the other hand, in the case of the cissoid of Diocles, the 2nd focus specified by the $\cos^2\theta$-condition is not lost and replaced; it merely goes off to infinity.

Since the focus of the cissoid of Diocles at infinity is not a homologue of one of the 3 foci at the axial point at infinity in the parabola--because it is specified by the $\cos^2\theta$-condition--a modification of the hypothesis is

that in focal inversions of the parabola the sum of the number of foci at the DP homologue of the inversion locus plus the number of foci at infinity is augmented by 1 over the sum in non-focal inversions.

Next we inquire as to the possibility of generalizing the hypothesis to the hyperbolic and elliptical species, in which the DP or DP homologue of focal inversions is not a cusp. In the cases of the vertex inversions, the modified hypothesis is valid, because the sum of the number of foci at the reciprocal inversion pole and at infinity *is* augmented by 1 over a nonfocal inversion. But in the cases of inversions about a DP or DP homologue, an additional focus is not present at the reciprocal inversion pole, nor is an additional focus present at infinity. However, with the exception of inversions about true centers, an additional line of symmetry is present. Accordingly, the hypothesis would have to be modified to exclude true centers and to assert that focal inversions augment by 1 the sum of the number of foci at the reciprocal inversion pole, the number of foci at infinity, and the number of orthogonal lines of symmetry, as compared to non-focal inversions.

Lastly, when inversions about the traditional foci of central conics are examined, no augmentation of foci is to be found in any of the above-mentioned areas, but the curves do differ from non-focal inversions in that they possess generic double-foci. It is clear from these considerations that, though some quantitative maxim concerning the sum of generic double-foci, foci at infinity, orthogonal lines of symmetry, and foci at the reciprocal inversion pole might be formulated, the distinguishing property of focal as opposed to non-focal inversions (excluding true centers) is that the focal inversion locus has one or more of these features, as compared to a non-focal inversion locus, whence Maxim 32.

CIRCUMPOLAR MAXIM 32: *Excluding self-inversions and inversions about true centers, inversion loci about focal poles are distinguished from those about non-focal poles by the increase or appearance (or both) in the former, as compared to the latter, of: (a) the focal multiplicity of the reciprocal inversion pole; (b) generic multiple-foci; (c) foci at infinity; or (d) an orthogonal line of symmetry.*

Quartic Circles

Introduction

The present analysis of quartic circles includes both an intersecting and a non-intersecting pair. The intersecting pair is a QBI curve, for it is the inversion of intersecting lines about a point in the plane. Intersecting lines, themselves, are a true conic section, comprising the limiting curve obtained by cutting a cone with planes parallel to its axis. For all non-zero distances of the plane from the axis, hyperbolas are obtained, but when the plane includes the axis, the curve is comprised of the asymptotes of the corresponding hyperbolae. The circumpolar symmetry of quartic circles is of particular interest because the curve is composed of two circles, because it has two lines of symmetry, and because intersecting circles are one of only 3 genera of QBI curves with two lines of symmetry.

A Point On the Axis of Intersection

The quartic eq., 35, of two circles of radius R with their centers at $y = \pm d$ is synthesized by taking the product of the expressions for the individual circles [if $f_1(x,y) = R$ and $f_2(x,y) = R$, the eq. is $\{f_1(x,y)-R\}\{f_2(x,y)-R\} = 0$]. The simple intercept eq. (x+H translation) for a

$$(x^2-R^2)^2 + 2(x^2-R^2)(y^2+d^2) + (y^2-d^2)^2 = 0 \qquad \text{quartic circles} \qquad (12\text{-}35)$$

$$4(h^2+d^2)x^2\cos^2\theta + 4h(h^2+d^2-R^2+x^2)x\cos\theta + x^4 +$$
$$2(h^2-d^2-R^2)x^2 + (h^2+d^2-R^2)^2 = 0 \qquad \begin{array}{c}\text{simple intercept eq.,}\\ \text{point on axis of} \quad (12\text{-}36)\\ \text{intersection}\end{array}$$

$$\cos\theta = \frac{-h(A^2+x^2) \pm d[4x^2(h^2+d^2)-A^2(A^2+2x^2)-x^4]^{\frac{1}{2}}}{2(h^2+d^2)x} \qquad \begin{array}{c}\text{simple intercept}\\ \text{format for eq. 36}\end{array} \quad (12\text{-}37)$$
$$A^2 = h^2+d^2-R^2$$

point on the axis of intersection, in this case the x-axis, is given by eq. 36 and the simple intercept format by eq. 37.

Inspection of eq. 36 reveals the locations of the 8 axial foci. Together with one line of symmetry this gives a total of 9 foci for the sum of axial foci and an orthogonal line of symmetry for the genus. The 8 axial point foci are derived

as follows. The $\cos^2\theta$-condition yields 2 imaginary axial foci at $h = \pm di$ (unless the circles are coincident, in which case the foci are real and at the center). The $\cos\theta$-condition (a condition for which the entire term in $\cos\theta$ vanishes) specifies the true center at $h = 0$, which is a generic double-focus of self-inversion. In addition, the constant-condition, $(h^2+d^2-R^2)^2 = 0$ specifies 2 vertex double-foci, one at $h = +(R^2-d^2)^{\frac{1}{2}}$ and one at $h = -(r^2-d^2)^{\frac{1}{2}}$, bringing the total number of point foci to 8. If the circles intersect, both double-foci consist of the coincidence of real vertices, if not, they consist of the coincidence of imaginary vertices.

In addition to the focal condition mentioned above, the $\cos\theta$-constant condition also specifies the real or imaginary poles of intersection of the circles. The x^2-condition specifies poles at $h^2 = d^2+R^2$, which have only subfocal rank.

The Double-Foci of Intersection

The following analysis for a vertex double-focus holds for both the real and imaginary foci (i.e., it holds whether the circles intersect or not) but the treatment assumes intersection. The simple intercept eq. and format of eqs. 36 and 37 greatly simplify to eqs. 38 and 39, whereupon the $0°$ and $180°$ transforms

$$R^2\cos^2\theta + (R^2-d^2)^{\frac{1}{2}}x\cos\theta + (x^2/4-d^2) = 0 \qquad \begin{array}{l}\text{simple intercept eq.} \\ \text{about vertex double-focus}\end{array} \qquad (12\text{-}38)$$

$$\cos\theta = \frac{-x(R^2-d^2)^{\frac{1}{2}} \pm d(4R^2-x^2)^{\frac{1}{2}}}{2R^2} \qquad \begin{array}{c}\text{simple intercept format} \\ \text{of eq. 38}\end{array} \qquad (12\text{-}39)$$

(a) $\quad R^2(x^2+y^2)\pm2(2d^2-R^2)xy-16d^2(R^2-d^2) = 0 \qquad 0° \text{ and } 180° \text{ transforms} \qquad (12\text{-}40)$

(b) $\quad d^2x^2 + (R^2-d^2)y^2 = 8d^2(R^2-d^2) \qquad \begin{array}{l}0° \text{ transform, } 45° \text{ CCW} \\ \text{rotation of axes}\end{array}$

(b') $\quad (R^2-d^2)x^2 + d^2y^2 = 8d^2(R^2-d^2) \qquad \begin{array}{l}180° \text{ transform, } 45° \text{ CCW} \\ \text{rotation of axes}\end{array}$

$$(2d^2-R^2)^2(x^2+y^2+4R^2)^2 - 4d^2(R^2-d^2)[4R^2(x^2+y^2)-(x^4+y^4)] \qquad \begin{array}{c}90° \\ \text{transform}\end{array} \qquad (12\text{-}41)$$
$$= 8d^2(R^2-d^2)xy[(4R^2-x^2)(4R^2-y^2)]^{\frac{1}{2}}$$

are two orthogonal, congruent, concentric ellipses (eq. 40). A $45°$ CCW rotation of axes displays them in more familiar form, 40b for $0°$ and 40b' for $180°$.

The 90° transform, 41, is of 8th degree and is given in the form it takes before the final squaring. We already have found that the 90° transform of a single circle about an incident point is only of 2nd degree.

A Point On the Major Axis

The axis that passes through the centers of the circles is called the major axis, by analogy with the major axis of the ellipse, since the 8 foci on this axis always are real. These foci are revealed by inspection of the simple intercept eq. 42 for a point on the axis. The $\sin^2\theta$-condition, $k = \pm d$, specifies the two always-real foci at the centers of the circles. These, of course, are variable penetrating foci. The true center, $k = 0$, which is a generic double-focus of self-inversion, is specified by the $\sin\theta$-condition, while the 4 always-real vertex foci are specified by the constant-condition.

$$4x^2(k^2-d^2)\sin^2\theta + 4k(x^2-R^2+k^2-d^2)x\sin\theta + x^4 +$$
$$2(k^2+d^2-R^2)x^2 + [R^4-2R^2(d^2+k^2)+(k^2-d^2)^2] = 0$$

simple intercept eq. for a point on the major axis (12-42)

$$\sin\theta = \frac{-k(x^2+B^2)\pm d(x^2-A^2)}{2x(k^2-d^2)} \qquad \begin{aligned} A^2 &= k^2-d^2+R^2 \\ B^2 &= k^2-d^2-R^2 \end{aligned}$$

simple intercept format for eq. 42 (12-43)

$$\frac{-k(x^2+B^2)\pm k(x^2-A^2)}{2(k^2-d^2)x} = \frac{-k(y^2+B^2)\pm k(y^2-A^2)}{2(k^2-d^2)y}$$

first step in obtaining the 0° transform (12-44)

The $\sin\theta$-constant condition specifies two always-real poles having subfocal rank, at $k^2 = d^2+R^2$, while the x^2-condition specifies two poles having subfocal rank, at $k^2 = R^2-d^2$, that are real only if the circles intersect.

The simple intercept format is eq. 43. For purposes of illustration, and because of the unusual nature of the transforms, algebraically complete transform eqs. are derived. This derivation is carried out for the 0° transforms. First, since $\sin\theta = f(x)$ and $\sin(\theta+0^\circ) = \sin\theta = f(y)$, the formats in x and y are equated, as in eq. 44, cross-multiplied, and terms collected to give eq. 45. The algebraically complete transform eq. is derived by taking the alternate signs in all 4 combinations and equating the product of factors thereby obtained to 0, as in eq. 46a. The corresponding 180° transform eq. is 40b.

$$k(x-y)(B^2-xy) = \pm dy(x^2-A^2) \pm dx(y^2-A^2)$$

eq. 44 after cross-multi-
plying and collecting terms

(12-45)

algebraically complete transforms eqs. for a point on the major axis

(a) $(x-y)^2[k(x-y)(B^2-xy)-d(x+y)(xy-A^2)][k(x-y)(B^2-xy)+d(x+y)(xy-A^2)]\cdot$ (12-46)

$[k(B^2-xy)-d(xy+A^2)][k(B^2-xy)+d(xy-A^2)] = 0$

(b) $(x+y)^2[k(x+y)(B^2+xy)+d(x-y)(xy+A^2)][k(x+y)(B^2+xy)-d(x-y)(xy+A^2)]\cdot$

$[k(B^2+xy)+d(xy-A^2)][k(B^2+xy)-d(xy-A^2)] = 0$

The $(x-y)^2$ and $(x+y)^2$ terms of 46a,b represent the trivial 0° and 180° trans-
forms, respectively. The remaining terms of eqs. 46a,b consist of two quadratic
factors and two cubic factors. The quadratic factors represent combinations of
positive and negative intercepts for transforms for intersections with the same
circle, in keeping with the fact that 2nd degree eqs. represent the 0° and 180°
transforms for a single circle (eqs. VI-16a,c). On the other hand, the cubic
factors represent combinations of positive and negative intercepts for transforms
for intersections with different circles. In other words, in order to accommo-
date transform relations for two circles about points on their major axis, an
increase in the degree of the transform eqs. from 2 to 3 is required.

For $k = 0$, i.e., for transforms about the true center, the first (left)
product of terms within each bracket of eqs. 46a,b vanishes and the algebraically
complete 0° and 180° transform eqs. become identical, as represented by eq. 47.

algebraically complete 0° and 180° trans-
form equation about the true center

$$(x+y)^2(x-y)^2(xy+d^2-R^2)(xy-d^2+R^2) = 0$$

(12-47)

(a) $xy = d^2-R^2$ 0° transform, (b) $xy = R^2-d^2$ 180° transform, (12-48)
 not intersecting intersecting

Viewed as a 0° transform, the $(x-y)^2$ term of 47 represents the trivial trans-
form $x = y$, while the $(x+y)^2$ term represents the valid $x = -y$ transform
for one positive and one negative intercept. The same terms have a complementary
significance for the 180° transform.

In the cases of the other two terms, if one considers only two positive or two negative intercepts, then eq. 48a, derived by equating the rightmost term of 47 to 0, represents the quadratic 0° transform for the case in which the circles do not intersect, while eq. 48b, derived by equating the other quadratic term to 0, represents the quadratic 0° transform for intersecting circles. Similarly for 180°; eq. 48a also is for the case in which the circles do not intersect, and eq. 48b for the case in which they do. Eq. 47, of course, covers all eventualities--all combinations of positive and negative intercepts for both intersecting and non-intersecting circles for both 0° and 180°.

An analysis of quartic circles provides an excellent opportunity to compare a case of an algebraically complete but degenerate transform eq.--that for a point on the major axis--with an algebraically complete but non-degenerate (except for the term representing the trivial transform) transform eq. of the same overall degree in the variables--that for a point on the axis of inter-section. For this purpose the algebraically complete 0° transform eq., 49, derived from the simple intercept format of eq. 37 is employed.

algebraically complete 0° transform for point on axis of intersection

$$(x-y)^2\{h^4(x-y)^2(A^2-xy)^4+2h^2d^2(A^2-xy)^2[x^2y^2(x^2+y^2+4A^2-8h^2-8d^2) + \tag{12-49}$$

$$A^2 = h^2+d^2-R^2 \qquad + A^4(x^2+y^2)] + d^4(x+y)^2(x^2y^2-A^4)^2\} = 0$$

(a) $(x+y)^2(x-y)^2(xy+d^2-R^2)(xy-d^2+R^2) = 0$ \qquad eq. 49 for true center (12-50)

(b) $x^4y^4(x-y)^2[(R^2-d^2)^2(x-y)^2+2d^2(R^2-d^2)(x^2+y^2-8R^2)$ \qquad eq. 49 for the double-foci of intersection

$$+d^4(x+y)^2] = 0$$

If the algebraically complete transform eq., 49, for the axis of intersection is compared with the equivalent eq. 46a, for the major axis, both are seen to possess a factor $(x-y)^2$, representing the trivial 0° transform, $x = y$, and both are seen to be of overall 10th degree in the variables in the remaining terms. The most significant difference is that the remainder of eq. 46a is degenerate, consisting of the product of two 3rd degree terms and two 2nd degree terms, while the remainder of eq. 49 consists of a non-degenerate sum of terms. Accordingly, quartic circles have significantly greater 0° and 180° symmetry

about a point on the major axis than about a point on the axis of intersection.

[Even if one were to adopt the convention of characterizing the symmetry class of algebraically complete transform eqs. as that of the overall degree in the variables, whether degenerate or not--and thus placing eqs. 46a and 49 in the same class--the symmetry of the curve about points on the major axis still would be greater. This ensues because the eq. about a point on the latter axis falls into factors of lower degree, whereas that about a point on the axis of intersection does not.]

It remains to demonstrate that eq. 49 reduces to previously derived 0° transforms about the double-foci of intersection and the true center. For the true center, one lets $h = 0$ and $A^2 = d^2-R^2$ in eq. 49, whereupon it reduces directly to eq. 50a, which is seen to be identical with eq. 47. In the case of the double-foci of intersection, one lets $h^2 = R^2-d^2$, whereupon $A^2 = 0$, and the eq. simplifies to 50b. In addition to the term $(x-y)^2$, representing the trivial 0° transform, $x = y$, there now factors out a term x^4y^4, representing the trivial 0° transform, $xy = 0$, for a point on the curve, leaving the non-trivial 2nd degree bracketed term on the right. When equated to 0 and regrouped and simplified, this becomes identical to eq. 40 (upper sign) for the 0° transform about the double-foci of intersection.

To obtain the 90° transform, we have $\sin\theta = f(x)$ from eq. 43, whence $\sin(\theta+90^{\circ}) = \cos\theta = f(y)$, and $f^2(x)+f^2(y) = 1$. Accordingly, one squaring of the expression of eq. 43 is required, leading to eq. 51a.

starting eq. for forming the algebraically complete
90° transform about a point on the major axis

(a) $(k^2+d^2)x^2y^2(x^2+y^2) - 4R^2(k^2+d^2)x^2y^2 + (d^2A^4+k^2B^4)(x^2+y^2) =$ (12-51)

$$\pm 2kdy^2(x^2+B^2)(x^2-A^2) \pm 2kdx^2(y^2+B^2)(y^2-A^2)$$

algebraically complete 90° transform about point on major axis

(b) $[(k-d)^2x^2y^2(x^2+y^2-4R^2)+(dA^2+kB^2)^2(x^2+y^2)]\cdot$

$[(k+d)^2x^2y^2(x^2+y^2-4R^2)+(dA^2-kB^2)^2(x^2+y^2)]\cdot$

$[(k^2+d^2)x^2y^2(x^2+y^2)+2kdx^2y^2(x^2-y^2)-4R^2(k^2+d^2)x^2y^2$

$$+(d^2A^4+k^2B^4)(x^2+y^2)+2kdA^2B^2(x^2-y^2)]\cdot$$

$[(k^2+d^2)x^2y^2(x^2+y^2)-2kdx^2y^2(x^2-y^2)-4R^2(k^2+d^2)x^2y^2$

$$+(d^2A^4+k^2B^4)(x^2+y^2)-2kdA^2B^2(x^2-y^2)] = 0$$

$$y^2(x^2+d^2-R^2)^2 + x^2(y^2+d^2-R^2)^2 = 4d^2x^2y^2 \qquad \text{eq. 51b for } k = 0 \qquad (12\text{-}52)$$

The degenerate, algebraically complete transform eq., 51a, is formed by taking all combinations of the two alternate signs into account, leading to eq. 51b, a product of four 6th-degree factors. The far greater complexity of these factors than of the $90°$ transform for a single circle (eq. VI-16b) is required to represent the more complicated situation presented by quartic circles.

On the other hand, if one lets $k = 0$, which yields the $90°$ transform about the true center, the situation becomes equivalent to that for a single circle, provided that algebraically complete transform eqs. are employed in both cases. Consistently with this fact, all 4 factors of eq. 51b simplify to an identical term; equated to 0, this gives eq. 52, which is identical with the algebraically complete transform eq., VI-16b, for a single circle.

The Foci At the Centers

The simple intercept format of eq. 43 does not hold for $k = \pm d$, corresponding to the pole of the transformation at the center of a circle. Derivation of the format for this case leads to eq. 53, which yields the simple intercept format, 54, and the $0°$ and $180°$ transforms of eq. 55. However, the latter are seen to be merely the transforms for the single contralateral circle. The format, 54, cannot yield transforms involving intercepts with the basis circle; it is invalid for intercepts, $x = \pm R$ or $y = \pm R$, because a term, (x^2-R^2), was factored from eq. 53. In fact, no transform for mixed intercepts can exist at any angle (except a trivial transform), because the intercept of the basis circle about its center is constant.

$$4d(x^2-R^2)x\sin\theta+4d^2(x^2-R^2)+(x^2-R^2)^2 = 0 \qquad \begin{array}{l}\text{simple intercept eq. for}\\ \text{the foci at the centers}\end{array} \qquad (12\text{-}53)$$

$$\sin\theta = \frac{R^2-4d^2-x^2}{4dx} \qquad \text{simple intercept format from eq. 53} \qquad (12\text{-}54)$$

$$(x\mp y)(R^2-4d^2\pm xy) = 0 \qquad \begin{array}{l}0° \text{ (upper signs) and } 180° \text{ transforms}\\ \text{from eq. 54}\end{array} \qquad (12\text{-}55)$$

The True Center

The simple intercept eq. for the true center, eq. 56, is obtained by letting $k = 0$ in eq. 42, whence the simple intercept format is 57a,a'. The $0°$, $180°$, and $90°$ transforms about this pole are given above (eqs. 47, 48, and 52).

$$-4d^2x^2\sin^2\theta + x^4 + 2x^2(d^2-R^2) + (d^2-R^2)^2 = 0 \quad \text{simple intercept eq. for true center} \quad (12\text{-}56)$$

(a) $\sin^2\theta = \dfrac{x^4+2x^2(d^2-R^2)+(d^2-R^2)^2}{4d^2x^2}$ \quad simple intercept format for true center \quad (12-57)

(a') $\sin\theta = \pm(x^2+d^2-R^2)/2dx$ \qquad roots of eq. 57a

Tangent Circles

Tangent circles represent the inversion of two parallel lines about a point on the midline. The latter can be regarded as a section of a cone with its vertex at infinity (i.e., a cylinder), in other words, as two lines intersecting at infinity. The situation that arises for quartic circles when the two circles become tangent is unusual. From the point of view of the foci on the axis of intersection, 4 vertices become coincident with the true center to form a *sextuple dual focus*, because the true center itself is a generic double-focus. But from the point of view of the foci on the major axis, 2 *other* vertices become coincident with the true center to form a quadruple-focus. If all 6 vertices were to be reckoned, the focus would be octuple.

Ordinal and Subordinal Rank

For purposes of comparison and hierarchical symmetry ordering (Table V-1), the ordinal and subordinal rank eqs. for transforms about the center of mutually-inverting quartic circles are obtained. Using the $\sin^2\theta$ format given above, with $A^2 = d^2-R^2$ (eq. 58a) and the $0°$ and $180°$ intercept transforms of self-inversion, 58b, yields eq. 59a, a 10th degree ordinal rank eq. The sub-ordinal rank eq. for the $0°$ and $180°$ transforms of self-inversion is obtained by substituting for x or y from 58b and clearing of fractions in the variables, which yields the 8th degree eq. 59b. The subordinal rank eq. for the linear $180°$ transform $x = y$ is obtained by letting $y = x$ in 59a, giving the 6th degree eq. 59c.

(a) $\sin^2\theta = \dfrac{x^4+2A^2x^2+A^4}{4d^2x^2}$ \qquad (b) $xy = (R^2-d^2)$ \qquad (12-58)

(a) $(x^2-A^2)^2(y^2-A^2)^2 S^2 = x^2(y^2-A^2)^2[4d^2x^2-(x^2+A^2)^2]$ \quad ordinal rank eq. for 58a \qquad (12-59)
$$+ y^2(x^2-A^2)^2[4d^2y^2-(y^2+A^2)^2]$$

(b) $(x^2-A^2)^2x^2 S^2 = (A^4+x^4)[4d^2x^2-(A^2+x^2)^2]$ \quad subordinal rank eq. for 58b

(c) $(x^2-A^2)^2 S^2 = 2x^2[4d^2x^2-(A^2+x^2)^2]$ \quad subordinal rank eq. for $180°$ transform $x = y$

These findings place mutually-inverting quartic circles transformed about the true center 8th on the list of 13 curve-focus combinations in the hyperbolic specific symmetry class and 12th on the list of 14 combinations in the linear specific symmetry class in Table V-1. In the latter case, only Cassinians and the quartic twin parabola have ordinal and subordinal rank eqs. of higher degree.

Covert Focal Loci and Non-Axial Inversions of Conics

Introduction

Covert focal loci have not been studied as intensively as other foci, both because it is natural to deal first with overt foci and because of the analytical difficulties encountered in dealing with them. Accordingly, the results of this section should be regarded as being tentative to a greater degree than for the other material. [An "orthogonal line of symmetry" or an "orthogonal axis" in the following refers to an axis orthogonal to the major or transverse axis of the basis central conic or line of symmetry of the basis parabola.]

Simple Intercept Equations About A Point In the Plane

The general form of the simple intercept eq. with mixed transcendental functions for all curves in the QBI superfamily (whether possessing a line of symmetry or not) can be expressed by eq. 60. Two specific examples are point-

$$A\cos^2\theta + B\cos\theta + C\sin\theta + D\sin\theta\cos\theta + E = 0 \qquad \text{simple intercept eq. for all QBI curves} \qquad (12\text{-}60)$$

eq. 60 for axial inversion cubics and quartics of the parabola

$$[16ahH^2+8aj^2H+j^4-16ahK^2]x^2\cos^2\theta + [4a(4hH+j^2)(x^2+H^2+K^2) + 8aj^2H^2]x\cos\theta \qquad (12\text{-}61)$$
$$+ 2K[8ah(x^2+H^2+K^2)-j^4+4aj^2H]x\sin\theta + 8aK[4hH +j^2]x^2\sin\theta\cos\theta + 4ahx^4$$
$$+ [8ah(H^2+3K^2)+4aj^2H-j^4]x^2 + 4ah(H^2+K^2)^2 + 4aj^2H(H^2+K^2) - j^4K^2 = 0$$

eq. 60 for axial inversion cubics and quartics of central conics

$$[4b^2(h^2-a^2)(H^2-K^2)+4b^2hHj^2+j^4(b^2\pm a^2)]x^2\cos^2\theta + \{2b^2[2(h^2-a^2)H+hj^2]\cdot \qquad (12\text{-}62)$$
$$\cdot(x^2+H^2+K^2)+4b^2hH^2j^2+2b^2j^4H\}x\cos\theta + K[4b^2(h^2-a^2)(x^2+H^2+K^2) +$$
$$4b^2hHj^2\mp2a^2j^4]x\sin\theta + 4b^2K[2(h^2-a^2)H+hj^2]x^2\sin\theta\cos\theta +$$
$$[b^2(h^2-a^2)(x^2+H^2+K^2)^2+4b^2(h^2-a^2)K^2x^2+2b^2hHj^2(x^2+H^2+K^2)+(b^2H^2\mp a^2K^2\mp a^2x^2)j^4] = 0$$

in-the-plane simple intercept eqs. for axial inversion cubics and quartics for the parabola (eq. 61) and central conics (eq. 62), in the derivation of which the basis conic in standard form was inverted about the axial pole at $x = h$, and $x+H$ and $y+K$ translations of the inversion locus were carried out before obtaining the intercepts relative to rotation of axes about the origin.

Focal Conditions

Eq. 60 can be put in the form of a simple intercept eq. in powers of $\cos\theta$ (or $\sin\theta$) alone by grouping the two terms containing $\sin\theta$ on the right and squaring once, yielding eq. 63. The coefficients A, B, C, D, and E are polynomials in x (the intercept), in the parameters a and b of the basis conic, in the coordinates h and k of the point about which it is inverted, and in the values H and K by which the inversion loci are translated.

$$(A^2+D^2)\cos^4\theta+2(AB+CD)\cos^3\theta+(B^2+C^2+2AE-D^2)\cos^2\theta+2(BE-CD)\cos\theta+(E^2-C^2) = 0 \quad (12\text{-}63)$$

(a) $C^2 = E^2$ (b) constant portion of $E = 0$ (c) $AB + CD = 0$ (12-64)

(d) $BE-CD = 0$ (e) $B^2 + C^2 + 2AE - D^2 = 0$ (f) $A^2 + D^2 = 0$

While it is possible to obtain analytical solutions to eq. 63 for the $\cos^2\theta$ or $\cos\theta$ simple intercept format, this is a formidable procedure. In essence, any condition on eq. 63, for example, eqs. 64a-f, that simplifies this procedure probably is focal, since if the procedure is simplified the degree of the resulting transform is likely to be reduced. It further can be asserted that any condition on eq. 63 that allows terms in the variable x to be factored out--whether the eq. is significantly simplified or not--is focal, because this inevitably leads to reduction of the transforms.

If the conditions in question involve specific relationships between H and K (with H and K non-zero), the focus in question will be curvilinear. If $K = 0$ but H can take on any value, the focal condition specifies a point on the horizontal axis (the x-axis) passing through the DP or its homologue: similarly, with $H = 0$, the focal condition specifies a point on the vertical axis (the y-axis) through the DP; for H or K having some specific value, the focal condition applies to a point on the corresponding horizontal or vertical axis. If the condition is for specific non-zero values of both H and K, the focal condition applies only for the pole (H,K).

The conditions discussed above apply at the level of all curves represented by the basis cubic or quartic. If this is an inversion of the basis conic about an incident or non-incident point in the plane, then it applies at the level of all inversion loci of the basis conic. If the basis cubic or quartic is an inversion about a point on the axis, it applies to all axial inversions, etc. On the other hand, if the conditions for the simplification of eq. 63 place a restraint on h or k, then the resulting loci will be focal only in the genus or genera so represented. Lastly, if the conditions place a restraint on the parameters a and b, or on alternate signs, the resulting loci will be focal only in the species or subspecies so represented, whether in all genera or only in specific genera.

The condition that specifies the lowest-ranking focal locus is 64b. When this holds, the focal locus is the curve itself and an x^2 factors out of each term of eq. 63. This focal condition applies at the level of the entire QBI superfamily, though the degrees of the transforms about points on the curves depend upon the genus and, in some cases, even on the subspecies. Another possible focal condition on eq. 63 is 64a, the vanishing of the non-transcendental term. If this term were to vanish, eq. 63 would reduce to a cubic in $\cos\theta$, with consequent reduction in the degree of transforms. However, condition 64a cannot be fulfilled in any QBI curve.

The conditions 64c-e, each of which leads to the vanishing of a single term, have not been pursued to their ultimate focal consequences. If they can be fulfilled, they probably are focal, but this is a matter for future resolution. Taking as specific examples the axial cubics and quartics of eq. 62, if the coefficients of the $\cos^3\theta$ term and the $\cos\theta$ term were to vanish simultaneously, this would leave an eq. with terms only in $\cos^4\theta$, $\cos^2\theta$, and a "constant term." This could be solved routinely to obtain a $\cos^2\theta$ simple intercept format. This indubitable focal condition requires either that $A = -E$, which cannot be fulfilled, or $B = 0$ together with either $C = 0$ or $D = 0$ ($B = 0$ calls for the coefficient of the $\cos\theta$ term in eq. 60 to vanish).

The condition $B = 0$ for eqs. 60 and 62 requires that both h and H equal 0. But when this occurs the coefficient D also vanishes. Accordingly,

the combination $B = 0$ and $D = 0$ yields the simple intercept eq. for a point on the orthogonal line of symmetry of central quartics. On the other hand, when the coefficient B vanishes, C will not also vanish unless $K = 0$. If, then, one also lets $K = 0$, one obtains the simple intercept eq. for the true center of central quartics. But for $K = 0$, alone, both C and D vanish, yielding the simple intercept eq. for a point on the line of symmetry (including the axial inversions of the parabola, eq. 61).

Non-Axial Covert Linear Focal Loci

Consider now condition 64f, for which the coefficient of the $\cos^4\theta$ term vanishes. The sum of A^2 and D^2 can equal 0 only if $A^2 = D^2 = 0$, i.e., only if both A and D vanish. But if this occurs, the coefficient of the $\cos^3\theta$ term also will vanish (condition 64c) and eq. 62 will reduce to only 2nd degree in $\cos\theta$. There are two ways in which the coefficients A and D can vanish simultaneously. In one case, $K = 0$, whereupon $A = 0$ yields the familiar $\cos^2\theta$-condition that specifies one or 2 real foci or 2 imaginary foci on the line of symmetry. In the other case, $D = 0$ yields eq. 65a, $H = hj^2/2(a^2-h^2)$. This defines the location of the "non-axial" (i.e., not passing through the cusp, DP, or DP homologue) covert linear focal locus.

(a) $H = hj^2/2(a^2-h^2)$ (b) $H = -j^2/4h$ (12-65)

(c) $K^2 = -a^2j^4[b^2 \mp (h^2-a^2)]/4b^2(h^2-a^2)^2$ (d) $K^2 = j^4(h-a)/4ah^2$

(e) $K^2 = -j^4(b^2 \pm a^2)/4a^2b^2$

When H of eq. 65a is substituted in the eq., $A = 0$ (where A is the coefficient of the $\cos^2\theta$ term of eq. 62), it yields the roots, 65c. This eq. specifies 2 imaginary point foci on the non-axial covert linear focal locus of post-focal elliptical species and pre-focal hyperbolic species, and 2 real point foci for post-focal hyperbolic species and pre-focal elliptical species. In limacons, for which $h^2 = a^2 \pm b^2$, these foci do not exist.

In central quartics, for which $h = 0$ and the condition 65a yields the orthogonal line of symmetry, the condition becomes 65e, which defines the 2 non-vertex, non-DP foci on this axis. These are real in the elliptical species

but imaginary in the hyperbolic species. For axial inversions of the parabola, the location of the non-axial covert linear focal locus is given by 65b and the point foci on this axis by 65d. Note that, since the vertex and DP homologue of these inversions are at $H = 0$ and $H = -j^2/h$, the non-axial covert linear focal locus always intersects the line of symmetry at a point $\frac{1}{4}$ of the distance from the DP homologue to the vertex.

Since the conditions defining the locations of one or the other of the non-axial covert linear focal loci or their two incident foci are exceptional in limacons and central quartics, results for the vertex cubics are considered next. Just as the existence of a point focus at infinity cannot be inferred from the simple intercept eq. for points on the line of symmetry of conic axial vertex cubics ($h = 0$, $K = 0$ in eq. 61, and $h = a$, $K = 0$ in eq. 62), the existence of a covert linear focal locus at infinity cannot be inferred from the simple intercept eq. for these curves about a point in the plane ($h = 0$ in eq. 61 and $h = a$ in eq. 62). However, the general eqs. 61 and 62 for axial QBI quartics indicate that the non-axial covert linear focal locus of these curves goes off to infinity for the vertex inversion (i.e., for the conic vertex cubics) and that the 2 foci that lie upon it become imaginary (as they do for all axial post-focal elliptical and pre-focal parabolic and hyperbolic species).

The Compound Intercept Equation and Format

The fact that the non-axial covert linear focal locus is a relatively high-ranking focal locus is evident from the fact that it is specified by the condition for the vanishing of the $\sin\theta\cos\theta$ term of eq. 60. When this term vanishes it becomes relatively simple to derive the compound intercept eqs. and formats for a point on this locus. This is illustrated for the 0° transform. If eq. 60 in x is divided by the same eq. with x replaced by y, as shown in eq. 66, the $\sin\theta$ term is eliminated and the quadratic eq. 67 in $\cos\theta$ is obtained.

$$\frac{A(x)\cos^2\theta + B(x)\cos\theta + E(x)}{A(y)\cos^2\theta + B(y)\cos\theta + E(y)} = \frac{-C(x)\sin\theta}{-C(y)\sin\theta} \qquad (12\text{-}66)$$

$$[C(x)A(y)-A(x)C(y)]\cos^2\theta + [B(y)C(x)-B(x)C(y)]\cos\theta + E(y) - E(x) = 0 \qquad (12\text{-}67)$$

This can be solved for $\cos^2\theta$ using the quadratic-root formula. Substitution in

eq. 60 (given by the terms in the numerators of eq. 66) makes it possible to eliminate the transcendental functions and obtain the 0^O transform after two squarings. This is found to be of 20th degree for the 0^O and 180^O transforms and of 56th degree for the 90^O transform. These are the same degrees as for limacons and, in fact, the transforms about a point on the non-axial covert linear focal locus have these degrees in all *axial* QBI cubics and quartics.

The basis for the above assertion is as follows. If eq. 60 is recast to depict the way in which the variable enters, it takes the form of eq. 68, which holds for all axial QBI cubics and quartics. When the condition $D^3 = 0$

$$A^3x^2\cos^2\theta+(B^4+F^2x^2)x\cos\theta+(C^4+G^2x^2)x\sin\theta+D^3x^2\sin\theta\cos\theta+(E^5+Mx^4+N^3x^2) = 0 \qquad (12\text{-}68)$$

(a) $A^3x^2\cos^2\theta + B^4x\cos\theta + (C^4+G^2x^2)x\sin\theta + (E^5+Mx^4+N^3x^2)= 0$ $\qquad (12\text{-}69)$

(b) $-A^3x^2\sin^2\theta + (C^4+G^2x^2)x\sin\theta + (E^5+Mx^4+N^3x^2+A^3x^2) = -B^4x\cos\theta$

$$\frac{-A^3x^2\sin^2\theta+(C^4+G^2x^2)x\sin\theta+(E^5+Mx^4+N^3x^2+A^3x^2)}{A^3y^2\sin^2\theta - B^4y\sin\theta + (E^5+ My^4 + N^3y^2)} = \frac{-B^4x\cos\theta}{-(C^4+G^2y^2)y\cos\theta} \qquad (12\text{-}70)$$

is fulfilled, specifying points on the non-axial covert linear focal locus, F^2 also vanishes and the eq. becomes 69a. This is rewritten in the form 69b and the compound 0^O intercept eq. is obtained as in eq. 66. The 180^O eq. is obtained in a similar manner, while the manner of obtaining the 90^O eq. is illustrated in eq. 70. Since these eqs. are valid for all axial QBI cubics and quartics, the degrees of transforms obtained by substituting the compound intercept formats in eq. 69a or 69b hold for all the curves.

It also can be shown that the point at which the non-axial covert linear focal locus intersects the line of symmetry generally is not a point focus in axial QBI curves, though it is for limacons (and central quartics). This is accomplished by letting $K = 0$ in eq. 69a, whereupon the $\sin\theta$ term vanishes and the general form of the simple intercept format is found to be given by eq. 71. The 0^O and 180^O transforms for this format are found to be of 10th

simple intercept format of axial QBI curves
for point of intersection of the non-axial
covert linear focal locus with the line
of symmetry

$$\cos\theta = \frac{P^3 \pm (Q^6+R^4x^2+S^2x^4)^{\frac{1}{2}}}{T^2x} \qquad (12\text{-}71)$$

degree, the same as for points on the line of symmetry of all axial QBI quartics. This is the basis for one of the exceptions to Maxim 5.

Covert Axial Focal Loci

The loss of an orthogonal line of symmetry in an axial inversion locus is accompanied by the gain of a covert *axial* focal locus, i.e., a covert linear focal locus that is orthogonal to the axis about which the inversion occurs (parallel to the lost line of symmetry) and passes through the reciprocal inversion pole. Using eqs. 61 and 62, which represent axial inversions of the parabola and central conics about a point in the plane as examples, substituting $H = 0$ gives the simple intercept eq. for the orthogonal axis passing through the DP or DP homologue. This substitution, however, results only in the simplification of the coefficients and "constant" term (i.e., the sum of the terms not involving transcendental functions); no term vanishes, nor can an x or x^2 be factored out.

Even though no term of eqs. 61 or 62 vanishes, it still is possible to obtain transforms for points on the $H = 0$ axis by the procedures outlined above. These are very complicated, however, and focal reduction has not been demonstrated. Accordingly, to this juncture the evidence that the $H = 0$ axis (and $K = 0$ axis for inversions about points on the orthogonal line of symmetry) is a focal locus rests entirely on the findings for inversions of QBI curves about points in the plane.

For example, if a hyperbola is inverted about a non-incident point in the plane, it is found (as mentioned in Chapter XI) that the foci of self-inversion lie on orthogonal axes that are parallel to the lines of symmetry of the basis curve and pass through the DP. Since no case is known of a point focus that does not lie on either a linear or a curvilinear focal locus (Maxim 2), the presumption is strong that these axes and, in consequence, the $H = 0$ axis of eq. 62 are focal loci (and, by homology, the $H = 0$ axis of eq. 61).

Covert Focal Loci of Point-In-the-Plane Inversions

When a central conic is inverted about a point in the plane, the reciprocal pole of the inversion becomes the DP or DP homologue and the 2 foci of self-inversion come to lie on orthogonal axes parallel to those of the basis curve.

For parabola inversions, one of the foci of self-inversion lies at the DP homologue (0° transform, xy = 0) and the other on the axis through this pole orthogonal to the parabola's line of symmetry. If an intercept eq. of the inversion locus about a point in the plane is obtained using x+H and y+K translations, setting H = 0 in this eq. gives the eq. for a point on one covert axial focal locus, and setting K = 0 gives the eq. for a point on the other.

Although these curves have not yet been studied sufficiently to characterize their foci, there can be little doubt that the axial foci of the basis curve come to lie on the covert axial focal loci of the inverse curve and that the axial vertices of the basis curve correspond to the points on the inverse curve at which it is intersected by the covert axial focal loci, etc.

The general eqs. for point-in-the-plane inversions of the parabola and central conics (and for all inversions of these inversions) are eqs. 72 and 73, respectively. The corresponding simple intercept eqs. about a point in the plane

$$(k^2-4ah)(x^2+y^2)^2-2j^2(2ax-ky)(x^2+y^2)+j^4y^2 = 0 \qquad \text{parabola point-in-the-plane inversions} \qquad (12\text{-}72)$$

$$(b^2h^2-a^2b^2\mp a^2k^2)(x^2+y^2)^2+2j^2(b^2hx\mp a^2ky)(x^2+y^2)$$
$$+ j^4(b^2x^2\mp a^2y^2) = 0 \qquad \text{central conic point-in-the-plane inversions} \qquad (12\text{-}73)$$

$$\text{simple mixed transcendental intercept eq.}$$
$$\text{of eq. 72 about a point in the plane}$$

$$[4C^2(H^2-K^2)-8aj^2H-4j^2kK-j^4]x^2\cos^2\theta + 4(A^2C^2H-B^2Hj^2-aA^2j^2)x\cos\theta + \qquad (12\text{-}74)$$
$$2(2A^2C^2K-2B^2j^2K+A^2j^2k+j^4K)x\sin\theta + 4(2C^2HK+Hj^2k-2aj^2K)x^2\sin\theta\cos\theta$$
$$+ 4K(j^2k+C^2K)x^2 + A^4C^2 - 2A^2B^2j^2 + j^4(x^2+K^2) = 0$$

$$A^2 = x^2+H^2+K^2, \qquad B^2 = 2aH-kK, \qquad C^2 = k^2-4ah$$

$$\text{simple mixed transcendental intercept eq.}$$
$$\text{of eq. 73 about a point in the plane} \qquad (12\text{-}75)$$

$$[4C^4(H^2-K^2)+4D^4j^2+j^4(b^2\pm a^2)]x^2\cos^2\theta + 2[2A^2C^4H+A^2b^2hj^2+b^2j^4H+2B^4j^2H]x\cos\theta$$
$$+ 2[2A^2C^4K\mp a^2A^2j^2k\mp a^2j^4K+2B^4j^2K]x\sin\theta + 4[2C^4HK+b^2j^2hK\mp a^2j^2Hk]x^2\sin\theta\cos\theta$$
$$+ A^4C^4 \mp a^2j^2(j^2+4kK)x^2 + 4C^4K^2x^2 + 2A^2B^4j^2 + j^4(b^2H^2\mp a^2K^2) = 0$$

$$A^2 = x^2+H^2+K^2, \qquad C^4 = b^2h^2-a^2b^2\mp a^2k^2$$
$$B^4 = b^2hH\mp a^2kK \qquad D^4 = b^2hH\pm a^2kK$$

(H,K) in mixed-transcendental functions are eqs. 74 and 75. Inspection of the latter eqs. reveals that they conform to the general form of eq. 68. Setting the constant term equal to 0 in these eqs. allows an x to be factored out and is a focal condition for a point on the curve.

The eqs. for points on the x-axis covert focal locus are obtained by setting K = 0 in both eqs., while the eqs. for points on the y-axis covert focal locus are obtained by setting H = 0. In any of these axial eqs., setting the constant term equal to 0 gives the condition for the corresponding axial vertices--real or imaginary. This condition is not necessarily focal, however, unless the reduction achieved exceeds that attendant upon setting the constant term equal to 0 in the point-in-the-plane eqs. Otherwise the reduction merely demonstrates that points on the curve have focal rank.

Covert Curvilinear Focal Loci

It was noted above that the $\sin\theta\cos\theta$-condition is focal in axial QBI cubics and quartics and that for K = 0 it defines a point on the line of symmetry (because the $\sin\theta$ term also vanishes), while for $H = hj^2/2(a^2-h^2)$ it defines the non-axial covert linear focal locus. Accordingly, it is of great interest to examine the results of setting the $\sin\theta\cos\theta$ term of eqs. 74 and 75 equal to 0. The surprising result emerges that the non-axial covert focal loci of all non-axial inversion quartics of the parabola and central conics are equilateral hyperbolas, eqs. 76a and 77a, respectively, oriented with their transverse axis

(a) $2(k^2-4ah)HK + j^2kH - 2aj^2K = 0$ (b) $K = kH/2a$ (12-76)

(a) $(b^2h^2-a^2b^2\mp a^2k^2)HK + b^2hj^2K \mp a^2j^2kH = 0$ (b) $K = \pm a^2kH/b^2h$ (12-77)

at $45°$ to the K = 0 axis and passing through the DP.

It will be noted that the coefficient of the quadratic term of both eqs. 76a and 77a vanishes if the point of inversion of the basis curve is an incident point. For such inversions the inversion loci are conic inversion cubics, and the non-axial covert focal loci become lines (eqs. 76b and 77b) of slopes $k/2a$ for parabola inversion cubics, and $\pm a^2k/b^2h$ for central conic inversion cubics. For the LR vertices, these slopes are $1/e = 1$ for the parabola, and $\pm 1/e$ for the central conics. For the axial vertex cubics the slopes are 0, and K of eqs. 76b and 77b equals 0.

The corresponding axial eqs. for axial-inversion loci are eq. 61 with $h = 0$ and eq. 62 with $h = a$. Were it not for the fact that the condition $K = 0$ becomes focal in the vertex cubics and defines the line of symmetry (because the $\sin\theta$ term also vanishes from the intercept eqs.), these progressive changes could be interpreted to mean that the covert linear focal locus (defined by $H = hj^2/2[a^2-h^2]$ and $H = -j^2/4h$ for axial inversions and $K = \pm a^2 kH/b^2 h$ and $K = kH/2a$ for point-in-the-plane inversions) that is non-axial in all the other QBI cubics and axial quartics becomes coincident with the line of symmetry of the axial vertex cubics.

CIRCUMPOLAR MAXIM 33: *The loss of two lines of symmetry in a non-incident inversion of a conic section is accompanied by the gain of (a) two linear focal loci passing through the reciprocal inversion pole and parallel to the lines of symmetry of the basis curve; and (b) an equilateral hyperbolic focal locus with one of its vertices coincident with the reciprocal inversion pole.*

CIRCUMPOLAR MAXIM 34: *The loss of two lines of symmetry in an incident but non-axial inversion of a conic section is accompanied by the gain of: (a) two linear focal loci passing through the reciprocal inversion pole and parallel to the lines of symmetry of the basis curve; and (b) a third linear focal locus passing through the reciprocal inversion pole and not coincident with either of the first two loci.*

The Degrees of $0°$ and $180°$ Transforms About Points on Non-Axial Covert Focal Loci

Eqs. 72 and 73 represent all the curves in the QBI superfamily obtained by inverting the parabola and central conics, respectively, about a point in the plane. The generalized simple intercept eq., 68, for transforms about a point in the plane represents all these curves. Expressed in terms of a, b, h, k, H, K, θ, and x, the corresponding simple mixed-transcendental intercept eqs. for inversions of the parabola and central conics are 74 and 75, respectively.

Axial inversions lead to simplifications of eqs. 74 and 75, but none of these is focal, and the degree of their $0°$ and $180°$ transforms about unexceptional poles is 56, the same as for non-incident, non-axial inversions (see Table XII-2). On the other hand, incident inversions yield conic inversion cubics. For such inversions, C^2 and C^4 of eqs. 74 and 75 vanish and

several simplifications of the eqs. occur but only the x^4-condition is focal (i.e., the vanishing of the non-transcendental term in x^4); when the x^4 term vanishes, the degree of the $0°$ and $180°$ transforms about unexceptional poles reduces to 48. When the poles of the intercept transformation are incident upon the curve, both the axial (for example, limacons) and non-incident, non-axial inversions (curves with two foci of self-inversion, two axial covert linear focal loci, and one equilateral hyperbolic covert focal locus) reduce from 56th to 44th degree.

Table XII-2. Degrees of Circumpolar Intercept Transforms of QBI Curves, Including Transforms About Points On Covert Focal Loci

Pole of transformation	Pole of Inversion					
	Non-incident		Incident (non-vertex)		Axial	
	$0°$ & $180°$	$90°$	$0°$ & $180°$	$90°$	$0°$ & $180°$	$90°$
Unexceptional (non-focal)	56	72	48	68	56	72
Incident (non-vertex)	44	60	40	56	44	60
Point on covert focal locus	36	72	36	68	20	72

For transforms about a point on the equilateral hyperbolic covert focal locus of non-incident, non-axial inversions, the degree reduces from 56 to 36, compared to 44 for a point on the curve. This reduction depends on the vanishing of the $\sin\theta\cos\theta$ term, as opposed to the mere vanishing of the constant term for the incident transform. Though the non-axial covert focal locus of conic inversion cubics is linear, rather than equilateral hyperbolic, the degree of the $0°$ and $180°$ transforms about it is unchanged at 36. [It is the degree of transforms of the basis curve about a point on the non-axial covert focal locus that is in question, not the degree of transforms of the focal locus, itself, about incident points.] This means that the $\sin\theta\cos\theta$ condition takes precedence over the x^4-condition, whereas the constant-condition does not.

On the other hand, when the inversion is axial (k or h = 0) and the covert focal locus is both linear and orthogonal to the line of symmetry, the reduction is from 56th to 20th degree and is the same for all genera. The degree for conic vertex cubics is the same as for limacons and other axial inversion loci because, again, the combined influences of the $\sin\theta\cos\theta$ condition and the $\cos\theta-x^2$ condition (which also comes into play for axial inversions) completely overshadow the influences of the x^4-condition.

Transforms With Complex Solutions

The definitions that have been given in preceding chapters for the focal loci of curves have been *algebraic*, as have been the treatments of the symmetry of curves. When the focal loci and the intercepts of the circumpolar analysis are real, geometrical interpretations in the real plane are "conventional" and straightforward. However, the algebraic treatments also lead to the specification of imaginary focal loci, to complex intercepts about both real and imaginary focal loci, to intercept transforms with complex solutions (about both real and imaginary focal loci), and, in consequence, to characterizations of the symmetry of curves for which there is no geometrical counterpart in the real plane.

These non-real solutions to the algebraic analyses are included in the treatment for two principal reasons. Firstly, there is no basis for limiting analytical treatments of symmetry only to solutions that have geometrical interpretations in the real plane. Secondly, only if both real and complex solutions are taken into account are results regarding the number and distribution of circumpolar focal loci possessed by curves, and the conservation of these loci under the inversion transformation, unified.

Since numerous instances of transforms about real focal loci that have complex solutions already have been encountered, of which two of the most notable examples are eqs. 25d, for the equilateral lemniscate, and VII-44c', for the equilateral hyperbola, further examples of such transforms are not considered here. Nor are interpretations of the circumpolar symmetry of curves about imaginary focal loci in some complex manifold pursued. Instead, some circumpolar intercept transforms about imaginary focal loci are derived for illus-

tration.

This derivation is readily carried out either by substituting the co-ordinates or conditions for imaginary focal loci into the simple or compound intercept eqs. and deriving the transforms therefrom, or by making these substitutions at the level of the intercept transforms themselves. Dealing algebraically with these transforms or confirming their applicability is straightforward, because the simple intercept eqs. define the complex equivalents of the distances from imaginary loci to the curve for specified angles, while the compound intercept eqs. (including intercept products) give the relationships between these complex equivalents of the distances for angles, θ and $\theta+\alpha$.

Several illustrative examples are given for conic sections. In each case, the function for the imaginary focus is given as the "(a)" example, and that for the equivalent or comparable real focus is given as the "(b)" example.

Eqs. 78a,b are the simple intercept eqs. about one of the imaginary foci on the minor axis of an ellipse at $k = \pm(b^2-a^2)^{\frac{1}{2}}$ and about one of the real traditional foci on the major axis at $h = \pm(a^2-b^2)^{\frac{1}{2}}$, respectively. The corresponding simple intercept formats are 79a,b and the 180° intercept transforms are 80a,b. The alternate signs of 79a,b are true alternates, which take into account both positive and negative intercepts. The corresponding 0° (upper signs) and 180° intercept products are 81a,b.

simple intercept equations

(a) $x^2(b^2-a^2)\sin^2\theta+2a^2(b^2-a^2)^{\frac{1}{2}}x\sin\theta-b^2x^2+a^4 = 0$ about imaginary focus (12-78)

(b) $x^2(a^2-b^2)\cos^2\theta+2b^2(a^2-b^2)^{\frac{1}{2}}x\cos\theta-a^2x^2+b^4 = 0$ about real focus

about imaginary focus about real focus

(a) $\sin\theta = \dfrac{-a^2\pm bx}{x(b^2-a^2)^{\frac{1}{2}}}$ (b) $\cos\theta = \dfrac{-b^2\pm ax}{x(a^2-b^2)^{\frac{1}{2}}}$ intercept formats (12-79)

(a) $2bxy = a^2(x+y)$ (b) $2axy = b^2(x+y)$ 180° intercept transforms (12-80)

(a) $xy = \dfrac{\mp a^4}{[(b^2-a^2)\cos^2\theta+a^2]}$ (b) $xy = \dfrac{\mp b^4}{[(b^2-a^2)\cos^2\theta+a^2]}$ 0° and 180° intercept products (12-81)

Eqs. 82a,b compare the 0° and 180° intercept transforms about a point on the imaginary asymptotes of the ellipse with the corresponding transforms for a point on the real asymptotes of the hyperbola. These differ only in the signs of the b terms. Lastly, in 83a,b the 90° 8th degree transform about an imaginary b vertex of a hyperbola is compared with that about a real b vertex of an ellipse.

0° and 180° intercept transforms about a point
on the imaginary asymptotes of an ellipse
(a) and real asymptotes of a hyperbola (b)

$$\text{(a) } 16(a^2-b^2)h^4x^2y^2 + a^4(a^2-b^2)(x\pm y)^4 = 8a^2h^2(x\pm y)^2xy[2xy\pm(a^2+b^2)] = 0 \quad (12\text{-}82)$$

$$\text{(b) } 16(a^2+b^2)h^4x^2y^2 + a^4(a^2+b^2)(x\pm y)^4 = 8a^2h^2(x\pm y)^2xy[2xy\pm(a^2-b^2)] = 0$$

90° intercept transforms about an imaginary
b vertex of a hyperbola (a) and a real
b vertex of an ellipse (b)

$$\text{(a) } (b^4-a^4)^4x^4y^4 + 8a^6b^2(a^2+b^2)(b^4-a^4)^2x^2y^2(x^2+y^2) + \qquad (12\text{-}83)$$

$$\text{(b) } (b^4-a^4)^4x^4y^4 + 8a^6b^2(b^2-a^2)(b^4-a^4)^2x^2y^2(x^2+y^2) +$$

$$16a^{12}b^4(a^2+b^2)^2(x^2+y^2)^2 + 16a^8b^4(a^8-6a^4b^4-8a^2b^6-3b^8)x^2y^2 +$$

$$16a^{12}b^4(b^2-a^2)^2(x^2+y^2)^2 + 16a^8b^4(a^8-6a^4b^4+8a^2b^6-3b^8)x^2y^2 -$$

$$64a^{12}b^6(a^2+b^2)^2(x^2+y^2) = 0$$

$$64a^{12}b^6(a^2-b^2)^2(x^2+y^2) = 0$$

The nature of the differences between transforms and other functions for: (a) real and imaginary foci that are specified by homologous conditions on the intercept eq. or format; and (b) comparable transforms about homologous real and imaginary focal loci of the ellipse and hyperbola is of considerable interest. It will be recalled that 0° and 180° functions and transforms about real focal loci generally differ only in the signs of terms (compare eqs. VII 3a-3b, 6a-6b, and 7a-7b) and that homologous functions and transforms for the ellipse and hyperbola often differ only in the signs of terms (compare eqs. VII-2a,b; 3a,b; 6a,b; 7a,b; etc.).

In the case of homologous functions and transforms about real and imaginary foci of the same basis curve, differences in sign also play an important role and, in some cases, the same role. At the level of the simple intercept eq. (78a,b) and format (79a,b) there are differences in sign, differences in transcendental functions, and exchanged parameters. On the other hand, for the 180° intercept transforms only parameter exchanges occur (80a,b). This also is true of the compound formats (81a,b).

Turning now to functions and transforms about homologous real and imaginary foci in hyperbolas as compared to ellipses, in the 0°, 180°, and 90° transforms (82a,b and 83a,b) only differences in the signs of terms are to be found. Although these examples are only special cases, it is not unlikely that they point the way fairly reliably toward the relationships that exist in other axial QBI curves, if not, indeed, quite generally. Clearly, the transforms about imaginary foci share almost all of the properties of those about real foci, their principal difference being that they have only complex or imaginary solutions.

The most significant feature of these and earlier findings is that an algebraic assessment of the circumpolar symmetry of curves in the complex domain is fully consistent with homologous assessments in the real plane and, in fact, it would appear that the complex and real analyses should be regarded as being complementary to one another.

CIRCUMLINEAR SYMMETRY OF QBI CURVES

Introduction

The fact that the *circumpolar* symmetry rank of points lying on the orthogonal covert linear focal loci passing through the DP or DP homologue generally appears to be very low, draws attention to the topic of the *circumlinear* symmetry of the curves about these loci. If one reflects briefly on the matter of circumlinear symmetry it becomes clear that a curve can have the highest possible symmetry about a line--mirror-image symmetry--without any point on the line necessarily having circumpolar focal rank. This follows because the construction of such a curve can be completely arbitrary save only for the possession of reflective symmetry through the line. The covert linear focal loci in question, however, have at least two incident point foci, namely, the DP or its homologues and a focus of self-inversion, and there can be little question but that the homologues of other axial foci also lie on these covert focal axes in non-axial QBI curves.

The analysis of circumlinear symmetry parallels that of circumpolar symmetry. Instead, however, of having two "circumpolar radii" emanating from a *fixed point-pole* at a fixed angle, α, to one another, one has two "circumlinear radii" emanating from points on a *fixed line-pole* at a fixed angle, α, to one another. Instead of having the two radii sweep the curve with changing values of θ, the angle the x radius makes with the reference axis--as in the circumpolar case--the two "circumlinear radii" sweep the curve with changing values of h or k (or H or K), the abscissa or ordinate of a point on the line-pole (or, if the line-pole is not parallel to a coordinate axis, with changing values of both H and K). The same angle, θ, between a radius vector and the x-axis is employed in circumlinear symmetry analyses, but this angle is constant for any given circumlinear intercept transform. In other words, circumlinear transforms involve *two* fixed angles: α is the fixed angle between the two radii emanating from a point on the line-pole, and θ is the fixed angle that the "x radius" makes with the x-axis. A third angle is employed for convenience in writing the eqs., namely $\omega = \theta + \alpha$.

The procedure for obtaining circumlinear intercept transforms also parallels

Fig. 1-1

that for obtaining circumpolar ones. The simple intercept eq. for a point in the plane, $f(x,\theta,H,K) = 0$, is the basic eq. (it is implicit that the function also involves the parameters of the curve). This eq. gives the value of the intercept with the curve of a radius--the x radius--emanating from the point (H,K) at the angle θ to the x-axis. The intercept eq. for the y radius then is obtained by substituting y for x and $\omega = \theta+\alpha$ for θ, i.e., $f(y,\omega,H,K) = 0$. Assume now that the circumlinear transform of the curve about a K-axis is desired, i.e., the circumlinear transform characterizing the symmetry of the curve about a line orthogonal to the x-axis. In that case, one solves both eqs. for K and equates these solutions, $g(x,\theta,H) = g(y,\omega,H)$. If the $180°$-orthogonal transform is desired, one substitutes $0°$ for θ (making the x radius vector orthogonal to the K-axis at $0°$) and $180°$ for ω (making the y radius vector orthogonal to the K-axis at $180°$) and eliminates any radicals by squaring.

The resulting eq. is the desired $180°$-orthogonal intercept transform of the curve about a K-axis at $x = H$. As this transform is a function of x, y, and H (and the parameters of the curve), K-axes of focal or subfocal rank can be identified from conditions on the coefficients or terms for which the transform reduces or simplifies.

On the other hand, if H is specified, but θ or ω ($\theta+\alpha$), or both, are unspecified, then one has the equivalent of a circumpolar α-transform--in this case an α-$\rho°$-transform, a $\rho°$-θ-transform, or an α-θ-transform for the symmetry of the curve about a specific K-axis at unspecified or incompletely specified angles. From this eq. one can ascertain the values for α or θ, or α and θ, for which the K-axis in question has higher focal or subfocal rank than for other values. For example, if the K-axis is parallel to a line of symmetry, the symmetry of the curve about that axis will be greatest, i.e., the transform will be of lowest degree, for $\theta = 0°$ or $180°$ and $\alpha = 180°$ ($\omega = \theta+180°$), in other words, when the two radii are orthogonal to the K-axis and oppositely directed.

Parallel procedures are employed to investigate the *circumcurvilinear* symmetry of a curve about any curvilinear locus. For example, one might enquire as to the nature of the symmetry of an ellipse in standard form about the major auxiliary circle, $x^2+y^2 = a^2$. In this case, one forms the simple circum-

polar mixed-transcendental intercept eqs. of an ellipse centered at (-h,-k), obtains the eqs. for the x and y intercepts at the angles θ and ω = θ+α, solves these simultaneously for h = f(x,y) and k = g(x,y), and substitutes h for x and k for y in the eq. of the circle. The resulting transform characterizes the circumcircular symmetry of the ellipse about its major auxiliary circle at angles α and θ, etc. (see the treatment below).

In circumpolar symmetry analyses, the identity of the two radii often may be disregarded, because circumpolar intercept transforms often are symmetric functions (see Chapter V, *Circumpolar Intercept Transforms As Symmetric Functions*). By contrast, circumlinear and circumcurvilinear intercept transforms rarely are symmetric functions. In the case of circumpolar transforms, each intercept takes on exactly the same range of values as the other--the values merely are α° out of phase. Furthermore, for all circumpolar intercept transforms about points on lines of symmetry, the values of intercepts become duplicated in reversed sequences during 180° sweeps of the radius vectors.

These characteristics do not hold for circumlinear or circumcurvilinear transforms because the latter are not generated by *rotation*, but by *translation*. As a consequence, labelling of circumlinear and circumcurvilinear intercepts is essential. The x intercept always is given by the point of intersection with the curve of a radius at the angle θ, and the y intercept always is given by the point of intersection of the radius at the angle ω = θ+α.

180°-Orthogonal Circumlinear Symmetry of QBI Curves

Lines of Symmetry and Lines Parallel to Lines of Symmetry

The designation *180°-orthogonal circumlinear symmetry* refers to the situation in which the radius vectors are oppositely directed (α = 180°) and orthogonal to the line-pole (for example, if the line-pole is parallel to the x-axis, θ = 90° or 270°, whereas if the line-pole is parallel to the y-axis, θ = 0° or 180°). The 180°-orthogonal circumlinear symmetry of any curve about a line of symmetry and about a line parallel to a line of symmetry can be dealt with intuitively, without recourse to an analytical treatment. The 180°-orthogonal circumlinear intercept transform of any curve about a line of symmetry is simply x = y; consequently, a line of symmetry (there may be more than one; there are an infinite number for the circle) always possesses the highest possible circum-

linear focal rank. [The midline of the parallel line-pair has the highest sub-focal rank of all lines of symmetry, inasmuch as x = y = constant; see below.]

Similarly, if the line-pole is taken to be a line parallel to a line of symmetry at a distance k therefrom, it is obvious that the circumlinear intercept transform of a curve about such a line is x-y = 2k, where y is the intercept in the direction of the displacement, and x is the intercept in the opposite direction (if the displacement carries a point on the line-pole "outside" the curve, the y intercept becomes negative). Carrying the preceding definitions of focal loci and focal and subfocal rank over to circumlinear symmetry, it follows that a line parallel to a line of symmetry has the same $180°$-orthogonal focal rank, namely 1, as the line of symmetry but lower subfocal rank (because the eq. has been made more complex by the addition of the constant 2k).

Inasmuch as the focal loci of circumlinear symmetry all are lines, the definition of a circumlinear focus differs somewhat from that of a circumpolar focus.

> *A line is a circumlinear focus of a curve if the circumlinear*
> *intercept transform of the curve about that line at given angles*
> *α and θ is of lower degree than that of corresponding trans-*
> *forms of the curve about intersecting lines.*

The qualification "intersecting" is employed because in circumlinear symmetry parallel lines always have the same focal rank, i.e., the degree of circumlinear transforms about parallel lines always is the same. This follows because the alteration of the eq. of a circumlinear transform occasioned by the parallel displacement of a line is merely in the nature of a translation of variables by x±H and y∓K. The consequence of this analytical relationship of chief concern is that *circumlinear symmetry is a domain in which differences in symmetry at the subfocal level receive heavy emphasis.*

Covert Linear Focal Loci of QBI Curves

Hyperbola Axial Vertex Cubics

An x+h and y+k translation of the standard eq. 84a for hyperbola axial vertex cubics gives the simple mixed-transcendental intercept eq. 84b. Letting

(a) $y^2(x+a) = x^2(b-x)$ hyperbola axial vertex cubics (12-84)

(b) $(x^2\sin^2\theta+2kx\sin\theta+k^2)(x\cos\theta+a+h) =$ simple mixed-transcendental intercept equation of 84a

$(x^2\cos^2\theta+2hx\cos\theta+h^2)(b-x\cos\theta-h)$

(c) $k^2 = (x+h)^2(b-h-x)/(a+h+x)$ k^2 solution of 84b with $\theta = 0^\circ$

(c') $k^2 = (y-h)^2(b-h+y)/(a+h-y)$ k^2 solution of 84b with $x = y$ and $\theta = 180^\circ$

180°-orthogonal circumlinear transform of hyperbola axial vertex cubics about a k-axis at $x = h$

(d) $xy(x^2-y^2) - (a+h)(x^3+y^3) + (3h-b)xy(x+y) -$

$(a+h)(3h-b)(x^2-y^2) + h[2(a+h)(b-h)-h(a+b)](x+y) = 0$

(d') $xy(x-y) - (a+h)(x^2+y^2) + (4h+a-b)xy -$

$(a+h)(3h-b)(x-y) + h[2(a+h)(b-h)-h(a+b)] = 0$

$\theta = 0^\circ$ in 84b and solving for k^2 yields 84c. A similar expression, 84c', for k^2 now is derived by letting $x = y$ and $\theta = 180^\circ$ in 84b. These and homologous equations are referred to hereafter as *simple circumlinear intercept eqs. (or formats) in k^2 (or K^2, or h^2 or H^2)*. The k^2 terms now are eliminated between eqs. 84c,c' and the resulting expression is cross-multiplied and terms regrouped, giving eq. 84d. An $(x+y)$ term, representing the trivial negative intercept relation, $x = -y$, can be factored from 84d, yielding the 180°-orthogonal circumlinear transform 84d'.

[It must be kept in mind that having factored a term in $(x+y)^n$ out of a transform eq., the residual transform, $f(x,y) = 0$, no longer necessarily holds for a solution $x = -y$. To be rigorous, if negative intercepts are not excluded, transforms obtained after factoring a term in $(x+y)^n$ should be represented as degenerate eqs., $(x+y)^n f(x,y) = 0$.]

It is evident from 84d' that the circumlinear focal rank of all axes orthogonal to the line of symmetry of hyperbola axial vertex cubics is 1/3rd, i.e., that the transforms of the curves about all such line-poles are of 3rd degree, because there is no condition under which the 3rd degree term will vanish. Accordingly, differences in the circumlinear symmetry of the curve about k-axes are entirely at the subfocal level. The fact that these circumlinear trans-

forms are of 3rd degree establishes that the line of symmetry and all line-poles parallel to it are *circumlinear foci*, because transforms about them are of only 1st degree (see above definition of a circumlinear focus). The k-axes also are circumlinear foci, because the degree of 180°-orthogonal transforms about lines at other angles is of higher than 3rd degree.

The comparative subfocal *circumlinear* symmetry ranking of hyperbola axial vertex cubics about line-poles orthogonal to the line of symmetry can be achieved by examining the conditions for simplification of the general circumlinear intercept transform 84d', which obtains for any k-axis (where h is the distance of this axis from the DP). The k-axis with the highest subfocal rank clearly is the asymptote at h = -a, for which the transform reduces to its simplest form, 85a, possessing only 3 terms. The 2nd-highest subfocal rank

circumlinear transforms about various k-axes of
hyperbola axial vertex cubics

(a) $xy(x-y)$ $\qquad -(3a+b)xy \qquad -a^2(a+b) = 0 \qquad$ (12-85)

(b) $xy(x-y)-(a+b/3)(x^2-xy+y^2) \qquad +(b^2/9)(3a+b/3) = 0$

(c) $xy(x-y)-a(x^2+y^2) \qquad +(a-b)xy +ab(x-y) \qquad = 0$

(c') $xy(x-y)-a(x^2+y^2) \qquad +a^2(x-y) \qquad = 0$

(d) $xy(x-y)-(3a+b)(x^2+y^2)/4 \qquad +(b+3a)^2(x-y)/16+(b-a)(9ab+5a^2+b^2)/32 = 0$

(e) $xy(x-y)-(a+b)(x^2+y^2) \qquad +(a+3b)xy-2b(a+b)(x-y) \qquad -b^2(a+b) = 0$

is possessed by a k-axis through the loop at h = b/3, for which both the xy and the (x-y) terms of 84d' vanish, yielding 85b. This transform also possesses only 3 terms but two of them are more complex than those in the transform for the asymptote, 85a.

The 3rd-highest subfocal rank is possessed by the k-axis through the DP, 85c, for which the constant term vanishes from 84d' and all three of the coefficients simplify. It also is evident from 85c that in the equilateral sub-species (a = b) the k-axis at the DP achieves its highest subfocal rank, because for the equilateral strophoid the transform loses another term, yielding 85c'. Eq. 84d' also will lose a term (85d) if h = (b-a)/4, which holds for a k- axis at a variable position, that is at the DP for the equilateral strophoid.

Lastly, the constant term of 84d' simplifies for $h = b$, a k-axis at the loop vertex (85e).

In summary, hyperbola axial vertex cubics have higher circumlinear symmetry (at the subfocal level) about 5 axes orthogonal to the line of symmetry than about other k-axes in the plane. Three of these are at the level of circumpolar axial foci ($h = -a$, 0, and b). The asymptote is the highest ranking of these, the axis at $h = b/3$ the 2nd-highest ranking, the axis at the DP the 3rd-highest ranking, and the axis at the loop vertex the lowest ranking. The k-axis passing through the DP is a circumpolar covert linear focal locus of axial vertex cubics (according to indirect evidence). For these curves at least, then, the only covert focal k-axis in the finite plane is not the highest-ranking circumlinear focal k-axis.

Limacons

The simple circumlinear intercept eqs. in k^2 for $180°$-orthogonal circumlinear symmetry of limacons are 86a,a'. The corresponding special cases for the

limacon simple circumlinear intercept eqs. in k^2

(a) $2k^2 = [a^2-2x^2-2h(h+b)-2x(b+2h)] \pm a(a^2-4bh-4bx)^{\frac{1}{2}}$ for any h (12-86)

(a') $2k^2 = [a^2-2y^2-2h(h+b)+2y(b+2h) \pm a(a^2-4bh+4by)^{\frac{1}{2}}$ for any h

(b) $2k^2 = (a^2+b^2/2-2x^2) \pm a(a^2+2b^2-4bx)^{\frac{1}{2}}$ for $h = -\frac{1}{2}b$

(c) $2k^2 = (a^2-2x^2-2bx) \pm a(a^2-4bx)^{\frac{1}{2}}$ for $h = 0$

$180°$-orthogonal circumlinear intercept transform
of limacons for a k-axis at $x = h$

$$(x^2-y^2)^2(x-y)^2 + 4(b+2h)(x^2-y^2)^2(x-y) + 6(b+2h)^2(x^2-y^2)^2 + 2a^2b(x-y)^3 \quad (12-87)$$

$$+ 4(b+2h)^3(x^2-y^2)(x+y) + a^2(4b^2+12bh-a^2)(x-y)^2 + (b+2h)^4(x+y)^2 +$$

$$\pm 2a^2(b+2h)(b^2+6bh-a^2)(x-y) + a^2[(b+2h)^2(4bh-a^2)+a^2b^2] = 0$$

$180°$-orthogonal circumlinear intercept transform
of limacons for the $-\frac{1}{2}b$ axis

$$(x^2-y^2)^2(x-y)^2 + 2a^2b(x-y)^3 - a^2(a^2+2b^2)(x-y)^2 + a^4b^2 = 0 \quad (12-88)$$

$180°$-orthogonal circumlinear intercept transform
of limacons for a k-axis through the DP

$$(x^2-y^2)^2(x-y)^2 + 4b(x^2-y^2)^2(x-y) + 6b^2(x^2-y^2)^2 + 2a^2b(x-y)^3 + \qquad (12-89)$$

$$4b^3(x^2-y^2)(x+y) + a^2(4b^2-a^2)(x-y)^2 + b^4(x+y)^2 + 2a^2b(b^2-a^2)(x-y) = 0$$

x intercepts for the $h = -\frac{1}{2}b$ and $h = 0$ k-axes are 86b,c, respectively. If k is eliminated between eqs. 86a,a' and the radicals are eliminated by squarings, it is possible--after various eliminations and regrouping of terms-- to factor out a term in $(x+y)^2$. This leads to the 6th degree general circum- linear $180°$-orthogonal intercept transform, 87, for a k-axis at $x = h$ (i.e., an axis orthogonal to the line of symmetry at $x = h$).

Unlike the case for the conic axial vertex cubics, the highest-ranking *circumpolar* covert linear focal locus of limacons--the k-axis at $h = -\frac{1}{2}b$--is established by analytical proof. This axis also is by far the highest-ranking $180°$-orthogonal *circumlinear* focal k-axis because, of a total of 9 terms in the circumlinear intercept transform of the curve about a k-axis at $x = h$, 5 vanish for $h = -\frac{1}{2}b$ and the constant term greatly simplifies, yielding eq. 88. On the other hand, for the k-axis through the DP, which is strongly indi- cated to be a circumpolar covert linear focal locus, only the constant term vanishes (eq. 89), although most of the coefficients also greatly simplify. This fact illustrates strikingly that vanishing of the external linear term in x in going from 86a to 86b has a far greater simplifying influence on the resulting intercept transform than vanishing of a portion of the constant term from the radical in going from 86a to 86c.

The intercept transform, 87, also simplifies for three other coefficient conditions. Thus, for $h = (a^2-4b^2)/12b$, the term in $(x-y)^2$ vanishes, for $h = (a^2-b^2)/6b$, the term in $(x-y)$ vanishes, while for $h = a^2/4b$, most of the constant term vanishes. The latter condition is the most interesting of the three because the k-axis at $h = a^2/4b$ is tangent to the protruding rims of the curve (for $b > a/2$). It also is noteworthy that the k-axis through the cusp of the cardioid has the highest subspecific circumlinear subfocal rank (for $180°$-orthogonal transforms) of any k-axis except that at $h = -\frac{1}{2}b$, because for $a = b$ the term in $(x-y)$ also vanishes, leaving only 7 terms in the intercept transform.

Axial QBI Curves

The 180°-orthogonal circumlinear analysis is extended to all axial QBI curves by applying it to eq. 61 for axial inversions of the parabola and to eq. 62 for axial inversions of central conics (conic parameters a and b). The solutions of eq. 61 for the simple circumlinear intercept formats in K^2 are 90a,a'. The increase in the complexity of these eqs. over those for limacons (and the cardioid) consists in two differences: (1) the greater

simple intercept formats in K^2 for axial
inversions of the parabola

(a) $(8ah)K^2 = [j^4-4aj^2H-8ahH^2-4a(4hH+j^2)x-8ahx^2]$ $\hspace{2cm}$ (12-90)

$$\pm [16aj^4(a-h)(H+x)^2-8aj^6(H+x)+64a^2h^2H^4]^{\frac{1}{2}}$$

(a') $(8ah)K^2 = [j^4-4aj^2H-8ahH^2+4a(4hH+j^2)y-8ahy^2]$

$$\pm [16aj^4(a-h)(H-y)^2-8aj^6(H-y)+64a^2h^2H^4]^{\frac{1}{2}}$$

complexity of the coefficients and constant terms; and (2) the fact that a term in x^2 (or y^2) is present in the radicals of 90a,a', but not of 86a,a' (or the corresponding eqs. for the cardioid; h = a in 90a,a'). Despite the latter factor, the corresponding 180°-orthogonal circumlinear intercept transforms also are of 6th degree, which highlights the fact that the vanishing of a term in the variable from the radical of an intercept format does not necessarily lead to a reduction in the transforms derived therefrom (unless the degree of the vanishing term in the radical is greater than twice that of the highest-degree external term or the radical becomes free of the variable).

The most significant feature to be noted concerning these eqs. is that the coefficient of the external linear term in x is $4hH+j^2$. It was noted above for limacons that the condition for the vanishing of this term is the same condition as that for a very high simplification of the circumpolar intercept transform derived from the format. In other words, for $H = -j^2/4h$ the circumlinear intercept transform of 90a,a' also will greatly simplify. But $H = -j^2/4h$ is precisely the condition specifying the location of the circumpolar non-axial covert linear focal locus of axial QBI curves of unit eccentricity. Accordingly, the correspondence of the highest-ranking circumlinear k-axis with the highest-ranking circumpolar k-axis for limacons

extends to all axial quartics of unit eccentricity and, in fact (as shown below), to *all* axial QBI quartics.

The circumlinear transforms of axial QBI curves about a k-axis at x = H are illustrated for axial inversions of central conics, for which eqs. 62 are the simple mixed-transcendental intercept eqs. Derivation of the simple circumlinear intercept formats in K^2 leads to eqs. 91a,a',a". The latter, by comparison with eq. 91a, defines the parameters, A^4, B^5, C^6, D^{10}, E^{11}, and F^{12} that are used to simplify the following derivation. It is most noteworthy that

<div align="center">

simple intercept formats in K^2 for axial
inversions of central conics

</div>

(a) $2b^2(h^2-a^2)K^2 = -\{2b^2(h^2-a^2)x^2 + 2b^2[2(h^2-a^2)H+hj^2]x + 2b^2hHj^2 \mp a^2j^4$ (12-91)

$+ 2b^2H^2(h^2-a^2)\} \pm \{4a^2b^2j^4[b^2 \mp (h^2-a^2)](H+x)^2 \mp 4a^2b^2hj^6(H+x)+a^4j^8\}^{\frac{1}{2}}$

(a') $2b^2(h^2-a^2)K^2 = -\{2b^2(h^2-a^2)y^2-2b^2[2(h^2-a^2)H+hj^2]y+2b^2hHj^2 \mp a^2j^4$

$+ 2b^2H^2(h^2-a^2)\} \pm \{4a^2b^2j^4[b^2 \mp (h^2-a^2)](H-y)^2 \mp 4a^2b^2hj^6(H-y)+a^4j^8\}^{\frac{1}{2}}$

(a") $A^4K^2 = -[A^4x^2+B^5x+C^6] \pm [D^{10}(H+x)^2+E^{11}(H+x)+F^{12}]^{\frac{1}{2}}$

(1) the parameter $D^{10} = 4a^2b^2j^4[b^2 \mp (h^2-a^2)]$ is the limacon inversion condition; and (2) the parameter $B^5 = 2b^2[2(h^2-a^2)H+hj^2]$ specifies the location of the circumpolar non-axial covert linear focal locus of all axial QBI quartics. For a point of inversion of the basis central conic at $h^2 = a^2 \pm b^2$, D^{10} vanishes and with it there vanish 5 of the 15 terms of the "unrefined" (i.e., left in the parameter-form without simplification; see below) intercept transform (eq. 93) and 3 others simplify. For $H = -hj^2/2(h^2-a^2)$, the location of the non-axial covert linear focal locus, 8 of the 15 terms vanish and one simplifies, while for the combination of the two conditions, determining the non-axial covert linear focal locus of limacons, 11 of the 15 terms vanish and 2 of the remaining 4 simplify.

Accordingly, it is seen that in addition to the other noted unique *circumpolar* symmetry properties of limacons, these curves also possess a unique homologous 180°-orthogonal *circumlinear* symmetry property, namely the vanishing

of the x^2 term of the radicand of the simple intercept format in K^2 (the homologue of the vanishing of the term in x^4 from the simple circumpolar intercept format for a point on the line of symmetry). The hereto noted unique properties of axial QBI curves are listed in Table XII-3.

Elimination of A^4K^2 from eqs. 91a,a' leads to eq. 92. After grouping the radicals on one side and squaring, and regrouping and squaring again, together with appropriate collecting, combining, and cancelling of terms (see Chapter XIV), the final transform in parameter-form, which holds for all axial QBI

$$-[A^4x^2+B^5x+C^6] \pm [D^{10}(H+x)^2+E^{11}(H+x)+F^{12}]^{\frac{1}{2}} = \qquad \text{eliminant} \qquad (12\text{-}92)$$
$$-[A^4y^2-B^5y+C^6] \pm [D^{10}(H-y)^2+E^{11}(H-y)+F^{12}]^{\frac{1}{2}} \qquad \text{of eq. 91a,a'}$$

<div align="center">simple circumlinear intercept transform of all
axial QBI quartics about a K axis at x = H</div>

$$A^{16}(x^2-y^2)^2(x-y)^2 + 4A^{12}B^5(x^2-y^2)^2(x-y) + 6A^8B^{10}(x^2-y^2)^2 - \qquad (12\text{-}93)$$

$$2A^8D^{10}(x-y)^2(x^2+y^2) - 2A^8(2D^{10}H+E^{11})(x-y)^3 + 4A^4B^{15}(x^2-y^2)(x+y)$$

$$- 4A^4B^5D^{10}(x-y)(x^2+y^2) + B^{20}(x+y)^2 + 4A^4[A^4(D^{10}H^2+E^{11}H+F^{12}) +$$

$$B^5(2D^{10}H+E^{11})](x-y)^2 - 2B^{10}D^{10}(x^2+y^2) + [D^{10}(2H+x-y)+E^{11}]^2 +$$

$$2B^5[4A^4(D^{10}H^2+E^{11}H+F^{12})-B^5(2D^{10}H+E^{11})](x-y) + 4B^{10}(D^{12}H^2+E^{11}H+F^{12}) = 0$$

<div align="center">simple circumlinear intercept transform of
limacons about a K axis at x = H</div>

$$A^{16}(x^2-y^2)^2(x-y)^2 + 4A^{12}B^5(x^2-y^2)^2(x-y) + 6A^8B^{10}(x^2-y^2)^2 - \qquad (12\text{-}94)$$

$$2A^8E^{11}(x-y)^3 + 4A^4B^{15}(x^2-y^2)(x+y) + B^{20}(x+y)^2 +$$

$$4A^4[A^4(E^{11}H+F^{12})-B^5E^{11}](x-y)^2 + 2B^5[4A^4(E^{11}H+F^{12})-B^5E^{11}](x-y)$$

$$+ E^{22} + 4B^{10}(E^{11}H+F^{12}) = 0$$

<div align="center">simple circumlinear intercept transform of all
axial QBI quartics about the K axis at H = -hj^2/2(h^2-a^2)</div>

$$A^{16}(x^2-y^2)^2(x-y)^2 - 2A^8D^{10}(x-y)^2(x^2+y^2) - 2A^8(2D^{10}H+E^{11})(x-y)^3 \qquad (12\text{-}95)$$

$$+ 4A^8(D^{10}H^2+E^{11}H+F^{12})(x-y)^2 + [D^{10}(2H+x-y)+E^{11}]^2 = 0$$

<div align="center">simple circumlinear intercept transform of
limacons about the K axis at H = -½b</div>

$$A^{16}(x^2-y^2)^2(x-y)^2 - 2A^8E^{11}(x-y)^3 + 4A^8(E^{11}H+F^{12})(x-y)^2 + E^{22} = 0 \qquad (12\text{-}96)$$

Table XII-3. Unique Symmetry Properties of Axial QBI
Cubics and Quartics

Limacons

1. There is no x^4 term in the radicand of the simple intercept format for a point on the line of symmetry.

2. The radicand constant-condition is focal.

3. The non-axial covert linear focal locus is specified by the $\cos^2\theta$-condition.

4. Comprise the only genus of QBI curves that possesses *near-conic* circumpolar transforms.

5. Possess one of the simplest possible simple intercept formats.

6. Possess only one non-vertex point focus on the non-axial covert linear focal locus. Other axial QBI cubics and quartics possess two real or imaginary foci on this axis.

7. Are the only axial QBI genus for which the point of intersection of the non-axial covert linear focal locus and the line of symmetry is a focus.

8. The $-\frac{1}{2}b$ K-axis has uniquely high circumlinear symmetry among axial QBI quartics.

Conic Axial Vertex Cubics

1. In the simple intercept format for a point on the line of symmetry, the square of the coefficient of the external x^2 term is equal to the coefficient of the x^4 term of the radicand (at unity), a condition that leads to the unique property of item 2, below (see Chapter XIV).

2. The $0°$ and $180°$ transforms about a point on the line of symmetry are of only 8th degree, and the $90°$ transforms are only of 22nd degree. Only the corresponding transforms of conics are of lower degree.

3. They have a point focus and a non-axial covert linear focal locus at infinity.

Limacons and Conic Axial Vertex Cubics

1. The $\cos^2\theta$-condition defines only a single axial point focus.

Limacons, Conic Axial Vertex Cubics, Mutually-Inverting Quartic Circles, Eccentricity-Dependent Self-Inverters, and Intersecting Lines

1. Possess a generic double-focus of self-inversion.

quartics, is 93. For limacons ($D^{10} = 0$) this simplifies to 94 (compare with eq. 87 in limacon parameters), while for the circumpolar non-axial covert linear focal locus and circumlinear K-axis focal locus of all QBI quartics at $H = -hj^2/2(h^2-a^2)$ it simplifies to 95. For the combination of both conditions, i.e., the circumlinear K-axis focal locus of limacons at $H = -\frac{1}{2}b$ (central conic parameters), it becomes eq. 96 (compare with eq. 88 in limacon parameters). The condition $A^4 = 0$, for which eq. 93 reduces to 2nd degree, is not allowed because, though this is the condition for axial vertex cubics, A^4 is the multiplier of the K^2 terms (or the divisor of the terms on the right) of eqs. 91a,a'.

Accordingly, although comparisons between covert linear focal loci and circumlinear focal loci are not clear cut in the case of the hyperbola axial vertex cubics, there is no difficulty in making such comparisons for axial QBI quartics. The K-axis at $H = -hj^2/2(h^2-a^2)$ is both: (1) a comparatively high-ranking circumpolar focal locus, with half the rank of the line of symmetry itself (20th degree 0° and 180° transforms, compared with 10th degree for the line of symmetry); and (2) the highest-ranking K-axis from the standpoint of subfocal circumlinear symmetry (with 6th degree 180°-orthogonal circumlinear transforms that are markedly simpler than those about any other K-axis). By comparison, the simplifications in the corresponding circumlinear transforms of the curves about the K-axis through the DP are minor.

α-θ-Circumlinear Symmetry of Quadratics

Introduction

The designation α-θ-*Circumlinear Symmetry* refers to the symmetry of a curve about a line expressed as the relationship between the values of the intercepts of two radii emanating to the curve from points on the line, with the x intercept being the intercept of the radius at an angle θ to the x-axis and the y intercept being that of a radius at an angle $\theta + \alpha = \omega$ to the x-axis. By analogy with the designations of circumpolar symmetry, the corresponding transform is referred to as an α-transform at the angle θ, or, for short, an α-θ-transform. For example, a 180° transform at an angle of 90° about a horizontal line of symmetry is simply the $x = y$ transform of mirror-image symmetry.

The identical transform could be designated as a $180°$ transform at the angle $270°$. α-θ-transforms and circumlinear symmetry are illustrated using quadratics as examples, because the derivations for cubics and quartics generally entail obtaining the general solutions of eqs. of greater than 2nd degree.

The Ellipse

Lines of Symmetry and Axes Parallel Thereto

The basis eq. for the derivation of α-θ-transforms of an ellipse is the simple intercept eq. VII-2a (x-h and y-k translations), repeated below in rearranged form, 97a. This eq. defines the x intercept of a radius to the curve from the origin (or from the point, [-h,-k], relative to the centered curve) at an angle θ to the x-axis. Similarly, eq. 97b defines the y intercept of a radius from the origin at an angle $\omega = \theta + \alpha$ to the x-axis. Equating the simple circumlinear intercept formats in k^2 obtained by quadratic-root solution of eqs. 97a,b yields 97c.

<div align="center">simple intercept equations of an ellipse
centered at (h, k)</div>

(a) $a^2k^2 - (2a^2x\sin\theta)k + [(b^2-a^2)x^2\cos^2\theta - 2b^2hx\cos\theta + (a^2x^2+b^2h^2-a^2b^2)] = 0$ (12-97)

(b) $a^2k^2 - (2a^2y\sin\omega)k + [(b^2-a^2)y^2\cos^2\omega - 2b^2hy\cos\omega + (a^2y^2+b^2h^2-a^2b^2)] = 0$

<div align="center">eliminant of 97a,b</div>

(c) $ax\sin\theta \pm b[(a^2-h^2)+(2h-x\cos\theta)x\cos\theta]^{\frac{1}{2}} =$

$$ay\sin\omega \pm b[(a^2-h^2)+(2h-y\cos\omega)y\cos\omega]^{\frac{1}{2}}$$

<div align="center">circumlinear α-θ-transform of the ellipse
about a k-axis at x = -h</div>

$a^4(y\sin\omega-x\sin\theta)^4 + 2a^2b^2(y\sin\omega-x\sin\theta)^2(y^2\cos^2\omega+x^2\cos^2\theta) -$ (12-98)

$\quad 4a^2b^2h(y\sin\omega-x\sin\theta)^2(y\cos\omega-x\cos\theta) - 4a^2b^2(a^2-h^2)(y\sin\omega-x\sin\theta)^2 +$

$\quad b^4(y^2\cos^2\omega-x^2\cos^2\theta)^2 + 4b^4h^2(y\cos\omega-x\cos\theta)^2 -$

$$4b^4h(y\cos\omega-x\cos\theta)^2(y\cos\omega+x\cos\theta) = 0$$

Regrouping terms as required, squaring twice, and combining corresponding

terms in x and y yields eq. 98, the general α-θ-transform of an ellipse about a k-axis at x = h. It is evident from inspection of this eq. that the general α-θ-transform about all k-axes--even the line of symmetry--is of 4th degree. The subfocal rank of the line of symmetry (eq. 99a) is greatest, because 3 terms of eq. 98 vanish at this locus (h = 0). α-θ-transforms of the circle about a diameter (eq. 100a) also are of 4th degree because letting a = b in eq. 99a leads only to factoring out of a term a^4.

<div align="center">α-θ-transform of an ellipse about the minor axis</div>

(a) $\quad a^4(y\sin\omega-x\sin\theta)^4 + 2a^2b^2(y\sin\omega-x\sin\theta)^2(y^2\cos^2\omega+x^2\cos^2\theta) -$ \qquad (12-99)

$$4a^4b^2(y\sin\omega-x\sin\theta)^2 + b^4(y^2\cos^2\omega-x^2\cos^2\theta)^2 = 0$$

<div align="center">$(180°-2\theta)$-θ-transform of an ellipse about the minor axis</div>

(b) $\quad (x-y)^2[a^4(x-y)^2\sin^4\theta+2a^2b^2(x^2+y^2)\sin^2\theta\cos^2\theta-4a^4b^2\sin^2\theta+b^4(x+y)^2\cos^4\theta] = 0$

<div align="center">α-θ-transform of the circle about the diameter
coincident with the y-axis</div>

(a) $\quad (y\sin\omega-x\sin\theta)^4 + 2(y\sin\omega-x\sin\theta)^2(y^2\cos^2\omega+x^2\cos^2\theta) +$ \qquad (12-100)

$$(y^2\cos^2\omega-x^2\cos^2\theta)^2 - 4a^2(y\sin\omega-x\sin\theta)^2 = 0$$

<div align="center">$(180°-2\theta)$-θ-transform of the circle about the diameter
coincident with the y-axis</div>

(b) $\quad (x-y)^2[(x-y)^2\sin^4\theta+2(x^2+y^2)\sin^2\theta\cos^2\theta-4a^2\sin^2\theta+(x+y)^2\cos^4\theta] = 0$

Accordingly, it can be concluded that α-θ-transforms of central conics about lines of symmetry and all axes parallel thereto generally are of 4th degree. Examination of eq. 98 from the point of view of conditions on ω and θ for which the eqs. will reduce from 4th degree, reveals that $\omega = \theta\pm180°$, i.e., $\alpha = \pm180°$ are the only reduction conditions on the transformation angles. In other words, the circumlinear symmetry of the curves is greatest for points lying on opposite sides of the axis in question and diametrically opposed to one another along ensembles of lines at any angle θ to the x-axis (except that if θ is the same as the angle of the line-pole in question to the x-axis,

i.e., if the radius vectors are coincident with the line-pole, the result is the trivial x+y = constant).

Letting $\omega = \theta+180°$ in eq. 98 leads to the $180°$-θ-transform 101, for which the degree is reduced from 4 to 2 by factoring out $(x+y)^2$, representing the trivial transform x = -y. Letting a = b, for the circle, allows factoring out of a term a^4 but leaves the degree unchanged. If one now lets h = 0,

<p style="text-align:center">$180°$-θ-transform of an ellipse about a
k-axis at x = h</p>

$$a^4(x+y)^2\sin^4\theta + 2a^2b^2(x^2+y^2)\sin^2\theta\cos^2\theta - 4a^2b^2h(x-y)\sin^2\theta\cos\theta \qquad (12\text{-}101)$$

$$+\, b^4(x-y)^2\cos^4\theta - 4b^4h(x-y)\cos^3\theta + 4b^2[b^2h^2\cos^2\theta - a^2(a^2-h^2)\sin^2\theta] = 0$$

<p style="text-align:center">$180°$-θ-transform of an ellipse about the
minor axis</p>

$$a^4(x+y)^2\sin^4\theta + 2a^2b^2(x^2+y^2)\sin^2\theta\cos^2\theta + b^4(x-y)^2\cos^4\theta - 4a^4b^2\sin^2\theta = 0 \quad (12\text{-}102)$$

(a) x = y (b) x+y = 2b eq. 102 for (a) $\theta = 0°$ or $180°$ or (b) $90°$ or $270°$ (12-103)

(a) x-y = 2h (b) $x+y = (2b/a)(a^2-h^2)^{1/2}$ eq. 98 for (a) $\omega = 180°$ and $\theta = 0°$ or $180°$ or (b) $\omega = 180°$ and $\theta = 90°$ or $270°$ (12-104)

the line-pole becomes a line of symmetry--the minor axis--and eq. 101 remains of 2nd degree but simplifies to 102. Accordingly, $180°$-θ-circumlinear transforms of the ellipse and circle about line poles parallel to or coincident with a line of symmetry are of 2nd degree regardless of location. Reduction from 2nd degree is possible only for the conditions, $\theta = 0°$, $90°$, $180°$, or $270°$, in which case the intercepts with the curve are along lines orthogonal to the line-pole ($0°$ or $180°$) yielding eq. 103a, or coincident with it, yielding eq. 103b. The corresponding eqs. for any k-axis are 104a,b, respectively. Eqs. 103b and 104b merely express the fact that the sum of the x and y intercepts with the curve along the k-axis in question is constant.

Although eq. 98 for the α-θ-transform of the ellipse about a k-axis at x = h reduced only for the conditions $\omega = \theta\pm180°$, the corresponding transform, 99a, about the minor axis also will reduce for the condition $\omega = 180°-\theta$, i.e.,

$\alpha = 180° - 2\theta$. For the latter values of ω, the 4th-degree eq., 99a, becomes degenerate, consisting of the product of two quadratic factors equated to 0, as given by 99b. The same is the case (100b) for the 4th-degree α-θ-transform of the circle, 100a, about the diameter coincident with the y-axis.

The condition $\alpha = 180° - 2\theta$ corresponds to having two radii emanating from points on the minor axis at plus and minus the same angle to the axis. The transform for positive intercepts (or for two negative intercepts) is simply $x = y$, which expresses the fact that the minor axis is a line of symmetry. In fact, the 180°-orthogonal circumlinear transform $x = y$ about the minor axis is merely a special case of the $(180° - 2\theta)$-θ-transform for $\theta = 0°$ or $180°$ [for the major axis the corresponding transform is the $(360° - 2\theta)$-θ-transform]. Corresponding to the $x = y$ $(180° - 2\theta)$-θ-transform, a term $(x-y)^2$ factors out of 99a and 100a, to become one of the quadratic product-terms of eqs. 99b and 100b.

It is noteworthy that once the term $(x-y)^2$, representing the transform for either two positive or two negative intercepts, is factored out of these eqs., the remaining quadratic terms represent only transforms for one positive and one negative intercept. Thus, when one lets $\theta = 180°$, in which case $\omega = 0°$ and $\alpha = -180°$--representing the 180°-orthogonal case--the right members of eqs. 99b and 100b yield only the solution $(x+y)^2 = 0$, i.e., $x = -y$, which is the trivial chord-segment transform for one positive and one negative intercept.

Although the algebraically complete solution for the circumlinear $(180° - 2\theta)$-θ-transforms is given by 99b (and 100b), these solutions are redundant because the $(x-y)^2$ term gives duplicate solutions $x = y$. All the symmetry information given by the circumlinear transforms would be present in eqs. 99b and 100b if one of the $(x-y)$ terms were to be factored out. Accordingly, the overall degree in the variables of these degenerate transform eqs. is regarded as being 3.

On the other hand, as mentioned earlier, the degree assigned to the transform of a curve about a pole for which the transform eq. is degenerate--for purposes of comparative symmetry analyses--is that of the lowest-degree non-trivial term in the eq.--in this case $(x-y)$. In other words, the symmetry of a curve about a pole at a given angle or angles is characterized by the highest degree of symmetry (lowest-degree transform) possessed by the curve about that pole. Thus, though the overall degree of the degenerate transform eqs. 99b and 100b is 3, the circumlinear-symmetry-characterizing degree of the $(180° - 2\theta)$-θ-transform is taken to be 1.

The circumlinear symmetry of the hyperbola about the line of symmetry and axes parallel thereto, as assessed by the α-θ-transforms, is essentially the same as that of the ellipse and need not be given separate treatment (the transforms differ only in the signs of terms).

The Parabola

The starting eq. for the α-θ-circumlinear symmetry analysis of the parabola is eq. VI-23a (x+h and y-k translation), repeated below in rearranged form as eqs. 105a,b. If corresponding eqs. are formed in y and ω, and k is eliminated from one set, the α-θ-transform, 106a, about a k-axis at x = h (relative to the vertex) is obtained, while if h is eliminated from the other set, the corresponding transform, 106b, about an h-axis at y = -k (relative to the vertex) is obtained.

(a) $k = x\sin\theta \pm [2p(x\cos\theta-h)]^{\frac{1}{2}}$ simple intercept format in k for the parabola (12-105)

(b) $h = [(x\sin\theta-k)^2-2xp\cos\theta]/2p$ simple intercept format in h for the parabola

α-θ-transform of the parabola about a k-axis
at x = h (relative to the vertex)

(a) $(y\sin\omega-x\sin\theta)^4 - 4p(y\sin\omega-x\sin\theta)^2(y\cos\omega+x\cos\theta) -$ (12-106)

$$8ph(y\sin\omega-x\sin\theta)^2 + 4p^2(y\cos\omega-x\cos\theta)^2 = 0$$

α-θ-transform of the parabola about an h-axis
at y = -k (relative to the vertex)

(b) $(x^2\sin^2\theta-y^2\sin^2\omega) - 2k(x\sin\theta-y\sin\omega) - 2p(x\cos\theta-y\cos\omega) = 0$

(a) $(x+y)^2\sin^4\theta-4p(x-y)\sin^2\theta\cos\theta-8ph\sin^2\theta+4p^2\cos^2\theta = 0$ 106a for $\omega = \theta+180°(\alpha = 180°)$ (12-107)

(b) $(x-y)\sin^2\theta - 2k\sin\theta - 2p\cos\theta = 0$ 106b for $\omega = \theta+180°$ $(\alpha = 180°)$

(a) $(x+y)^2\sin^4\theta = 4p(x-y)\sin^2\theta\cos\theta + 4p^2\cos^2\theta = 0$ 107a for vertex tangent (12-108)

(b) $(x-y)\sin^2\theta = 2p\cos\theta$ 107b for line of symmetry

It is evident from eqs. 106 that, whereas the *circumpolar* symmetry of the parabola about the traditional focus is greater than that of central conics at the subfocal level only (see Table V-1), its *circumlinear* symmetry is greater at both the focal and the subfocal level. Thus, α-θ-transforms of the parabola about any h-axis are of only 2nd degree, compared to 4th degree for central conics, while the transform about any k-axis possesses only 4 terms, compared to 6 for central conics; both of the latter transforms are of 4th degree.

As in the cases of central conics, reduction of the α-θ-transforms, 106a,b, occurs for $\alpha = 180°$ ($\omega = \theta + 180°$), yielding 107a,b, respectively. For the vertex tangent and the line of symmetry, 107a,b becomes 108a,b. The $180°$-θ-transforms for k axes (106a) for $\theta = 0°$ become simply the trivial $x = -y$, while the $180°$-θ-transforms for h axes (107b) for $\theta = 90°$ become the familiar $x-y = 2k$ (y-k translation). Lastly, for the line of symmetry the latter becomes $x = y$.

A Line In the Plane

The subfocal α-θ-circumlinear symmetry of conics about a line-pole in the plane generally is much lower than that about line-poles parallel to lines of symmetry. In the case of the circle (which has no circumlinear foci), however, any line in the plane is parallel to a line of symmetry, so there can be no difference in the subfocal symmetry of the circle about lines in the plane.

An impression of the greater complexity of circumlinear transforms of the parabola and central conics about a line in the plane ($k = mh+d$ or $y = mx+d$) as compared to that about a line parallel to a line of symmetry is conveyed by a comparison of the simple circumlinear intercept formats for h. Eqs. 109a,b make the comparison for the parabola, while 110a,b make it for the hyperbola.

The α-θ-transforms are obtained for each curve by forming corresponding expressions in y and ω, eliminating h, squaring twice to eliminate radicals, etc. Though both sets of formats are linear in x external to the radical and contain both linear and quadratic terms in x in the radicand--and both sets lead to 4th degree transforms--it is apparent that the transforms derived from 109b and 110b will be vastly more complex than those derived from 109a and 110a.

simple circumlinear intercept formats
in h for the parabola

(a) $(2p)h = (x\sin\theta-k)^2 - 2px\cos\theta$ about a line-pole parallel to (12-109)
 the line of symmetry

(b) $(m^2)h = (p-md+mx\sin\theta) \pm$ about a line-pole in the plane

$$[x^2(m^2-1)\sin^2\theta-2dx(m^2-1)\sin\theta+(p-md)^2+d^2+2p(x\cos\theta+mx\sin\theta)]^{\frac{1}{2}}$$

simple circumlinear intercept formats
in h for a hyperbola

(a) $(b)h = bx\cos\theta \pm a[(x\sin\theta-k)^2+b^2]^{\frac{1}{2}}$ about a line-pole parallel (12-110)
 to the transverse axis

(b) $[2(b^2-a^2m^2)]h = (a^2dm+b^2x\cos\theta-a^2mx\sin\theta)$ about a line-pole in the plane

$$\pm \, a[(a^2+b^2)(1-m^2)x^2\sin^2\theta+2b^2dx(m\cos\theta-\sin\theta) -$$

$$2b^2mx^2\sin\theta\cos\theta+b^2(b^2+d^2-a^2m^2+m^2x^2)]^{\frac{1}{2}}$$

simple intercept equation of a hyperbola about
a point on the line k = mh+d

(c) $h^2(b^2-a^2m^2) + 2h(a^2mx\sin\theta-b^2x\cos\theta+a^2dm) +$

$$x^2(a^2+b^2)\cos^2\theta - a^2(b^2+d^2+x^2-2dx\sin\theta) = 0$$

In the derivation of the format 110b, the simple intercept eq. about a
point on the line k = mh+d is formed by substituting mh+d for k in the
simple intercept eq. for a hyperbola centered at (h,k) (eq. VII-2b), yielding
110c. Eq. 110b is simply the solution of eq. 110c for h. But it is evident
from inspection of 110c that for $b^2 = a^2m^2$, the term in h^2 will vanish
and the remainder can be solved directly for h. This means that the corre-
sponding α-θ-transforms for line-poles of slopes m = ±b/a will reduce to a
maximum of 3rd degree. The slopes ±b/a, however, are the slopes of the
asymptotes. Since the degrees of circumlinear transforms of curves about paral-
lel lines are the same, the corresponding transforms about the asymptotes
also will be of 3rd degree. Since the latter are found to be of the greatest
interest, their derivation is carried out below.

The Parallel Line-Pair

Before considering the circumlinear symmetry of the hyperbola about its asymptotes, however, another curve with exceptional circumlinear symmetry is considered, namely the parallel line-pair, for which the α-θ-transforms are derived. The general slope-intercept eq. for the parallel line-pair of slope m, with the origin incident upon the midline and y intercepts of $\pm b$ is 111a. The simple intercept eq. of this curve about a point on the line

(a) $(y-mx)^2 = b^2$ parallel line-pair (12-111)

(b) $[x(\sin\theta-m\cos\theta)+h(m_1-m)+b_1]^2 - b^2 = 0$ simple intercept eq. of 111a about a point on the line $k = m_1h+b_1$

(c) $h = \dfrac{-x(\sin\theta-m\cos\theta)\pm b}{(m_1-m)}$ simple circumlinear intercept format in h for 111b

(d) $y(\sin\omega-m\cos\theta) - x(\sin\theta-m\cos\theta) = \pm b \pm b$ eliminant of 111c and identical eq. in y and ω

algebraically complete circumlinear α-θ-transform of the parallel line-pair about any line in the plane (except the midline)

(d') $[y(\sin\omega-m\cos\omega)-x(\sin\theta-m\cos\theta)]^2 [y(\sin\omega-m\cos\omega)-x(\sin\theta-m\cos\theta)-2b]\cdot$

$\quad\quad [y(\sin\omega-m\cos\omega)-x(\sin\theta-m\cos\theta)+2b] = 0$

algebraically complete circumlinear α-θ-transform eqs. of the parallel line pair $y^2 = b^2$ about any line in the plane (except the midline)

(e) $[y\sin\omega-x\sin\theta]^2 [(y\sin\omega-x\sin\theta)-2b][(y\sin\omega-x\sin\theta)+2b] = 0$

(e') $[y\sin\omega-x\sin\theta][(y\sin\omega-x\sin\theta)-2b][(y\sin\omega-x\sin\theta)+2b] = 0$

(f) $[x+y][(x+y)\sin\theta-2b][(x+y)\sin\theta+2b] = 0$ algebraically complete $180°$-θ-transform eq. from 111e'

(f') $x = -y$ trivial solution to 111f

(f'') $x+y = -2b/\sin\theta$ dual negative intercept solution to 111f

(f''') $x+y = 2b/\sin\theta$ solution to 111f for positive intercepts

(g) $[y-x][(y-x)/2^{\frac{1}{2}}-2b][(y-x)/2^{\frac{1}{2}}+2b] = 0$ algebraically complete (12-111)
 90°-45°-transform eq. from 111e'

(g') $x = y$ solution of 111g for both intercepts
 positive (or both intercepts negative)

(g") $y-x = \pm 2 \cdot 2^{\frac{1}{2}}b$ solutions of 111g for one intercept
 positive and one intercept negative

(h) $[x\sin\theta+y\sin\omega][x\sin\theta-y\sin\omega] = 0$ algebraically complete α-θ-transform
 of the parallel line-pair $y^2 = b^2$
 about the midline

(h') $(x-y)(x+y) = 0$ algebraically complete 180°-90°-trans-
 form of mirror-image symmetry for 111h

$k = m_1h+b_1$ is 111b, which leads to the simple intercept format in h, 111c.

Elimination of h between 111c and an identical eq. in y and ω (θ+α) yields eq. 111d. Taking the alternate signs in all combinations results in the degenerate, algebraically complete transform eq. 111d'. It will be noted that 111d' possesses the remarkable property--for a circumlinear α-θ-transform--of being independent of the parameters, m_1 and b_1, of the line in the plane about which the transform was derived. This means that the same general transform holds for all lines in the plane (except the midline) and, in fact, for any *point* in the plane (not lying on the midline).

Since 111d' is the algebraically complete α-θ-transform eq., it includes transforms for all combinations of positive and negative intercepts, including trivial transforms. For a further examination of the properties of this eq., it is simplified to represent a parallel line-pair with the x-axis as midline ($y^2 = b^2$) by letting m = 0. This yields eq. 111e. The latter can be reduced from overall 4th degree in the variables to overall 3rd degree without any loss of generality by factoring out a term ($y\sin\omega-x\sin\theta$), giving 111e'. The transforms yielded by the bracketed terms of eq. 111e' for various combinations of positive and negative intercepts are illustrated by considering the 180°-θ- and 90°-45°-transform solutions. These are the linear relations of 111f',f", and f'", and 111g' and g" .

Most noteworthy is the fact that the transform 111g', namely x = y, has the same subfocal rank as the transform x = y about the midline, for which the α-θ-transform is 111h. If this were a valid comparison of these transforms, the

assertion that a curve possesses the highest degree of circumlinear symmetry about a line of symmetry would be contradicted. However, it is not a valid comparison, because the algebraically complete transform eqs. are not being compared, i.e., transforms for other combinations of positive and negative intercepts are not being taken into account. The algebraically complete transform eq. of mirror-image symmetry about the midline is 111h', as compared to 111g, the corresponding complete $90°$-$45°$-transform eq. about any line in the plane. The transform of mirror-image symmetry clearly has the higher subfocal rank of these two alternative eqs.

It is evident that the $90°$-$45°$-transform is not the only other α-θ-transform of the parallel line-pair $y^2 = b^2$ (besides any $180°$-θ-transform about the line of symmetry) that has a solution $x = y$. Any circumlinear $(180°$-$2\theta)$-θ-transform will have the same property (although the $0°$-$90°$-transform is trivial). In fact, if one uses as criteria the $(180°$-$2\theta)$-θ-transform *and* the $180°$-θ-transform about a line of symmetry--both of which are $x = y$--the parallel line-pair emerges as the curve with the highest circumlinear symmetry, and its midline is the highest ranking of all lines of symmetry.

Omnidirectional Circumlinear Self-Inversion of the Hyperbola

The α-θ-circumlinear symmetry of the hyperbola about the asymptotes is determined as follows. The simple intercept eq. for hyperbolas centered at (h,k) is 112a. One now forms a corresponding eq. 112b in y and ω and substitutes $k = bh/a$, the eq. for one of the asymptotes, leading to 113a,b. Eliminating

<div align="center">

simple intercept eqs. of a hyperbola centered
at a point in the plane (h,k)
</div>

(a) $\quad (a^2+b^2)x^2\cos^2\theta - 2b^2hx\cos\theta + (b^2h^2-a^2k^2-a^2b^2-a^2x^2) = -2a^2kx\sin\theta$ \qquad (12-112)

(b) $\quad (a^2+b^2)y^2\cos^2\omega - 2b^2hy\cos\omega + (b^2h^2-a^2k^2-a^2b^2-a^2y^2) = -2a\,ky\sin\omega$

<div align="center">

simple intercept formats in h for a
hyperbola about the asymptotes
</div>

(a) $\quad [2b(ax\sin\theta-bx\cos\theta)]h = a^2(b^2+x^2) - x^2(a^2+b^2)\cos\theta$ \qquad (12-113)

(b) $\quad [2b(ay\sin\omega-by\cos\omega)]h = a^2(b^2+y^2) - y^2(a^2+b^2)\cos\omega$

h, cross-multiplying, and gathering terms leads to the 3rd-degree circumlinear α-θ-transform of eq. 114. It follows that the degree of the circumlinear α-θ-transforms about all lines parallel to the asymptotes is 3.

<div align="center">

α-θ-circumlinear intercept transforms of a
hyperbola about the asymptotes

</div>

(12-114)

$$a^2b^2[a(x\sin\theta-y\sin\omega)+b(y\cos\omega-x\cos\theta)] + a^2xy[a(y\sin\theta-x\sin\omega)+b(x\cos\omega-y\cos\theta]$$

$$+ (a^2+b^2)xy[a(x\sin\omega\cos^2\theta-y\cos^2\omega\sin\theta)+b(y\cos\omega-x\cos\theta)\cos\theta\cos\omega] = 0$$

<div align="center">

$180°$-θ-circumlinear intercept transform of a
hyperbola about the asymptotes

</div>

(a) $xy = \dfrac{a^2b^2}{(a^2+b^2)\cos^2\theta - a^2}$ any value of θ (12-115)

(b) $xy = \dfrac{a^2b^2}{b^2-a^2}$ $\cos\theta = b/(a^2+b^2)^{\frac{1}{2}}$, i.e., along lines orthogonal to the asymptotes

(c) $xy = \dfrac{2a^2b^2}{b^2-a^2}$ $\theta = 45°$ (d) $xy = a^2$ $\theta = 0°$

Examination of eq. 114 reveals that it will reduce only for the condition $\alpha = 180°$, i.e., $\omega = \theta+180°$, whereupon the circumlinear $180°$-θ-transform of hyperbolas about the asymptotes becomes 115a. This most interesting result shows that hyperbolas self-invert about the asymptotes at all angles. For example, for the $180°$-orthogonal case, $\cos\theta = b/(a^2+b^2)^{\frac{1}{2}}$, whereupon 115a becomes 115b. This means that for a line orthogonal to an asymptote at any point, the product of the intercepts is constant and equal to $a^2b^2/(b^2-a^2)$. The product is negative for $e < 1$ ($b < a$), infinite for the equilateral hyperbola, and positive for $e > 1$ ($b > a$). This simply means that since the distances are directed, one intercept is negative and the other positive for $e < 1$. For $e > 1$, one intercept of each pair is on each arm. For other angles the product has a different value. For example, for the radius vectors at an angle of $45°$ to the x-axis, the eq. becomes 115c, while for $\theta = 0°$, i.e., along lines parallel to the transverse axis (the x-axis), the product achieves its simplest form, a^2.

Referring to eq. VII-3b (upper sign), the intercept product for hyperbolas about a point in the plane, it is seen that eq. 115 is simply the intercept product with $b^2h^2 = a^2k^2$, i.e., the intercept product for a point on an asymptote. Accordingly, the present circumlinear result also was evident from the circumpolar symmetry analysis. This property of hyperbolas is well known (see treatment in Salmon, 1879).

If one refers to eq. VII-3a, for the ellipse, it is seen that this central conic "self-inverts" in the complex domain for the locus $b^2h^2 = -a^2k^2$ (eq. 116). In other words, it self-inverts about the imaginary asymptotes, $k = \pm bhi/a$.

$$xy = \frac{a^2b^2}{[(b^2-a^2)\cos^2\theta + a^2]}$$

intercept product for "self-inversion" of the ellipse about the imaginary asymptotes (12-116)

In the case of the parabola, vanishing of the terms in k and h of the intercept product (eq. VI-24b) requires that $k^2 = 2ph$, which corresponds to incident points. This leads to the eq., $xy = 0$, for self-inversion about a point on the curve. Although trivial, this is the result obtained for all other axial QBI curves of unit eccentricity, where the focus of self-inversion also comes to lie on the curve--at the cusp. The degrees of circumlinear transforms are summarized in Table XII-4.

$90^\circ - 0^\circ -$ CIRCUMCURVILINEAR SYMMETRY OF CONICS

Introduction

The topic of α-θ-*circumcurvilinear symmetry* is one of vast extent, the present treatment being purely introductory in nature. Although procedures for deriving α-θ-circumcurvilinear transforms are quite straightforward, the derivations often become very complex. Only the relatively simple cases of 90°-0°-circumconical symmetry of conics are pursued here. The latter designation refers to the symmetry of conics relative to the same or other conics; this is assessed by the use of an x radius vector directed along the positive direction of the x-

Fig. 1-1c

Table XII-4. Degrees of Circumlinear Intercept Transforms
of Axial QBI Curves*

180°-Orthogonal Circumlinear Symmetry

Curves	Axes	Degree	Highest-ranking axis (focal or subfocal)
Parabola	H	1	line of symmetry
Parallel line-pair	H	1	midline
Central conics	H & K	1	lines of symmetry
Cubics	K	3	asymptote
	H	1	line of symmetry
Limacons	K	6	$-\frac{1}{2}b$
	H	1	line of symmetry
Axial QBI curves	K	6	non-axial circumpolar covert linear focal locus
	H	1	line of symmetry

Other Circumlinear Symmetry

Curves	Axes	Type of symmetry	Degree	Highest-ranking axis (focal or subfocal)
Parallel line-pair	lines in plane	$\alpha-\theta$	1	midline
	midline	$\alpha-\theta$	1	midline
Central conics	H & K	$\alpha-\theta$	4	lines of symmetry
	minor, conjugate	$(180°-2\theta)-\theta$	1	line of symmetry
	major, transverse	$(360°-2\theta)-\theta$	1	line of symmetry
	H & K	$180°-\theta$	2	lines of symmetry
Hyperbola	lines parallel to asymptotes	$\alpha-\theta$	3	asymptotes
	"	$180°-\theta$	2	asymptotes
Parabola	H	$\alpha-\theta$	2	line of symmetry
	K	$\alpha-\theta$	4	vertex tangent
	K	$180°-\theta$	2	vertex tangent

*All curves in standard position.

axis $(\theta = 0°)$ and a y radius vector directed along the positive direction of the y-axis $(\alpha + \theta = 90° + 0° = 90°)$. These vectors emanate from a pole on the reference conic to intercepts with the basis conic. The transforms relate the x and the y intercepts with the basis curve for all positions of the poles on the reference curve.

Derivation of 90°-0°-Circumcurvilinear Transforms

To derive 90°-0°-circumcurvilinear transforms one first obtains the simple mixed-transcendental intercept eq. of the basis curve for $(x+h)$ and $(y+k)$ translations. As in previous derivations, the pole of the transformation is at the origin, and the centers of central conics and the axial vertex of the parabola are translated to the position $(-h,-k)$. For basis curves in standard form these eqs. are 117.

<div align="center">

simple mixed-transcendental intercept eqs.
of conics
</div>

(a) $(x\sin\theta+k)^2 = 4a(x\cos\theta+h)$ parabola (12-117)

(b) $(x\cos\theta+h)^2 + (x\sin\theta+k)^2 = R^2$ circle

(c) $b^2(x\cos\theta+h)^2 \mp a^2(x\sin\theta+k)^2 = a^2b^2$ central conics

<div align="center">

solutions of equations 117 for h and k,
with $\theta = 0°$ for x, and $\theta = 90°$ for y
</div>

(a) $k = \dfrac{4ax+y^2}{-2y}$ $h = \dfrac{(y^2-4ax)^2}{16ay^2}$ parabola (12-118)

(b) $h = -\dfrac{x}{2} \pm \dfrac{y(4R^2-x^2-y^2)^{\frac{1}{2}}}{2(x^2+y^2)^{\frac{1}{2}}}$ $k = -\dfrac{y}{2} \pm \dfrac{x(4R^2-x^2-y^2)^{\frac{1}{2}}}{2(x^2+y^2)^{\frac{1}{2}}}$ circle

(c) $h^2 = \pm(a^2/b^2)[y/2 \pm bx(\pm a^2y^2-b^2x^2+4a^2b^2)^{\frac{1}{2}}/2a(a^2y^2\mp b^2x^2)^{\frac{1}{2}}]^2 + a^2$ central conics

 $k = -y/2 \pm bx(\pm a^2y^2-b^2x^2+4a^2b^2)^{\frac{1}{2}}/2a(a^2y^2\mp b^2x^2)^{\frac{1}{2}}$

The x intercepts about the origin now are obtained by letting $\theta = 0°$, and the y intercepts by letting $x = y$ and $\theta = 90°$ in eqs. 117. The sets of eqs. in x and y now are solved simultaneously for h and k, yielding eqs. 118.

For given displacements h and k along the x and y-axes, the x and y
intercepts are related by these eqs. On the other hand, the same relations
hold if the pole of the transformation is taken to be at the point (h,k), with
the basis curve in standard position. Accordingly, the $90°$-$0°$-circumcurvi-
linear symmetry of these standard position conics with respect to any curve,
$f(x,y) = 0$, can be examined by substituting h for x and k for y in the eq.
of the reference curve, and then replacing h and k according to eqs. 118.
This relates the x and y intercepts from a point on the reference curve
to the basis conic.

$90°$-$0°$-Identical Self-Circumcurvilinear Symmetry
of Conics

The α-θ-identical self-circumcurvilinear transforms of basis curves can be
obtained simply by substituting the h and k values (in terms of the inter-
cepts at the angles θ and $\theta+\alpha$) into the eq. of the identical (congruent
and coincident) basis curve. When this is done for conics, the $90°$-$0°$-circum-
curvilinear transforms are found to be eqs. 119.

$$90°\text{-}0°\text{-identical self-circumcurvilinear}$$
$$\text{symmetry of conics}$$

(a) $xy^2 = 0$ parabola (12-119)

(b) $x^2 + y^2 = 4R^2$ circle

(c) $b^2x^2 \mp a^2y^2 = 4a^2b^2$ central conics

In the case of the parabola the transforms are trivial, because the x
intercept always is 0. However, non-trivial α-θ-identical self-circum-
curvilinear transforms of the parabola exist for all other combinations of
angles (excluding $0°$). It will be noted that the transforms of central conics
are curves belonging to the same subspecies. In the case of the circle, the
$90°$-$0°$-identical self-circumcurvilinear transform is identical with the $90°$
circumpolar transform about an incident point. Among curves of finite degree,
this correspondence appears to be unique to the circle.

90°-0°-Congruent Self-Circumcurvilinear
 Symmetry of the Parabola

The 90°-0°-congruent circumparabolic transforms of the parabola, $y^2 = 4ax$,
are obtained relative to a translated congruent curve, $(y+K)^2 = \pm 4a(x+H)$,
with either the same or opposed orientation. The general transform is the
quartic of 120a. If the curves have the same orientation, this reduces to the

90°-0°-congruent circumparabolic symmetry of
the parabola

(a) $(1\mp 1)[y^4+16a^2x^2]+(1\pm 1)8axy^2+(4K^2\mp 16aH)y^2-16aKxy$ either similar or opposed (12-120)
$$-4Ky^3 = 0 \quad \text{orientation}$$

(b) $Ky^2-4axy+(4aH-K^2)y+4aKx = 0$ similar orientation

(c) $x = H$ similar orientation with vertex on x axis

(d) $y^4-2Ky^3+2(K^2+4aH)y^2-8aKxy+16a^2x^2 = 0$ opposed orientation

(e) $(y^2+4aH)^2 = -16a^2(x^2-H^2)$ opposed orientation with vertex on x axis

(e') $y^4 + 8aHy^2 + 16a^2x^2 = 0$ simplification of 120e

the ellipses of 120b (as identified by rotating CCW through an angle θ
specified by $\tan 2\theta = 4a/K$). For $K = 0$, this becomes 120c. There can be no
transform relation $f(x,y) = 0$ for this case, since x is equal to H for all
poles on the reference curve.

If the orientation is opposed, the general eq., 120d, is of 4th degree. For
the vertex on the x axis this simplifies to 120e. This transform has real
solutions for all negative values of H (in which case the curves overlap),
provided that $H^2 \geq x^2$ (in which case the poles for the transformation lie in
the region of overlap).

90°-0°-Circumcircular Symmetry of the Parabola

If the general reference circle is taken to be eq. 121a, and the substi-
tutions 118a are made (h for x and k for y), the general 90°-0°-circumcircular
transform of the parabola is found to be given by the octic of eq. 121b. In-
creases in the symmetry of the parabola about circles of different size and

(a) $(x+H)^2 + (y+K)^2 = R^2$ reference circle of radius R centered at $(-H,-K)$ (12-121)

(b) $[(y^2-4ax)^2+16aHy^2]^2 +$

$64a^2y^2[(y^2+4ax) - 2Ky\]^2 = 256a^2y^4R^2$

$90°-0°$-circumcircular intercept transform of standard parabola

(c) $(y^2-4ax)^4+64a^2y^2(y^2+4ax)^2 = 256a^2y^4R^2$

$90°-0°$-circumcircular intercept transform of standard parabola about circles centered at vertex

(d) $[(y^2-4ax)^2-16a^2y^2]^2 = 64a^2y^2[4R^2y^2-(y^2+4ax)^2]$

121b about circles centered at focus

(e) $(y^2-4ax)^4 +32a^2y^2[(y^2+12ax)^2-128a^2x^2] = 0$

121d for circle tangent at the vertex

location are entirely at the subfocal level, since there is no condition for reduction.

The parabola clearly has the highest degree of $90°-0°$-symmetry about circles centered at the vertex (eq. 121c). The size of these vertex circles plays little role. Its next-highest degree of $90°-0°$-circumcircular symmetry is possessed about the "focus circles" of eq. 121d. With reference to the latter circles, it is most symmetrical about the circle of radius a, which is tangent at the vertex (eq. 121e).

$90°-0°$-Circumelliptical and Circumhyperbolic Symmetry of the Parabola

Taking the basis reference central conics, 122a, leads to the $90°-0°$-circum-

(a) $B^2(x+H)^2 \mp A^2(y+K)^2 = A^2B^2$ reference central conics (12-122)

(b) $B^2[(y^2-4ax)^2+16aHy^2]^2 \mp$

$64a^2A^2y^2[(y^2+4ax)-2Ky]^2 = 256a^2A^2B^2y^4$

general $90°-0°$-circumcurvilinear transform of the parabola about central conics

(c) $B^2(y^2-4ax)^4 \mp 64a^2A^2y^2(y^2+4ax)^2 = 256a^2A^2B^2y^4$

122b for reference curves centered at the vertex ($H = K = 0$)

(d) $B^2(y^2-4ax)^4-32aAB^2y^2(y^2-4ax)^2 \mp$

$64a^2A^2y^2(y^2+4ax)^2 = 0$

122b for reference curve left vertex incident on basis curve vertex ($H = -A$, $K = 0$)

(d') $B^2(y^2-4ax)^4-32a^2B^2y^2(y^2-4ax)^2 \mp 64a^4y^2(y^2+4ax)^2 = 0$

122d for center at parabola focus ($A = a$)

(d'') $(y^2-4ax)^4-32a^2y^2(3y^4+8axy^2+48a^2x^2) = 0$

122d' for equilateral hyperbola

curvilinear transforms 122b. The $90°-0°$-symmetry of the basis curve about central conics centered at its vertex is high (as it is about the circle), as can be seen from eq. 122c. It also is high when the vertex of the central conic is incident on the vertex of the basis curve, 122d. Further increases in subfocal symmetry for other relationships, such as 122d', with the center of 122d at the focus $(a = A)$, are minor. The chief increase in subfocal symmetry for the circum-curvilinear relationship represented by 122d' occurs for the equilateral sub-species, i.e., for $A = B$. The transform for the $90°-0°$-symmetry of the parabola about an equilateral hyperbola with vertices in coincidence and the center at the parabola focus is 122d", which is simpler even than that for the case where the equilateral hyperbola reference curve is centered at the parabola vertex (122c with $A = B$).

Reciprocal Circumcurvilinear Symmetry

$90°-0°$-Reciprocal Circumcurvilinear Symmetry of the Circle and the Parabola

A topic of considerable interest is the comparative circumcurvilinear symmetry of curves relative to one another, i.e., their *reciprocal circumcurvilinear symmetry*. Reciprocal transforms for circumcurvilinear symmetry are not expected to be identical, because although a radius vector between two poles—one on each curve—may be regarded as common (but of opposite sign for each), the other radius vector from each pole is different.

As a first illustration, the $90°-0°$-reciprocal circumcurvilinear transforms of the parabola and the vertex circle of radius R are compared. The intercept transform of eq. 123a, for the $90°-0°$-circumparabolic symmetry of the vertex circle, is derived by substituting eqs. 118b in the eq. for the standard parabola, $y^2 = 4ax$ $(k^2 = 4ah)$.

(a) $[(y^4-x^4+4R^2x^2)+8ax(x^2+y^2)]^2 =$ $90°-0°$-circumparabolic \quad (12-123)
symmetry of vertex circles

$\qquad 4y^2(16a^2+x^2\pm8ax)(x^2+y^2)(4R^2-x^2-y^2)$

(b) $(y^2-4ax)^4+64a^2y^2(y^2+4ax)^2 = 256a^2R^2y^4$ \quad $90°-0°$-circumcircular symmetry of the parabola about vertex circles

It will be noted that, like the corresponding transform for the circumcircu-

lar symmetry of the parabola (repeated as eq. 123b), the eq. is of 8th degree; it is highly likely that reciprocal circumcurvilinear transforms making up any given pair always are of the same degree. In the case of eq. 123a, the transform is degenerate. Because of the occurrence of the linear multiplicative term, 8ax, alternate signs are required to allow for both positive and negative intercepts (upper sign for positive intercepts). Expressed as a product of two factors equated to 0, the eq. consists of two 8th-degree factors.

Based upon a comparison of the complexity of eqs. 123, the circumcircular symmetry of the parabola is much greater than the circumparabolic symmetry of the circle. One may speculate that in cases of reciprocal circumcurvilinear symmetry of different curves, one of the curves generally has a higher degree of symmetry about the other than the other has about the one. Circumcircular symmetry doubtless is characteristically greater than the reciprocal type. Although different types of symmetry are being compared, the comparisons are valid because of the existence of the reciprocal relationship.

The Identical Reciprocal Circumcurvilinear
 Symmetry of the Centered Circle and Equi-
 lateral Hyperbola--The Devil's Curve

The above treatment inevitably raises questions concerning the comparative reciprocal circumcurvilinear symmetry of the circle and equilateral hyperbola. In view of the very high degree of symmetry of these conics and the homologies that exist between them (see page V-8), one expects them to have unusual reciprocal circumcurvilinear symmetry features. This proves to be the case. Not only are the reciprocal $90°-0°$-circumcurvilinear transforms identical (eqs. 124a,b), they are of only 4th degree and are identical with the well-known Devil's Curve (eq. 124c). Intersubspecific circumcurvilinear transforms for other central conics and the parabola are of 8th degree. It is a reasonable speculation that this identical reciprocal circumcurvilinear symmetry of the centered circle and equilateral hyperbola is unique to these two curves, and that it extends to the α-θ-transforms.

(a) $(x^4-y^4)-2(R^2+a^2)x^2+2(R^2-a^2)y^2 = 0$ $90°-0°$-reciprocal circumcurvilinear transform of centered circle and equilateral hyperbola (12-124)

(b) $[x^2-(R^2+a^2)]^2-[y^2-(R^2-a^2)]^2 = 4a^2R^2$ 124a in another form

(c) $y^4 + mb^2y^2 - x^4 + nb^2x^2 = 0$ Devil's Curve (dimensionally balanced, m and n dimensionless)

As represented in eq. 124b, the identical reciprocal transform eq. is seen to have the same form as that for a translated equilateral hyperbola, except that the variables x and y occur within the brackets to the 2nd degree. The curve consists of 3 branches. A centered, central lemniscate-like branch, with its transverse axis along the y-axis, arises from intercept pairs with small positive and negative x intercepts (that do not cross the y-axis). In addition, there are two side branches resembling the basis hyperbola but with the vertex regions flattened over a broad expanse--reminiscent of the *hyperbola segment* of the $0°$ near-line transforms of limacons about the $-\frac{1}{2}b$ focus (see Chapter X, *The Near-Conics*). The flattened regions are gently concave to one another in the region of the x-axis. These branches represent intercept pairs in which the radius extends across the y-axis to the contralateral region.

[The Devil's Curve was studied first by G. Cramer in the mid-18th century for the case m = -96 and n = 100. This corresponds to a circle of radius 7 and equilateral hyperbola of semi-major axis 1 (R = 7, a = 1). The relationship of the curve to the reciprocal circumcurvilinear symmetry of the circle and equilateral hyperbola was, of course, unknown. For the case m = -1 and n = 2 (R = $3^{\frac{1}{2}}/2$, a = ½), the Devil's Curve is said to be an excellent example for use in presenting the theory of Riemann surfaces and Abelian integrals.]

$90°-0°$-Circumcurvilinear Symmetry of the Parabola About the Cissoid of Diocles

An interesting area of circumcurvilinear symmetry concerns that of an inverse locus about the basis curve. As a sole example, the parabola, $y^2 = 4ax$, is inverted to yield the cissoid of Diocles, 125a. This is expressed in terms of h and k, and the latter are eliminated by the substitutions of eqs. 118a.

(a) $j^2y^2 = 4ax(x^2+y^2)$ cissoid of Diocles (12-125)

(b) $(y^2-4ax)^6 + 64a^2y^2(y^2-4ax)^2(y^2+4ax)^2$ $90°-0°$-circumcurvilinear transform of the parabola
$$- 256a^2j^2y^4(y^2+4ax)^2 = 0$$ about the cissoid of Diocles

This yields the dodecic transform 125b for the vertex of the parabola in coincidence with the cissoid cusp in the inversion orientation.

It will be evident to the reader that the topic of circumcurvilinear symmetry could be expanded in many directions. The present very brief introductory treatment points the way for some of these extensions. I have made but few

comments along the avenue of generalizations because these must await the investigation of the α-θ-circumcurvilinear transforms about reference curves with various locations and orientations.

Table XII-5. Degrees of 90°-0°-Circumcurvilinear Transforms

Basis Curve	Reference Curve	Degree	Properties
Identical Self-Circumcurvilinear Symmetry			
parabola	parabola	2	trivial
circle	circle	2	
central conics	central conics	2	identical with 90° circum-polar transform
Congruent Self-Circumcurvilinear Symmetry			
parabola	parabola with same orientation	2	
parabola	parabola with opposite orientation	4	
parabola	same as above, vertex on x axis	4	highest 4th-degree subfocal symmetry
Circumconical Symmetry of Parabola			
parabola	general circle	8	
"	vertex circle	8	
"	focus circle	8	
"	tangent focus circle	8	highest subfocal symmetry about focus circles
"	general central conic	8	
"	vertex-centered central conic	8	
"	vertex-tangent central conic	8	
"	vertex-tangent, center-at-focus equilateral hyperbola	8	highest subfocal symmetry of vertex-tangent ellipse and hyperbola reference curves
Reciprocal Circumcurvilinear Symmetry			
vertex circles	parabola	8	
parabola	vertex circles	8	very much greater subfocal symmetry than reciprocal parabola pairs
centered circle	equilateral hyperbola	4	transform identical to that directly below
equilateral hyperbola	centered circle	4	transform identical to that directly above

Introduction

In this Chapter a treatment of the 1st-generation tangent-pedal taxonomy of conic sections is given from points of view of greatest interest in relation to the circumpolar symmetry and classification of curves. Normal pedals also are examined briefly. Treatments of the tangent-pedal transformation from the classical point of view are to be found in Salmon (1879 and 1934), Yates (1947), and Zwikker (1950). In the interests of simplicity, the tangent pedal is usually referred to in the following simply as the "pedal."

The pedal of a basis curve, B, with respect to a point, O, is the locus of the feet of the perpendiculars from O on the tangents to B. It is formed by: (1) determining y_i so that eq. 1b represents the tangent line(s) to the basis curve, 1a; and (2) eliminating m from the eqs. of the tangent lines and normals from the origin to the tangent lines, 1c. In this formulation the

(a) $(y-k) = f(x-h)$ basis curve with vertex at (h,k) (13-1)

(b) $y = mx + y_i$ tangent lines to basis curve

(c) $my + x = 0$ normals through origin to tangent lines

pedal is taken about the origin, with the curve translated an amount h along the x-axis and k along the y-axis, relative to its standard position. Accordingly, the pedal-point or "pole" relative to the curve in standard form is at $(-h,-k)$. This format is followed throughout the Chapter.

First-Generation Quadratic-Based Tangent-Pedal Taxonomy

The Point, the Line, and the Circle,
* and Ensembles Thereof*

The pedal of a point about another point is a circle having the connecting segment as a diameter (also true of the normal pedal). Hence, the pedal of two points about a pole on the midline is mutually-inverting quartic circles

or, if the pole also lies on the connecting segment, externally tangent circles. For a pole that lies on the connecting segment on either side of both points, internally tangent circles result.

The pedal of a line about any pole is the point of intersection of the line and a perpendicular from the pole to the line. Accordingly, the pedal of the parallel line-pair is two points, one on each line at points incident upon their common normal to the pole. The pedal of two intersecting lines is two points that can lie on the lines in any relationship. The two points are co-incident at the point of intersection for the case in which the pole also is coincident with this point. The pedal of a circle about a non-incident, non-central pole is a limacon, the pedal about an incident pole is the cardioid, and the pedal about the center is the identical circle.

It is evident from these relationships that all the pedals of these most sym-metrical conic sections also are QBI curves or ensembles thereof. It is shown in the following that *all* the 1st-generation pedals of *all* conic sections are QBI curves (or ensembles thereof). In fact, it appears further, that the en-semble of 1st-generation pedals of the parabola and central conics about all points in the plane duplicates the ensemble of inversions of the same curves about all such points. QBI curves that are not 1st-generation tangent pedals of the parabola and central conics include the parabola, central conics, mutu-ally-inverting quartic circles, tangent circles, intersecting lines, and the parallel line-pair.

The Parabola

To form the pedal of the parabola, 2a, about a point in the plane, one first determines the eq. of lines tangent to it at the point (x_1, y_1), yielding 2b. Solving 2a for x_1 as a function of y_1 and substituting in 2b gives 2c. Eliminating y_1 between 2c and 2d, the eq. for normals through the origin to the tangent lines, gives the general eqs. 2e,e' for the pedals of the parabola about the origin (the point [-h,-k] relative to the parabola in standard position). The pedals about points on the line of symmetry ("axial pedals") are given by eq. 2f. Unlike the inversion loci of parabolas, which include both cubics and quartics, the pedals are seen to be cubics only, with the sole exception of the linear pedal about the focus (h = -a, k = 0). The latter pedal-point yields the locus x = -a, the vertex tangent. The axial vertex is the only point that lies on every axial pedal.

(a) $(y-k)^2 = 4a(x-h)$ basis parabola with vertex at (h,k) (13-2)

(b) $(y-y_1) = [2a/(y_1-k)](x-x_1)$ lines tangent to 2a at (x_1,y_1)

(c) $(y-y_1) = [2a/(y_1-k)[(x-h)-(y_1-k)^2/4a]$ eliminant of 2a and 2b
 (x_1 eliminated)

(d) $2ay/(y_1-k) + x = 0$ normals through origin to the
 tangent lines

(e) $y^2(x+a) = x^2(h-x) + kxy$ pedal about the origin (eliminant
 of 2c and 2d; y_1 eliminated)

(e') $x[x(x-h)+y(y-k)] + ay^2 = 0$ pedal about the origin
 (2e rearranged)

(f) $y^2(x+a) = x^2(h-x)$ axial pedal

(g) $hx^2 - ay^2 + kxy - j^2x = 0$ inversion of general pedal

(h) $hx^2 - j^2x - ay^2 = 0$ inversion of axial pedal

(h') $(x-j^2/2h)^2 - ay^2/h = j^4/4h^2$ eq. 2h rearranged

Inversion of 2e and 2f about the origin gives 2g and 2h,h', respectively. Since the latter eqs. are quadratics, it is clear that: (a) all the pedals of parabolas are conic inversion cubics; and (b) the pole or pedal-point becomes the DP or DP homologue of the axial pedal, because all axial QBI curves invert to conics about this pole. With the possible exception of poles of self-inversion, the pole of the pedal transformation also is the highest-ranking focus of the pedal.

CIRCUMPOLAR MAXIM 35: *With the possible exception of poles of self-inversion, the pole for an inversion or tangent-pedal transformation of a conic becomes the highest-ranking circumpolar focus of the transform curve.*

The qualification in the above Maxim is necessary for two reasons: (1) except for QBI curves for which 1st-degree intercept transforms exist about the DP, such as limacons and central quartics, the transform of self-inversion (xy = constant) usually is simpler than other 0° or 180° transforms about the DP or DP homologue; and (2) non-axial inversions of QBI cubics, quartics, central conics, and the parabola produce inversion loci without a line of symmetry but with one or two poles of self-inversion. Although the circumpolar symmetry of

these latter curves has been studied very little, unless they were to possess a focus with a linear or circular transform, the pole of self-inversion would be the highest-ranking focus.

Examination of eqs. 2h,h' reveals that, for h positive, the curves are hyperbolas of eccentricity given by $e^2 = (a+h)/a$. Accordingly, these pedals include *all* hyperbola vertex cubics (since e^2 takes on all values greater than 1 for all values of h > 0). A positive value of h, with k = 0, represents a pole at (-h,0) relative to the parabola in standard position, in other words, a point on the line of symmetry or x-axis *outside* the curve.

For h = 0, eq. 2h is a parabola ($e^2 = 1$) and the corresponding pedal, 2f, is the cissoid of Diocles; in this instance the pedal of a conic section belongs to the same subspecies as the inversion locus about the same pole (congruence depends upon a selection of j = 2a, in which case the curves would be images in the x-axis).

For h negative but $|h| < |a|$, eqs. 2h,h' are ellipses of eccentricity $e^2 = (a+h)/a$, and the corresponding pedals of 2f comprise *all* the ellipse a-vertex cubics. For h = -a, the pole is at the focus (a,0) and the inverse curve, 2h,h', is a circle ($e^2 = [a+h]/a = 0$). The corresponding pedal, 2f, is the vertex tangent (as opposed to the inversion locus about the focus, which is the cardioid). Accordingly, the symmetry ranks of the focal pedals of the parabola, like those of its focal inversions, follow the same order as the circumpolar focal ranks of the poles about which they are formed--in each case the curve of highest symmetry rank is the transform about the traditional focus.

For h negative and $|h| > |a|$, i.e., post-focal poles, eqs. 2h,h' also yield ellipses, but for these $e^2 = (a+h)/h$, and it is the minor axis that is coincident with the x-axis. In other words, the corresponding pedals comprise *all* the ellipse b-vertex cubics.

In summary, the above findings for line-of-symmetry pedals of the parabola constitute the fascinating result that this group of pedals encompasses all the line-of-symmetry *vertex* inversions of conic sections, including inversions about points on the line, points on the circle, the a vertices of hyperbolas, and both the a and b vertices of ellipses (note in this connection that eqs. 2h,h' are cast about a point on the curve).

With this result realized, the presumption is very strong, based upon considerations of continuity alone, that the non-axial pedals of the parabola

encompass all the other conic inversion cubics, i.e., all the inversions of
the parabola and central conics about incident points exclusive of the line-
of-symmetry vertices.

The above results raise several interesting questions: (1) what is the locus
of pedal-points for pedals that give all the parabola inversion cubics (i.e.,
those in addition to the cissoid of Diocles); (2) if this locus is the basis
parabola itself, do the other pedals of the parabola about incident poles
belong to the same subspecies as the inversions about the same poles, or is
the cissoid of Diocles case unique; and (3) what are the loci of pedal-points
for pedals of constant eccentricity (i.e., pedals that invert to the same
subspecies of conics)--for example, what is the locus of the pedal-points of
pedals that are equilateral hyperbola inversion cubics?

In the cases of the first two queries the above results lead one to expect
that the locus is the parabola itself, and that the pedal about a given pole
belongs to the same subspecies as the inversion locus about that pole. To show
that these expectations are fulfilled, eq. 2g (the inversion of the general
pedal) is cast for pedal-points that are incident upon the basis parabola 2a,
by letting $k^2 = -4ah$ (keeping in mind that h always is negative for this
situation). The axes then are rotated to eliminate the xy term. The eq. of
the resultant parabola is found to be cast about a point homologous to the
pole about which the pedal of the basis parabola was formed. For example, if
the pedal is formed about an LR vertex, the eq. of the parabola to which it
inverts is cast about the same LR vertex. In other words: (1) the pedals of
the parabola about all incident points consist of all the subspecies of
parabola inversion cubics; and (2) the cubic obtained by forming the pedal about
a specific pole is the same one obtained by inverting the curve about that pole.

PEDAL TAXONOMY MAXIM 1: *The pedals of the parabola about all points in the
plane, including incident points, comprise the conic
inversion cubics, i.e., the inversions of conics
about all incident points.*

PEDAL TAXONOMY MAXIM 2: *The pedals of the parabola about all incident points
comprise the parabola inversion cubics, i.e., the
inversions of the parabola about all incident points.*

PEDAL TAXONOMY MAXIM 3: *The pedal of the parabola about a specific incident
point belongs to the same subspecies of parabola
inversion cubic as the inversion about that point,
i.e., for the appropriate selection of the unit of
linear dimension the pedal and the inversion are
congruent.*

To answer question (3) above, eq. 2g, the inversion of the general pedal, is rotated CW through an angle θ (eq. 3a) to bring its axis into coincidence with the x-axis, giving 3b. The eccentricity of this inversion locus of the general pedal now is obtained in terms of the coefficients of the x^2 and y^2 terms, leading to eq. 3c, which expresses the relationship between e of the pedal inversion locus and the coordinates h and k of the vertex of the basis parabola.

(a) $\cos^2\theta = (h+a+A)/2A$ $\qquad A = [(a+h)^2+k^2)]^{\frac{1}{2}}$ \qquad eqs. defining θ for axial coincidence \qquad (13-3)

$$\text{inversion of the general parabola pedal rotated to bring its axis into coincidence with the } x \text{ axis}$$

(b) $x^2[(h-a+A)/2] + y^2[(h-a-A)/2] - j^2x[(h+a+A)/2a]^{\frac{1}{2}} + j^2y[(A-a-h)/2a]^{\frac{1}{2}} = 0$

$$\text{eccentricity of inversion locus of general parabola pedal 4b in terms of coordinates } h \text{ and } k \text{ of vertex of basis parabola}$$

(c) $4h^2(1-e^2) + 4ah(e^4-2e^2+2) + 4a^2(1-e^2) + (e^2-2)^2k^2 = 0$

$$\text{constant pedal-eccentricity loci of the parabola (eq. 4c in standard form)}$$

(c') $[h+a(e^4-2e^2+2)/2(1-e^2)]^2 + k^2(e^2-2)/4(1-e^2) = a^2e^4(e^2-2)^2/4(1-e^2)$

(d) $[e] = e^2/|2-e^2|$ \qquad eccentricity of elliptical loci of pedal-points of pedals that invert to ellipses of eccentricity e

To obtain the loci of the pedal-points for which the pedals have constant eccentricity, *constant pedal-eccentricity loci* for short, one now assigns a value to e in 3c (or 3c', which is in standard form); the resulting eq. in h and k gives the desired loci. This eq. has the remarkable properties that it: (a) represents almost all the conic sections--a point-circle, ellipses, hyperbolas, the parabola, and a line; (b) includes conic sections of all eccentricities, 0 to ∞; (c) represents *monoconfocal* loci; and (d) fills the entire plane without intersection or overlap, i.e., by nestling together of all the loci that it represents. Property (d), of course, is a requirement of the

problem, since the eq. must account for all pedal-points in the plane, and loci with different e may not intersect nor overlap.

Specifically: (1) a focus of all the conic sections except the line is at h = -a, which is the traditional focus of the basis parabola--in the cases of the elliptical constant pedal-eccentricity loci, it is the left focus that is coincident with the focus of the basis parabola, while for hyperbolic constant pedal-eccentricity loci it is the right focus; (2) the constant pedal-eccentricity locus for e = 0 is a point locus at the focus of the basis parabola--this is the unique point about which the pedal of the basis parabola is the vertex-tangent line, namely, the sole pedal that inverts to a circle; (3) the constant pedal-eccentricity loci for 1 > e > 0 are ellipses of eccentricity [e] given by 3d, i.e., [e] is the eccentricity of the elliptical constant pedal-eccentricity loci, each of which represents the pedal-points for pedals of the basis parabola that invert to conics (ellipses) of eccentricity e; (4) for e = 1 the constant pedal-eccentricity locus is identical with the basis parabola; (5) for $2^{\frac{1}{2}} > e > 1$, the constant pedal-eccentricity loci are the right arms of hyperbolas of eccentricity [e] given by 3d; (6) for $e = 2^{\frac{1}{2}}$, the constant pedal-eccentricity locus is a line at x = a, namely, the directrix of the basis parabola--in other words, all the pedals of the parabola about poles on the directrix are cubics that invert to equilateral hyperbolas; (7) for $e > 2^{\frac{1}{2}}$, the loci are the left arms of the loci mentioned above.

The plane is filled with nestling conics as follows. The point-circle at the traditional focus of the basis parabola "opens out" to tiny, nearly circular ellipses. As the ellipses enlarge and their eccentricity increases, their centers progressively migrate along the x axis to the right. With this progression the entire interior of the parabola becomes filled with ellipses. There are as many ellipse vertices to the left, between the vertex and focus of the basis parabola, as to the right of the focus. As noted above, the left vertices are the poles about which the pedals are a-vertex cubics, and the right ones the poles about which the pedals are b-vertex cubics.

A similar process fills the plane exterior to the parabola but in this case the space-filling curves are hyperbolas. The right arms nestle into one another and fill the entire exterior to the right of the directrix, with [e] progressing from 1 to ∞ as the eccentricity of the pedal progresses from 1 to $2^{\frac{1}{2}}$. For $e = 2^{\frac{1}{2}}$, [e] = ∞, and the locus is the directrix line. The left

arms fill the entire plane to the left of the directrix line, with e increasing to ∞ along successive loci to the left while [e] decreases toward 1.

[The constant pedal-eccentricity loci of the parabola provide another instance of a homology between the circle and the equilateral hyperbola. The two most symmetrical constant pedal-eccentricity loci of the parabola are the point at the focus (for e = 0) and the directrix line (for e = $[2]^{\frac{1}{2}}$). The pedals of the parabola about these loci are, respectively, the incident inversions of the circle and of the equilateral hyperbola.]

Central Conics

The pedal of a central conic with center (h,k), 4a, about the origin is given by the very simple-appearing eq. 4b (the similar formulation for the parabola is 2e'). For points on the lines of symmetry 4b becomes 4c,d. The respective quadratic loci obtained by inverting these pedals about the origin are 4e-g.

(a) $b^2(x-h)^2 \mp a^2(y-k)^2 = a^2b^2$ basis central conic with center at (h,k) (13-4)

(b) $[x(x-h)+y(y-k)]^2 = a^2x^2 \mp b^2y^2$ pedal of central conic 4a about the origin

(c) $[x(x-h)+y^2]^2 = a^2x^2 \mp b^2y^2$ central conic major and transverse axis pedals

(d) $[x^2+y(y-k)]^2 = a^2x^2 \mp b^2y^2$ central conic minor and conjugate axis pedals

(e) $(j^2-hx-ky)^2 = a^2x^2 \mp b^2y^2$ inversions of central conic pedals 4b about the origin

(f) $(h^2-a^2)x^2 - 2hj^2x \pm b^2y^2 = -j^4$ inversions of central conic pedals 4c about the origin

(g) $-a^2x^2 + (k^2\pm b^2)y^2 - 2j^2ky = -j^4$ inversions of central conic pedals 4d about the origin

Since the general eqs., 4b, for central conic pedals invert to conic sections, it is clear that all the pedals of central conics are QBI quartics. The identity of the axial QBI quartics, 4c,d, is examined first by identifying their inversion loci, 4f,g.

[The fact that the pedals of conic sections invert to conic sections is known and was mentioned, in passing, by Tweedie (1902). It is important to note the distinction that the "eccentricity" of a pedal of a basis conic section (which generally is a QBI cubic or quartic) is defined as the eccentricity of the conic section to which the pedal inverts about its DP or DP homologue, not the eccentricity of the basis curve from which the pedal was derived.]

I begin with the pedals of central conics about their 5 axial foci because the eccentricities of these pedals provide useful references for consideration of the general axial pedals. The pedals about the left foci, centers, left a-vertices, and lower b-vertex are given by eqs. 5a-d, respectively. The inversions of these pedals about the DP or DP homologue, about which the eqs. are cast, are eqs. 5a'-d', respectively.

(a) $[x-(a^2 \pm b^2)^{\frac{1}{2}}]^2 + y^2 = a^2$ pedals about the left foci (13-5)

(a') $\pm b^2(x^2+y^2) - 2j^2 x(a^2+b^2)^{\frac{1}{2}} + j^4 = 0$ inversions of focus pedals

(b) $(x^2+y^2)^2 = a^2 x^2 \mp b^2 y^2$ pedals about centers

(b') $a^2 x^2 \mp b^2 y^2 = j^4$ inversions of center pedals

(b'') $b^2 x^2 \mp a^2 y^2 = (a^2 b^2/j^4)(x^2+y^2)^2$ central quartics

(c) $[x(x-a)^2+y^2]^2 = a^2 x^2 \mp b^2 y^2$ pedals about left a-vertices

(c') $y^2 = \pm(2aj^2/b^2)(x-j^2/2a)$ inversions of a-vertex pedals

(d) $[x^2+y(y-b)]^2 = a^2 x^2 + b^2 y^2$ pedals about ellipse lower b-vertices

(d') $x^2 = -(2bj^2/a^2)(y-j^2/2b)$ inversions of ellipse b-vertex pedals

The focus pedals are seen to be circles of radius a centered at the center (recall that the left focus is at the origin). These are known as the "major auxiliary circles." Of course, their inversions, 5a', also are circles. The pedals about the center will be recognized as being central quartics. However, they are not the same subspecies of central quartics (5b'') obtained by *inverting* central conics about the same pole. The principal difference is that the coefficients a and b become exchanged in the center pedals as opposed to the center inversions. In the case of an ellipse basis curve this has the effect of rotating the pedal through 90°, leaving the eccentricity unchanged. The center pedals of hyperbolas, however, maintain the same orientation but their eccentricity is altered by a factor of a/b. Accordingly, only the pedal of the equilateral hyperbola--the equilateral lemniscate--has the same eccentricity as the inversion locus about the same pole (for j^2 =ab, the curves are identical).

All of the pedals about the vertices, 5c, are axial inversions of the parabola. Moreover, an examination of the coefficients and terms of these eqs. reveals that all of the line-of-symmetry inversion quartics of the parabola are accounted for by the vertex pedals of central conics (including the circle). The hyperbola a-vertex pedals consist of all the inversion quartics of the parabola about poles on the external axis (the translations to the right of the origin include all multiples, b^2/a^2, of the vertex-focus distance $aj^2/2b^2$ from 0 to ∞).

The ellipse a-vertex pedals include all the internal-axis inversion quartics of the parabola about poles between the vertex and the focus, while the ellipse b-vertex pedals include all those about poles beyond the focus. The pedal of the circle about an incident point gives the inversion quartic (the cardioid) about the focus. Hence there is a one-to-one correspondence between all conic vertex pedals (including central conics, the parabola, and the circle) and axial inversions of the parabola.

PEDAL TAXONOMY MAXIM 4: *The axial vertex pedals of all conic sections comprise--in one-to-one correspondence--the inversions of the parabola about all poles on its line of symmetry.*

The above results for the focal pedals of central conics establish several eccentricity reference poles for the following treatment of the non-focal axial pedals. Considerations of continuity also dictate the values of the eccentricities of pedals about neighboring poles. Thus, since pedals about the foci have an eccentricity of 0, the neighboring pedals on both sides must be ellipses of near-zero eccentricity. Since the pedals about the vertices have unit eccentricity, the eccentricities of intermediate pedals must decrease monotonically from 1 to 0 between the vertex and the focus for both ellipses and hyperbolas. Similarly, the eccentricity must increase monotonically from the vertex to the center of hyperbolas and from the focus to the center of ellipses, and decrease monotonically from the b vertex to the center of ellipses.

The assertion that the progression will be monotonic hinges on the fact that there are no other foci between the limiting foci in question. [In the following, for the sake of simplicity, eccentricity limits of pedals (and their inversion loci) formed about poles that lie between foci include the values

of e at the foci, even though the inverse curves belong to different species.]

Turning now to the non-focal axial pedals, consider first the inversions of pedals of a basis hyperbola about points on its transverse axis, eq. 6a.

(a) $(h^2-a^2)x^2 - 2hj^2x + b^2y^2 = -j^4$ inversions of hyperbola transverse-axis pedals (13-6)

(a') $(a^2-h^2)x^2 + 2hj^2x - b^2y^2 = j^4$ inversions of hyperbola inter-vertex pedals (a > h)

(b) $a^2x^2 - (b^2+k^2)y^2 + 2j^2ky = j^4$ inversions of hyperbola conjugate-axis pedals

For h > a, i.e., post-vertex pedals, the inversion loci are seen to be ellipses. If the pedal-points are pre-focal, $h^2 < a^2+b^2$, these are *major axis ellipses*--ellipses with their major axes coincident with the x-axis. If they are post-focal, $h^2 > a^2+b^2$, they are *minor axis ellipses*--ellipses with their minor axes coincident with the x-axis. The eccentricity of these ellipses decreases from 1 to 0 as the pedal pole moves from the vertex to the focus, and from 0 toward 1 as it moves from the focus toward infinity. In other words, the post-vertex axial pedals of the hyperbola include both major and minor axis inversions of ellipses of all eccentricities.

For h < a, i.e., inter-vertex pedals of the hyperbola, the inversion loci, 6a', are seen to be *transverse axis hyperbolas*, i.e., hyperbolas with their transverse axies coincident with the x-axis. The eccentricity of these hyperbolas increases from 1 to $(1+a^2/b^2)^{\frac{1}{2}}$ as the pedal pole moves from the vertex to the center. Thus, the pedals of hyperbolas about inter-vertex poles comprise quartics that are inversions of hyperbolas about poles on the transverse axis and have eccentricities from 1 to $(1+a^2/b^2)^{\frac{1}{2}}$.

The inversion loci of pedals of hyperbolas about points on the conjugate axis, eq. 6b, also are found to be *transverse axis hyperbolas* for all values of k. The eccentricity of the pedals (and their hyperbola inversion loci) varies from $(1+a^2/b^2)^{\frac{1}{2}}$ toward 1 as the pedal-point moves from the center toward infinity along the conjugate axis. Accordingly, line-of-symmetry pedals of a hyperbola of any given eccentricity encompass both major and minor axis inversions of ellipses of all eccentricities, and transverse axis inversions of hyperbolas with eccentricities of from $(1+a^2/b^2)^{\frac{1}{2}}$--at the center--to 1--at infinity or the axial vertices.

For major axis pedals of a basis ellipse, the inversion loci are given by 7a. For $h > a$, i.e., post-vertex pedals, this eq. represents transverse axis hyperbolas with e increasing from 1 to ∞ as the pedal-point moves from the vertex toward ∞. For inter-vertex poles, $h < a$, the inversions are ellipses. The pre-focal pedals invert to minor axis ellipses with e decreasing from $(1-b^2/a^2)^{\frac{1}{2}}$ to 0 as the pole moves from the center to the focus. The post-focal pedals invert to major axis ellipses, with e increasing from 0 to 1 as the pole moves from the focus to the vertex.

For minor axis pedals of the same basis ellipse, the inversion loci are represented by 7b. For $k < b$, i.e., the inter-vertex minor axis pedals, the in-

(a) $(a^2-h^2)x^2 + 2hj^2x + b^2y^2 = j^4$ inversions of ellipse major axis pedals (13-7)

(b) $a^2x^2 + (b^2-k^2)y^2 + 2j^2ky = j^4$ inversions of ellipse minor axis pedals

version loci are minor axis ellipses of eccentricity increasing from $(1-b^2/a^2)^{\frac{1}{2}}$ to 1 as the pole moves from the center to the vertex. For post-vertex minor axis pedals of ellipses, the inversion loci are conjugate axis hyperbolas, with e increasing from 1 to ∞ as the pedal-point moves from the vertex to ∞. There are no major axis ellipses among the inversion loci about inter-vertex minor axis pedal-points (as there are for post-focal major axis pedals) because this would require that $b^2-k^2 > a^2$, which cannot occur for a basis ellipse (because $a > b$).

Accordingly, interior line-of-symmetry pedals of an ellipse of any given eccentricity include major and minor axis inversions of ellipses of all eccentricities, while exterior line-of-symmetry pedals include transverse and conjugate axis inversions of hyperbolas of all eccentricities.

Broadly summarizing the above results for line-of-symmetry pedals of central conics, the exterior pedals of ellipses about poles on both axes invert to hyperbolas of all eccentricities from 1 to ∞ as the poles move from the a and b vertices to infinity along the axes. The corresponding situation in which the pedal-points on the axes of a basis hyperbola move outward from the center along the axes produces pedals whose eccentricity decreases from $(1+a^2/b^2)^{\frac{1}{2}}$ to 1 along the conjugate axis. Along the transverse axis, the eccentricity decreases to 1 at the vertex and continues to decrease until it reaches 0 at the focus; thereafter it increases to 1. As a pole approaches the center along a

major, transverse, or conjugate axis, the eccentricity of the pedal about this pole increases. On the other hand, it decreases as the pole approaches the center along the minor axis of an ellipse.

While line-of-symmetry pedals of a basis ellipse invert to conics of all eccentricities, and possessing reciprocal inversion poles on each of all 4 axes, line-of-symmetry pedals of a basis hyperbola invert to both major and minor axis ellipses of all eccentricities but include no conjugate axis inversions of hyperbolas nor transverse axis inversions of eccentricities greater than $(1+a^2/b^2)^{\frac{1}{2}}$.

Based upon considerations of continuity and the findings for the pedals of the parabola (Pedal Taxonomy Maxim 1) and the conic vertex pedals (Pedal Taxonomy Maxim 4), the presumption is strong that the pedals of central conics about all non-incident points in the plane include all the QBI quartics, and that the pedals about all incident points include all the parabola inversion quartics. In the latter connection it is shown readily that the pedals about all incident poles invert to parabolas.

PEDAL TAXONOMY MAXIM 5: *The pedals of central conics about all poles on the lines of symmetry, including an extended diameter of the circle, include all axial QBI quartics (QBI quartics with at least one line of symmetry.*

PEDAL TAXONOMY MAXIM 6: *The pedals of central conics about all incident points include all the parabola inversion quartics.*

PEDAL TAXONOMY MAXIM 7: *The pedals of central conics about all non-incident points in the plane include all central conic inversion quartics.*

These findings raise a number of interesting questions, two of which are considered here. As noted above, the axial pedals of hyperbolas about inter-vertex transverse axis poles, and about all poles on the conjugate axis, invert to subspecific sets of transverse axis hyperbolas, each of which possesses members of all eccentricities from 1 to $(1+a^2/b^2)^{\frac{1}{2}}$. Moreover, these subspecific sets (of which there are two for each line of symmetry of the basis hyperbola) intersect at the origin for a hyperbola of eccentricity $e = (1+a^2/b^2)^{\frac{1}{2}}$. But the members of the two sets for the basis transverse axis are inversions of pedals with poles along axial line segments which are only

of length a, whereas the members of the two sets for the basis conjugate axis are inversions of pedals with poles along axial line segments of infinite length.

The question then arises, "since both classes of sets contain transverse axis hyperbolas of all eccentricities between 1 and $(1+a^2/b^2)^{\frac{1}{2}}$, yet one set has its origin in the inversions of pedals about poles on a line segment of length a, and the other on a line segment of infinite length, what is the relationship between the axial coordinates h and k for the pedal-points of pedals that invert to transverse axis hyperbolas of the same eccentricity?"

To answer this question one forms the expression, 8a, for e^2 of the pedals about poles on the basis transverse-axis segments of length a, and the corresponding expression, 8b, for e^2 of the pedals about poles on the basis conjugate axis segments of infinite length and eliminates e^2. This yields eq. 8c, which will be recognized as the well-known Bullet-Nose curve. This is the first demonstration of a relationship of this curve to the circumpolar symmetry of the hyperbola (the curve derives from a 90° bilinear type of construction; see Chapter VII).

(a) $e^2 = \dfrac{a^2+b^2-h^2}{b^2}$ eq. defining the eccentricities of pedals about the basis transverse axis from h = 0 to h = a (13-8)

(b) $e^2 = \dfrac{a^2+b^2+k^2}{b^2+k^2}$ eq. defining the eccentricities of pedals about the basis conjugate axis from k = 0 to k = ∞

(c) $\dfrac{a^2}{h^2} - \dfrac{b^2}{k^2} = 1$ eliminant of 8a and 8b, the Bullet-Nose curve of the hyperbola (letting h = x and k = y)

(d) $e^2 = \dfrac{a^2-b^2+k^2}{a^2}$ eq. defining the eccentricities of pedals about the basis minor axis from h = a to h = ∞

(e) $e^2 = \dfrac{b^2-a^2+h^2}{b^2}$ eq. defining the eccentricities of pedals about the basis major axis from h = a to h = ∞

(f) $\dfrac{h^2}{b^2} - \dfrac{k^2}{a^2} = \dfrac{a^4-b^4}{a^2 b^2}$ hyperbolic eliminant of 8d and 8e

The second question has to do with the axial pedals of the ellipse. Exterior axial pedals of the ellipse invert to both transverse and conjugate axis

hyperbolas of all eccentricities from 1 to ∞. The former derive about pedal-points on the major axis (from $h = a$ to $h = \infty$) and the latter about pedal-points on the minor axis (from $k = b$ to $k = \infty$). What is the relationship between the axial coordinates h and k of pedal-points for pairs of external axial pedals that have the same eccentricity? The answer is obtained in the same manner. The expression 8d for e^2 of pedals about poles on the basis minor axis segment is equated to 8e for e^2 of pedals about poles on the basis major axis, yielding the hyperbolic relationship, 8f. The latter eq. also expresses the relationship between h and k for interior major-axis focus-to-a-vertex pedals of the same eccentricity as interior minor-axis center-to-b-vertex pedals.

Accordingly, although the Bullet-Nose curve of the hyperbola is found to express a relationship satisfied by hyperbolic pedals of the same eccentricity for pedal-points on the axes of a hyperbola, there is no homologous relationship for axial pedals of the ellipse to the unicursal Cross Curve. However, the two cases are not completely homologous for several reasons. For example, though the pedals have the same eccentricity, those of both sets invert to transverse axis hyperbolas in the first case (eqs. 8a-c) but not in the second case (eqs. 8d-f)(nor do the interior sets of pedals of the second case both invert to ellipses having the same orientation).

As a final topic in this section, the loci of the pedals of an ellipse and hyperbola of constant eccentricity are derived by the identical procedure used for the parabola. First, eq. 4e for inversions of the general pedals of central conics is rotated through the angle θ, specified by eq. 9a, to bring the major or transverse axis into coincidence with the x-axis. From this general eq. one forms an expression for the eccentricity [e] of the pedal and its inversion locus in terms of the coefficients of the x^2 and y^2 terms. Eliminating the radical from this expression by squaring leads to the equivalent eqs. 9b,b' relating [e] and the values of h and k of the pedal pole ([-h,-k] relative to the centered basis curves). These give a genus of previously unknown quartics that: (1) fill the plane by nestling, for all values of [e] from 0 to ∞; and (2) reduce to the basis central conics for [e] = 1.

To obtain the locus of constant pedal eccentricity for a given [e], one now assigns the desired value and plots the corresponding locus. For example, if the value [e] = 1 is selected, the eqs. reduce to the basis curve in standard

(a) $\quad \tan 2\theta = 2hk/(h^2-k^2-a^2\mp b^2)$

eq. defining θ to bring the major and transverse axes into coincidence with the x-axis

(13-9)

(b) $\quad (e^2-2)^2h^2k^2 + (1-e^2)(h^2-k^2-a^2\mp b^2)^2 =$

$$e^4(h^2-a^2)(k^2\pm b^2)$$

general equation of constant pedal-eccentricity loci of central conics

(b') $(1-e^2)(h^2+k^2)^2-2(1-e^2)(a^2\pm b^2)(h^2-k^2) +$

$$e^4(a^2k^2\mp b^2h^2)+(1-e^2)(a^2\pm b^2)^2\pm e^4a^2b^2 = 0$$

(c) $\quad b^2h^2 \pm a^2k^2 = a^2b^2$

constant pedal-eccentricity loci for [e] = 1

(d) $\quad h^2 + k^2 = a^2e^2$

constant pedal-eccentricity loci for a circle

(e) $\quad (h^2+k^2)^2(1-e^2) + a^4(e^2-2)^2 =$

$$(e^2-2)^2a^2(h^2-k^2)$$

constant pedal-eccentricity loci of the equilateral hyperbola

(f) $\quad a^2b^2(h^2+k^2)^2-(a^4-b^4)(b^2h^2-a^2k^2) = 0$

constant pedal eccentricity locus of ellipse for [e] = e

(g) $\quad a^2b^2(x^2+y^2)^2 - j^4(b^2x^2-a^2y^2)$

central inversion of hyperbola

form, 9c, showing that pedals about poles on the curves have unit eccentricity. On the other hand, if one takes the basis curve to be a circle (a = b and the lower alternate signs), one obtains eq. 9d. This eq. reveals that the loci of constant pedal-eccentricity for a basis circle also are circles, and that for [e] = 1 these poles lie on the circle (the pedals are cardioids).

For a basis equilateral hyperbola (a = b and upper alternate signs) 9e is obtained. For [e] = 1 9e yields the basis hyperbola in standard form (9c, lower alternate sign); for $[e]^2 = 2$ it yields the point-circle, $x^2+y^2 = 0$, showing that the unique point about which the pedal of the equilateral hyperbola also has an eccentricity $[e]^2 = 2$ is the center, for which the pedal is the equilateral lemniscate.

In the cases of the central conics, the manner in which the plane is filled with nestling quartic loci of constant pedal-eccentricity resembles that for

the parabola. Beginning with [e] of 0, for the pedals about the traditional foci of a basis hyperbola, the locus consists of the two point-poles at the traditional foci. For increasing [e] the loci "open out" to almost circular ovals that gradually enlarge and fill the interiors of the two arms (bear in mind that the symbol "[e]" for central conics refers to the eccentricity of the pedals, themselves, not the loci of constant pedal-eccentricity). The closer the near vertices of the ovals approach to the vertices of the basis hyperbola, the more nearly the proximal oval face assumes hyperbolic shape, and the farther away the far vertices recede. For [e] = 1, the quartic locus reduces to that of the basis hyperbola itself.

For [e] > 1 the nestling quartics recede from the convex faces of the basis curve. Each locus now is a single quartic oval, but decidedly non-ovular in shape. Though following the convex faces of the basis curve for a considerable distance, the arms of the now biconcave ovals eventually "break away" and swing over toward and join at the y-axis. With increasing [e] the loci come to resemble the cross-sections of biconcave red blood cells. As [e] approaches the limiting value of ae/b, the ovals become more and more elliptical and then more and more circular as they "collapse" to the point locus for the central quartic pedal at the center.

The [e] = 0 locus for a basis ellipse begins in the same manner as for the hyperbola, with two point-poles at the traditional foci. As the pedal [e] increases, the quartic loci "open out" and their vertices extend to the right and the left toward the a vertices and center. For [e] = e, the two ovals merge and the locus of constant pedal-eccentricity becomes a *hyperbolic* central quartic with its DP at the center of the basis ellipse. The pedal about the center is the same *elliptical* central quartic subspecies as the inversion locus about the same pole, except that the pedal is rotated 90° about the center. Since, by definition, pedals about other points on the [e] = e hyperbolic central quartic locus of constant pedal-eccentricity have the same eccentricity as the elliptical central quartic pedal for the center, the situation differs from that for the hyperbola; in the case of the hyperbola, the locus of constant pedal-eccentricity for pedals with [e] equal to the [e] of the central pedal is merely the point-pole at the center.

The eq. of the hyperbolic central quartic locus for [e] = e can be derived by setting e^2 of eq. 9b,b' equal to $(a^2-b^2)/a^2$, yielding the quartic locus

9f. The locus also can be derived by making use of the fact that the origin lies on the curve. Thus, by setting the sum of the two constant terms of eq. 9b' equal to 0, the same condition, $e^2 = (a^2-b^2)/a^2$, is obtained. The eq. of this locus of constant pedal-eccentricity (for pedals having the same [e] as the central pedal) now is compared to the eq. of the central quartic, 9g, obtained by inverting a hyperbola about its center. The curves are seen to be identical for hyperbolas that have the same parameters, a and b, as the ellipse, provided that j^4 is chosen to be equal to (a^4-b^4).

Accordingly, for the appropriate selection of j, the central quartic obtained by *inverting* a hyperbola about its center is identical to the specific locus of constant pedal-eccentricity that passes through the center of an ellipse that has the same parameter values as the hyperbola. This particular ensemble of central quartics excludes the equilateral lemniscate as a subspecies, because for a = b the locus collapses to a point-circle.

[Recall in this connection that it is more common that the complementary situation arises; the equilateral lemniscate is the *sole* hyperbolic central quartic represented by an eq. for a group of curves for which it is the curve of demarcation. For example, the equilateral lemniscate is the sole Cassinian that is a central quartic, and it lies at the intersection of the single-oval and double-oval members.]

For [e] < e the two ovals merge into a single oval. As [e] increases this oval "opens out" into centered ellipse-like ovals that become more and more elliptical as [e] approximates to 1, and they nestle against the basis curve. At [e] = 1 the constant pedal-eccentricity locus becomes identical with the basis curve and the pedals are inversions of parabolas. When [e] exceeds 1, the loci of constant pedal-eccentricity "open away" from the basis ellipse and enlarge progressively as [e] increases without limit. They retain an elliptical appearance but the major axis of the quartic is orthogonal to the major axis of the basis ellipse.

These loci for the poles of constant pedal-eccentricity of central conics, 9b,b', comprise an extremely interesting genus of quartics that includes as species: (a) single ovals; (b) non-intersecting double ovals; (c) hyperbolas; (d) ellipses (including circles and the point-circle); and (e) all hyperbolic central quartics except the equilateral lemniscate. These loci are not to be confused with the pedals themselves, which comprise all QBI quartics and the circle.

Compounded Positive and Negative Tangent Pedals

In the early 18th century, Maclaurin showed that positive and negative pedals of the sinusoidal spirals, 10a,b, about the polar pole could be formed merely by substituting for n, $n_{positive\ pedal} = n/(n+1)$ and $n_{negative\ pedal} = n/(1-n)$. Because of the existence of such a simple device for compounding this line of pedals, the sinusoidal spiral line has been widely quoted and appears to have served as the exclusive example of pedal compounding: for example, the 5th negative pedal of the cardioid is Tschirnhausen's cubic, and the 4th positive pedal of the parabola is the cardioid.

(a) $r^n = a^n \sin(n\theta)$ (b) $r^n = a^n \cos(n\theta)$ (13-10)

Because of its relationship to Tangent-Pedal Taxonomy, a listing of compounded quadratic-based sinusoidal spiral pedals is given in Table XIII-1, in which the positive pedal sequence runs from bottom to top. It will be noted that since $\cos(n\theta) = \cos(-n\theta)$, it follows from 10b that sinusoidal spirals for n and $-n$ always are inversions of one another. For example, the spiral for $n = \frac{1}{2}$ is the cardioid, while for $n = -\frac{1}{2}$ it is the inversion of the cardioid about its cusp, namely the parabola. Similarly, Tschirnhausen's cubic ($n = -1/3$) is the inversion of Cayley's sextic ($n = 1/3$) about the loop vertex, the line ($n = -1$) is the inversion of the circle ($n = 1$) about an incident point, and the equilateral hyperbola ($n = -2$) is the inversion of the equilateral lemniscate ($n = 2$) about the DP. The inverse curves for $n = \frac{1}{4}$ and $n = -\frac{1}{4}$ are given by eqs. 11 and 12, respectively

pedals of sinusoidal spirals

$4a^2(x^2+y^2)(24x^2+24y^2+ax)^2 = [(8x^2+8y^2-ax)^2+a^2(x^2+y^2)]^2$ $n = \frac{1}{4}$ (13-11)

$4(x^2+y^2)(x+24a)^2 = [(x^2+y^2)+(x+8a)^2]^2$ $n = -\frac{1}{4}$ (13-12)

It can be shown readily that the presence of matched pairs of positive and negative values of n in sinusoidal spiral pedal sequences is unique to the two sequences of Table XIII-1, i.e., to the two sequences that contain quadratics. For example, the sequence 13a, that possesses a value, $n = -3$,

Table XIII-1. Compounded Quadratic-Based Sinusoidal-Spiral Pedals

Curve	n	Degree	Curve	n	Degree
_____	2/9	—	_____	1/5	10
_____	2/7	—	Equation 11	1/4	8
_____	2/5	—	Cayley's sextic	1/3	6
_____	2/3	—	Cardioid	1/2	4
Equilateral lemniscate	2	4	Circle	1	2
Equilateral hyperbola	-2	2	Point	∞	0
_____	-2/3	—	Line	-1	1
_____	-2/5	—	Parabola	-1/2	2
_____	-2/7	—	Tschirnhausen's cubic	-1/3	3
_____	-2/9	—	Equation 12	-1/4	4
_____	-2/11	—	_____	-1/5	5

and the sequence 13b, that possesses a value, $n = 3$, contain no such pairs. The values $n = 3/2$ and $n = -3/2$ correspond to the dodecic and sextic of eqs. 14 and 15.

 n sequences for sinusoidal spiral pedals
 that contain values of $n = 3, -3$

(a) $-3/10, -3/7, -3/4, -3, 3/2, 3/5, 3/8, 3/11$,.... (13-13)

(b) $-3/11, -3/8, -3/5, -3/2, 3, 3/4, 3/7, 3/10$,....

$$[2(x^2+y^2)^3-a^3x(x^2-3y^2)]^2 = a^6(x^2+y^2)^3 \qquad \text{dodecic pedal for } n = 3/2 \quad (13\text{-}14)$$

$$[2a^3-x(x^2-3y^2)]^2 = (x^2+y^2)^3 \qquad \text{sextic pedal for } n = -3/2 \quad (13\text{-}15)$$

Tangent-Pedal Taxonomy Versus Compounded
 Positive and Negative Pedals

The program of the taxonomy of any transformation is to arrive at a classification of, or relationships between, curves upon the basis of an examination of the membership of each generation in the transformation chain, where the membership of a given generation is defined as being comprised of the transforms of *all* the members of the previous generation about *all* points in the plane.

On the other hand, compounded positive and negative pedals of sinusoidal spirals inevitably involve only pedals about the highest or second-highest ranking foci of a member curve, because the pole of a polar eq. of the form $r^n = f(\theta)$ always is such a focus. It has been noted above that the pedals of conic sections about high-ranking foci may give "exceptional" curves, in the sense that the degree of these pedals may not be typical of the degree of the general pedal of the generation in which they occur. For example: (a) the focus pedal of the parabola is a line, whereas the general parabola pedal is a cubic; (b) the focus pedal of a central conic is a circle, while the general central conic pedal is a quartic; and (c) the center pedal of the circle is the identical circle, whereas the general circle pedal is a quartic. Accordingly, the chains of positive and negative pedals arrived at employing sinusoidal spirals are not necessarily typical of successive generations of pedals and, thus, are of limited taxonomic utility.

Furthermore, in addition to the above limitation, the sinusoidal spirals are *single-parameter curves*; as such, they do not represent species or genera but merely highly symmetrical, or even the most symmetrical, subspecies of the taxons to which they belong. In the light of these considerations there are at least two good reasons why the pedals of the sinusoidal spirals could fall short of being of representative degree. Though the parabola line is manifestly atypical, that may not be true of the line in which the equilateral hyperbola occurs, the eqs. of the members of which are cast about a true center (see Table XIII-1).

Though the general 2nd-generation quadratic-based pedals have not been studied, some conclusions can be based upon the results incorporated into Table XIII-1. First, it is clear that the tangent-pedal transformation of quadratic-based curves is not ultimately conservative of degree, and that in some cases it even can lead to curves of reduced degree. Second, in addition to including the entire ensemble of QBI cubics and quartics, the quadratic-based pedal superfamily includes an infinite number of taxons of curves with eqs. of all values of even degree, and perhaps also of odd degree--depending upon the nature of successive generations of pedals of the conic inversion cubics. The degree of the eqs. of these generations is, of course, not subject to the limitation imposed on the degree of loci in the sinusoidal spiral pedal lines.

In this connection it should be noted that although the maximum known increase in the degree of a positive pedal to be found in the sequences of Table XIII-1 is 2 units, higher values occur in other sequences. For example, in passing from $n = -3$ to $n = 3/2$ in the sequence 13a, the degree of the corresponding locus progresses from 3 to 12. Contrariwise, in the progression from $n = -3/2$ to $n = 3$ of 13b, the progression is from 6th degree to 6th degree, i.e., no change. The eqs. of the cubic and sextic corresponding to $n = -3$ and $n = 3$ are 16 and 17.

pedals of sinusoidal spirals

$$a^3 + 3x(x^2+y^2) = 4x^3$$ cubic pedal for $n = -3$ (13-16)

$$a^3(x^2+y^2)^3 + 3j^6x(x^2+y^2) = 4j^6x^3$$ sextic pedal for $n = 3$ (13-17)

NORMAL PEDALS OF CONIC SECTIONS

In view of the fascinating systematic relationships between the tangent pedals and the inversions of conic sections, one expects the *normal pedals* or *contrapedals* also to bear some systematic relationship to the loci obtained by some other point transformation of conic sections. Systematic relationships may well exist for the normal pedals but they are not evident.

A brief treatment of the normal pedals is given here but a systematic investigation of their significance is deferred. The normal pedal of a point about a non-incident point is identical to the tangent pedal--a circle with the connecting segment as diameter. The normal pedal of a line or ensemble of lines about either an incident or non-incident point is also a line or lines, compared to a point or points for the tangent pedals. For the parabola and central conics (x-h and y-k translations), the normal pedals about a point in the plane, with the pedal-point at the origin, are eqs. 18 and 19, respectively. These were derived by the appropriate modifications of the derivation outlined above for the normal pedals.

(a) $\quad y^2[(x-h)x+(y-k)y] = ax(x^2+2y^2)$ normal pedals of the parabola about a point in the plane (13-18)

(b) $\quad y^2[(x-h)x+y^2] \quad = ax(x^2+2y^2)$ axial normal pedals of the parabola

(c) $\quad (x^2+y^2)y^2 \quad = ax(x^2+2y^2)$ vertex normal pedal of the parabola

(d) $\quad y^2 = ax$ normal pedal of the parabola about the traditional focus

(a) $\quad (a^2y^2 \mp b^2x^2)[(x-h)x+(y-k)y]^2 = x^2y^2(a^2 \pm b^2)^2$ normal pedals of central conics about a point in the plane (13-19)

(b) $\quad (a^2y^2 \mp b^2x^2)[(x-h)x+y^2]^2 \quad = x^2y^2(a^2 \pm b^2)^2$ axial normal pedals of central conics

(c) $\quad (a^2y^2 \mp b^2x^2)(x^2+y^2)^2 \quad = x^2y^2(a^2 \pm b^2)^2$ central normal pedals of central conics

(d) $\quad (x-h)x + (y-k)y = 0$ normal pedals of the circle about a point in the plane

(d') $\quad (x-h/2)^2 + (y-k/2)^2 = (h^2+k^2)/4$ " " " "

It is evident from eqs. 18 and 19 that the normal pedals of the parabola generally are quartics, and those of central conics generally are sextics. Except for special cases these loci are not QBI curves. In fact, other than such special cases these loci appear to be unknown except in the context of being the normal pedals of conic sections.

[While treatments and eqs. of normal pedals doubtless exist in the literature, they are not to be found in the standard works. It is, however, well known (see Zwikker, 1950) that the normal pedal of a basis curve is the same subspecies as the tangent pedal of the evolute of the basis curve. This is but one of numerous known relationships between elementary point transformations (Salmon, 1879 and 1934; Zwikker, 1950).]

The axial normal pedals of conics are given by 18b and 19b. The vertex normal pedal of the parabola is 18c, while the center normal pedals of central conics are 19c. There is only one condition, each, for the parabola and central conics for which the eqs. of the normal pedals reduce. In the case of the parabola, reduction is for the normal pedal about the traditional focus, for which pedal-point the pedal is a similarly-oriented parabola of ¼ the size, with its vertex at the pedal-point.

For central conics, reduction occurs only for the circle subspecies, for which all of the normal pedals also are circles (eqs. 19d,d'), compared to limacons for the tangent pedals. The pedal circles pass through the pedal-point and are centered at $(h/2,k/2)$. Normal pedals for the circle are the only such pedals for which the degree is lower than that of the corresponding tangent pedals.

Inversions of parabola normal pedals about the pedal-points are the cubics of 20a, while the corresponding inversions for central conics are the quartics of 21a. The inversion of the focus pedal of the parabola ($h = -a$ in 20a), of course, is the cissoid of Diocles, 20b. The inversion of the normal pedal of the parabola about $h = -2a$ (the reflection of the vertex in the focus) is the simple cubic 20c.

(a) $\quad y^2[j^2-ky-(h+2a)x] = ax^3 \quad$ inversions of parabola normal pedals $\qquad (13\text{-}20)$

(b) $\qquad y^2(j^2-ax) = ax^3 \quad$ inversion of parabola normal pedal about the traditional focus ($h = -a$)

(c) $\qquad j^2y^2 = ax^3 \quad$ inversion of parabola normal pedal about $h = -2a$

(a) $(a^2y^2 \mp b^2x^2)(j^2-hx-ky)^2 = x^2y^2(a^2 \pm b^2)^2$ inversions of central conic normal pedals (13-21)

(b) $(a^2y^2 \mp b^2x^2)j^4 = x^2y^2(a^2 \pm b^2)^2$ inversions of normal pedals of central conics about the center

(c) $\dfrac{a^2}{x^2} \mp \dfrac{b^2}{y^2} = \dfrac{(a^2 \pm b^2)^2}{j^4}$ " " "

$\dfrac{a^2}{x^2} \mp \dfrac{b^2}{y^2} = 1$ Bullet-Nose and uni-cursal Cross Curves (13-22)

In the cases of the central conics, the inversions of the normal pedals about the center are eqs. 21b,b'. These are seen to be of the same subspecies as the well-known Bullet-Nose curve, eq. 22 (upper sign), for the hyperbola, and uni-cursal Cross Curve, eq. 22 (lower sign), for the ellipse. For a choice of the unit of linear dimension, $j = (a^2 \pm b^2)^{\frac{1}{2}}$, which is the center-focus distance, the inversion loci are identical to these curves (eqs. 22).

Appearance of Axial Normal Pedals

Axial normal pedals of the parabola are parabola-like curves, interior to the parabola for interior pedal-points and exterior for exterior pedal-points. Only the pedal about the traditional focus is another parabola.

The center normal pedal of an ellipse is a curve that resembles a 4-leaf rose. The latter also is a sextic and there are certain equational similarities between the two curves (compare eqs. 23a,b). Each lobe of the pedal inverts to

(a) $(x^2+y^2)^2(a^2x^2+b^2y^2) = (a^2-b^2)^2x^2y^2$ center normal pedal of ellipse (13-23)

(b) $(x^2+y^2)^2(x^2+y^2) = 4a^2x^2y^2$ 4-leaf rose

one branch of the unicursal Cross Curve. The other interior pedals of an ellipse consist of two ovals, one within the other, sharing a common diameter (major axis). A DP of the two ovals occurs at the center of the ellipse, and the ovals are tangent to one another at the pedal-point.

The center normal pedals of a hyperbola consist of two congruent, opposed, asymptotic, hyperbola-like arms, with vertices at the center. These arms share

the asymptotes of the basis curve, which are *interior* to the center pedal. The vertex pedal of a hyperbola consists of two non-congruent opposed arms, both having a vertex at the pedal-point vertex of the basis hyperbola. One arm is interior to the basis arm, the other is external to both branches and bends over toward the contralateral arm of the basis curve.

PART III AND CHAPTER XIV.

THE HOW AND THE WHY OF CIRCUMPOLAR SYMMETRY

Introduction

In the immediately preceding 9 Chapters the emphasis has been almost entirely on the substantive *what* of circumpolar and circumlinear symmetry. In this final Chapter concern is more with the *how* and the *why*, particularly the *how*. In other words, more emphasis here is given to discussion and clarification of how the operations employed in symmetry and inversion analyses lead to the results that have been obtained.

To start with, it should be pointed out to the reader for whom it may not already be apparent, that the eqs. that have been employed in this work are merely a shorthand way of expressing the underlying geometrical relationships. In theory, each eq., term-by-term, could be replaced by verbal statements of these geometrical relationships, though this procedure soon would lead to greater confusion than enlightenment. It is essential to be fully cognizant of the fact that the underlying geometry is the *sine qua non* of symmetry analyses. To disregard this, and place one's faith in eqs. and computer readout alone, often will lead to misconceptions, confusion, and waste of time. The geometry, itself, always must be foremost in mind and always is the last court of appeal. This, after all, is the principal, if not sole, way in which ancient geometers arrived at their results (with parallelograms, proportions, areal relations, and the like)--results that are staggeringly impressive when considered in the light of the practical tools at their command.

The acceptance of algebraic solutions for imaginary focal loci, complex intercepts about real and imaginary focal loci, and intercept transforms with complex solutions is not a contradiction to the principle of regarding the underlying geometry as the sine qua non of symmetry analyses. These complex algebraic solutions are the shorthand expressions of the underlying geometrical relationships in some complex manifold, as yet undefined.

The ideal way to achieve the goals of this Chapter would be to explain every result in terms of its geometrical elements. That surely would lead to the

fullest awareness and appreciation of the matters at hand. Unfortunately, however desirable, this would be totally impractical, even for real solutions. Of necessity, then, the treatment remains principally in the same mathematical shorthand as employed hereto.

The Circumpolar Symmetry Versus the Inversion Analysis

An appropriate starting point is the topic of the circumpolar symmetry analysis versus the inversion analysis. This comparison already is fairly well in hand. A circumpolar symmetry analysis encompasses the full range from complete specificity of angle-dependent properties of curves--such as when the intercept transform is derived for a specific angle--to complete generality of angle-dependent properties--such as when the α-transform is derived (and the same is true of a circumlinear symmetry analysis). The inversion analysis, on the other hand, takes no explicit account of angle-dependent symmetry properties of curves.

In an inversion, each point on a basis curve transforms to a single point on a transform curve. The points on the transform curve traditionally have been located on lines connecting the reference pole for the inversion to the corresponding points on the basis curve. Whether this convention is adhered to, however, is essentially inconsequential. Inversions at other angles simply yield congruent but correspondingly rotated inversion loci. Only for self-inversion, is specification of the angle of inversion crucial.

An inversion analysis includes determination of all possible transform curves by carrying out the inversions for all possible reference poles. Inversion Taxonomy carries the process further by applying the transformation to the 1st-generation inversion loci, as well, and determining the inversion relations between all of the loci. As a result of the Inversion Taxonomy analysis of QBI curves, it can be predicted with confidence that no curves that are not already represented in the 1st generation result when the 2nd generation is obtained (with the possible exception of the basis curve, i.e., if a parabola is the basis curve it will not appear in the 1st generation but it will appear in the 2nd generation).

In a circumpolar symmetry analysis, on the other hand, one investigates the relationship between distances to pairs of points on a basis curve, specified by an angle of separation of the radii from the reference pole to these points.

In this case, a pair of points on the basis curve transforms to a single point on the transform curve. But the latter is only one of an infinite number of transforms, one corresponding to each of an infinite number of possible angles. As with the inversion analysis, the transformation process is carried out for all possible reference poles.

To what extent can a circumpolar symmetry analysis provide the same information provided by an inversion analysis? One expects neither to get exactly the same information from the two methods nor all of the information from either, because the former analysis involves direct probing of the symmetry of the curve, whereas the latter elucidates the relationships between curves that are derivable from one another by inversion, quite irrespective of the nature of their symmetry.

When a single radius from a pole in the plane intersects a curve at more than one point, the circumpolar symmetry analysis can detect whether positive self-inversion occurs about that pole and can yield the eq. of self-inversion in terms of the parameters of the curve. When two radii through a pole in the plane at 180° to one another intersect a curve at more than one point, the circumpolar symmetry analysis can yield the same information about the negative self-inversion (and similarly for self-inversion at any angle, α, i.e., *α-self-inversion*). This is the essence of one aspect of the informational overlap of the two types of analysis.

[The distinction between the 0° and 180° transforms based upon coincident-radii and chord-segment intercepts (when two positive intercepts exist) is maintained in this Chapter. Accordingly, comparative statements regarding these transforms are to be interpreted in this light. A statement that the 0° and 180° transforms are identical means that an identical transform (for positive intercepts) exists for both coincident radii and chord segments. It is, of course, clear that algebraically complete transform eqs. for 0° and 180° are identical—except for signs—in any event—where all combinations of positive and negative intercepts are represented (see Chapter VII, *Negative Intercepts, Trivial Transforms, the Degree of Transforms, and the Duality of 0° and 180° Transforms*).]

The goal in the following is to compare another aspect of the informational overlap, namely, in the areas of identification of foci and the degree of the transform curves. To this end, the simple intercept eq., 1b, is compared with the inversion locus, 1c, for a limacon basis curve, 1a.

In the case of inversion, eq. 1c gives directly the general eq. of the inversion locus. In the case of the intercept transformation, eq. 1b gives merely

the basis limacon

(a) $(x^2+y^2)^2 + 2bx(x^2+y^2) + (b^2-a^2)x^2 - a^2y^2 = 0$ (14-1)

the simple intercept eq.

(b) $(b+2h)^2x^2\cos^2\theta + 2(b+2h)x^3\cos\theta + 2h[(b+2h)(b+h)-a^2]x\cos\theta \quad + x^4$

the inversion locus

(c) $(b+2h)^2x^2j^4 \quad + 2(b+2h)xj^6 \quad + 2h[(b+2h)(b+h)-a^2]xj^2(x^2+y^2) + j^8$

the translated basis limacon (x+h translation)

(d) $(b+2h)^2x^2 \quad + 2(b+2h)x(x^2+y^2)+ 2h[(b+2h)(b+h)-a^2]x \quad + (x^2+y^2)^2$

(b) $+ [2h(b+h)-a^2]x^2 \quad + h^2[(b+h)^2-a^2] \quad = 0$

(c) $+ [2h(b+h)-a^2]j^4(x^2+y^2) + h^2[(b+h)^2-a^2](x^2+y^2)^2 = 0$

(d) $+ [2h(b+h)-a^2](x^2+y^2) \quad + h^2[(b+h)^2-a^2] \quad = 0$

the starting eq. that specifies all intercepts for all angles of a single radius vector emanating from the pole. To obtain the transform, one must form a second eq. in y and $\theta+\alpha$ (where α is the angle of the transformation) and then eliminate θ between these eqs. The α-transform eq. could be given instead of the simple intercept eq., but it generally would be very complex and there would be little to gain in giving it, because most of the pertinent information is contained in the unmodified simple intercept eq.

To facilitate comparisons, the rectangular eq., 1d, from which the simple intercept eq., 1b, was derived also is given, since in making such a comparison it is easy to overlook the fact that the x^2 of the intercept eq. corresponds to (x^2+y^2) of the rectangular eq., or r^2 of the polar eq. When the eqs. are juxtaposed as in 1b-d, with identical coefficients one above the other, it is clearly evident that the basis eq., 1d, and its inversion locus, 1c, are identical, term for term, except that *some* of the coefficients have been exchanged. The unit of linear dimension, j, apears in the appropriate power to bring the terms of the inversion locus into dimensional balance.

If the nature of the coefficient exchanges is examined, it is found to follow a simple systematic rule. The term of highest degree--$(x^2+y^2)^2$--of the basis

eq. becomes the term of lowest degree--j^8--of the inverse locus (i.e., the coefficients of the terms of degrees 4 and 0 in the variables are exchanged). The term of 2nd-highest degree--$x(x^2+y^2)$--of the basis eq. becomes the term of 2nd-lowest degree--x--of the inverse locus (i.e., the coefficients of 3rd and 1st degree terms are exchanged). Lastly, the terms of 2nd degree in the variables--x^2 and (x^2+y^2)--remain unaltered.

When one considers the fact that the degree of the intercept transform is dependent upon the terms and coefficients thereof in the simple intercept eq., 1b, and that the degree of the ultimate inversion locus (whatever eq. 1c yields when the value of h is specified) is dependent upon the terms and coefficients thereof in the standard form of the inversion locus, 1c, it becomes evident that the relationships (or lack thereof) between the two transform curves hinge upon the nature of the exchanges between the coefficients that occur on inversion, which can be summarized as follows.

1. Both transformations bestow focal rank upon the vertices. For the vertex condition, the 0-degree term of the simple intercept eq. vanishes, allowing an x to be factored out from 1b (i.e., an r from the polar eq.), with a corresponding reduction in degree of the intercept transforms. For the inversion locus the 4th degree term vanishes and the locus becomes a cubic. When the eqs. are cast about a pole in the plane, rather than an axial pole, both transformations confer focal rank on all incident points.

2. Both transformations confer higher rank on the DP or DP homologue than on the vertices. Thus, when $h = 0$, the cubic term also vanishes from the inversion locus, leaving a quadratic eq. Similarly, the 1st-degree term of the simple intercept eq. vanishes (the $\cos\theta$-constant condition) allowing an x^2 to be factored out, with a correspondingly greater reduction in the degree of the intercept transforms.

3. There is no direct relationship at the focal level between any other circumpolar focal properties of the simple intercept eq. and the properties of the inversion transformation and loci. The basis for this lack of relationship is that the other conditions on the simple intercept eq.--that lead to reduction of the degree of the transforms--do not alter the degree of the inversion locus. Thus, the $\cos^2\theta$-condition, which is a powerful focal con-

dition, inasmuch as it eliminates the radical from the simple intercept format, carries only subfocal weight in the inversion locus; it leads only to the vanishing of the x^2 term, leaving the locus (for h = 0) still of 2nd degree. Moreover, both 2nd-degree terms cannot vanish simultaneously; this would require $b^2 = -2a^2$, which is not permitted.

4. There is no direct relationship at the focal level between the potential focal conditions on the simple intercept eq. and the properties of the inversion transformation and inversion loci. Thus, the $\cos\theta-x^2$ condition only leads to the vanishing of a 1st-degree term in the inversion locus; the x^2-condition leads only to the vanishing of the 2nd-degree term in (x^2+y^2); the $\cos\theta$-constant condition carries greater subfocal weight, since it leads to vanishing of the cubic term, but that still leaves the inversion locus of 4th degree.

A parallel analysis between the intercept transformation and the inversion transformation also could be carried out for basis eqs. of higher degree, since the types of relationships disclosed have general validity. This comparison of the significance of the intercept transformation versus the inversion transformation--in relation to circumpolar symmetry--leaves only the matter of the pole of self-inversion untouched. As noted in Chapter XII, this pole must, by definition, have circumpolar focal rank (points in the plane of the circle and incident upon the line are the only exceptions). The treatment in Chapter XII, however, covered the fundamentals of the interrelationships between the intercept transformation about a point and self-inversion about the same point. It only need be repeated here that the intercept transformation defines a pole of axial self-inversion in terms of a condition on the general intercept transform for a point on that axis; for a given angle, α, that value of h for which the axial transform reduces to the equilateral hyperbolic eq., xy = constant, defines the location of a pole of α-*self-inversion*.

Conservation of Focal Loci

The conservative properties of the inversion transformation--as embodied in the statement that "to a focus of any curve corresponds a focus of the inverse curve" (Salmon, 1879 and 1934; Hilton, 1920)--have long been recognized. The

fact that inversion is a conformal mapping, i.e., a mapping that does not change an angle of intersection of segments of curves, also is well known. Indeed, it is quite reasonable to expect that, if a curve has greater symmetry about some specific pole than about neighboring points, the inverse curve, being a conformal mapping, also will have greater symmetry about some corresponding pole.

Classical workers did not resolve the issue of *non-conservation of foci of self-inversion*, i.e., the fact that foci of self-inversion are gained in certain classes of inversion but lost in others. As it happens, the workers who concerned themselves with conservation of foci, such as the British investigators, were not the ones who explored the phenomenon of self-inversion; the latter were almost exclusively French researchers. But as long as the concept of a focus was limited to point loci, the conservation issue was doomed to lie unresolved.

In fact, the gain of foci of self-inversion in certain classes of inversions, but their loss in others, was the clearest early signpost of the existence of a close relationship between a point focus and the symmetry of a curve. In essence, when an indubitable locus of symmetry of a curve, the *line of symmetry*, is lost in an inversion, a focus of self-inversion is gained. But self-inversion through a point at an angle, α, is merely a type of reflective symmetry through the point, namely reciprocal reflective symmetry at the angle α. In other words, one type of locus, in which the curve is reflected in one manner, is "replaced" in the inverse curve by another type of locus, in which the curve is reflected in another manner. Both loci thus bear clear relationships to the symmetry of the curve. [I use quotation marks about "replaced" in the above because a focus of self-inversion is only one of the loci that replace a line of symmetry.]

With broadening of the conception of circumpolar focal loci to include non-point loci, with recognition of the close association of such loci with properties of curves that are subject to precise analysis, and with the ability to identify and enumerate these loci, it has become possible to address and largely resolve the matter of conservation of the circumpolar focal loci of curves under inversion, i.e., of the loci about which curves have exceptional circumpolar symmetry properties.

If one addresses first the question of conservation of circumpolar point foci that are specified by conditions on intercept eqs. and formats, including conditions on coefficients, radicands, and entire eqs., the indications are strong that the number of such foci is conserved. Included in the category under consideration are both real and imaginary foci in the finite plane and at infinity. If one now includes foci of self-inversion, the indications also

are strong that the sum of the number of axial point foci in all categories and the number of orthogonal lines of symmetry is conserved (the latter number is either 0 or 1).

It is only in the domain of linear and curvilinear focal loci that one-to-one correspondences between the basis and inverse curves do not appear to hold. In the case of the loss of one line of symmetry, two covert linear focal loci appear to be gained (together with a focus of self-inversion). One of these--apparently the lower ranking of the two--passes through the DP or DP homologue (including cusps) and is orthogonal to the line of symmetry. The other also is orthogonal to the line of symmetry but generally does not intersect it at the location of a point focus.

In the case of the loss of two lines of symmetry, there is a gain of two low-ranking orthogonal covert focal loci that pass through the DP (and of two foci of self-inversion, one lying on each of these axes). The homologues of the axial foci also appear to lie on these orthogonal axes. On the other hand, there is a gain of only one non-axial covert focal locus. For inversion about a non-incident point in the plane, this locus (for QBI curves) is an equilateral hyperbola with the vertex of one arm at the DP. For inversion about a non-axial point that is incident upon the curve, the locus is linear and passes through the DP, but is discrete from both of the two orthogonal covert linear focal loci that also pass through this pole.

Analytical proof is at hand for the focal character of a point on any of the covert focal loci except those passing through the DP orthogonal to a line of symmetry. The focal character of the former loci is dependent upon the fact that they are defined by the condition for the vanishing of the $\sin\theta\cos\theta$ term of the simple mixed-transcendental intercept eq. On the other hand, deduction of the focal character of the latter loci is purely inferential, based upon the fact that the DP and foci of self-inversion lie upon them.

An analytical proof of the focal character of the latter focal loci would have to be based either upon conditions for simplification of solutions for roots of eqs. of higher than 2nd degree (i.e., conditions analogous to radicand conditions on solutions of quadratic eqs.) or upon conditions on intercept transforms. Conditions on intercept transforms, however, are known to exist only for foci of self-inversion. But if these covert focal loci were to be

specified by conditions on intercept transforms that led to simplification by root taking, their focal rank would be at least doubled. For example, the 0° and 180° transforms for non-incident inversions about a point on these axes might be of only 28th degree rather than the value of 56th degree (see Table XII-2) for unexceptional points in the plane. Until these matters receive further resolution, results relating to the covert focal loci that pass through the DP and are orthogonal to the lines of symmetry of the basis curve remain tentative.

For examples of the relations that hold between focal loci and structural features of basis curves and their inversion loci, I take the equilateral axial QBI subspecies. In the inversion of the equilateral lemniscate to the equilateral hyperbola, two loops open, with the loss of the DP, which is "replaced" by two asymptotes (intersecting at the same angle as that between the DP tangents). In other words, an intersection of two lowest-ranking curvilinear circumpolar focal loci (the segments of the curve that intersect at the DP) is replaced by an intersection of two lowest-ranking covert linear focal loci --the asymptotes (both intersections also occur at a point of intersection of two lines of symmetry).

In the inversion of the equilateral lemniscate to the equilateral strophoid, only one loop opens and only one asymptote is formed. The loss of a vertex focus is offset by the gain of an asymptote-point focus, while the corresponding "loop focus" goes off to infinity. Although a line of symmetry is lost in the inversion, this is offset by 3 gains (see Circumpolar Maxims 11 and 18). First, an axial focus of self-inversion is added. Second, there is the gain of an orthogonal axial covert focal locus (passing through the DP). Third, there is the gain of an orthogonal non-axial covert linear focal locus (passing through the axial point at infinity and orthogonal to the line of symmetry).

In the case of the inversion of the equilateral limacon to the equilateral strophoid, the large loop opens and one asymptote replaces it, with the lost vertex focus being replaced by the asymptote-point focus. The $-\tfrac{1}{2}b$ covert linear focal locus goes off to infinity.

Turning now to non-axial inversions, an equilateral hyperbola inverted about a point in the plane loses two lines of symmetry. At the same time it gains two foci of self-inversion and two covert focal axes (the lines parallel to the

lines of symmetry of the basis curve that pass through the DP of the inverse locus) and an equilateral hyperbolic covert focal locus. In the case of a non-axial but incident inversion, the equilateral hyperbolic covert focal locus is replaced by a linear covert focal locus that passes through the DP but is distinct from the orthogonal focal loci that also pass through it.

[We now are in a position to understand better the relationships of Cayley's sextic and the folium of Descartes to the superfamilies to which they belong. Both of these curves, since their eqs. involve only a single parameter, are to be regarded as highly symmetrical subspecies within their respective super-families--perhaps akin to curves with unit eccentricity in the QBI superfamily, such as the parabola, the cissoid of Diocles, and the cardioid. Their DP inversion quartics may be presumed to belong to the genera that provide the basis curves for the respective superfamilies. Since neither Cayley's sextic nor the folium of Descartes self-inverts, it follows from Circumpolar Maxim 18 that none of their axial inversions possesses a second line of symmetry and, accordingly, none of them possesses a true center--just as, in the QBI super-family, no axial inversion of the parabola self-inverts or possesses a true center. On the other hand, just as there exist species in the QBI superfamily that possess a true center (the hyperbolic and elliptical central conics and central quartics), it is quite likely that there also exist species in the superfamilies under consideration that possess a true center--though this remains to be established.]

 In summary, the following correspondences appear to exist in inversions of hyperbolic QBI curves. In transverse axis inversions, 5 axial foci replace 5 axial foci. Loss of a line of symmetry is accompanied by the gain of a focus of self-inversion and two covert linear focal loci. Loss of two lines of symmetry is accompanied by the gain of two foci of self-inversion, two ortho-gonal covert focal loci passing through the DP, and either an equilateral hyperbolic covert focal locus or a third, distinct, covert linear focal locus that passes through the DP. Corresponding to the opening of a single loop and the loss of a vertex focus, an asymptote and an asymptote-point focus are gained. Corresponding to the opening of two loops and the loss of an inter-section of two low-ranking curvilinear focal loci--the DP--there is a gain of two low-ranking, intersecting covert linear focal loci--the asymptotes.

Complementary Intercept Formats

 The complementary relationships between the simple intercept eq. and the inversion locus that are highlighted by the above analysis also carry over to

the intercept *formats* of the basis curve and its inverse locus. This is revealed most strikingly in highly symmetrical *single-parameter subspecies*, in which the parameters, a and b, are equal. Three examples are given. Eqs. 2a,b,c are the simple intercept formats for the equilateral hyperbola about the vertex, the equilateral strophoid about the loop pole at 2b/3, and Cayley's sextic about the loop vertex, respectively; eqs. 2d,e,f are the simple intercept formats for the inversion loci about the reciprocal poles of inversion, namely, the equilateral strophoid about the DP, the pseudo-ex-change-limacon about the small-loop vertex, and Tschirnhausen's cubic about the "loop focus" (a pole within the loop at 1/9th the axial distance from the loop vertex), respectively. Note that these formats are derivable from one another simply by exchanging a and x.

equilateral hyperbola
 (vertex)

equilateral strophoid
 (double point)

(a) $\cos\theta = \dfrac{a \pm (a^2+2x^2)^{\frac{1}{2}}}{2x}$

(d) $\cos\theta = \dfrac{x \pm (x^2+2a^2)^{\frac{1}{2}}}{2a}$ (14-2)

equilateral strophoid
(loop pole at h = 2b/3)

pseudo-exchange-limacon
 (small-loop vertex)

(b) $\cos\theta = \dfrac{9x^2\pm(81x^4+360a^2x^2-32a^4)^{\frac{1}{2}}}{12ax}$

(e) $\cos\theta = \dfrac{9a^2\pm(81a^4+360a^2x^2-32x^4)^{\frac{1}{2}}}{12ax}$

Cayley's sextic
(small-loop vertex)

Tschirnhausen's cubic
(loop focus)

(c) $\cos\theta = \dfrac{x - 3(a^2x/4)^{1/3}}{a}$

(f) $\cos\theta = \dfrac{a - 3(ax^2/4)^{1/3}}{x}$

90° Transforms of Greater Than Double the
 Degree of 0° Transforms

*Transforms About the Double-Foci of Intersection
 of Mutually-Inverting Quartic Circles*

There are no hard and fast general rules regarding relationships between the degrees of transforms for different transformation angles. However, in the case where the simple intercept format contains a square-root radical in the variable, the degree of the 0° and 180° transforms typically is 2 units

less than half that of the 90° transform, i.e., the degrees stand in the ratio, degree$_{90^\circ}$/degree$_{0^\circ,180^\circ}$ = $2(n+2)/n$.

Two factors lead to the above-described relationship. The first is that an additional squaring is necessary to eliminate radicals in deriving the 90° transform, compared to the number of squarings needed to eliminate them for the 0° and 180° transforms. This has the effect of doubling the degree of the former transform compared to that for the latter transforms. The relationship is altered, however, by a second factor. Under these conditions, a term in $(x\mp y)^2$ factors out from the algebraically complete 0° and 180° transform eqs., reducing their degree by two units, without a comparable reduction occurring in the corresponding 90° transform. The basis for this difference between the algebraically complete transform eqs. is that trivial transforms, $x=y$ (two positive intercepts for the 0° transform) and $x=-y$ (one positive and one negative intercept for the 180° transform), exist for 0° and 180° transformation angles but do not exist for non-incident poles for the 90° angle.

[Terms representing trivial transforms, such as $x^n y^n$ and $(x\pm y)^n$ frequently factor from α-transforms about incident poles. In these cases, one or both intercepts are 0.]

The manner in which the 0° and 180° transform terms cancel one another and combine to permit factoring out an $(x\mp y)^2$ is diverse. Two methods are illustrated here based upon the generalized simple intercept format for mutually-inverting quartic circles about the double-foci of self-inversion, considered in Chapter XII (*Quartic Circles*).

The simple intercept format for the double-foci of intersection is eq. 3. This leads to 2nd degree eqs. of ellipses, XII-40a,b,b', for the 0° and 180° transforms but to a complex 8th degree eq. (XII-41) for the 90° transform. This comes about in the following manner. After performing the second squaring of the terms of eq. 4, in order to eliminate the cross-product radicals from the first squaring--in the process of obtaining the 0° and 180° transforms--a term

$$\cos\theta = \frac{-A^4 x \pm (4B^{10}-C^8 x^2)^{\frac{1}{2}}}{2D^5}$$

simple intercept format for the double-foci of intersection of mutually-inverting quartic circles
(14-3)

$$\frac{-A^4 x \pm (4B^{10}-C^8 x^2)^{\frac{1}{2}}}{2D^5} = \frac{-A^4 x \pm (4B^{10}-C^8 y^2)^{\frac{1}{2}}}{2D^5}$$

first step in the derivation of 0° and 180° transforms for the format of eq. 3
(14-4)

$64B^{20}$ is produced on both sides of the equal sign (these are the only constant terms in the eq). The cancellation of these terms is one of the conditions that allows a term in $(x\mp y)^2$, representing the trivial 0° and 180° transforms to be factored out from the eq., reducing the degree from 4 to 2.

If an x occurs in the denominator of the format of eq. 3, there will be no constant terms after the second squaring, and the origin of the factorable terms, $(x\mp y)^2$, takes a different course. The terms that otherwise were identical and cancelled one another after the second squaring become, instead, $16B^{20}(x^2+y^2)^2$ on the left, and $64B^{20}x^2y^2$ on the right. Although these terms no longer cancel one another, in combination they still allow a term in $(x\mp y)^2$ to be factored out. Because this is a basic symmetry relationship that occurs repeatedly in the derivation of many intercept transforms (including the present example), it is illustrated further by eqs. 5.

(a) $C^{16}(x^2+y^2)^2 =$

$\quad\quad (x\mp y)^2 f(x,y)+4C^{16}x^2y^2$

rightmost term in x^2y^2 is twice the cross-product of leftmost term in $(x^2+y^2)^2$

(14-5)

(b) $C^{16}(x^2-y^2)^2 = (x\mp y)^2 f(x,y)$

rightmost and leftmost terms of 5a combine to give term in $(x^2-y^2)^2$

(c) $C^{16}(x\pm y)^2 = f(x,y)$

5b with $(x\mp y)^2$ factored out

Referring to eqs. 5, it is a typical occurrence in circumpolar symmetry analyses that a term emerges (rightmost term of 5a) in a derivation of a transform that is exactly twice the cross-product (internal product) of another term that occurs as the square of a sum (5a, left side). Combining these terms leads to a single term which is the square of the difference (5b, left side). It now is possible to factor $(x+y)^2$ or $(x-y)^2$, leading to 5c, the degree of which is reduced by two units.

Returning to the central illustration of the reduction of the 0° and 180° transforms from 4th to 2nd degree, a second condition that leads to the presence of a factorable $(x\mp y)^2$ term is precisely that illustrated in eqs. 5. After the final squaring and cancellation of the constant terms, there are still 4 terms in the transform (of a total of 7) from which an $(x\mp y)^2$ will not factor. The first of these is the left member and the second the rightmost

member of 5a. But these two terms combine as illustrated in eqs. 5, allowing and $(x\mp y)^2$ term to be factored out, yielding the left term of 5c.

This circumstance always prevails when the radicand of the simple intercept format possesses a term in x^2, because the term on the right in x^2y^2 always has a coefficient four times as great as the term on the left in $(x^2+y^2)^2$. That is the basis for the frequent combining of terms in this manner. Thus, the first squaring of the sum or difference of the radicals (say, a+b) produces a 2 in the cross-product $(a^2+2ab+b^2)$. The cross-product now is the only term in the eq. involving radicals. After segregating it on the right side and squaring again, the 2 yields a 4. This becomes a multiplicative component of the product of the x^2 and y^2 terms in the radicands which, accordingly, is twice as great as the cross-product term of the square of their sum, $(x^2+y^2)^2$, on the left side.

The last two of the original 6 terms in the 9-term transform that would have prevented factoring out a term in $(x\mp y)^2$, like the first two, are two identical terms, $-16B^{10}C^8(x^2+y^2)$. This term arises on the right as the cross-product of the coefficients of the radicals times the cross-product of the radicands. On the left it also arises as the cross-product of two terms that had their origin in the radicand. Upon their cancellation, the $(x\mp y)^2$ term can be factored out.

*Transforms About the True Center of Mutually-
 Inverting Quartic Circles*

A second example of the origin of $0°$ and $180°$ transforms of less than half the degree of the $90°$ transform employs the simple intercept format for mutually-inverting quartic circles about the true center. Though the $90°$ transform is of 6th degree, the $0°$ and $180°$ transforms are only of 2nd degree, and a linear $180°$ transform also exists. In this case, the generalized simple intercept format (left member of eq. 6) is in the $\cos^2\theta$ form. This means that both the $0°$ and $180°$ transforms are obtained merely by equating the format in x to the identical format in y (eq. 6), since $\cos^2\theta = \cos^2(\theta+0°) = \cos^2(\theta+180°)$. As in the example above, the denominators cancel, except for the x^2 and y^2 portions.

$$\cos^2\theta = \frac{A^4x^4+E^6x^2+D^8}{F^6x^2} = \frac{A^4y^4+E^6y^2+D^8}{F^6y^2}$$

first step in derivation of $0°$ and $180°$ transforms about the true center of mutually-inverting quartic circles (14-6)

(a) $-A^4x^4y^2-D^8y^2-E^6x^2y^2 = -A^4x^4y^2-D^8x^2-E^6x^2y^2$ eq. 6 cleared of (14-7)
fractions

(b) $A^4(y^2-x^2)x^2y^2 - D^8(y^2-x^2) = 0$ eq. 7a after cancellation
of terms

(c) $A^4x^2y^2 = D^8$ eq. 7b after factoring out (y^2-x^2)

(d) $xy = \pm D^4/A^2$ 0° and 180° intercept transforms

Clearing of fractions yields eq. 7a. The key condition for reduction from 6th degree to 2nd degree is the cancellation of the rightmost term on each side of the eq., leading to 7b. The (y^2-x^2) terms now factor out, yielding 7c, the square root of which is 7d. The factored term, (y^2-x^2), equated to 0 yields the eqs. $x = \pm y$. The upper alternate sign yields both the valid 180° transform and the trivial 0° transform, while the lower alternate sign yields the trivial 180° transform and the valid 0° transform for one positive and one negative intercept. The positive self-inversion root, 7d, represents the valid 0° and 180° transforms. The negative root, of course, gives the equivalent valid transforms for one positive and one negative intercept.

It is evident that the crucial condition for the root reduction is the occurrence of a term in x^2 in both the numerator and denominator of the format; by virtue of this, when the simple intercept formats in x and y are cross-multiplied, the x^2y^2 terms of the cross-products cancel. The factoring of the terms in (y^2-x^2) occurs regardless of the nature of the terms in the numerator, so that reduction from 6th to 4th degree is inevitable. The reduction from the 4th degree eq. to the 2nd degree eq. of self-inversion, however, is dependent upon the nature of the remaining terms. Reduction of an eq. containing an x^2y^2 term can occur in several ways, but there are few ways for it to occur with a resultant eq. of self-inversion of the form $xy = $ constant. In this case, the x^2y^2 term was the only remaining term in the variables, so that the root led directly to the transform of self-inversion.

Transforms of Pseudo-Exchange-Limacons
About the Double Point

In this example, the derivation of the 0° and 180° transforms of a pseudo-exchange-limacon about the DP is followed in detail. First, the eq. of a pseudo-exchange-limacon, 8a, is derived by inverting a hyperbola vertex cubic

about the loop pole at $2b/3$. The unit of linear dimension, j, then is taken to be equal to the loop axis length, b, and the eq. is recast about the DP at $-3b/2$. This leads to the simple intercept eq. 8b, and the simple intercept format, 8c. Now the numerical coefficients are replaced with the capital letters, A, B, C, and D, which are dimensionless, yielding 8d.

(a) $j^6x+j^4bx^2+j^4(a+2b/3)y^2 = 4b^3(x^2+y^2)^2/27$ pseudo-exchange-limacon (14-8)

(b) $b(a+b)\cos^2\theta-(8bx/9)\cos\theta+4x^2/27-ab = 0$ simple intercept eq. for 8a cast about DP at $x = -3b/2$

(c) $\cos\theta = \dfrac{4bx\pm[16b^2x^2-12bx^2(a+b)+81ab^2(a+b)]^{\frac{1}{2}}}{9b(a+b)}$ simple intercept format of 8b

(d) $\cos\theta = \dfrac{Abx\pm[Ab^2x^2-bCx^2(a+b)+ab^2B(a+b)]^{\frac{1}{2}}}{bD(a+b)}$ 8c with numerical coefficients replaced

(a) $\dfrac{Abx\pm[A^2b^2x^2-Cbx^2(a+b)+ab^2B(a+b)]^{\frac{1}{2}}}{bD(a+b)} =$ first step in derivation (14-9) of $0°$ and $180°$ transforms of 8d

$\dfrac{Aby\pm[A^2b^2y^2-bCy^2(a+b)+ab^2B(a+b)]^{\frac{1}{2}}}{\pm bD(a+b)}$

(b) $Ab(y\mp x) = \pm[A^2b^2y^2-bCy^2(a+b)+ab^2B(a+b)]^{\frac{1}{2}} \pm$ 9a after cancellation of denominators and regrouping

$[A^2b^2x^2-bCx^2(a+b)+ab^2B(a+b)]^{\frac{1}{2}}$

(c) $A^2b^2(y\mp x)^2 = A^2b^2(x^2+y^2)+2ab^2B(a+b) -$ 9b after squaring both sides and regrouping

$bC(a+b)(x^2+y^2)-2[X]^{\frac{1}{2}}[Y]^{\frac{1}{2}}$

(d) $\mp A^2b^2xy-ab^2B(a+b)+(C/2)b(a+b)(x^2+y^2) = -[X]^{\frac{1}{2}}[Y]^{\frac{1}{2}}$ 9c after cancellations and regrouping

(e) $A^4b^4x^2y^2+(C^2/4)b^2(a+b)^2(x^2+y^2)^2+a^2b^4B^2(a+b)^2 -$ 9d squared

$ab^3BC(a+b)^2(x^2+y^2) \pm 2aA^2b^4B(a+b)xy \mp$

$A^2b^3C(a+b)xy(x^2+y^2) = A^4b^4x^2y^2+b^2C^2(a+b)^2x^2y^2 +$

$a^2b^4B^2(a+b)^2 - ab^3BC(a+b)^2(x^2+y^2) +$

$aA^2b^4B(a+b)(x^2+y^2) - 2A^2b^3C(a+b)x^2y^2$

(f) $(C^2/4)b^2(a+b)^2(x^2-y^2)^2 - aA^2b^4B(a+b)(x\mp y)^2 \mp$
$$A^2b^3C(a+b)xy(x\mp y)^2 = 0$$

9e after cancellations, (14-9) combinations, and regrouping

(g) $(C^2/4)(a+b)(x\pm y)^2 \mp A^2bCxy = aA^2b^2B$

9f after factoring out $(a+b)b^2(x\mp y)^2$

(h) $3(a+b)(x\pm y)^2 \mp 16bxy = 108ab^2$

9g with numerical coefficients restored

(i) $x \pm y = 9a$

9h for $b = 3a$ (the $e = 2$ limacon)

The format for $\cos\theta$ in the variable x now is equated to the format for $\pm\cos\theta$, with x replaced by y, giving eq. 9a as the first step in the derivation of the $0°$ and $180°$ transforms. Cancelling the denominators and regrouping yields 9b. Squaring both sides and regrouping gives 9c (with the radicands replaced by the symbols [X] and [Y]). Cancelling $A^2b^2(x^2+y^2)$ from the leftmost two terms and rearranging gives 9d, which squared yields 9e. The first two terms on each side now cancel, while the second two terms combine as discussed above (5a,b). The third and fourth terms also cancel, while the fifth term on the right provides the $2xy$ cross-product for the fifth term on the left, converting the (x^2+y^2) term to $(x\mp y)^2$.

In the case of the sixth terms, the $-2x^2y^2$ term on the right provides the cross product for the $xy(x^2+y^2)$ term on the left, yielding a resultant in $\mp xy(x\mp y)^2$. The resulting eq. is 9f. One now factors out $(a+b)b^2(x\mp y)^2$, which represents the trivial $0°$ and $180°$ transforms, $x = \pm y$. This leaves the transform 9g. Restoring the numerical values of the coefficients gives 9h. These transforms already have been discussed (see eq. XII-20c).

For $b = 3a$, the basis vertex cubic is the trisectrix of Maclaurin. For this subspecies, the pseudo-exchange-limacon intersects both true exchange-limacons and limacons; it is the $e = 2$ limacon. The latter is the curve of demarcation between true exchange-limacons with 4 and 6 axial foci (Table VIII-1). For the $e = 2$ limacon, the $0°$ and $180°$ transforms, 9h, now reduce to the linear eqs. 9i.

Despite the many cancellations, combinations, and reductions leading to the $0°$ and $180°$ transforms, and many cancellations and combinations en route to the corresponding $90°$ transforms, the latter do not reduce from 8th degree.

180° Transforms About a Point On the Line
of Symmetry of Limacons

The $0°$ and $180°$ transforms of all axial QBI quartics about a point on the
line of symmetry reduce from an expected 12th degree to 10th degree (compared
to 56th degree for a non-incident, non-axial point in the plane). This is
illustrated for the $180°$ transform of limacons. The substitutions of eq. 10a
are made to simplify the $\cos\theta$ format. To obtain the $180°$ transform, one now
equates the $\cos\theta$ format as a function of x to the $-\cos\theta$ format as a function
of y, yielding 10b. Note that two additional squarings without reduction
would lead to an eq. of 12th degree.

(a) $\cos\theta = \dfrac{ah^2-A(x^2+B^2)\pm a(Abx^2+C^2h^2)^{\frac{1}{2}}}{A^2x} =$ equation defining (14-10)
 simplifying substi-
 tutions

$$\dfrac{a^2h-(b+2h)(x^2+h^2+bh)\pm a[b(b+2h)x^2+h^2(a^2-2bh-b^2)]^{\frac{1}{2}}}{x(b+2h)^2}$$

(b) $(a^2h-Axy-AB^2)(x+y) = \mp ay(Abx^2+C^2h^2)^{\frac{1}{2}}$ starting equation
 for derivation of
 $\mp ax(Aby^2+C^2h^2)^{\frac{1}{2}}$ 180° transforms

(c) $2a^2Abx^2y^2+a^2C^2h^2(x^2+y^2)+a^2xy[X]^{\frac{1}{2}}[Y]^{\frac{1}{2}}\cdot 2$ right terms of 10b
 after squaring

(d) $4a^4A^2b^2x^4y^4+4a^4AbC^2h^2x^2y^2(x^2+y^2) +$ square of two left
 terms of 10c
 $a^4C^4h^4(x^2+y^2)^2$

(e) $4a^4A^2b^2x^4y^4+4a^4AbC^2h^2x^2y^2(x^2+y^2) +$ square of cross-
 product of radicals
 $4a^4C^4h^4x^2y^2$ of 10c

(f) $a^4C^4h^4(x^2-y^2)^2 = a^4C^4h^4(x-y)^2(x+y)^2$ combination of rightmost terms
 of 10d,e after transferring
 term from 10e to left side

The processes leading to reduction now can be described almost independently
of the product on the left side of 10b. In the first squaring, the radicals on
the right yield two terms and a cross-product of the radicals, 10c. The two
terms are transferred to the left side without any cancellations, to leave the

radical cross-product alone on the right. In the second squaring the two terms transferred to the left give rise to two pure square terms plus a cross-product term, 10d, on the left, all of which are of purely radical origin. Meanwhile, the square of the radical cross-product term on the right yields 10e. The first two terms of 10d,e now cancel one another, while the third term of 10e, brought over to the left side, converts the last term of 10d to 10f.

Through the course of these operations, the original product on the left of 10b has yielded squares and cross-product terms with the terms transferred from the right. All of these derivative terms possess a multiplicative component, $(x+y)^2$. With the cancellations and combinations of 10d and 10e to yield 10f, it becomes possible to factor a term, $(x+y)^2$, the trivial 180° transform, yielding a reduction of the 180° axial transform from 12th to 10th degree (see below for the complete general solution; *General Circumpolar Symmetry Analysis of Axial QBI Curves*).

The above-described reduction of the 180° transform from 12th to 10th degree through the factoring out of a term in $(x+y)^2$ is characteristic of the format of eq. 11, and is the minimum amount of reduction that will occur. If

$$\cos\theta = \frac{D^3 - Ex^2 \pm (F^4x^2+G^6)^{\frac{1}{2}}}{H^2x} \qquad \text{general form of format 10a} \qquad (14\text{-}11)$$

one takes the resultant 180° axial transform and substitutes values of h corresponding to the locations of axial poles of focal rank, one obtains the corresponding 180° transforms for the axial point foci. In the case of the variable focus at $h = -\frac{1}{2}b$ (for which the denominator of the format vanishes), it is necessary to return to the simple intercept eq., X-12a.

90° Transforms of the Equilateral Strophoid
About the Double Point

These examples could be multiplied manifold, as it always is possible to work back from the point of occurrence of a reduction of the degree of a transform to the characteristic properties of the simple intercept format or simple intercept eq., or even to the specific geometry of the curve, that lead to the occurrence of the reduction.

As an example of the mode of reduction of a 90° transform, I take the quite simple case of the equilateral strophoid transformed about its DP. The $\cos\theta$

simple intercept format is eq. 12a and the $\sin\theta$ format is 12a', where $\sin\theta =$ $-\cos(\theta+90^\circ)$. The 90° transform is obtained by forming the eq., $\sin^2\theta+\cos^2\theta = 1$, given by 12b. After completing the squaring, clearing of fractions, and combining terms, 12c is obtained. At this point the constant terms, $4a^2$, on

simple intercept formats for the equilateral strophoid cast about the DP

(a) $\cos\theta = \dfrac{x \pm (x^2+2a^2)^{\frac{1}{2}}}{2a}$ (a') $\sin\theta = \dfrac{y \pm (y^2+2a^2)^{\frac{1}{2}}}{-2a}$ (14-12)

(b) $[x\pm(x^2+2a^2)^{\frac{1}{2}}]^2/4a^2 + [y\pm(y^2+2a^2)^{\frac{1}{2}}]^2/4a^2 = 1$ sum of squares of 12a equated to 1

(c) $2(x^2+y^2)\pm2x(x^2+2a^2)^{\frac{1}{2}}\pm2y(y^2+2a^2)^{\frac{1}{2}}+4a^2 = 4a^2$ 12b after squaring, clearing of fractions and combining terms

(d) $(x^2+y^2)^2 = 2a^2(x^2+y^2)+(x^4+y^4)+2xy(x^2+2a^2)^{\frac{1}{2}}(y^2+2a^2)^{\frac{1}{2}}$ 12c after cancellations, segregation & squaring

(e) $2x^2y^2-2a^2(x^2+y^2) = 2xy(x^2+2a^2)^{\frac{1}{2}}(y^2+2a^2)^{\frac{1}{2}}$ 12d after combination and segregation

(f) $x^4y^4-2a^2x^2y^2(x^2+y^2)+a^4(x^2+y^2)^2 = x^4y^4+4a^4x^2y^2+2a^2x^2y^2(x^2+y^2)$ 12e after squaring

(g) $a^2(x^2-y^2)^2 = 4x^2y^2(x^2+y^2)$ 12f after cancellations, combinations, and factoring out a^2

$8a^2(n-2)x^2y^2(x^2+y^2) + 4a^4(n^2-4)x^2y^2 + n^4a^8 +$
$4a^4(n-1)^2(x^2+y^2)^2 + 4a^6n^2(n-1)(x^2+y^2)$ equivalent of 12g without cancellation of $4a^2$ terms of 12c (14-13)

the right and left cancel one another. Segregating the radicals on the right and squaring again gives 12d. Combining the (x^4+y^4) term with the $(x^2+y^2)^2$ term and segregating leads to 12e. Squaring again gives 12f. The x^4y^4 terms now cancel (this is the reduction cancellation), the $4a^4x^2y^2$ term converts $a^4(x^2+y^2)^2$ to $a^4(x^2-y^2)^2$, the $2a^2x^2y^2(x^2+y^2)$ terms combine, and a term in a^2 factors out, yielding the 6th degree transform 12g.

Cancellation of the $4a^2$ terms of 12c is not focal because the transforms are of 6th degree in any event. But the subfocal influence of the cancellation is extensive; in its absence the 90° transform is 13, where n is the coefficient of the remaining a^2 term on the left of 12c.

Inversion Loci With Reciprocal Intercept Formats

An unusual case now is considered of a simple intercept format that is the reciprocal of the format of the inverse curve about the reciprocal inversion pole. The $\cos\theta$ simple intercept format for the cissoid of Diocles about the focus at $x = -a$ (the homologue of the variable focus of the central conic axial vertex cubics) has the highly unusual form, 14a, in which the numerator and denominator are identical but with the parameter and variable interchanged.

(a) $\quad \cos\theta = \dfrac{a(a^2+3x^2)}{x(x^2+3a^2)}$
 simple intercept format of the cissoid of Diocles about the $-a$ focus \qquad (14-14)

(b) $\quad \cos\theta = \dfrac{x(x^2+3a^2)}{a(a^2+3x^2)}$
 simple intercept format of the $-a$ focal-inversion quartic of the cissoid of Diocles about the reciprocal inversion pole

(c) $\quad \sin^2\theta = (1-\cos^2\theta)[\text{numerator only}] = x^2(3a^2+x^2)^2 - a^2(a^2+3x^2)^2 =$

$\quad (x^6-a^6) - 3a^2x^2(x^2-a^2) = x^6 - 3x^4a^2 + 3x^2a^4 - a^6 = (x^2-a^2)^3$

(d) $\quad \sin^2\theta = \dfrac{(x^2-a^2)}{x^2(3a^2+x^2)}$ \quad 14a in $\sin^2\theta$ form \qquad (e) $\quad \sin^2\theta = \dfrac{(a^2-x^2)}{a^2(3x^2+a^2)}$ \quad 14b in $\sin^2\theta$ form

At the beginning of this Chapter it was pointed out that the simple intercept format of the inverse of a *single-parameter curve* about a given pole is the same as that of the inverse curve about the same pole but with the variables and the parameter exchanged (with $j = a$). Accordingly, the format of the *-a focal-inversion quartic* of the cissoid of Diocles about the reciprocal inversion pole is 14b, the reciprocal of 14a. Additionally, as discussed below (*Symmetry Mimics*), possession of $\cos\theta$ formats that are the inverse of one another leads to the possession of the same $0°$ and the same $180°$ intercept transforms, which makes the -a focal-inversion quartic a *symmetry mimic* of the basis curve about the -a focus.

Unusual symmetry relationships such as these appear to go hand in hand with the high symmetry of single-parameter curves, such as the axial inversion loci of QBI curves of eccentricity 1. Another unusual feature of the format, 14a, is that the equivalent format for the $\sin^2\theta$ is a perfect cube in the numerator, 14c. The $\sin^2\theta$ formats stand merely in the *exchange* relationship, 14d,e.

General Circumpolar Symmetry Analysis of Axial QBI Curves

Focal and Potential Focal Conditions On Simple
 Intercept Equations and Formats

The simple intercept eq. for a point on the line of symmetry of all axial QBI curves can be cast in the general form of eq. 15a. The coefficients, M^3, N^4, P^2, Q, R^3, and S^5, correspond to previously designated focal and potential focal conditions as listed in 15b, where the parenthetical abbreviations are those that are applied in the following.

simple intercept eq. for all axial QBI curves

(a) $$M^3x^2\cos^2\theta + (N^4+P^2x^2)x\cos\theta + Qx^4 + R^3x^2 + S^5 = 0 \qquad (14\text{-}15)$$

	focal and potential focal conditions		abbreviation
(b)	M^3 =	$\cos^2\theta$-condition	= $(\cos^2\theta\text{-}C)$
	N^4 =	$\cos\theta$-constant condition	= $(\cos\theta\text{-}cC)$
	P^2 =	$\cos\theta\text{-}x^2$ condition	= $(\cos\theta\text{-}x^2C)$
	Q =	x^4-condition	= $(x^4\text{-}C)$
	R^3 =	x^2-condition	= $(x^2\text{-}C)$
	S^5 =	constant-condition	= (cC)

[Although the term *axial QBI curves* is used to refer to conic sections and all curves derived by inverting them about points on the major and transverse axes (and the line of symmetry of the parabola), the general form of eq. 15a applies to all line-of-symmetry inversions of all conic sections and, accordingly, to all QBI curves with a line of symmetry.]

The designations *simple* and *compound*, as applied to focal and potential focal conditions, are used in the following to differentiate between situations where a single condition applies, as opposed to situations in which at least two conditions apply. In the interests of simplicity, the term *focal condition* is used to refer to both focal and potential focal conditions. The exponents of the coefficients indicate dimensions, i.e., the exponent of M^3 designates that M^3 has the dimension of distance cubed; it does not signify that M itself is cubed. On the other hand, the exponent of M^6 signifies both that M^3 is squared and that the coefficient has the dimension of distance to the 6th power.

The simple intercept format derived from eq. 15a is eq. 16a. In 16b the conditions for the simplification of the format are listed together with the simple and compound focal conditions on the simple intercept eq. to which they correspond.

(a) $\cos\theta = \dfrac{-(N^4+P^2x^2) \pm [(P^4-4M^3Q)x^4+(2N^4P^2-4M^3R^3)x^2+(N^8-4M^3S^5)]^{\frac{1}{2}}}{2M^3x}$ (14-16)

(b) format conditions simple intercept equation conditions

1. external-(cC) $= N^4$ $= (\cos\theta-cC)$

2. external-$(x^2$-C) $= P^2$ $= (\cos\theta-x^2C)$

3. radicand-$(x^4$-C) $= (P^4-4M^3Q)$ $= (\cos\theta-x^2C)^2 - 4(\cos^2\theta-C)(x^4-C)$

4. radicand-$(x^2$-C) $= (2N^4P^2-4M^3R^3)$ $= 2(\cos\theta-cC)(\cos\theta-x^2C)-4(\cos^2\theta-C)(x^2-C)$

5. radicand-(cC) $= (N^8-4M^3S^5)$ $= (\cos\theta-cC)^2 - 4(\cos^2\theta-C)(cC)$

6. denominator-(x-C) $= M^3$ $= (\cos^2\theta-C)$

The ultimate degree of intercept transforms, whether circumpolar or circumlinear, is determined by the properties of the corresponding simple intercept format which, in turn, are determined by the properties of the corresponding simple intercept eq. The objective in this section is to derive the intercept transforms in terms of the conditions on the simple intercept format and ascertain therefrom whether any new focal conditions arise as a result of intercept transform conditions. Such conditions ultimately are expressible in terms of the intercept-eq. conditions so that, once known, it becomes possible to ascertain the ultimate degree of a transform by examination of the coefficients of the simple intercept eq.

In order to simplify the representation of the intercept transforms the coefficients of the simple intercept format are reassigned as in eq. 17a, with the new assignments listed in 17b. Eq. 17a is the general simple intercept format for a point on the line of symmetry of all axial QBI curves.

(a) $\cos\theta = \dfrac{Ax^2 + B^3 \pm (C^2x^4+D^4x^2+E^6)^{\frac{1}{2}}}{F^2x}$ (14-17)

(b) $A = -P^2$ $C^2 = (P^4-4M^3Q)$ $E^6 = (N^8-4M^3S^5)$

 $B^3 = -N^4$ $D^4 = (2N^4P^2-4M^3R^3)$ $F^2 = 2M^3$

Before proceeding to an examination of the transforms, I review the specific properties of the corresponding simple intercept formats for points on the lines of symmetry of conics, conic axial vertex cubics, and limacons. For conics, both A and C^2 vanish, so there is no external term in x^2 and no term in x^4 in the radicand. For conic axial vertex cubics, all terms are present, but $A^2 = C^2$. Reference to 16b and 17b reveals that this is equivalent to the compound condition 18a, which holds only if either the coefficient of the $\cos^2\theta$ term or the x^4 term of the simple intercept eq. vanishes. The former condition defines specific foci for all axial QBI curves, whereas the latter (absence of an x^4 term in the simple axial intercept eq.) is a generic condition that holds for all axial vertex cubics (in fact, this is true of the simple intercept eq. of any cubic; see Maxim 37).

In the case of limacons, $C^2 = P^4 - 4M^3Q = 0$, i.e., there is no x^4 term in the radicand. Reference to 16b, No. 3, reveals that this corresponds to condition

(a) $(\cos\theta - x^2 C)^2 = (\cos\theta - x^2 C)^2 - 4(\cos^2\theta - C)(x^4 - C)$　　　　　(14-18)

(b) $(\cos\theta - x^2 C)^2 = 4(\cos^2\theta - C)(x^4 - C)$

(c) $[2(b+2h)]^2 = 4(b+2h)^2 \cdot 1$

(d) $\{2b^2[2H(h^2 - a^2) + hj^2]\}^2 = 4[4b^2(h^2 - a^2)H^2 + 4b^2 hj^2 H + j^4(b^2 \pm a^2)]b^2(h^2 - a^2)$

18b, which translates to 18c, which holds for all h and, hence, all points on the line of symmetry of limacons. If this condition is tested in eq. XII-12 for all axial QBI cubics and quartics derived by axial inversions of central conics, it is confirmed that it holds only in the genus, limacons. It is, however, only subfocal for general axial transforms of limacons, because the degree of $0°$, $90°$, and $180°$ general intercept transforms for a point on the line of symmetry of limacons is the same as that for all axial QBI quartics. It carries focal weight only for the variable focus at $(a^2 - b^2)/2b$.

Accordingly, each of the three most highly symmetrical genera of axial QBI curves possesses a distinctive property of its simple intercept eq. or format for a point on its line(s) of symmetry. Insofar as the general circumpolar intercept transforms for points on these focal loci are concerned, the condition for conics, $A^2 = C^2 = 0$, confers the highest degree of symmetry, that for conic axial vertex cubics, $A^2 = C^2 \neq 0$, confers the next-highest degree of

symmetry, while that for limacons, $C^2 = 0$, has the least influence on the degree of symmetry of the basis genus. Regarding the degrees of the general axial transforms, it is shown below that the values for the 3 genera (conics, vertex cubics and limacons, respectively) are 4, 8, and 10 for the 0° and 180° transforms, and 16, 22, and 24 for the 90° transforms. The corresponding values for other genera in the superfamily are 10 and 24, the same as for limacons.

0° and 180° Transforms

The general 0° (upper alternate signs) and 180° transforms for a point on a line of symmetry of an axial QBI curve are given by eq. 19, which is of 10th degree, confirming that the limacon transform is unexceptional. The reduction of this transform from 12th degree occurred by the factoring out of a term in $(x \mp y)^2$, which, equated to 0, yields the trivial 0° and 180° transforms. All generic and subspecific focal conditions for the reduction of this general transform, as well as reduction conditions for determining individual point foci, can be deduced through detailed examination. Some salient features are covered here.

polynomial terms of equation — degree

$$x^4 y^4 [A^4(x \mp y)^2 - 2A^2 C^2(x^2+y^2) + C^4(x \pm y)^2] + \qquad \text{10th} \qquad (14\text{-}19)$$

$$4Ax^3 y^3 [\pm B^3 C^2(x^2+y^2) \mp A^2 B^3(x \mp y)^2 - AD^4 xy] + \qquad \text{8th}$$

$$2x^2 y^2 [3A^2 B^6(x \mp y)^2 - (A^2 E^6 + B^6 C^2)(x^2+y^2) \pm 4AB^3 D^4 xy - C^2 E^6(x \pm y)^2] + \qquad \text{6th}$$

$$+ 4xy[\pm AB^3 E^6(x^2+y^2) - B^6 D^4 xy \mp AB^9(x \mp y)^2] + \qquad \text{4th}$$

$$E^{12}(x \pm y)^2 - 2B^6 E^6(x^2+y^2) + B^{12}(x \mp y)^2 = 0 \qquad \text{2nd}$$

One manner of reduction of the transforms is by the vanishing of the term of highest degree. Examination of the expression in the brackets of the 10th degree term reveals that it vanishes only for $A^2 = C^2$, a generic condition that holds for both conics and conic axial vertex cubics, but not for limacons. The condition $A^2 = C^2$ corresponds to $-4M^3 Q = 0$, so that in addition to holding for conics and conic axial vertex cubics, the 10th degree term also vanishes if 20a holds. Accordingly, the 0° and 180° transforms also will reduce from 10th to 8th degree at the foci defined by the $\cos^2\theta$-condition and for all subspecies in which the x^4 term vanishes. If one refers to eqs. XII-12 and XII-62, this is seen to occur only in the vertex inversions, so that it

applies only to subspecies within the genus of conic axial vertex cubics.

For further reduction within the categories that qualify (conics, conic axial vertex cubics, and all foci defined by the $\cos^2\theta$-condition), one investigates the conditions for vanishing of the 8th degree term. Letting $C^2 = A^2$, it is found that this term also will vanish if $AD^4 = 2A^2B^3$, which leads to $4P^2M^3R^3 = 0$, which corresponds to 20b. From 20b it follows that

(a) $-4(\cos^2\theta-C)(x^4-C) = 0$ (14-20)

(b) $4(\cos\theta-x^2C)(\cos^2\theta-C)(x^2-C) = 0$

(c) $-4(\cos\theta-cC)^2[2(\cos\theta-cC)(\cos\theta-x^2C) - 4(\cos^2\theta-C)(x^2-C)] = 0$

reduction of eq. 19 will be from 8th to 6th degree if the $\cos^2\theta$ term vanishes (because the 10th degree term also vanishes for this condition), and that the 8th degree term, alone, vanishes if the x^2 term vanishes or if $(\cos\theta-x^2C) = 0$. The latter condition is purely subfocal because, though the 8th degree term vanishes the 10th degree term does not.

On the other hand, the vanishing of the x^2 term of the simple intercept eq. occurs at the asymptote-point of all conic axial vertex cubics. Since the 10th degree term already has vanished for this genus, this condition is focal for them and the asymptote-point achieves point-focal rank with 0^O and 180^O transforms of maximum 6th degree. To pursue this line of analysis further one now lets $A^2 = C^2$ and $AD^4 = 2A^2B^3$ in the 6th degree term of eq. 19 and determines the resulting conditions for vanishing of the term. This has the potential to lead to further reduction for the foci defined by the $\cos^2\theta$-condition (which it does) or for the asymptote-point in certain subspecies of conic axial vertex cubics (which it does not). However, letting $A^2 = C^2 = 0$ leads to the vanishing of the 10th, 8th, and 6th degree terms from eq. 19, leaving the general 0^O and 180^O transforms about points on lines of symmetry of central conics and the parabola at 4th degree.

The remaining 4th degree term is $-4B^6D^4x^2y^2$, i.e., $-4N^8(2N^4P^2-4M^3R^3)$. For this term to vanish, eq. 20c must hold. Reference to eq. VII-2a reveals that the only condition under which this will occur is $h = 0$ (there is no condition for the parabola), i.e., for the transform about the center. For this pole,

however, $B^3 = 0$, whereupon the transforms about the center of ellipses become 21a, which yields the $0°$ and $180°$ transforms 21b, of which that for $0°$ (upper sign) is for one positive and one negative intercept.

(a) $E^{12}(x\pm y)^2 = (N^8-4M^3S^5)^2(x\pm y)^2 = 16(b^2-a^2)^2 a^4 b^4(x\pm y)^2 = 0$ (14-21)

(b) $0°$, $x = -y$ $180°$, $x = y$

But the vanishing of a highest degree term is only one mode by which a transform can reduce. Another mode is the factoring out of terms in the variables. It can be seen that if an xy term could be factored from the combined 2nd degree terms of eq. 19, an xy term could be factored out of the entire eq. and it would reduce to 8th degree. Expanding and combining the 2nd degree terms yields 22a, from which it is evident that the only condition for which an xy

(a) $(E^6-B^6)^2(x^2+y^2) \pm 2(E^{12}-B^{12})xy = 0$ (14-22)

(b) $(\cos^2\theta-C)(cC) = 0$

term can be factored is that $B^6 = E^6$, whereupon the whole term vanishes. But $B^6 = E^6$ is equivalent to the compound focal condition $N^8 = N^8 - 4M^3S^5$, which is equivalent to $M^3S^5 = 0$, which translates to the compound condition, 22b. This focal condition will hold if either the constant term or the $\cos^2\theta$ term of the simple intercept eq. vanishes. Hence, the 2nd degree terms of eq. 19 will vanish for transforms about the DP, the vertices, and the locations of the foci defined by the $\cos^2\theta$-condition.

The new term of lowest degree after factoring out an xy term from the entire transform is the 4th degree term of eq. 19, which becomes 23a. Letting

(a) $4[\pm AB^3E^6(x^2+y^2) - B^6D^4xy \mp AB^9(x\mp y)^2]$ (14-23)

(b) $4[(\pm AB^9 \mp AB^9)(x^2+y^2) + (2AB^9 - B^6D^4)xy]$

$E^6 = B^6$ (the condition for vanishing of the original 2nd degree term) and expanding and collecting terms gives 23b. It is seen that when $B^6 = E^6$, the x^2 and y^2 terms of 23b vanish and an additional xy term can be factored,

bringing the degree for the vertices, DP, and foci defined by the $\cos^2\theta$-condition down to 6 (eq. 24).

<p style="text-align:center">0° and 180° transforms that hold for the vertices,
DP, and foci defined by the $\cos^2\theta$-condition
for all axial QBI curves</p>

$$x^2y^2[(A^2-C^2)^2(x^2+y^2) \pm 2(C^4-A^4)xy] + \tag{14-24}$$

$$4Axy[\pm B^3C^2(x^2+y^2) \mp A^2B^3(x\mp y)^2 - AD^4xy] +$$

$$4[B^6(A^2-C^2)(x^2+y^2) \pm B^3(2AD^4-B^3C^2-3A^2B^3)xy] + 4B^6(2AB^3-D^4) = 0$$

[Although conclusions regarding the influences of the $\cos^2\theta$-condition are valid, the eqs. derived for intercept transforms about foci defined by this condition (such as eq. 24 above) are not. The reason is that the coefficient of the $\cos^2\theta$ term occurs as a multiplicative coefficient for the denominator of the simple intercept format of eq. 16. Accordingly, to derive the transforms about these foci one must set $M^3 = 0$ in eq. 15 and derive them from the resulting basis simple intercept format.]

Reduction of the transforms of eq. 24 for these foci to a lower degree than 6 by the factoring out of xy terms has a dual requirement. First, the constant term, $4B^6(2AB^3-D^4)$, must vanish. Second, the original 6th degree term of eq. 19, which has become reduced to the expression 25, must take a form

$$4[B^6(A^2-C^2)(x^2+y^2) \pm B^3(2AD^4-B^3C^2-3A^2B^3)xy] \tag{14-25}$$

from which an xy term can be factored. Inspection of 25 reveals that to factor an xy term requires merely that $A^2 = C^2$. But $A^2 = C^2$ is the compound generic focal condition for conic axial vertex cubics and for the foci of the $\cos^2\theta$-condition. This is the condition that led to the vanishing of the original 10th degree term of eq. 19 in the mode of reduction examined above.

Accordingly, the number of options for the reduction of eq. 24 is increased. Taking one route, one simply lets $A^2 = C^2$, which gives eq. 26a. The latter holds for the vertices and DP (and DP homologues) of axial vertex cubics. Factoring out the term $4(2AB^3-D^4)$ leaves eq. 26b, which factors to 26c, from which 26d and 26e are obtained. Eq. 26e holds for both the loop

$0°$ and $180°$ transforms for the vertices and
DP of conic axial vertex cubics

(a) $4A^2(2AB^3-D^4)x^2y^2 \mp 8(2AB^3-D^4)AB^3xy + 4B^6(2AB^3-D^4) = 0$ (14-26)

(b) $A^2x^2y^2 \mp 2AB^3xy + B^6 = 0$ (c) $(Axy \mp B^3)^2 = 0$

(d) $xy = \pm B^3/A$ (e) $xy = h(3h-2b)$ (f) $xy = \pm b^2,\ 0$

vertex, $h = b$, and the DP, $h = 0$. Substitution of these values in 26e
gives 26f, the $0°$ transform of self-inversion about the loop vertex (and the
$180°$ transform for a negative intercept) and the trivial transform $xy = 0$
about the DP. Interestingly, $h(3h-2b)$ of 26e is the $\cos\theta$-constant condition,
the parenthetical portion of which defines the loop pole at $h = 2b/3$, which
has only subfocal rank in the conic axial vertex cubics.

Taking the other route, one lets $A^2 = C^2$ and also lets $2AB^3 = D^4$, which
leads to the vanishing of the constant term of eq. 24 and allows an additional
xy term to be factored out. The condition $2AB^3 = D^4$ is the equivalent of
the compound focal condition 20b, which holds for the $\cos\theta$-x^2 condition, the
$\cos^2\theta$-condition, and the x^2-condition, i.e., for any one of the 3 conditions
(for the vanishing of the coefficient of any one of the 3 terms in the simple
intercept eq.). But since eq. 24 holds only for one of these conditions--
namely the $\cos^2\theta$-condition--the resulting eq. will hold only for foci defined
by the $\cos^2\theta$-condition (for which $A^2 = C^2$ also holds). Accordingly, to
obtain the corresponding transform one lets $2AB^3 = D^4$ in eq. 26a. But this
leads to the vanishing of the entire eq. for reasons mentioned in the note
above. To derive the sought after eq. one returns to eq. 15 and lets $M^3 = 0$.
The resulting new simple intercept format will yield the basis transform for
foci defined by the $\cos^2\theta$-condition for all axial QBI cubics and quartics.

Since no further reduction for the vertices of all axial QBI curves can
occur by the route of factoring out xy terms (or any other route, for that
matter) eqs. 24 are the basis 6th degree eqs. for the $0°$ and $180°$ transforms
for the vertices of all axial QBI curves. To express this eq. in the more
familiar parameters of the quadratic-based axial inversions, h, H, a, and b,
the parameters A, B^3, C^2, and D^4 are replaced by their equivalents from the
simple intercept format XII-16 (or the simple intercept eq. XII-61 for curves
of unit eccentricity). H then is given its vertex values of $-j^2/(h\pm a)$ (or

0 and $-j^2/h$, for curves of unit eccentricity) and the eq. becomes specific for the vertices of curves obtained by inverting conics about axial poles at $x = h$.

Accordingly, derivation of the $0°$ and $180°$ intercept transforms for axial QBI curves in terms of coefficients that are traceable back to the simple intercept format and eq., and examination thereof, has led to no new intercept transform conditions for degree reduction. All of the conditions for reduction that have been examined, though they may begin as sums or differences, resolve into products of conditions on the simple intercept eq. itself (as opposed to sums or differences that lead to new conditions). Since only reductions by factoring and vanishing of highest-degree terms have been examined, whereas reduction also can occur by root-taking, there is a possibility that other intercept transform conditions for reduction exist. To this juncture, however, the only known intercept transform condition is that for reduction of the $0°$ or $180°$ transform (or both, for mutually-inverting quartic circles) to the form $xy = $ constant for foci of self-inversion.

$90°$ Transforms

The starting eq. for the $90°$ transform based upon the simple intercept format of eq. 17 is eq. 27. The complete transform, consisting of 55 to 60 terms (depending upon how the terms are grouped) does not lend itself to concise reproduction but its complete expression is unnecessary in any event. Instead, the 16th through 24th-degree terms are given together with the two lowest-degree terms in the variables that limit factoring of $x^n y^n$ terms, which are of 8th and 10th degree (eq. 28).

$$y^2[Ax^2+B^3\pm(C^2x^4+D^4x^2+E^6)^{\frac{1}{2}}]^2 + x^2[Ay^2+B^3\pm(C^2y^4+D^4y^2+E^6)^{\frac{1}{2}}]^2 = F^4x^2y^2 \qquad (14\text{-}27)$$

$$-64A^4C^4x^{12}y^{12} + (A^4+C^4)^2x^8y^8(x^2+y^2)^4 + \qquad (14\text{-}28)$$

$$(-2A^2C^2)^2x^8y^8(x^2-y^2)^4 - 4A^2C^2(A^4+C^4)x^8y^8(x^2+y^2)^2(x^2-y^2)^2$$

24th

$$-64A^2C^4(2AB^3+D^4)x^{10}y^{10}(x^2+y^2) +$$

$$2(A^4+C^4)G^6x^8y^8(x^2+y^2)^3$$

22nd

$$-4A^2C^2G^6x^8y^8(x^2-y^2)^2(x^2+y^2)$$

$$[G^{12}-128A^3B^3C^2D^4+2(A^4+C^4)J^8]x^8y^8(x^2+y^2)^2 \qquad (14\text{-}28)$$

$$-4A^2C^2H^8x^8y^8(x^2-y^2)^2-64A^2(A^2D^8+4B^6C^4)x^{10}y^{10} \qquad \text{20th}$$

$$-64A^2C^2(B^6C^2+A^2E^6)x^8y^8(x^4+y^4)$$

$$+[2G^6H^8+64A^2D^4(A^2E^6+B^6C^2+2AB^3D^4)]x^8y^8(x^2+y^2) \; +$$

$$(A^4+C^4)L^{10}x^6y^6(x^2+y^2)^3 \; - \; 4A^2C^2L^{10}x^6y^6(x^2-y^2)^2(x^2+y^2) \qquad \text{18th}$$

$$-64A^2B^3C^2(B^3D^4+AE^6)x^6y^6(x^2+y^2)(x^4+y^4)$$

$$+J^{16}x^8y^8 \; + \; 2G^6L^{10}x^6y^6(x^2+y^2)^2 \; + \; 2(A^4+C^4)(B^{12}+E^{12})x^4y^4(x^2+y^2)^4$$

$$-4[B^6E^6(A^4+C^4)+A^2C^2(B^{12}+E^{12})]x^4y^4(x^2-y^2)^2(x^2+y^2)^2 \qquad \text{16th}$$

$$+8A^2B^6C^2E^6x^4y^4(x^2-y^2)^4$$

$$+ \quad + \quad + \quad + \quad + \quad + \quad +$$

$$2L^{10}[(B^{12}+E^{12})(x^2+y^2)^2-2B^6E^6(x^2-y^2)^2]x^2y^2(x^2+y^2) \qquad \text{10th}$$

$$(B^{12}+E^{12})^2(x^2+y^2)^4 \; + \; (2B^6E^6)^2(x^2-y^2)^4 \qquad\qquad \text{8th}$$

$$-4B^6E^6(B^{12}+E^{12})(x^2+y^2)^2(x^2-y^2)^2 \; = \; 0$$

$$G^6 = [8A^3B^3-2(A^2+C^2)F^4+4C^2D^4] \qquad L^{10} = [8AB^9-2(B^6+C^6)F^4+4D^4E^6]$$

$$J^8 = [(4aB^3+2D^4-F^4)^2-8(B^6C^2+AB^3D^4+A^2E^6)]$$

If we consider first reduction of eq. 28 by vanishing of terms of highest degree, it is evident that for $A^2 = C^2 = 0$, the generic condition for conics, the 18th through 24th degree terms all vanish, leaving the transform at 16th degree, which is the expected value (Table VII-1) for $90°$ transforms about the lines of symmetry of conic sections. Moreover, further reduction for the point foci on the major and transverse axes of central conics and the line of symmetry of the parabola does not occur by the vanishing of the 16th degree term. The latter simplifies to $(2D^4-F^4)^4x^8y^8$, which cannot vanish because $2D^4 = F^4$ cannot be fulfilled in conics* Accordingly, lower degree transforms for the axial point foci have to be achieved through root-taking or factoring.

The condition for the vanishing of the 24th degree term is the same as that for the vanishing of the 10th degree term for the $0°$ and $180°$ transforms,

*[except in the circle and the equilateral hyperbola]

namely $A^2 = C^2$. The latter is the compound focal condition 18a, which is generic for the conic axial vertex cubics and point-focal for the foci specified by the $\cos^2\theta$-condition. Accordingly, reduction of eq. 28 to 22nd degree occurs for the conic axial vertex cubics and the foci of the $\cos^2\theta$-condition. Letting $A^2 = C^2$ in the 22nd degree term leads to the condition $F^4 = 0$ for vanishing of this term. Since this is the simple focal condition corresponding to the $\cos^2\theta$-condition, eq. 28 will not reduce below 22nd degree by this route for the conic axial vertex cubics. Further reduction by this route is possible only for the foci of the $\cos^2\theta$-condition, but this is invalid in any event because $F^4 = 0$ corresponds to the denominator $(2M^3)$ of the simple intercept format of eq. 16 being equal to 0, which is not allowed (the reduction will occur and is permissible but the resulting transforms are not valid).

Accordingly, we proceed now to the other route of factoring of terms in $x^n y^n$. The first limiting term is the 8th degree term of eq. 28. Examination of this term reveals that the same condition holds for factoring terms in $x^n y^n$ as held for the 0^o and 180^o transforms, namely $B^6 = E^6$. This translates to the compound focal condition 22b, which is satisfied at the DP and its homologues and the vertices (the constant-condition), and for the foci of the $\cos^2\theta$-condition. In fact, for $B^6 = E^6$, the entire 8th degree term vanishes, leaving the 10th degree term as the limiting term. Letting $B^6 = E^6$ in the latter term yields the expression 29, which contains a mutiplicative term in $x^4 y^4$. Since

$$32B^{12}[4AB^9-(B^6+E^6)F^4+2B^6D^4]x^4y^4(x^2+y^2) \qquad (14\text{-}29)$$

all other terms of the complete 90^o transform also contain an $x^n y^n$ term of at least 8th degree, this allows immediate reduction for the transform for the vertices and DP to 16th degree ($x^4 y^4 = 0$ is the trivial transform for a point incident anywhere upon the curve).

Other reductions for other axial foci have to occur by other routes that also involve root-taking. Since the complete 90^o transform represented by eq. 28 is invalid for the foci of the $\cos^2\theta$-condition, the 90^o transforms for the latter foci have to be derived by recourse to eq. 15, as described above for the 0^o and 180^o transforms.

Thus, examination of the conditions for the reduction of the 90^o transforms

for the line(s) of symmetry of axial QBI curves leads to the same conclusions as for reduction of the 0° and 180° transforms. The overt conditions for reduction merely reproduce generic or point-focus-specific focal conditions on the simple intercept eqs. The general 24th degree transforms undergo generic reduction only for conics and conic axial vertex cubics.

Circumlinear Symmetry of Axial QBI Curves

The analytical procedures involved in the derivation of cirumlinear intercept transforms are sufficiently similar to those for circumpolar transforms that no separate treatment of them is required. The higher rank of $180°-\theta$ and $180°$-orthogonal transforms is understood readily by reference to eqs. XII-84b,c,c', repeated here for convenience in slightly modified arrangement as eqs. 30a,b,b'.

simple mixed-transcendental intercept equation for a point
on the line of symmetry of hyperbola axial vertex cubics

(a) $(x^2\sin^2\theta+2kx\sin\theta+k^2)(x\cos\theta+a+h) = (x^2\cos^2\theta+2hx\cos\theta+h^2)(b-x\cos\theta-h)$ (14-30)

(b) $k^2(a+h+x) = (x+h)^2(b-h-x)$ k^2 solution of 30a with $\theta = 0°$

(c) $k^2(a+h-y) = (y-h)^2(b-h+y)$ k^2 solution of 30a with $x = y$ and $\theta = 180°$

Since the simple circumlinear intercept formats in k^2 of 30b,b' are derived by substitution of specific angles θ and $\theta+\alpha = \omega$ in 30a, it is clear that the eqs. will be most simple for values of θ and α for which the transcendental functions take on the values 0 and ±1, or if θ remains a variable, for $\omega = \theta+180°$. For example, if k axes are to be investigated, $\theta = 0°$ and $180°$ are the angles of highest symmetry for the x radius vector because the terms in $\sin\theta$ and $\sin^2\theta$ vanish, permitting a simple expression in k^2 to be obtained directly (i.e., without recourse to the quadratic-root formula). With $\theta = 0°$, $\alpha = 0°$, $90°$, $180°$, and $270°$ give the simplest overall solutions, but all of these angles except $180°$ give trivial solutions. Accordingly, $\theta = 0°$ and $\alpha = 180°$ give the simplest possible non-trivial solutions of these eqs.; in other words the highest degree of circumlinear symmetry about the k axes is in the $180°$-orthogonal category.

As in the derivation of circumpolar intercept transforms, combinations, cancellations, and factoring of sums and differences frequently are encountered that lead to reduction in the degrees of transforms. For example, the identity, 31, leads to the reduction of the 180°-orthogonal circumlinear transform for k axes of all axial QBI quartics from 8th to 6th degree. If all of the negative signs except that between the two bracketed expressions on the left are made positive, the identity holds for the case in which the expression $(x+y)^2$ on the right is altered to $(x-y)^2$.

$$[D^{10}(H+x)^2+E^{11}(H+x)+D^{10}(H-y)^2+E^{11}(H-y)+2F^{12}]^2 - \qquad (14\text{-}31)$$

$$-4[D^{10}(H+x)^2+E^{11}(H+x)+F^{12}][D^{10}(H-y)^2+E^{11}(H-y)+F^{12}]$$

$$= [D^{10}(2H+x-y)+E^{11}]^2(x+y)^2$$

On the Origin of Focal Conditions

The $-\frac{1}{2}a$ Focus of Cayley's Sextic

A few illustrations now are given relating to the origin of focal conditions on the intercept eqs. of curves. To begin with, how does it come about that there is a focal condition on the $\cos^3\theta$ term, 32c, of the simple intercept eq., 32b, for Cayley's sextic, 32a, but not on the $\cos^3\theta$ term, 33c, of its small-loop vertex inversion cubic--Tschirnhausen's cubic, 33a? The rule of con-

(a) $(x^2+y^2-ax)^3 = (27a^2/4)(x^2+y^2)^2$ Cayley's sextic (14-32)

(b) $(x^2\cos^2\theta-2hx\cos\theta+h^2+x^2\sin^2\theta-ax\cos\theta+ah)^3 =$ simple axial intercept

$[(x^2-(2h+a)x\cos\theta+h(h+a)]^3 = (27a^2/4)(x^2-2hx\cos\theta+h^2)^2$ eq. of 32a

(c) $-(2h+a)^3x^3\cos^3\theta$ $\cos^3\theta$ term of 32b

(a) $(a-x)^3 = (27a/4)(x^2+y^2)$ Tschirnhausen's cubic (14-33)

(b) $[a-(x\cos\theta-h)]^3 = (a-x\cos\theta+h)^3$ simple axial intercept eq. of 33a

(c) $-x^3\cos^3\theta$ $\cos^3\theta$ term of 33b

struction for Cayley's sextic is that the cube of the difference between the
square of the distance from the loop vertex to a point on the curve and a
times the abscissa of the point equals $27a^2/4$ times the 4th power of the
distance. In other words, the 6th power of a quantity somewhat less than the
distance equals $27a^2/4$ times the 4th power of the distance.

When the eq. for the intercepts of Cayley's sextic about an axial pole h
units to the left of the loop vertex is formed, the cubic term, 32b-left,
simplifies to 32b-middle (an x-h translation shifts the loop vertex h units
to the right of the origin). Geometrically, the middle term indicates that one
cubes the resultant of the square of the intercept at the angle θ diminished
by (2h+a) times the abscissa (xcosθ) and augmented by h(h+a). The coefficient,
(2h+a), is twice the axial distance of the pole, h, from the loop vertex,
plus the basic parameter-distance of the curve (twice the loop diameter),
while h(h+a) is the axial distance of the pole from the vertex times the
same distance augmented by a. The coefficient (2h+a) is the key to the focal
condition, because it depends additively on both the size of the loop and the
distance of the pole from the loop vertex, and because it is a pure multipli-
cative coefficient of the $\cos^3\theta$ term. In other words, for the appropriate
selection of h, the $\cos^3\theta$ term, 32c, will vanish, the construction rules for
the curve will be simplified greatly, and the degrees of the transforms about
h will reduce.

In the case of Tschirnhausen's cubic, the rule for construction of the curve
is that the cube of the resultant of diminishing the parameter, a, of the
curve (4/9ths of the loop diameter) by the abscissa of a point on the curve is
equal to 27a/4 times the square of the distance to the point on the curve.
When the intercept eq. about the pole h is formed, the coefficient of the
$\cos^3\theta$ term that becomes cubed is merely x, the intercept itself (see 33b),
so that the product (xcosθ) simply is the abscissa of the point on the curve.
Accordingly, since this is the sole occurrence of a $\cos^3\theta$ term in the eq.,
the construction rule for the curve is invariant insofar as this term is con-
cerned, which is another way of saying that there is no focal condition on
the $\cos^3\theta$ term, 33c, of the simple intercept eq.

The above explanation accounts for the lack of a focal condition on the
$\cos^3\theta$ term of Tschirnhausen's cubic if the starting point is eq. 33a. But one
also can inquire how it came about that the eq. of the cubic came to be con-

stituted in such a way that this result ensued. In other words, when the sextic is inverted through the loop vertex, how is the $\cos^3\theta$ focal condition lost. The answer lies in the algebra of the inversion process. First, the cubed term, 34a, is converted to polar coordinates, 34b. The inversion is carried out by

<div style="text-align: center;">

origin of the x^3 term of Tschirnhausen's cubic
in the inversion of Cayley's sextic

</div>

(a) $(x^2+y^2-ax)^3$ (b) $(r^2-arcos\theta)^3$ (c) $(j^4/r^2-aj^2\cos\theta/r)^3$ (14-34)

(d) $(j^4-aj^2rcos\theta)^3$ (e) $(j^4-aj^2x)^3$ (f) $a^9(a-x)^3$

replacing r by j^2/r at every occurrence, 34c. Then the eq. is multiplied through by r^6 to clear of fractions, 34d. Following this the eq. is restored to rectangular coordinates, 34e, and j is set equal to the characteristic parameter of the curve, with consequent extraction of a^9, 34f.

Since it was shown above that the term, 34f, gives no focal condition on the $\cos^3\theta$ term, and since no other $\cos^3\theta$ term results from the inversion, this is the reason why the $\cos^3\theta$ focal condition is lost, namely, because x^2+y^2 of the cubed term, 34a, inverts to j^4 of 34d, with the consequent loss of a subsequent cross-product term in $-2hx\cos\theta$ (which arises in the sextic on going from 32a to 32b). Whether or not the $\cos\theta$ term derived from $-x$ of 34e,f has a coefficient in a or j is immaterial.

The $-\frac{1}{2}$b Focus of Limacons

The $-\frac{1}{2}$b Focus of Limacons arises in essentially the same way as did the $-\frac{1}{2}$a focus of Cayley's sextic. The starting rectangular eq. is 35a, which

<div style="text-align: center;">

origin of the $-\frac{1}{2}$b focus of limacons

</div>

(a) $(x^2+y^2+bx)^2 = a^2(x^2+y^2)$ rectangular eq. of limacons (14-35)

(b) $[(x\cos\theta+h)^2+x^2\sin^2\theta+b(x\cos\theta+h)]^2 =$ simple axial intercept eq.
 $a^2[(x\cos\theta+h)^2+x^2\sin^2\theta]$ of 35a

(c) $[x^2+bh+h^2+(2h+b)x\cos\theta]^2 = a^2(x^2+2hx\cos\theta+h^2)$ simplification of 35b

(d) $(2h+b)^2x^2\cos^2\theta$ $\cos^2\theta$ term of 35c

leads to the simple intercept eq. 35b, which simplifies to 35c. When the term on the left is squared, the only term in $\cos^2\theta$ is 35d. If $h = -\frac{1}{2}b$, this term vanishes and the radical is eliminated from the $\cos\theta$ simple intercept format, with consequent great reduction in the degree of the transforms.

Accordingly, the focal condition for the $-\frac{1}{2}b$ focus derives entirely from the expression on the left in 35a-c. Geometrically this expression represents the square of the resultant of adding to the square of the distance from the pole to a point on the curve a length b times the abscissa of the same point. The axial distance of the resulting $-\frac{1}{2}b$ focus from the reference pole, then, is directly proportional to the coefficient of the x term in 35a. If one adds to the square of the distance a length $2b$ times the abscissa, the focus will be at twice the axial distance from the reference pole, while if the length is $3b$ times the distance it will be at thrice the distance, etc.; if one adds only a fractional amount, the distance will be reduced in the same proportion.

The 2 in the denominator of $-\frac{1}{2}b$ arises from the cross-product in the square of the term, $(x\cos\theta + h)$ of 35b. This number also can be altered. For example, if one takes twice the square of the distance in the constructional rule, instead of merely the square, the distance of the focus from the reference pole will be halved, etc. The left term of 18a-c will yield a focal condition on the $\cos^2\theta$ term of the simple intercept eq., so long as it is the square of the resultant of two terms, one of which is proportional to the square of the distance to the point on the curve and the other of which is proportional to the product of the abscissa of this distance and a second length that is independent of this distance. Moreover, the focus will continue to exist—barring a cancellation—if other terms in the eq. of the curve also give rise to terms in $x^2\cos^2\theta$ in the simple intercept eq. But if terms in $x\cos^2\theta$, $x^3\cos^2\theta$, or $x^4\cos^2\theta$ were to arise, the condition usually would not remain focal.

The Variable Focus of Hyperbola Axial
 Vertex Cubics

Consider now an example of a focus of more complex origin than the $-\frac{1}{2}b$ focus, inasmuch as more than two terms contribute to its determinant eq. The starting eq., 36a, is that for the hyperbola axial vertex cubics, utilizing vertex cubic parameters. The basis eq. is thrown into the intercept form for

origin of the variable focus of hyperbola
axial vertex cubics

(a) $y^2(x+a) = x^2(b-x)$ hyperbola axial vertex cubics (14-36)

(b) $x^2(1-\cos^2\theta)[(x\cos\theta+h)+a] =$

$(x^2\cos^2\theta+2hx\cos\theta+h^2)[b-(x\cos\theta+h)]$

first step in forming
the simple axial inter-
cept eq. of 36a

(c) $x^3\cos\theta+ax^2-x^3\cos^3\theta-ax^2\cos^2\theta+hx^2-hx^2\cos^2\theta =$ expansion of 36b

$bx^2\cos^2\theta+2bhx\cos\theta+bh^2-x^3\cos^3\theta-2hx^2\cos^2\theta-$

$h^2x\cos\theta-hx^2\cos^2\theta-2h^2x\cos\theta-h^3$

(d) $(2h+h-h-a-b)x^2\cos^2\theta+(x^2-2bh+h^2+2h^2)x\cos\theta +$

$(a+h)x^2 - h^2(b-h) = 0$

eq. 36c after cancel-
ations and regrouping

(e) $(2h-a-b)x^2\cos^2\theta+[x^2+h(3h-2b)]x\cos\theta+(a+h)x^2-h^2(b-h) = 0$ consolidation of 36d

a pole on the axis at a distance, h, from the DP (36b). Expansion, 36c, cancellation of the $\cos^3\theta$ terms, and grouping of the remaining terms lead to 36d, from which it can be seen that 5 different terms contribute to the $\cos^2\theta$-condition defining the variable focus at h = (a+b)/2 (36e), while 3 different terms contribute to the $\cos\theta$-constant potential focal condition defining both the DP, h = 0, and the loop pole at h = 2b/3 (36e). The asymptote-point focus, h = -a, is the result of only two contributions, both from the left member of the eq., while the loop-vertex focus also is the result of a contribution of only two terms, but both of these have their origin in the right member.

The $A^2d/(A^2-B^2)$ Focus of Bipolar Linear Cartesians

As a last illustration of the origin of focal conditions, the derivation of the $A^2d/(A^2-B^2)$ focus of bipolar linear Cartesians is illustrated; this is the homologue of the $-\frac{1}{2}b$ focus of limacons. The bipolar eq. 37a takes the form 37b in polar coordinates when cast about the pole p_u, which is one of the foci of self-inversion. Squaring gives 37c, and throwing this into the form

origin of the $A^2d/(A^2-B^2)$ focus of
bipolar linear Cartesians

(a) $Bu + Av = Cd$ bipolar linear Cartesians (14-37)

(b) $Br + A(r^2-2drcos\theta+d^2)^{\frac{1}{2}} = Cd$ polar eq. of 37a cast about pole p_u

(c) $r^2(A^2-B^2)-2A^2drcos\theta +d^2(A^2-C^2) = -2BCdr$ 37b squared

(d) $[(x^2+2hxcos\theta+h^2)(A^2-B^2)-2A^2d(xcos\theta+h)+d^2(A^2-C^2)]^2 =$ simple axial
intercept eq.
$$4B^2C^2d^2(x^2+2hxcos\theta+h^2)$$ of 37c

(e) $cos\theta = \dfrac{x^2(A^2-B^2) + 2BCdx + d^2(A^2-C^2)}{2A^2dx}$ simple intercept format about
focus of self-inversion at p_u

(f) $h = A^2d/(A^2-B^2)$ $cos^2\theta$-condition on eq. 37d

simple intercept format of 37d for
$cos^2\theta$-condition 37f

(g) $cos\theta = \dfrac{[d^2(A^2B^2+A^2C^2-B^2C^2) + x^2(A^2-B^2)^2]^2 - 4B^2C^2d^2[(B^2-A^2)^2x^2+A^4d^2]}{8A^2B^2C^2d^3x(A^2-B^2)}$

(h) $d^4(A^2B^2+A^2C^2-B^2C^2)^2 = 4A^4B^2C^2d^4$ condition for vanishing of constant
term of numerator of 37g, which is
the vertex-coincidence condition

(h') $A^2B^2 + A^2C^2 - B^2C^2 = \pm2A^2BC$ roots of 37h

(i) $d(A-C)/(A-B)$, $d(A+C)/(A+B)$, $d(A-C)/(A+B)$, $d(A+C)/(A-B)$ locations of
axial vertices

(j) $d^4(A^2-C^2)^2/(A^2-B^2)^2$ product of the vertex locations

of the intercept eq. for a point on the axis gives 37d. [Eq. 37c yields
directly the simple intercept format, 37e, for the focus of self-inversion at
p_u].

 Inspection of 37d reveals a powerful focal condition, homologous to
that for the $-\frac{1}{2}b$ focus of limacons; if $cos\theta$ is eliminated from the bracketed
expression on the left, no $cos^2\theta$ term will appear in the simple intercept eq.
for the pole defined by the $cos^2\theta$-condition. The condition for this elimination
is 37f (giving a variable penetrating focus), whereupon the simple intercept
format becomes 37g.

Three factors contribute to the origin of the $A^2d/(A^2-B^2)$ focus. The square of the radius from the pole p_v to a point on the curve times A^2 is $A^2(d^2-2dr\cos\theta+r^2)$. This yields a component A^2r^2. The square of the radius from the pole, p_u, times B^2, B^2r^2, also contributes a component. In the intercept eq. about an axial pole, h, the difference between them becomes $(A^2-B^2)(x^2+2hx\cos\theta+h^2)$, from which the cross-product term, $(2hx\cos\theta)(A^2-B^2)$, contributes to the $\cos^2\theta$ focal condition in the denominator of 37f.

The numerator arises from a second component contributed by the square of the radius from p_v, namely $-2A^2dr\cos\theta$. In rectangular coordinates this becomes $-2A^2dx$, while cast about the pole h it is $-2A^2d(x\cos\theta+h)$. The $-2A^2dx\cos\theta$ portion of this term contributes to the numerator. The condition for vanishing of the $\cos^2\theta$ term is that the sum of the contributions of these two components be 0, i.e., $2(A^2-B^2)hx\cos\theta = 2A^2dx\cos\theta$, whence 37f.

Inspection of the $\cos\theta$ simple intercept format, 37g, for this focus reveals a further focal condition. When the constant terms of both expressions in the brackets in the numerator are equal, 37h, an x can be factored from the numerator, which cancels the x in the denominator. This is the condition for the $A^2d/(A^2-B^2)$ focus being coincident with a vertex, thereby giving rise to a double-focus. The 4 vertices are at the axial locations given by 37i. [Note that the product of the vertices, 20j, is simply the square of the 0^o transform of self-inversion, $xy = d^2(A^2-C^2)/(A^2-B^2)$, for the p_u focus.]

Given the existence of the above-described vertex-coincidence focal condition, the question arises as to which vertices become involved in the coincidence. To answer this question, an analysis of the peripheral vertices was carried out paralleling that given for limacons in Chapter X (*The Limacon Vertices*). The expression for the peripheral vertices at the level of the $A^2d(A^2-B^2)$ focus (i.e., the intersections with the curve of a line orthogonal to the line of symmetry at the position of the focus) is 38a.

From eq. 38a it is clear that there always are at least two peripheral vertices for the focus in question (the upper of the alternate signs always leads to two roots). This means that the focal coincidence always is with a small-loop axial vertex, because if the coincidence were with an axial vertex of the large loop, there would be no peripheral vertices. Furthermore, the

ordinates of peripheral vertices
of $A^2d/(A^2-B^2)$ focus

(a) $y^2 = d^2[A^2B^2+A^2C^2+B^2C^2\pm2ABC(A^2+B^2+C^2)^{\frac{1}{2}}]/(A^2-B^2)^2$ (14-38)

(b) $(A^2B^2+A^2C^2+B^2C^2)$ \qquad (B') $2ABC(A^2+B^2+C^2)^{\frac{1}{2}}$

expression in the brackets is equivalent to the focal condition, 37h, for a coincidence of the $A^2d/(A^2-B^2)$ focus with an axial vertex. It follows that when 38b equals 38b', the focus is at a small-loop axial vertex, when 38b > 38b', the focus is within the small loop and there are 4 peripheral vertices, while when 38b' > 38b, the focus is outside the small loop and there are only 2 peripheral vertices.

Origin of the Special Symmetry of Pseudo-Exchange-Limacons

The manner in which pseudo-exchange-limacons originate by the cancellation of the cubic terms characteristic of most other axial QBI quartics now is illustrated. The starting eq. is that of central conic axial vertex cubics with conic parameters, 39a. To obtain the pseudo-exchange-limacon, 39a is

(a) $y^2(x\pm aj^2/2b^2) = x^2(j^2/2a-x)$ central conic axial vertex cubics (14-39)

(b) $y^2[x+j^2(2b^2\pm3a^2)/6ab^2] = (x+j^2/3a)^2(j^2/6a-x)$ translation of origin of 39a from DP to loop pole at $j^2/3a$

(c) $j^4y^2[j^2x+j^2(x^2+y^2)(2b^2\pm3a^2)/6ab^2] =$ inversion of 39b
$[j^4x^2+2j^4x(x^2+y^2)/3a+j^4(x^2+y^2)^2/9a^2][j^2(x^2+y^2)/6a-j^2x]$

(d) $j^6xy^2+j^6y^2(x^2+y^2)(2b^2\pm3a^2)/6ab^2 = -j^6x^3+j^6x^2(x^2+y^2)/6a$ expansion of 39c
$+ 2j^6x(x^2+y^2)^2/18a^2-2j^6x^2(x^2+y^2)/3a + j^6(x^2+y^2)^3/54a^3$
$- j^6x(x^2+y^2)^2/9a^2$

(e) $j^6x +(2b^2\pm3a^2)j^6y^2/6ab^2 = j^6x^2/6a+2j^6x(x^2+y^2)/18a^2$ 39d regrouped and (x^2+y^2)
$- 2j^6x^2/3a+j^6(x^2+y^2)^2/54a^3-j^6x(x^2+y^2)/9a^2$ factored out

(f) $[x^2+(2/3\pm a^2/b^2)y^2+2ax] = (x^2+y^2)^2/27a^2$ pseudo-exchange-limacon derived from 39e

inverted about the loop pole, 2/3rds of the length of the loop from the DP. This length is $j^2/2a$ in conic parameters (b in axial vertex cubic parameters). Accordingly, an $x+j^2/3a$ translation of 39a (which is cast about the DP) is employed, yielding 39b. Inversion now leads to 39c and expansion to 39d. The latter eq. is seen to be of 6th degree. But the leftmost terms on each side of the eq. combine to give a term in $j^6x(x^2+y^2)$, which makes it possible to factor out a term, (x^2+y^2), with a consequent reduction of the degree of the eq. to 4.

This reduction only occurs if the linear term in x in both parenthetical expressions of 39a has the same coefficient. It already has been shown (Chapter IX) through a circumpolar symmetry analysis (eq. IX-28b) that, unless the coefficients are the same, the $\cos^3\theta$ terms of the simple intercept eq. will not cancel one another (see also 36c), with a consequent great reduction in the symmetry of the curve. The finding here is that if these coefficients are unequal, the locus of the inversion through the loop pole will be 6th degree. Only when the coefficients are equal is the inversion locus 4th degree and the basis and transform curves members of the QBI superfamily (see also the analysis of the folium of Descartes in Chapter IX).

The 4th degree eq. obtained after factoring an (x^2+y^2) term from 39d is 39e. The symmetry condition for conversion to a pseudo-exchange-limacon, 39f, is evident at this point (as well as in 39d), because the only cubic terms in the eq., the 2nd and 5th on the right, cancel one another. Combining terms and clearing of fractions leads to the pseudo-exchange-limacon, 39f. There are only two axial poles of inversion for which the cubic terms vanish in this manner--the loop pole at 2b/3 and the DP; for the latter, the reciprocal inversion to the basis central conic takes place.

Origin of the Special Symmetry of Quadratic-
 Based Inversions

The QBI loci discussed in Chapter VIII are repeated here for convenience; the basis curves are the parabola, 40a, central conics, 40b, the circle, 40c, and the line, 40d. The expanded eq. of the conic basis curve is juxtaposed, term-by-term above that of the inversion locus, 40a'-d', as was done in the earlier illustration at the beginning of the Chapter.

(a) $y^2-(2ky+4ax)$ $+(k^2+4ah)$ $= 0$ the parabola (14-40)

(a') $j^4y^2-(2ky+4ax)j^2(x^2+y^2)+(k^2+4ah)(x^2+y^2)^2 = 0$ point-in-the-plane
 inversion of 40a

<div align="center">

central conics (b) and point-in-the-
plane inversions thereof (b')

</div>

(b) $(b^2x^2\mp a^2y^2)$ $-2(b^2hx\mp a^2ky)$ $+(b^2h^2\mp a^2k^2-a^2b^2)$ $= 0$

(b') $(b^2x^2\mp a^2y^2)j^4-2(b^2hx\mp a^2ky)j^2(x^2+y^2)+(b^2h^2\mp a^2k^2-a^2b^2)(x^2+y^2)^2 = 0$

(c) $(x^2+y^2) - 2(hx+ky)$ $+ (h^2+k^2-R^2)$ $= 0$ the circle

(c') $j^4- 2(hx+ky)j^2 + (h^2+k^2-R^2)(x^2+y^2) = 0$ point-in-the-plane
 inversion of 40c

(d) $y - mx - b$ $= 0$ the line

 $j^2y - j^2mx - b(x^2+y^2) = 0$ point-in-the-plane inversion of 40d

From inspecting these eqs., one notes that the only basis curve for which the inversion locus does not increase in degree is the circle, 40c. Of the other eqs., the only one for which the degree would not increase for a special location of the inversion pole is that for the line, for which the inversion locus would be a coincident line if the pole of inversion were to be incident upon the line (i.e., $b = 0$). This latter circumstance is of no further interest because inversion of a linear term to a quadratic term cannot influence the degree of the inversion locus of a basis quadratic (except about a point incident upon the circle), cubic, or quartic.

The analytical basis for the fact that the inversion locus of the circle is another circle is that the term of highest degree is (x^2+y^2). In the first step of the inversion process, this term gives rise to a term, j^4/r^2. Being the term of highest degree, this term determines the power of r by which each term in the eq. must be multiplied to clear of fractions in r. That power is the square. When multiplying through by r^2, terms that originally were $ax+by$, and have become $(aj^2\cos\theta)/r+(bj^2\sin\theta)/r$, now become $aj^2r\cos\theta+bj^2r\sin\theta$, while the constant term becomes C^2r^2.

A key step for understanding the degree changes on inversion comes at this

point. In this example, one can convert directly to rectangular coordinates without having to clear of fractions a second time, because $r\cos\theta = x$, $r\sin\theta = y$, and $r^2 = x^2+y^2$. But one cannot make this direct conversion without clearing of fractions a second time if the highest degree term is ax^2+by^2, i.e., when the coefficients of the x^2 and y^2 terms are unequal.

When the latter is the case in a quadratic eq., the sum of the two terms gives rise, not to a single term in j^4/r^2, but to two terms, $[(j^4a\cos^2\theta)/r^2 + (j^4b\sin^2\theta)/r^2]$. It still is necessary to multiply through by r^2 to clear of fractions, but now the cleared term is not j^4, but $[j^4a\cos^2\theta+j^4b\sin^2\theta]$. Now when one reconverts to rectangular coordinates, this term becomes $[j^4ax^2/(x^2+y^2)+j^4by^2/(x^2+y^2)]$, so that it is necessary to multiply through a second time by (x^2+y^2), thereby doubling the degree of the equation from 2 to 4.

It is clear from this example and our knowledge of conic sections (the circle as opposed to ellipses), that terms in (x^2+y^2) in the eq. of a curve convey higher symmetry to the curve than terms in (ax^2+by^2). The basis for this is that (x^2+y^2) is simply the square of the distance coordinate of the system. As such, rules of construction involving (x^2+y^2) are virtually the most simple that can be employed. By comparison, a rule employing (ax^2+by^2), which translates to $ar^2\cos^2\theta+br^2\sin^2\theta$, as compared to just r^2, is quite complex and, accordingly, leads to a more complex inversion locus.

For purposes of illustration, $[(ax^2+by^2)^n+A^{3n}]$ is inverted. First one converts to polar coordinates, 41a, then inverts, 41b. To clear of fractions,

(a) $(ax^2+by^2)^n+A^{3n} = (ar^2\cos^2\theta+br^2\sin^2\theta)^n+A^{3n}$ conversion of basis terms to polar coordinates (14-41)

(b) $(aj^4\cos^2\theta/r^2+bj^4\sin^2\theta/r^2)^n+A^{3n}$ first step in inversion of 41a

(c) $(aj^4\cos^2\theta+bj^4\sin^2\theta)^n+A^{3n}r^{2n}$ 41b times r^{2n}

(d) $[aj^4x^2/(x^2+y^2)+bj^4y^2/(x^2+y^2)]^n+A^{3n}(x^2+y^2)^n$ 41c in rectangular coordinates

(e) $(aj^4x^2+bj^4y^2)^n+A^{3n}(x^2+y^2)^{2n}$ 41d cleared of fractions

41b is multiplied by r^{2n}, yielding 41c. The latter now is converted to rectangular coordinates, 41d, with the former constant term becoming of degree 2n. Now, if a and b were equal, the expression in the brackets of 41d would

simply be aj^4 (or bj^4) and the new term of highest degree would be $A^{3n}(x^2+y^2)^n$, which is of the same degree in the variables as the original term of highest degree in 41a.

Since a and b are not equal, however, one must clear of fractions in the variables, which means multiplying through by $(x^2+y^2)^n$. This clears the term in question, which becomes of degree 2n, but the other term now becomes of degree 4n. Since this is twice the degree of the original eq., we see that when the coefficients of x^2 and y^2 are unequal in the term of highest degree in a basis eq., the degree of the inversion locus will increase to a maximum of twice the degree of the original term of highest degree.

Returning to the inversion loci of the conic sections, 40a',b', it is found that, although the inversion loci of the parabola and central conics are at most of 4th degree, the 4th degree terms are in $(x^2+y^2)^2$, in which the coefficents of x^2 and y^2 are equal. Accordingly, these loci will invert to curves of no higher than 4th degree, and similarly for the 2nd-generation inversion loci. However, it already has been shown in Chapter XI that eqs. 40 represent all the QBI loci, so the present demonstration is superfluous.

Consider now the inversion properties of polynomials in which the terms of highest degree are cubics. Eq. 42a, in which the cubic terms are $x(x^2+y^2)$

(a) $x(x^2+y^2) + y(x^2+y^2) + Ax^2 \qquad By^2 \qquad + Cxy \qquad + \qquad$ (14-42)

(b) $r^3\cos\theta + r^3\sin\theta + Ar^2\cos^2\theta + Br^2\sin^2\theta + Cr^2\sin\theta\cos\theta +$

(c) $j^6\cos\theta + j^6\sin\theta + Arj^4\cos^2\theta + Brj^4\sin^2\theta + Crj^4\sin\theta\cos\theta +$

(d) $j^6x \qquad + j^6y \qquad + Aj^4x^2 \qquad + Bj^4y^2 \qquad Cj^4xy \qquad +$

(a) $D^2x \qquad + E^2y \qquad + F^3 \qquad = 0$ cubic basis curve

(b) $D^2r\cos\theta \qquad + E^2r\sin\theta \qquad + F^3 \qquad = 0$ 42a in polar coordinates

(c) $D^2j^2r^2\cos\theta + E^2j^2r^2\sin\theta + F^3r^3 \qquad = 0$ 42b inverted and cleared of fractions in r

(d) $D^2j^2x(x^2+y^2) + E^2j^2y(x^2+y^2) + F^3(x^2+y^2)^2 = 0$ inversion locus in rectangular coordinates

and $y(x^2+y^2)$, or $(x\pm y)(x^2+y^2)$, is taken first. Converting to polar co-

ordinates gives 42b, inverting and clearing of fractions in r (i.e., substituting j^2/r for r and multiplying through by r^3) gives 42c, while restoring rectangular coordinates and clearing of fractions in $(x^2+y^2)^{\frac{1}{2}} = r$, gives 42d.

It is clear from inspection of 42d that if the original eq. contains a constant term the inversion locus will be a quartic; if it contains terms in x or y, but no constant term, it will be a cubic; while if it contains no term lower than 2nd degree the inversion locus will be a quadratic. But the latter statement is the equivalent of saying that eq. 42a, with only cubic and quadratic terms, is the eq. of a conic vertex cubic cast about the DP or DP homologue. With linear terms added, the eq. is cast about a point incident upon the curve but not coincident with the DP, while with a constant term added, the pole is a non-incident point in the plane.

The types of terms in a cubic eq. that lead to inversion loci of higher degree than quartic--for equivalent arrays of lesser degree--are terms in $x^3 \pm y^3$ and $xy^2 \pm x^2y$, or any single one of these terms not accompanied by a term that would allow a combination yielding $x(x^2+y^2)$ or $y(x^2+y^2)$. Taking one of these terms plus a constant term leads to the following sequence of inversion steps to a sextic: x^3+E^3, $r^3\cos^3\theta+E^3$, $(j^6/r^3)\cos^3\theta+E^3$, $j^6\cos^3\theta+E^3r^3$, $j^6x^3/(x^2+y^2)^{3/2}+E^3(x^2+y^2)^{3/2}$, $j^6x^3+E^3(x^2+y^2)^3$. These considerations lead us directly into the next topic.

Design and Synthesis of Highly Symmetrical Curves

The Coordinate System Approach

The coordinate system approach attacks the problem of the design and synthesis of highly symmetrical curves directly from the point of view of the type of symmetry--circumpolar, bipolar, tripolar, polar-linear, bilinear, linear-circular, etc. The theory of the most symmetrical curves in different coordinate systems already has been dealt with in detail in Chapters I-IV. With the exception of the polar system, this topic is not dealt with further here.

The Building-Block Approach

In the building-block approach one synthesizes new curves by constructing eqs. from the same kinds of terms that occur in the eqs. of known highly symmetrical curves, such as the circle, conic axial vertex cubics, limacons, eccentricity-dependent self-inverters, Cartesians, etc. Recall in this connection that, in essence, Cayley's sextic (eq. 32) is nothing more than the eq. of a limacon (eq. 35) with the degree of each parenthetical expression in the variables raised by one unit. Raising the degree by another unit to an octic or by two more units to a decic, etc., also will yield curves of high symmetry.

As the building-block polynomials of highest degree, one employs terms such as $(x^2+y^2)^n$ or, more generally, $(Ax^2+Ay^2+B^2x+C^2y+D^3)^n$. In the addition of lower degree terms to a basis eq. of degree n, a good rule is to employ no term that inverts to higher degree than n. For example, in a 4th degree eq., possession of a term having the form $(x^2+y^2)^2+A^2x^2+B^4$ is expected to confer higher symmetry upon the quartic than $(x^2+y^2)^2+A(A+x)^3+B^4$, because the former inverts to another quartic whereas the latter inverts to a sextic.

Addition of a term in x^2y^2 to a highly symmetrical quartic does not preserve the latter's high symmetry. Cubic terms that preserve the high symmetry of a quartic eq. are $x(x^2+y^2)$ and $y(x^2+y^2)$, but not x^3, y^3, xy^2, $x(ax^2+by^2)$ or $y(ax^2+by^2)$, unless they are taken in a combination that yields an (x^2+y^2) factor. A quadratic term conferring the highest symmetry is $A(x^2+y^2)$; single terms in Ax^2, By^2, and Cxy apparently generally confer lower symmetry.

Some of the other characteristics of eqs. of highly symmetrical curves of high degree that provide guidelines for building-block syntheses will become abundantly clear in the following.

The Intercept Format Approach Through Generic Double-Foci of Self-Inversion

If one is guided by the findings for axial members of the QBI superfamily and Cartesians, it would appear that of any given group of curves of specified degree, the most symmetrical, i.e., the ones with the highest circumpolar hierarchical curve-focus ranking (see Table V-1 and Circumpolar Maxim 30), are the curves that possess a *generic double-focus of self-inversion* (in other words, curves for which the focus of self-inversion coincides with a pole specified by a focal condition on the simple intercept eq. or format). The central conics, axial QBI curves of unit eccentricity, central quartics, and certain other highly symmetrical curves that possess a true center are exceptions, in that they do not self-invert about a point-pole.

In a quite different, and much more specific, approach than the building-block method, one can employ the intercept formats of the circumpolar symmetry analyses as guides to the derivation of other curves with generic double-foci of self-inversion. We already have encountered 5 pure-polynomial simple intercept formats for generic double-foci of self-inversion. These are reproduced for convenience in 43a-e together with the coefficient ratio that forms the constant term of the 0° transform of self-inversion. In every case, the xy product is equal to the appropriate root of the ratio of the constant term to the coefficient of the term of highest degree in the variable, whether in the numerator or denominator.

Intercept format	Transform of self-inversion	Basis curve	
(a) $\cos\theta = \dfrac{Cx^2+B^3}{A^2x}$	(a') $xy = B^3/C$	Circle	(14-43)
(b) $\cos\theta = \dfrac{A^2x}{Cx^2+B^3}$	(b') $xy = B^3/C$	Equilateral strophoid	
(c) $\cos\theta = \dfrac{A^3x+B^2x^2+C^4}{D^3x}$	(c') $xy = C^4/B^2$	Cartesian self-inverters	
(d) $\cos\theta = \dfrac{F^6x^4+G^8x^2+H^{10}}{J^7x^3+K^9x}$	(d') $xy = (H^{10}/F^6)^{\frac{1}{2}}$	Eccentricity-dependent self-inverters	
(e) $\cos^2\theta = \dfrac{A^4x^4+E^6x^2+D^8}{F^6x^2}$	(e') $xy = (D^8/A^4)^{\frac{1}{2}}$	Mutually-inverting quartic circles	

There are three ways in which the simple intercept formats for generic double-foci of self-inversion can lead to the disclosure of new, highly-symmetrical curves. The first of these is through the construction of new formats that yield a 0^O transform, $xy = $ constant, using the formats given above as guides. Though other simple formats, such as those of eqs. 44, do not lead to

$$\cos\theta = \frac{Ax^2}{B^3+Cx^2}, \quad \cos\theta = \frac{Ax^3}{B^4+C^2x^2}, \quad \cos\theta = \frac{A^3x+Bx^3}{C^4+D^2x^2}, \quad \cos\theta = \frac{Ax^4}{B^5+C^3x^2} \qquad (14\text{-}44)$$

a 0^O transform of self-inversion, one fruitful method for this purpose is given below (see *Equilateral Hyperbolic Specific Symmetry Class*).

The operations of the second and third methods hinge on the manner of derivation of the 0^O (and 180^O) transform. In the case of a $\cos\theta$ simple intercept format, since $\cos\theta = \cos(\theta+0^O)$, to form the 0^O transform one simply equates the expression in the variable x to the same expression in y, clears of fractions, reduces, simplifies, etc. Clearing of fractions involves multiplying the numerator of the x format by the denominator of the y format, and vice versa.

In this connection, it is impossible to obtain a 0^O or 180^O transform of self-inversion unless the denominator of the simple intercept format contains a term in the variable, because the cross-multiplication is the only manner in which an xy term (or the forerunner thereof) can arise. But, this being the manner of formation, it is evident that the reciprocal of a simple intercept format for generic double-foci of self-inversion also will yield a 0^O transform of self-inversion. That fact was evident from the finding that the formats for the circle (43a) and the equilateral strophoid (43b) were the reciprocals of one another--a case of *self-inverting reciprocal-format symmetry*.

CIRCUMPOLAR MAXIM 36: *A necessary condition for a curve to self-invert about a pole p_u is that the polar equation of the curve cast about the pole p_u contain terms in both $f(r)g(\theta)$ and $h(r)$.*

Accordingly, since the reciprocals of formats 43c,d,e do not appear in the group, these reciprocals constitute 3 new genera of curves with generic double-foci of self-inversion. It also is characteristic of the 0^O transform that it is formed in the same manner for the $\cos^2\theta$ format (which, since n is even,

also will yield the 180° transform), the $\cos^3\theta$ format, the $\cos^4\theta$ format, etc. But this fact means that any format that leads to a 0° transform of self-inversion for, say, $\cos^n\theta$, also will do so for $\cos^{(n+1)}\theta$. In other words, any simple intercept format that leads to a 0° transform of self-inversion also defines an infinite number of other genera of curves with simple intercept formats, 45a, for generic double-foci of self-inversion. These curves are related to one another by *self-inverting root-format symmetry*.

(a) $\quad \cos^n\theta \;=\; \dfrac{f(x)}{g(x)}$ (b) $\quad f(\theta) \;=\; \dfrac{Cx^2+B^3}{A^2x}$ (14-45)

Since, as n increases without limit, the degrees of the basis curves represented by the formats also increase without limit, this observation also reveals that there is no upper limit to the degrees of self-inverting curves with generic double-foci of self-inversion. Note that *self-inverting reciprocal-format symmetry* involves pairs of genera with reciprocal formats, whereas *self-inverting root-format symmetry* defines a supergenus or subfamily containing an infinite number of self-inverting genera, for each of which there exists a reciprocal format with self-inverting reciprocal-format symmetry.

The above analysis can be carried a step further with the realization that an intercept format need not be an expression for $\cos^n\theta$ or $\sin^n\theta$. It may be given by any function of θ, as illustrated by the generalization (45b) of the simple intercept format for the circle. This enormously broadens membership in the group of self-inverting curves with generic double-foci of self-inversion (it seems a reasonable assumption that the poles of self-inversion defined by this generalization will be generic double-foci of self-inversion for all $f[\theta]$).

Lastly, note that for all even n in eq. 45a, the represented curve has a true center (since there is reflective symmetry through both the x and the y-axes). This means that for each set of intercepts, r_1 and r_2, of a radius vector emanating from the center at any angle, there will exist intercepts of the same lengths, r_1' and r_2', for the oppositely-directed radius vector. Accordingly, since $r_1 r_2 = $ constant, and $r_1' = r_1$ and $r_2' = r_2$, one also will have $r_1 r_2' = $ constant and $r_2 r_1' = $ constant, which means that all such curves self-invert both positively and negatively, and have the same formula of self-inversion for all. Curves of this type, that have the same 0° transform

as a given basis curve, as well as the same 180° transform as the basis curve (whether the 0° and 180° transforms are identical to one another or not), have been designated as *symmetry mimics* of the basis curve (and of one another). These are treated further below.

Reciprocal-Format Symmetry

As a first example of reciprocal-format symmetry of a curve with a generic double-focus of self-inversion, consider the sextics of eq. 46, with reciprocal-format symmetry to the quartic circles of eq. XII-57a. These curves consist of two ovals tangent to one another and the x axis at the origin (for all values of d and R, i.e., regardless of whether the basis circles intersect).

$$y^2(x^2+y^2+d^2-R^2)^2 = 4d^2(x^2+y^2)^2 \tag{14-46}$$

A second example of reciprocal format symmetry employs the reciprocal of the simple intercept format 43c for Cartesian self-inverters, with limacon parameters. Other genera would be obtained using bipolar parabolic or linear (or polar-circular linear) Cartesian parameters. All of these curves also are sextics; those for the reciprocal of the limacon format are represented by eq. 47. Cases for $b = 2^{\frac{1}{2}}, 2$, and 10 were examined.

$$16b^6x^2(x^2+y^2) = [4a^2b(x^2+y^2)+4b^2x(x^2+y^2)+(a^2-b^2)^2x]^2 \tag{14-47}$$

The curves typically consist of two segments. For $b = 2$, for which $xy = (a^2-b^2)^2/4b^2 = 9/16$, one segment is a tiny oval, with the pole of self-inversion as one of the vertices. The other segment is a gently-sloping curve resembling an ellipse vertex cubic, with asymptotic arms and an asymptote at $x = -\frac{1}{2}$. For $b = 10$, $xy = 24.5$, and the tiny oval is much enlarged relative to the size of the "bowed" midsection of the other segment. The latter is asymptotic to the line $x = -0.1$.

For $b = 2^{\frac{1}{2}}$, $xy = 1/8$ (which corresponds to the reciprocal intercept format of the equilateral limacon), the oval segment has a DP at the pole of self-inversion, with the lateral arms extending from the DP and becoming asymptotic to the same line at $x = -1/2^{\frac{1}{2}}$ to which the lateral arms of the other segment are asymptotic.

These curves bear no resemblance to hyperbolic limacons. There is, of course, no more reason to expect a resemblance from taking the reciprocal of the $\cos\theta$ simple intercept format, which is a transformation involving the inversion of the cosine of an angle, than from taking the reciprocal of a distance.

Root-Format Symmetry Groups

Root-Format Symmetry Groups of the Circle

The $\cos^n\theta$ format for a circle is 48a. The corresponding rectangular eq. (n integral and positive) is 48b. In all cases, these curves, that are related

$$\text{(a)} \quad \cos^n\theta = (Ax^2+B^3)/C^2x \qquad \text{(b)} \quad (x^2+y^2)^{(n-1)/2}[A(x^2+y^2)+B^3] = C^2x^n \qquad (14\text{-}48)$$

$$\begin{array}{c|ccccccccc} n & \tfrac{1}{2} & 1 & 2 & 3 & 4 & 5 & 6 & 7 & 8 \\ \text{degree} & 8 & 2 & 6 & 4 & 10 & 6 & 14 & 8 & 18 \end{array} \qquad (14\text{-}49)$$

to the circle by *root-format symmetry*, consist of one or two flattened "circles," with the flattening increasing with degree. The individual ovals have only one line of symmetry, since they are more sharply curved at the vertex proximal to the pole of self-inversion than at the distal vertex. For n even, the curves self-invert both positively and negatively, with $xy = B^3/A$. The dependence of the degree of these curves on n is shown in 49.

Root-Format Symmetry Groups of the Equilateral Strophoid

The $\cos^n\theta$ format for the equilateral strophoid is 50a, while the rectangular eq. is 50b. The curves in this group resemble equilateral strophoids but the loop becomes progressively flattened with increasing n, with a corresponding increasing outward displacement of the lateral arms (for a given value of the loop diameter), which are not asymptotic.

$$\text{(a)} \quad \cos^n\theta = C^2x/(Ax^2+B^3) \qquad \text{(b)} \quad C^2(x^2+y^2)^{(n+1)/2} = x^n[A(x^2+y^2)+B^3] \qquad (14\text{-}50)$$

$$\begin{array}{c|cccccccc} n & 1 & 2 & 3 & 4 & 5 & 6 & 7 & 8 \\ \text{degree} & 3 & 8 & 5 & 12 & 7 & 16 & 9 & 20 \end{array} \qquad (14\text{-}51)$$

Again, for n even, the curves are reflected in both the x and the y axes

and self-invert both positively and negatively through the true center. The ordinal rank for these curves for $n = 2$ is 11th degree. For the 180° transform, $x = y$, the subordinal rank is 7th degree, while for the 0° and 180° transforms of self-inversion, $xy = B^3/A$, it is 10th degree.

For n odd, the curves are not reflected in the y axis and, hence, consist of only a single loop. The degrees of these self-inverting curves, that have root-format symmetry with the equilateral strophoid, follow the sequence 51.

Root-Format Symmetry Groups of Mutually-
Inverting Quartic Circles

For curves related to mutually-inverting quartic circles by root-format symmetry, the simple intercept format in $\sin^n\theta$ is 52a, and the rectangular eq. is 52b. This case differs notably from the others in that the basis format is for a squared transcendental function rather than for $\sin\theta$ or $\cos\theta$. As a consequence, $\sin^n\theta$ for n integral does not give integral powers of the quartic circle format (i.e., integral powers of the $\sin^2\theta$ format, such as the $\sin^4\theta$ format, the $\sin^6\theta$ format, etc.)--only the even values of n lead to integral powers of the format. Accordingly, the curves fall into two groups of quite different type. For even powers of $\sin\theta$ (the "true" root-format symmetry groups) they greatly resemble the basis quartic circles, including the possession of a true center and both positive and negative self-inversion through it.

(a) $\quad \sin^n\theta = \dfrac{x^4+2x^2(d^2-R^2)+(d^2-R^2)^2}{4d^2x^2}$ $\hspace{2cm}$ (14-52)

(b) $\quad 4d^2y^n = (x^2+y^2)^{(n-2)/2}(x^2+y^2+d^2-R^2)^2$

n	1	2	3	4	5	6	7	8	9	10	11
degree	8	4	10	6	14	8	18	10	22	12	26

(14-53)

In the cases of the odd powers, the loci are modified considerably from the basis curve. One of the double points is lost, with the result that the curves greatly resemble limacons. The pole of self-inversion, of course, is within the small loop. The sequence of degree increase of these curves with n is 53.

Inasmuch as eqs. 48, 50, and 52 represent self-inverting curves of all degrees and are all derived from simple intercept formats of curves with generic double-foci of self-inversion, they give an indication of the form

taken by the eqs. of some of the most symmetrical curves of high degree (see
also many additional examples below).

The Intercept Format Approach To the Synthesis of
 Curves With Designated Specific Symmetry

Introduction

 In Table 1 of Chapter V examples were given of only 4 curves with circular
specific symmetry, 3 for a 90° transformation angle and one for a 45° angle.
It is indicated here how other curves with circular specific symmetry, as well
as curves with designated specific symmetry of other types can be synthesized.
If one examines the three sets of eqs. 54a-a''', 54b-b''', and 54c-c''', it is
evident how one could approach the design of intercept formats, 54a,b,c, that

(a) $\cos\theta = x^2(x^2-a^2)/b^4$ (14-54)

(a') $x^2(x^2-a^2) = y^2(y^2-a^2)$

(a") $(x^4-y^4) = a^2(x^2-y^2)$

(a''') $x^2 + y^2 = a^2$ (b) $\cos\theta = x(x^2-a^2)/b^3$

 (b') $x(x^2-a^2) = y(y^2-a^2)$

 (b") $(x^3-y^3) = a^2(x-y)$

 (b''') $x^2+xy+y^2 = a^2$ (c) $\cos\theta = x(x-a)/b^2$

 (c') $x(x-a) = y(y-a)$

 (c") $(x^2-y^2) = a(x-y)$

 (c''') $x + y = a$

yield desired specific symmetry classes for the 0° transformation--in these
obvious cases, circular (54a'''), elliptical (54b'''), and linear (54c'''). Eq.
54b is essentially the format of true exchange-limacons (eq. XI-9c,d) but
the formats 54a,c have not been encountered previously. The format 54a now is
employed to illustrate the derivation of curves with "circular" specific
symmetry of any degree n, i.e., $x^n+y^n = a^n$.

Circular Specific Symmetry Class

The polar and rectangular eqs. represented by the format 54a, rewritten as 55a, are 55b,c. Referring to 55b it can be seen that, for each value of θ

(a) $x^4 - a^2x^2 - b^4\cos\theta = 0$ intercept format (14-55)

(b) $r^2 = [a^2 \pm (a^4+4b^4\cos\theta)^{\frac{1}{2}}]/2$ polar solution in r^2

(c) $b^8x^2 = (x^2+y^2)^3(x^2+y^2-a^2)^2$ rectangular equation

for which the radicand is positive but smaller than a^4, there are 4 real roots, r_1, $-r_1$, r_2, and $-r_2$. Moreover, the roots always stand in the relationship $r_1^2+r_2^2=a^2$, which means that both the $0°$ and $180°$ transforms of eqs. 55 have circular specific symmetry. The basis for this is that the subspecies of eqs. 55 consist of two congruent loci, each the reflection of the other in the y axis. Since each locus also has reflective symmetry in the x axis, the curves possess a true center. In the interests of simplicity, only one of the two congruent loci possessed by each subspecies and only the $0°$ transforms are treated in the following.

Accordingly, pursuing this line, the subspecies in question are members of two species, one a species of single ovals (actually double) and the other a species of non-communicating double ovals (actually quadruple), the morphology of which changes with b in precisely the manner described in Chapter VIII in the section on *curves of demarcation*. In this case, the curve of demarcation is a limacon-like curve (eq. 56), for which the value of b is $a/2^{\frac{1}{2}}$. The center pole is a vertex of the curve. It is incident upon the small loop of the two-looped species, and at the point of deepest indentation of the loop of the single-looped species (this indentation is the incipient small loop).

$$4r^4 - 4a^2r^2 - a^4\cos\theta = 0 \qquad\qquad (14\text{-}56)$$

In any given subspecies, the circular $0°$ transform applies for all angles θ for which there are two positive or two negative intercepts, and the trivial transforms, $x^2 = y^2$, for all other angles (valid $180°$ transforms, $x = y$, exist, since the full curves, consisting of both congruent portions, have a true center).

It will be noted that the curves 57a-c, that have root-format symmetry with the curves of eqs. 55, also will have circular $0°$ intercept transforms for odd

powers of $\cos\theta$. For even powers of $\cos\theta$ the radicand of 57b is greater than a^4 for all θ except 90° and 270°, leading to two complex roots and two real roots. Since the latter are equal and opposite in sign, only the trivial 0° transforms $x = \pm y$ hold. The 180° transforms are identical to those for 0° for even n, and yield the valid 180° relation $x = y$, typical of curves with a true center (for $n = 2$ the curves are the highly symmetrical sextics of 57c).

(a) $\quad x^2(x^2-a^2)/b^4 = \cos^n\theta$ \qquad intercept format $\qquad\qquad$ (14-57)

(b) $\quad r^2 = \{a^2 \pm (a^4+4b^4\cos^n\theta)^{\frac{1}{2}}\}/2$ \qquad polar solution in r^2

(c) $\quad b^4x^2 = (x^2+y^2)^2(x^2+y^2-a^2)$ \qquad rectangular eq. for $n = 2$

(d) $\quad (2x^2-a^2)^2(2y^2-a^2)^2 S^2 = (2y^2-a^2)^2(x^2-a^2)(b^4+a^2x^2-x^4)$

$\qquad\qquad + (2x^2-a^2)^2(y^2-a^2)(b^4+a^2y^2-y^4)$ \qquad ordinal rank eq. for 57a, $n = 2$

(d') $\quad (a^2-2x^2)^2 S^2 = a^2(x^4-a^2x^2-b^4)$ \qquad 0° subordinal rank eq. for 57a, $n = 2$

(e) $\quad 4x^2y^2(2x^2-a^2)^2(2y^2-a^2)^2 S^2 = b^4y^2(2y^2-a^2)^2(b^4+a^2x^2-x^4)$

$\qquad\qquad + b^4x^2(2x^2-a^2)^2(b^4+a^2y^2-y^4)$ \qquad ordinal rank eq. for 57a, $n = 1$

(e') $\quad 4x^2(a^2-x^2)(2x^2-a^2)^2 S^2 = a^2b^4(b^4+a^2x^2-x^4)$ \qquad 0° subordinal rank eq. for 57a, $n = 1$

Accordingly, there exist an infinite number of curves, 57a,b (n odd) that have 0° circular transforms. These closely resemble one another, the chief differences being that the size of the interior oval decreases with increasing n and complementary changes in the curvature of different portions of the large loop take place.

One can take a step further in regard to 0° transforms that have circular specific symmetry if one notes that the solutions for circular transforms of 55a,b are independent of the function of θ, i.e., they hold for any $f(\theta)$ for which negative values exist. Thus, general transcendental eqs. for curves possessing 0° transforms of circular specific symmetry can be written as 58a-c.

(a) $x^2(x^2-a^2)/b^4 = f(\theta)$ simple intercept format (14-58)

(b) $r^4 - a^2r^2 - b^4f(\theta) = 0$ polar equation

(c) $r^2 = \{a^2 \pm (a^4+4b^4f[\theta])^{\frac{1}{2}}\}/2$ polar solution in r

nth Degree "Circular" Specific Symmetry Class

Still another generalization is possible if one notes that eqs. 58a-c and the transforms derived therefrom are not restricted in regard to the values of the exponents. Accordingly, they may be expressed more generally in the form 59a-c, all of which have nth degree "circular" transforms, 59d, for functions $f(\theta)$ for which negative values exist, but only trivial 0° transforms in other ranges. ["Circular" transforms exist in all ranges if complex solutions are taken into account.]

(a) $x^n(x^n-a^n)/b^{2n} = f(\theta)$ simple intercept format (14-59)

(b) $r^{2n} - a^nr^n - b^{2n}f(\theta) = 0$ polar equation

(c) $r^n = \{a^n \pm (a^{2n}+4b^{2n}f[\theta])^{\frac{1}{2}}\}/2$ polar solution in r^n

(d) $x^n + y^n = a^n$ 0° (and 180°) transform

Although an infinite number of curves exist having identical 0° transforms $x^n+y^n = a^n$ for all positive integral n, these are readily distinguished from one another on the basis of their 3-dimensional transforms (see Chapter V) or, what is equivalent, upon the basis of the ordinal and subordinal rank eqs. This is demonstrated for eqs. 57a, for $n = 1$ and 2. For $n = 2$ (for which only complex solutions for the circular 0° transform exist), the ordinal rank is 10 (10th degree ordinal rank eq. 57d) and the subordinal rank 4 (4th degree subordinal rank eq. 57d'). The corresponding ranks are 12 and 8 for $n = 1$ (eqs. 57e,e').

Appendix III contains a complete inventory of ordinal and subordinal rankings for curve-pole combinations treated in this work (linear, circular, and hyperbolic specific symmetry classes). Examination of the listings under circular specific symmetry reveals that no valid comparison of the decic of

eqs. 55 (eq. 57a, n = 1) can be made. No other listed curve has circular specific symmetry about a true center for a transformation angle of $0°$ or $180°$. The degrees of the ordinal and subordinal rank eqs., 57d,d',e,e', however, are higher than those of any of the other entries for curve-pole combinations with circular specific symmetry.

Equilateral Hyperbolic Specific Symmetry Class

An identical approach to that described above could be used to synthesize curves in the equilateral hyperbolic specific symmetry class. Thus, for an eq. of the form 60a, where $f(\theta)$ is any function of θ, the quadratic root

(a) $Ar^{2n}f(\theta) - B^{n+1}r^n + C^{2n+1}f(\theta) = 0$ simple intercept format (14-60)

(b) $r^n = \{B^{n+1} \pm [B^{2n+2} - 4AC^{2n+1}f^2(\theta)]^{\frac{1}{2}}\}/2Af(\theta)$ polar solution in r^n

(c) $x^n y^n = C^{2n+1}/A$, (c') $xy = (C^{2n+1}/A)^{1/n}$ $0°$ intercept transform

(d) $f(\theta) = \dfrac{B^{n+1}r^n}{Ar^{2n} + C^{2n+1}}$ 60a solved for $f(\theta)$

solutions are 60b. But the product of these roots is given by 60c, which is a transform of self-inversion. Moreover, eq. 60a solved for $f(\theta)$ becomes 60d. This will be recognized as being a generalization of the simple intercept format for the equilateral strophoid (for which n = 1).

Accordingly, the present analysis of a method of synthesizing curves possessing a pole about which they have equilateral hyperbolic symmetry has pointed the way to one of the sought-after generalizations of the intercept formats of self-inversion, 43a-e. If the exponents of all the variables of these formats are multiplied by the same positive integer n, the formats remain formats for generic double-foci of self-inversion but represent new and different curves for each value of n (the dimensions of the coefficients also are adjusted to give dimensional balance).

Linear Specific Symmetry Class

In this section three purposes are served: (1) the synthesis of curves that have linear symmetry about a pole is treated; (2) the synthesis of highly

symmetrical curves in polar coordinates using the coordinate-system approach is discussed; and (3) it is illustrated that curves whose construction rules meet the requirements for high symmetry discussed above will be highly symmetrical from the points of view of certain criteria, no matter how high their degree.

The most highly symmetrical curves in polar coordinates are those of eqs. 61. We take now as our basis eq. that of limacons in the intercept format form

(a) $r = a\theta$ (b) $r = a$ (c) $r = a - b\cos\theta$ (d) $r = b\cos\theta$ (14-61)

(e) $j\theta = a$ (f) $r = a - b\cos^2\theta$

(a) $b\cos\theta = a - x$ limacons (b) $b\cos\theta = (a-x)j/x$ conics (14-62)

(c) $b\cos^2\theta = (x-a)j/x$ inverse-$\cos^2\theta$ group (d) $b^2\cos\theta = x(x-a)$ LCQ sextics

(e) $b^2\cos^2\theta = x(x-a)$ LLC octics

62a and inquire as to possible simple modifications of this eq. that will yield highly symmetrical curves. One possibility is to divide the right member by x and multiply by j (the unit of linear dimension), giving 62b, which will be recognized as the simple intercept format of conic sections about the focus. If now one squares the $\cos\theta$ term of 62b, 62c is obtained, which is the eq. of the inverse-$\cos^2\theta$ group. This is a highly symmetrical group of curves that already has been mentioned and is represented in Table V-1.

Another possibility for a simple modification of 62a is to multiply the right member by x, either alone (62d) or in conjunction with squaring the $\cos\theta$ term (62e), while at the same time squaring b for dimensional balance. These operations give two highly symmetrical new curves of high degree, designated as the *LCQ sextics* and *LLC octics* for reasons given below. It will be noted that the formats of 62d,e yield non-trivial 0^o transforms, as illustrated in eqs. 54c-c'''.

The LCQ sextics and LLC octics are closely related equationally to the highly symmetrical $\cos^2\theta$-group which, as has already been noted, leads the hierarchy of curves heretofore encountered that have linear symmetry about a true center (Table V-2; additional entries are to be found in Appendix III). This close similarity is illustrated by eqs. 63a-c. It will be noted how the terms of these eqs. conform to the requirements for high symmetry discussed above. It

(a) $(x^2+y^2)^3 - a^2(x^2+y^2)^2 + 2abx^2(x^2+y^2) + b^2x^4 = 0$ $\cos^2\theta$-group (14-63)

(b) $(x^2+y^2)^3 - a^2(x^2+y^2)^2 - 2ab^2x(x^2+y^2) + b^4x^2 = 0$ LCQ sextics

(c) $(x^2+y^2)^4 - a^2(x^2+y^2)^3 - 2b^2x^2(x^2+y^2)^2 + b^4x^4 = 0$ LLC octics

is apparent on inspection of 63a-c that the symmetry of the LLC octics most resembles that of the $\cos^2\theta$-group in that they also have a true center, whereas the LCQ sextics are more akin to limacons in that they have only one line of symmetry (because of the presence of the term of odd degree, $-2ab^2x[x^2+y^2]$).

Since the preceding treatments have amply illustrated how an infinite number of new curves with linear 0° (and 180°) symmetry can be based upon the formats 62d,e, this need not be discussed further. But it should be emphasized that all curves derived from 62d by taking $\cos\theta$ in odd powers will have transforms for the 0° and 180° reference angles that are identical to those of the basis LCQ sextics, since the derivations for these transforms are identical for every odd power of $\cos\theta$. It also will be true of the 0° transforms for which $\cos^n\theta$ is replaced by an $f(\theta)$ that has a range of negative values such that $a^4 > 16b^4f^2(\theta)$ [This is merely the condition that the radicand of the quadratic-root solution to 62d with $f(\theta)$ replacing $\cos^2\theta$ be positive for negative values of $f(\theta)$.] Similarly, all curves derived from 62e by taking $\cos\theta$ in even powers will have transforms for the 0° and 180° reference angles that are identical with those for the basis LLC octics.

The Linear-Circular-Quartic Sextics

The terminology *linear-circular-quartic sextics* designates a sextic with *linear* 0° transforms, *circular* 180° transforms, and *quartic* 90° transforms. The transforms for the LCQ sextic of 62d are given by eqs. 64a-c.

(a) $x + y = a$ 0° transform of LCQ sextic (14-64)

(b) $x^2 + y^2 = a(x+y)$ 180° " " "

(c) $x^2(x-a)^2 + y^2(y-a)^2 = b^4$ 90° " " "

The LCQ sextics possess 3 discrete ovals in all subspecies for which $b^2 < a^2/4$. The smallest oval is interior to and tangent to the medium-sized one. The tangent point is the polar center of the curve cast in the form 63b

and, thus, is the pole about which the transforms 64a-c apply. The two smaller ovals are within a third much larger oval; the disparity in size increases as b decreases. For $b^2 = a^2/8$ the diameters have the relative sizes 1:1.303:17.494.

Since the pole of the transformation is a tangent point, there are no non-trivial 180° transforms between the two smaller ovals. As was noted for limacons in Chapter X (*Analytical Transforms Versus Geometrical Expectations*), both 0° and 180° transforms in which the smallest loop participates involve intercepts that have negative values. For example, for $\theta = 0^\circ$, $r_1 = \alpha$ and $r_2 = -\beta$. The 0° transform 64b then holds for $x = \alpha$ and $y = -\beta$, and this is true for all θ from 0° to 90°. At 90° the vector from the pole begins to intersect all 3 loops in the same direction from the pole. Accordingly, the same transform cannot apply to both sets of intersections. It is found that, as expected, the 0° transform applies for the medium loop-large loop intersections, and the 180° transform (with negative values of β) for the small loop-large loop inter-sections. These relationships are illustrated in Table XIV-1.

Table XIV-1. 0° and 180° Transforms of the LCQ Sextic

Oval	large	medium	small
large	0° trivial	0° linear	0° circular*
	180° circular	180° circular	180° linear*
medium	0° linear	0° trivial	0° circular*
	180° circular	180° trivial	180° trivial
small	0° circular*	0° circular*	0° trivial
	180° linear*	180° trivial	180° trivial

*negative value of small-loop intercept

The curve of demarcation between the genus in which 3 discrete ovals are present and the genus in which only 2 discrete ovals are present occurs for the value $b^2 = a^2/4$. It greatly resembles a limacon but with the difference that the small loop is tangent to and encloses a smaller loop. The loop diameters have the relative values 1:2.414:8.243.

For $b^2 > a^2/4$ the medium-sized and large ovals "detach" from one another at the DP forming a single oval, with a deep indentation remaining from what had been the medium-sized oval. The small oval remains tangent to the innermost

region of this indentation. With increasing values of b the indentation gradually disappears as the corresponding face of the curve flattens against the y axis (which it crosses at the point [0,a]).

While the 0° and 180° transforms are identical to those of 64a,b for all odd powers of $\cos\theta$ in the format $b^2\cos^n\theta = x(x-a)$, the ordinal and subordinal rank eqs. will be specific for each n and will be of lower degree the lower the (odd) value of n, and the lower the degree of the rectangular eq. of the curve. The ordinal rank eq. for the LCQ sextics is 65, while 66a-c are the subordinal rank eqs. that characterize the transforms 64a-c.

$$(2x-a)^2(2y-a)^2\overset{0}{s}{}^2 = (2y-a)^2[b^4-x^2(x-a)^2] +$$
$$(2x-a)^2[b^4-y^2(y-a)^2]$$

ordinal rank eq. for LCQ sextics \qquad (14-65)

(a) $(a-2x)^2\overset{0}{s}{}^2 = 2[b^4-x^2(x-a)^2]$ \qquad 0° subordinal rank eq. \quad (14-66)

(b) $(a-2x)^2[2a^2-(a-2x)^2]\overset{0}{s}{}^2 = 2a^2[b^4-x^2(x-a)^2]$ $\quad 180^\circ$ \qquad " \qquad " "

(c) $4A^4(B^2\overset{0}{s}{}^2-A^4)^2 = [B^2x^2(x-a)^2-a^2B^2\overset{0}{s}{}^2+a^2A^4]^2$ $\quad 90^\circ$ \qquad " \qquad " "

$$A^4 = [b^4-x^2(x-a)^2] \qquad B^2 = (a-2x)^2$$

The rectangular eq. corresponding to 63b for n = 3 is a decic (10th degree curve); for other values of n the degree may be ascertained from the degree rule, degree = 2n+4. All the curves in this series have 0° linear and 180° circular transforms but the degree of the 90° transforms varies with n. Since the degrees of these transforms have not been ascertained, the designation *LCX* is employed for such curves, for example, the *LCX decic*.

An ordinal rank of 6 and subordinal rank of 4 for the 0° linear transform places the LCQ sextic midway on the hierarchical listing for curve-pole combinations with linear specific symmetry (Appendix III). No valid direct comparison (as in Table V-2) is possible, though, because no other listed curve has linear symmetry solely for a 0° transformation angle, nor is there another listing for a pole consisting of the tangent point of two ovals.

In the case of the 180° circular transform, a direct valid comparison is not possible either, for essentially the same reasons. If one disregards the fact that the poles of the transformations are not homologous, one can make comparisons with the root-$\cos^2\theta$ group and the decic of eqs. 55. The LCQ sextic has

ordinal and subordinal ranks identical to those of the root-$\cos^2\theta$ group, but the latter group would emerge with greater symmetry because its rankings are for a $90°$ angle of transformation and these usually are of higher degree than for the $180°$ transformation. But in the comparison with the decic of eqs. 55, the LCQ sextic would emerge with greater symmetry by virtue of its ordinal and subordinal rank eqs. having only one-half the degree of those of the decic.

The Linear-Linear-Circular Octics

The LLC octic 62e has linear $0°$ and $180°$ transforms and a circular $90°$ transform (eqs. 67a-c). As mentioned earlier, these curves have a true center, and all the other curves in the series derived from the format $b^2\cos^n\theta = x(x-a)$ for even powers of n will have linear $0°$ and $180°$ symmetry and a true center.

(a) $x + y = a$ $\qquad\qquad$ $0°$ transform of LLC octics $\qquad\qquad$ (14-67)

(b) $x + y = a, \quad x = y$ $\qquad\quad$ $180°$ transforms of LLC octics

(c) $x(x-a) + y(y-a) = b^2$ $\qquad\quad$ $90°$ transform of LLC octics

These curves consist of a large external oval and two small opposed ovals tangent to one another at the true center. The curves in the series for larger even values of n than 2 greatly resemble the $n = 2$ genus but some changes in form take place. If one consults eq. 68 it can be seen that the radicand

$$r = [a \pm (a^2 + 4b^2\cos^n\theta)^{\frac{1}{2}}]/2 \qquad\qquad (14\text{-}68)$$

rapidly approaches the value a^2 as θ departs appreciably from $0°$ and $180°$. In other words, the two roots rapidly approach a and 0. Since the values of the roots at $\theta = 0°$ and $\theta = 180°$ are independent of n, the diameters of the loops also are independent of n. The result is that as n increases, the small loops become greatly flattened and the large loop becomes more nearly circular for large departures of θ from $0°$ and $180°$. For example, for $n = 16$ the large loop is almost perfectly circular from $30°$ to $150°$ and $210°$ to $330°$. In other words, the axial bulge of the large loop is inescapable and this becomes more like a planetary ring the larger the value of n; the small interior loops concomitantly become more like discs.

Negative values of the intercept also are involved for the $0°$ and $180°$

transforms of the LLC octics. The $0°$ transform $x+y=a$ is the sum of a posi-
tively-directed intercept on the large loop and a negatively-directed inter-
cept on the oppositely directed small loop, because for all values of θ
except $90°$ and $270°$ one root of eq. 68 (the intercept on the large oval) is
positive and the other (an intercept on a small oval) is negative. A geometri-
cally valid $0°$ transform for two positive intercepts exists but its eq. would
have to be $x-y=a$. Similarly, the $180°$ transform $x+y=a$ is the sum of a
positive intercept on the large oval and a negative intercept on a small oval.
A geometrically valid $180°$ transform other than $x=y$ would have the form $x-y=a$.

In the case of the $90°$ transform, eq. 67c holds for two intercepts on the large
oval. It also holds for negative values of the two intercepts on the small ovals.
For one intercept on the large oval and one on a small oval, eq. 67c holds for
negative values for the intercept on the small oval. In other words, all of the
transforms apply if the intercepts have the signs yielded by the analytical
solution at the respective angles, but, from the point of view of a purely
geometrical assessment, signs would have to be changed in some of the trans-
forms for some combinations of intercepts (see the treatment of these matters
in Chapter VII, *Negative Intercepts, Trivial Transforms, the Degree of Trans-
forms, and the Duality of $0°$ and $180°$ Transforms*).

The ordinal rank eq. for LLC octics is 69, while the subordinal rank eqs.
for the linear $0°$ and $180°$ transforms and for the $90°$ circular transform are
70a,b. The high degree of symmetry of these curves about the true center is
attested to by the fact that the ordinal rank eq. is of only 6th degree and the
subordinal rank eqs. of only 4th degree.

$$(2x-a)^2(2y-a)^2 s^2 = 4x(x-a)(2y-a)^2[b^2-x(x-a)]$$
$$+ 4y(y-a)(2x-a)^2[b^2-y(y-a)]$$

ordinal rank eq. for LLC octics (14-69)

(a) $(2x-a)^2 s^2 = 8x(x-a)[b^2-x(x-a)]$

subordinal rank eq. for $0°$ and $180°$ (14-70)

(b) $(2x-a)^2[4b^2+2a^2-(2x-a)^2] s^2 =$
$$8(a^2+2b^2)x(x-a)[b^2-x(x-a)]$$

subordinal rank eq. for $90°$

There is no curve in the listing for the linear specific symmetry class of
Appendix III that has linear symmetry about a true center at both $0°$ and $180°$
with which a direct valid comparison can be made, but if the comparison is
made with curves having solely $180°$ linear symmetry about a true center, the

LLC octics fall about midway on the list.

In the case of circular symmetry at 90° a direct valid comparison is possible with the root-$\cos^2\theta$ group and tangent circles. In this comparison the tangent circles emerge with by far the higher symmetry about the true center, with ordinal and subordinal rank eqs. of only 2nd and 0 degree, respectively, compared to 6th and 4th degree for both LLC octics and the root-$\cos^2\theta$ group. It is no coincidence that all 3 of these groups bear very close equational relationships to one another in polar coordinates, namely, $\cos^2\theta = r^2/a^2$, $(r^2-ar)/b^2$, and $(r^2-a^2)/b^2$, respectively, for tangent circles, the LLC octics, and the root-$\cos^2\theta$ group.

The next curve in the series for the format $b^2\cos^n\theta = x(x-a)$, with n even, is $n = 4$, for which the LLX dodecic (12th degree curve) is obtained. Again, it is emphasized that all the curves in this series have identical 0° and 180° symmetry about the true center, but the symmetry for a 90° transformation angle decreases with increasing n, while the degree of the ordinal and subordinal rank eqs. increases.

Symmetry Mimics

Symmetry mimics are curves of higher degree than a basis curve that have 0° and 180° transforms about some specific pole that are identical to the corresponding transforms of the basis curve about the homologous pole. The mimics are designated after the basis curve and the pole in question, for example, *symmetry mimics of central conics about the center.*

If one selects curves with a very high degree of 0° and 180° symmetry as basis curves, i.e., curves with 0° and 180° transforms of no higher than 2nd degree, then their mimics also will have a very high degree of 0° and 180° symmetry, since they will have the identical transforms. The curves of finite degree of highest symmetry (as gauged by all transforms--or the α-transform--rather than merely by the 0° and 180° transforms) in polar coordinates, aside from centered circles and lines through the origin, are curves with formats expressible in the form $\cos^n\theta = f(x)$, with n a small integer and $f(x)$ a simple function of x.

Accordingly, if one examines the symmetry mimics of these curves, one obtains information about the form of eqs. of highly symmetrical curves of high degree. [Bear in mind that as used in this connection *highly symmetrical* connotes highly symmetrical with respect to their 0° and 180° symmetry about the pole

in question.] Although it is fairly obvious how the form of these eqs. will be related to the form of the basis curve--if they are synthesized by the $\cos^n\theta$ format approach used in the foregoing--this does not lessen the desirability of examining the eqs. of these highly interesting curves and discussing their properties, although these objectives are treated only very briefly. Table XIV-2 lists the basis eqs. and the two symmetry mimics of next-highest degree for: (1) the parallel line-pair cast about a point on the mid-line; (2) conics cast about the traditional focus and the true center; (3) limacons cast about the DP and its homologues; and (4) the $\cos^2\theta$-group cast about the true center.

It is evident from inspection of Table XIV-2 that the successive mimics are formed by multiplying each term of the basis eq. either by (x^2+y^2) or $(x^2+y^2)^2$, or by x^2 or x^4 (or y^2 or y^4). The multiplier that is applied depends upon whether a term in the format is in the numerator or denominator and whether the eq. derived from the format (by augmenting n of $\cos^n\theta$ or $\sin^n\theta$ by two units) need be squared to eliminate radicals. The precise rules are readily ascertained by working with a few examples.

All of the symmetry mimics have $0°$ and $180°$ transforms that are identical to those of the basis curve. All also have a similar morphology to that of the basis curve--in the sense that no additional loops, arms, double points, etc., are present, although *additional points of inflection are characteristic* of them. The similarity of structure, of course, follows from their manner of synthesis--since only the magnitude of the intercepts is changed--and, in fact, such similarity is prerequisite if the $0°$ and $180°$ transforms are to be identical.

Additionally, the mimics always have eqs. of higher degree (in rectangular coordinates) than the basis eq. and, in general, their $90°$ transforms and ordinal and subordinal rank eqs. are of higher degree than those of the basis curve. Two notable exceptions to these rules are treated below. It also will be noted that, as is the case for their basis curves, the mimics of the conic sections and the parallel line-pair do not conserve degree under inversion but invert to loci of degree $n+2$.

Table XIV-2. Symmetry Mimics

Parallel line-pair about a point on the midline

(a) $a^2 y^2 = j^4$ basis curve (14-71)

(b) $a^2 y^4 = j^4 (x^2 + y^2)$ $\sin^4\theta$ quartic mimic

(c) $a^2 y^6 = j^4 (x^2 + y^2)^2$ $\sin^6\theta$ sextic mimic

Conic sections about the traditional focus

(a) $j^2 (x^2 + y^2) - a^2 j^2 + 2abjx - b^2 x^2 = 0$ basis curve

(b) $j^2 (x^2 + y^2)^3 - a^2 j^2 (x^2 + y^2)^2 + 2abjx^3 (x^2 + y^2) - b^2 x^6 = 0$ $\cos^3\theta$ sextic mimic

(c) $j^2 (x^2 + y^2)^5 - a^2 j^2 (x^2 + y^2)^4 + 2abjx^5 (x^2 + y^2)^2 - b^2 x^{10} = 0$ $\cos^5\theta$ decic mimic

Central conics about the true center

(a) $\pm a^2 (x^2 + y^2) + a^2 b^2 - x^2 (b^2 \pm a^2) = 0$ basis curve

(b) $\pm a^2 (x^2 + y^2)^2 + a^2 b^2 (x^2 + y^2) - x^4 (b^2 \pm a^2) = 0$ $\cos^4\theta$ quartic mimic

(c) $\pm a^2 (x^2 + y^2)^3 + a^2 b^2 (x^2 + y^2)^2 - x^6 (b^2 \pm a^2) = 0$ $\cos^6\theta$ sextic mimic

Limacons about the double point

(a) $[(x^2 + y^2) + bx]^2 = a^2 (x^2 + y^2)$ basis curve

(b) $[(x^2 + y^2)^2 + bx^3]^2 = a^2 (x^2 + y^2)^3$ $\cos^3\theta$ sextic mimic

(c) $[(x^2 + y^2)^3 + bx^5]^2 = a^2 (x^2 + y^2)^5$ $\cos^5\theta$ decic mimic

Cos²θ-group about the true center

(a) $[a(x^2 + y^2) + bx^2]^2 = (x^2 + y^2)^3$ basis curve

(b) $[a(x^2 + y^2)^2 + bx^4]^2 = (x^2 + y^2)^5$ $\cos^4\theta$ decic mimic

(c) $[a(x^2 + y^2)^3 + bx^6]^2 = (x^2 + y^2)^7$ $\cos^6\theta$ tetradecic mimic

The Quartic Symmetry Mimic of the Parallel
 Line-Pair

The quartic symmetry mimic of the parallel line-pair has a higher degree of
symmetry than the basis curve and, in fact, is one of the most symmetrical
curves in polar coordinates. The curve consist of two opposed non-asymptotic
branches vaguely reminiscent of a hyperbola of high eccentricity. The branches
are convex toward the x axis at their vertices but the lateral arms inflect
at about $\pm 25^{\circ}$ from the vertical to become concave toward this axis.

The symmetry properties of the quartic symmetry mimic of the parallel line-
pair now are compared with those of the basis curve. The comparisons also hold
with a single line, because the transforms of the latter differ from those for
the parallel line-pair only in that the 180° transform for the single line is
trivial; the subordinal and ordinal rank eqs. are identical.

parallel line-pair	quartic symmetry mimic		
(a) $\quad a^2y^2 = j^4$	(a') $\quad a^2y^4 = j^4(x^2+y^2)$	basis curves	(14-72)
(b) $\quad \sin^2\theta = j^4/a^2x^2$	(b') $\quad \sin^4\theta = j^4/a^2x^2$	intercept formats	
(c) $\quad x = y$	(c') $\quad x = y$	trivial 0° transforms	
(d) $\quad x = y$	(d') $\quad x = y$	180° transforms	
(e) $\quad j^4(x^2+y^2) = a^2x^2y^2$	(e') $\quad j^2(x+y) = axy$	90° transforms	
(f) $\quad j^4\overset{o}{s}{}^2 = x^2(a^2x^2-j^4)$ $\quad\quad + y^2(a^2y^2-j^4)$	(f') $\quad j^2\overset{o}{s}{}^2 = 4x^2(ax-j^2)$ $\quad\quad + 4y^2(ay-j^2)$	ordinal rank eqs.	
(g) $\quad j^4\overset{o}{s}{}^2 = 2x^2(a^2x^2-j^4)$	(g') $\quad j^2\overset{o}{s}{}^2 = 8x^2(ax-j^2)$	0° and 180° sub-ordinal rank eqs.	
(h) $\quad j^4(a^2x^2-j^4)^2\overset{o}{s}{}^2 =$ $\quad x^2(a^2x^2-j^4)^3+j^{12}x^2$	(h') $\quad j^2(ax-j^2)^3\overset{o}{s}{}^2 =$ $\quad 4x^2(ax-j^2)^4+4x^2j^8$	90° subordinal rank eq.	

The notable results that emerge from this comparison are that: (a) the 90°
transform (72e') of the symmetry mimic is an equilateral hyperbola, compared
to a quartic (72e) for the basis curve; (b) the ordinal rank eq. (72f') is
of only 3rd degree, compared to 4th degree for the ordinal rank eq. (72f) of

the transforms of the basis curve; and (3) the subordinal rank eqs. (72g', h') are of only 3rd and 6th degree, compared to 4th and 8th degree for the basis curve (72g,h).

Considering first the linear 180° transform, valid direct comparisons (i.e., for the same angle of transformation about a comparable focus) can be made with 18 other curves listed in Appendix III (linear specific symmetry class), for which rankings for 180° transforms about a true center are given. The quartic symmetry mimic of the parallel line-pair outranks (i.e., has lower degree ordinal rank eqs. and a higher degree of symmetry about the true center) 14 of these, namely, all except the symmetry mimic of tangent circles, the 4-leaf rose, the $\cos^2\theta$-group, and tangent circles, while the basis curve itself outranks 12 of them and has the same rank as another. The eqs. corresponding to eqs. 72 for the $\cos^2\theta$-group are eqs. 73.

equation of $\cos^2\theta$-group

(a) $[a(x^2+y^2)+bx^2]^2 = (x^2+y^2)^3$ basis curve (14-73)

(b) $\cos^2\theta = (x-a)/b$ simple intercept format

(c) $x = y$ trivial 0° transform

(d) $x = y$ 180° intercept transform

(e) $x + y = 2a + b$ 90° intercept transform

(f) $\overset{o}{s}{}^2 = 4(x-a)[b-(x-a)]+4(y-a)[b-(y-a)]$ ordinal rank equation

(g,h) $\overset{o}{s}{}^2 = 8(x-a)[b-(x-a)]$ subordinal rank eq. for 0°, 90°, and 180° transforms

In the case of the 90° transform of the quartic symmetry mimic, valid direct comparisons can be made with 3 curves ranked in Appendix III (hyperbolic specific symmetry class). These are the inverse-$\cos^2\theta$ group (ordinal rank 4), the tri-angle self-inverters (ordinal rank 10), and Cassinians (ordinal rank 18), all 3 of which have hyperbolic 90° transforms about a true center and all 3 of which are outranked by the quartic symmetry mimic of the parallel line-pair (ordinal rank 3).

Valid indirect comparisons also can be made with two other curves--mutu-

ally-inverting quartic circles and the $n = 2$ representative of the root-format symmetry group of the equilateral strophoid--both of which have hyperbolic $0°$ and $180°$ transforms (of self-inversion) about a true center and ordinal ranks of 10 and 11, respectively. These curves also are outranked by a large margin but, of course, this already was evident from the comparisons within the linear specific symmetry class.

[Strictly speaking, symmetry comparisons for transformations at different angles about a comparable pole should be considered to be indirect only when it is necessary to carry them to the level of subordinal rank, i.e., when the ordinal ranks are the same. Since ordinal rank is independent of transformation angle, comparisons of the ordinal ranks of curves about comparable poles have direct validity for all transformation angles.]

While the quartic symmetry mimic of the parallel line-pair has greater symmetry about its center than does a single line about a non-incident point in the plane, it does not have greater symmetry--for any angle or about any pole--than a single line about an incident point. The latter belongs to the 0-degree circumpolar symmetry phylum and has no transform that falls into either the linear or quadratic symmetry class.

The Sextic Symmetry Mimic of Tangent Circles

The present example has intrinsic interest both because of its relationship to tangent circles and because it has the highest degree of symmetry about a true center of any curve in the linear specific symmetry class. The eqs. for tangent circles and their sextic symmetry mimic--which consists of "compressed"

tangent circles	sextic symmetry mimic		
(a) $(x^2+y^2)^2 = a^2x^2$	(a') $(x^2+y^2)^3 = a^2x^4$	basis curve	(14-74)
(b) $\cos^2\theta = x^2/a^2$	(b') $\cos^4\theta = x^2/a^2$	simple intercept format	
(c) $x = y$	(c') $x = y$	trivial $0°$ transform	
(d) $x = y$	(d') $x = y$	$180°$ transform	
(e) $x^2 + y^2 = a^2$	(e') $x + y = a$	$90°$ transform	
(f) $\overset{o}{s}^2 = (a^2-x^2)+(a^2-y^2)$	(f') $\overset{o}{s}^2 = 4x(a-x)+4y(a-y)$	ordinal rank equation	
(g) $\overset{o}{s}^2 = 2(a^2-x^2)$	(g') $\overset{o}{s}^2 = 8x(a-x)$	$0°$ and $180°$ subordinal rank equations	
(h) $\overset{o}{s}^2 = a^2$	(h') $\overset{o}{s}^2 = 8x(a-x)$	$90°$ subordinal rank eq.	

tangent ovals, each of which has only one line of symmetry—are given in 74, following the same arrangement as in eqs. 72 and 73.

It is seen that the sextic symmetry mimic of tangent circles is more symmetrical about the true center than the tangent circles themselves, inasmuch as its 90° transform about this pole is linear, compared to circular for the basis curve. In fact, its possession of both 90° and 180° transforms that are linear, together with both ordinal and subordinal ranks of 2, give it the identical transform degrees and ordinal and subordinal rankings about the true center as those for the $\cos^2\theta$-group. This is not unexpected, however, since these curves have a close polar-equational relationship, namely, $r = a+b\cos^2\theta$ for the $\cos^2\theta$-group and $r = a\cos^2\theta$ for the sextic symmetry mimic of tangent circles (both of these groups also have 45° circular transforms).

The close polar-equational relationship between these two groups allows one to compare the results of the analytical circumpolar symmetry analysis of the curves with theoretical expectations. Thus, according to the principles enunciated in Chapter I, the symmetry mimic of tangent circles is expected to have a higher degree of symmetry about the true center than do members of the $\cos^2\theta$-group, because its polar eq. is simpler (i.e., its rule of construction in polar coordinates is simpler). This comparison is made in eqs. 75.

$\cos^2\theta$-group		sextic symmetry mimic of tangent circles			
(a)	$x + y = 2a + b$	(a)	$x + y = a$	90° transforms	(14-75)
(f)	$\overset{o}{s}{}^2 = 4(x-a)[b-(x-a)]$ $+ 4(y-a)[b-(y-a)]$	(f')	$\overset{o}{s}{}^2 = 4x(a-x)$ $+ 4y(a-y)$	ordinal rank eqs.	
(g,h)	$\overset{o}{s}{}^2 = 8(x-a)[b-(x-a)]$	(g',h')	$\overset{o}{s}{}^2 = 8x(a-x)$	0°, 90°, and 180° subordinal rank eqs.	

It is clear from eqs. 75 that the symmetry mimic is more symmetrical about its center, albeit at the subfocal level, than are the curves of the $\cos^2\theta$-group about their centers, because it has a simpler 90° transform (and simpler ordinal and subordinal rank eqs.). It also is of interest to take note of the fact that altering the curve $r = b\cos^2\theta$ to $r = a+b\cos^2\theta$, by the addition of the constant a, has but a minor influence on the symmetry of the resulting curves about the true center (as compared to the basis curves). If the corre-

sponding polar eq. for the single circle similarly is altered to that of the limacon, i.e., $r = b\cos\theta$ to $r = a+b\cos\theta$, the symmetry of the curve is changed profoundly and the mirror-image symmetry about orthogonal axes is lost. [Note that for $a = 0$ in eqs. 75a,f,g,h the eqs. become identical to 75a',f', g',h' (if the parameters are given the same symbol). This, of course, is as expected, since letting $a = 0$ in the eq. of the $\cos^2\theta$-group yields the eq. of the sextic symmetry mimic of tangent circles.]

Symmetry Mimics of Central Conics

Symmetry mimics of central conics about the center are used as examples of the types of morphological changes that occur on progressing from the basis curve to symmetry mimics of ever greater degree.

Taking an ellipse ($e^2 = \frac{1}{2}$) first, the $\cos^4\theta$ mimic (see eqs. 71, Table XIV-2) departs from the form of the basis curve in having a pronounced flattening (increase in radius of curvature) between about $5°$ and $65°$ (using the 1st quadrant for illustration), but with no change in axial dimensions, which remain the same as those of the basis curve in all mimics. In the $\cos^{16}\theta$ mimic the curve is essentially circular (of radius $b = a/2^{\frac{1}{2}}$) from $40°$ to $90°$, whereas there is a broad bulge from $0°$ to $40°$. In the $\cos^{128}\theta$ mimic the circular region has expanded to from $15°$ to $90°$, with great narrowing of the bulge. In the $\cos^{1024}\theta$ mimic the total width of the bulge (including both the 1st and 4th quadrants) is only $10°$ at its widest (at the periphery of the circle) and only $4°$ at about 75% of the distance to its tip. In other words, the figure resembles the profile of a sphere with an attached equatorial disc.

For the hyperbola ($e = 2$) symmetry mimics the asymptotes of the basis curve are at $\pm60°$ to the x axis. The $\cos^4\theta$ mimic also has asymptotic branches but its asymptotes are at $\pm45°$. The curve continues to be compressed in higher-degree mimics. For the $\cos^{16}\theta$ mimic the asymptotes are at $\pm23.5°$, for the $\cos^{128}\theta$ mimic they are at ±8.41 degrees, while in the $\cos^{1024}\theta$ mimic they are at $\pm2.98°$, and the curve consists of two opposed greatly narrowed branches, only about $1°$ thick near the vertices and $4-5°$ thick at $x = 2a$.

"Pure" Intercept Products

Circumpolar Maxim 7 states that "the possession of "pure" xy compound 0^o and 180^o intercept-product formats that hold for a point in the plane and are expressible in very simple form, $xy = f(\theta,h,k)$, is an indication of a higher degree of circumpolar symmetry of a curve than the property of self-inversion about one or more poles." The basis for this Maxim now is examined. The simple intercept eq. 76a for a point in the plane of the ellipse, rearranged for quadratic solution as eq. 76b, is used for illustration.

<div align="center">

simple intercept equation of the ellipse
about a point in the plane

</div>

(a) $\quad x^2(b^2-a^2)\cos^2\theta - 2b^2hx\cos\theta + a^2x^2 + (b^2h^2+a^2k^2-a^2b^2) = 2a^2kx\sin\theta \qquad$ (14-76)

(b) $\quad [(b^2-a^2)\cos^2\theta+a^2]x^2 - 2(b^2h\cos\theta+a^2k\sin\theta)x + (b^2h^2+a^2k^2-a^2b^2) = 0$

(c) $\quad x_1x_2 = \dfrac{b^2h^2 + a^2k^2 - a^2b^2}{(b^2-a^2)\cos^2\theta + a^2} \qquad$ product of the roots
of equation 76b

The product of the two roots of this eq. (76c) is the ratio of the constant term to the coefficient of the x^2 term. It thus is independent of the coefficient of the x term. This root-product is the intercept product for a point (h,k) in the plane of the ellipse along lines through the point at the angle θ; it represents the intercept product for angles of both 0^o and 180^o. The condition for which the terms in h and k vanish from 76c defines the locus, for points of which the intercept product is constant for a given value of θ, in this case for points incident upon the imaginary asymptotes, $k^2 = -b^2h^2/a^2$.

It is evident from the manner of formation of the product of the roots, 77a'-c', for an eq. in x^{2n}, x^n, $f(\theta)$, and a constant term, that "pure"

(a) $\quad Ax^{2n}f(\theta) + B^2x^n + C^3 = 0 \qquad\qquad$ (a') $\quad x_1x_2 = C^3/Af(\theta) \qquad$ (14-77)

(b) $\quad Ax^{2n} + B^2x^n + C^3f(\theta) = 0 \qquad\qquad$ (b') $\quad x_1x_2 = C^3f(\theta)/A$

(c) $\quad Ax^{2n} + B^2x^nf(\theta) + C^3 = 0 \qquad\qquad$ (c') $\quad x_1x_2 = C^3/A$

(c") $\quad f(\theta) = (-Ax^{2n}-C^3)/B^2x^n$

intercept products in a function of θ, $x_1x_2 = C^3/Af(\theta)$ and $x_1x_2 = C^3f(\theta)/A$, are obtained for an eq. of any even degree when $f(\theta)$ occurs in the x^{2n} or constant term, whereas transforms of self-inversion, $x_1x_2 = C^3/A$, are obtained when transcendental expressions occur only in the coefficient of the term in x^n.

Accordingly, it is clear that an infinite number of curves can be synthesized along these lines that possess at least one pole for which a simply expressed "pure" intercept product $x_1x_2 = g(\theta)$ exists, as well as an infinite number for which a generic double-focus of self-inversion ($x_1x_2 = C^3/A$) exists. The latter curves already have been encountered above, since eq. 77c leads to the generalized intercept format, 77c", derived from the intercept format for the circle about a non-incident, non-central point in the plane.

The essential feature of the simple intercept eqs. of conic sections that fall into the category of expressibility in terms x^{2n}, x^n, and a constant term is that this is true of their eqs. about a point in the plane. Specifically, both the constants B^2 and C^3 are functions of the distances h and k, through which the curve is translated along the coordinate axes. It is by virtue of this feature that there exist simple expressions for the "pure" intercept products of conic sections about a point in the plane, as opposed merely to the existence of such products about a specific pole.

The key question, then, in regard to affirming Maxim 7, is whether the simple intercept eqs. of any other curves about a point in the plane can be expressed in the form 77a,b, because unless this can be achieved, simple expressions for "pure" intercept products, $xy = g(\theta,h,k)$, about a point in the plane cannot ensue by this route. [The association of a transcendental function only with one term is not an essential feature of eqs. 77a and 77b, though it is for eq. 77c.] Since the manner in which h and k enter the simple intercept eq. about a point in the plane is through association with x and y, respectively, i.e., $x\pm h$ and $y\pm k$, it is readily demonstrated that no simple intercept eq. with a term x^{2n}, for $n > 1$, can arise in the absence of association with terms in x^{2n-1}, x^{2n-2}, x^{2n-3},......x.

In other words, no curve of greater than 2nd degree possessing simple expressions for "pure" $xy = g(\theta,h,k)$ intercept products can be synthesized by this route. The only other known route for such a synthesis for a given

basis curve of higher than 2nd degree is to solve the simple mixed-transcen-
dental intercept eq. cast about a point in the plane for x and for y (with
θ replaced by θ+α) and to take the product of these solutions. But it is
clear from the foregoing treatments (as formulated in Maxim 37, below) that
the degree of these eqs., the one in x and the other in y (both x and y
being equivalent to the polar coordinate, r) is the same as the degree of the
basis curve in rectangular coordinates. Accordingly, the products of these
solutions will be the products of the general solutions for the roots of eqs.
of 3rd degree and higher, which will be immensely complex.

CIRCUMPOLAR MAXIM 37: *If a basis curve, f(x,y) = 0, of degree n in
rectangular coordinates is translated along (either or)
both coordinate axes to yield a rectangular equation,
f[(x+h),(y+k)] = 0, with f(h,k) ≠ 0, the polar
equation, r = g(θ,h,k) of the translated curve also
will be of degree n in r. If f(h,k) = 0, the polar
equation will be of degree (n-1) in r. In other words,
if the translated curve with rectangular equation of
degree n does not pass through the origin, its polar
equation also will be of degree n in r; if it passes
through the origin, it will be of degree (n-1) in r
(see also Circumpolar Maxim 4).*

[This Maxim, of course, is simply an explicit formulation of relationships
between eqs. in polar and rectangular coordinates; a reworded Maxim 4 would be
simply an explicit formulation of some properties of polar eqs.]

Accordingly, since conic sections have emerged as the most symmetrical
curves of finite degree by almost every measure, and they are the only genus
possessing simple expressions for "pure" intercept products, xy = g(θ,h,k),
about a point in the plane, Circumpolar Maxim 7 receives strong support from
this analysis.

Self-Inversion At 90°

Only two genera of curves have been encountered in the foregoing, subspecies of which possess equilateral hyperbolic 90° transforms--Cassinians and the inverse-$\cos^2\theta$ group--and of these transforms only those of single-oval Cassinians are intercept products of self-inversion.

It is illustrated here how an infinite number of superspecies or genera of single-oval curves that self-invert at 90° can be synthesized. The simple intercept format for Cassinians (eq. XII-27b) in the generalized form of eq. 78a provides the starting point. The key aspect of this intercept format that

(a) $\quad \cos^2\theta = \dfrac{x^4 + B^2 x^2/2 - C^4}{B^2 x^2}$ \quad generalized simple intercept format for single-oval Cassinians \hfill (14-78)

(b) $\quad x^2 y^2 = +C^4$ \qquad (b') $\quad xy = \pm C^2$ \quad 90° transforms of self-inversion

(c) $\quad x^2 + y^2 = 0$ $\qquad\qquad\qquad\qquad$ 90° transform with imaginary solutions

(d) $\quad x^2 = y^2$ \qquad (d') $\quad x = \pm y$ \qquad 0° and 180° transforms

(e) $\quad x^2 y^2 = -C^4$ $\qquad\qquad\qquad\qquad$ 0° and 180° transforms with imaginary solutions

leads to a 90° transform of self-inversion is that the coefficient of the x^2 term in the denominator be double that of the x^2 term in the numerator. When this relationship holds one obtains 78b,b',c for the 90° transforms. Eq. 78b' with the plus sign is the 90° transform of self-inversion for positive intercepts (or for both intercepts negative) while with the negative sign it is for one positive and one negative intercept (for a 90° angle of transformation, the transforms for one or both intercepts negative are not trivial). The point-circle of eq. 78c also is a 90° transform for these curves but it has only imaginary solutions (eq. XII-27b also leads to a point-circle 90° intercept transform with imaginary solutions).

The 0° and 180° transforms are eq. 78d. For 0°, the $x = -y$ transform is valid (eqs. 78d'), whereas for 180° a valid $x = y$ transform exists (since the curves all have a true center). There also are 0° and 180° transforms of self-inversion, 78e, with only imaginary solutions.

It will be noted that the transform of self-inversion, 78b,b', is given by

the same ratio of the coefficients as for the 0° and 180° transforms of self-inversion deriving from the formats of eqs. 43, namely the constant term of the numerator (or denominator) divided by the coefficient of the term of highest degree. But this is not the only parallel. It also is found that the format itself can be generalized to eq. 79a. For n even this also leads to 90° transforms of self-inversion (79b) and other homologous solutions (79c-e) to those for eqs. 78.

(a) $\cos^2\theta = \dfrac{Ax^{2n}+B^{n+1}x^n/2-C^{2n+1}}{B^{n+1}x^n}$ further generalization of the simple intercept format for single-oval Cassinians (14-79)

(b) $x^n y^n = +C^{2n+1}/A$ (b') $xy = (C^{2n+1}/A)^{1/n}$ 90° transform of self-inversion

(c) $x^n + y^n = 0$ 90° transform with imaginary solutions

(d) $x^n = y^n$ (d') $x = \pm y$ 0° and 180° transforms

(e) $x^n y^n = -C^{2n+1}/A$ 0° and 180° transforms with imaginary solutions

The above analysis applies in the cases where the constant term of the numerator of 78a and 79a is subtracted (corresponding to $C > \frac{1}{4}$ in eq. XII-27b) from the other two terms. On the other hand, if the constant term is added, the eqs. represent curves that possess two ovals, and the 90° transform of self-inversion (78b and 79b with the sign changed) has only imaginary solutions, while the 0° and 180° transforms of self-inversion (78e and 79e with the sign changed) have real solutions.

Tri-Angle Self-Inverters

It is shown above that two supergenera can be synthesized using the simple intercept format of Cassinians as the basis format. For $n = 2$ in eqs. 79 the two genera of curves are Cassinians and the curve of demarcation between the one and two-oval genera is the equilateral lemniscate. For n even and greater than 2, the curves resemble the corresponding genera of Cassinian ovals, and the curves of demarcation (with $C^{2n+1} = 0$) are the curves $B^{(n+1)}\cos^2\theta = Ax^n+B^{(n+1)}/2$.

It also is shown above that for a given n, one genus (the two-oval group) self-inverts at 0° and 180°, while the other genus (the single-oval group) self-inverts at 90°. The next question to be addressed is whether one also can synthesize curves that self-invert at all three angles.

The mode of accomplishing this synthesis hinged upon noting that for $n = 1$, the format 79a has root-format symmetry with Cartesian self-inverters, and, accordingly, leads to self-inversion both for the cases where the constant in the numerator is added and subtracted. In other words, real 0° and 180° transforms, 79e, exist because when $x^n y^n = -C^{2n+1}/A = xy = -C^3/A$, no root need be taken to obtain the transform of self-inversion.

However, this is true for any odd value of n. Accordingly, for n odd, the solutions for the *tri-angle self-inverters* are eqs. 80.

(a) $\cos^2\theta = \dfrac{Ax^{2n} + B^{n+1}x^n/2 - C^{2n+1}}{B^{n+1}x^n}$ simple intercept format for tri-angle self-inverters (n odd) (14-80)

(b) $xy = (C^{2n+1}/A)^{1/n}$ 90° transform of self-inversion

(c) $x^n + y^n = 0$ 90° transform with imaginary solutions

(d) $x = \pm y$ linear 0° and 180° transforms

(e) $xy = (-C^{2n+1}/A)^{1/n}$ 0° and 180° transforms of self-inversion

The basis for the negative sign for the 0° and 180° transforms of self-inversion (eq. 80e) is algebraic. For each angle θ the solution of eq. 80a for x yields two values, one of which always is positive (for the positive sign of the radical) and traces one oval, and the other of which always is negative and traces the other oval. Though the vectors are oppositely directed, they are only 90° out of phase with respect to the ovals. Accordingly, the product of the intercepts for the 0° transform is negative (80e).

In the case of the 180° transformation the members of each pair of complementary intercepts for self-inversion also are of opposite sign, yielding a negative product (80e). For the 90° transformation, however, the members of each pair of complementary intercepts for self-inversion are of the same sign, yielding a positive product (80b).

Lastly, I address the question of the properties of these unusual curves that self-invert at 3 angles. As to appearance, they consist of two concentric, congruent, orthogonal ovals. Individually, each of the two ovals self-inverts at 90° but not at 0° or 180°. The latter inversions are achieved, not by altering the symmetry of the individual ovals to yield 0°, 90°, and 180° self-inversion within each oval--that property would appear to be unique to the circle--but by having the ovals oriented at 90° to one another. In this way the property of self-inversion at 90° also becomes one of self-inversion at 0° and 180°. In other words, of two intercepts from the true center that give a self-inversion for, say, 0° between the two ovals, one would be 90° out of phase with the other if the two ovals were to be superimposed.

The basis curve for 80a for $n = 1$ is the sextic of eq. 81a, for which the 10th degree ordinal rank eq. about the true center is 81b. For the transforms of self-inversion, the subordinal rank eqs. 81c are of 8th degree, while for the linear 180° transform $x = y$, they are of 6th degree (81d).

(a) $\quad A^2(x^2+y^2)^3+(B^4/4+2AC^3)(x^2+y^2)^2-B^4x^2y^2-C^6(x^2+y^2) = 0 \qquad$ tri-angle self-inverter \qquad (14-81)

(b) $\quad (Ax^2+C^3)^2(Ay^2+C^3)^2 \overset{o}{s}{}^2 = (Ay^2+C^3)^2x^2[B^4x^2-4(C^3-Ax^2)^2]$ \qquad ordinal rank eq. of 81a about true center

$\qquad\qquad + (Ax^2+C^3)^2y^2[B^4y^2-4(C^3-Ay^2)^2]$

(c) $\quad A^2x^2(C^3+Ax^2)^2 \overset{o}{s}{}^2 = (C^6+A^2x^4)[B^4x^2-4(C^3-Ax^2)^2]$ \qquad subordinal rank eq. of 81b for 3 transforms of self-inversion

(c') $\quad x^2(x^2-A^2)^2 \overset{o}{s}{}^2 = (A^4+x^4)[4d^2x^2-(A^2+x^2)^2]$ \qquad subordinal rank eq. of mutually-inverting quartic circles

(c'') $\quad x^2(x^4+Ad^4) \overset{o}{s}{}^2 = d^4x^4/4 - (x^4+Ad^4)^2$ \qquad subordinal rank eq. of Cassinians, $A = 1/16 - C^2$

(d) $\quad (Ax^2+C^3)^2 \overset{o}{s}{}^2 = 2x^2[B^4x^2-4(C^3-Ax^2)^2]$ \qquad subordinal rank eq. of 81b for linear $x = y$ transform

(d') $\quad (x^2-A^2)^2 \overset{o}{s}{}^2 = 2x^2[4d^2x^2-(A^2+x^2)^2]$ \qquad subordinal rank eq. of mutually-inverting quartic circles for linear $x = y$ transform

(d'') $\quad (x^4-Ad^4)^2 \overset{o}{s}{}^2 = 2x^2[d^4x^4/4-(x^4+Ad^4)^2]$ \qquad subordinal rank eq. of Cassinians for linear $x = y$ transform

A comparison of the ordinal and subordinal rank eqs. for tri-angle self-inverters with those of curves listed in Appendix III (linear and hyperbolic specific symmetry classes) shows that for corresponding transforms their ordinal rank eqs. are of the same degree as those for mutually-inverting quartic circles but of lower degree than those for Cassinians. Tri-angle self-inverters, however, must be regarded as having higher symmetry than either of these other groups.

In circumpolar symmetry comparisons of tri-angle self-inverters and mutually-inverting quartic circles, though the degrees of the ordinal and comparable subordinal rank eqs. are the same, mutually-inverting quartic circles self-invert at only two angles (0° and 180°); their 90° transforms are of 6th degree (eq. XII-52). The close relationships between these two groups is to be seen in the similarity of corresponding subordinal rank eqs. (compare 81c to 81c' for transforms of self-inversion, and 81d to 81d' for the linear transforms, $x = y$).

In a corresponding circumpolar symmetry comparison with Cassinians, the tri-angle self-inverters have ordinal rank eqs. of much lower degree (10 compared to 18). Furthermore, one genus of Cassinians self-inverts only at 90° and the other only at 0° and 180°. Accordingly, even though the individual ovals of tri-angle self-inverters are very similar to the 90° self-inverting ovals of single-oval Cassinians, the combination of two concentric orthogonal ovals is more highly symmetrical than a single oval. A comparison of the subordinal rank eqs. for self-inversion supports the conclusion that tri-angle self-inverters more closely resemble mutually-inverting quartic circles than Cassinians (compare eqs. 81c and 81c' to eq. 81c"). But a comparison of the subordinal rank eqs. for the linear transforms, $x = y$, is less conclusive (eqs. 81d,d',d").

On the other hand, the comparatively high degree of the ordinal rank eqs. of tri-angle self-inverters, both in the linear and hyperbolic specific symmetry classes, again emphasizes the fact that even the highly unusual property of self-inversion of a curve about a pole at 3 different angles (actually 4 angles reckoning the 270° angle) is not a highly discriminating criterion of hierarchical circumpolar symmetry rank. Thus, several other curves with a true center that do not self-invert through any pole at any angle have a much higher degree of circumpolar symmetry than the tri-angle self-inverters (for example, judging upon the basis of valid comparisons between curve-pole combinations in the linear specific symmetry class; Appendix III).

Multi-Angle Self-Inverters

The above treatment of tri-angle self-inverters points the way for a synthesis of curves that self-invert at many angles--as many as desired. While the previous syntheses of self-inverters have hinged upon algebraic manipulations of intercept formats, the present treatment depends primarily upon geometrical considerations. The analysis, in fact, would have to be regarded as essentially trivial were it not for the fact that all previous considerations of self-inversion appear to have been concerned exclusively with the positive (0°) and negative (180°) varieties.

Since single-oval Cassinians provided the basis format for the derivation of the tri-angle self-inverters, two-oval Cassinians are used for illustration of the method of synthesis of *multi-angle self-inverters*. The generalized simple intercept format for two-oval Cassinians is 82a (generalized in the sense that the parameters B^2 and C^4 have replaced d^2 and $d^4[1/16-C^2]$ of the bipolar eq. $uv = Cd^2$). Quadratic-root solution of the simple intercept eq 82a'

(a) $\cos^2\theta = \dfrac{x^4+B^2x^2+C^4}{B^2x^2}$ generalized simple intercept format for 2-oval Cassinians (14-82)

(a') $x^4 + B^2x^2(\frac{1}{2}-\cos^2\theta) + C^4 = 0$ simple intercept eq. for 2-oval Cassinians

(b) $x^2 = \dfrac{B^2(\cos^2\theta-\frac{1}{2}) \pm [B^4(\cos^2\theta-\frac{1}{2})^2-4C^4]^{\frac{1}{2}}}{2}$ quadratic-root solution of 82a'

yields 82b.

The method of synthesis of multi-angle self-inverters from eqs. 82 is to apply the principle by which a tri-angle self-inverter was synthesized from an oval self-inverting at 90°, namely, by employing a curve with a second, congruent, concentric oval. However, whereas the latter synthesis hinged upon manipulations of the format that led to non-degenerate eqs., the present synthesis employs direct multiplication of loci by the use of degenerate eqs.

Since the two-oval Cassinians of eqs. 82 consist of two opposed ovals self-inverting at 0° and 180° about a true center lying midway between them, it is evident that if a second, congruent, concentric, orthogonal set of ovals is cast about the same center, the 4 ovals so constituted also will be tri-angle

self-inverters, self-inverting at $0°$, $90°$, and $180°$. I deviate from the convention of the above section, however, in designating this 4-oval curve as a tetra-angle self-inverter, since it (like the tri-angle self-inverter) also self-inverts at $270°$.

Similarly, if a congruent, concentric 4-oval dual Cassinian is superimposed upon the above 4-oval locus, with the corresponding axes of one at $45°$ to those of the other, an 8-oval locus that self-inverts at $0°$, $45°$, $90°$, $135°$, $180°$, $225°$, $270°$, and $315°$ is obtained. This method clearly can be employed to synthesize curves that self-invert at as many angles as desired.

It remains to give some examples of how non-intersecting loci having transforms of self-inversion with real solutions at all angles, α, are achieved. The above two objectives are attained by employing tangent ovals. The angular width of an oval is calculated by a consideration of the radicand of eq. 82b. When $4C^4 > B^4(\cos^2\theta-\frac{1}{2})^2$, all 4 roots become complex. Accordingly, the angular width of the ovals is determined by letting $4C^4 = B^4(\cos^2\theta-\frac{1}{2})^2$, whence $\cos^2\theta = 2C^2/B^2+\frac{1}{2}$, and $\theta = \pm\cos^{-1}(2C^2/B^2+\frac{1}{2})^{\frac{1}{2}}$. Since the oval extends from the positive to the negative value of the arccosine, its width is 2θ. Accordingly, for a tetra-angle self-inverter, one seeks $\cos^{-1}(2C^2/B^2+\frac{1}{2})^{\frac{1}{2}} = 45°$, whereupon the ovals will have an angular width of $90°$, and two orthogonal, concentric pairs of them will be mutually tangent along the $45°$ bisectors. Similarly, for tangent ovals in an octa-angle self-inverter, one seeks $\cos^{-1}(2C^2/B^2+\frac{1}{2})^{\frac{1}{2}} = 22\frac{1}{2}°$.

(a) $r^4 + 64j^2x^2(\frac{1}{2}-\cos^2\theta) + j^4 = 0$

2-oval Cassinians, ovals of width $86.417°$

(14-83)

(b) $r^4 + 4\cdot2^{\frac{1}{2}}j^2x^2(\frac{1}{2}-\cos^2\theta) + j^4 = 0$

2-oval Cassinians, ovals of width $45°$

(a') $[r^4+64j^2x^2(\frac{1}{2}-\cos^2\theta)+j^4]\cdot$

$[r^4+64j^2x^2(\frac{1}{2}-\cos^2\{\theta+90°\})+j^4] = 0$

tetra-angle self-inverter synthesized from basis curve 83a, ovals not tangent

(b') $[r^4+4\cdot2^{\frac{1}{2}}j^2r^2(\frac{1}{2}-\cos^2\theta)+j^4]\cdot$

$[r^4+4\cdot2^{\frac{1}{2}}j^2r^2(\frac{1}{2}-\cos^2\{\theta+45°\})+j^4]\cdot$

$[r^4+4\cdot2^{\frac{1}{2}}j^2r^2(\frac{1}{2}-\cos^2\{\theta+90°\})+j^4]\cdot$

$[r^4+4\cdot2^{\frac{1}{2}}j^2r^2(\frac{1}{2}-\cos^2\{\theta+135°\})+j^4] = 0$

octa-angle self-inverter synthesized from basis curve 83b, ovals tangent

In the particular case of two-oval Cassinians, tetra-angle self-inverters with tangent ovals cannot be achieved because the curve with ovals of 90° width is the curve of demarcation--the equilateral lemniscate--between the single-oval and two-oval genera, and it does not self-invert. Accordingly, the two cases used for illustration are eq. 83a', a 4-oval, non-tangent, tetra-angle self-inverter, consisting of dual Cassinians with ovals of width 86.417°, and 83b', an 8-oval, octa-angle self-inverting, tetra Cassinian with tangent ovals of width 45°. The corresponding eqs. for the component two-oval basis Cassinians with transverse axes coincident with the x-axis are 83a,b (in conventional polar form). Both eqs. 83a' and 83b' are, of course, degenerate, and of overall degrees 8 and 16, respectively, in rectangular coordinates.

The question of the comparative symmetry of these curves naturally arises. Is an 8-oval tetra Cassinian more symmetrical than a 4-oval dual Cassinian, and is the latter more symmetrical than a two-oval Cassinian? Intuitively, the answers are "yes" because the 8-oval curve possesses 8 lines of symmetry, and the 4-oval curve 4 lines of symmetry, whereas the two-oval curve possesses only 2 lines of symmetry. The answer also is "yes" from consideration of the fact that the 8-oval curve self-inverts at 8 angles, compared to 4 for the 4-oval curve and only 2 for the basis Cassinian. This matter is considered further below.

Comparative Symmetry of Multi-Oval Curves
With a True Center

It seems quite likely from the above considerations that increases in the number of lines of symmetry by superposition of several congruent loci of a two-oval basis curve is accompanied by increases in circumpolar symmetry. This matter is considered briefly here by comparing the symmetry of a basis equilateral lemniscate (84a,a') having 2 lines of symmetry, with that of a dual equilateral lemniscate (84c,c') having 4 lines of symmetry. The 4-leaf rose

(a) $r^2 = a^2(2\cos^2\theta-1)$ (a') $r = \pm a(2\cos^2\theta-1)^{\frac{1}{2}}$ equilateral lemniscate (14-84)

(b) $r = a(2\cos^2\theta-1)$ 4-leaf rose

(c) $r^4 = a^4(2\cos^2\theta-1)^2$ (c') $r^2 = \pm a^2(2\cos^2\theta-1)$ dual equilateral lemniscate

(84b) also is examined, both because it is closely related equationally to the equilateral lemniscate and because of its exceptionally high symmetry (see Appendix III).

It can be seen that the equilateral lemniscate (84a') is derived from the 4-leaf rose (84b) by taking the square root of the parenthetical portion of the right-hand term. This has the effect of (a) discarding (relegating to the imaginary domain) two of the loops, and (b) increasing the size of the remaining loops compared to those of the basis curve. The latter effect occurs because $(2\cos^2\theta-1)^{\frac{1}{2}}$ is greater than $(2\cos^2\theta-1)$ for all positive values of the radicand except 1. Accordingly, all the r coordinates are increased and the loop enlarged, though it retains the same angular width.

The degenerate eq., 84c, of the dual equilateral lemniscate is synthesized by rotating the basis locus, 84a, by 90° and combining the locus so obtained with the basis locus itself, as in eq. 83a', to give 84c. As can be seen, in this case this procedure is the equivalent of simply squaring the basis eq. In the case of mutually-inverting quartic circles, which also are represented by a degenerate eq., the centers of the individual circles are displaced relative to one another and a new true center comes into existence. Accordingly, many of the symmetry properties of the resulting curve differ from those of a single circle, including $\overset{o}{s}{}^2$ for transforms about the true center.

In the present case, in which the new locus is obtained by superposition of an orthogonal, congruent, centered curve, and there is no intersection of the curves except at the true center, $\overset{o}{s}{}^2$, i.e., $(ds/d\theta)^2$, about the true center is unaltered. This can be confirmed by forming $\overset{o}{s}{}^2$ from eqs. 84a and 84c.

In view of the above result, an assessment of the comparative symmetry of these two loci about the center must be based upon comparisons at the level of the transforms alone. This is the method that was employed above with the self-inverting Cassinian derivatives, but in the case of the latter curves it was not confirmed that $\overset{o}{s}{}^2$ for the derivative loci about the center was unaltered from that for the component two-loop loci.

In essence, the symmetry of the dual equilateral lemniscate differs from that of the basis curve in the existence of a real, linear 90° transform, $x = y$. The latter has the same ordinal and subordinal rank eqs. as for the 180° transform, $x = y$, of both the dual curve and the basis curve. On this analytical basis, and the possession of 4 lines of symmetry, as opposed to

merely 2 for the basis curve, one concludes that the dual curve possesses a higher degree of symmetry than the basis curve.

The eq. (84b) of the 4-leaf rose (which is a single-parameter subspecies of the $\cos^2\theta$-group) is not degenerate. Its 90° and 180° transforms, and trivial 0° transform also are identical ($x = y$), but the 4-leaf rose is found to be more highly symmetrical than the dual equilateral lemniscate on the basis of comparisons of their ordinal and subordinal rank eqs. (eqs. 85; a versus a', and b versus b').

<div style="text-align:center">the dual equilateral lemniscate the 4-leaf rose</div>

(a) $x^2 y^2 \overset{o}{s}{}^2 = y^2(a^4 - x^4) + x^2(a^4 - y^4)$ (a') $\overset{o}{s}{}^2 = 4(a^2 - x^2) + 4(a^2 - y^2)$ ordinal rank eqs. (14-85)

(b) $x^2 \overset{o}{s}{}^2 = 2(a^4 - x^4)$ (b') $\overset{o}{s}{}^2 = 8(a^2 - x^2)$ subordinal rank eqs., linear transform $x = y$

In fact, eq. 85b' is a member of the group of subordinal rank eqs. that has the lowest degree for linear specific symmetry about a true center (Appendix III). The subordinal rank eqs. for all known curves of finite degree with 2nd degree ordinal and subordinal rank for 180° transforms about a true center are listed as eqs. 86.

<div style="text-align:center">basis curve subordinal rank equations for linear transforms $x = y$</div>

(a) $r^2 = a^2\cos^2\theta$, $\overset{o}{s}{}^2 = 2(a^2 - x^2) = 2a^2\sin^2\theta$ tangent circles (14-86)

(b) $r = a(2\cos^2\theta - 1)$, $\overset{o}{s}{}^2 = 8(a^2 - x^2) = 32a^2\sin^2\theta\cos^2\theta$ 4-leaf rose

(c) $r^2 = a^2\cos^4\theta$ $\overset{o}{s}{}^2 = 8(ax - x^2) = 8a^2\sin^2\theta\cos^2\theta$ sextic symmetry mimic of tangent circles

(d) $r = a + b\cos^2\theta$ $\overset{o}{s}{}^2 = 8(x - a)\cdot = 8b^2\sin^2\theta\cos^2\theta$ $\cos^2\theta$-group
 $(b + x - a)$

All of these curves have an exceptionally high degree of symmetry about the true center. If one confines attention only to a comparison of the subordinal rank eqs. for 180° transformations, the tangent circles emerge as the most highly symmetrical curves in this category, i.e., they have the highest degree

of symmetry about a true center for a transformation angle of $180°$. [Although the eqs. in x for tangent circles and the 4-leaf rose come within a factor of 4 of being identical, the corresponding transcendental eqs. provide an additional measure of discrimination.] On the other hand, for a transformation angle of $90°$ all 3 of the other groups are more highly symmetrical than tangent circles; they all have *linear* (x = y) $90°$ transforms about the true center, compared to a circular transform for tangent circles (eq. 74e).

The True-Center Approach--Central Cartesians

Introduction

A non-axial inversion of a curve with a line of symmetry yields a curve with a focus of self-inversion. A geometrical proof of this was given by Maleyx (1875); an algebraic proof also is readily achieved. The properties of the basis curve are inconsequential; the proof holds for all pairs of points in the plane that are reflected in a given line. It also is true that for every basis curve that self-inverts there exists at least one pole about which this curve inverts to a curve with a line of symmetry; if the basis curve also possesses a line of symmetry, the poles in question lie on that line.

CIRCUMPOLAR MAXIM 38: *To every self-inverting subspecies of curve with a single line of symmetry there correspond one or two inversion subspecies with a true center (two orthogonal lines of symmetry). If only one inversion subspecies exists, it belongs to the basis genus for the inversion superfamily; if two inversion subspecies exist, they invert to one another through their true centers and one of them belongs to the basis genus.*

These relationships form the basis for the *true-center approach* to the synthesis of highly symmetrical curves. Since a curve with a true center has a $180°$ transform x = y about the center, it belongs to the 1st-degree symmetry phylum. Accordingly, it usually will be more symmetrical than any of its axial[*]inversions, in this respect, and always will have a simpler $180°$ transform than any of these inversions (even in the event that one of the latter curves has a linear transform). Additionally, a curve with a true center (or its central inversion)--derived by an axial inversion of a self-inverting basis curve with a line of symmetry--bears the same relationship to the corresponding inversion superfamily that conic sections bear to the QBI superfamily.

*[but non-central]

Circumpolar Symmetry of Bipolar Linear Cartesians

As examples of the true-center approach, bipolar linear Cartesians are employed. Their pertinent circumpolar symmetry properties are described briefly here as a preliminary to the application of the true-center approach, with attention confined to foci on the line of symmetry. Aspects of the self-inversion of "bicircular quartics" (two *conjugate* non-communicating quartic ovals) and of "serpentine circular cubics" (cubics consisting of an oval and a non-communicating serpentine arm) are largely known (see Salmon, 1879 and 1934; Williamson, 1887; Hilton, 1920). However, emphasis of previous work was different--there having been no consideration of Inversion Taxonomy and little attention to conservation properties--and there appears to have been no previous study of central Cartesians.

In bipolar coordinates the ovals of a linear Cartesian are represented by different eqs. The polar and rectangular eqs. (eq. 87), however, represent both ovals, and the corresponding circumpolar symmetry analysis applies to the two-oval system.

Fig. 2-1e

Eight discrete point foci are present on the line of symmetry; 4 lowest-ranking vertices at $(A+C)d/(A+B)$, $(A+C)d/(A-B)$, $(A-C)d/(A+B)$, and $(A-C)d/(A-B)$ [where the formulae hold for absolute values of A, B, and C]; 3 highest-ranking foci of self-inversion, at $x=0$, $x=d$, and $x=(A^2-C^2)d/(A^2-B^2)$; and an intermediate-ranking, penetrating variable focus at $x=A^2d/(A^2-B^2)$, which is the homologue of the limacon $-\frac{1}{2}b$ focus. This focus may be in the small oval, in the large oval, or in coincidence with a vertex of the small oval. On the other hand, neither the vertices nor the foci of self-inversion ever come into coincidence with each other or with one another, because $A^2=C^2$ and $B^2=C^2$ lead to the limacon condition.

$$[(x^2+y^2)(A^2-B^2)-2A^2dx+(A^2-C^2)d^2]^2 = 4B^2C^2d^2(x^2+y^2) \qquad \text{bipolar linear Cartesians} \qquad (14\text{-}87)$$

$$\text{simple axial intercept equation}$$
$$(x+h) \text{ translation}$$

$$4[h(A^2-B^2)-A^2d]^2x^2\cos^2\theta - 8B^2C^2d^2hx\cos\theta +$$

$$4[(x^2+h^2)(A^2-B^2)-2A^2dh+(A^2-C^2)d^2][h(A^2-B^2)-2A^2d]x\cos\theta +$$

$$[(x^2+h^2)(A^2-B^2)-2A^2dh+(A^2-C^2)d^2]^2 - 4B^2C^2d^2(x^2+h^2) = 0$$

simple axial intercept format, $\cos\theta = \dfrac{-B \pm (B^2 - 4AC)^{\frac{1}{2}}}{2A}$ (14-89)

$-B = -[(x^2 + h^2)(A^2 - B^2) - 2A^2 dh + (A^2 - C^2)d^2][h(A^2 - B^2) - A^2 d] + 2B^2 C^2 d^2 h$

$\pm(B^2 - 4AC)^{\frac{1}{2}} = \pm 2ABCd\{[A^2 d - (A^2 - B^2)h]dx^2 + (B^2 + C^2 - 2A^2)d^2 h^2 + (A^2 - C^2)d^3 h + (A^2 - B^2)dh^3\}^{\frac{1}{2}}$

$2A = 2[h(A^2 - B^2) - A^2 d]^2 x$

[Note that the form of the simple axial intercept format for linear Cartesians is the same as that for limacons (eq. X-12b), including a precise homology of the roles of the coefficients that define the $A^2 d/(A^2 - B^2)$ and $-\frac{1}{2}b$ foci, as they affect the terms in x^2 and x. This, of course, is to be expected, since limacons are members of *The Cartesian Group* (see Chapter X), for which either $A^2 = C^2$ or $B^2 = C^2$. Inasmuch as conics also are members of The Cartesian Group, for which $A^2 = B^2$, eq. 89 also takes the form of the simple axial intercept format for conics (for example, eq. VII-11) when $A^2 = B^2$.]

One focus of self-inversion, the center pole, $h = 0$, of eq. 87, is within the small oval. The ovals invert into one another (*inter-oval self-inversion*) either positively or negatively through this pole. The $x = d$ focus is either inside the small oval or outside of both ovals. When in the small oval, the ovals invert to one another through it, in complementary fashion to the manner of inversion through the $x = 0$ focus. When the $x = d$ focus is external the ovals always self-invert positively through it (*intra-oval self-inversion*). The $(A^2 - C^2)d/(A^2 - B^2)$ focus of self-inversion is in the complementary location, and the inversion about it is complementary to that for the $x = d$ focus--if the latter is within the small oval the former is external to both ovals, if the latter is external to both ovals, the former is within the small oval.

In other words, linear Cartesians possess 3 equivalent-ranking (but not equivalent in other respects) foci of self-inversion, two within the small oval and one external to both ovals. The ovals undergo positive intra-oval self-inversion about the external focus, and both positive and negative inter-oval self-inversion about the internal foci (positive about one and negative about the other).

These 3 foci of self-inversion have been known for many years. But the focus at $x = A^2 d/(A^2 - B^2)$ was not previously known. This focus, like the limacon $-\frac{1}{2}b$ focus, is defined by a $\cos^2\theta$-condition (vanishing of the coefficient of the $\cos^2\theta$ term of eq. 88), whereas the foci of self-inversion are defined by radicand conditions.

The simple axial intercept eq. and format are eqs. 88 and 89 (x+h translation). For $h = 0$ eq. 89 becomes 90a, for $h = d$ it becomes eq. 91a, and for $h = (A^2-C^2)d/(A^2-B^2)$ it becomes 92a. The first two formats are identical except for the exchange of the coefficients A and B. In all 3 cases simplification and reduction of the transforms arise through elimination of the radical as a result of the vanishing of the constant term of the radicand. The formats of eqs. 90a-92a will be recognized as formats of self-inversion; the corresponding transforms of self-inversion are 90b-92b. Vanishing of the coefficient of the $\cos^2\theta$ term of eq. 88 leads to the format of eq. X-26b for the focus at $x = A^2d/(A^2-B^2)$.

(a) $\cos\theta = \dfrac{(A^2-B^2)x^2+(A^2-C^2)d^2 \pm 2BCdx}{2A^2dx}$ simple intercept format for $x = 0$ focus of self-inversion (14-90)

(b) $xy = \pm(A^2-C^2)d^2/(A^2-B^2)$ eq. of self-inversion for format 90a

(a) $\cos\theta = \dfrac{(A^2-B^2)x^2+(C^2-B^2)d^2 \pm 2ACdx}{2B^2dx}$ simple intercept format for $x = d$ focus of self-inversion (14-91)

(b) $xy = \pm(B^2-C^2)d^2/(B^2-A^2)$ eq. of self-inversion for format 91a

(a) $\cos\theta = \dfrac{(A^2-B^2)^2x^2-(C^2-A^2)(B^2-C^2)d^2 \pm 2BA(A^2-B^2)dx}{2(A^2-B^2)C^2dx}$ simple intercept format for focus of self-inversion at $(A^2-C^2)d/(A^2-B^2)$ (14-92)

(b) $xy = \pm(B^2-C^2)(A^2-C^2)d^2/(A^2-B^2)^2$, eq. of self-inversion for format 92a

The Poles About Which Axial Self-Inverting Curves Invert to Curves With A True Center

The poles about which two-oval axial self-inverting curves invert to curves with a true center can be located readily by a vertex analysis, since the distances from each outer vertex to the adjacent inner vertex must be identical. Alternatively, they can be located by inverting the basis curve about an axial pole at $x = h$, followed by an $x+H$ translation of the inversion locus. The location of the pole H is determined by applying the conditions for a true center (Maxim 23 or reflective symmetry through both rectangular axes). This in turn yields the location of the pole(s) h.

The first method is illustrated for 4 linear Cartesian basis curves (Table XIV-3). Assume that an axial pole for inversion to a curve with a true center exists at an external location to the right of ovals with vertices at -a, -b, α and β. The condition for an identical separation of each outer vertex from the adjacent inner vertex leads to eq. 93a. It readily follows that the sought-after inversion poles lie at the locations given by eqs. 93b or 93c, depending upon the relative values of A, B, and C (eq. 93b, for example, is valid for Cartesian ovals for which both A^2 and B^2 are less than or greater than C^2).

(a) $\dfrac{j^2}{x+b} - \dfrac{j^2}{x+a} = \dfrac{j^2}{x-\beta} - \dfrac{j^2}{x-\alpha}$ vertex condition defining pairs of poles of inversion of linear Cartesians to central Cartesians (14-93)

(b) $x = \dfrac{d(A^2-C^2) \pm d[(A^2-C^2)(B^2-C^2)]^{\frac{1}{2}}}{(A^2-B^2)}$ (c) $x = \dfrac{d(B^2-A^2) \pm d[(B^2-A^2)(B^2-C^2)]^{\frac{1}{2}}}{(A^2-B^2)}$

Inversions of qualifying linear Cartesian ovals about the pole-pairs defined by eq. 93 lead to the unexpected result that the two *central Cartesian* inversion loci belong to a single subspecies; they merely differ in size and location. By contrast, the two curves with a true center--to which axial QBI curves invert--belong to different genera (an equilateral strophoid, for example, inverts to an equilateral hyperbola and an equilateral lemniscate).

A second unexpected result is that the poles of inversion of linear Cartesians to central Cartesians do not appear to have circumpolar focal rank. For QBI curves, the homologous inversions to central conic basis curves occur about the highest-ranking circumpolar focus (the DP or DP homologue). If these poles are not point foci of linear Cartesians, it is unlikely that the central Cartesian reciprocal inversion poles have focal rank.

A third unexpected result is that the reciprocal inversion poles are located asymmetrically about the centers of central Cartesians. Although their displacements from the central Cartesian centers are of the same magnitude and in opposite directions, their positions are asymmetrical because the central Cartesian inversion loci are incongruent (see Table XIV-3).

[When an inversion pole of linear Cartesian ovals is external, the reciprocal inversion pole is external to the central Cartesian ovals. In other cases, reciprocal inversion poles are internal. When a pole of inversion is within a large linear Cartesian oval but external to a small one, two opposed central Cartesian ovals are obtained (ovals No. 2 of Table XIV-3). In all other cases the central Cartesian ovals are "annular" (one oval is within the other).]

Table XIV-3. Inversions of Linear Cartesians to Central Cartesians

parameters A B C	vertices of linear Cartesians (relative to x = 0 focus)* other foci**	poles for inversion to central Cartesians	vertices of central Cartesians (relative to pole of inversion)	j^2 for self-inversion of central Cartesians
		Ovals No. 1	**(annular)**	
15/16 1/16 1	-0.0714285714 -0.0625 1.9375 2.214285714	-0.535312799	-3.115001963 -3.030710284 0.511310540 0.595602223	3.285777041
	0 1 -0.138392852 1.004464286	0.258527085	0.363689461 0.404397778 2.115001960 2.155710282	0.766359578
		Ovals No. 2	**(opposed)**	
$1+3^{\frac{1}{2}}$ $2+3^{\frac{1}{2}}$ 1	$-(2+3^{\frac{1}{2}})$ $-3^{\frac{1}{2}}$ 0.2679491924 0.5773502692	$(2^{\frac{1}{2}}-1)$	-6.836935065 -0.465925826 -0.241180955 6.129828280	0.728553399
	0 1 -1 1.154700539	$-(2^{\frac{1}{2}}+1)$	-0.758819045 0.334273329 0.372833453 1.465925828	0.021446610
		Ovals No. 3	**(annular)**	
0.7126096407 0.125 1	-0.4890838057 -0.343107750 2.044639361 2.914536322	$(2^{\frac{1}{2}}-1)$	-1.320443514 -1.107055161 0.399948363 0.613336709	0.728553399
	0 1 -1 1.03174603	$-(2^{\frac{1}{2}}+1)$	0.187661276 0.224272928 0.482833856 0.519445509	0.021446610
		Ovals No. 6	**(annular)**	
1 1.05 1.075	-41.5 -0.0365853659 1.012195122 1.5	0.631207575 2.40537779	-1.497470159 -0.023735375 1.151022927 2.624757706	1.21065535
	0 1 1.518292683 -9.756	2.40537779	-1.10451130 -0.717780965 -0.409506588 -0.022776253	0.08336780

*All values in units of d or d^2.
**Sequence: $x=0$, $x=d$, 3rd focus of self-inversion, $A^2d/(A^2-B^2)$

 Additional findings are that: (a) all axial-vertex inversions of a given
subspecies of linear Cartesian, and all axial-vertex inversions of all of its
axial inversions (including central Cartesians) give the same serpentine
circular cubic subspecies of central Cartesian axial vertex cubic; and (b)
all axial vertex cubics in the central Cartesian-based inversion superfamily
self-invert about all 3 axial vertices--by a different mode and typically
for a different value of the unit of linear dimension about each vertex.
Based upon the Inversion Taxonomy of the QBI superfamily, these findings are
not unexpected.

[In connection with Table XIV-3, note that the coefficients of the xy products
for self-inversion about the 3 foci of linear Cartesians are related to one
another--$xy_{eq.90a}xy_{eq.91a} = xy_{eq.92a}$--and each of these products for a given
focus is the product of the distances from that focus to the other 2 foci.
Similarly, the product of all coefficients of the vertex locations is the
square of the xy-product coefficient of eq. 90a, the pairwise product of the
coefficients of appropriate vertices gives the xy-product coefficient of eq.
90a, which is identical to the coefficient of the location of the
$(A^2-C^2)d/(A^2-B^2)$ focus, etc. Since most of the functions characterizing the
properties of both the linear and central Cartesians involve ratios of differ-
ences between the squares of A, B, and C, these functions are of the same
absolute magnitude for all ovals for which the differences between the squares
of A, B, and C are the same in absolute magnitude.
Ovals Nos. 2 and 3 illustrate this relatedness. Although these ovals bear
little resemblance to one another (the central Cartesian derived from ovals
No. 2 has opposed ovals, while the ovals derived from No. 3 are annular),
most of the functions characterizing them, their central Cartesians, and
inversions to central Cartesians are identical (positions of inversion poles,
j^2, location of 3rd focus of self-inversion, distances of true centers from
reciprocal inversion poles, etc.]

 Two concentric or congruent opposed circles and their inversions (none of
which belongs to the QBI superfamily) possess the inversion properties and in-
version modes of central Cartesians and axial members of the central Cartesian-
based inversion superfamily.* The functions characterizing their properties
(relationships between coefficients of xy products, etc.), however, are not
the same, with the exception that the magnitudes of the displacements of the
true centers from the reciprocal inversion poles are identical. [In this
connection, constructions for linear Cartesians from circles are known (see
Williamson, 1887).]

*[The negative intra-oval mode, however, is unique to the circle.]

Central Self-Inversion of Central Cartesians

All central Cartesians are found to undergo both positive and negative self-inversion about the true center. The mode of self-inversion that is lost --and replaced by a second line of symmetry--is the positive intra-oval mode if the central Cartesians are annular, but the positive inter-oval mode if they are opposed. These findings have led to the elucidation of a number of relationships between the inversion loci of curves with multiple modes of self-inversion. The following maxims are based on findings for axial cubic and quartic members of the central Cartesian-based inversion superfamily.

[In the treatments above and below, the term *axial* refers to the line of symmetry of linear Cartesians and to the homologous lines of symmetry of all of their axial inversions. An "open" arm of an axial vertex inversion cubic is referred to as a *serpentine arm*; both ovals and serpentine arms sometimes are referred to as *segments*.]

CIRCUMPOLAR MAXIMS

39: *Axial-vertex inversions of bicircular quartics with a single line of symmetry and 3 modes of self-inversion about poles thereon yield serpentine circular cubics that self-invert about all 3 axial vertices. Positive intra-arm and intra-oval self-inversion occur about the vertex of the serpentine arm (which possesses an asymptote), positive inter-segment self-inversion occurs about the far vertex of the oval, and negative inter-segment self-inversion occurs about the near vertex of the oval.*

40: *Axial inversions of bicircular quartics and serpentine circular cubics with a single line of symmetry and multiple modes of self-inversion about poles thereon, conserve the number of modes of self-inversion and the number of poles of self-inversion in inversion loci that also possess a single line of symmetry.*

41: *Axial inversions of bicircular quartics and serpentine circular cubics with a single line of symmetry and multiple modes of self-inversion about poles thereon, conserve the sum of the number of modes of self-inversion and the number of lines of symmetry.*

42: *On a given line of symmetry, all bicircular quartics with multiple modes of self-inversion possess a negative mode of inter-oval self-inversion.*

43: *Of the 3 modes of self-inversion of a bicircular quartic--positive inter-oval, positive intra-oval, and negative inter-oval--no more than one of each is possessed about poles* on the line of symmetry.*

44: *The axial-vertex inversions of a given subspecies of central Cartesian, as well as the axial-vertex inversions of all of its bicircular axial inversions, belong to the same subspecies of central Cartesian axial vertex cubic.*

*[In connection with references to poles of intra-segment self-inversion, it is understood that reference is to *common* poles about which *both* segments self-invert.]

45: *The axial-vertex inversions of a given subspecies of bicircular quartic with a single line of symmetry and multiple modes of self-inversion about poles thereon, as well as the axial-vertex inversions of all its bicircular axial inversions, belong to the same subspecies.*

Many new curves that self-invert in multiple modes about a true center have been described in the foregoing. It is a reasonable expectation that, aside from considerations of exponential degree, these curves and the axial members of inversion superfamilies based upon them will conform to the substance of these Maxims. Accordingly, non-quartic curves lacking a true center but possessing multiple modes of self-inversion probably are common. But linear Cartesians probably are the most symmetrical of these *tri-mode self-inverters* (by virtue of the fact that they are representable by linear bipolar and tripolar eqs.).

Number of Axial Point Foci of Members of the Central Cartesian-Based Inversion Superfamily

Linear Cartesians possess 11 known axial point foci, of which 8 usually are discrete. Reduction of the number of discrete foci to 7 occurs only when the $A^2d/(A^2-B^2)$ penetrating, variable focus is in coincidence with a vertex focus. The 3 additional foci beyond the discrete ones are accounted for by the fact that the 3 highest-ranking foci are generic double-foci of self-inversion.

The number, identity, and properties of the foci in other bicircular axial inversions of central Cartesians are expected to be the same. For the central Cartesians themselves, because of the gain of a line of symmetry, the number of axial point foci is expected to be only 10. Subtracting the 4 vertices leaves 6 axial point foci to be accounted for. Since the true center is a generic double-focus of self-inversion, this number is reduced to 4.

It is tempting, by analogy with the high-ranking focal inversions of axial QBI curves, to assume that the other 4 foci of central Cartesians are the 4 reciprocal inversion poles about which they invert to linear Cartesians. If one assumes that linear Cartesians are the most symmetrical inversions of central Cartesians, these 4 foci would be homologues of the traditional foci of conics. On the other hand, if the reciprocal inversion poles were focal, one also would have to assume that the two inversion poles about which linear Cartesians invert to central Cartesians are focal. But this would raise the

number of axial point foci of linear Cartesians to 13. Conservation of the sum of the number of axial point foci and the number of lines of symmetry then would require the presence of two additional point foci in central Cartesians, bringing the total number to 12.

A circumpolar symmetry analysis has not yet been carried out for central Cartesians but the analysis of linear Cartesians provides no indication of the presence of two additional foci beyond the 11 already treated. The resolution of this matter will have to await further studies.

Circumpolar Symmetry and the $0°$ and $180°$ Transforms Versus the $90°$ and α-Transforms

It already has been demonstrated in Chapter XII (see Circumpolar Maxim 31) that, unless it is a component of a generic double-focus, a focus of self-inversion does not possess circumpolar focal rank at any angle other than the angle of self-inversion (which is $0°$ in most of the cases considered). Since self-inversion is a highly specific type of symmetry, namely, reciprocal reflection of the curve through a point, this result already gave some reason to believe that the $0°$ reference angle does not provide a high degree of discrimination for general comparisons of the circumpolar symmetry of curves.

In the above treatments it has been found that, given a simple intercept format $\cos^n\theta = f(x)$, the curves have identical $0°$ transforms for all n. Furthermore, if the $\cos^n\theta$ function is generalized to an ensemble of functions $g_i(\theta)$, then all the curves represented by the simple intercept formats $g_i(\theta) = f(x)$, no matter the properties of the functions $g_i(\theta)$, also have identical $0°$ transforms. Accordingly, if the degrees of symmetry of an ensemble of curves about a comparable focus with a given $0°$ transform are to be compared *upon the basis of intercept transforms alone*, it is necessary to employ transforms at other angles as criteria.

The fact that many curves have $180°$ transforms of self-inversion also leads one to believe that the $180°$ reference angle does not provide a high degree of discrimination for general assessments of the comparative circumpolar symmetry of curves. [Of course, since the algebraically complete transform eqs. for $0°$ and $180°$ are identical except for signs, any conclusion bases on transforms for one of the angles also holds for the other angle.] It also has been shown

above that for transforms of the form $\cos^n\theta = f(x)$, all curves for which n is even have identical $0°$ and $180°$ transforms (i.e., identical to one another and identical from curve to curve), while all curves for which n is odd have the same $0°$ transform as those for which n is even and, in addition, have identical but different $180°$ transforms (i.e., different from those of the curves for which n is even).

Furthermore, if $\cos^n\theta$ is generalized to an ensemble of funtions $g_j(\theta)$, then for all those functions of the ensemble for which $g_j(\theta) = -g_j(\theta+180°)$ [corresponding to odd values of n for the $\cos^n\theta$ function], the $180°$ transforms will be identical with one another, and for all those functions for which $g_j(\theta) = g_j(\theta+180°)$, the $180°$ transforms not only will be identical with one another, they also will be identical to the $0°$ transforms. Accordingly, there also exist infinite numbers of sets of curves, all members of which have the same identical $0°$ and $180°$ transforms, and infinite numbers of sets, all members of which have the same $0°$ transforms and the same but different $180°$ transforms.

It follows from the above considerations that, if the circumpolar symmetry of these sets of curves is to be assessed upon the basis of intercept transforms alone, it is necessary to employ transforms for other reference angles, of which those for the $90°$ angle appear to be most suitable, or to employ the α-transform (which is pre-eminent but much more difficult to work with).

CIRCUMPOLAR MAXIM 46: *For the hierarchical ranking of curves according to their circumpolar symmetry about specific poles, among the three reference angles, 0°, 90°, and 180°, the highest degree of discrimination is provided by the intercept transform for a 90° reference angle.*

CIRCUMPOLAR MAXIM 47: *Positive and negative reciprocal reflective symmetry (self-inversion at 0° and 180°) of a curve through a point constitutes a high degree of symmetry about that point but is not indicative of a high degree of symmetry of any other type with respect to that point, or with respect to any other locus.*

CIRCUMPOLAR MAXIM 48: *Reflective (mirror-image) symmetry of a curve through a line constitutes a high degree of symmetry about that line and all parallel lines but is not indicative of a high degree of symmetry with respect to any other locus.*

CIRCUMPOLAR MAXIM 49: *The possession by a curve of a high degree of circumpolar symmetry about any pole for a 90° reference angle (90° circumpolar intercept transforms of low exponential degree) is a strong indication of a high degree of circumpolar symmetry of the curve about that locus at other angles.*

The origin of this book traces back to a discovery made in 1955, while calculating the movements of the platform of a newly-developed laboratory shaker of unique design. Thoughts concerning the symmetry of curves were not in my mind; nor was it anticipated that the curves traced out by the movements of this platform, using even circular and elliptical drive-cams, would be unknown. The heart of the discovery was a universally applicable transformation, wherein the rotation of one curve or figure (the shaker drive-cam) about a specific point generated another curve or figure. Even when the former curve, the "basis curve" (i.e., the initial or "starting" curve) is well known, the generated curve, or *circumpolar intercept transform*, most frequently is unknown. Only when highly symmetrical curves are rotated about certain specific points, their *highest-ranking foci*, are these intercept transforms sometimes common curves.

Figs.
1-2

1-1

5-1

Since I hardly was prepared to entertain the likelihood that unknown properties of the circle or ellipse would be disclosed through such a simple procedure, I little suspected that at my fingertips lay keys to an extensive unexplored domain of geometry—keys that would: reveal fascinating new areas of geometrical beauty, establish powerful analytical foundations for the study of the symmetry of curves and surfaces, greatly enlarge the bases for the analysis and classification of curves, lead to new insights regarding relationships between curves, and between reference elements and the concept of symmetry, and lead to the discovery of remarkable new curves (*near-conics, the confocal two-arm parabola, harmonic* and *partial parabolas, disparate two-arm hyperbolas, compound and disparate ellipses, polar-circular Cartesians, pseudo-exchange-limaçons, eccentricity-dependent self-inverters*) and new relationships between curves (relationships that led to *non-focal self-inversion loci, inversion images, constant pedal-eccentricity loci, symmetry mimics,* and curves having *polar exchange symmetry, root-format symmetry,* and *congruent and incongruent extremal-distance symmetry*), including extraordinary homologies between the circle and equilateral hyperbola.

Though my curiosity was aroused by initial studies of intercept transforms, I was not compelled to carry out a thorough analysis, as there was no reason to believe that the transforms and transformation were unknown. The intercept transformation is so simple and straightforward that I felt it would have been a logical object of investigation for the first ancient geometer to study the rotation of an off-center wheel. In fact, any student of geometry since classical Grecian

times could have chanced upon and explored the generative potentials of this transformation with only the most primitive tools of the geometer.

From the time of its initial discovery I was intrigued by an aspect of the transformation that ultimately proved to be of the greatest significance. This was the matter of how the properties of a circumpolar intercept transform of a basis curve are influenced by the location of the pole about which the transformation is carried out. In time, I came to realize that the symmetry of a basis curve about a specific pole could be characterized completely in terms of the properties of its transforms about that pole.

Eleven years after discovering the circumpolar intercept transformation, I consulted knowledgeable colleagues concerning it, but it was unknown to them. It was not until 12 more years had passed, when I decided to use the transformation as an exercise in a course I gave in mathematical modeling, that I undertook a detailed analysis of it. At first I concentrated on the fascinating geometrical relationships to be found between common basis curves and their ofttimes common but frequently unknown transform curves.

My first mapping of the exponential degree of circumpolar intercept transforms onto the reference poles of conic sections led to a key finding. This was the discovery of the fundamental property of the traditional foci of curves: *a point focus is a point about which a curve has greater symmetry than it has about neighboring points*. It then became evident that the various previous definitions of the foci of curves depended upon relationships of these points to the curves that merely were concomitants of this basic property.

Mapping of the degree of the transforms also revealed that, from the point of view of symmetry, the traditional point foci of curves were not their only focal loci. Since that time it has been clear that the circumpolar intercept transformation and its properties could not be known; because of their fundamental nature, they would have been common knowledge.

These findings shifted the emphasis of my studies; I began to investigate the symmetry of well-known curves about their foci, as revealed by the corresponding intercept transforms. The approach was to select a highly symmetrical curve and then locate its focal loci by mapping the degree of its intercept transforms onto points in the plane considered as poles for the transformation. Very shortly after its inception, this goal was changed. The new emphasis was on synthesizing curves for which the highest-ranking focal loci automatically would be known. This was accomplished by formulating simple linear

equations in the undirected distances from a point on an unknown curve to two fixed reference poles, converting these *bipolar* equations to equations in polar or rectangular coordinates, and studying the transformations of the represented curves about the two poles. These poles automatically included the highest-ranking circumpolar foci, because linear bipolar rules for the construction of each curve had been formulated relative to them.

But once this new program had been put into practice, the conclusion became inescapable that concepts of the symmetry of a curve could not be separated from elements of reference. A curve possessing the highest symmetry relative to a single point-pole might not occupy the position of highest symmetry relative to an ensemble of two points, including the pole in question, or relative to a point and a line, a point and a circle, etc. Accordingly, the emphasis of my studies took still another turn. I ceased studying exclusively the properties of the foci of curves, as revealed by their circumpolar intercept transforms, and took up the study of the most symmetrical curves relative to the reference elements of different coordinate systems, i.e., *the curves with the simplest and lowest-degree equations in the respective coordinates.*

Up to this juncture my investigations had been carried out independently of the original literature of geometry. But from the time I realized that concepts of symmetry and coordinate reference elements are inseparably linked, it became desirable to examine the pertinent original literature, including studies of Descartes, Newton, Chasles, Cayley, Moutard, Darboux, and Crofton. Key texts included Salmon's *Treatise On the Conic Sections* (1879) and his *Treatise On the Higher Plane Curves* (1879 and 1934), Williamson's *Treatise On the Differential Calculus* (1887), Hilton's *Plane Algebraic Curves* (1920), Yates' *Curves and Their Properties* (1947), and Zwikker's *Advanced Plane Geometry* (1950).

Even a cursory examination of these works sufficed to reveal that the literature contains no hint of an interdependence between concepts of symmetry and coordinate reference elements. In fact, most specialized geometry texts do not even contain an entry of "symmetry" in their index. Nor is there discussion or mention of a significant property of bipolar coordinates that was evident from my preliminary studies, namely, that a great deal of information about both the foci and the symmetry of a curve generally can be obtained through mere inspection of its bipolar equations (a property possessed to lesser degree by the equations of curves in polar and rectangular coordinates).

Tripolar coordinates were mentioned only infrequently. There was little to be found relative to polar-linear constructions beyond the focus-directrix constructions for conics and the conchoid construction. Only very infrequently was there mention of the polar-circular construction for central conics. The feasibility of basing a coordinate system on the reference elements for these known constructions, i.e., a point and a line or a point and a circle appears not to have received serious consideration. Nor was there mention of multi-polar constructions with more than 4 poles or of linear-circular or bicircular coordinates. The only non-rectangular bilinear system treated was the "oblique" system, and this with non-orthogonal distances and exclusively within a directed-distance framework. Similarly, trilinear coordinates were employed exclusively with directed distances.

There seemed to be little realization that the well-known focus-directrix and focus-focus constructional rules for conics, and the lesser known focus-directive circle construction, are only highly exceptional cases among numerous undirected-distance constructions that exist for these and other curves relative to the same pairs of reference elements.

It is well known that it is possible to formulate many rectangular eqs. for congruent curves, each depending upon the curve's location and orientation. All these equations are of the same degree in the variables. But in coordinate systems in which no more than one reference element consists of a line (but not necessarily including a line), different equations for congruent curves not only can have vastly different complexity, they also can be of different degree in the variables. These differences are highly significant, because they relate directly to the concept of the symmetry of a curve relative to the coordinate reference elements.

In view of these observations and certain other impressions from the literature, I felt there was little to be gained at that time from an extensive literature study. My studies to that juncture already had provided sufficient insight and perspective to point the way for a broader approach in greater depth, without the need for a closer acquaintanceship with, say, the teachings of projective and affine geometry. Accordingly, in the next months I concentrated on studies of the types of curves defined by various degree classes of equations in undirected-distance coordinate systems (the topics of Chapters II-IV).

 In the last phases of the work I was much occupied with the significance of
elementary point transformations, particularly inversion, in relation to the
symmetry and classification of curves. Much of the material in the last four
chapters was derived concurrently with their first drafting, whereas earlier
chapters were written months after the pertinent studies had been made.

 My inversion analyses were carried out independently of the methods employed
by previous workers. Consequently, it is not surprising that my approach was
different. Considerations of symmetry and questions relating to the classifi-
cation of curves directed my concerns to very specific questions--framed ana-
lytically--about the relationships between the inversion loci of conics about
lines of symmetry, and the inversion loci of these inversion loci, etc. Ac-
cordingly, I was at least as interested in the properties of each of the loci
in an inversion chain relative to one another and the basis conic as in the
properties of the transformation itself. On the contrary, in the classical
work, the emphasis is chiefly on the most general properties of the trans-
formation and on the questions of the circumstances under which self-inversion
occurs and in how many different ways.

 It was only after completing a first rough draft of the book and returning
to an examination of the literature that two major treatments of self-inversion
were located. In the course of searching for pioneering papers by Moutard,
dating from 1864, a review by Tweedie (1902) was found in which references were
made to works by Maleyx (1874, 1875) and Königs (1892). The latter are by far
the most extensive works on self-inversion in existence, yet they are virtu-
ally unknown in the literature. Very few of my specific results concerning the
inversion transformation and, particularly, the systematic organization of
curves by their relatedness through inversion, are to be found either in the
elegant general treatments of Maleyx and Königs or elsewhere. Of course, the
possibility always exists that a pertinent prior study has been overlooked
and that a result derived by a symmetry analysis is known in some more or less
unrelated context.

APPENDIX I. Transformation Formats

α-Transforms

(a)* $$f^2(x) + f^2(y) - 2f(x)f(y)\cos\alpha = \sin^2\alpha$$

(b)* $$[f(x)-\sin^2\alpha]^2 + [f(y)-\sin^2\alpha]^2 - 2f(x)f(y)(\cos^2\alpha-\sin^2\alpha) = \sin^4\alpha$$

0° and 180° (lower signs) Transforms

(a) $$f^2(x) + f^2(y) \mp 2f(x)f(y) = 0$$

$$[f(x) \mp f(y)]^2 = 0$$

$$f(x) = \pm f(y)$$

(b) $$f^2(x) + f^2(y) - 2f(x)f(y) = 0$$

$$[f(x) - f(y)]^2 = 0$$

$$f(x) = f(y)$$

90° Transforms

(a) $$f^2(x) + f^2(y) = 1$$

(b) $$[f(x)-1]^2 + [f(y)-1]^2 + 2f(x)f(y) = 1$$

$$[f(x)+f(y)]^2 - 2[f(x)+f(y)] + 1 = 0$$

$$f(x) + f(y) = 1$$

45° Transforms

(a) $$f^2(x) + f^2(y) - 2^{\frac{1}{2}}f(x)f(y) = \tfrac{1}{2}$$

(b) $$[f(x)-\tfrac{1}{2}]^2 + [f(y)-\tfrac{1}{2}]^2 = \tfrac{1}{4}$$

$$f^2(x) + f^2(y) + \tfrac{1}{4} = f(x) + f(y)$$

*(a) is for format, $\sin\theta$ or $\cos\theta = f(x)$, (b) is for format, $\sin^2\theta$ or $\cos^2\theta = f(x)$

APPENDIX II. Inventory of Axial and Point-In-the-Plane
Simple Intercept Equations*

CONICS

Line (x axis, y+k translation)

$$x\sin\theta + k = 0$$

Parallel Line-Pair

$$a^2 x^2 \sin^2\theta = j^4 \tag{6-2a}$$

Circle

$$2hx\cos\theta - x^2 + (R^2 - h^2) = 0 \tag{6-14a}$$

Parabola

$$x^2\cos^2\theta + 4ax\cos\theta - x^2 + 4ah = 0 \tag{6-23a}$$

Central Conics

$$x^2(b^2 \mp a^2)\cos^2\theta - 2b^2 hx\cos\theta + a^2 x^2 + b^2(h^2 - a^2) = 0 \tag{7-2a,b}$$

CUBICS

Cissoid of Diocles

$$2(a+h)x^2\cos^2\theta + (x^2 + 3h^2)x\cos\theta + (h-2a)x^2 + h^3 = 0 \tag{9-2a}$$

Hyperbola Axial Vertex Cubics

$$(2h-a-b)x^2\cos^2\theta + [x^2 + h(3h-2b)]x\cos\theta + (a+h)x^2 - h^2(b-h) = 0 \tag{9-8a}$$

Ellipse Axial Vertex Cubics

$$(2h+a-b)x^2\cos^2\theta + [x^2 + h(3h-2b)]x\cos\theta + (h-a)x^2 - h^2(b-h) = 0 \tag{9-17}$$

Folium of Descartes

$$2x^3\cos^3\theta + 2bx^2\cos^2\theta - [3x^2 + h(3h-2b)]x\cos\theta - (b+3h)x^2 - h^2(h-b) = 0 \tag{9-23}$$

*Equation numbers, where given, refer to location of equation, or related equation in text.

CUBICS (continued)

Parent Axial Vertex Cubic

$$(1-C)x^3\cos^3\theta + [h(3-C)-a-b]x^2\cos^2\theta + [Cx^2+h(3h-2b)]x\cos\theta +$$

$$(Ch+a)x^2 + h^2(h-b) = 0 \qquad (9-28)$$

Tschirnhausen's Cubic

$$x^3\cos^3\theta - 3(a+h)x^2\cos^2\theta + 3(h^2-5ah/2+a^2)x\cos\theta - 27ax^2/4 -$$

$$(h-2a)^2(h+a/4) = 0 \qquad (9-33)$$

QUARTICS

Double-Point Inversion Quartic of the Folium of Descartes

$$2(b+2h)x^3\cos^3\theta + 2(x^2+3h^2)x^2\cos^2\theta + [h^2(4h-3b)-3bx^2]x\cos\theta -$$

$$x^2(x^2+3bh) - h^3(b-h) = 0 \qquad (9-30)$$

Limacons

$$(b+2h)^2x^2\cos^2\theta + 2[x^2(b+2h)+h(2h^2+3bh+b^2-a^2)]x\cos\theta + x^4 +$$

$$[2h(b+h)-a^2]x^2 + h^2[(b+h)^2-a^2] = 0 \qquad (10-12a)$$

Limacon Non-Axial (-b/2) Covert Linear Focal Locus

$$4k^2x^2\sin^2\theta-2k(a^2-2B^2-2x^2)x\sin\theta+x^2[x^2+(2B^2-a^2)]+(B^4-a^2C^2) = -a^2bx\cos\theta \qquad (10-15a)$$

$$B^2 = (k^2-b^2/4) \qquad C^2 = (k^2+b^2/4)$$

Central Quartics (conic parameters)

$$[j^4(b^2\pm a^2)-4a^2b^2h^2]x^2\cos^2\theta + 2b^2h(j^4-2a^2h^2-2a^2x^2)x\cos\theta-a^2b^2x^4 +$$

$$a^2x^2(\mp j^4-2h^2b^2) +h^2b^2(j^4-a^2h^2) = 0$$

Central Quartics (minor and conjugate axes)

$$[j^4(b^2\pm a^2)+4a^2b^2k^2]x^2\sin^2\theta + 2a^2k(2b^2x^2+2b^2k^2\pm j^4)x\sin\theta + a^2b^2x^4 +$$

$$b^2x^2(2a^2k^2-j^4) + a^2k^2(b^2k^2\pm j^4) = 0$$

QUARTICS (continued)

Bipolar Parabolic Cartesians ($u^2 = Cdv$)

$$[2(h-a)x\cos\theta + x^2 + d(d-2h) + h^2]^2 = C^2d^2(x^2 + 2hx\cos\theta + h^2) \tag{12-9}$$

Bipolar Linear Cartesians ($Bu + Av = Cd$)

$$\{2[h(A^2-B^2) - A^2d]x\cos\theta + x^2(A^2-B^2) - 2A^2dh + h^2(A^2-B^2) + d^2(A^2-C^2)\}^2 =$$

$$4B^2C^2d^2(x^2 + 2hx\cos\theta + h^2) \tag{12-10}$$

All Axial QBI Quartics and Cubics (except those for e = 1)

$$[4b^2(h^2-a^2)H^2 + 4b^2hj^2H + j^4(b^2\pm a^2)]x^2\cos^2\theta + \tag{12-12}$$

$$2b^2x\{[2(h^2-a^2)H + hj^2]x^2 + H[2(h^2-a^2)H^2 + 3hj^2H + j^4]\}\cos\theta +$$

$$b^2(h^2-a^2)x^4 + [2b^2(h^2-a^2)H^2 + 2b^2hj^2H \mp a^2j^4]x^2 + b^2H^2[(h^2-a^2)H^2 + 2hj^2H + j^4] = 0$$

Axial (H,0) Parabola Axial (h,0) Inversions

$$[16ahH^2 + 8ah^2H + j^4]x^2\cos^2\theta + 4a[x^2(4hH+j^2) + (4hH+3j^2)H^2]x\cos\theta + \tag{12-34a}$$

$$4ahx^4 + (8ahH^2 + 4aj^2H - j^4)x^2 + 4a(hH+j^2)H^3 = 0$$

Eccentricity-Dependent Self-Inverters

$$[4b^2(b^2-a^2)H^2 + 4b^3j^2H + j^4(b^2\pm a^2)]x^2\cos^2\theta + \tag{12-12,}$$
$$\tag*{$h = b$}$$

$$2b^2x\{[2(b^2-a^2)H + bj^2]x^2 + H[2(b^2-a^2)H^2 + 3bj^2H + j^4]\}\cos\theta +$$

$$b^2(b^2-a^2)x^4 + [2b^2(b^2-a^2)H^2 + 2b^3j^2H \mp a^2j^4]x^2 + b^2H^2[(b^2-a^2)H^2 + 2bj^2H + j^4] = 0$$

Mutually-Inverting Quartic Circles (axis [h,0] of intersection)

$$4(h^2+d^2)x^2\cos^2\theta + 4h(h^2+d^2-R^2+x^2)x\cos\theta + x^4 + 2(h^2-d^2-R^2)x^2 + (h^2+d^2-R^2)^2 = 0 \tag{12-36}$$

Mutually-Inverting Quartic Circles (major axis [0,k]) (12-42)

$$4(k^2-d^2)x^2\sin^2\theta + 4k(k^2-d^2-R^2+x^2)x\sin\theta + x^4 + 2(k^2+d^2-R^2)x^2 + [R^4 - 2R^2(k^2+d^2) + (k^2-d^2)^2] = 0$$

Point-In-the-Plane (H,K) Parabola Axial (h,0) Inversion Cubics and Quartics

$$[16ahH^2 + 8aj^2H + j^4 - 16ahK^2]x^2\cos^2\theta + [4a(4hH+j^2)(x^2+H^2+K^2) + 8aj^2H^2]x\cos\theta \tag{12-61}$$

$$+ 2K[8ah(x^2+H^2+K^2) - j^4 + 4aj^2H]x\sin\theta + 8aK[4hH+j^2]x^2\sin\theta\cos\theta + 4ahx^4$$

$$+ [8ah(H^2+3K^2) + 4aj^2H - j^4]x^2 + 4ah(H^2+K^2)^2 + 4aj^2H(H^2+K^2) - j^4K^2 = 0$$

QUARTICS (continued)

Point-In-the Plane (H,K) Central Conic Axial (h,0) Inversion Cubics and Quartics

$$[4b^2(h^2-a^2)(H^2-K^2)+4b^2hHj^2+j^4(b^2\pm a^2)]x^2\cos^2\theta + \qquad (12\text{-}62)$$

$$\{2b^2[2(h^2-a^2)H+hj^2](x^2+H^2+K^2)+4b^2hH^2j^2+2b^2j^4H\}x\cos\theta +$$

$$K[4b^2(h^2-a^2)(x^2+H^2+K^2)+4b^2hHj^2\mp 2a^2j^4]x\sin\theta +$$

$$4b^2K[2(h^2-a^2)H+hj^2]x^2\sin\theta\cos\theta + [b^2(h^2-a^2)(x^2+H^2+K^2)^2 +$$

$$4b^2(h^2-a^2)K^2x^2 + 2b^2hHj^2(x^2+H^2+K^2) + (b^2H^2\mp a^2K^2\mp a^2x^2)j^4] = 0$$

Point-In-the-Plane (H,K) Parabola Point-In-the-Plane (h,k)
Inversion Cubics and Quartics

$$[4C^2(H^2-K^2)-8aj^2H-4j^2kK-j^4]x^2\cos^2\theta + 4(A^2C^2H-B^2Hj^2-aA^2j^2)x\cos\theta + \qquad (12\text{-}74)$$

$$2(2A^2C^2K-2B^2j^2K+A^2j^2k+j^4K)x\sin\theta + 4(2C^2HK+Hj^2k-2aj^2K)x^2\sin\theta\cos\theta +$$

$$4K(j^2k+C^2K)x^2 + A^4C^2 - 2A^2B^2j^2 + j^4(x^2+K^2) = 0$$

$$A^2 = x^2+H^2+K^2 \qquad B^2 = 2aH-kK \qquad C^2 = k^2-4ah$$

Point-In-the-Plane (H,K) Central Conic Point-In-the-Plane (h,k)
Inversion Cubics and Quartics

$$[4C^4(H^2-K^2)+4D^4j^2+j^4(b^2\pm a^2)]x^2\cos^2\theta+2[2A^2C^4H+A^2b^2hj^2+b^2j^4H+2B^4j^2H]x\cos\theta \qquad (12\text{-}75)$$

$$+ 2[2A^2C^4K\mp a^2A^2j^2k\mp a^2j^4K+2B^4j^2K]x\sin\theta +4[2C^4HK+b^2j^2hK\mp a^2j^2Hk]x^2\sin\theta\cos\theta$$

$$+ A^4C^4 \mp a^2j^2(j^2+4kK)x^2 + 4C^4K^2x^2 + 2A^2B^4j^2 + j^4(b^2H^2\mp a^2K^2) = 0$$

$$A^2 = x^2+H^2+K^2 \qquad C^4 = b^2h^2-a^2b^2\mp a^2k^2$$
$$B^4 = b^2hH\mp a^2kK \qquad D^4 = b^2hH\pm a^2kK$$

Cayley's Sextic

$$-x^3(a-2h)^3\cos^3\theta + x^2[3(a-2h)^2x^2-3h(a-h)(a-2h)^2-27a^2h^2]\cos^2\theta + \qquad (9\text{-}47)$$

$$\{-3(a-2h)x^4+2hx^2[3(a-h)(a-2h)-27a^2/2] - 3h^2(a-h)^2(a-2h)-27a^2h^3\}x\cos\theta +$$

$$\{x^6-x^4[3h(a-h)+27a^2/4]+3h^2x^2[(a-h)^2-9a^2/2]-h^3[(a-h)^3+27a^2h/4]\} = 0$$

APPENDIX III. Complete Inventory of Curve-Pole Combinations With
High Ordinal and Subordinal Circumpolar Rank

LINEAR SPECIFIC SYMMETRY CLASS

	Curve	Angle°	Order	Suborder	Pole			
1.	Spiral of Archimedes	all	0	0	Polar pole			
2.	Logarithmic spiral	all	2	2	"	"		
3.	Limacons	0, 180	2	2	DP or DP homologue			
4.	Symmetry mimic of tangent circles (eq. XIV-74a')	90	2	2	Polar pole (true center)			
		180	2	2	"	"	"	"
5.	4-Leaf rose*(eq. XIV-84b)	90	2	2	"	"	"	"
		180	2	2	"	"	"	"
6.	Cos$^2\theta$-group	90	2	2	"	"	"	"
		180	2	2	"	"	"	"
7.	Tangent circles	180	2	2	"	"	"	"
8.	Symmetry mimic of parallel line-pair (eq. XIV-71b)	180	3	3	"	"	"	"
9.	Inverse-cos$^2\theta$ group	180	4	4	"	"	"	"
10.	Parallel line-pair	180	4	4	"	"	"	"
11.	Dual equilateral lemnicate (eq. XIV-84c)	90	6	4	"	"	"	"
		180	6	4	"	"	"	"
12.	Root-cos$^2\theta$ group	180	6	4	"	"	"	"
13.	LCQ Sextics (eq. XIV-63b)	0	6	4	Tangent point of two ovals			
14.	LLC Octics (eq. XIV-63c)	0, 180	6	4	Polar pole (true center)			
15.	Ellipses	180	6	6	"	"	"	"
16.	Hyperbolas	180	6	6	"	"	"	"
17.	Squared-cos$^2\theta$ group	180	8	4	"	"	"	"
18.	Sextic of eq. XIV-67c	180	10	4	"	"	"	"
19.	Mutually-inverting quartic circles	180	10	6	"	"	"	"
20.	Tri-angle self-inverters (eq. XIV-81a)	180	10	6	"	"	"	"
21.	Root-format symmetry group of equilateral strophoid (eqs. XIV-50, n = 2)	180	11	7	"	"	"	"
22.	Cassinians (C < ¼)	0,180	18	10	"	"	"	"
23.	Quartic twin parabola	180	20	10	"	"	"	"

*The 4-leaf rose is a single-parameter subspecies of the cos$^2\theta$-group

APPENDIX III. CIRCULAR SPECIFIC SYMMETRY CLASS

Curve	Angle°	Order	Suborder	Pole
1. Circle	90	2	0	Polar pole
2. Limacons	90	2	0	DP or DP homologue
3. Symmetry mimic of tangent circles (eq. XIV-74a')	45	2	0	Polar pole (true center)
4. Cos²θ-group	45	2	0	" " " "
5. Tangent circles	90	2	0	" " " "
6. Root-cos²θ group	90	6	4	" " " "
7. LLC octic (eq. XIV-63c)	90	6	4	" " " "
8. LCQ sextic (eq. XIV-63b)	180	6	4	Tangent point of two ovals
9. Decic of eqs. XIV-55	0,180	12	8	Polar pole (true center)

HYPERBOLIC SPECIFIC SYMMETRY CLASS

Curve	Angle°	Order	Suborder	Pole
1. Parabola	180	3	6	Traditional focus
2. Symmetry mimic of parallel line-pair (eq. XIV-71b)	90	3	6	True center
3. Equilateral hyperbola	180	4	8	Traditional focus
4. Hyperbolas	0,180	4	8	" "
5. Ellipses	180	4	8	" "
6. Reciprocal spiral	all*	4	8	Polar pole
7. Inverse-cos²θ group	90	4	8	" " (true center)
8. Equilateral strophoid	0	4	8	Loop vertex (focus of self-inversion)
9. Tri-angle self-inverters (eq. XIV-81a)	90 0,180	10 10	8 8	Polar pole (true center) " " " "
10. Mutually-inverting quartic circles	0,180	10	8	" " " "
11. Limacon	0	10	8	Focus of self-inversion
12 Linear Cartesian	0	10	8	" " " "
13. Parabolic Cartesian	0	10	8	" " " "
14. Circle	0,180	10	14	Point in plane**
15. Root-format symmetry group of equilateral strophoid (eqs. XIV-50, n = 2)	0,180	11	10	True center
16. Cassinian (C > ¼)	90	18	8	" "

* Only the trivial transform, $x = y$, is obtained for 0°.
**Non-central, non-incident

APPENDIX IV. SYMMETRY MAXIMS

BIPOLAR MAXIMS

1. Simple bipolar equations of low exponential degree define highly symmetrical curves and high-ranking bipolar foci.

2. A line connecting the poles of a bipolar equation of exponential degree 1 or 2 is a line of symmetry of the represented curve and a focal locus, i.e., a locus upon which any pole-pairs have bipolar focal rank.

3. The bipolar focal rank of a pole-pair is the inverse of the exponential degree of the equation of the curve cast about the pole-pair. An individual bipolar focal rank can be assigned to the poles if they are equivalent, i.e., if the equation is symmetrical in u and v.

4. If a bipolar equation is linear in u and v, the corresponding poles will either be the highest-ranking foci of the curve, or one will be the highest-ranking and the other the second-highest.

5. If a bipolar equation is linear in v but not in u, the pole p_v is the highest-ranking focus of the curve.

6. A bipolar equation that is symmetrical in u and v represents a curve that is symmetrical with respect to the bipolar midline.

7. If the bipolar equation of a curve cast about equivalent poles is of 1st or 2nd degree, a true center lies midway between the poles p_u and p_v (also frequently true of bipolar equations of 4th degree).

8. In a bipolar equation, the focal rank of a pole represented by a linear term in u or v, or the square of the resultant of a linear term augmented or diminished by a constant, generally is greater than the focal rank of a pole for which u or v occurs only as the pure square.

9. The pole with greater "weight" in a bipolar equation in which the highest degree of the variables is the same generally is the pole of higher focal rank.

10. Bipolar equations simplify and reduce for pole-pairs located on a line of symmetry, and for pole-pairs symmetrically located in relation to lines of symmetry, as compared to pole-pairs not so located. For a given member of a pole-pair, the simplification generally is greater the higher the circumpolar focal rank of the second member.

11. Comparative subfocal ranking of the poles of a bipolar equation is valid only if the basis curve possesses an equivalent pole for either both or neither of the poles about which the equation is cast.

CIRCUMPOLAR MAXIMS

1. If no circumpolar point focus of a curve exists at a specific valid locus for either the 0° or 180° transformation, then no focus exists for any angle of transformation.

2. No point focus is known that does not lie on a linear or curvilinear focal locus. All point foci lie on linear or curvilinear point arrays, every point of which has or is presumed to have transforms of lower degree than the transforms about neighboring points that are not members of the array.

3. Highly symmetrical curves invert to one another through poles on their lines of symmetry. For curves of even degree, the higher the circumpolar symmetry rank of the pole of inversion, the higher, in general, the circumpolar symmetry rank of the inverse curve.

4. In the simple intercept equation cast about a point in the plane, the vanishing of the constant term gives the focal condition for points incident upon the curve (the constant term equated to 0 is, in fact, merely the equation of the curve in h and k rather than x and y). In simple intercept equations for points on a linear focal locus, the vanishing of the constant term gives the focal condition for the vertices (see also Maxim 37).

5. Points of intersection of linear and curvilinear focal loci have higher focal rank than either of the intersecting loci (exceptions: many covert focal loci and the vertex foci of the ellipse and hyperbola when they are eclipsed in the circle and the equilateral hyperbola).

6. A condition for which the square-root radicand of an intercept format is converted to a perfect square in the variables reveals the location of a high-ranking focus.

7. The possession of "pure" xy compound 0° and 180° intercept-product formats that hold for a point in the plane and are expressible in very simple form, $xy = f(\theta,h,k)$, is an indication of a higher degree of circumpolar symmetry of a curve than the property of self-inversion about one or more poles.

8. Inversions through homologous non-variable foci of basis curves that belong to the same genus produce members of a single genus.

9. With the possible exceptions of foci of self-inversion, inversions about a point on a line of symmetry conserve the number of circumpolar foci on that axis.

10. The weakest condition for reduction in the degree of an inversion locus for a curve inverted about a point in the plane is that this point be incident upon the curve. For such a location, at the very least the highest-degree term of the inversion locus vanishes. If the inversion locus is obtained about a point on a line of symmetry, reduction occurs at the vertices.

11. The loss of a line of symmetry in an axial QBI locus is accompanied by the gain of both an axial and a non-axial covert linear focal locus.

12. The reciprocal inversion pole of the curve obtained by inverting a parabola or central conic about a point on a line of symmetry is the highest-ranking focus of the inversion locus. Contrariwise, the reciprocal inversion pole of the curve obtained by inverting other QBI curves about a point on a line of symmetry generally is non-focal in the inversion locus.

13. All quadratic-based axial-inversion quartics invert to conics through their double point or its homologue.

14. Inversions within the QBI superfamily conserve eccentricity.

15. The members of the QBI superfamily that possess at least one line of symmetry consist of all conics plus all curves to which conics invert about all axial poles.

16. The members of the QBI superfamily of eccentricity e, and possessing at least one line of symmetry consist of the conic of that eccentricity plus all curves to which that conic inverts about all axial poles.

17. Any member of the QBI superfamily of eccentricity e, and possessing at least one line of symmetry inverts through poles on its line(s) of symmetry to all other members of the superfamily of the same eccentricity that have at least one line of symmetry.

18. The loss of a line of symmetry in an axial inversion locus is accompanied by the gain of a focus of self-inversion.

19. It is a necessary condition for axial self-inversion of a QBI curve that the unit value of distance be assigned to the distance between the pole of inversion and the double point.

20. All non-central axial inversions of central conics self-invert.

21. Excepting central quartics, central conics, and axial QBI curves of unit eccentricity, all axial QBI curves self-invert.

22. A focus of self-inversion typically is specified by a condition on the 0° or 180° intercept transform, rather than by a condition on the simple intercept equation or format.

23. A non-parameter-involving condition for which the entire $\cos\theta$ term of a simple intercept equation in $\cos^2\theta$ and $\cos\theta$ vanishes (specifically when h is a multiplicative coefficient for the entire term) establishes that the equation of the basis curve is cast about a true center. One of the conditions for which only the $\cos\theta$-constant term vanishes usually corresponds to the point about which the equation is cast.

24. Excluding a focus of self-inversion, all line-of-symmetry inversions of the parabola and central conics conserve the number of real and imaginary axial circumpolar foci.

25. For the parabola and central conics and all their line-of-symmetry inversions, the number of real and imaginary axial circumpolar foci, excluding foci of self-inversion, is 5.

26. The sum of the number of real and imaginary axial circumpolar foci and the number of orthogonal lines of symmetry of a basis curve is conserved by line-of-symmetry inversions.

27. For the parabola and central conics, and all their line-of-symmetry inversions, the sum of the number of real and imaginary axial circumpolar foci and the number of orthogonal lines of symmetry is 6.

28. For any given axial QBI curve except the line, the circle, and quartic circles, and for all its line-of-symmetry inversions, the sum of the number of real and imaginary axial circumpolar foci and the number of orthogonal lines of symmetry is constant.

29. Among axial QBI curves, only limacons, conic axial vertex cubics, eccentricity-dependent self-inverters, mutually-inverting quartic circles, the circle, and intersecting lines, self-invert about a pole specified by the simple intercept equation or format.

30. The most highly symmetrical curves of a given degree within an inversion superfamily are those axial members that self-invert about axial poles that are specified by the simple intercept equation or format, i.e., for which the pole of self-inversion is coincident with a circumpolar focus so specified.

31. With the exception of the foci occurring in limacons, conic axial vertex cubics, eccentricity-dependent self-inverters, mutually-inverting quartic circles, the circle, and intersecting lines, foci of self-inversion of axial QBI curves do not qualify as circumpolar point foci at any angle other than the angle of self-inversion (0° or 180° or both).

32. Excluding self-inversions and inversions about true centers, inversion loci about focal poles are distinguished from those about non-focal poles by the increase or appearance (or both) in the former, as compared to the latter, of: (a) the focal multiplicity of the reciprocal inversion pole; (b) generic multiple foci; (c) foci at infinity; or (d) an orthogonal line of symmetry.

33. The loss of two lines of symmetry in a non-incident inversion of a conic section is accompanied by the gain of (a) two linear focal loci passing through the reciprocal inversion pole and parallel to the lines of symmetry of the basis curve; and (b) an equilateral hyperbolic focal locus with one of its vertices coincident with the reciprocal inversion pole.

34. The loss of two lines of symmetry in an incident but non-axial inversion of a conic section is accompanied by the gain of: (a) two linear focal loci passing through the reciprocal inversion pole and parallel to the lines of symmetry of the basis curve; and (b) a third linear focal locus passing through the reciprocal inversion pole and not coincident with either of the first two loci.

35. With the possible exception of poles of self-inversion, the pole for an inversion or tangent-pedal transformation of a conic becomes the highest-ranking circumpolar focus of the transform curve.

36. A necessary condition for a curve to self-invert about a pole p_u is that the polar equation of the curve cast about p_u contain terms in both $f(r)g(\theta)$ and $h(r)$.

37. If a basis curve, $f(x,y)$, of degree n in rectangular coordinates is translated along (either or) both coordinate axes to yield a rectangular equation, $f[(x+h),(y+k)] = 0$, with $f(h,k) \neq 0$, the polar equation, $r = g(\theta,h,k)$ of the translated curve also will be of degree n in r. If $f(h,k) = 0$, the polar equation will be of degree $(n-1)$ in r. In other words, if the translated curve with rectangular equation of degree n does not pass through the origin, its polar equation also will be of degree n in r; if it passes through the origin, it will be of degree $(n-1)$ in r (see also Circumpolar Maxim 4).

38. To every self-inverting subspecies of curve with a single line of symmetry there correspond one or two inversion subspecies with a true center (two orthogonal lines of symmetry). If only one inversion subspecies exists, it belongs to the basis genus for the inversion superfamily; if two inversion subspecies exist, they invert to one another through their true centers and one of them belongs to the basis genus.

39. Axial-vertex inversions of bicircular quartics with a single line of symmetry and 3 modes of self-inversion about poles thereon yield serpentine circular cubics that self-invert about all 3 axial vertices. Positive intra-arm and intra-oval self-inversion occur about the vertex of the serpentine arm (which possesses an asymptote), positive inter-segment self-inversion occurs about the far vertex of the oval, and negative inter-segment self-inversion occurs about the near vertex of the oval.

40. Axial inversions of bicircular quartics and serpentine circular cubics with a single line of symmetry and multiple modes of self-inversion about poles thereon, conserve the number of modes of self-inversion and the number of poles of self-inversion in inversion loci that also possess a single line of symmetry.

41. Axial inversions of bicircular quartics and serpentine circular cubics with a single line of symmetry and multiple modes of self-inversion about poles thereon, conserve the sum of the number of modes of self-inversion and the number of lines of symmetry.

42. On a given line of symmetry, all bicircular quartics with multiple modes of self-inversion possess a negative mode of inter-oval self-inversion.

43. Of the 3 modes of self-inversion of a bicircular quartic--positive inter-oval, positive intra-oval, and negative inter-oval--no more than one of each is possessed about poles on the line of symmetry.

44. The axial-vertex inversions of a given subspecies of central Cartesian, as well as the axial-vertex inversions of all of its bicircular axial inversions, belong to the same subspecies of central Cartesian axial vertex cubic.

45. The axial-vertex inversions of a given subspecies of bicircular quartic with a single line of symmetry and multiple modes of self-inversion about poles thereon, as well as the axial-vertex inversions of all its bicircular axial inversions, belong to the same subspecies.

46. For the hierarchical ranking of curves according to their circumpolar symmetry about specific poles, among the 3 reference angles, 0°, 90°, and 180°, the highest degree of discrimination is provided by the intercept transform for a 90° reference angle.

47. Positive and negative reciprocal reflective symmetry (self-inversion at 0° and 180°) of a curve through a point constitutes a high degree of symmetry about that point but is not indicative of a high degree of symmetry of any other type with respect to that point, or with respect to any other locus.

48. Reflective (mirror-image) symmetry of a curve through a line constitutes a high degree of symmetry about that line and all parallel lines but is not indicative of a high degree of symmetry with respect to any other locus.

49. The possession by a curve of a high degree of circumpolar symmetry about any pole for a 90° reference angle (90° circumpolar intercept transforms of low exponential degree) is a strong indication of a high degree of circumpolar symmetry of the curve about that locus at other angles.

TANGENT-PEDAL TAXONOMY MAXIMS

1. The pedals of the parabola about all points in the plane, including incident points, comprise the conic inversion cubics, i.e., the inversions of conics about all incident points.

2. The pedals of the parabola about all incident points comprise the parabola inversion cubics, i.e., the inversions of the parabola about all incident points.

3. The pedal of the parabola about a specific incident point belongs to the same subspecies of parabola inversion cubic as the inversion about that point, i.e., for the appropriate selection of the unit of linear dimension the pedal and the inversion are congruent.

4. The axial vertex pedals of all conic sections comprise--in one-to-one correspondence--the inversions of the parabola about all poles on its line of symmetry.

5. The pedals of central conics about all poles on the lines of symmetry, including an extended diameter of the circle, include all axial QBI quartics (QBI quartics with at least one line of symmetry).

6. The pedals of central conics about all incident points include all the parabola inversion quartics.

7. The pedals of central conics about all non-incident points in the plane include all central conic inversion quartics.

APPENDIX V. GLOSSARY OF TERMS

Algebraically complete transform equation see **Intercept transform.**

α-Transform the general expression for the circumpolar intercept transform
for any angle α between the two radii; see **Intercept transform.**

α-θ-Transform circumlinear or circumcurvilinear intercept transform; relates
the x intercepts of a radius vector from a pole at the angle θ
to the x-axis to the y intercepts of a radius vector from the
same pole at the angle θ+α to the x-axis; the poles from which
these radius vectors are measured consist of points on the line
or curve to which the symmetry of the basis curve is being referred.

Asymptote point the point of intersection of the asymptote of asymptotic
looped cubics with the line of symmetry.

Axial equality the condition wherein the number of lines of symmetry is the
same for two or more different configurations of a given
ensemble of reference elements.

Axial focal locus a line, all the points of which have focal rank.

Basis curve subject curve or "starting" curve" for an operation or transformation.

Bicircular two circles (of quartics: two self-inverting non-communicating ovals).

Bilinear two lines

Bipolar two points

 coordinates a coordinate system based upon undirected distances from two
fixed point poles.

Cartesians loci defined by certain simple bipolar, tripolar, and polar-circular eqs.

Cassinians loci defined by an equilateral hyperbolic bipolar eq.

Catacaustic of a curve the envelope of light rays, emitted from a pole, after
reflection at all points of the curve.

Caustic see **Catacaustic, Diacaustaic.**

Central conic a conic section with two lines of symmetry

Central quartic the curve obtained by inverting a central conic about its center.

Circumcurvilinear about a curve as reference element (includes the line).

Circumlinear about a line as reference element.

Circumpolar about a point as reference element.

Class of circumpolar symmetry the exponential degree of the intercept trans-
form of a curve about a given pole at a given angle.

Compound intercept equation equation for a specified angle α expressing the
relationship between the x and y intercepts of radius vectors
from the reference pole at angles θ and θ+α, respectively, as a
function of θ.

Compound intercept format solution of the compound intercept eq. for $\cos^n\theta$
or $\sin^n\theta$, but often for $\cos\theta$ or $\sin\theta$.

Congruent having the same size and shape.

Conic axial vertex cubic cubic obtained by inverting an axial QBI curve (in-
cluding conic sections) about a major or transverse axis vertex.

Conjugate point or pole a point equidistant from the origin (or from a vertex
or line) but in the opposite direction.

Conservation of degree property of certain eqs. whereby degree does not
increase under the inversion transformation, i.e., no inverse
locus is of higher degree than the basis curve.

 ultimately conservative of degree describes the property of the inversion
transformation wherein there is an upper limit to the exponential
degree of inversion loci obtained by a chain of successive in-
versions of a basis curve.

Conservation of eccentricity property of axial QBI inversion cycles whereby
the image conic (see **Inversion image**) has the same eccentricity
as the basis conic.

Covert linear focal locus a linear focal locus that is not a line of symmetry.
 axial orthogonal to the line of symmetry and passing through the DP.
 non-axial orthogonal to the line of symmetry but not passing through the DP.

Cubic curve of 3rd degree in the variables.

Curve of demarcation a curve possessing two or more communicating loops,
specified by the same eq. that specifies two genera or species
of curves, the members of at least one of which groups have a
different number of axial foci than the curve of demarcation
(see Chapter VIII and Table VIII-1).

Decic curve of 10th degree in the variables.

Diacaustic of a curve the envelope of light rays emitted from a pole, after
refraction at all points of the curve.

Dodecic curve of 12th degree in the variables.

Eccentricity-correlated rank phenomenon whereby the α-transform of a hyperbola
reduces, not for a specific angle of transformation, but for a
variable angle determined by its eccentricity.

Eliminant the eq. obtained by eliminating one or more variables between
two or more eqs.

Elliptical limacon see **Limacons**

Equational a relationship between curves based upon a similarity between
their eqs., i.e., the rules for their construction.

 focal condition a focal condition on the entire simple intercept eq., for
example, conversion of the eq. to a perfect square.

Extremal-distance symmetry designation for the relationship between curves
defined by an identical eq., one locus given by the greatest-
distance construction, the other by the least-distance construction.

Focus a locus about which a curve has greater symmetry than about
neighboring points off the locus
 axial a line, all points of which have focal rank.
 compound a curvilinear focal locus upon which there also lie point foci.
 eclipsable a pole or curvilinear locus that loses its focal rank in certain
highly symmetrical subspecies.
 loop a point focus that lies within a loop in all subspecies.
 of self-inversion any pole through which a curve self-inverts.
 multiple two or more point foci in coincidence.
 generic a focus that is multiple in all subspecies of a genus (or in all
but a finite number of subspecies).
 subspecific a focus that is multiple only in a certain subspecies.
 simple a curvilinear focal locus upon which there lie no point foci.
 variable a focus that has different relationships to a curve in different
subspecies, for example, within a small loop in some, within
a large loop in some, and outside of the curve in others.

 Focal condition condition on an intercept eq. or format that leads to a
reduction in the degree of transforms (a term in x or x^2
generally factors from the simple intercept eq.).

Focus-vertex group axial inversions of central conics at poles between the
focus and the vertex.

Genus broadly speaking, all curves obtained from a rectangular or polar
eq. having more than one parameter, for all parameter values.

h or H axis any axis parallel to the x-axis.

Hyperbolic limacon see Limacons

Identical congruent to and coincident with.

Individual bipolar focal rank the bipolar focal rank of single poles as opposed to the bipolar focal rank of pole pairs.

Intercept Product the expression for the product of intercepts from a point to a curve along a line.

 chord-segment the distances (in the positive sense) from the reference point to the points of intersection with the curve are measured in opposite directions along a chord through the reference point.

 coincident-radii the distances (in the positive sense) from the reference point to the points of intersection with the curve are measured in the same direction along a radius from the reference point.

 "pure" product of the intercepts of the form $xy = f(\theta,h,k)$ that is valid for all points in the plane; these exist in simply expressible form only for conic sections.

Intercept transform equation relating the intercepts with a curve, of two radii emanating from a point at a fixed angle to one another, as these radii rotate about the point to which the symmetry is being referred, or translate or travel along the locus to which the symmetry is being referred.

 algebraically complete transform equation transform equation, usually degenerate, that is valid for all possible combinations of positive and negative intercepts.

 circumcurvilinear the pole from which the radii emanate travels along a curve.

 circumlinear the pole from which the radii emanate translates along a line.

 circumpolar the two radii *rotate* about the pole from which they emanate.

 condition a condition on an intercept transform which, if satisfied, leads to a reduction in its degree in the variables.

 trivial a transform that merely expresses the equality of identical intercepts, i.e., intercepts for which the radius vectors are both equal and coincident, excluding cases for which the intercepts are 0 for all angles for which they are defined.

Inter-vertex group axial inversions of central conics at poles lying between the vertices

Inverse-$\cos^2\theta$-group curves defined by the polar equation $r = j^2/(a+b\cos^2\theta)$.

Inverse locus the locus obtained relative to a point reference pole by measuring off distances along radius vectors from the pole that are the reciprocals of the distances to the curve along the same radius vectors.

Inverse-root-$\cos^2\theta$ group curves defined by polar equation $r^2 = j^4/(a^2\pm b^2\cos^2\theta)$.

Inversion the transformation whereby a curve is inverted about a point-pole (see Inverse locus).

 cycle closed inversion chain, i.e., an inversion chain in which the basis curve is recovered as an image in the terminal member of the chain (see Inversion image).

 image recovery through a chain of inversions of a curve belonging to the same subspecies as the basis curve.

 taxonomy the classification or systematic organization of curves on the basis of their inversions about all points in the plane and the inversion relationships between these inversion loci.

k or K axis any axis parallel to the y-axis.

Limacons inversions of conic sections about the traditional foci.
 elliptical inversions of ellipses about their traditional foci.
 hyperbolic inversions of hyperbolas about their traditional foci
 parabolic inversion of the parabola about its traditional focus (cardioid).
Linear-circular a line and a circle
Line of symmetry an axis of a curve about which reflective symmetry exists,
 or a line of reflective symmetry of a coordinate system.
Maxim employed here in the sense of a rule based upon experience.
Mimics see Symmetry mimics
Monoconfocal the condition wherein two central conics have only one of their
 traditional foci in coincidence (the term *confocal* is employed
 generally to connote two central conics having both of their
 traditional foci in coincidence).
Multipolar more than two point-poles.
Multiple-focus see Focus
Near-circles see Near-conics
Near-ellipses see Near-conics
Near-lines see Near-conics
Near-conics near-line, near-circle, and near-ellipse transforms of the $-\frac{1}{2}$b
 focus of limacons and of its homologue in linear Cartesians.
Non-concentric, congruent, bicircular coordinates undirected-distance co-
 ordinate system in which the fixed-position reference elements
 consist of two non-concentric congruent circles.
Non-polarized bipolar coordinates bipolar coordinate system in which the poles
 are unordered, preserving reflective redundancy in both the polar
 axis and the midline.
Non-focal self-inversion self-inversion through a curvilinear locus relative
 to a given reference pole for the inversion.
Octic curve of 8th degree in the variables.
 LLC octic with linear 0° and 180° transforms and a circular 90°
 transform about a given pole.
Omnidirectional circumlinear self-inversion see Self-inversion
Ordinal rank the degree in x and y of the ordinal rank equations for $\overset{\circ}{s}{}^2$
 of the α-transform.
Orthotomic of a curve the locus of the points that are the reflections of the
 pole in the tangents to the basis curve (same subspecies as the
 tangent pedal).
Pedal
 normal the normal pedal P of a basis curve B with respect to a point
 O is the locus of the feet of the perpendiculars from O on the
 normals to B (also called the *contrapedal*).
 tangent the tangent pedal P of a basis curve B with respect to a
 point O is the locus of the feet of the perpendiculars from O
 on the tangents to B.
 taxonomy the classification or systematic organization of curves according
 to their pedals about all points in the plane, the relationships
 between these pedals, the pedals of these pedals, etc.
Peripheral vertices the intersections with the curve of normals to its major
 or transverse axis at the positions of the axial foci.
Phylum of circumpolar symmetry the lowest degree non-trivial class of circum-
 polar symmetry of a curve about any point at any angle.
Point in the plane a point (h,k) in the plane.

Polar-circular a point and a circle
Polarized bipolar coordinates a bipolar coordinate system in which the poles
 bear fixed labels and there is no reflective redundancy in the
 midline of the system.
Polar-linear a point and a line
Pole of conditional focal rank a point that attains point-focal rank only in
 certain subspecies of a species or genus through coming into
 coincidence with a point focus.
Post-focal group axial inversions of central conics at points beyond the
 focus, as reckoned from the center.
Post-vertex group axial inversions of central conics at poles external to the
 a vertices of ellipses, and beyond the vertices (in the direction
 of the foci) of hyperbolas.
Potential focal condition condition on an intercept equation for which a term
 in the variables vanishes (without leading to the factoring out
 of a term in a variable).
Pre-focal group axial inversions of central conics at points between the
 center and the focus.
Pseudo-exchange-limacon the curves obtained by axial inversions of central
 conics about a pole at twice the distance of the a vertex from
 the center.
QBI curves quadratic-based inversion curves, i.e. the curves obtained by
 inverting conic sections about all points in the plane.
Quadratic curve of second degree in the variables.
Quartic curve of fourth degree in the variables.
Quintic curve of fifth degree in the variables.
Radial of a curve the locus of the end points of lines drawn from a pole,
 where these lines are parallel and congruent to the radii of
 curvature for all points on the basis curve.
Radicand constant-condition the condition yielded by setting the constant term
 of the radicand of the simple intercept format equal to 0.
Rank usually a comparative quantitative measure of symmetry.
 focal reciprocal of the degree of the rank-determining transform.
 ordinal degree of the ordinal rank equation.
 subfocal based upon comparisons of the complexity of the rank-determining
 equations (no quantitative index).
 subordinal degree of the subordinal rank equation.
 symmetry non-specific characterization of either or both focal and sub-
 focal rank.
Requirement for axial equality a necessary condition for valid comparisons of
 the symmetry of different curves relative to different configu-
 rations of a given ensemble of reference elements (see Axial
 equality).
Root-cos$^2\theta$ group curves defined by the polar equation $r^2 = a^2 \pm b^2 \cos^2\theta$.
Self-inversion the process of inversion wherein the inverse locus is identical
 to (congruent and coincident with) the basis curve.
 α- the intercepts are measured at an angle α to one another.
 negative the intercepts are measured in opposite directions from the
 reference pole.
 positive the intercepts are measured in the same direction from the
 reference pole.

Serpentine circular cubic an oval and a non-communicating serpentine arm.

Sextic curve of 6th degree in the variables

 LCQ sextic with linear 0° transform, circular 180° transform, and quartic 90° transform about a given pole.

Simple intercept equation equation expressing the x intercept of a radius vector from the reference pole to a point on the curve as a function of θ, the angle from the reference axis.

 mixed-transcendental simple intercept equation containing more than one transcendental function of θ.

Simple intercept format solution of the simple intercept equation for $\cos^n\theta$ or $\sin^n\theta$, very frequently for n = 1.

Single-parameter curves subspecies of a genus of curves in which all the parameters have the same value (only a single parameter occurs).

Species broadly speaking, all curves obtained from an equation for a certain range of parameter values.

Specific symmetry class a more precise categorization than merely the exponential degree, for the class of circumpolar symmetry defined by an intercept transform.

Squared-$\cos^2\theta$ group curves defined by the polar equation $jr = (a+b\cos^2\theta)^2$.

Subfocal rank a comparative ranking within focal rank categories based upon measures of the simplicity or complexity (aside from exponential degree in the variables) of the equations or intercept transforms of two or more curves or of a given curve about two or more poles.

Subordinal rank the degree of the ordinal rank equations with y replaced by $f(x)$ for the specific pole and angle of the transformation.

Subspecies the curve obtained from an equation for specific values of the parameters.

Symmetric function a function that remains unchanged upon interchanging of the variables.

Symmetry the characterization of construction rules for a curve or for the intercept transform of a curve relative to specific reference elements.

 circumlinear symmetry about a line.

 circumpolar symmetry about a point.

 greater symmetry see more symmetrical

 more symmetrical having a simpler construction rule (relative to specific reference elements.

 most symmetrical having the simplest construction rule (relative to specific reference elements).

Symmetry class see Class of circumpolar symmetry and Specific symmetry class.

Symmetry mimics curves of higher degree than a basis curve that have identical 0° and 180° transforms to those of the basis curve about a homologous pole.

Taxonomy a paradigm of classification.

θ Self-inversion locus locus of the points of self-inversion along chords cutting the x-axis at an angle θ.

Traditional focus term used primarily to refer to the only heretofore recognized real focus of a conic section, to distinguish it from the other real focal loci (center, vertex, etc.).

Transform see Intercept transform, α-Transform, α-θ-Transform

Transformation format general equations for α-transforms in terms of simple intercept formats expressed as the $\sin\theta$, $\cos\theta$, $\sin^2\theta$, $\cos^2\theta$, etc.

Tripolar three points

Trivial intercept transform see Intercept transform

True center point of intersection of two orthogonal lines of symmetry.

True two-arm parabola a parabola possessing two arms or branches (not necessarily congruent) and represented by a non-degenerate equation.

Valid locus a locus for which non-trivial transforms exist at the angle in question.

Variable-angle transform α-transform of the hyperbola for which there exists a variable-angle focal condition dependent upon eccentricity.

Variable focus see Focus

Vertex-focus group see Focus-vertex group.

Weight of a variable greater weighting of a variable in, say, a bipolar equation implies the presence of the variable in terms (or as a multiplier) that do not also occur in the other variable, or the possession of a greater coefficient by the former variable in otherwise identical terms, or any other feature that gives greater prominence to one variable than to the other. The concept of weighting is applied only if the maximum exponential degree to which the variables exist is the same for both.

BIBLIOGRAPHY

Hilton, H., Plane Algebraic Curves, Oxford, Clarendon Press, 1920

Königs, G., Leçons de L'Agrégation Classique de Mathématiques, Paris, Librairie Scientifique A. Herman, 1892

Maleyx, M. L., Proprietes de la Strophoide, *Nouv. Ann. de Math. Deuxième Série, Tome Treizième,* 468-480, 1874; *Tome Quatorzième,* 193-217, 241-259, 1875.

Salmon, G., A Treatise On Conic Sections, London, Longmans, Green, and Co., 1879.

Salmon, G., A Treatise On The Higher Plane Curves, New York, G. E. Stechert & Co., 1934 (reprint of 3rd ed., 1879).

Tweedie, C., Anallagmatic Curves. I., *Edinb. Math. Soc. Proc.* 19-20: 76-82, 1900-1902.

Williamson, B., An Elementary Treatise On The Differential Calculus, London, Longmans, Green, and Co., 1887.

Yates, R. C., Curves And Their Properties, Ann Arbor, Michigan, Edwards Brothers, Inc., 1947.

Zwikker, C., Advanced Plane Geometry, Amsterdam, North-Holland Publishing Co., 1950.

α-transforms, see Intercept trans-
　　forms
Archimedes' spiral, 1-16,5-3,13,17,
　　24, *xii*
Asymptote point and asymptote-point
　　focus, 9-2,3,6,11,14 to 21,12-8,
　　11,12,33,36,14-9,10,26,38
Asymptotes, 7-8,17,18,9-2,19,12-86,
　　14-9,10,51,72
　　as circumpolar focal loci, 12-66,67
　　imaginary, 12-3,18,85,14-73
　　intercept transforms about, 12-59,
　　　83 to 85
Axial equality, requirement for, 3-4,
　　5,11
Axial segments, as most symmetrical
　　curves, 1-17,4-1

Bicircular coordinates, 4-20,21
　　concentric, 1-8,4-21
　　congruent non-concentric, 4-20,21
Bilinear systems, 1-9,18,24,4-21 to
　　30
Bipolar coordinates, 1-15,17,2-1 to 24
　　polarized versus unpolarized, 2-23,24
Bipolar eqs., 2-1 to 24
Bullet-Nose curve, 7-16,13-14,15,25

Cardioid (parabolic limacon), 1-23,
　　2-6,4-16,5-25,29,8-22,9-25,26
　　10-1,4 to 10,14,23,39,43,11-33,36,
　　12-4,35,36,68,69,72,13-2,4,20
Cartesian Group, 1-22,10-1,2
Cartesian near-conics, see near-conics
Cartesian self-inverters, 10-2,3,
　　12-14,18,30,31,14-48,51,78
　　curves with reciprocal format
　　　symmetry to, 14-51
Cartesians,
　　bipolar linear, 1-18,2-5,6,5-13,21,
　　　8-1,9-1,7,8,9,10-32 to 37,12-3,5,
　　　14-38 to 40, *x,xiii*
　　bipolar parabolic, 2-6,5-13,21,7-24,
　　　25,8-1,9-1,7,8,9,10-32,33,11-11,
　　　12-3,5, *x,xiii*
　　central, 14-86 to 95
　　polar-circular linear, 4-6,10,32,
　　　12-3,5
Cassinians,　2-7,5-13,22,8-20,12-3,
　　5,27,28,46,14-69, *xii,xiii*
　　4-oval dual, 14-81 to 83
　　8-oval, 14-82,83

Cassinians (continued),
　　self-inversion of, 14-76 to 83
　　single-oval, 5-13,12-27,14-76 to
　　　81, *xiii*
　　two-oval, 5-13,14-77 to 83, *xiii*
Catacaustic, 8-26
Cayley's sextic, 9-1,25,28 to 33,
　　11-12,13-19,20,14-10,11,47
　　affinity with limacons, 9-25
　　circumpolar symmetry analysis,
　　　9-32,33
　　foci of, 9-29 to 33,12-16
　　inversion about DP, 11-12,12-2,4
　　inversion analysis, 9-28 to 30,
　　　14-10
Central Cartesians, 14-86 to 95
Central conics,
　　axial inversions,
　　　point-in-the-plane simple inter-
　　　　cept eqs. of, 12-46 to 50
　　axial vertex cubics, see Hyperbolas,
　　　Ellipses
　　bipolar, 2-5,11
　　circumcurvilinear symmetry, 12-62,
　　　63,85 to 88,94
　　　identical self, 12-88,94
　　　reciprocal,
　　　　with parabola, 12-91
　　　　with equilateral hyperbola,
　　　　　12-92 to 94
　　circumlinear symmetry, 12-73 to 76
　　circumpolar symmetry, 7-1 to 24
　　circumpolar transforms, 5-5,6,7-1
　　　to 24, *xii,xiii*
　　　degrees of, 7-19
　　focal loci, 10-40,12-17,18
　　inversions, 8-21 to 25,10-10,11-20,
　　　12-2,4,37, *xi*
　　　point-in-the-plane, 8-21,12-52
　　　　to 57
　　　　covert focal loci of, 12-52 to 57
　　linear-circular, 4-19,20
　　normal pedals, 13-23 to 26
　　　inversions of, 13-24,25
　　pentapolar, 4-9
　　polar-circular, 4-15,16
　　polar-linear, 3-1,3,5-8
　　simple intercept eqs., 7-1,7, *viii*
　　symmetry mimics,
　　　about traditional foci, 14-67
　　　about true center, 14-67,72

Central conics (continued),
 tangent pedals, 13-8 to 18
 tripolar, 4-2
Central quartics, 8-22,11-7,12-7,8,13,
 15,25 to 27,29,49 to 51,13-9,17,
 18,*ix*
 axial inversion quartics, 11-7,8,9,
 18,19
 inversion to conics, 11-18,19
 focal loci, 10-40,11-19,12-7,12,17,
 18
 "loop foci," 11-8,19,12-7,8,29,30
 vertex cubics, 11-17,18
 inversions of, 11-17,18
Circle, 6-4 to 8,14-48,49,72,*viii,xiii*
 bipolar, 2-7 to 13
 circumcurvilinear symmetry, 12-88,
 91 to 94
 identical self, 12-88
 circumlinear symmetry, 12-75 to 77
 circumpolar symmetry, 6-4 to 8
 intercept transforms, 5-4,13,21,
 6-4 to 8
 4th degree, 5-5,12-26,27
 45° and 135° bilinear, 4-25
 homologies with equilateral hyperbo-
 la, 4-7,5-8,27,29,12-92,93,13-8
 linear-circular, 4-19,20
 major auxiliary, 13-9
 normal pedals, 13-24
 nth degree, 12-92,93
 of Apollonius, 2-8
 polar-circular, 4-16
 polar-linear, 3-12 to 14
 root-format symmetry groups of,
 14-52
 tangent pedals, 13-2,16
Circulars, 2-8,3-12,4-16,22,24
Circumcurvilinear symmetry, 12-62, 85
 to 94
 circumcircular symmetry of the pa-
 rabola, 12-89,90
 congruent self-circumcurvilinear
 symmetry of the parabola, 12-89
 derivation of 90°-0°-transforms,
 12-87,88
 identical self-circumcurvilinear
 symmetry of conics, 12-88

Circumcurvilinear symmetry (continued),
 of the parabola about central
 conics, 12-90,91
 of the parabola about the cissoid
 of Diocles, 12-93,94
 reciprocal,
 centered circle and equilateral
 hyperbola, 12-91,92
 circle and parabola, 12-92,93
Circumlinear symmetry, 12-61 to 86
 α-θ of quadratics, 12-73 to 86
 axial QBI curves, 12-69 to 73, 14-33,34
 hyperbola axial vertex cubics, 12-64
 to 67,72
 limacons, 12-67 to 73
 180°-orthogonal of QBI curves, 12-63
 to 73
Circumpolar symmetry, 1-10 to 13,
 Chapters V,VI,VII,VIII,IX,X,XI,XII,
 XIV
 angle-dependent and independent
 indices, 6-12,12-14,15
 0° and 180° versus 90° transforms,
 14-95,96
Circumpolar symmetry analysis versus
 inversion analysis, 1-2,3,4,9-31,
 14-2 to 6
Cissoid of Diocles, 5-24,8-18,22 to 24,
 9-1 to 7,14,15,12-15,36,93,94,13-4,
 5,24,14-21,*viii*
Classification of curves, x,xv,1-2,3,4,
 19 to 23
Class of circumpolar symmetry, 1-20,
 5-5,6,7,11,19
Complementarity of polar and rectangu-
 lar coordinates, 5-15 to 17
Complementary intercept formats, see
 Intercept formats
Conchoids,
 and polar exchange symmetry, 3-14,15
 of a line, see Conchoid of Nicomedes
 of Nicomedes, 3-14,15,8-7
 polar-linear equilateral hyperbolic,
 3-15
 polar-linear parabolic, 3-14,15
Conformal mapping, 14-7
Conic axial vertex cubics, 5-28,8-23,
 24,9-1 to 16,10-10,11-2,12-9,11 to
 14,19,23,30,50,72,14-24 to 26,28,
 32,33,*viii*

Conic axial vertex cubics (continued)
 axial inversion quartics, 10-10,11
 unique aspects of symmetry of,
 12-23,72,14-24,25
Conics,
 inversions, origin of special sym-
 metry of, 14-42 to 46
 non-axial inversions, 8-21,10-17
 symmetry mimics,
 about traditional focus, 14-66,67
 about true center, 14-66,67,72
 transforms about points on lines of
 symmetry, 14-22 to 34
 unique aspects of symmetry of,
 14-24,25
Conservation under inversion,
 eccentricity, 11-13,15,17,22,23,29
 degree, 1-21,8-18,9-23,11-1,2
 focal loci, 9-6,12-16 to 18,57,
 14-6 to 10
Constant pedal-eccentricity loci,
 central conics, 13-15 to 18
 parabola, 13-6,7,8
Construction rules and symmetry, 1-4,
 7,8
Cos²θ-group, 5-13,14,22,14-59,69,71,
 72,85,xii,xiii
 symmetry mimics, 14-66,67,85
 transforms, 14-69
Cos⁴θ-group, 5-11
Covert focal loci, see Focal loci
Cubics, 9-1 to 33
Curves of demarcation, 8-19 to 21,
 10-10,33,11-11,12,12-5,27,14-17,
 55,61,77,83
Cusp point, 9-2,3,7,25,10-8,14,11-3,
 33,12-15,33 to 37,53,68,93

Degrees of transforms, 7-19,9-15,
 10-40,12-51,55 to 57
Design and synthesis of highly-
 symmetrical curves, 14-47 to 94
Diacaustic, 8-26
Dimensional balance of eqs., ix,5-9
Directed versus undirected distances,
 see Undirected distances
Directrix, 1-5,2-13,17,18,20 to 22,
 3-3,8,10,11,4-10,6-13,18,10-5

Disparate two-arm,
 hyperbolas, 3-3,6,7
 parabolas, 3-3,4-16 to 18
Double-point focus, see Foci and
 focal loci

Eccentricity conservation, see
 Conservation of eccentricity
Eccentricity-correlated rank, 7-8 to
 12,12-19
Eclipsed and eclipsable foci, 1-1,
 5-6,27,29,7-15
Ellipses, 7-1 to 26,xii,xiii
 bipolar, 2-1,5,11 to 15
 circumlinear symmetry of, 12-71 to 78
 normal pedals, 13-23 to 25
 partial, 3-11,12,4-23
 polar-linear, 3-3,5 to 8,11,12
 tangent pedals, 13-8 to 18
Ellipse axial vertex cubics, 8-23 to 25,
 9-6,13,14,11-8,9,12 to 15,72,viii
Equilateral axial QBI curves,
 hyperbola, 2-6,7,5-6,7,11,13,22,24,
 27,29,31,32,6-9,10,11,7-2,9,10,
 13 to 16,18,8-4,15,24,9-5,10,10-4,
 10,11-12,19,12-27,57,92 to 94,
 13-9,16,20,22
 homologies with circle,4-7,5-8,
 27,29,12-92,93,13-8
 lemniscate, 2-7,16,17,5-5,6,11,24,
 6-10,11,8-22,10-10,44,11-1,3,8,9,
 12,13,19,12-5,8,26,27,29,13-9,16,
 18,20,14-9,77,83 to 86
 bipolar, 2-7,16,17
 dual, 14-83 to 85,xii
 limacon, 2-6,5-24,6-9,10,8-22,9-7,
 8,10-4,10,23,33,11-8,12,19,12-5
 strophoid, 1-3,5-13,20,24,28,6-10,
 11,8-9,22 to 24,9-5,9 to 16,10-2,
 11-1,2,9,13,14,12-21,30,66,14-9,
 11,48,49,58,xiii
 root-format symmetry group, 14-52,
 53,70,xii,xiii
 transforms about DP, 14-19,20,48,
 49
Equilateral hyperbolics, 2-7,3-12,15,
 4-24,25,9-14,10-3
Evolute, 13-24
Exponential degree restriction, 1-8,9

Focal and potential focal conditions,
9-4,5,6,19,23,24,30,12-6 to 19,47,
47,49,14-22 to 33
 constant, 9-2,6,19,22,24,26,10-11,
 11-15,12-6,10,19,19,34 to 36,39,
 54,72,14-22,23
 $\cos\theta$, 9-26,12-15,16,19,39,48
 $\cos\theta$-constant, 9-5,13,17,22 to 24,
 32,10-12,11-15,12-6,8,9,12,15,16,
 19,39,14-5,6,22,23,26,38
 $\cos\theta$-x^2, 12-6,7,10,12,57,14-6,22 to
 24,26,29
 $\cos^2\theta$ and $\sin^2\theta$, 9-2,5,15,17,19,22,
 24,10-13,11-15,12-6,7,10 to 13,
 16,18,19,21,34 to 36,39,40,49,72,
 14-5,6,22 to 26,28,29,32,39
 $\cos^2\theta$-constant, 9-23
 $\cos^3\theta$, 9-18,19,22 to 24,32,14-34
 to 36
 eccentricity independence of
 potential focal conditions, 12-7,8
 equational, 9-26,27,12-16
 incident points, 6-12,7-2
 intercept transform, 9-27,10-13,12-9,
 15,16,14-6,8,9,23,30
 radicand, 7-7,13,9-27
 radicand constant, 10-13,12-8,13,16,
 18,19,23,35
 origin of, 14-34 to 41
 -½a focus of Cayley's sextic,
 14-34 to 36
 -½b focus of limacons, 14-36,37
 variable focus of hyperbola axial
 vertex cubics, 14-37,38
 $A^2d/(A^2-B^2)$ focus of bipolar
 linear Cartesians, 14-38 to 40
 $\sin\theta\cos\theta$, 10-11,12-50,54,56,14-8
 variable angle, 7-8 to 12
 vertex (see also constant condition),
 7-2,9-5,13,22,24,10-12,12-54,14-5
 vertex-coincidence, 10-34,35,14-40
 x^2, 9-2,6,22,23,11-15,12-6,8,10,12,
 16,39,14-6,22,23,26,29
 x^4, 12-56,71,14-22 to 26
Focal rank,
 bipolar, 2-3,4,11 to 17
 circumlinear, 12-65
Foci and focal loci,
 circumlinear, 12-61 to 86
 definition, 12-64
 circumpolar,
 angle-dependent versus angle-
 independent, 12-14,15

Foci and focal loci (continued)
 circumpolar (continued)
 asymptote-point, 9-2,3,11,16
 at infinity, 9-6,12,13,22,12-7,11,
 12,34,36,37,50,72,14-9
 compound, 5-26,28
 conditions, 12-14 to 18
 conservation of under inversion,
 9-6,7,12-14 to 18,57,14-6 to 10
 covert linear, 5-27 to 31,12-46 to
 57,64 to 73,14-8 to 10
 axial, 10-15 to 17,12-52 to 54,73
 non-axial, 10-11,15 to 17,12-48
 to 51,54,69 to 73
 covert curvilinear, 12-47,54,55,
 14-10
 gain and loss under inversion,
 12-52,55,14-8,10
 definitions, 1-2,13,14,5-25 to 27,
 7-4,5,ii
 classical, xvi,xvii,1-2
 double point (and homologues), 9-3,
 9,10,16,10-18,19,12-15,18,24 to
 26,35,37
 simple intercept eqs. and formats
 about, 9-9,16,10-18,19,12-24,25
 dual, 5-27,28,12-45
 eclipsable, 5-6,27,29,7-15
 examples, 5-28,29
 generic double-foci of self-in-
 version, 9-1,10-5,12-9,13,14,17,
 19,35,37,39,40,45,72,14-48 to
 53,74,86,93
 hyperbolic QBI curves, 10-40
 identification by inversion ana-
 lysis, 9-20,21,29,30
 imaginary or complex, 7-5,8,12-3,
 7,11,14 to 19,24,39,49,50,57 to
 60
 loop pole at $h = 2b/3$, 9-12,16 to 18
 loop vertex of cubics, 9-10,16
 loss or gain in inversion locus,
 11-24,31,12-52 to 57
 multiple, 5-26 to 28
 dual, 5-27
 generic, 5-27,28
 non-conservation of foci of self-
 inversion, 14-7
 number of, 10-40,12-17
 of self-inversion, 2-6,5-27,9-27,
 12-32,33,52,53,14-6,38,39
 ordinary or intrinsic, 5-24,28,
 10-13

Foci and focal loci (continued),
 circumpolar (continued),
 penetrating, 5-27,29,9-5,8,10-13,
 24,25,45,11-19,12-33,40
 rank of, 2-3,5-30
 individual bipolar, 2-3
 simple, 5-26,28
 single, 5-26
 traditional focus of conics as
 pole of demarcation, 11-36,12-18
 types, 5-26,27
 variable, 5-27,29,9-5,6,8,10 to 13,
 26,10-13,24,25,45,11-19,33,12-33,
 40, 14-39
 penetrating, 5-27,29,9-5,8,10-13,
 24,25,45,11-19,12-33,40,14-39
Folium of Descartes, 1-3,9-6,15 to 18,
 23 to 26,12-4,14-10,*viii*
 double-point inversion quartic of,
 9-22 to 24,12-3,4,*viii*
 inversions of, 9-23,24,12-3,4
 foci of, 9-16 to 18,23,12-16
 inversion analysis, 9-19,20,23,24,
 14-10
4-leaf rose, see Rose

Genus, 1-22,23,5-26
Geometrical expectations versus
 analytical transforms, 10-19 to 22
Geometry as the *sine qua non* of sym-
 metry analyses, 14-1

Harmonic mean, xvi,xvii,7-4,5
Harmonic parabolas, see Parabolas
Hexapolar coordinates, 4-10,11
Hierarchical ordering of curves by
 circumpolar symmetry, 5-13,14,20 to
 24,14-87,*xii,xiii*
Homogeneous polynomials, 5-9
Hyperbolas, 2-1,7-1 to 26,*xii,xiii*
 asymptotes, 5-31,32,12-83 to 86
 circumlinear symmetry, 12-78,80,
 83 to 86
 circumlinear self-inversion, 12-83
 to 86
 equilateral, see equilateral axial
 QBI curves
 normal pedals, 13-23 to 26
 partial, 3-7,8

Hyperbolas (continued),
 tangent pedals, 13-8 to 18
 with incongruent arms, 3-3,6,7
Hyperbola axial vertex cubics, 9-4 to
 13,11-8,9,12-7,15,21,30,64 to 67,
 72,73,14-37,38,*viii*
 circumlinear transforms, 12-64 to 67
 subfocal comparisons of k axes,
 12-66,67
 foci,
 asymptote point, 9-6,11,13,15,
 12-11,14-38
 axial point at infinity, 9-6,12,
 13,22,12-7,11,12,72,14-9
 double point, 9-5,6,9,10,15,14-38
 loop vertex, 9-6,10,13 to 15,14-38
 variable, 9-5,10,11,13 to 15,
 14-37,38
 loop pole at h = 2b/3, 9-6,12,13,
 15,10-10,44,45,11-2,3,14-29,38
 simple intercept eq. for point on
 line of symmetry, 14-33

Imaginary and complex focal loci, see
 Foci and focal loci
Incomplete linears, 1-16
Inflection, points of, 8-14,15,17,14-68
 characteristic of symmetry mimics,
 14-66
Intercept eqs. *viii* to *xi*
 about imaginary foci, 12-57 to 60
 compound, see also Intercept products,
 6-15,9-27,28,10-15 to 17,12-51
 simple, 5-1, *viii* to *xi*
 derivation of, 5-1
 mixed transcendental, 5-2,6-12,
 17,18,10-11,15,12-46,53,64,65,70,
 14-33,75,*x,xi*
Intercept formats,
 circumlinear, 12-65
 circumpolar,
 about imaginary foci, 12-57 to 60
 compound, 5-2,6-13,15,17,7-2,8,
 12,13,9-17,18,27,28,10-15 to 17,
 11-2,12-50 to 52
 derivation, 5-1,6-12,13,15,7-2
 simple, 5-1,6-15,16,7-7,8,14,15,16,
 21,24,9-3,5,9 to 12,32,33,10-2,
 12,18,21,22,24,32,41,43,11-10,13,

Intercept formats (continued),
 circumpolar,
 simple, 12-5,14,15,20,21,22,24,
 26,30,31,34,38 to 40,44,45,47,
 51,14-10, to 12,14,16,20,23,24,
 30,39,40,48,49,68,76,78,81,86
 complementary, 14-10,11
 of self-inversion, 10-24,12-30,31,
 14-48,49,58
 reciprocal, 14-21
 use for synthesis of curves with
 designated specific symmetry,
 14-54 to 69
Intercepts, negative, 7-20 to 26
Intercept transforms, xv,xvi,1-10,
 14,8-4,5,6
 about non-focal poles, 10-30 to 32
 algebraically complete eqs., 7-20
 to 26,12-40 to 44,81,82
 α-transforms, xvii,5-1,4,10,6-1,4,
 12,15,7-8 to 12,9-3,10-18,12-26
 circumcurvilinear, 12-62,6s,85 to 94
 90°-0°, of conics, 12-85 to 94
 congruent self, 12-88,94
 derivation of, 12-87,88
 identical self, 12-88,94
 circumpolar,
 about imaginary foci, 12-57 to 60
 conics, 7-19
 cubics, 9-15
 derivation of, 5-1,14-11 to 21
 0° and 180°, 14-25 to 30
 90°, 14-30 to 33
 duality of 0° and 180°, 7-20 to 26
 45° circular, 5-19,14-71,*xiii*
 helical, 5-17,18
 limacons, 10-40
 QBI curves, 12-55,56
 3-dimensional, 5-17,18
 trivial, 5-3,7-20 to 26
 variable-angle, 7-8 to 12, 9-1
 with complex or imaginary
 solutions, 6-5,7-9,15,12-22,27,
 57 to 60,14-76,77
 circumlinear, 12-61 to 86
 condition, see Focal and potential
 focal conditions
 degrees of, 7-19,9-15,10-40,12-51,
 55 to 57
 versus intercept products, 8-4 to 6

Intercept transformation,
 as two-vector transformation, 6-11
 circumcurvilinear, 12-62,63,85 to 94
 90°-0°, of conics, 12-85 to 94
 circumlinear, 12-61 to 86
 $\alpha-\theta$, 12-62,73 to 75,78,79,81 to
 83,84,86
 90°-45°, 12-82,83
 180°-orthogonal, 12-63 to 70,73,86
 180°-θ, 12-76,81,86
 (180°-2θ)-θ, 12-77,86
 180°-90°, 12-82,86
 circumpolar, 1-10 to 13, Chapters V
 to XII,XIV
Inter-vertex quartics, 11-7,32,12-1,20
Inverse-cos$^2\theta$ group, 5-6,13,14,20,21,
 23,24,14-59,69,76,*xiii*
Inverse-root cos$^2\theta$ group, 5-4,23,24,
 xii,xiii
Inversion,
 about focal as opposed to non-focal
 poles, 12-36,37
 about 2nd line of symmetry, 11-36,37
 analysis versus circumpolar sym-
 metry analysis, 1-2 to 4,6-11,9-20,
 21,29 to 31,14-2 to 6
 and circumpolar symmetry, 6-9 to 12
 as circumpolar construction, 1-6
 as conformal mapping, 14-7
 as single-vector transformation,
 6-11,9-31
 cycles and images, 11-11 to 23
 images, 11-11 to 23
 literature, 11-1,2,36,37
 loci,
 conics, 8-21 to 25
 equilateral curves, 6-9 to 11
 limacons, 10-43 to 47
 QBI curves, 11-1 to 37
 of cubic polynomials, 14-45,46
 pairs, circumcurvilinear symmetry of,
 12-93,94
 point-in-the-plane, 8-21,11-35 to 37,
 12-46,47,52,53,14-9,10
 covert focal loci of, 12-52 to 57
 reciprocal inversion pole, 6-10,11,
 10-17,11-1,3,9,12-37,14-11
 as triple focus, 11-33
 Taxonomy, see Taxonomy, Inversion
Inversion image analysis of self-in-
 version, 11-28 to 32

Inversion, self, see Self-inversion

Latus rectum, 5-31,6-17,18,7-8,17,18,
 10-6
 vertices, 6-17,7-8,14,15

Law of cosines, 6-5

LCQ sextics, 14-59,60 to 63,*xii,xiii*

Limacons, 2-5,21,10-1 to 47,12-22 to
 27,69 to 73,14-24
 axial inversion quartics, 11-26
 axial vertex cubics, 10-46,47,11-14,
 15
 circumpolar symmetry, 11-15,16
 inversions of, 11-14,15
 circle deviation, 10-37 to 39
 circumlinear symmetry, 12-67 to 73
 circumpolar symmetry, 5-13,8-9,10-11
 to 43,*xii,xiii*
 condition for self-inversion, 11-6,7
 construction from circles, 10-4
 covert linear focal loci, 10-15 to
 17,*ix*
 curves with reciprocal-format sym-
 metry to, 14-51
 equations about different foci,
 10-3,12-2,4
 foci,
 $(a^2-b^2)/2b$, 2-6,5-28,29,6-9,10,
 8-9,9-1,10-3,4,5,8,9,13,14,17,
 22,23,31,11-7,33,12-13,21 to 23,
 33,35,14-24
 $-\frac{1}{2}b$, 5-7,6-9,10,10-3,4,5,8,9,10,
 13 to 15,23 to 32, 35 to 39,44,
 11-2,12-11,21,14-19,36,37,39
 DP and homologues, 6-9,8-9,10-4,
 5,6,14,18,19,43
 vertices, 6-10,10-4,5,10,13 to 15,
 41,44,11-33
 focal-inversion quartics, 10-44,
 11-13,14
 inversion correspondences with
 conics, 10-5,6
 inversion quartics, 10-46
 inversions, 10-43 to 47
 classification of, 10-47
 line-of-symmetry inversion quartics,
 11-3,5,6,7
 line-of-symmetry transforms, 14-18,
 19,24
 origin of foci of cardioid, 12-34
 to 36
 overt homologies with conics, 10-9,10

Limacons (continued),
 pedal construction, 10-4
 simple intercept eqs., 10-11,12,
 15,16,*ix*
 subspecies, 10-14,15,22,23,30,31,
 41 to 45
 $2\cos\theta$ (e = 2), 5-7,8-22,10-10,19,
 20,21,23 to 25,29,31,33,35,
 11-11,12,14,12-4,14-17
 equilateral, see Equilateral axial
 QBI curves
 symmetry mimics, 14-66,67
 unique aspects of symmetry of,
 12-18,21 to 23,31,70 to 72,
 14-24,25
 vertices, 10-6 to 9,16,17

Linear-circular coordinates, 1-5,18,
 4-17 to 20

Linears, 2-5,6,3-5 to 8,4-1,19-23

Lines,
 any line pair, 6-3
 intersecting, 8-10,13-2
 polar-linear, 3-3 to 8
 inversion of, 6-9
 of symmetry, 1-9,2-2,3,5,12,13,23,
 24,3-4,5,12,5-8,6-14,19,8-10,11,
 9-15,23,31,10-12,17,12-33,37,38,
 41,63,74,83,14-7 to 10,87
 coordinate, 1-9,2-2,23,24,3-4,5,12
 intrinsic versus elective, 3-4,5
 inversions about points on, 11-1
 to 37,12-17,14-22
 loss and gain by inversion, 11-24,
 31,35,12-17,52 to 57
 parallel bilinear system, 4-21,22
 parallel line-pair, 4-22,5-4,13,14,
 21 to 24,6-1,2,3,8-10,13-2,
 14-66,67,*viii,xii*
 bipolar, 2-15,16
 circumlinear symmetry of, 12-81
 to 83
 circumpolar symmetry of, 6-1,2,3
 intercept transforms, 5-4,13,
 14,21,6-1,2,3
 degrees of, 7-19
 non-focal self-inversion loci,
 8-7,8
 quartic symmetry mimic, 14-67 to
 70,*xii,xiii*
 segments, polar-linear, 3-6,7,8

Lines (continued),
 single, 6-3
 symmetry of curves about, 12-61 to
 86
LLC octics, 14-59,63 to 65, *xii,xiii*
LLX dodecic 14-65
Logarithmic spiral, 5-13,24, *xii*

Master eq., 4-2 to 5,11-13
Master pole, 4-2 to 5, 11-13
Maxims,
 bipolar, *xiv*
 circumpolar, *xv* to *xviii*
 Tangent-Pedal Taxonomy, *xix*
Mirror-image symmetry, see lines of
 symmetry
Monoconfocal hyperbola-ellipse pair,
 5-2,7-4,18
Multi-angle self-inverters, 14-81 to 83
Multi-oval curves, comparative sym-
 metry of, 14-83 to 86
Mutually-inverting quartic circles,
 see Quartic circles

Near-conics,
 Cartesian, 10-32 to 37
 near-circles, 5-7,10-24 to 28,34,
 36,37
 near-ellipses, 5-7,10-23,25,28 to
 30,36,37
 near-lines, 5-7,10-24 to 28,34,36,
 37,12-93
 origin of, 10-37 to 39
Nestling curves, 13-7,8,15 to 17
Non-focal self-inversion loci, 6-6 to
 8,8-1 to 4,6 to 17
Normal pedals, see Pedals
Norwich spiral, 5-11

Order of Circumpolar symmetry, 5-10,18
Ordinal rank, 1-11,5-18,20,23,24,6-2,
 3,8,19,7-18,9-14,15,10-18,19,
 12-45,46,14-53,56 to 58,62 to 64,
 68-71,79,85
 independent of transformation angle,
 5-18,19

Parabola,
 bipolar, 2-13 to 15,19 to 22
 circumcurvilinear symmetry,
 about cissoid of Diocles, 12-83,94
 circumcircular, 12-89,94

Parabola,
 circumcurvilinear symmetry (con-
 tinued),
 circumelliptical, 12-90,91,94
 circumhyperbolic, 12-90,91,94
 congruent self, 12-89,94
 identical self, 12-88,94
 circumlinear symmetry, 12-78,79
 circumpolar intercept transforms,
 5-6,9,13,21,22,6-12 to 19,12-85
 degrees of, 7-19
 confocal two-arm, 1-2,18,4-17 to
 19
 disparate two-arm, 3-3
 harmonic, 4-4 to 6,11 to 14
 inversions,
 axial, 11-32 to 36,12-1,2,4,50,
 13-10, *x*
 non-self-inversion of, **11-34**
 point-in-the-plane simple inter-
 cept eqs. of, 12-46,47 to 50
 circumpolar symmetry, 12-33 to 37
 point-in-the-plane, 8-21,11-35,
 12-53 to 57, *x,xi*
 self-inversion of, **11-35**
 normal pedals, 13-23 to 26
 inversions of, 13-24
 orthogonal line of symmetry at
 infinity, 9-7
 partial, 3-3
 pentapolar, 4-10
 polar-circular, 4-16,17
 pole-intersecting, two-arm, 4-8
 satellite, 4-4,5,7,10 to 13
 simple intercept eq., 6-12, *viii*
 symmetry comparisons with central
 conics,
 circumlinear, 12-79,86
 circumpolar, 5-13,21,22, *xiii*
 linear-circular, 1-2,4-18,19
 polar-linear, 3-3
 tripolar, 4-1,2
 quartic twin, 2-17,18,5-13,14,22, *xii*
 tangent pedals, 13-2 to 8
 tetrapolar, 4-3
 triple focus at axial point at
 infinity, 9-7
 tripolar, 4-1,2
 two-arm, 3-3,4-45,7,8,10 to 13
Parabolics, 2-6,7,3-13,14,4-16,25
Parallel line-pair, see Lines
Parent axial vertex cubics, 9-18,19,
 viii

Partial conics,
 ellipses, 3-12,4-22
 hyperbolas, 3-7,8
 parabolas, 3-3,4-23
Parameter interconversions, 8-24,9-4,
 13,11-16,12-8,22
Parameter pole, 4-6,11,13
Pedals,
 compounded tangent, 13-19 to 22
 normal, x,13-23 to 26
 tangent, 1-25,9-1,13-1 to 22
Pentapolar coordinates, 4-8,9
Phylum of circumpolar symmetry, 5-5,
 6-11
Point transformations, 8-26,27
Polar-circular coordinates, 1-5,18,
 4-15 to 17
Polar coordinate system, 1-6,4-29
Polar exchange symmetry, 3-9,4-7,10,
 16,24
Polarized bipolar coordinates, see
 Bipolar coordinates
Polar-linear coordinates, 1-5,10,15,
 17,3-1 to 15
 incident, 3-3,4,5
Poles of conditional focal rank,
 5-26,28,10-13 to 15,41 to 43
 definition, 5-26
Post-vertex group, 11-32,12-1
Pseudo-exchange-limacons, 6-10,8-18,
 10-10,11-10,16,17,12-4,9,13,18,
 25,29,14-11,16
 inversion to conics, 11-16,17
 origin of special symmetry of,
 14-41,42
 transforms about DP, 14-16 to 18
"Pure" intercept products, see
 Intercept products

QBI superfamily, 1-18,8-18,19,9-23,
 11-1 to 37,14-22 to 25
 axial curves, 14-22 to 34
 0° and 180° transforms, 14-25 to
 30
 90° transforms, 14-30 to 33
 cubics and quartics, 12-2,5,
 14-24,*x*
 loop axial diameter ratio,12-9
 simple intercept eq., 12-5,6,
 10,11,46,51
 simple intercept format,12-21,22

QBI superfamily (continued),
 unique symmetry properties of,
 12-18,21 to 23,31,70 to 72
 $-\frac{1}{2}$b focus and homologues, 12-29,30
 circumlinear symmetry, 12-69 to 73,
 14-33,34
 about k axis at x = H,12-69 to 73
 covert focal loci, 12-46 to 57,
 69,70
 curves of unit eccentricity, 11-32
 to 36,12-33 to 36,69,70
 DP and DP homologues, 12-24 to 29,
 34
 focus of self-inversion, 12-31 to
 34
 general circumpolar symmetry ana-
 lysis, 14-22 to 34
 inversions between subspecies of
 given eccentricity, 11-22
 locational terminology, 12-1
 open or closed membership, 11-1
 origin of special symmetry, 14-42
 to 46
 self-inversion within,11-23 to 32
Quartic circles, 5-13,14,21,11-26 to
 28,12-2,4,15,17,19,38 to 46,72,
 13-1,14-30,48,51,70,80,84,*x,xii,xiii*
 centers, 12-44
 curves with reciprocal-format sym-
 metry to, 14-51
 double-foci of intersection, 12-19,
 39,40,42,43,14-11 to 14
 major axis, 12-41 to 45
 root-format symmetry groups of,
 14-53
 tangent circles, 12-45,85,86,13-2,
 14-65,69,*xii,xiii*
 sextic symmetry mimic of, 14-69
 to 72,85,86,*xii,xiii*
 true center, 5-28,12-15,40,42 to 45,
 14-14,15
Quartic twin parabola, see Parabola
Quartics, inventory of, 12-2,3

Radicand, conditions on, 7-13,14,
 12-8,13,16,22,72
Radial transformation, 8-26
Reciprocal inversion pole, see Inversion
Reciprocal reflective symmetry, see
 Self-inversion
Reciprocal spiral, 5-13,20,*xiii*

Reciprocal-format symmetry, 14-49 to 52
 self-inverting, 14-49,50
 Cartesian self-inverters, 14-51
 equilateral limacon, 14-51,52
 quartic circles, 14-51
Rectangular coordinate system, 1-6,7,
 18,24,4-25-30,5-13 to 15
Redundancy, see Reflective redundancy
Reflective redundancy, 1-9,3-3,12,4-22
 to 25
 in midline, 2-23,24,4-22,24
 in polar axis, 2-2
Representational restriction, 1-7
Requirement for axial equality, 3-4,5,
 11
Restrictiveness of coordinate systems,
 bilinear systems and complete degree
 restriction, 1-9,4-25
 exponential degree, 1-8,9
 representational, 1-7,8
Root-cos$^2\theta$ group, 5-13,14,24,6-11,
 8-22,10-2,11-7,14-62,63,65, xii,
 xiii
Root-format symmetry, 14-52 to 54,78
 self-inverting, 14-50
 Cartesian self-inverters, 14-78
 circle, 14-52
 equilateral strophoid, 14-52,53
 mutually-inverting quartic circles,
 14-53
Rose, 4-leaf, 14-69,83 to 86, xii
Roulette, 9-25

Self-inversion,
 α-, 1-25,12-28,29,14-3,6,7
 and symmetry, 8-8,9,10,12-12,13,28,
 29,14-7,86,87
 as reciprocal reflective symmetry
 through a point, 1-11,25,12-12,
 28,29,14-7,86
 at 90°, 12-27,14-76,77
 focal, 8-1,2,8,9,10
 focal rank of pole of, 12-12,12,32
 foci of, see Foci and focal loci
 generic double-foci of, 9-1,10-5,
 12-9,13,14-47 to 54,58,74,86
 inversion image analysis, 11-28 to
 32
 non-focal, xi,8-1,2,6,7,8,10 to 17,
 12-28

Self-inversion (continued),
 non-focal,
 axial centers for, 8-11,13,14
 of non-central axial inversions of
 central conics, 11-28 to 32
 omnidirectional circumlinear, 12-83
 to 86
 pole of for axial QBI curves, 12-6,
 8,12
 simple intercept formats of, 10-24,
 12-30,31,14-48,49,58
 θ-self-inversion loci, 8-2,3,4
 transforms of, 10-22,12-30,31
 within the QBI superfamily, 11-23 to
 32
Self-inverters,
 Cartesian, 7-24,10-2,3,12-18,30,
 14-48, 86 to 95, x
 eccentricity-dependent, 12-18 to 21,
 25,30,14-48, x
 multi-angle, 14-81 to 83
 octa-angle, 14-82,83
 tetra-angle, 14-82,83
 tri-angle, 14-69,77 to 80
Single-parameter curves, 5-24,10-10,
 14-11,21,85
Sinusoidal spirals, 13-19 to 21
Species, 1-22,23
Specific symmetry class, 5-5,6,7,11,11-11
 circular, 5-13,19,22,12-27,14-55 to
 57, xiii
 elliptical, 5-11,23,6-6,10-19,12-24,
 39
 equilateral hyperbolic, 14-58
 hyperbolic, 5-13,19,20,21,6-14,7-5,
 10,12-28,14-69,80, xiii
 linear, 5-13,19,22,10-18,14-58 to
 60,69,70,80,85, xii
 nth degree "Circular," 14-57,58
 parabolic, 5-11
 0-degree, 5-5,11,24
Spirals,
 Archimedes, 1-16,17,5-13,17,24, xii
 logarithmic, 5-13,14, xii
 Norwich, 5-11
 reciprocal, 5-13,20, xiii
 sinusoidal, 13-13,14,21
Squared-cos$^2\theta$ group, 5-13,14,20,24,
 xii

Subfocal rank,
 bipolar, 2-1 to 24
 circumlinear, 12-64 to 68,73,75,
 79,81
 circumpolar, 5-31,32,9-10,11
Subfocal symmetry, see Symmetry
Suborder of circumpolar symmetry, 5-19
Subordinal rank, 1-11,5-19 to 21,23,
 24,6-2,3,8,19,7-18,9-14,15,10-18,
 19,12-28,45,46,14-53,56 to 58,62
 to 64,68 to 71,79,85
Subspecies, 1-22,23
Superfamily, 1-21,8-18,19
Symmetric functions, 5-8,9,12-63
Symmetry,
 circumcurvilinear, 12-62,85 to 94,
 see also,Circumcurvilinear sym-
 metry
 circumlinear, see Circumlinear sym-
 metry
 circumpolar, Chapters I,V-XIV
 angle-dependent and independent
 indices of, 12-14,15
 class, 1-20,5-5,6,7,11
 comparisons for transformations at
 different angles, 14-70
 intuitive concepts, 1-4,5
 mimics, 1-24,14-50,51,65 to 73
 additional points of inflection,
 14-66
 of central conics, 14-67,72
 of the parallel line-pair, 1-67
 to 70,*xii*
 of tangent circles, 5-23,14-70 to
 72,*xii*
 mirror image, see Line of symmetry
 most symmetrical curves, 1-2,4,16,
 17,*iii*
 rank, 1-15
 reciprocal reflective through a
 point, see Self-inversion
 relativity of, 1-1,2
 subfocal, 1-14,15,3-5,5-31,6-18,
 7-17,18,9-11,21,12-23,61 to 86
 of bipolar circles, 2-8 to 11
Synthesis of highly-symmetrical
 curves, 1-24,14-47 to 86
 building-block approach, 1-24,14-47

Synthesis of highly-symmetrical
 curves (continued),
 designated specific symmetry approach,
 14-54 to 61
 circular, 14-54 to 57
 equilateral hyperbolic, 14-58
 linear, 14-58 to 65
 nth degree "circular," 14-57,58
 double-foci of self-inversion
 approach, 1-24,14-48 to 54

Tangent circles, see Quartic circles
Tangent pedals,
 definition and derivation of, 10-5,
 13-1
 of central conics, 13-8 to 18
 of point, line, and circle, 13-1,2
 of the parabola, 13-2 to 8
Taxonomy,
 Circumpolar Symmetry, 1-19,6-12,9-7,
 8,11-12
 Inversion, 1-20,21,6-11,8-18,19,9-1,
 25,10-10,11-1 to 37,14-2
 fundamental properties of, 11-21,22
 of curves of unit eccentricity,
 11-32 to 36
 Normal-Pedal, 8-26
 QBI curves of unit eccentricity,
 11-32 to 35
 Tangent-Pedal, 1-25,8-26,9-1,13-1 to
 18
 versus compounded pedals, 13-21,22
Tetrapolar coordinates, 4-3 to 8
 non-collinear, 4-7,8
Transcendental ordinal and subordinal
 rank eqs., 5-20,23,6-2,3,8,19,7-18,
 14-85
Transformation formats, 5-10,6-1,3,
 12-27,*vii*
Transforms, see Intercept transforms
Tri-angle self-inverters, 14-69,77
 to 81,*xii,xiii*
Tripolar coordinates,1-15,18,4-1,2
 non-collinear, 4-1
Trisectrix of Maclaurin, 8-18,22,24,
 9-6,9 to 16,10-44,45,11-2,3,10,
 11,14,12-4,14-17
True exchange-limacons, 8-20,10-10,
 11-10,14-17,54

Tschirnhausen's cubic, 9-1,15,23,25
 to 28,33,11-12,12-16,13-19,20,
 14-11,34 to 36, *viii*

Undirected distances, 1-5,6,7,4-26 to 30
Unicursal Cross Curve, 7-16,13-15,25
Unpolarized bipolar coordinates, see
 Bipolar coordinates

Vertex-focus group, 12-2,20
Vertex tangent, 3-6,7,6-18
Vertices,
 imaginary, 12-59
 intercept transforms about, 12-59

FIGURES AND FIGURE LEGENDS

FIGURE LEGENDS

Fig. 1-1. Symmetry relative to single reference elements. The symmetry of curves relative to single reference elements is assessed, in general, by means of two radius vectors emanating from points on the reference elements to the curves. In the case for which the reference element is a point, only a single angle is associated with a given characterization of the symmetry, namely the angle, α, between the two radius vectors. In the broadest sense, the symmetry of a basis curve about a given point-pole at a given angle--α-*circumpolar symmetry*--is characterized by a transform curve--the *intercept transform*. This is obtained from a rectangular plot of the lengths (intercepts) of two radius vectors, x and y, that emanate from the reference pole to the curve at a fixed angle, α, to one another, as these vectors rotate about the pole and "scan" the basis curve. Fig. a illustrates the manner in which the 90°-circumpolar symmetry of an ellipse about a non-axial interior pole is obtained (see also Fig. 1-2k). Successive lengths of the 4 pairs of orthogonal vectors at the left are plotted at the right along rectangular axes.

The manner of derivation of an intercept transform curve that characterizes the α-θ-*circumlinear symmetry* of a basis curve is illustrated in Fig. b. In this case the symmetry is assessed relative to two reference angles, the angle, α between the two radius vectors, and the angle θ between the x vector and the x-axis; both angles are taken to be 45° in the illustration of Fig. b. In the case of circumlinear symmetry, the radius vectors do not rotate about a pole but, rather, translate from point to point along the reference line, always maintaining the same orientation to one another and the line. The x and y intercepts obtained in this manner at 3 positions of a pole on a reference line consisting of the major axis of the basis ellipse, at the left in Fig. b, are plotted on rectangular axes at the right.

The characterization of the α-θ-*circumcurvilinear symmetry* of a basis curve is accomplished in a parallel fashion in Fig. c. The intercept transform curve that characterizes the 90°-0°-circumelliptical symmetry of a basis circle--the major auxiliary circle of an ellipse--is derived by plotting at the right the intercepts obtained at the left along the reference ellipse. This is illustrated for 3 pairs of radius vectors.

Symmetry Relative to Single Reference Elements

radius vectors

a

b

c

90°-Circumpolar symmetry of ellipse

45°-45°Circumlinear symmetry of ellipse

0°-90°-Circumelliptical symmetry of the circle

Fig. 1-1

Fig. 1-2. Representative $90°$-circumpolar intercept transforms of an ellipse of eccentricity, 0.745 (Fig. f). If two orthogonal radius vectors are rotated about a pole (h,k) in the plane of this ellipse at one of the positions indicated in the figure, and the intercepts of these vectors with the basis curve are plotted along orthogonal axes (see Fig. 1-1a), the intercept transform curve for this pole (or a segment thereof), is obtained. Figs. a-e,g-1 show the transforms for various values of h and k. The plotting of positive intercepts for the internal poles gives the complete figures shown, whereas, for the incident poles (all of which are vertices), only a quarter-segment of the curve (in the 1st quadrant) results. [Inasmuch as ellipses have a true center (the point of intersection of two orthogonal lines of symmetry), the coordinates of the poles all are represented as being positive in the labels, although all do not lie in the 1st quadrant.]

All transforms about axial poles--all the loci except those of Figs. j and k--have, at the least, symmetry about the line $x = y$ (as plotted in the 1st quadrant). The curve of Fig. j has symmetry about the origin, i.e., a line passing through the origin has equal intercepts with the curve. Fig. b is a recurrent arc that is traced in one direction for each $90°$ of rotation. This can be visualized by examination of Fig. h, for a displacement of a/24 along the minor axis.

The $90°$-transforms about a point in the plane, such as the curve of Fig. k, are of 20th degree. Accordingly, the pole for any transform with degree less than 20 either is a point focus or lies on a focal locus. Thus, all points on the major and minor axes and their extensions give transforms of no greater than 16th degree, while all points incident upon the curve give transforms of no greater than 12th degree. Although both the center and the traditional focus have $90°$ transforms of 4th degree, the center is the higher ranking of the two foci, inasmuch as its $180°$ transform is of 1st degree, compared to 2nd degree (equilateral hyperbolic) for the traditional focus (see Fig. 5-1 and eqs. VII-8a,b).

Transforms of high degree frequently possess many points of inflection, which cannot all be shown at the scale employed. For example, the square-looking transform of Fig. i for the b vertex--which has "rounded" corners--has two unillustrated points of inflection on each side (see also Figs. g and j).

Ellipse 90°-Circumpolar Intercept Transforms

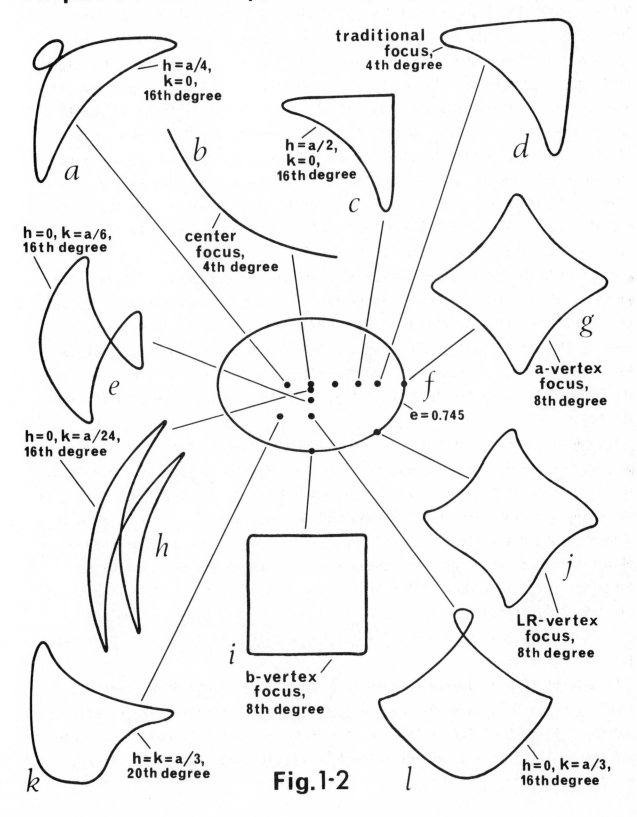

**h = a/4,
k = 0,
16th degree** — *a*

b

**traditional
focus,
4th degree** — *d*

**h = a/2,
k = 0,
16th degree** — *c*

**center
focus,
4th degree**

**h = 0, k = a/6,
16th degree** — *e*

**a-vertex
focus,
8th degree** — *g*

e = 0.745 — *f*

**h = 0, k = a/24,
16th degree**

h

**LR-vertex
focus,
8th degree** — *j*

**b-vertex
focus,
8th degree** — *i*

**h = k = a/3,
20th degree** — *k*

Fig. 1-2

**h = 0, k = a/3,
16th degree** — *l*

Fig. 2-1. The most symmetrical loci in the unpolarized, non-coincident bipolar coordinate system. The loci of Figs. a, b, and c are represented in their entirety, whereas those of Figs. d, e, and f are represented as they would be in the polarized system, i.e., they have not been reflected in the midline; this is purely in the interests of simplicity of representation. The poles of Figs. e and f are labelled for reference.

Fig. a is for the simplest *complete linear* eq., $u = v$, and, accordingly, represents the most symmetrical curve, namely the midline. The variables, u and v, are the undirected distances from the poles p_u and p_v, respectively. If the eq. is made more complicated by the addition of the single constant, d (the distance between the poles), the curves of Figs. b_1, b_2, and b_3 are obtained.

In the polarized system, the locus of Fig. b_2 is most symmetrical because of its symmetry about the midline, which is characteristic of loci defined by bipolar eqs. that are symmetrical in u and v (in the polarized system, the eqs. of Figs. b_1 and b_3 represent only one circle and one lateral line segment). However, in the unpolarized system--as represented--the curves of all 3 of these figures are symmetrical about the midline, and all 3 curves are essentially equally symmetrical. Fig. b_1 consists of two circles of Apollonius, Fig. b_2 is the connecting line segment, and Fig. b_3 consists of the lateral arms, coincident with the bipolar axis and extending from the poles to infinity.

If the eqs. $u \pm v = d$ are made more complicated by the employment of a second constant, to yield $u \pm v = d/e$ (or, what is equivalent, by the employment of a distance other than the polar separation, d), the symmetry of the loci is reduced, yielding the ellipse and hyperbola of Figs. c_1 and c_2. The poles now are the traditional foci.

If the absolute magnitudes of the coefficients of u and v are made different, but with one of these coefficients equal to the coefficient of the d term, less symmetrical bipolar curves are obtained, namely, the limacons of Figs. d_1 and d_2. Examples of both an elliptical (d_1) and hyperbolic (d_2) limacon are given. The poles of these linear bipolar limacons are the DP or its homologue (p_u in the polarized system) and the focus of self-inversion (p_v in the polarized system; the latter is external to the curve in d_1 and within the loop in d_2). [The parabolic limacon--the cardioid--cannot be represented by a *linear* bipolar eq.]

The Most Symmetrical Bipolar Loci

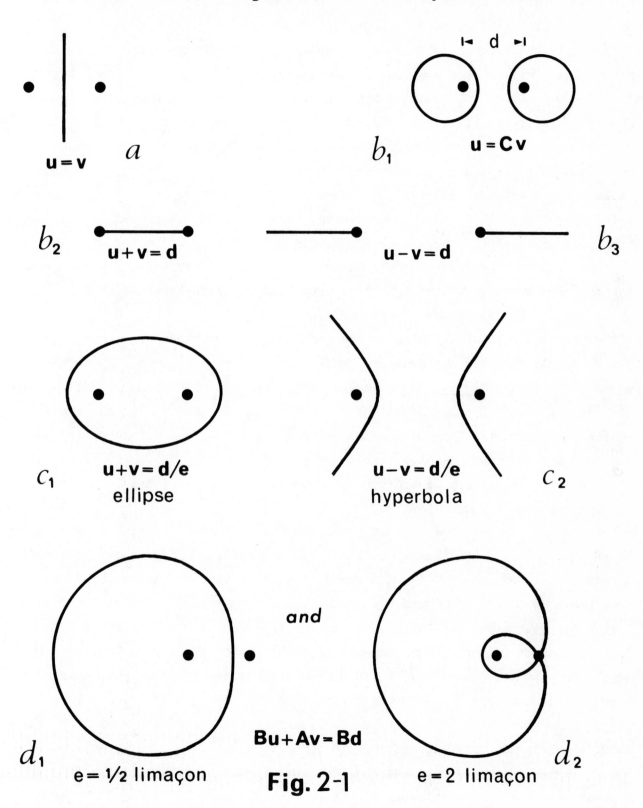

$u = v$ *a*

b_1 **u = Cv**

b_2 **u + v = d** **u − v = d** b_3

c_1 **u + v = d/e** ellipse **u − v = d/e** hyperbola c_2

and

Bu + Av = Bd

d_1 e = ½ limaçon **Fig. 2-1** e = 2 limaçon d_2

If the coefficients of all 3 terms now are made different, a further decrease in symmetry occurs, yielding the *linear Cartesian ovals* of Fig. e. In the example depicted, the eq. of the interior oval is $(1+3^{\frac{1}{2}})u-(2+3^{\frac{1}{2}})v = d$, while that of the large oval is $(2+3^{\frac{1}{2}})v-(1+3^{\frac{1}{2}})u = d$.

The ovals self-invert in 3 different modes about 3 different foci of equivalent rank. They undergo *positive intra-oval self-inversion* (i.e., each into itself along coincident radii) about the pole p_u; they undergo *negative inter-oval self-inversion* (i.e., each into the other along oppositely-directed chords) about p_v; and they undergo *positive inter-oval self-inversion* about a focus which, in this particular subspecies, is the reflection of p_u in p_v (see also Table XIV-3, Ovals No. 3).

The pole labelled f_3 is a penetrating, variable focus--the homologue of the $-\frac{1}{2}b$ focus of limacons; *near-conic* transforms are obtained about this focus (see Chapter X, *Cartesian Near-Conics*). Inversion to a subspecies of the basis genus (*central Cartesians*) for the inversion superfamily occurs about axial poles lying between the ovals (see Chapter XIV).

The 2nd-degree parabolic bipolar eqs. of Figs. f give curves of lesser symmetry, namely the *bipolar parabolic Cartesians*. The most symmetrical of these, $u^2 = dv$, resembles Fig. f_1, but with the right face essentially flat over half its course. For $C < 1$, the curves are everywhere convex, for $C > 1$, the concavity at the right appears. The smaller the value of C, the more nearly circular the oval and the more central the location of p_u. For $C = 1$, p_v is $(5^{\frac{1}{2}}-1)d/2$ units distant from the vertex. As C decreases from 1, the indentation enlarges and p_v approaches ever closer to the vertex.

For a value of $C = 4$, the rims of the indenting oval make contact, forming a DP (double point) and yielding the *curve of demarcation*, which is the equilateral limacon ($e = 2^{\frac{1}{2}}$) of Fig. f_2. The focus p_v thereby becomes internalized (a *conditionally penetrating variable focus*; see pages V-27,29). The eq. of this limacon is cast about the $(a^2-b^2)/2b$ and $-\frac{1}{2}b$ (p_u) foci. A 1st-degree eq. of limacons cannot be cast about pole-pairs of which the $-\frac{1}{2}b$ focus is one member. Accordingly, the locus of Fig. f_2 is a less symmetrical bipolar limacon than those of Figs. d_1 and d_2. In other words, limacons have greater symmetry about a pole-pair consisting of the DP and the focus of self-inversion than they have about a pole-pair consisting of the $-\frac{1}{2}b$ focus and the focus of self-inversion. For $C = 4$, the loops separate and the foci move inward. Positive inter-oval self-inversion occurs about the pole p_v.

The Most Symmetrical Bipolar Loci

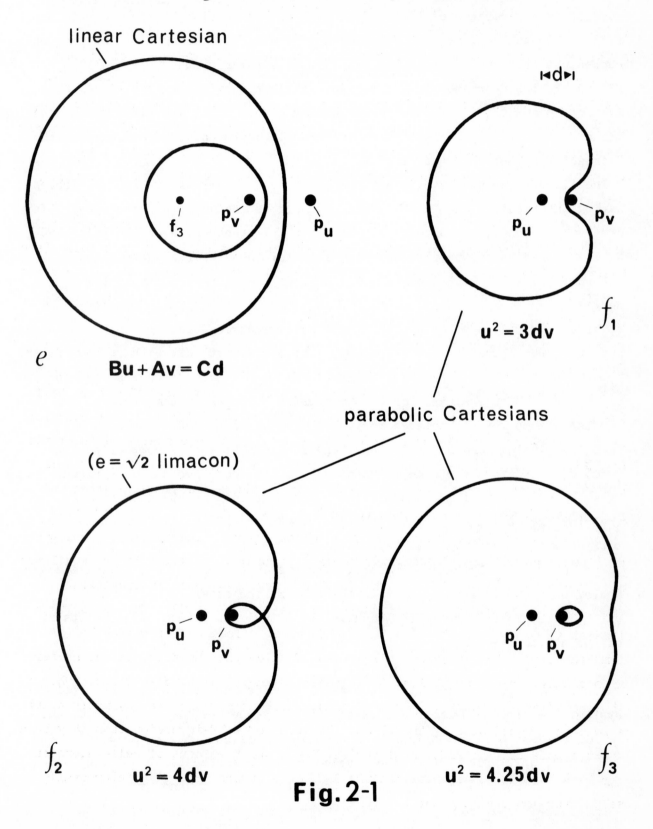

Fig. 2-1

Fig. 2-2. Bipolar symmetry of axial circles. The most symmetrical circles in the non-coincident *unpolarized* bipolar system are the circles of Fig. b. These consist of two circles of Apollonius, each the reflection of the other in the midline (in the conventionally-employed *polarized* bipolar system, the same eq. represents only one circle). The unpolarized bipolar symmetry of the illustrated circles decreases in the sequence indicated by the arrows, i.e., b, c, d and d', e and e', and f. The corresponding bipolar eqs. are given with each illustration. By definition, these increase in degree and/or complexity with decreasing symmetry of the circles.

The illustrated sequence is not complete, i.e., other axial bipolar circles having intermediate and lesser symmetry could be included in the sequence. In cases b through f, the dimension, d, is the distance between the poles and R is the radius of the circles. Fig. f is for the specific case of two external poles, each at a distance d/2 from the nearest point on the nearest circle.

The eqs. for Figs b, e, e', and f are not symmetrical in the variables u and v, even though the corresponding loci are symmetrical with respect to the bipolar midline (see Appendix IV, Bipolar Maxim 6). This is because the loci plotted for these eqs. are for the *unpolarized* bipolar system, whereas the bipolar maxims were formulated for the eqs. of loci as represented in the polarized system. On the other hand, the loci of the eqs. accompanying Figs. a, c, d, and d' are the same in both systems. The eqs. needed to represent Figs. b, e, e', and f in the polarized system are degenerate; for example, that for Fig. b is $(u-Cv)(v-Cu) = 0$ or $uv = (u^2+v^2)[C/(C^2+1)]$, which is symmetrical in u and v.

Fig. a is the only valid circle that exists in the coincident system and one of only two loci that exist in the system. The other locus is $u = v$, which is the most symmetrical locus in the coincident system; it consists of all points in the plane.

Fig. 2-3. Bipolar symmetry of non-axial circles in the unpolarized bipolar system. The bipolar symmetry increases in the sequences, a, b, c, and d, and a, b', c', and d'. Fig. a is for circles in the plane, for $k \neq R$, d, d/2 and for $h \neq 0$, d/2. For $h = 0$, the circles become bisected by the midline and eq. 7a simplifies to eq. 7c, which is symmetrical in u and v. Eq. 7c simplifies further for $k = \frac{1}{2}d$. The greater simplicity of eqs. 8, and the

Bipolar Symmetry of Axial Circles

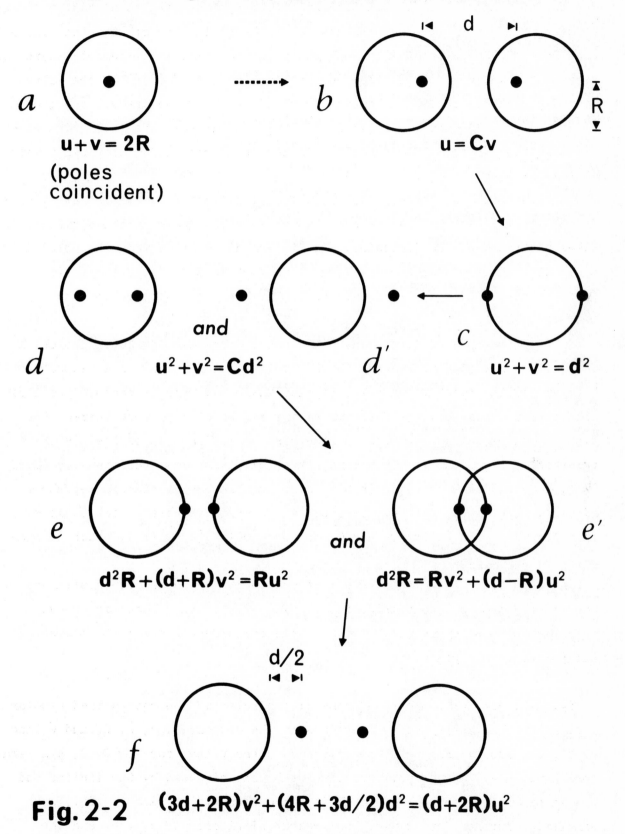

a

u + v = 2R

(poles coincident)

b

u = Cv

d

u² + v² = Cd²

d'

c

u² + v² = d²

e

d²R + (d + R)v² = Ru²

and

e'

d²R = Rv² + (d − R)u²

d/2

f

Fig. 2-2 **(3d + 2R)v² + (4R + 3d/2)d² = (d + 2R)u²**

greater symmetry of Fig. d are achieved for $k^2 + d^2/4 = R^2$, whereupon the poles become incident. These are the most symmetrical non-axial bipolar circles. Greater symmetry is achieved only in *axial* circles (for $d = 2R$, the poles are diametrically opposed and the locus is that of Fig. 2-2c).

For $h = \frac{1}{2}d$, eq. 7a simplifies to 7b (see pages II-9-11) and there is an increase in symmetry to the circles of Fig. b'. A simplification of eq. 7b and further increase in symmetry to the circles of Fig. c' is achieved for $k = d$. Still further simplification of eq. 7b and increase in symmetry to the circles of Fig. d' is achieved for $R = d$, whereupon the circles become tangent to one another in pairs. No further increase in the symmetry of the circles within the non-coincident system is possible for $h = \frac{1}{2}d$. For $d = 0$, however, the point circle of the coincident system is obtained (see Fig. 2-2 and its legend).

The illustrated sequences are not complete or unique. Non-axial circles with symmetry intermediate between members of the sequences exist, and different sequences could be given. For example, instead of letting $h = \frac{1}{2}d$ in eq. 7a, leading to eq. 7b and Fig. b', one could have let $k = d$, leading to a different figure as the next in the sequence. Then, letting $h = \frac{1}{2}d$ would lead to Fig. c'. [Circles similar to the intersecting circles of Fig. d', but with adjacent members also tangent to one another ($k = d/2 = R$ instead of $k = d = R$), are less symmetrical. Thus, the coefficients in the eq. of the mutually-tangent circles, $u^4 + 5v^4 = 2u^2v^2 + 8R^2(u^2+v^2) - 16R^4$, deviate more from unity than those in the eq. of the intersecting circles, $u^4 + 2v^4 = 2u^2v^2 + 2R^2(u^2+v^2) - R^4$. Note that neither eq. is symmetrical in u and v. In the polarized system, these circles consist only of a single pair, tangent at p_v but not reflected in the bipolar midline.]

Fig. 2-4. Bipolar conics with quadratic and higher-degree eqs. Of the loci illustrated here, only the parallel line-pair is symmetrical about the bipolar midline. Accordingly, since none of the other loci has been reflected in the bipolar midline, the other loci represent plots of the accompanying eqs. for the *polarized* system; for this reason the poles are labelled. Additionally, since the poles of Fig. c_6 do not lie on the line of symmetry of the curve, the complete locus for the given eq.--even in the polarized system--includes the reflection of the curve in the bipolar axis (not illustrated).

The 2nd-most-symmetrical central conics are those cast about a traditional focus paired with the center (Fig. a_1). The eq. for hyperbolas in Fig. a_1 is expressed in terms of the semi-axes, a and b. For ellipses, the corresponding eq. is $u^2 - b^2 = (v-a)^2$. In terms of d and e, the eqs. are $u^2 + d^2(e^2-1)/e^2 = (v+d/e)^2$, for hyperbolas, and $u^2 - d^2(1-e^2)/e^2 = (v-d/e)^2$, for

Bipolar Symmetry of Non-Axial Circles

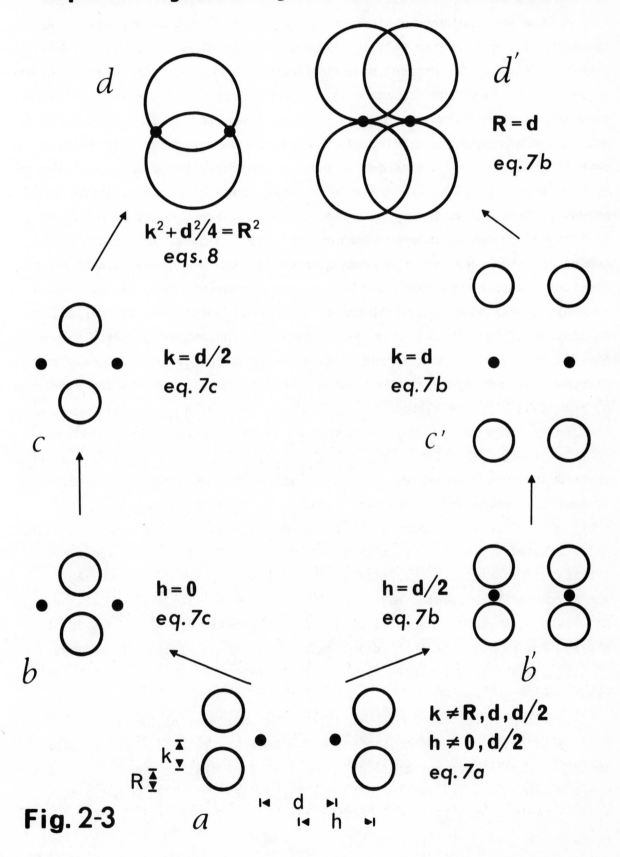

d

d'

$R = d$

eq. 7b

$k^2 + d^2/4 = R^2$
eqs. 8

$k = d/2$
eq. 7c

$k = d$
eq. 7b

c

c'

$h = 0$
eq. 7c

$h = d/2$
eq. 7b

b

b'

$k \neq R, d, d/2$
$h \neq 0, d/2$
eq. 7a

Fig. 2-3

a

R k

d

h

ellipses. When the latter eq. is compared with the corresponding eq. for the ellipses of Fig. a_2, which are cast about the traditional focus and a vertex, the two pole combinations are seen to convey not-greatly-different symmetry. The eqs. differ only in signs and the presence of an $(e+1)^2$ expression (Fig. a_2) as opposed to an expression $(1-e^2)$ for ellipses cast about a traditional focus and the center. Since this difference corresponds to the presence of an additional term $(1+2e+e^2$, as compared to $1-e^2)$ in the eq. for curves cast about a traditional focus and a vertex (which are 3rd-most symmetrical), central conics cast about a traditional focus and the center have greater symmetry. [The difference in the complexity of the eqs. is far more marked if both are expressed in terms of the semi-axes, but the comparison in terms of d and e is more appropriate.] The 4th-most symmetrical central conics are those cast about a traditional focus and any unexceptional (non-focal) axial pole, for which the more complex quadratic eq., II-13, applies.

Axial bipolar eqs. of central conics cast about poles that do not include a traditional focus (including poles on the minor and conjugate axes) are of 4th degree (see Chapter IV, page IV-2, for the basis for this increase in degree). The most symmetrical of these are those cast about the two vertices, as represented by the ellipse and quartic eq. of Fig. a_3, and those cast about the center and a vertex, for which the eq. for ellipses is $(v^2-u^2+d^2)^2 = 4d^2[v^2-d^2(1-e^2)]/e^2$. Note that the eq. of Fig. a_3 is symmetrical in u and v, whereas the vertex-center eq. is not (in all cases, eqs. for the two species of central conics differ only in the signs of certain terms).

Of lesser bipolar symmetry are central conics cast about unexceptional axial poles located symmetrically about the center (eq. II-11), while least symmetrical of the axial representatives are those cast about two unexceptional and asymmetrically-located axial poles, all of which have eqs. of 4th degree. Eqs. cast about poles not lying on a line of symmetry are a maximum of 8th degree. For example, central conics cast about contralateral LR vertices are of 8th degree (see eq. II-12; Fig. c_6, for a parabola, also is of interest in this connection).

Fig. 2-4b depicts the bipolar parallel line-pair cast about poles on the midline of the curve. The eq. is valid for both the polarized and unpolarized systems. When the two poles lie on a parallel line that is not coincident with the midline (nor coincident with either line), the eq. is of 8th degree (after

Bipolar Conics With Quadratic And
Higher-Degree Equations

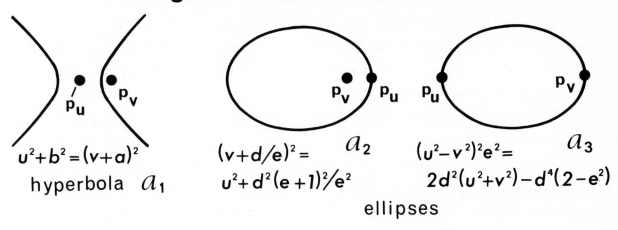

$u^2+b^2=(v+a)^2$

hyperbola a_1

$(v+d/e)^2 =$
$u^2+d^2(e+1)^2/e^2$

a_2

$(u^2-v^2)^2e^2 =$
$2d^2(u^2+v^2)-d^4(2-e^2)$

a_3

ellipses

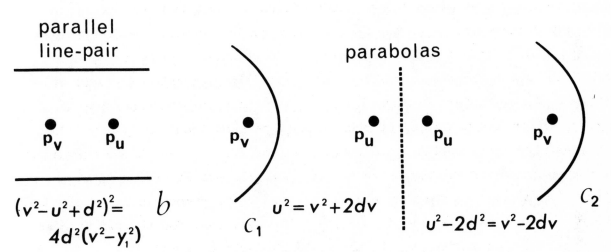

parallel
line-pair

$(v^2-u^2+d^2)^2 =$
$4d^2(v^2-y_1^2)$

b

parabolas

$u^2=v^2+2dv$

C_1

$u^2-2d^2=v^2-2dv$

C_2

parabolas

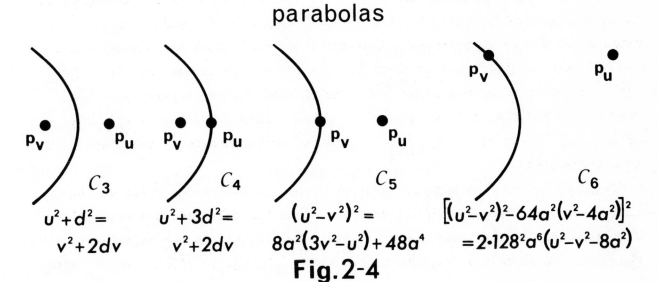

C_3

$u^2+d^2 =$
v^2+2dv

C_4

$u^2+3d^2 =$
v^2+2dv

C_5

$(u^2-v^2)^2 =$
$8a^2(3v^2-u^2)+48a^4$

C_6

$[(u^2-v^2)^2-64a^2(v^2-4a^2)]^2$
$=2\cdot128^2a^6(u^2-v^2-8a^2)$

Fig. 2-4

squaring to eliminate alternate signs), $4d^2u^2 = (u^2-v^2+d^2)^2+4d^2(y_1 \pm a)^2$, where a is the displacement from the midline and $2y_1$ is the separation of the lines of the parallel line-pair. If the poles lie symmetrically about the midline on a line orthogonal to the line-pair, the eq. for the polarized system also is of 4th degree, $(u^2-v^2+2dy_1)(u^2-v^2-2dy_1) = 0$, whereas in the unpolarized system, this configuration has an eq. of only 2nd degree, $u^2-v^2 = 2dy_1$ (or $u^2-v^2 = -2dy_1$).

Figs. 2-4c_1-c_4 are examples of the most symmetrical bipolar parabolas. These are parabolas cast about the traditional focus paired with any other axial pole. The most symmetrical bipolar parabola is that of Fig. c_1, where the 2nd pole is the conjugate point, i.e., the reflection of the focus in the directrix. Next-most symmetrical are the parabolas of Figs. c_2 and c_3. For the former, the 2nd pole is the reflection of the conjugate point in the focus, while for the latter it is the foot of the directrix on the line of symmetry. The next-most symmetrical bipolar parabola has the 2nd pole at the vertex (Fig. c_4). The eqs. become of 4th degree if neither pole is at the traditional focus; an example of this is the parabola of Fig. c_5, for poles at the vertex plus the image of the vertex in the directrix.

Bipolar eqs. of parabolas cast about non-axial poles are of 8th degree. In the **non-axial** example of Fig. c_6, one pole is at an LR vertex and the other is at its image in the directrix. The most symmetrical parabolas cast about one axial and one non-axial pole are those for which the axial pole is the traditional focus. For example, the eq. of a parabola cast about the traditional focus and an LR vertex is only of 4th degree, $(u^2-v^2-4a^2)^2 = 64a^3(v-a)$, whereas that for a parabola cast about an LR vertex and the axial vertex is of 8th degree, $[(u^2-v^2-9a^2)^2+4a^2(36a^2+v^2)]^2 = 16a^2(4a^2+v^2)[25a^2-(u^2-v^2)]^2$.

Fig. 2-5. Bipolar equilateral lemniscates and Cassinian ovals. As in Figs. 2-1 and 2-4, the curves in these figures have not been reflected in the bipolar midline. In the cases of Figs. a, e_1, and e_2, the curves are bisected by the coordinate midline in any event; in the cases of Figs. b, c, and d, however, the curves should be reflected in the bipolar midline if they are to be represented as they exist in the unpolarized bipolar system.

Fig. a depicts 3 loci of Cassinian ovals represented by the bipolar equilateral hyperbolic eq., $uv = Cd^2$. The bipolar poles also are circumpolar foci (all high-ranking bipolar foci also have circumpolar focal rank) for all 3

Bipolar Equilateral Lemniscates And Cassinian Ovals

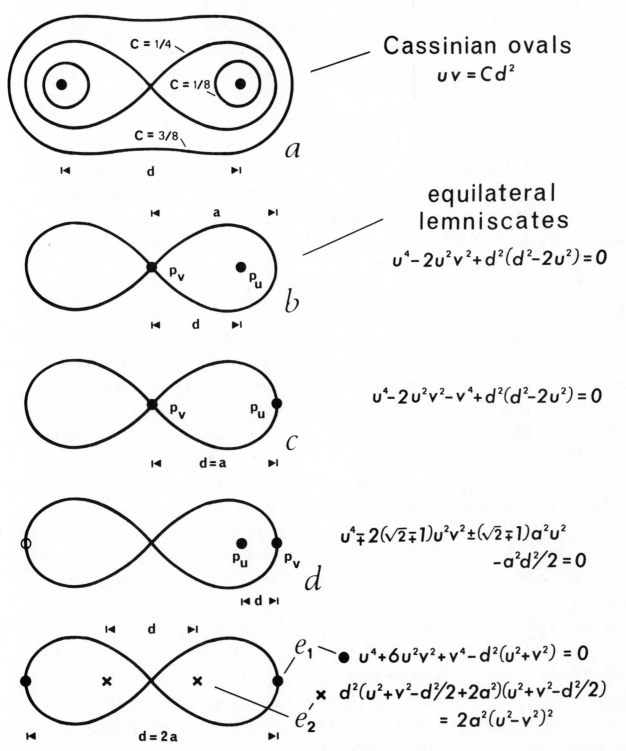

Cassinian ovals
$$uv = Cd^2$$

$C = 1/4$

$C = 1/8$

$C = 3/8$

a

equilateral lemniscates
$$u^4 - 2u^2v^2 + d^2(d^2 - 2u^2) = 0$$

b

$$u^4 - 2u^2v^2 - v^4 + d^2(d^2 - 2u^2) = 0$$

c

$$u^4 \mp 2(\sqrt{2} \mp 1)u^2v^2 \pm (\sqrt{2} \mp 1)a^2u^2 - a^2d^2/2 = 0$$

d

e_1 — ● $u^4 + 6u^2v^2 + v^4 - d^2(u^2 + v^2) = 0$

e_2 — ✕ $d^2(u^2 + v^2 - d^2/2 + 2a^2)(u^2 + v^2 - d^2/2) = 2a^2(u^2 - v^2)^2$

Fig. 2-5

curves. For $C < \frac{1}{4}$, the eq. represents a genus or species possessing two discrete ovals. As C increases from the value of $1/8$th for the two-oval subspecies depicted in Fig. a, the ovals enlarge until, for a value of $C = \frac{1}{4}$, they come into contact at a DP to form the equilateral lemniscate, which is the *curve of demarcation* between one-oval and two-oval Cassinians. For $C > \frac{1}{4}$, the two loops of the equilateral lemniscate "open" into one another at the position of the DP to form a single oval of Cassini, of which the $C = 3/8$ths subspecies is represented.

A bipolar eq. of the equilateral lemniscate takes the simplest and lowest-degree form, $uv = d^2/4$, when cast about the two loop foci, which are $a/2^{\frac{1}{2}}$ units distant from the center, where a is the length of the semi-transverse axis. Accordingly, the equilateral lemniscate of Fig. a is the most symmetrical of its bipolar representatives. An equilateral lemniscate cast about any other pair of axial poles has eqs. of 4th degree, the general form of which for the transverse axis is

$$2[(Hu^2-hv^2)+hH(H-h)][(Hu^2-hv^2)+hH(H-h)+a^2(H-h)] = a^2(u^2-v^2-h^2+H^2)^2 \ ,$$ where

h and H are the axial locations of poles p_u and p_v, respectively.

Since the eqs. of equilateral lemniscates cast about pole-pairs that are not axial have eqs. of higher degree than 4, the transverse axis is a bipolar focal axis (which also is the case for the lines of symmetry of the parabola and central conics), i.e., all points upon it have bipolar focal rank. The general axial eq. takes its simplest 4th-degree form when cast about the loop focus ($h = a/2^{\frac{1}{2}}$ or $H = -a/2^{\frac{1}{2}}$) and the center ($H = 0$ or $h = 0$), as in Fig. b. Accordingly, the center has the highest subfocal rank of all the axial poles of focal rank $\frac{1}{4}$ (i.e., all the axial poles except the loop foci), and the equilateral lemniscate of Fig. b is the next-most symmetrical of its bipolar representatives.

The 4 next-most symmetrical bipolar equilateral lemniscates are those cast about the remaining pair-combinations of the axial *circumpolar* point foci, namely, DP-vertex, loop focus-near vertex, loop focus-far vertex, and vertex-vertex. Of these, the curves of Figs. c (DP-vertex) and e_1 (vertex-vertex) are of comparable symmetry, based upon equational simplicity. Next-most symmetrical are equilateral lemniscates cast about (a) a loop focus and the near vertex (upper alternate signs in Fig. d) and (b) a loop focus and the far vertex (lower alternate signs; vertex pole consisting of open circle). The eqs. of these curves become slightly more complicated than those given in Fig. d after a is eliminated by the substitutions, $a = d/(1\mp2^{\frac{1}{2}})$.

The next-most symmetrical bipolar equilateral lemniscates are those cast about any pair of axial poles symmetrically located about the center (Fig. e_2, crosses), for which the complexity of the eq. is greatly increased (of course, for $d^2 = 2a^2$, the condition for the loop foci, this eq. reduces and simplifies to $uv = d^2/4$). Lastly, the least symmetrical axial bipolar equilateral lemniscates are those cast about asymmetrically-located, unexceptional axial poles (i.e., not including the loop foci, DP or vertices), for which the complexity of the eq. is greatly increased to that given in paragraph 3 above.

Fig. 3-1. The most symmetrical loci in non-incident polar-linear coordinates. The most symmetrical curve, $v = u$, is the parabola of Fig. **a**, with the well-known focus-directrix relationship. The introduction of a single multiplicative or additive constant into this eq. leads to the less symmetrical loci of central conics (Figs. b_1, b_2). Fig. b_1 is an ellipse, and Fig. b_2 a hyperbola, with the eq. $v = eu$ (e, the eccentricity), also with the conventional focus-directrix relationships. Fig. c_1 is the orthogonal, non-intersecting lateral

[There also is an intuitive basis for regarding the polar-linear parabola, $v = u$, to be more symmetrical than the central conics, $v = eu$. This is the fact that the parabola has no second axial vertex. In the cases of the central conics, the two axial vertices are asymmetrically located with respect to the point and the line reference elements (in the case of the hyperbola, this might be asserted for the entire arms). Essentially the same line of reasoning leads one to regard the parabola as being more symmetrical about its traditional focus than are central conics about one of their traditional foci.]

line-segment, $u-v = d$, extending from the point-pole to infinity, where d is the distance between the point-pole and the line-pole. Fig. c_2 is the orthogonal, connecting line-segment, $u+v = d$, between the line-pole and the point-pole, while Fig. c_3 is the combination of a parabola and its external axis from the vertex to infinity, where the point-pole is its focus and the line-pole is its vertex tangent ($v-u = d$).

Note in Fig. c_3 that as the point-pole approaches the line-pole, the parabola becomes smaller and smaller; when the point-pole becomes incident upon the line-pole, the parabola "collapses" to a line segment, leading to a locus consisting of the orthogonal midline, $u = v$, the most symmetrical curve in the incident polar-linear system (Fig. 3-3a).

Loci of next-lesser symmetry are obtained by introducing another parameter into the eqs. of Figs. c_1 to c_3, either as a product with d, i.e., by

The Most Symmetrical Non-Incident Polar-Linear Loci

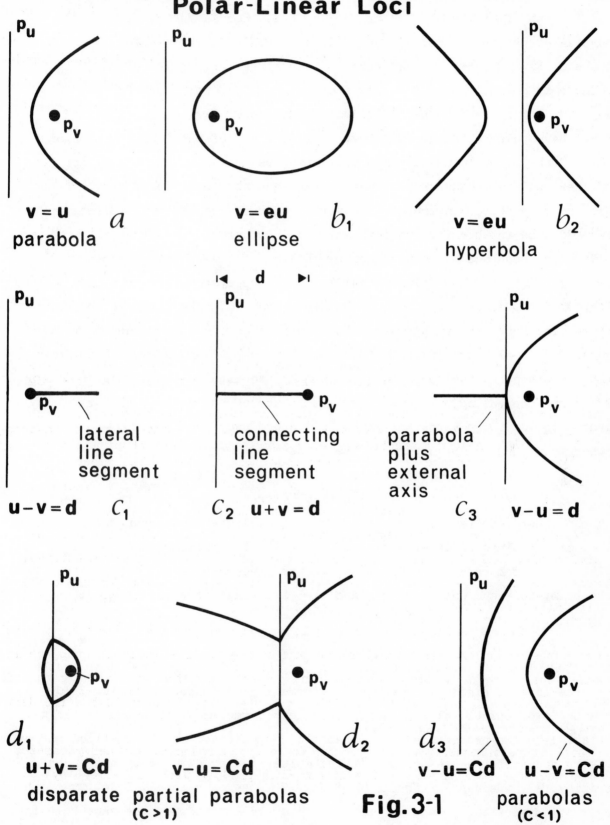

v = u a
parabola

v = eu b_1
ellipse

v = eu b_2
hyperbola

lateral
line
segment

connecting
line
segment

parabola
plus
external
axis

u − v = d c_1

c_2 **u + v = d**

c_3 **v − u = d**

d_1

u + v = Cd
disparate

v − u = Cd
partial parabolas
(C > 1)

d_2

d_3 **v − u = Cd**

Fig. 3-1

u − v = Cd
parabolas
(C < 1)

employing a multiple or fractional value of d, leaving the absolute magnitudes of the coefficients of u and v unchanged (Figs. d_1, d_2, d_3), or as a coefficient of the term in u or v (Fig. 3-2). For u+v = Cd, C > 1, the partial disparate parabolas of Fig. d_1 are obtained, whereas for v-u = Cd, those of Fig. d_2 are obtained (these figures are for a value of C = 2).

There is no real locus for u+v < d or u-v > d. For v-u = Cd and u-v = Cd, with C < 1, the individual parabolas of Fig. d_3 are obtained. These have polar exchange symmetry, i.e., the eq. of one locus is the same as that of the other locus but with the variables u and v exchanged. For both of these polar-exchange symmetrical parabolas, the focus is at the point-pole, but the line-pole is nearer to the vertex than the conventional directrix for v-u = Cd and further from it for u-v = Cd (both loci are for a value of C = ½).

Note the sequence of forms taken by the loci of v-u = Cd, with C ≠ 0. For C = 0, one gets the most symmetrical locus of the system, the parabola v = u of Fig. **a.** For C increasing from 0 but less than 1, the parabola approaches the line-pole. For both cases no real locus exists on the other side of the line-pole. For C = 1, the parabola touches the line-pole and a real locus comes into existence on the opposite side, namely the external axis (Fig. c_3). For C > 1 and increasing, the external-axis locus "opens" to partial parabolic arms (Fig. d_2), the vertex of which "migrates" away from the line-pole on the other side (but is not a part of the locus).

The parabola on the point-pole side of the line-pole also becomes partial parabolic arms, the vertex of which also "migrates" away from the line-pole on the other side (and is not part of the locus). As these changes take place, the common points of intersection of the partial arms migrate in opposite directions to more distant positions on the line-pole (i.e., more distant from the point-pole and one another), and the parabolas, of which the loci are segments, progressively enlarge.

Fig. 3-2. The most symmetrical loci in the non-incident polar-linear system. All the loci of Figs. **a-c** are equally symmetrical to those of Figs. 3-1d--on the basis of equational simplicity (but less symmetrical than those of Figs. 3-1a-c). In the present cases, the absolute magnitudes of the coefficients of the u and v terms are unequal (being multiplied or divided by the eccentricity, e), whereas for the loci of Fig. 3-1 they are equal. Equality of the coefficients of the u and v terms, however, does not play the same role in

The Most Symmetrical Non-Incident Polar-Linear Loci

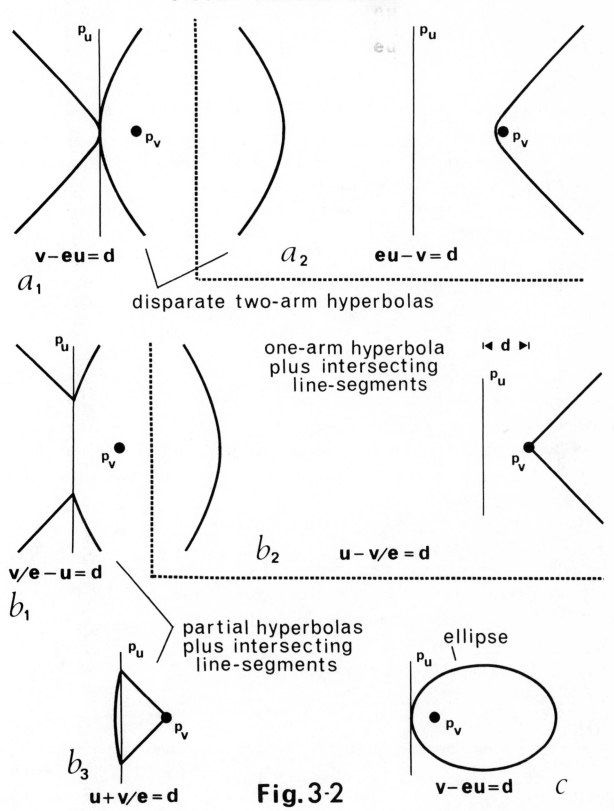

a_1 **v − eu = d**

a_2 **eu − v = d**

disparate two-arm hyperbolas

one-arm hyperbola plus intersecting line-segments

◄ **d** ►

b_1 **v/e − u = d**

b_2 **u − v/e = d**

partial hyperbolas plus intersecting line-segments

b_3 **u + v/e = d**

ellipse

v − eu = d C

Fig. 3-2

polar-linear coordinates that it plays in polarized bipolar coordinates; it exerts its influence through its effects on equational simplicity. The loci of Figs. b_2 and c have polar exchange symmetry, i.e., the eq. of one locus is the same as that of the other locus, but with the variables u and v exchanged (for those pairs of eqs. for which the two values of the eccentricity stand in a reciprocal relationship).

Fig. 3-3. The most symmetrical loci in the incident polar-linear coordinate system. When the point-pole, p_v, is incident upon the line-pole, p_u, the coordinate system has two lines of symmetry and all curves consist of segments that are reflected in both the line-pole and an orthogonal axis passing through the point-pole. The curve $v = u$ is the most symmetrical curve in the system; since it consists of a line passing through the point-pole orthogonal to the line-pole, it is coincident with one of the lines of symmetry of the system. If the eq. $v = u$ is made more complicated by the employment of a constant C, the less symmetrical curves of Figs. b, c_1, and c_2 are obtained (j is the unit of linear dimension, C is dimensionless).

Fig. b, representing the eq., $v = Cu$, consists of intersecting lines, while Fig. c_1, representing the eq., $v+u = Cj$, consists of opposed, vertex-containing segments of parabolas (*partial parabolas*) that have the point-pole as traditional focus and the line-pole as latus rectum. Fig. c_2, for the eq. $v-u = Cj$, consists of the remaining segments of the same parabolas, namely the lateral arms beyond the latus rectum, extending in opposed orientations from the latus rectum vertices.

Fig. d, consisting of a *reflective, vertex-tangent two-arm parabola*, is not one of the most symmetrical loci in the incident system. It illustrates the fact that a 2nd-degree eq. is required to represent incident polar-linear parabolas when the point-pole is coincident with the vertex and the line-pole is the vertex tangent. In other words, incident polar-linear parabolas (or partial parabolas) cast about the traditional focus as point-pole and the latus rectum as line-pole are more symmetrical than those cast about the vertex and vertex tangent.

[On the other hand, if a comparison is to be made between the symmetry of different representations of two *complete* congruent parabolas, rather than merely between the symmetry of two loci (whatever their nature) represented by two specific eqs., Fig. d is more symmetrical than the combination of Figs. c_1 and c_2, since the eq., $v^2-u^2 = 4au$ is simpler than the eq., $v^2-u^2 = 2Cjv-C^2j^2$.]

The Most Symmetrical Incident
Polar-Linear Loci

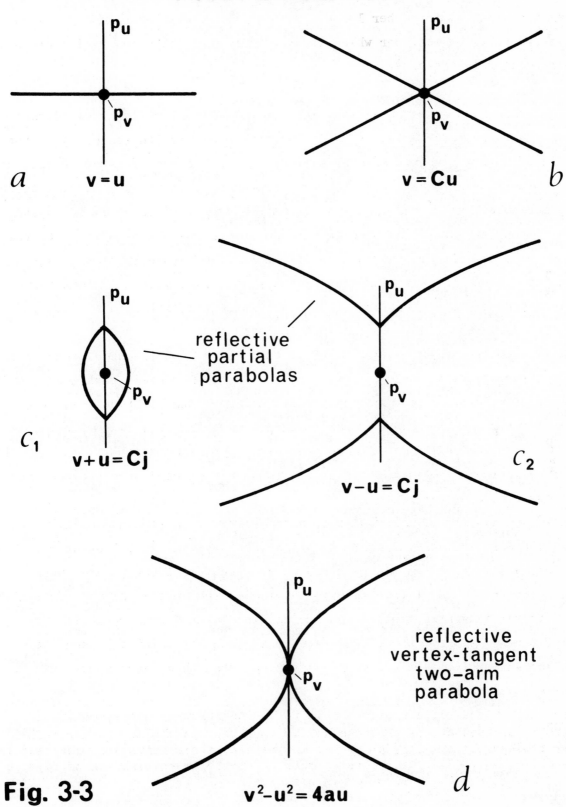

Fig. 3-3

Fig. 3-4. Quadratic and higher-degree polar-linear parabolas. The most symmetrical parabolic loci in the incident polar-linear system are reflective partial parabolas with linear eqs. (Figs. 3-3c_1,c_2), where the line-pole is orthogonal to the line of symmetry. Of lesser symmetry, with a quadratic eq., is the reflective, vertex-tangent two-arm parabola (Fig. 3-3d).

The most symmetrical incident polar-linear parabolas cast about a line-pole coinciding with the line of symmetry are reflective two-arm parabolas with quartic eqs., namely those of Figs. a_1,a_2. Although these quartic eqs. represent complete parabolic arms, if the point-pole is not incident upon the line of symmetry, a degenerate octic eq. is required to represent the complete arms. The quartic root eqs. of this octic (Fig. d_1) represent reflective hemi-parabolas (other solutions to the root eqs. are for negative or imaginary u). The symmetry of these is increased if the point-pole is taken to be coincident with an LR vertex (Fig. d_2).

In the non-incident system, the most symmetrical quadratic parabola cast about the vertex and a line parallel to the directrix, is that for which the line-pole does not intersect the curve and is at twice the distance of the directrix from the vertex (Fig. b_2). The eq. of a parabola cast about the vertex and the directrix (Fig. b_1) is more complicated, corresponding to a less symmetrical curve (the locus on the other side of the line is imaginary).

If the eq. of the curve is cast about the vertex and a k-axis that intersects the curve, quartic eqs. (for ex., eqs. III-11a) are required to represent the entire parabola. These also represent a second disparate parabola with opposed orientation that intersects the basis parabola at the line-pole. The root eqs. derived from these eqs. represent segments of the basis parabola on one side of the line or the other, plus segments of the opposed disparate parabola on the other side or the one. Figs. c_1 and c_2 represent the case for which the LR of the basis curve is the line-pole, in which instance the opposed parabola is of twice the linear dimensions of the basis curve, with the eq., $y^2 = 8a(x+a/2)$.

Fig. 3-5. Quadratic polar-linear "central conics." The most symmetrical non-incident, quadratic, polar-linear central conics are the ellipses of Fig. c, of eccentricity $1/2^{\frac{1}{2}}$ ($a = 2^{\frac{1}{2}}b$), represented by the circular eq., $u^2+v^2 = Cd^2$. The most symmetrical of these, for $C = 1$, is tangent to the line-pole at one b vertex and passes through the point-pole at the position of its other

Quadratic And Higher Degree
Polar-Linear Parabolas

incident
system

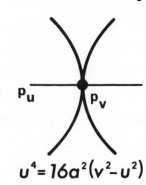

a_1

$u^4 = 16a^2(v^2 - u^2)$

reflective
two-arm

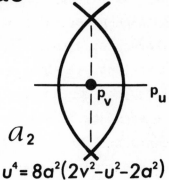

a_2

$u^4 = 8a^2(2v^2 - u^2 - 2a^2)$

non-incident
system

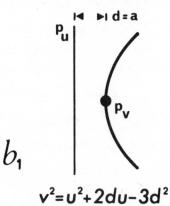

b_1

$v^2 = u^2 + 2du - 3d^2$

one-arm

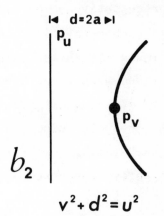

b_2

$v^2 + d^2 = u^2$

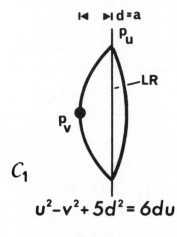

c_1

$u^2 - v^2 + 5d^2 = 6du$

disparate
partial

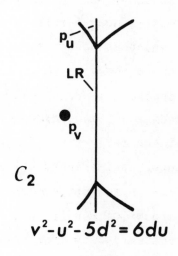

c_2

$v^2 - u^2 - 5d^2 = 6du$

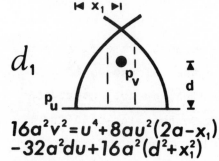

d_1

reflective
dual hemi-

$16a^2v^2 = u^4 + 8au^2(2a - x_1)$
$-32a^2du + 16a^2(d^2 + x_1^2)$

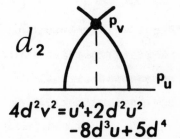

d_2

$4d^2v^2 = u^4 + 2d^2u^2$
$-8d^3u + 5d^4$

Fig. 3·4

b vertex (Fig. c, $C = 1$). Eqs. III-14 and III-15 represent disparate two-arm hyperbolas and *compound ellipses*, the latter being ovals that consist of a hemi-ellipse plus a segment of a larger ellipse, both of which intersect at the line-pole, as in Figs. a_1, a_2.

For cases with the point-pole coincident with an a vertex of the basis curve (eqs. III-15), for which Figs. a_1 and a_2 give the elliptical representatives, the linear size ratio of the two represented curves is $(4a^4+b^4)^{\frac{1}{2}}/b^2$; the segments of the two member-curves are not monoconfocal--nor do they share a vertex. However, in the cases of the point-pole at a traditional focus of the basis curve (eqs. III-14), for which Figs. b_1 and b_2 give the hyperbolic representatives, the segments of the two member-curves are monoconfocal and in the size ratio, $(2a^2 \pm b^2)/b^2$.

Highly symmetrical, incident, quadratic, polar-linear central conics are obtained when the line-pole coincides with a line of symmetry of the curve (eqs. III-17), of which Fig. d_2 depicts an elliptical representative, with the line-pole coincident with the minor axis. Of comparable but slightly lesser symmetry are reflective, vertex-tangent two-arm hyperbolas (Fig. d_1) and reflective vertex-tangent dual ellipses (eq. III-16, lower sign).

Fig. 3-6. Polar-linear symmetry of circles. The most symmetrical non-incident polar-linear circles are axial circles (circles centered on the polar-linear axis) that do not pass through the line-pole. These are represented by 2nd-degree eqs., of which the simplest is the parabolic, $v^2 = Cdu$, for the circles of Fig. a_1. For $C \geq 4$, this yields two circles centered at $(2 \pm C)d/2$, of radius $[C(C \pm 4)]^{\frac{1}{2}}d/2$. For $C = 4$, one of these circles is a point-circle centered at the reflection of the point-pole in the line-pole, while for $C < 4$, one locus is imaginary.

The next-most-symmetrical non-incident polar-linear circles are the axial circles of Fig. a_2 that pass through the point-pole at either the nearest or farthest point from the line-pole. These also are represented by a quadratic eq., $v^2 = 2(d-u)(d-h)$, where h is the distance of the center of the circle from the line-pole and $R = \pm(h-d)$.

Less symmetrical polar-linear circles than those of Figs a_1 and a_2 are represented by eqs. of greater than 2nd degree. Those that do not intersect the line-pole, Figs. c_1 and c_2, are of 4th degree (eq. III-19 with either the

Quadratic Polar-Linear "Central Conics"

non-incident

compound ellipses

$$v^2 - u^2 + b^2u^2/a^2 - a^2 - b^2 = -2au \qquad a_1$$

$$v^2 - u^2 + b^2u^2/a^2 - a^2 - b^2 = +2au \qquad a_2$$

disparate two-arm hyperbolas

$$v^2 - u^2 - b^2u^2/a^2 - a^2 = -2u\sqrt{a^2+b^2} \qquad b_1$$

$$v^2 - u^2 - b^2u^2/a^2 - a^2 = +2u\sqrt{a^2+b^2} \qquad b_2$$

ellipses

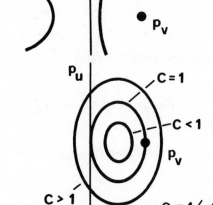

$C=1$

$C<1$

$C>1$

$e = 1/\sqrt{2}$

$$u^2 + v^2 = Cd^2 \qquad C$$

incident

reflective vertex-tangent two-arm hyperbola

$$a^2v^2 = u^2(a^2+b^2) + 2ab^2u \qquad d_1$$

ellipse

$$a^2(v^2-b^2) = u^2(a^2-b^2) \qquad d_2$$

Fig. 3-5

upper or lower alternate signs), while those that intersect the line-pole are of 8th degree (eq. 3-19 with both alternate signs). [Of course, if only upper or lower alternate signs are taken for circles that intersect the line-pole, only *partial circles* are obtained, consisting, respectively, of the segments to the right or left of the line-pole.] The 4th-degree axial circle of Fig. b_1 is the sole exception. It is bisected by the line-pole, passes through the point-pole on an orthogonal diameter, and is the 3rd-most symmetrical non-incident polar-linear circle.

The general 4th-degree eq. for non-axial circles that do not intersect the line-pole but pass through the point-pole (not illustrated) is $[v^2+2(d-h)u-2(d^2-dh+k^2)]^2 = 4k^2[(d^2+k^2)+2h(u-d)]$. Non-axial circles that are bisected by the line-pole and pass through the point-pole are the most symmetrical 8th-degree polar-linear circles (or the most symmetrical 4th-degree *partial circles*), one representative of which is given in Fig. d.

Less symmetrical are non-axial circles that are bisected by the line-pole but do not pass through the point-pole (Fig. e), while the least symmetrical are those that intersect the line-pole asymmetrically but do not pass through the point-pole, as in Figs. f_1 and f_2. As in the cases mentioned above, the circles of Figs. f_1 and f_2 can be represented as partial circles by 4th-degree eqs. that hold for the segments on one side of the line-pole or the other, but not for both.

The most symmetrical *incident* polar-linear circles are represented by 4th-degree eqs. Of these, the most symmetrical are those of Fig. a_3, which are tangent to one another at the point of intersection with the line-pole and the point of incidence of the point-pole. Less symmetrical are the circles of Fig. b_2, where y_1 is the undirected displacement of the centers of the circles from the point-pole. The intermediate examples represented here for the sequence of circles of decreasing symmetry--from the most symmetrical to the least symmetrical polar-linear circles--are neither complete in number nor unique.

Polar-Linear Symmetry of Circles

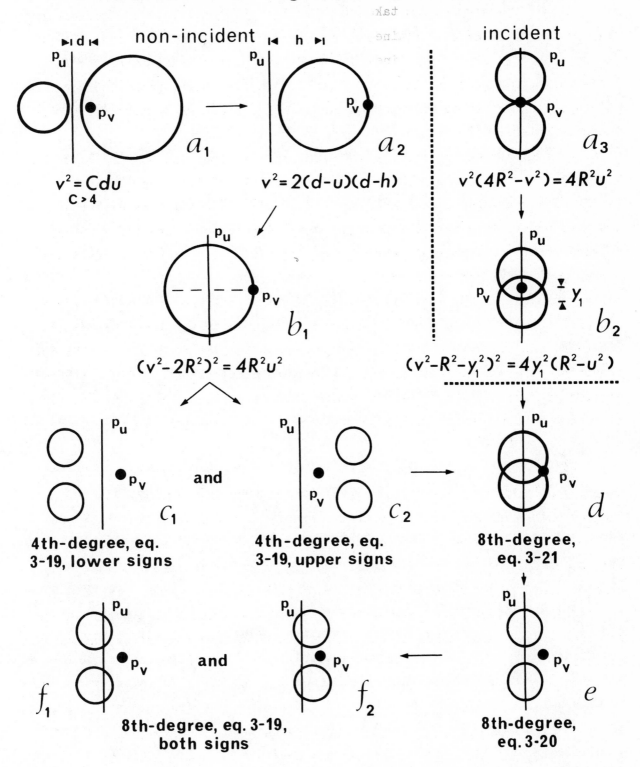

Fig. 3-6

Fig. 4-1. Multipolar *harmonic parabolas*. For a basis parabola, $y^2 = 4a(x-h)$, the general rectangular eq. of its harmonic satellite parabolas is $y^2 = 4(g-a)[x-ah/(g-a)]$. For the vertex-tangent ensemble of Fig. a, the vertex of the basis curve is at the origin; for the opposed non-intersecting ensemble of Fig. b, the vertex is at $x = 4a$; for the opposed intersecting ensemble of Fig. c, the vertex is at $x = -4a$. The multipolar eqs. (eqs. cast about 3 or more point-poles) for the basis curve and a satellite generally are octics. In cases in which the satellite is both congruent and co-incident with the basis curve ($g = 2a$), the multipolar eq. is degenerate, consisting of the product of two identical quartic factors equated to 0.

The parameter g gives the location of the *master pole*, i.e., the pole whose distance eq. (see pp. IV-3-6) is used in forming the eliminant in the derivation of the multipolar eqs. For a given value of h of the basis parabola, the location of this pole determines the nature, size, location, and orientation of the satellite locus. For example, if the master pole is at $x = a$, the satellite locus is either the x-axis (Fig. a), imaginary (Fig. b), or the parallel line-pair, $x^2 = 4a^2$ (Fig. c). As the location of the master pole progresses to the right from a to $2a$, the satellites consist of parabolas that open to the right and gradually increase in size to become (at $x = 2a$) congruent and coincident with the basis curve [with LR lengths progressing from 0 to $4(g-a)$].

Likewise, as the location of the master pole progresses to the left from a to 0, the satellites consist of parabolas that open to the left and gradually increase in size, to become (at $x = 0$) congruent with the basis curve and the reflection thereof in the y-axis. As the location of the master pole progresses to the right beyond $2a$ and to the left beyond 0, the orientations of the satellites remain unchanged but their size increases progressively [LR length $= 4| g-a |$].

In the case of the vertex-tangent ensemble of Fig. a, all of the vertices are at the origin, since the eq. of a satellite is $y^2 = 4(g-a)x$. In the case of the opposed non-intersecting ensemble of Fig. b, there is no intersection because all the satellites that open to the right are to the right of the y-axis, whereas all those that open to the left are to its left--both of the quantities, $4a^2/(g-a)$ and $4(g-a)$, are positive for all $g > a$ (i.e., vertices on the positive x-axis and all curves opening to the right), whereas both quantities are negative for all $g < a$ (vertices on the negative x-axis and

Harmonic Parabolas

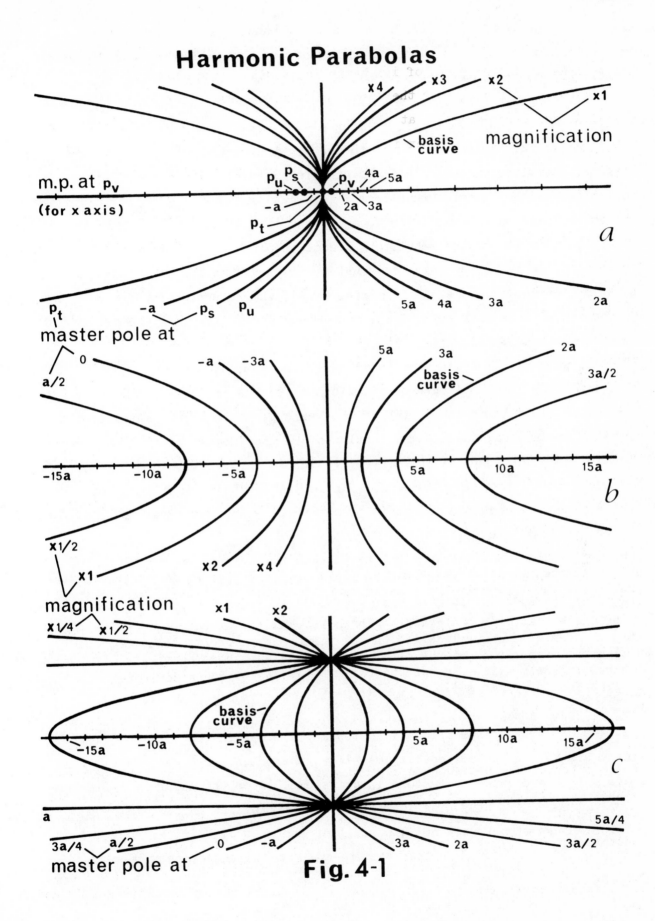

Fig. 4-1

all curves opening to the left). On the other hand, for the opposed inter-
secting ensemble (Fig. c) with the vertex of the basis curve on the negative
x-axis, all curves intersect at $x = \pm 4a$, because all curves opening to the right
have vertices on the negative x-axis and all curves opening to the left have
vertices on the positive x-axis $[-4a^2(g-a)$ and $4(g-a)$ are of opposite sign].

For master pole locations at and to the right of $x = 2a$ and at and to the left
of $x = 0$, satellite parabolas become magnified increasingly by one linear unit
for each a-unit of displacement from $x = a$. Thus, at $x = 2a$ and 0, the magnifi-
cation is 1, at 3a and -a, it is 2, at 4a and -2a, it is 3, at 5a and -3a, it
is 4, etc. Similarly, the satellites become reduced in proportion to the
fraction of an a-unit by which the master pole deviates from the position $x = a$.
Thus, if the deviation is a/4 ($x = 3a/4$, 5a/4), the reduction factor is ¼, if
the deviation is a/2 ($x = a/2$, 3a/2), the reduction factor is ½, if the deviation
is 3a/4 ($x = a/4$, 7a/4), it is 3/4, etc.

Except when the vertex of the basis parabola is at the origin, the location
of a satellite stands in inverse relationship to its magnification. For a
magnification of 1 and the vertex of the basis parabola at na, satellite
vertices are at ±na, for a magnification of 2, they are at ±na/2, for a magni-
fication of 3, they are at ±na/3, etc. (which is the relationship that prompted
the designation *harmonic parabolas*). Similarly, if their reduction is to 3/4,
the vertices are at ±4na/3, if it is ½, the vertices are at ±2na, if ¼, at ±4na,
if 1/8, at ±8na, etc.

[The derivation of multipolar loci that leads to harmonic parabolas is not
unique to the parabola. Other curves yield homologous satellites with similar
properties and typically the same subspecies as the basis curve. For central
conics, $(x-h)^2 \mp a^2y^2/b^2 = a^2$, the satellites are represented by the eqs.,
$(x+h\pm 2a^2g/b^2)^2 \mp a^2y^2/b^2 = a^2+4a^2g(a^2g/b^2\pm h)/b^2$. As in the cases of vertex parabo-
las, (a) centered central conics (h = 0) yield only larger satellites, and (b)
taking the master pole at the origin (g = 0) yields a congruent satellite re-
flected in the y axis. The condition for an identical satellite is h = g = 0,
whereas for the parabola it is g = 2a.]

Fig. 4-2. Polar exchange symmetry in tetrapolar coordinates. The loci repre-
sented are for the polarized systems (i.e., the poles labelled), though Figs.
c and d also are valid for unpolarized systems, since the loci are reflected
in all lines of symmetry. The tetrapolar system provides unique examples of
polar exchange symmetry, since the simplest and most symmetrical eqs. and
exchanges of poles apply in this system--without the employment of coef-
ficients or interpolar distances.

Polar Exchange Symmetry In Tetrapolar Coordinates

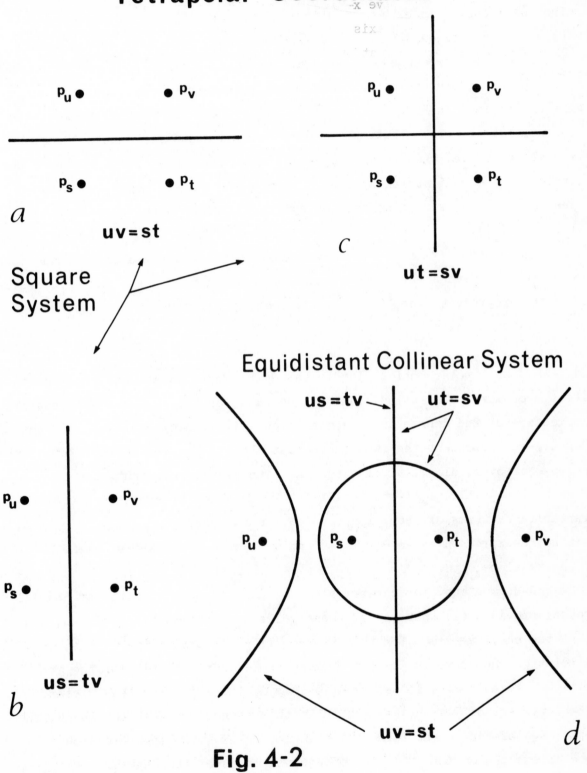

Fig. 4-2

In the polarized "square" system, as labelled, eqs. expressing the equality of the products (and sums) of the distances from opposed adjacent pairs of poles represent one or the other of the midlines, whereas for non-adjacent pairs the locus includes both midlines. There are 4 lines of symmetry in the unpolarized system, and all 3 polar exchange eqs. represent both midlines.

The same polar exchange eqs.--for all possible combinations of the products of two poles in the equidistant collinear system--represent the remarkable ensemble of loci in Fig. d. The eqs., $us = tv$ and $ut = sv$, represent the midline, $ut = sv$ represents the circle, and $uv = st$ represents the equilateral hyperbola. This polar-exchange symmetrical relationship between the circle and the equilateral hyperbola is one of 5 known homologies between these curves that were disclosed by symmetry analyses (see also Chapters V, XII, and XIII).

The eqs. $u+s = t+v$ and $u+t = s+v$ also represent the midline. In addition, $u+t = s+v$ represents the axial segment connecting poles p_s and p_t, while $u+v = s+t$ represents the line segments extending laterally from poles p_u and p_v to infinity.

Fig. 4-3. Multipolar conics. The lowest degree multipolar eqs. (eqs. cast about 3 or more point-poles) that can be cast for the parabola and central conics are of 2nd degree and are not unique, i.e., many eqs.--even of the same degree--can represent the same curve cast about any given ensemble of point-poles. Moreover, all multipolar eqs. are inherently redundant, because it always is possible to eliminate all but 2 variables by expressing the other variables in terms of them, i.e., an eq. in the variables, u, v, s, and t, can be re-expressed as an eq. in u and v alone, or v and s alone, or s and t alone, etc.

Second-degree eqs. for parabolas can be cast for any ensemble of coaxial poles, provided (a) that one of these poles is the traditional focus, and (b) that the eq., $v = x+a$, for the distance from the traditional focus, p_v, to a point on the curve is used in forming the eliminant (only for the traditional focus does a linear relationship in x exist for this distance). The lower eq. of Fig. a was derived in this manner. On the other hand, the upper eq. of Fig. a was formed by eliminating x from an expression for u^2-v^2 and an expression for t^2; in consequence it is of 4th degree.

Multipolar Conics

Tripolar

Parabola a

$64a^2t^2 + 256a^4$
$= (u^2 - v^2 + 8a^2)^2$
$u^2 + t^2 + 3a^2 = 2v(v + 5a)$

Ellipse b

$16a^4(w^2 - b^2) =$
$(a^2 - b^2)(s^2 - t^2)^2$

Hyperbola
c

$u^2 - w^2 + 2av =$
$3a^2 + b^2$

Non-Collinear Tetrapolar Parabolas

d

$u^2 + s^2 + t^2 =$
$3v^2 + 2av + 5a^2$

e

$256a^2(s^2 - u^2) + 16^2 \cdot 27a^4 =$
$3(t^2 - s^2)(v^2 - u^2) + 128a^2(t^2 - s^2)$

f

$[(t^2 - s^2)/8a - 2a]^2 = s^2 -$
$[(t^2 - s^2)(v^2 - u^2)/2^9 a^3 - a]^2$

Pentapolar

Parabola g

$u^2 + w^2 - s^2 - t^2 =$
$4av + 2a^2$

h Equilateral Hyperbolas i

$u^2 + s^2 - t^2 - w^2 =$
$(2\sqrt{2} + 4)a^2 + (2\sqrt{2} + 2)av$

$u^2 + s^2 - t^2 - w^2 =$
$6a^2 + 4av$

Fig. 4-3

One also can cast 2nd-degree multipolar eqs. for central conics, provided that a traditional focus is included in the ensemble and that the eq. for the distance of this focus from points on the curve (i.e., the eq. for u or v of Fig. c) is used in forming the eliminant. As in the case of the parabola, the basis for these requirements for central conics also is that only for the traditional foci can the distance to a point on the curve be expressed as a linear function of the abscissa of the point (see Chapter IV, *Tripolar Coordinates*).

These conditions are fulfilled for the hyperbola of Fig. c, leading to the accompanying 2nd-degree eq. Because of reflective redundancy, this represents both arms in the unpolarized system. Using the right vertex as the 3rd pole in place of the right focus, gives the more complex 2nd-degree eq. (and less symmetrical curve relative to the reference elements), $2a[(a^2+b^2)^{\frac{1}{2}}-a](u-a) = (w^2-v^2+b^2)(a^2+b^2)^{\frac{1}{2}}$. However, because the midline of symmetry is lost in the latter case, only the right arm is represented.

The ellipse of Fig. b is taken as an example of a central conic with its eq. cast about 3 symmetrically-located poles that do not include either traditional focus. For this case the eq. is of 4th degree. In all 3 cases (Figs. a-c), the eqs. can be converted to bipolar eqs. by expressing one of the variables in terms of the other two. For the parabola, elimination of p_u or p_t leads to a 2nd-degree eq., but if p_v is eliminated, the resulting bipolar eq. is of 4th degree. For the hyperbola, elimination of either of the traditional foci leaves the degree of the resulting (bipolar) eq. at 2 (but if p_v is to be eliminated, the complementary tripolar eq., $v^2-w^2+2au = 3a^2+b^2$, must be employed). Elimination of the center, however, yields the well-known linear bipolar construction ($u-v = 2a$ or $v-u = 2a$). In the case of the ellipse, elimination of any one of the 3 poles leaves the degree of the resulting eq. unchanged from 4.

In the cases of the non-collinear tetrapolar parabolas, it is possible to cast 2nd-degree eqs. only if 4 conditions are fulfilled: (a) the traditional focus must be one of the point poles; (b) if condition (a) is fulfilled, one of the other 3 poles must be axial; (c) the remaining two poles must be reflections of one another in the line of symmetry; and (d) the distance eq., $v = x+a$, must be employed in obtaining the eliminant.

These 4 conditions are fulfilled only for the parabola of Fig. d, for which

a 2nd-degree eq. is given. If condition (d) is not fulfilled, 4th-degree eqs. are obtained. If only condition (c) is fulfilled--but for both pairs of poles-- the eqs. are of 4th degree (Fig. e). The 8th-degree eq. of Fig. f is required to represent one of several possible types of *pole-intersecting two-arm parabolas*. The example illustrated consists of the basis parabola plus its reflection in the LR (see Chapter IV).

[One method of origin of congruent multipolar satellites to a basis parabola is understood readily from the rectangular analogue. Let $s^2 = (x-h)^2 + (y-k)^2$ be the distance from the point (h,k) to any point in the plane (x,y). Letting the point (x,y) lie on a basis parabola $y^2 = 4ax$, we have
(a) $s^2 = (x-h)^2 + [\pm(4ax)^{1/2}-k]^2$ or (b) $s^2 = (y^2/4a-h)^2 + (y-k)^2$ However, these two distance-squared eqs. also are satisfied by satellite parabolas in rectangular coordinates. These are derived by solving the eq.,
$(y-k)^2 = [\pm(4ax)^{1/2}-k]^2$ for case (a) and the eq., $(y^2/4a-h)^2 = (x-h)^2$ for case (b). These lead to degenerate eqs. for two congruent parabolas,
$(y^2-4ax)[(y-2k)^2-4ax] = 0$ for case (a), and $(y^2-4ax)[y^2+4a(x-2h)] = 0$ for case (b).

The parabolas of case (a) intersect on the line $x = h$, are mirror images in the line $x = h$, and are equidistant from any point on the line $x = h$., i.e., for a given value of y, the corresponding points on each parabola are equidistant from any point on the line $x = h$. These parabolas correspond to Fig. f. Similarly, the parabolas of case (b) intersect on the line $y = k$, are mirror images in the line $y = k$, and are equidistant from any point on the line $y = k$, i.e., for a given value of x, the corresponding points on each parabola are equidistant from any point on the line $y = k$.

When the harmonic parabolas of Fig. 4-1 are examined from this point of view, it is seen that in every case the parabola congruent (but not coincident) with the basis parabola is its reflection in the line $x = 0$ and is for a master pole at the origin. In other words, both parabolas satisfy the distance-squared eq. for the distance from the origin to points with a given ordinate on both curves.]

All the eqs. of Figs. d-f can be converted to bipolar eqs. by expressing two of the distance variables in terms of the other two. For Fig. d the eqs. will be of 2nd degree only if poles p_s and p_t are eliminated. For Figs. e and f the eqs. will remain of the same degree only if the poles of a reflected pair are eliminated, otherwise the degree will increase. In the case of Fig. f, elimination of a reflected pole-pair will lead to a degenerate eq. consisting of the product of two 4th-degree factors equated to 0. These two factors equated individually to 0 represent the two parabolas of the figure.

The parabola of Fig. g, in equidistant, collinear pentapolar coordinates, also can be represented by a 2nd-degree eq. when the traditional focus is one of the poles and its distance eq., $v = a+x$, is employed to obtain the eliminant. Otherwise, a 4th-degree eq. is required. A second arm, reflected in the midline, is present in the unpolarized system.

Figs. **h** and **i** compare equilateral hyperbolas in the collinear, pentapolar unpolarized coordinate system for two cases in which the curves have in common the fact of being cast about their 3 highest-ranking circumpolar foci--the two traditional foci and the center. The eqs. of these curves suggest that greater symmetry is possessed about the 5-pole ensemble when the 4th and 5th poles lead to an equidistant (i.e., equally spaced) pentapolar arrangement--for which the coefficients are simpler and nearer to unity--than when the poles are located at the 5 axial circumpolar foci, i.e., when the 4th and 5th poles are the axial vertices.

Fig. 4-4. The most symmetrical polar-circular loci. The eq. $u = v$ defines the most symmetrical loci in any two-reference-element coordinate system. Usually, as in polar-circular coordinates, this eq. defines conic sections, though these are not always the conventional curves to which the term "conic sections" usually is applied. In the case of polar-circular coordinates, the type of conic section defined by this eq. depends upon the position of the point-pole, p_v, with respect to the circle-pole, p_u, because $e = d/R$ $(d \neq R)$.

If p_v is outside p_u, constructions exist for both a greatest and least distance for u (the extremal distances to the circle-pole). These are the arms of the hyperbola of Fig. a_1, where the arm given by the greatest-distance construction intersects the circle-pole and the one given by the least-distance construction does not.

If p_v is incident upon the circle-pole, the locus is the line passing through p_v and the center of p_u. The least-distance construction gives the line segment from the center of p_u through p_v to infinity, and the greatest-distance construction gives the line segment extending to infinity in the opposite direction. When p_v is within p_u, the loci are ellipses (Fig. a_2) which decrease in eccentricity as p_v approaches the center of p_u, until, at the center, the locus is the mid-circle $(e = 0)$.

Among the next-most-symmetrical polar-circular loci are the central conics represented by the linear eqs. $u \pm v = Cd$, of eccentricity $e = d/(Cd \pm R)$, where the upper alternate sign is for u the least distance to the circle-pole and the lower for the greatest distance. Accordingly, when $Cd > R$, each eq. represents conics of two different eccentricities, i.e., *disparate two-arm hyperbolas* and *disparate ellipses*. These are illustrated in Figs. b_1 and b_2.

The Most Symmetrical Polar-Circular Loci

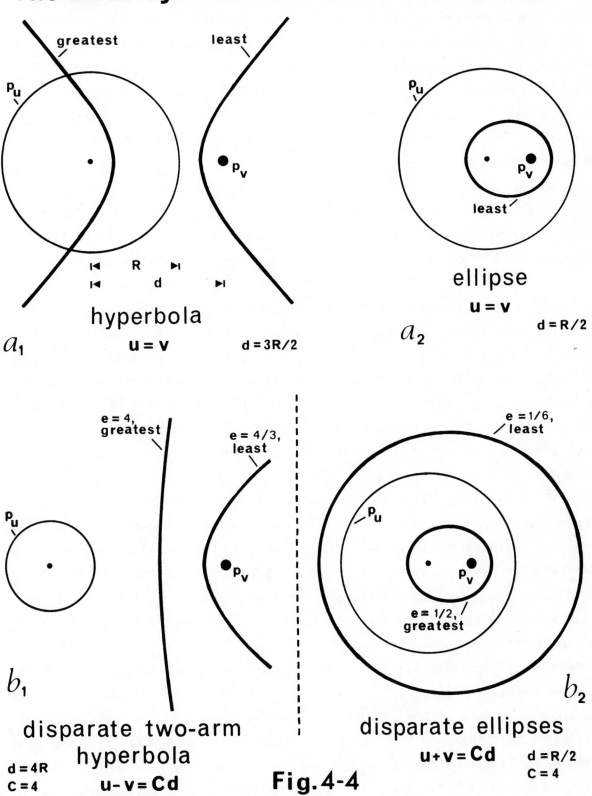

greatest

least

p_u

p_v

R

d

hyperbola

a_1

u = v

d = 3R/2

p_u

p_v

least

ellipse

u = v

a_2

d = R/2

e = 4,
greatest

e = 4/3,
least

p_u

p_v

b_1

disparate two-arm
hyperbola

d = 4R
C = 4

u − v = Cd

e = 1/6,
least

p_u

p_v

e = 1/2,
greatest

disparate ellipses

u + v = Cd

d = R/2
C = 4

b_2

Fig. 4-4

The disparate two-arm hyperbola of Fig. b_1 has arms of eccentricities 4 and 4/3, with the former given by the greatest-distance construction and with CD = 16R. The disparate ellipses of Fig. b_2 have eccentricities of ½ and 1/6, Cd = 2R, and, again, the greatest-distance construction represents the curve with the greatest eccentricity.

The ellipse example of Fig. b_2, with the greatest-distance construction, was selected to illustrate the only known instance of *identical extremal-distance symmetry*. In this case, identical loci with respect to identical reference elements are represented by different eqs., where one eq. represents the locus for the least-distance construction and the other for the greatest-distance construction. In the other instances of *extremal-distance symmetry* of Figs. a_1, b_1, b_2, 4-5a_1 and a_2, and 4-7b_2 and c_4, an identical eq. represents congruent or incongruent, but differently located, loci.

Fig. 4-5. Linear-circular confocal two-arm parabolas. In linear-circular coordinates, the most symmetrical loci, represented by the eq., $u = v$, are parabolas and line segments, the former generally incongruent. Obvious parallels and differences are shown with the corresponding polar-linear loci of Fig. 4-4, with respect to changes in the loci with changes in d, the distance of the line-pole from the center of the circle-pole.

For the line pole, p_v, not intersecting the circle-pole, p_u, incongruent two-arm parabolas, both opening to the left, are obtained. One arm (arm 2) is represented by the greatest-distance construction and intersects the circle-pole. The other arm (arm 1) is represented by the least-distance construction and does not intersect the circle-pole. All arms are confocal at the center of the circle-pole. As the line-pole approaches the circle-pole, both arms decrease in size. Whereas arm 1 approaches a limiting size of $a = R$, arm 2 decreases to size 0 when $d = R$; in other words, it "collapses" to the x-axis.

When the line-pole is tangent to the circle-pole, arm 1, for which $a = R$, also becomes tangent to it, while arm 2 has become a line coincident with the x-axis. The segment of the x-axis from the center of the circle-pole that intersects the line-pole and extends to infinity is represented by the least-distance construction, while the opposed segment extending from the center of the circle-pole to infinity is represented by the greatest-distance con-

Linear-Circular Confocal Two-Arm Parabolas

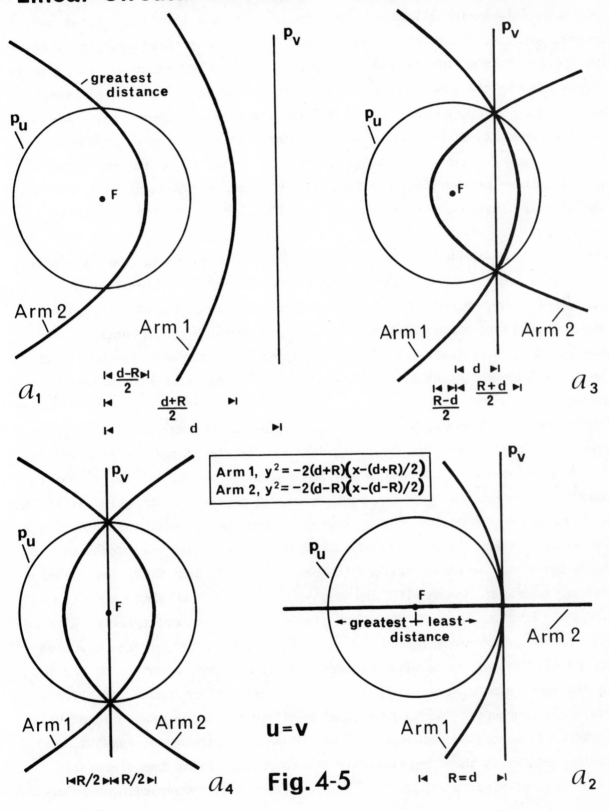

greatest distance

p_u

p_v

•F

Arm 2

Arm 1

$\left|\leftarrow \dfrac{d-R}{2} \rightarrow\right|$

$\left|\leftarrow \qquad \dfrac{d+R}{2} \qquad \rightarrow\right|$

$\left|\leftarrow \qquad\qquad d \qquad\qquad \rightarrow\right|$

a_1

p_v

p_u

•F

Arm 1

Arm 2

$|\leftarrow d \rightarrow|$

$\left|\leftarrow\rightarrow\right|\left|\leftarrow \dfrac{R+d}{2} \rightarrow\right|$

$\dfrac{R-d}{2}$

a_3

Arm 1, $y^2 = -2(d+R)\left(x-(d+R)/2\right)$

Arm 2, $y^2 = -2(d-R)\left(x-(d-R)/2\right)$

p_v

p_u

F

Arm 1

Arm 2

$|\leftarrow R/2 \rightarrow|\leftarrow R/2 \rightarrow|$

a_4

u=v

Fig. 4-5

p_v

p_u

F

←greatest + least→
distance

Arm 2

Arm 1

$|\leftarrow R=d \rightarrow|$

a_2

struction.

For all positions of the line-pole in which it intersects the circle-pole, both arms intersect one another, the circle-pole, and the line-pole at common points. Arm 1 continues to be represented by a least-distance construction and to open to the left, whereas arm 2 now opens to the right and now also is represented by the least-distance construction. As p_v moves toward the center of p_u, arm 1 continues to decrease in size, whereas arm 2 increases in size. When the line-pole becomes coincident with a diameter of the circle-pole, the arms become congruent (with $a = R/2$), they intersect the circle-pole and each other on the line-pole (which also becomes coincident with the LR), and they are images of one another in the LR.

Fig. 4-6. Polar-circular axial parabolas, a collinear, equidistant hexapolar quartic, a congruent, non-concentric, non-intersecting bicircular ellipse, and a congruent, non-concentric, intersecting bicircular ellipse. Fig. **a** depicts and gives the general eq. for an axial parabola, $y^2 = 4a(x-h)$, that does not intersect the circle-pole (the upper alternate sign is for u the least distance to the circle-pole, and the lower for u the greatest distance).

With the values of a, h, and d relative to one another and to R un-specified, the general eq. is of 4th degree (the circle pole is centered at the origin and the point-pole is on the x-axis at $x = d$, where d may be positive or negative). This eq. reduces to 2nd degree and the parabola becomes more symmetrical relative to the reference elements for either the condition $h = -a$ or $d = a+h$, the former of which places the traditional focus of the parabola at the center of the circle-pole (Fig. a_2), and the latter of which places it in coincidence with the point-pole (Fig. a_4 and upper eq.).

The eq. of Fig. a_2 simplifies, and its locus becomes more symmetrical rela-tive to the reference elements, if $d = -4a$, whereupon the circle-pole lies at the traditional focus and the point-pole is at the reflection of the focus in the directrix (Fig. a_3). Similarly, the upper eq. of Fig. a_4 simplifies and its locus becomes more symmetrical relative to the reference elements if $h = 3a$, whereupon the point-pole is coincident with the traditional focus and the center of the circle-pole is at its reflection in the directrix.

The eqs. of Figs. a_1-a_4 become identical with the corresponding bipolar eqs.

Polar-Circular Axial Parabolas

general equation

a,d,h,
unspecified

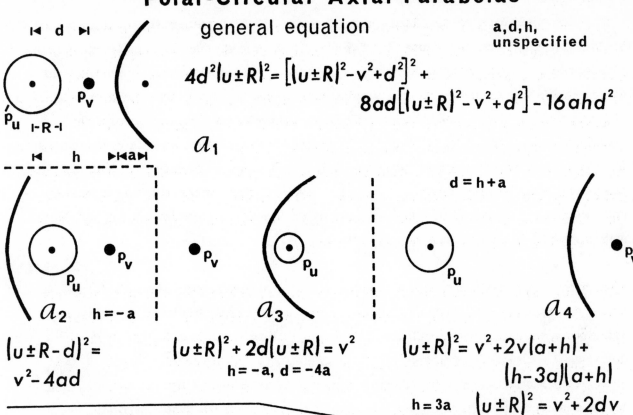

$$4d^2|u \pm R|^2 = \left[|u \pm R|^2 - v^2 + d^2\right]^2 +$$
$$8ad\left[|u \pm R|^2 - v^2 + d^2\right] - 16ahd^2$$

a_1

a_2 $\quad h = -a$

a_3

$d = h + a$

a_4

$|u \pm R - d|^2 =$
$v^2 - 4ad$

$|u \pm R|^2 + 2d|u \pm R| = v^2$
$h = -a, \; d = -4a$

$|u \pm R|^2 = v^2 + 2v|a + h| +$
$|h - 3a||a + h|$
$h = 3a \quad |u \pm R|^2 = v^2 + 2dv$

Hexapolar quartic

Bicircular ellipses

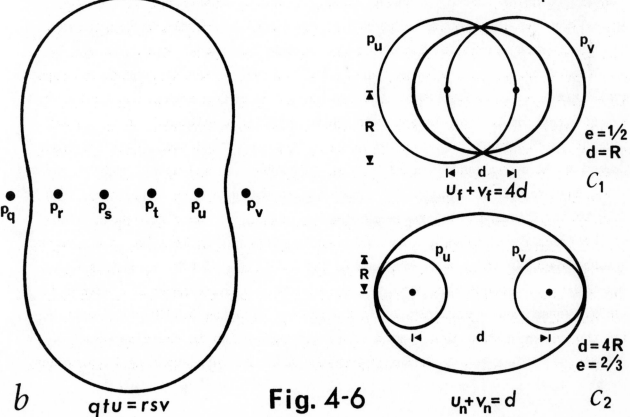

$e = \tfrac{1}{2}$
$d = R$

$U_f + v_f = 4d$

C_1

$d = 4R$
$e = \tfrac{2}{3}$

b $\qquad qtu = rsv$ \qquad **Fig. 4-6** $\qquad u_n + v_n = d$ $\qquad C_2$

if the quantity $(u \pm R)$ is replaced by u alone. This is because when the eqs. for a non-intersecting parabola are formulated with u grouped always with $\pm R$ (with the upper sign for u the least distance, and the lower the greatest distance), the quantity $(u \pm R)$ is simply the distance from the center of the circle. For cases in which the parabola intersects the circle-pole, the eqs. corresponding to those of Figs. a_3 and a_4 (lower) are $v^2 = [\pm(u-R)+d/2]^2 + d[\pm(u-R)-d/4]$ and $(u-R)^2 = (d/2+v)^2 + d(d/2+v) - 3d^2/4$. For the former eq., $R > d/4$ (the condition for intersection), the upper sign is for the greatest distance from the circle-pole and the lower is for the least distance. For the latter eq., $R > 3d/4$ (the condition for intersection), and the eq. holds for both the greatest and least distances from the circle-pole.

The symmetrical triple-product eq. of Fig. b, for equally-spaced, collinear hexapolar coordinates, represents the illustrated quartic curve (eq. IV-20) plus the midline (not shown). Other symmetrical triple-product eqs. (i.e., eqs. involving products such as $qrs = tuv$, $qrt = suv$, and $qsu = rtv$) generally represent quintics.

Fig. c_2 illustrates a bicircular construction of an ellipse for both co-ordinate distances (u_n and v_n) the *least* distances from the circle-poles. Because of the linearity of the eq., similar eqs. hold for greatest-distance constructions, for example, $u_f + v_f = 2d$ for the same ellipse. An example of an ellipse construction in which the ellipse intersects the circle-poles (Fig. c_1) and the circle-poles also intersect one another, is $u_f + v_f = 4d$, for a centered ellipse with $a = R$, $b = 3^{\frac{1}{2}}R/2$, and $d = R$. Linear eqs. in congruent bicircular coordinates also represent hyperbolas, but these eqs. involve differences, rather than sums, of the coordinate distances, i.e., $u - v = Cd$.

Fig. 4-7. Linear-circular axial conics. Linear-circular one-arm axial parabolas are less symmetrical than confocal two-arm parabolas. Their general eq. (IV-37) is of 2nd degree. A specific example, with $d = 2R$, $h = 3R$, and opening away from both the line-pole and the circle-pole, is represented by Fig. a.

Axial central conics are represented by the linear eq., $u = ev$. Two specific examples are the $e = \frac{1}{2}$ ellipse of Fig. b_1, with $d = 4R$, and the $e = 2$ two-arm hyperbola of Fig. b_2, with $d = 4R$. For the latter locus, one arm is represented by the least-distance construction and the other by the greatest-distance construction. The curves are centered at $e(de-R)/(e^2-1)$, with respect to the center of the circle-pole.

Linear-Circular Axial Conics

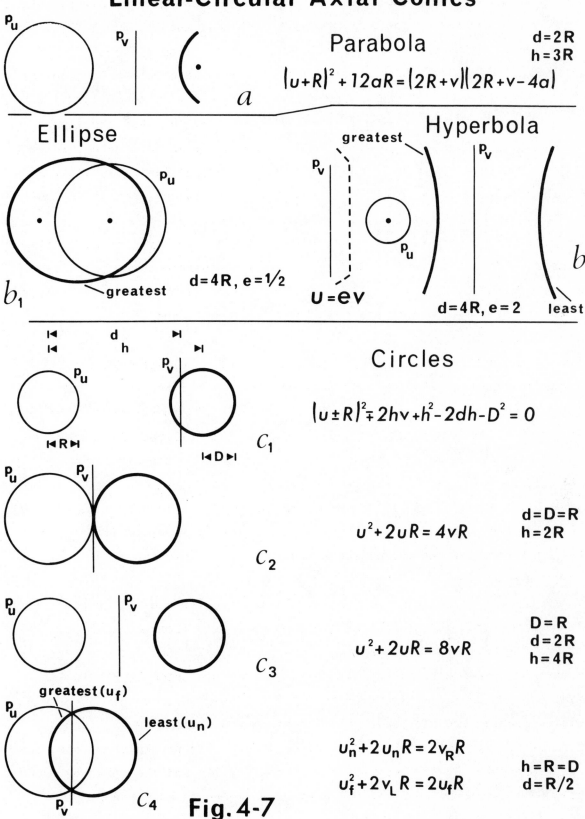

Parabola

$d=2R$
$h=3R$

$$(u+R)^2+12aR=(2R+v)(2R+v-4a)$$

a

Ellipse

$d=4R,\ e=\tfrac{1}{2}$

greatest

b_1

Hyperbola

greatest

$u=ev$

$d=4R,\ e=2$

least

b_2

Circles

$$(u\pm R)^2\mp 2hv+h^2-2dh-D^2=0$$

C_1

$$u^2+2uR=4vR$$

$d=D=R$
$h=2R$

C_2

$$u^2+2uR=8vR$$

$D=R$
$d=2R$
$h=4R$

C_3

greatest (u_f)

least (u_n)

$$u_n^2+2u_nR=2v_RR$$

$$u_f^2+2v_LR=2u_fR$$

$h=R=D$
$d=R/2$

C_4

Fig. 4-7

Circles centered at a point in the plane have a 4th-degree linear-circular eq. (IV-39a), which includes two independent sets of alternate signs. For axial circles ($k = 0$), however, this reduces and simplifies to the 2nd-degree eq. of Fig. c_1. The upper alternate sign of R is for u the least distance to the circle-pole and the lower for u the greatest distance, while the upper alternate sign for the 2hv term is for the portion of the locus to the right of the line-pole, and the lower alternate sign for the portion to the left of it. Although this formulation assumes non-intersection with the circle-pole, the combinations of alternate signs for greatest and least distances, and for portions of loci to the right and left of the line-pole, usually include an appropriate one for portions of loci that intersect the circle-pole.

The most symmetrical axial circles (radius, D) are those for which the constant term of the eq. of Fig. c_1 vanishes, i.e., $R^2+h^2-2dh-D^2 = 0$. Several examples of these are given in Figs. c_2-c_4. Fig. c_2 is the case for which the circle-pole (p_u), the line-pole (p_v), and the axial circle are mutually tangent, with $d = D = R$, and $h = 2R$, for which great simplification occurs in the eq. of Fig. c_1.

The case for $D = R$, $d = 2R$, and $h = 4R$ finds the locus congruent to p_u and the line-pole midway between them (Fig. c_3). The symmetry of this circle is slightly less than that of the circle of Fig. c_2, inasmuch as the coefficient of the vR term is of greater magnitude.

If the circle-pole, the line-pole, and the axial circle intersect one another at common points, as in Fig. c_4 ($h = R = D$; $d = R/2$), the complete locus no longer can be represented by a single 2nd-degree eq., but requires a degenerate 4th-degree eq. Upon this basis the circle of Fig. c_4 is less symmetrical than the circles of Figs. c_2 and c_3 but more symmetrical than those of Fig. c_1. [If one could regard a comparison between a segment of a circle and a full circle as valid, the circle segments of Fig. c_4 would have to be regarded as being slightly more symmetrical than the circles of Figs. c_2 and c_3, inasmuch as the coefficient of the vR term is neared to unit value.]

Fig. 4-8. Plots of loci in the polarized 45° and 135° bilinear systems employing undirected distances. The 45° system consists of the segments of the plane lying between the two lines in the 45° sectors; the 135° system consists of the remaining two segments, as indicated for one of each of the two sectors in Fig. c_1. For purposes of illustration the systems are juxtaposed.

The most symmetrical curve in each system is the midline or bisector (Fig. a). Among the next-most-symmetrical curves are the line segments given by the eqs. $u+v = j$ and $u-v = j$, as illustrated in Figs. c_1 and c_2. The circular eq., $u^2+v^2 = j^2$, represents an ellipse of eccentricity, $e = 0.910$ (Fig. b), the equilateral hyperbolic eq., $uv = j^2$, represents hyperbolas of eccentricity 1.082 in the 45° system and 2.613 in the 135° system, the equilateral hyperbolic eq., $u^2-v^2 = j^2$, represents segments of equilateral hyperbolas (Fig. e), while the parabolic eq., $u^2 = jv$, represents segments of parabolas. Segments of a single circle are represented by different eqs. for the two systems, as given in Fig. f.

In the cases of Figs. a, b, c_1, d, and f, the loci represented by the accompanying eqs. are the same for the unpolarized systems. On the other hand, for the other figures the loci depicted would have to be reflected through *both* lines of symmetry to be representative of the unpolarized systems (both bisectors of Fig. a). Although the curves given in both systems by a single eq. (which excludes Fig. f) are continuous between the two systems for all cases except Fig. d, only in the cases of Figs. b and e do the curves join to form a locus with a single rectangular eq. that has the same degree as the eq. in u and v. The analytical requirement for this, which holds for all complementary $\theta-(180^{\circ}-\theta)$-bilinear systems, is that the values of u and v occur only in even powers, as in the eqs. for the loci of Figs. b and e. Otherwise, as many as 4 rectangular eqs. of the same degree may be required.

Eqs. of a given type in rectangular coordinates give curves or curve segments of a given type in all bilinear systems, regardless of whether the systems are polarized or unpolarized, or employ directed or undirected distances, i.e., rectangular eqs. of central conics represent central conics in bilinear systems, rectangular eqs. of parabolas represent parabolas, and rectangular eqs. of lines represent lines.

45° And 135° Bilinear Loci

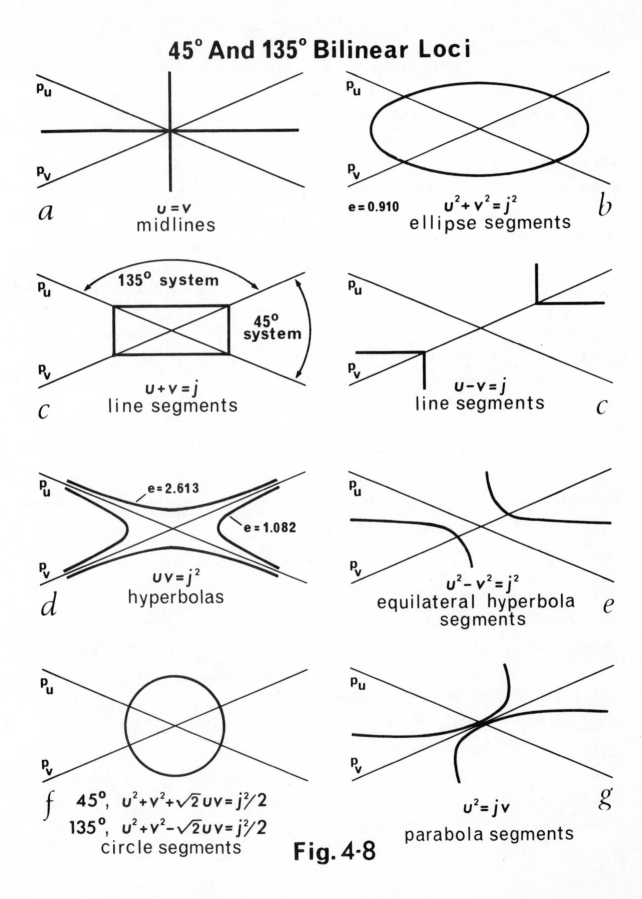

a $u = v$ midlines

b $e = 0.910$ $u^2 + v^2 = j^2$ ellipse segments

c 135° system 45° system $u + v = j$ line segments

c $u - v = j$ line segments

d $e = 2.613$ $e = 1.082$ $uv = j^2$ hyperbolas

e $u^2 - v^2 = j^2$ equilateral hyperbola segments

f 45°, $u^2 + v^2 + \sqrt{2}\, uv = j^2/2$
135°, $u^2 + v^2 - \sqrt{2}\, uv = j^2/2$
circle segments

g $u^2 = jv$ parabola segments

Fig. 4-8

Fig. 5-1. The 180°-circumpolar intercept transform about the traditional foci of central conics. This transform is illustrated with an ellipse and hyperbola (labelled "basis ellipse" and "basis hyperbola") that have identical parameters a and b and are monoconfocal (see page V-12). The 180° transforms of these curves about the traditional foci consist of identical equilateral hyperbolas, $2axy = b^2(x+y)$. Only one arm of the 180° transform, shown at the left and labelled "transform equilateral hyperbola," is traced out by a plot of the intercepts of the basis curves. The x-axis is coincident with the major (and transverse) axis, and the y-axis is coincident with the common LR; the common traditional focus is at the origin.

To illustrate the manner in which the transform curve is generated as the x and y radius vectors rotate about the left traditional foci, the angles that the x radius vectors make with the x-axis are marked off along the transform at positions corresponding to lengths of the intercepts along the axes. As examples of correspondences between positions of the radius vectors and points on the transform curve, for $\theta = 0^\circ$, the x intercept for the ellipse is a(e+1)--the distance from the left focus to the right vertex--and the y intercept for the ellipse is a(1-e)--the distance from the left focus to the left vertex. The point on the transform curve corresponding to these lengths of the intercepts is at [a(e+1), a(1-e)] at the top of the figure to the left of the major-axis vertex, marked 0 for 0°, etc. For the basis hyperbola, the point on the transform curve corresponding to 0° is at [a(e-1),∞]. At $\theta = 90^\circ$, all radius vectors come into coincidence with the common LR of the basis curves (which are coincident with the y-axis), yielding a common point on the transform curve at $(b^2/a, b^2/a)$.

Note that there are differences in the spacing of equal increments of θ for the two basis curves. These provide the basis for the ordinal rank eqs., $\overset{o}{s}{}^2 = (ds/d\theta)^2 = f(x,y)$, and subordinal rank eqs., $\overset{o}{s}{}^2_\theta = g(x)$, that serve for hierarchical circumpolar symmetry ranking at the next level of discrimination beyond the degree of the corresponding transform eq. (see Tables I-1 and V-1,2, and Appendix III).

180°-Circumpolar Intercept Transform About The Traditional Foci of Central Conics

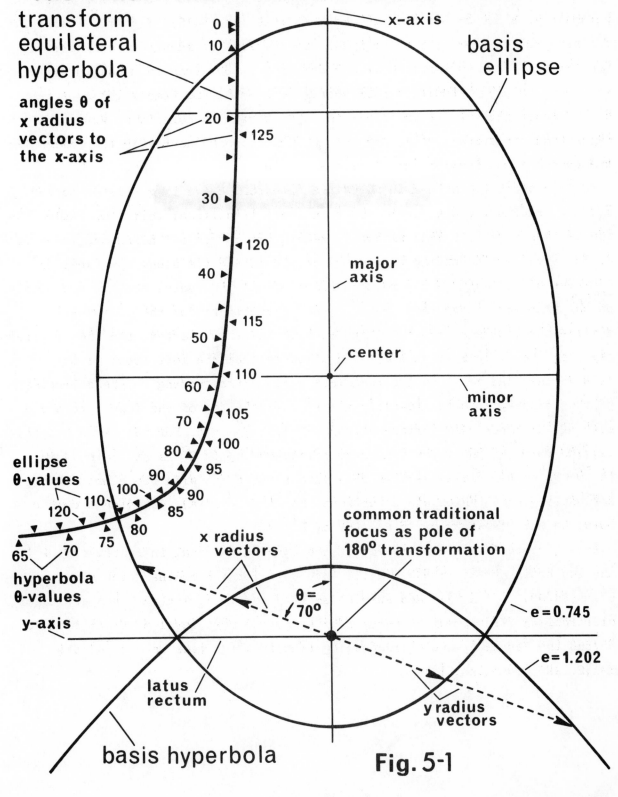

transform equilateral hyperbola

angles θ of x radius vectors to the x-axis

x-axis

basis ellipse

0
10
20
125
30
120
major axis
40
115
50
center
110
60
minor axis
70 — 105
80 — 100
95
ellipse θ-values
90
100
90
120 110
85
90
80
75
65 70
hyperbola θ-values

common traditional focus as pole of 180° transformation

x radius vectors

θ = 70°

e = 0.745

y-axis

e = 1.202

latus rectum

y radius vectors

basis hyperbola

Fig. 5-1